THE MAGIC IMAGE

CECIL BEATON AND GAIL BUCKLAND

THE MAGIC IMAGE

THE GENIUS OF PHOTOGRAPHY

PAVILION

This edition published in 1989 by
PAVILION BOOKS LIMITED
196 Shaftesbury Avenue, London WC2H 8JL
First hardback edition published in 1975 by
George Weidenfeld and Nicolson Ltd

Designed by Barney Wan

A CIP catalogue record for this book is available from the British Library

ISBN 1 85145 343 1

10 9 8 7 6 5 4 3 2

Filmset by BAS Printers Limited,
Over Wallop, Hampshire.
Printed in Italy by
Arnoldo Mondadori Editore – Verona.

CONTENTS

Preface to the New Edition

The Magic Image: The Genius of Photography from 1839 to the Present Day was an eye opener. When it was originally published in 1975, there was no comparable survey. We resurrected forgotten masters and proclaimed equality among photographers whose work had been classified as fashion, art, commercial and 'primitive'. We chose to salute those we most admired and reproduced inspiring examples of their work.

Cecil Beaton and I were very different. I am an American of the sixties generation, schooled in looking at photographs for their social, aesthetic, psychological and yes, even metaphysical relevance. Cecil, as the whole world knew, had style. When I told him, for example, that Paul Strand *must* go into the book, he declared that he found Strand 'boring' but invited me to give evidence to convince him otherwise. I argued effectively and Strand is in the book. Subsequently, Cecil suggested that if *either* of us were ardent about any individual photographer or picture, it would be included. The book may at times seem uneven, but it is never dull.

Since his youth, Cecil Beaton had been a student of photographic history. He always cut out pictures to paste into his innumerable scrapbooks, investigated the lives of his favourite photographers and recorded in his diaries his encounters with his contemporaries, from Steichen in the twenties to Bailey in the seventies.

As he approached his seventieth year, our book of photographic history became his most pressing commitment, his most heartfelt project. For over a year we worked on it together almost daily. I learned to respect Cecil not only for his past accomplishments, his incomparable talent and his flair for choosing wonderful pictures, but also for the seriousness and dedication with which he worked on the book.

Both Cecil and I always wanted *The Magic Image* to be reissued as a paperback. The original edition, designed by the sensitive and deft Barney Wan who Cecil handpicked for the book, was sold out in England within a few months of publication. As *The Magic Image* has become a classic, only the most minor changes have been made to this current reprint: birth and death dates up-dated; some factual errors corrected, and one photograph added that had inadvertently been left out. I am delighted that *The Magic Image* is once again available for the serious student of photography and those just becoming interested in the field.

Gail Buckland, March 1989

Authors' Note

Since this is an entirely personal selection of photographers whose work we most admire, it is inevitable that there will be criticism of our choice. No doubt many will object that certain important branches of photography have been omitted, while others have been given undue emphasis. This cannot be avoided in a book of this nature. Any dictionary or compendium, on no matter what subject, must at any given moment be incomplete. Newcomers have not yet been spotted, or their appearance was too late for even 'stop press' inclusion.

Many photographers with claim to fame have been left out – perhaps purposely or, unfortunately, because examples of their work have not come to light. We can only sympathize with those who feel that they have not been worthily represented. We express gratitude to those who have given co-operation and have supplied us with their best.

CB *and* GB

Since the original publication of *The Magic Image*, there has been a surge in photographic research, exhibitions and books. Readers of *The Magic Image* may like to refer to the following encyclopaedias of photography for more up-to-date information on photographers in the book:

Brown, Turner and Partnow, Elaine. *Macmillan Biographical Encyclopaedia of Photographic Artists and Innovators* Macmillan Publishing Company New York, 1983, and Collier Macmillan, London, 1983.
International Center of Photography *Encyclopaedia of Photography* Crown Publishers, New York, 1984.
Auer, Michèle and Auer, Michel *Photographer's Encyclopaedia International 1839 to the Present* (2 Volumes) Editions Camera Obscura, Geneva, 1985.

Acknowledgments

The authors and publishers would like to thank all the photographers, their families and their friends who generously supplied the information and images which made this book possible.

They should also like to express their deep gratitude to Eileen Hose for her untiring devotion to this undertaking, and to L.Fritz Gruber who provided invaluable assistance at every stage of the project.

Hundreds of individuals have helped in the preparation of this book and to them the authors and publishers extend their appreciation. A special debt of thanks goes to the following people: Odette M.Appel, Richard Avedon, Albert K.Baragwanath, Pamela Booth, Irene Borger, Sue Davies, Anna Fárová, Leo De Freitas, Helmut Gernsheim, Kahlil Gibran, Arthur Gill, Ceuzon Grayson, John Hannavy, John Hillelson, H.P.Horst, Peter Hunter, Harold Jones, Zdeněk Kirschner, Lincoln Kirstein, Terence Le Goubin, M. Lemagny, Alexander Liberman, Valerie Lloyd, Bernd Lohse, Dennis Longwell, John J. McKendry, Romeo Martinez, George Nash, Colin Osman, Irving Penn, L. Roosens, Elizabeth Shaw, Joel Snyder, Robert Sobieszek, John Szarkowski, David Thomas, Peter Turner, John Ward and Kenneth Warr.

Many of the photographs reproduced in this book have come from the photographers themselves, from the authors' personal collections and also from untraceable sources. Whenever possible credit has been given to the source of each photograph, except (for reasons of space) in the case of living photographers who have supplied their own photographs, in which case, unless stated otherwise, the photograph is the copyright of the individual photographer. If any oversight in the credits has occurred, the authors and publishers extend their sincere apologies.

Thanks are due to the following individuals and institutions who have provided illustrations (when more than one picture appears on the page, the photographs are assigned letters alphabetically from left to right, top to bottom): Kathryn Abbé 185B; © Aperture Foundation Inc., Paul Strand Archive 191; Berea College, Kentucky 140; © Ian Berry/Magnum Photos 247B; Bibliothèque Nationale, Paris 13A, 13B, 13C, 69A, 74, 90A, 90B, 90C; Birmingham Public Library 88A; © Werner Bischof/Magnum Photos 211B; Margaret Bourke-White (Life Magazine © Time Inc. 1989), Colorific Photo Library Ltd 182A; Larry Burrows (Life Magazine © Time Inc. 1989) Colorific Photo Library Ltd 216, 217; © Robert Capa/Magnum Photos 174, 175A, 175B; © Henri Cartier-Bresson/Magnum Photos 186, 187, 188A, 188B, 189A, 189B; Greater London Photographic Library (Corporation of London), London 48B; Alfred Eisenstaedt (Life Magazine © Time Inc. 1989) Colorific Photo Library Ltd 182B; © Elliot Erwitt/Magnum Photos 228; Fondazione Primoli, Rome 82A, 82B, 82C, 83; © Leonard Freed/Magnum Photos 246B; Lady Freyberg 27A; Galerie Klihm, Munich © Hattula Moholy-Nagy, Zurich 145, 154–5; © George Gerster, from the John Hillelson Agency 218–19, 225; © Philip Jones Griffiths/Magnum Photos 236, 237A, 237B, 238, 239; L. Fritz Gruber Collection 152, 293B; Mrs Cora Harris 106; © Frau Tutti Heartfield, Heartfield Archive, Deutsche Akademie der Kunste 183; Ernst Haas/Magnum Photos 221; The Hulton Deutsche Collection 287C; H.P. Horst 147, 190A; International Museum of Photography at George Eastman House 42B, 43B, 71, 105B; André Jammes 48C; Mrs Dudley Johnston 124; Dmitri Kessel (Life Magazine © Time Inc. 1975), Colorific Photo Library Ltd 202; © Josef Koudelka/

Magnum Photos 266A, 266B, 267, 268–9; J.H. Lartigue, from the John Hillelson Agency 116, 117A, 117B, 130–31; Library and Museum of the Performing Arts, Lincoln Center, New York (Roger P. Dodge Collection, Dance Division) 295, 296, 297C; Library of Congress, Washington D.C. (Arthur Rothstein Collection) 169, (Frisell Collection) 190B; Life Magazine © Time Inc. 1989, Colorific Photo Library Ltd 288C; Light Gallery, New York 211A, 256B; Professor Lubomir Linhart, Prague 142; © Danny Lyon/Magnum Photos 246A; McCord Museum, McGill University, Montreal 72B; Mansell Collection Limited, London 68; Mme F. Masclet 166C; Musée Carnavalet, Paris 70; Musée du Conservatoire des Arts et Métiers 129B; Museum of the City of New York 86–7, 125A, 292A; Museum of Decorative Arts, Prague 151; Museum voor Fotografie, Antwerp 125C; NASA (Life Magazine © Time Inc. 1989), Colorific Photo Library Ltd 31B; National Archives, Washington D.C. 13D, 60; National Portrait Gallery, London 38A, 38B, 39A, 39B, 40A, 40B, 41; Natural History Museum of Los Angeles County 122A; Courtesy of the Dorothea Lange Collection © The City of Oakland, the Oakland Museum, 1989, 168; Anthony D'Offay 91, 143; Graham Ovenden 15A; Gordon Parks (Life Magazine © Time Inc. 1989), Colorific Photo Library Ltd 235; Lord Pembroke 16A, 16B, 16C, 20C, 20A, 20B, 20C; Irving Penn (by kind permission of the Condé Nast Publications Inc., New York), 240A, 240B, 241, 242, 243; From *Petit Musée de la Curiosité Photographique* (ed. L. Chéronnet), 14, 15B, 15C, 17A, 21, 22A, 22B, 23; Rapho Agence de Presse Photographique Paris 229A; Anna Ray-Jones 259A; Jürgen Wilde/Albert Renger-Patzsch Archiv 198; © Marc Riboud/Magnum Photos 234A, 234B; © George Rodger/Magnum Photos 180; Lady Rothermere 27B; Mrs K. Buck/Francis Frith Collection 73A; Royal Library, Windsor (by gracious permission of HM the Queen) 12A, 72A; Royal Photographic Society, Bath 10A, 18, 19, 22C, 26, 28A, 29 (right), 44, 44–5, 46, 46–7, 50, 51, 52, 53A, 53B, 62, 63, 64A, 64B, 64C, 65, 67, 73B, 75A, 75B, 75C, 76A, 76–7, 77A, 77B, 79, 80A, 80B, 81, 88B, 89, 92A, 92B, 93, 94–5, 96, 96, 98–9, 100, 101A, 101B, 102, 103A, 103B, 108B, 110, 111, 112, 113A, 113B, 114, 115A, 115B, 118A, 118B, 119A, 119B, 119C, 120, 121A, 121B, 125A, 126, 127A, 127B, 127C, 150, 179C, 276B, 277A, 277B, 291D; Royal Society of Medicine, London 48A; Franco Rubartelli-Vogue France–copyright © Les Publications Condé Nast S.A. 220; © Erich Salomon, from the John Hillelson Agency Ltd 162, 163A, 163B, 163C; Marie-Loup Sanchez-Cascado Sougez/Bibliothèque Nationale, Paris 193; Gerd Sander/August Sander Archive 141; Marina Schinz 132, 159, 160; Lennart Nilsson/Science Av, Stockholm 210; Trustees, Science Museum, London 10B, 32, 33A, 33B, 34A, 34B, 35; © David Seymour (Chim)/Magnum Photos 231B; The Sutcliffe Gallery, Whitby (by agreement with the Whitby Literary and Philosophical Society) 78; George Silk (Life Magazine © Time Inc. 1989), Colorific Photo Library Ltd 134, 256A; Olive Smith 206; W. Eugene Smith/Magnum Photos 204A, 204–5; Société Francaise de Photographie, Paris 11A, 11B, 36A, 36B, 37, 129A; Staatliche Landesbildstelle, Hamburg 43A; Harry Ransom Humanities Research Center, the University of Texas at Austin 9, 54; Tessa Traeger 264B; By courtesy of the Board of Trustees of the Victoria and Albert Museum, London 11C, 12B, 17B, 25, 42A, 49B, 49C, 55A, 55B, 56, 57, 290A, 290B, 290C, (Guy Little Collection) 291A, 291B, 294C, 294D; © 1981 Arizona Board of Regents, Center for Creative Photography 157, 158.

Photography may be said to have begun with man's discovery that the tanning of his face in summer was due to the chemical effect of the sun's rays on his skin. Primitive natives enjoyed making patterns by sticking leaves on their bodies. When these were removed, a pale design was revealed.

Two thousand years ago china plates heated chemically were made sensitive to light. Among the ruins of Nineveh, Egypt and Pompeii lens-shaped pieces of glass have been unearthed; Euclid and Aristophanes were acquainted with the 'burning lens'; and a thirteenth-century Franciscan friar, Roger Bacon, considered by his contemporaries to be a wizard, used lenses and mirrors to produce 'visible pictures'. Alberti invented a camera obscura which he described as a *miracolo della pittura*; Leonardo da Vinci's scientific manuscripts contain detailed descriptions of his 'darkroom'; while the Neapolitan, Battista Porta, in his book, *Natural Magic*, described how he exhibited a facsimile of the view from his room on the opposite wall by means of a pin-hole in an otherwise blacked-out window.

During the eighteenth century, draughtsmen used a camera obscura, a rather bulky machine, as an aid to drawing in perfect perspective. At first, they were obliged to enter a dark room in order to trace by hand the outlines of the image thrown from a small box fitted with a lens on to a ground-glass screen. The image was viewed through the screen at the back, and the artist, having pointed the lens at the scene he wished to delineate, traced what he saw on a thin piece of paper placed over the glass. Later, when the *camera obscura portabilis* of a reflex design was invented, the Canaletto family used this portable small box to help them in their ambitious attempts to record vast architectural views of cities, river scenes and the façades of palaces with their terraces and noble gardens.

In 1798 Aloys Senefelder invented a method of surface printing on stone – a cheap substitute for copper plates – and Thomas Wedgwood, son of the potter, made successful shadow prints of lace, leaves and transparent objects utilizing silver nitrate. Wedgwood also carried out experiments in order to try and help his artists with decorations for grand table services. These images had to be examined by the light of a candle. But how to fix the picture permanently? Though none of the work of Wedgwood has survived, his experiments were the forerunners of the silver-printing process of today.

In April 1816, Nicéphore Niepce, a French landowner with scientific interests, an experimenter in lithography and heliography ('sun drawing'), wrote to his brother in England of the 'artificial eye' he had made from a box six inches square with a lenticular

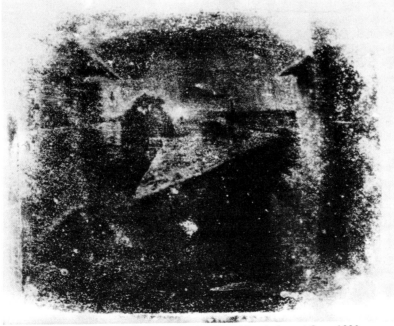

Nicéphore Niepce. Heliograph taken from his window at Gras, 1826.

Above, left Calvert Jones, Calotype negative. *Right* W. H. F. Talbot, The earliest extant negative, August 1835. The lilac negative is roughly 1 inch square.

glass. Later, from a jewel-case, with the lens of a microscope, he made a miniature camera one and a half inches square, with which he produced an impression of the bird-house seen from his casement window. In 1827 he visited his brother at Kew, where he showed the secretary of the Royal Society 'the first picture copied from nature', a view from the attic window of his house – the result of an eight-hour exposure.

Meanwhile, in the west of England William Henry Fox Talbot, a man blessed with an unusual imagination, uncommon knowledge and a wide range of interests, was at work experimenting with heliography. Fox Talbot had been engrossed in mathematics, physics, astronomy, botany, archaeology and chemistry, and for two years he was a Member of Parliament. At an early age he began scientific research. He saw the future of this art of producing permanent and visible images by the action of light and how it might be adapted to microscopic work and used as a means of reproduction: he even envisaged the possibility of taking photographs by invisible rays. 'What a dénouement for a novel', he wrote, 'if we could suppose the secrets of the darkened chamber to be revealed by the testimony of the imprinted paper!' With an instrument called the camera lucida, Talbot sketched landscapes from the image seen on paper through a four-sided glass frame. This contraption had often proved useful to the practised draughtsman; but, since it required a knowledge of drawing which he did not possess, Talbot abandoned it and turned to the camera obscura. But he was dissatisfied with the results, and was determined to capture the projected image permanently. At home in Wiltshire, Talbot recorded what he considered a great 'breakthrough'. He produced some 'photogenic drawings' (of his house, etc.) which consisted of exposing sensitized paper in a camera until an image appeared which was then 'fixed'. Later, by using a mixture of gallic acid with a solution of silver nitrate he sensitized a sheet of paper; this was then exposed to light in a camera; in a comparatively short time – of minutes rather than hours – the 'latent image' was produced which on development resulted in a negative from which a positive could be obtained. This new process, which Talbot called the calotype (*kalos* means beautiful) but which his friends preferred to refer to as the 'Talbotype', produced paper portraits for the first time, though in fact, the first negative–positive print was of the oriel window of Talbot's home at Lacock Abbey where, today, the yellow damask roses lean against the leaded panes. But Talbot's hope of being the first to announce to the world the new invention was shattered when on 7 January 1839 Louis Daguerre in Paris made public his copper plates.

Daguerre, early in the nineteenth century, drifted into the world of the theatre, and became a scenic artist rich in ingenious stage effects. With his magic lanterns he created 'dissolving views', and his Diorama, in which theatrical painting was used in conjunction with lights that changed in colour and direction, reproduced grandiose effects of sunrise and sunset, and storms complete with lightning.

Nine-tenths of Daguerre's time was spent in his laboratory, and so great was his enthusiasm that his alarmed wife suggested he was going mad; Daguerre had probably been working on the problem of capturing an image on to a plate for at least fourteen years when suddenly his determination to succeed was rewarded. One day Daguerre put away in a cupboard, among various bottles of acid, a plate which had been inadequately exposed in his camera and which he intended to have re-polished. When, twenty-four hours later, he returned to the cupboard, he found on the plate an exquisite picture. 'I have seized the

10

light, I have arrested its flight,' shouted the inventor to his appalled wife. Once more he hid a plate in his magic cupboard, and next day again it showed a picture. The miracle proved to have been brought about by vapours of mercury acting on the invisible image of the under-exposed plate in an exact ratio to the amount of light to which the sensitive copper had previously been exposed.

The whole world was fascinated by Daguerre's narrative of his romantic discovery. Unbelievers examining the highly polished surface of the copper plate exclaimed: 'Why, we can count the paving stones, see the dampness produced by rain, read the name of a shop!' The historical painter, Paul Delaroche, is claimed to have said: 'From today painting is dead!'

Immediately after Daguerre's bombshell, on 25 January, Michael Faraday informed the Royal Institution of Henry Fox Talbot's photographic experiments, and displayed on the walls of the upper library of the Institution examples of his 'photogenic drawings', both negatives and positives. On 31 January Talbot presented his paper to the Royal Society telling how he had constructed a simple box camera for taking views of his home on paper sensitized by silver nitrate. These pictures he claimed to be the earliest photographs of any building. Talbot thus anticipated Daguerre's publication of the details of his process by six months.

When both processes were known, it was seen that they were completely different. Daguerre produced a single opaque plate on which the image was reversed, while Talbot gave us a negative from which any number of copies could be made and was, in fact, the forerunner of modern photography as we know it throughout the world today.

In his *Pencil of Nature*, the first book to be illustrated by more than one photograph, Fox Talbot described how the beauty of the pictures thrown by the glass lens on to the paper, inspired in him the determination to capture these images. He reasoned that, considered dispassionately, these pictures, like any others, consisted of no more than a succession of various tones upon paper. If he could prepare the paper so that it would react to light giving a succession of shades – and he knew that light could exert action – might he not expect them to leave their beauty behind? The prints which included the leaf of a plant in positive, a shadowgraph of lace, and the gnarled roots of a wistaria were chosen to illustrate the variety of subjects that the camera could portray.

These same subjects – plaster-cast copies of Greek and Roman sculpture, garden implements, barns and pots – were being photographed in France by a dear, pug-nosed, but sad man in a smoking-cap named Hippolyte Bayard. He was sad because he was never acclaimed – as he and many others today consider he should have been – as one of the real inventors of photography. Bayard used a sheet of paper sensitized in silver nitrate and allowed it to darken in the light; he then resensitized the paper in potassium iodide just before using it. In the darkroom a strange metamorphosis took place for the picture became positive. It was not possible to reproduce this unique print, nor had it the detailed clarity of a daguerreotype, but Bayard organized an exhibition of thirty of these prints in 1839, a month before details of the discoveries of Niepce and Daguerre were announced. Thus he gave the first photographic exhibition in the world. Bayard continued his experiments, adopted the Talbotype or calotype and produced some of the best early photographs.

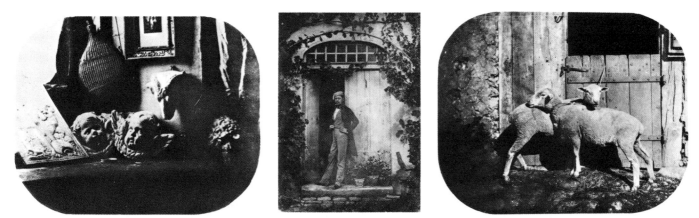

Above, left Louis Daguerre, *The Photographer's Studio*, 1837. *Centre* Portrait of Bayard, from a daguerreotype. *Right* Camille Silvy, *Sheep*.

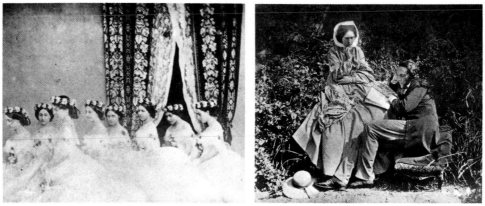

Left T. R. Williams, Daguerreotype of the Princess Royal's bridesmaids, 1858. *Right* F. R. Pickersgill, *Sunshine and Shade, c.* 1859.

Daguerre had proposed that he and Niepce should meet since, he claimed, they were working on similar experiments. Though suspicious at first, Niepce on his way home from England visited Daguerre in Paris and, as a result, the two entered into partnership in 1829. Soon afterwards, in 1833, Niepce died. When the French government later granted a lifetime pension to Daguerre of six thousand francs per annum in exchange for his secret invention, a grant was made to the son of Niepce. It was considered that, if left to individual initiative, all the advantages of the new invention might be lost. Daguerre accepted the grant on condition that his discovery, 'the first practical and successful photographic process', should be given to the entire civilized world and that its knowledge should become public property; but he took out a patent for his process in England, possibly because he was aware of the rival researches of Henry Fox Talbot.

The chemically treated copper plates which the French experimenters, Niepce and Daguerre, were using were extremely fine in texture and detail, but there was no way of making copies. Nevertheless, at first it was the daguerreotype which caught on. Public enthusiasm was extraordinary, and when the secret was divulged by the physicist Arago at a sitting of the Académie des Sciences on 7 January 1839, a mob stormed the Institute.

The earliest surviving daguerreotype was an atmospheric mood-picture of a corner of Daguerre's studio, showing a litter of plaster casts by a window. But, in general, the daguerreotype was without aesthetic pretensions. By 1841 a number of studios were making hay with their technically perfect, if somewhat stereotyped, likenesses. There was no choice of pose, and any elaborations were made only from commercial motives. The portly paterfamilias in his 'Sunday best', with watch-chain and protruding stomach, sat with his hands on his knees; the women, with spaniel hair and compact bodices, were somewhat overawed.

The daguerreotype was so delicate that it had to be handled with extreme care and was presented in an elaborate case or frame, possibly of gold tooled leather and plush. At first the sitters, accustomed to the flattery of such portrait-painters as Winterhalter, were appalled by their straightforward and unbecoming likenesses, and although retouching was impossible, in an attempt to soften the shock the faces were sometimes rosily tinted. The procedure of being photographed was not without its hardships for the earliest sitters. In some instances they had to submit to having their faces painted white; the exposure might last as long as one minute.

Talbot's process, at first almost eclipsed by that of Daguerre, was gradually developed and improved, and his exposures cut down considerably, so that the calotypes with their sepia warm tones and gentler tonality became so popular that, after twenty years, the daguerreotype was extinct.

The rise of photography was so sudden that by 1842 it was already being used to document objects, furniture and paintings, so that Lord Hertford of the Wallace Collection wrote to Sotheby's to complain of the delay of arrival of the latest batch of photographs – no doubt of ormulu-mounted commodes or Fragonards that he wished to buy.

In 1851 Frederick Scott Archer invented a method by which a glass plate, coated with a thin film of collodion and potassium iodide and then dipped into a solution of silver nitrate, produced a scrupulously clean, detailed, transparent negative of greatly increased sensitivity. These plates, which had to be exposed and developed while the chemicals were still wet, have not yet been surpassed in exactitude of tone-value.

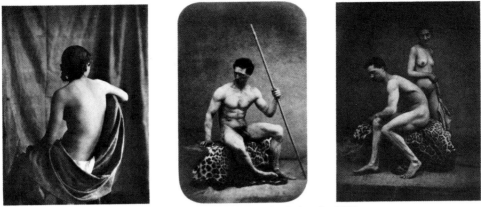

Eugène Durieu, Models posed by Delacroix, 1854.

Cartes-de-visite used as calling-cards became as fashionable in England after John Mayall took these delightful small pictures of the royal family in 1860, as in France when Disderi photographed Napoleon III. The artistic aristocrat Silvy made a fortune out of these miniature pictures by placing his sitters in romantic poses against fanciful decors which he himself skilfully painted.

In 1861 James Clerk Maxwell showed at the Royal Institution a colour photo of a tartan rosette. On one of her public appearances a pistol was pointed at Queen Victoria by Thomas Scaife, who when arrested explained the 'pistol' contained two wet plates two inches square. Model cameras had come in. Later with dry plates the 'detective' cameras, together with the 'waistcoat' and 'handbag' cameras, were popular innovations.

Cameras were hidden in umbrellas, hats, coat-buttons and suspenders. Technical improvements and simplifications were made. Lenses became faster, and plates that were more sensitive were put on the market, so that photographs could be made in cloudy weather. In 1907 the Lumière brothers produced screen plates coated with a solution sensitive to all colours.

Even in studio work, the technique of using wet plates was a complicated procedure: the sitter waited while the photographer vanished to prepare the plates in the darkroom, then hurried to put the plates in the camera. When the exposure was at length made the plate had to be developed within ten minutes. The alfresco photographer's difficulties were far greater since only distilled water could be used, and a fleck of dust or a fly might ruin a plate. However, the zest of the pioneers in the 'black art' brooked no obstacles. A year was spent in tracking down, close to the lens, the red deer in the park at Stoke. Animals were placed in head-rests and other such contraptions to keep them from moving, and policemen had to protect from the inquisitive crowds the photographer erecting his tent in Trafalgar Square, prior to 'taking' Landseer's lions.

With the advent of dry plates in the mid-1880s, retouching became popular, and the beautifying process, which still has the same fascination today, could be carried on without restriction. Sitters who wished to be idealized saw themselves with complexions of an egg-shell smoothness. However, P. H. Emerson, an eminent photographer of the Norfolk

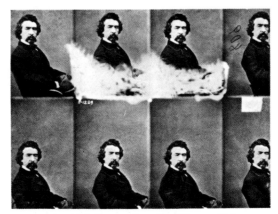

Mathew B. Brady, Self-portrait made with a multi-lens camera.

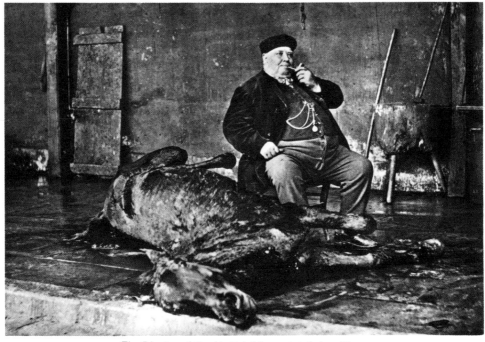

The Director of the Abattoir Marguet at Aubervilliers.

Broads, wrote in shocked terms in *Naturalistic Photography* that 'when it comes to re-touching, to straightening noses, removing double chins, eliminating squints, fattening cheeks, smoothing skins, we descend to an abyss of charlatanism and jugglery which we will not stoop to discuss'.

Enormous glass-plate negatives gained popularity, and Muybridge, Frith and other early travelogue-photographers had extra weight to carry with their already cumbersome, expensive equipment, which included barrels of distilled and ordinary water and a collapsible dark tent. Moreover, they had to run the risk of illness brought on by inhaling the fumes of ether when preparing the developer, for it was not until *c.* 1880 that factory-prepared plates and paper were available.

Man, having mastered a representation of himself and his surroundings in daylight, then determined to probe with the camera the secrets of the dark. His first attempts in 1864 with unpredictable explosions of gunpowder from a long narrow tray held aloft were followed by igniting strips of magnesium wire. This was far from satisfactory for it was never certain when the wire would light, and often it painfully burnt the holder's fingers. In the earliest studios, equipped with the novelty of artificial light, the sitter was revealed in circumstances in which red and yellow registered black. It is not surprising that the likeness was not always recognizable.

To begin with photography had been mostly practised by painters and scientists, but soon a separate profession was evolved of workers who were trained for photography alone. Courses of photography were introduced into polytechnics and schools.

In the 1860s the best photographic work was done by amateurs, by actors, surgeons, caricaturists, engravers, civil servants or aristocrats. Much of the work of these unknown photographers shows an astonishing technical perfection and often a sensitivity of outlook.

Although etchings, woodcuts and silhouettes had been launched successfully on the commercial market, it was photography that democratized the hitherto restricted art of producing pictures. The rise of the middle classes, the widening of people's interests, the trend towards mass production in industry and the rationalization of all processes in the Victorian machine age produced the desire for the use of the mechanical – even in the manual realms of art.

Already, in the mid-nineteenth century, cameras were available for amateurs which produced remarkably sharp negatives with subtle tonality. Enjoying its first popularity was the wide-angle lens which enabled the photographer to include the whole 'country house and grounds', the entire village high street, or the gaily attired group on the river launch. Some of the snaps in family albums hold such absorbing interest that it is difficult to turn the pages. Even those with no historical sense are loath to throw away old snapshots

of aunts and seashore acquaintances. For those with a keen sense of the passage of time, early photographs can take on an importance that perhaps the actual moment, when the shutter opened, did not possess: two boys pause to talk on a beach – nothing of consequence is said, yet an unknown snooper clicks his camera at them . . . an enigma is created that can last to the end of our days.

Many of the topographical photographers were, without knowing it, truly artists. Some of them may have had recourse to embellishing their negatives by adding clouds and foliage, but they were completely lacking in pretension, and most of their work of a straightforward recording nature has a Douanier Rousseau naïveté that is delightfully disarming.

Often these photographic pioneers present us with village streets, jubilee processions, busy markets, and every other sort of rustic activity, brought to a complete standstill. At the camera's command bee-keepers, woodcutters, foresters, rabbit-trappers, anglers, coach-builders, postmen, as well as donkeys, horses, hens, ducks, pigs, cattle, even hounds, remain obedient to the command: 'Don't move!' Aproned assistants stand stiffly outside grocers' and drapers' shops, and a string orchestra, rehearsing in the vicarage garden, and even the competitors in the potato-race, are caught in immobile poses. Sometimes these tacitly obedient sitters are seen in cleverly arranged groups: in a team with scythes, harvesting with a crook-stick and reap-hook, or harrowing with oxen wearing collars rather than yokes. Travelling gipsies pose with their dancing bears; women herring-curers in Northumberland are resplendent in beautiful oilskin aprons and headscarves; top-hatted drivers of gigs are perched aloft, and little boys, leaning on a fence, wear their sisters' discarded skirts and pinafores because their parents could not afford to supply them with jackets and trousers. It seems right that these personages should be seen in a moment of repose: every face appears extremely happy and secure with an expression of contentment and tranquillity now rarely seen.

These early lenses sometimes created exaggerated effects of perspective which are surprising and delightfully dramatic. Francis Frith's postcards of architectural or winter river scenes with phalanxes of willow trees diminishing in the distance, or the formally clipped yew-trees in rural churchyards, come happily to mind.

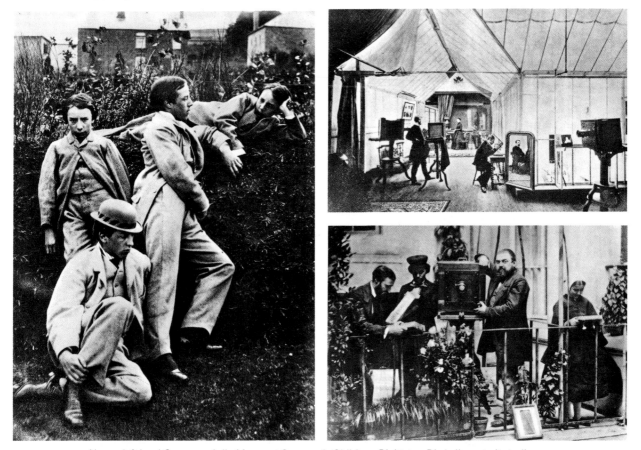

Above, left Lord Sommer, *Julia Margaret Cameron's Children. Right, top* Disderi's portrait studio, rue Lafitte, *c.* 1865. *Bottom* A nineteenth-century French photographer and friends holding printing frames.

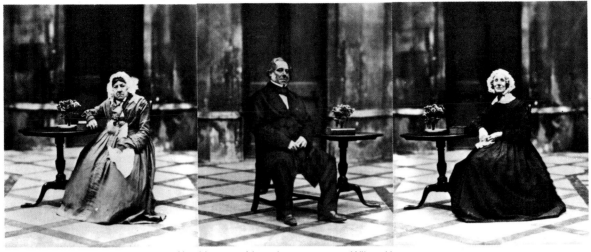

Head housemaids and manservant at Wilton House.

The photographers of urban life show us the street-beggars, flower-girls, urchins, coster-mongers and roadmenders in tall stovepipe bowlers; we peer at the merchandise displayed in the shop-windows, the lettering on the posters plastered on the walls, or hanging from the news-seller's tray. Our impressions of the period are heightened when we read that a baroness has left £15,000 to charities, that a famous actor has died. In photographs of the wealthy Victorian interior we catch the essence of that domestic age. In the farmer's cottage we seem to hear the rustle of the fire in the open hearth. Thanks to the camera, the Victorian age is more real to us than any previous period.

Other photographers determined to explore with lens and plate the secrets of the world of nature. Photographs were taken of a nest near the top of a high, isolated tree with cameras hidden in boxes in neighbouring trees, while the photographer waited many days for a bird to come within range. These photographs are monuments of extraordinary patience and tenacity, for the illustrations were obtained with the use of most elaborate equipment, including such things as a bull's-eye lantern, binoculars, a revolver, ropes for climbing tall trees or going over the face of perpendicular cliffs. Wild beasts in their native haunts, winged insects at play and work, sleeping swallows and chaffinches feeding their young, were thus caught by the lens for the first time in history.

The number of travel photographers grew surprisingly: all parts of the globe were visited by enthusiasts who dived under a black velvet cloth to focus the foreign scene on the ground glass. Herbert G. Ponting was only one such pioneer who, on his return from Japan, and later India, gave illustrated lectures. Scott, the explorer, was an enthusiastic admirer of his and later Ponting went with him to the Antarctic. He was fortunate enough to return, and brought back, apart from documents of historic and geographical interest, striking images of icebergs, ice grottoes, penguins and dog-teams resting under mysterious formations of ice and snow.

Early photographers-without-names who were employed to commemorate clubs, organizations and sports teams often displayed a great deal of artistry. An Edwardian photo-grapher named Heath discovered that, whenever a group photograph was about to be taken, everyone coveted the best position in the centre and was likely to stand strictly to attention, looking straight into the lens. To avoid this unnatural and formal result Mr Heath, when asked to perpetuate Lady Burdett-Coutts's Holly Hill garden-party on the Isle of Wight, requested her to announce on the invitation cards that at 'five-thirty o'clock' he would take a photograph. A bugle-call would warn the guests to prepare for the exposure. At the second call everyone must remain still: a third call would indicate the picture had been taken. At the first note of the bugle the guests rushed around the lawns looking desperately, but in vain, for the camera which was hidden in a nearby window conveniently camouflaged by some ivy. At the second bugle-call there was nothing for it but to stand still. In consequence Mr Heath considered his negatives 'artistic and satisfactory, for the chemistry was good and the bulk of those photographed had stood in natural attitudes'.

Landscape photographers sold their work to adorn the carriages of railway trains: Payne Jennings, who became the official photographer for the North-Eastern Railway, perfected a

photogram colouring process of platinum in monochrome, coloured by hand with aniline dyes which became the delight of travellers. Fred Judge made a series of brown carbon picture-postcards which not only raised the commercial standard of such photography, but also proved a most satisfactory venture.

Hand-painted postcards developed into something almost abstract with a totally unreal use of brilliant ink and dyes. A quiet village scene or landscape became an aurora borealis of emerald green, orange and crimson. In sentimental photographs of lovers cooing (perhaps with doves), holding hands and kissing, the ink colouring was every bit as wild as Andy Warhol's silkscreen portrait of Marilyn Monroe. Roses were magenta and turquoise blue, ladies' hair violet or aureolin, and the gentlemen's cheeks as pink as a peppermint sugar-cushion. In these attempts at improving on the magpie or sepia print, there seems a desire not so much to approximate nature as to provide an aesthetic effect.

Compared with the work of the writer or painter as a portraitist, the efforts of the photographer may seem bare and superficial. Nevertheless it is the camera that often shows us the most lifelike representation of the contented, assured and perhaps proud Victorian countenance. It brings Queen Victoria, Lincoln, Mark Twain, Dickens and Tennyson before our eyes complete down to the smallest detail; their clothes, expressions and the attitudes they affected. This leads us to regret that Leonardo had not brought his photographic discoveries to perfection, for then we might have had a 'Layfayette' wedding group of Henry VIII, or a 'Cartier Bresson' of the arrival of the Pilgrim Fathers.

Almost at its inception, the cry was heard, 'Can photography be art?' The argument as to whether an individual can assert his personal point of view over the camera, and break away from the mere reproduction of nature, has continued ever since. The desire to make pictures is inherent in both photographer and artist. Each should possess instinctive knowledge; but at the same time obey basic laws. The medium with its vagaries and limitations must be mastered. It should never be allowed to dominate. The ghost in the machine is as important as the soul in the body.

In the view of many Victorian painters the value of a canvas depended upon the amount of work which had gone into it. Painting was considered an arduous, but purifying, moral trial. Photography with its exact eye made detail even more minute so that painters took advantage of working from photographs. For this they were much criticized until Ruskin vigorously defended them. Edwin Landseer sneered, 'Foe to graphic art!'

Photography gave to a vast majority glimpses of the human body that formerly were only to be seen in sculpture museums and picture galleries. Nude studies were framed and hung in respectable homes, but their correct place was considered 'upstairs' – possibly in the bedrooms and guest rooms. By degrees they became less solemn. Great courtesans convolving on *capitonné* plush divans posed voluptuously as they admired their contours in looking-glasses.

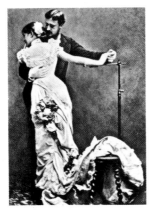

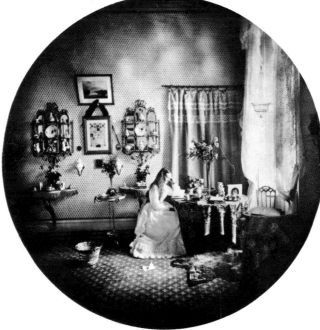

Above La Valse.
Right Interior, *c.* 1858.

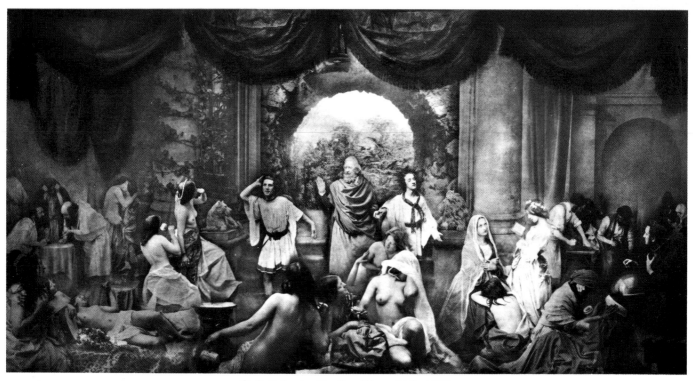

O. G. Rejlander, *The Two Ways of Life*, 1857.

From the early days photography has been considered an ideal medium for conveying pornography. Some of the first sepia prints of sexual extravagances, staged in studios, had a sinister and somewhat macabre fascination and were, of course, only to be seen under clandestine conditions. But the merely 'naughty' photography, which could be acceptable to a larger majority, inspired the creation of amusing *tableaux vivants* with semi-naked ladies coming out of Easter eggs, or cavorting in mock bathrooms with their Comice pear-shaped bodies half hidden behind Persian curtains or pleated screens. In this genre the French excelled and dominated. The ribaldries that were once thought salacious appear now merely absurd.

Almost immediately after its birth, painters realized the possibilities of using photography as an aid in their work. Some painters have taken their own pictures especially for this purpose, but in many instances an unknown photographer has been brought in to do the painter's specific bidding.

Delacroix was so influenced by the new medium that he took up the camera himself and made one particular study of a woman, partly draped and seen back view, which might have been Ingres's model for his odalisques in the Turkish bath. Gustave Courbet copied Reutlinger's photograph for his portrait of Proudhon, Gauguin utilized photographs for his Tahitian natives, Cézanne for his *Bathers* and Lautrec for his café figures. William Powell Frith made free with panoramic photographs for his *Derby Day*. Paul Valéry tells us of how much Degas loved and appreciated photography at a period when artists disclaimed it or did not admit that they made use of it.

Degas often took advantage of the haphazard compositions of his photographs by imitating them in his canvases. He painted galloping horses with outstretched legs, but 'stop action' proved him wrong. Degas himself took pictures at night with the help of nine gasolene lamps, and nearly a quarter of an hour's immobility on the part of the sitters.

James Jacques Tissot used a snapshot for his *Waiting for the Ferry*. Walter Sickert, in old age, abundantly relied upon newspaper photographs of stage performers, royalty in carriages and even still lifes of china ornaments and fruit in dishes, for subjects with unusual compositions. Alphonse Mucha, the designer of Art Nouveau posters for Sarah Bernhardt, was a friend of Nadar who influenced him to buy a camera. Although, by now, many professional photographers made a speciality of taking nudes for painters, the poses were seldom to Mucha's liking. He discovered that his photographs were a more substantial aid to his illustrative drawings and paintings, and particularly helpful as a guide to the folds of the drapery in the voluminous clothes worn by some of his Greek-style dancers.

Mucha later developed a satisfactory way of taking self-portraits, and helped the Lumière brothers with their early experiments in cinematography.

Édouard Vuillard owned a Kodak which, on an impulse, he would snatch from its accustomed place on the sideboard. Balancing it on the back of a chair, he would point the lens at his mother as she shelled peas, sewed or stood at the kitchen stove and at groups of other members of his family around the lunch-table.

In the 1920s, Paul Nash used his No. 2 folding Kodak to provide ammunition for his paintings which were intended to be pure abstractions. Nash had an unexpected way of seeing the decks of ocean liners, wrecked aircraft dumps, the bare downlands of Berkshire and Dorset, ploughed fields, details of a tree trunk, a haystack, rubble walls, the seats on the esplanade at Swanage, bits of flint, and diving suits drying against a wooden hut. As the subject-matter for later designs Nash used his photographs of such things as an egg-cup, a tennis-ball, and a wooden hut to make witty, surrealistic designs and patterns.

Charles Sheeler copied with exactitude the lamps and cactus he photographed. Derain used 'camera-studies'. Dali and Picasso (particularly in *The Charnel House* (1945) and his portrait drawings) sought the assistance of photography. Among contemporary portrait-painters Graham Sutherland does not hide his use of the lens as a guide to his portraits. Francis Bacon has based canvases on 'stills' from Eisenstein films, and he tells us of his indebtedness to Muybridge, particularly in his rhinoceros and mastiff dog: we see also how closely he followed the sequences of a paralytic child walking on all fours, a man heaving and lifting, men wrestling, and a woman walking downstairs. The Spanish Juan Genovés peers through a magnifying-glass at aerial news-shots of mobs fleeing from disaster for his large colourless paintings. Recently, the Prince of Wales, having sat for many official portraits, was surprised when the painter, Derek Hill, at no time during the sittings brought in a camera 'just for reference'. Many of the best contemporary painters, including Rauschenberg, apply photographs as part of their collages. Peter Blake, David Hockney, and Patrick Procktor, and many young English painters bring a camera's eye to their work, though perhaps it is the Americans who find the greatest inspiration in photography: Jim Dine, Kitaj, Ben Shahn, Larry Rivers, and Robert Delaunay.

Artists have become accustomed now to photographs as aids in their paintings. It is difficult to imagine that even as late as the Twenties anyone could have been disgraced by the newspapers for sending to the Royal Academy a portrait based on a photograph. Yet such was the fate of Reginald Eaves.

In late Victorian years more elaborate photographic methods were being perfected: Craig Annan, a native of Glasgow, whose father was a friend of David Octavius Hill, appreciated the advantages of a mobile camera, and Paul Martin, formerly a wood-engraver, wandered about London in his lunch-hour, with his camera disguised as a brown paper parcel under his arm, taking snapshots of subjects that had not before been photographed.

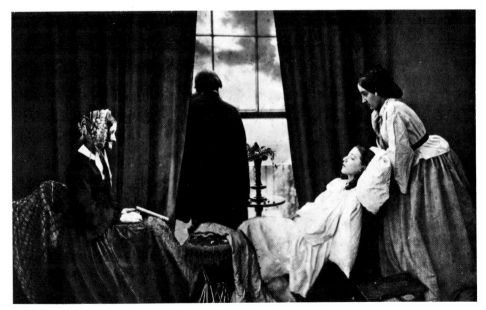

H. P. Robinson, *Fading Away*, 1858.

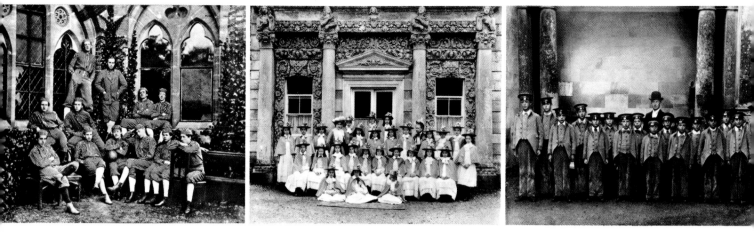

Above, left Harrow football team. *Centre* Park School for Girls, 1903. *Right* Wilton Free School for Boys, 1901.

It had been noticed in the dawn of photography that negatives which produced a good sky effect often yielded poor tone-values in the trees and the grass. As a result double negatives were used, and on occasions three or more simultaneously. A typical 'combination-print' was Mr H. P. Robinson's *Fading Away*, the representation of a pretty girl dying against studio curtains and a fake window. This 'picture with a story', produced with the use of five negatives, had a great emotional effect on a public treated for the first time to a display of Victorian sentiment in terms of modern photographic technique. But Mr O. G. Rejlander beat Mr Robinson hollow by making a jigsaw puzzle of over thirty different negatives for his sensational *Two Ways of Life*.

It is thanks to a group in America, which formed around Stieglitz, called the Secessionists, and their counterparts in Edwardian England, the Linked Ring, that the battle to make photography recognized as an art was finally won.

Many of these aesthetically inclined turn-of-the-century pioneers were influenced by the genius of the painter William Turner. His new 'field of light' influenced them to produce photographs which, by using the gum bichromate or pigment processes, they made look as unphotographic, and therefore as 'artistic', as possible. Other photographers purposely restricted the scale tones, even producing prints that appeared like lithographs; but where the process controlled the worker, rather than the worker the process, they were treading on dangerous ground. Trickery was brought to such a pitch that personages were superimposed on to landscapes, and sometimes, in the second print of an otherwise identical photograph, the author might think better of two lovers and replace them with a cow. Mr W. J. Roberts excelled at this tinkering. Mr Moffat of Edinburgh, one of the earliest bromoil artists, in his attempts to idealize nature, used sunlit lanes and vistas of flecked trees. His *Proclamation from Mercat Cross*, outside St Giles' Cathedral, has positively the glint of pantomine sequins. Mr Batkin of Birmingham, author of *The Rift in the Fog* and *Mists of the Morning*, was one of the most indefatigable gum workers. Mr J. Whitehead, a Scotsman, specialized in Italianate still-life – Chianti bottles and bunches of green grapes with the bloom faithfully reproduced. Mr Dudley Johnston, twice President of the Royal Photographic Society, working often in the mountains of Switzerland, produced impressionistic and romantic illustrations in the manner of Gustave Doré engravings; his *Dalmatian Picnic* is a pretty pattern of arabesques. Mr F. J. Mortimer concentrated on sea and yacht views, but his war scene in 1917, *The Gate of Goodbye*, has an added historical value. The first piece of 'modern' photography in landscape is *The Onion Field* by George Davison. Its horizontal ruthlessness was considered quite revolutionary in 1890.

The American Secessionists, also using bromoil and gum prints, mounted on rice-paper or silk – Stieglitz, F. Holland Day, Clarence White, Steichen and a dozen others vied with one another to produce photographs that appeared to be the product of brush and paint. Demachy indulged in oil-and-gum legerdemain to the extent that little remains visible of the photographic quality of the original negative.

The Royal Photographic Society exhibitions also aimed at elevating photography, and the Great Camera Masters everywhere were in full flood. Alexander Keighley produced his imitation paintings: in fact so much retouching was done to his prints that they might

have been sold as 'handwork'. Like their equivalents at the Royal Academy, these calendar-picture-makers adorned their exhibits with elaborate titles.

The earliest 'portraitists', such as Adam-Salomon, went in for rich tonal values which inevitably gave way to a change in fashion. Suddenly all was of a terracotta lightness. These portraits were 'vignetted' (a cotton-wool smog framed the figure) when the composition was weak, or were tinted with water-colour in very watery brush-strokes, with a delicate shading of blue over the eyes, while a palest coral blushed the cheeks. To the white 'limbo' background a few pencil strokes were deftly added. These hand-tinted photographs were, in their way, delightful, and so much more restrained and unpretentious than the imitation-oil-colour portraits which are still popular in certain states of America today.

Miss Kate Smith used draped figures of naiads, Bacchantes and Greek goddesses to express her particularly Edwardian idiom. She concentrated upon the pale silvery effects – sparks from sun through the low-hanging branches of beech-trees and the like – and she succeeded in creating a radiance around many an elaborately-coifed head. Her *Ladybird* in 1912 is utterly delightful in the manner of a Condor fan.

Lord Carnarvon was a man of many interests, a famous Egyptologist, and a picture-restorer. When he was taught photography by his friends, Bertram Park and Lewis J. Steele, he built himself a large studio where he developed and enlarged his picturesque studies of nude female models posing among the water-lilies of the lake at Highclere Castle, his country estate.

Scherril V. Schell, an American who came to work in London, made the famous profile of Rupert Brooke. For this the romantic young poet, according to the photographer, stripped to the waist revealing a 'torso that recalled the young Hermes'.

In the early 1920s a few painters emerged rather tentatively as professional portrait photographers. One of these painters-turned-photographers even went so far as to sign his name 'Instead'. He placed his sitters against a wall covered with potato sacking and balanced the composition with a framed engraving or a classical statuette. The Mesdames Morter, two sweet and delicate ladies, produced delightfully 'arty' photographs which they signed with a mapping-pen in a spidery flourish of Indian ink.

In the 1920s the year's best photographs (amateur and professional combined) were exhibited in the London 'Salon' with much pomp and reverence. The shows were in-distinguishable from one year to the next. The captions to the pictures of the same old rugged fishermen were inevitably *Jolly Jack* or *Old Salt*, while *A Modern Maid* showed a young girl with shingled hair in a riding habit; *Salome* leered with an unpleasant smell

Moulin-Rouge.

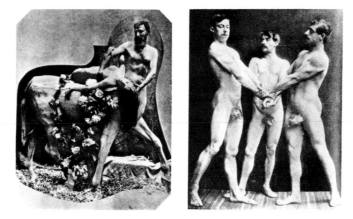

Above, left Centaur's Luck. Right The Oath of the Horatii.

beneath her dilated nostrils. Naked young women were caught by surprise, capering in forest dells and waterfalls, or abandoned beside a canyon. Others, warm in the studio, were smeared with glycerine and persuaded to throw themselves into picturesque contortions with a toy balloon or a hoop and were forthwith entitled *The Bubble, Espérance, Lassitude, Composition,* or merely *Curves.* The hazy concoctions *In a Garden Fair, A New Pet,* or *A Norfolk Haymaker,* were of rosette calibre.

England and the United States were lagging behind the Middle European countries where Cubist, Dadaist, Vorticist, Neo-Romanticist, and later Surrealist influences were bringing new life to the camera. Max Burchartz photographed half a girl's freckled face. It appeared on covers of *avant-garde* magazines and became a historic period-piece. In Paris Man Ray was working on his 'solarizations', and Hoyningen-Huene gave glamour to Cocteau and his circle. In New York the greatly underestimated De Meyer became a poet of the soft-focus lens. He played a practical joke on Helena Rubinstein by transforming a male waxwork model into a nun and making this transvestite into a symbol of American beauty. Carl Van Vechten's novel *Nigger Heaven* brought him vast acclaim, but when his literary fount ran dry he resorted to placing his interesting and decorative friends against a patterned cotton background and clicked a camera at them. His essentially amateur pictures

A. B. Tagliaferro, *Behind the Scenes.*

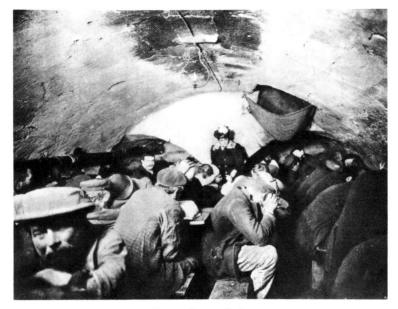
Beggars' cave, Paris.

give a much truer picture than those of more successful professionals of those doomed days.

German *avant-garde* moving pictures also had a widespread influence, but Hitler brought a halt to virtually all forms of photography except war reportage. English photographers produced fantastic action pictures of battle-scenes which were made even more dramatic when relayed on the *pointilliste* technique of radio telephotography. The Germans, however, became masters of war colour photography, more advanced even than Life Magazine's photographers.

Between the two world wars, the use of colour on a wide scale was confined to advertising and art 'colour reproductions'. After 1948, through the discovery of faster film emulsions, colour photography became used for reportage, and the weekly newspaper supplements enormously encouraged the advance.

When, soon after the war, an American arrived on the refreshingly delightful mission of photographing the rococo monuments in Westminster Abbey for the Rockefeller Foundation, and his dramatic lights were switched onto these great national treasures, it was as if we saw them for the first time. As Kenneth Clark, who has always been interested in the subject, said: 'One of the blessings of intelligently handled photography is that it can, by isolating and lighting, bring out architectural detail more intensely, and in such a way as to discover values which would otherwise remain hidden even from the eyes of a careful observer of the originals.'

One of the earliest functions of photography was the documentation of works of art. André Malraux has written in admiration of the extent to which photography of paintings and sculpture has extended our understanding of the world's art.

Photography is capable of conveying sculptural relief, it can seldom register volume or depth. But by enlarging certain details of a bas-relief, or the decoration on a coin, the photographer has caused certain art-forms which for centuries have been considered minor to be regarded as major arts.

Today we photograph the works of lesser masters and the *objets d'art* that once were unknown. In fact, everything that can be considered in terms of style is now being documented, and often with understanding and expertise. Today lenses and equipment are so perfected that an astonishing degree of clarity and detail becomes automatic. This is an advantage when handled with tact and artistry, but too rigid a technical perfection can vanquish the artist. When André Derain, the Fauvist painter, was first shown the work of the Victorian Julia Margaret Cameron, he exclaimed: 'It is the perfection of the mechanics that has ruined photography!' He was wrong, in fact, in that he did not realize that Mrs Cameron purposely, for effect, used her camera out of focus, but he was right in principle: many contemporary photographers find it difficult to overcome the technical performance of the apparatus. Fashions in photography could not revert to pre-war styles, and the 'realism' and sense of movement caught by Munkacsi were accepted as part of the idiom of

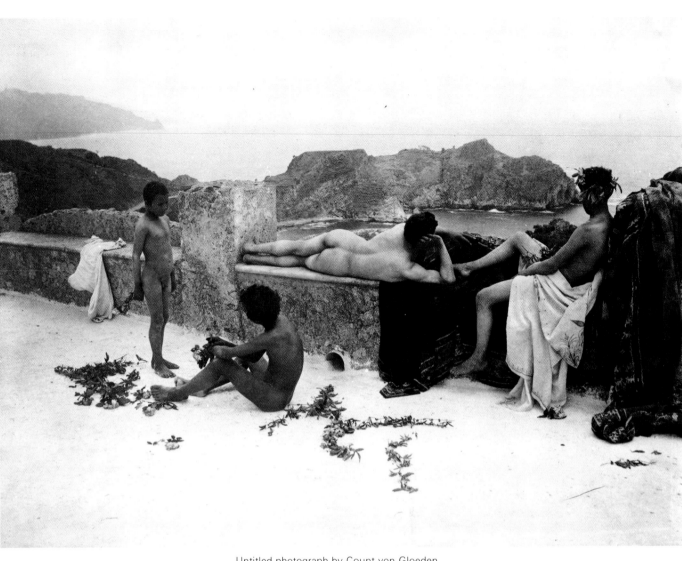

Untitled photograph by Count von Gloeden.

the day. Most young people felt they could take these candid snaps, and Dan Farson produced 'anti-artistic' pictures that were before their time, and their validity was not fully recognized until he quit the field.

The 'warts-and-all' vogue became exaggerated to the extent that ordinary people with clear complexions were made to appear as if sadly in need of a 'clean-up' by a barber. Pores were open, and hair sprouted from chin, nose and ears with an effect that is seldom seen by the human eye.

Perhaps a study could be made of the fashions in printing the negatives of leading photographers. Bill Brandt was perhaps the first to realize the effective advantages of foregoing certain half-tones, and sometimes made his prints as inspissated as patent leather or as white as aspirin. Penn and Avedon produced 'close-ups' that had the strength of woodcuts. John Deakin, a valuable addition to the ranks, made a staggering magpie shot of Francis Bacon stripped to the waist, standing between huge Rembrandtesque carcasses of meat. In the 1940s, 1950s and 1960s the tendency was to use ever harsher contrasts: the blacker the shadows and the whiter the flesh tints, the stronger the impact. But no mere technical feat is likely, on its own, to produce a masterpiece.

Three cockney boys rushed out of the somewhat staid John French's darkroom and gave a signature to their times. The 1970s have already produced a spate of young people, all with 'something to say' and the ambition to make it heard.

All the while facilities for photographers, both professional and amateur, have improved immeasurably. The Instamatic camera, loved by tourists, was chosen to photograph the 1970 ascent of Everest because it was compact and easy to use. Today anyone can be a

photographer – and most people are. Sue Davies of the Photographers Gallery tells us that in England camera clubs have grown from 256 in 1908 to nearly 10,000 today. In New York Judith Richardson at the Sonnabend Gallery has said that 'every third person is now taking photography courses at the School of Visual Arts'.

To many of the young people today, the idea of going off to a portrait photographer is preposterous. They are unwilling to submit to his strictures, or to be portrayed only as he wishes, in the contrived atmosphere of his studio. The days are past when the tyrannical portrait photographer insisted on his 'taste' being applied to every pose.

Today photo-reportage is pre-eminent. But few realize that it is a branch of photography that takes more than visual political comment, social awareness, technical ability, tact and daring. The reason why Philip Jones Griffiths and Don McCullin are so outstanding is that, as well as all these rare qualities, they both possess sensitivity and compassion. Larry Burrows knew how to compose a picture even in the heat of battle, and proved the practitioner must always retain the eye of an artist.

Violence, in terms of war and natural disaster, is a subject that has been treated by certain star photo reportage not only with courage, but with an astonishing artistry.

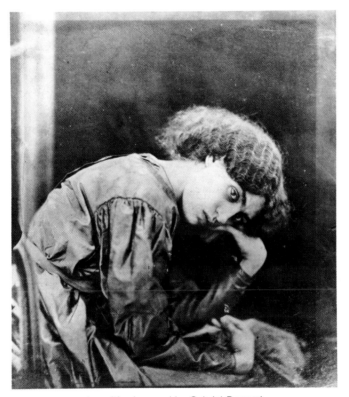

Jane Morris posed by Gabriel Rossetti.

Some – like Don McCullin – have shown that they are both fascinated and repelled by the subject, while Philip Jones Griffiths perhaps more than any other photographer has made an epic plea that such nightmare cruelty should never again be loosed as in the Vietnamese War.

Many of the newest generation seem to take the pleasure that they may find in a horror movie into real life. Hence the photograph exhibitions to which they flock in such great numbers are often straightforward documents – taken without compassion – of people in madhouses, of freaks, elderly transvestites, hermaphrodites, and ill-shapen nudists. It is only a short step on the road towards photographing criminal violence.

Peter Beard has taken pictures inside prisons of young murderers and their slashed victims – the results of *crimes passionnels* – which have a certain beauty as well as a ghoulish fascination. Danny Lyon, however, sets about his reports in a quite different mood: one feels he sympathizes with the need for speed and violence among certain youthful bodies, and has compassion for them when they run foul of the law and are suitably punished. In some cases the pursuit of danger brings with it a youthful death, and this Danny Lyon endows with a *real* quality of Greek tragedy.

Each month further statistical records will have been broken, but in the 1960s the expenditure on amateur photography more than doubled. In Great Britain in 1971 colour exposures alone rose by 20 per cent. Some 325,000,000 colour prints were made by about 9,000,000 people. In 1970 £100,000,000 was spent on amateur photography.

Many of the contributions by photography have been mundane: reproducing millions of engineers' drawings, microfilming tons of records and documenting the results of scientific tests. Methods of photography have shown us the microscopic worlds of plants, crustacea, amoebae. The camera has probed the depths of the sea and the forests, bringing to light rare creatures; it has helped in detecting the origins of all manner of works of art and has revealed other paintings beneath the surface of well-known masterpieces.

The technological advance of photography is a continual source of wonder. We think nothing extraordinary any more about a photograph that stops or extends time and motion, movement caught in a hundred-thousandth of a second, and other things invisible to the human eye. Photography has taken us to vantage-points inaccessible to man: inside a blast-furnace, or the world as seen from outer space. Exposures are taken without visible light; we can photograph a hair on a fly's tongue, a microbe in close-up, lockjaw, diphtheria, a sound picture of a thrush's song, images formed by heat, even the photograph of a smell.

G. Wilkes, *The Race for the Jubilee Stakes at Yardley*, 1899.

We have seen telephotographs of an extinct star. Many of our television news-photographs are bounced from a satellite.

Much of this century's progress in astronomy has been due to photography. Billions of stars never seen before by the human eye have been photographed on film. In 1965 historic views were taken of the planet Mars nearly eight thousand miles away. Each year knowledge gained through photography teaches us more about nuclear physics; it has helped to make polio a disease of the past, and has shown other virus particles enlarged sixty thousand times. Photography plays an increasingly important role in medical science: the pioneers of X-ray photography would no doubt be amazed and heartened to see how today, even in the less advanced hospitals, lives are saved by the use of X-ray negatives, which when developed, facilitate the location of disease. Photography plays a role in tracking pollution and in the designing of prototype aircraft, such as the Concorde. The research work of scientific experts has made discoveries which have influenced the world. Various colour processes, and the comparatively recent use of invisible electromagnetic radiation – which we call infra-red photography – make it possible to see beyond the visible spectrum, and to record mountains and sea coasts which are invisible to the naked eye. Through radiography and infra-red photography, the invisible becomes visible enabling art historians and other scholars to unlock two-thousand-year-old mysteries without destroying them.

Until man sent cameras into space, the earth's weather systems and cloud-patterns had never been comprehensively observed. In modern expeditions, unlike those of early explorers, the camera goes first. The trek to the moon was helped by thousands of photographs taken beyond the reaches of the earth's atmosphere, and the lunar landing was seen by millions at the moment it took place. 'Apollo' spacecraft have brought back hundreds of photographs which will stand as the definite source of lunar information for many years.

A photograph by Gertrude Jekyll, artist, gardener, writer, photographer, metalworker in silver, brass and cast-iron, woodcarver, needlewoman and interior decorator.

For the first time the camera has 'proofected' in space and has shown us the entire western hemisphere, and we have seen the earth as a sphere – one of the most dramatic of colour pictures being that of the 'earth-rise' over the moon.

Striking as some dramatic moment caught by the click of a shutter may be, it is often the photographic expression of the photographer's individual point of view that lasts longest in our mind's eye. New conceptions and inspirations are as rare in photography as in any other form of art.

Masters of the camera are less numerous than those of other types of picture-making. Edward Weston said that not many realize that good photographs, like anything else, are made with one's brains. According to Vishniac: 'There are many photographs by famous photographers that have absolutely no value at all.' By this he means that the photographs have no inner depth; that they are merely superficial shadows. What Vishniac is looking for in photography is what lies beneath the surface. 'What is on the paper and the canvas is not enough.' Bernard Shaw, a great camera enthusiast, probably meant the same thing when he likened photography to the cod which spawned thousands of eggs but brought only one or two to fruition.

Even the creatively fertile land of France has produced few photographic masters since the pioneer, Hippolyte Bayard, exhibited luminous and atmospheric prints made without a negative, and Nadar in a captive balloon attempted to 'raise photography to an art'. As journalists working for *Paris-Match* the French are unsurpassed; generally, however, as modern photographers they are gimmicky and commercial; few seem to be doing anything else besides making money. With the possible exception of Japan, America seems to have become the adopted home of the photograph and has produced the biggest quota of outstanding photographers. Since the days of the earliest photographic illustrations in newspapers and periodicals, the film has had a tremendous influence on the public mind, and has become perhaps the potential of greatest importance as propaganda. Since the inveterate

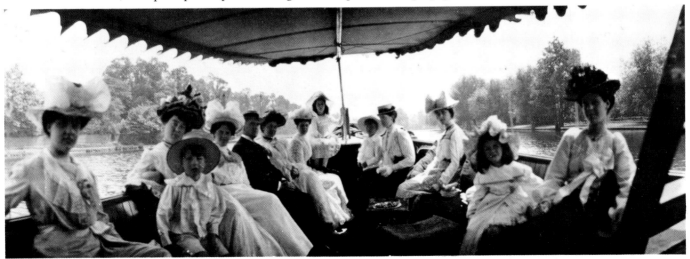

Untitled photograph by Lilian Hammersmith.

Above, left F. J. Mortimer, *Portrait of A. L. Coburn,* 1906. *Right* Edouard Vuillard, *Annette in Curlers.*

Stieglitz took command of the scene, America has abounded in what seems to be a natural form of expression. Photography is so widely taught in schools that, as with swimming, pupils are brought up early to acquire impeccable technique.

As an art-form photography is still in a state of flux. Certain photographers realize the mistake of trying to imitate paintings, and wide use of colour only makes that problem more acute. Too often a photographer will try to use colour to its 'fullest effect', and choose a subject containing as many colours as possible. Hence the disappointment of the herbaceous border in the gardening catalogue. The painter can be the master of his palette, regulating the density of reflected colour, accentuating or modifying his various tones. The photographer can do so only if he is his own colour technician – and that is a highly specialized skill. In the commercial darkroom, any intentional stressing of one colour the artist may have wished to create may be 'rectified' by the unknowing exponent who is taught to 'play safe', and another colour, purposely subdued, may be 'brought up'. Seldom do photographers make allowances for the decreasing effect when their transparencies are transferred to paper, and few seem to realize that often the most satisfactory results are from transparencies in which colour is reduced almost to a monochrome. There is nothing lovelier than certain black-and-white subjects when photographed in colour, while often it is the soft greys and olive-greens of the Polaroid prints which produce the most harmonious results.

Boy with flower.

Whenever the old question is still asked about whether photography is an art-form, we can but answer that if a dozen expert photographers are given the same subject and conditions, their pictures would be just as different as if a dozen painters had been set the same task. Peter Rose Pulham wrote in 1952: 'The question, whether or not photography is an art, has always seemed to me irritating, meaningless, and beside the point. If photography is used merely as a technical process to record some visible fact, it is an adjunct to science. But if it is used to express, since all expression is emotional, selective and personal, it cannot avoid the use of art.'

It is part of the professional photographer's technique to know when to take advantage of the happy chances that come to him seemingly from nowhere; but it is the wealth of experience, and his natural tastes and sensibilities as an artist, that give his pictures their real meaning. The more mature the control over his medium, the more revealing is the work of the man behind the camera. A quality of personality is surely an essential by which a photographer's work is to be judged. If the individual does not show his personal attitude of mind towards his subject, then mastery of the mechanism and technique go by the board.

Rose Pulham wrote a short while before his death: 'I believe that the photographer has just as much scope as the painter for the expression of his feelings. . . . The only point, *raison d'être*, of art that I can see, is the attempt to express some supposed reality, to illuminate ordinary objects with that vivid flash of light which suddenly makes everything seem clear and inevitably right.' When many of the pictures in this book first appeared, they were revelations. If their first shocking impact can no longer be felt, the unique quality can still be sensed – a quality rarely found today when most camera-owners, and even successful professional photographers, are influenced by what they have seen, not by what they see.

The details of everyday existence change so rapidly that they leave little behind them, and with the lapse of time these forgotten minutiae are often puzzling and surprising. They are often the reason many photographs are still fascinating. For those who wish to preserve the fly in amber, no pen or pencil can delineate more accurately for instance that moment when those strangely assorted people who rode down the Strand in a bus on that winter day seventy years ago are caught in the click of a camera. How clear and vivid is the vignette of the man forever tying his shoe-lace, and the old woman exhorting the passers-by to buy

Above, left W. & D. Downey, *Gabrielle Ray. Right* Rudolf Koppitz, *Life*, 1927.

29

Above, left Peter Rose Pulham, *Christian Bérard. Right* Lucinda Lambton, Composite photograph of her sister, *c.* 1960.

her bunches of violets. These personages are all long since dead, but, in a small but accurate way, they live for always.

Recently several collectors have sold their paintings in order to invest in period photographs; swiftly mounting prices are already paid in the auction-rooms for original prints by Margaret Cameron, Muybridge, Stieglitz, Coburn, Sarony, or even an early Hollywood 'still'. Future collectors will, no doubt, grasp avidly for the true and completely unself-conscious examples of unconscious 'pop art', such as are seen in advertisements for Californian fruit, or travelling salesmen's 'sample' hand-coloured photographs of a $69 lamp, complete with pleated shade, suitable for any picture-window of dentist's split-level ranch-type home in Oconamawalk, Wisconsin.

Moholy-Nagy wrote that the illiterate of the future would be the person who could not use a camera. Today any young person can pretend to be a photographer; the mechanical process of the Polaroid has made picture-taking foolproof. Is it not ironic that, at the moment when pictorial photography plays an ever more important role in contemporary life, *Look* and *Life* magazines have disappeared and many other picture-magazines are on the brink of disaster? The opportunities for good photographers to show their work on the printed page are rarer. American book-publishers find that the economy prevents them from having their plates engraved in Japan, Italy and Switzerland, and since the cost of local labour is so high, have to abandon many a project. Perhaps today's photographers will – like their forbears – have to rely on the sale of prints for their living.

Where is the beacon to light the way to the expression of the future? There is an acute dissatisfaction with 'instant art' in all of its forms. However, we can take comfort in the fact that again today there is a creeping respect for technique, disciplined instinct, for measure and proportion, and other such things long since bypassed. Perfect tailoring in the crafts can only be accomplished by the devout.

Among young painters there is the urge to be able to achieve the simplicity of statement that Dürer could make with a drawing of a hand, Leonardo with a lily, or the Pre-Raphaelites with a frond of honeysuckle. In photography the same emotion has been achieved by Callahan with nothing but a blade of grass, by Sommer with an amputated foot, by Josef Koudelka with a naked gipsy, or by Sudre with his eggs in a glass. Perhaps more than anyone among today's photographers we should respect Penn. Although commercially successful, he realizes that to exist in times of crisis, when most people have given up hand-work in favour of machines which can do the work so much more quickly and inadequately, one must return to basic logic and ideology. Penn is busy in his laboratory coating his own

Top Ger Van Elk, From *Adieu* series ; oil paint on photograph. *Bottom* NASA, *Earthrise.*

printing-paper, using the platinum process which no one but the individual artist can manipulate, and which is truest in tonality, and as a means of photographic expression has never been surpassed.

One hundred and thirty years after the first use of photography, we are still wondering where the new direction lies. Some may be able to give a glimmer of light into new vistas, but most of us know we are still at the beginning of the optical age.

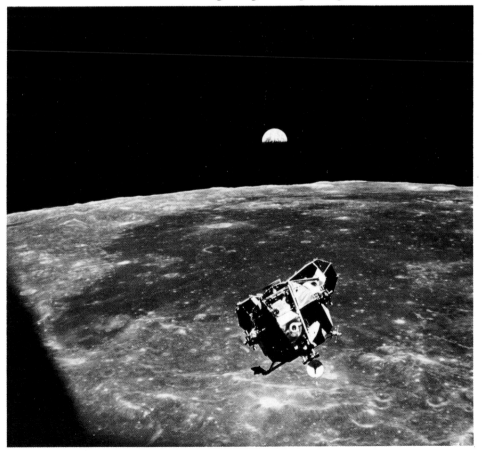

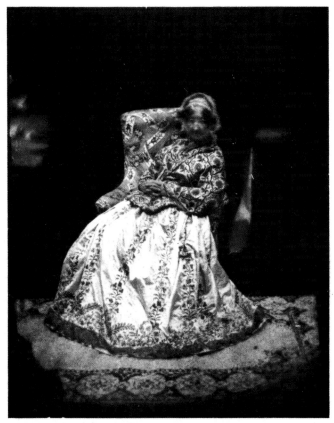

W. H. F. Talbot, Possibly Lady Feilding.

W. H. F. Talbot,
Man in Doorway.

In his honey-coloured castle, William Fox Talbot could look out upon the River Avon winding among the fields of buttercups and Queen-Anne's-lace, from the oriel window in his drawing-room. It was of this window that he took the first negative–positive photograph in existence.

Talbot, who had been educated at Harrow and Cambridge, was a man of wide interests which encompassed mathematics, physics, astronomy, botany, archaeology and chemistry. He became a member of the Royal Society and for two years was in Parliament. Like most fashionable young men of his day, Talbot made the 'Grand Tour' of Europe, and it was when he was on Lake Como in 1833 that he used the camera obscura as an aid to sketching the picturesque surroundings. This device, by means of a lens and reflex mirror, projected an image on to paper which then could be traced with a pencil. Talbot was fired with enthusiasm and on his return home to the west country was determined to try to capture the projected image permanently and immediately began an attempt to prove that it could be done. He started logically with silver nitrate, noting and utilizing the retarding effect of strong salt solution. He experimented with increased sensitivity to obtain *camera obscura* pictures.

Talbot kept a detailed account of his experiments. Eventually he was able to show his wife and family his first 'photogenic drawings'. Some of these were shadowgraphs (or photograms) of lace and leaves. His perseverance over several years was rewarded when he obtained 'very perfect, but extremely small pictures; such . . . as might be supposed to be the work of some

Born in Melbury, Dorset. Went to Rottingdean, 1808–11; Harrow, 1811–16. Attended Cambridge University, 1818–21; received MA, 1825. Elected member of Royal Astronomical Society, 1822. On the basis of his mathematical papers was admitted a Fellow of Royal Society, 1832. Member of Parliament, 1833–4. During the winter of 1834 was probably most actively engaged in his photographic experiments. Elected a member of council of Royal Society (in consequence of new mathematical papers), 1836. Studied antiquarian subjects and published various works. Had Michael Faraday exhibit some of his photogenic drawings at Royal Institution, 25 January 1839; read paper, 'The Art of Photogenic Drawing', to Royal Society, 31 January 1839. Sent Nicholas Henneman, his assistant in his photographic experiments, to Reading to set up an establishment for making and printing calotypes; travelled to Scotland to take photographs, 1844. Began photographic association with Reverend Calvert Jones, 1845; sold patent for his process to be practised in USA to Langenheim, 1848. Granted free use of calotype process for illustration of catalogue of Great Exhibition; fought first patent case; discovered method by which instantaneous pictures could be taken, 1851. Invented method of photo-engraving, 1852. Invented the 'traveller's camera' (combination of camera and two tanks, one containing solution of nitrate of silver for sensitizing the wet plate, the other with gallic acid to develop the picture), 1854. After the Talbot *v.* Laroche patent case (the practice of wet-collodion process was *not* an infringement of Talbot's patent), the calotype process was given to the world without restriction, 1854. Renewed interest in deciphering Assyrian inscriptions and published papers in Journals of the Royal Society of Literature and the Society of Biblical Archaeology, 1854, 1857, 1860 and 1864; with Sir Henry Rawlinson and Dr Hincks, was one of the first to decipher the cuneiform inscriptions brought from Nineveh. Produced 'Assyrian Glossaries', 1866; a 'Commentary on the Deluge Tablet' and 'The Revolt in Heaven', 1874 and 1876. Poor health prevented him from forming a company to work his 'photoglyphic engraving' process; died while writing an appendix for a new edition of Tissandier's *History of Photography*. Major collections: Lacock Abbey, Wiltshire; Science Museum, London; Royal Photographic Society. Books produced at the Talbot Establishment in Reading: *The Pencil of Nature*, 1844–6; *Sun Pictures of Scotland*, 1845; *The Talbotype applied to Hieroglyphics*, 1846; *Annals of the Artists of Spain* by Sir William Stirling, 1847. Other books: *Legendary Tales in verse and prose*, collected, 1830; *Hermes, or Classical and Antiquarian Researches*, 1838–9; *The Antiquity of the Book of Genesis*, 1839; *English Etymologies*, 1847; *Assyrian Texts translated*, 1856.

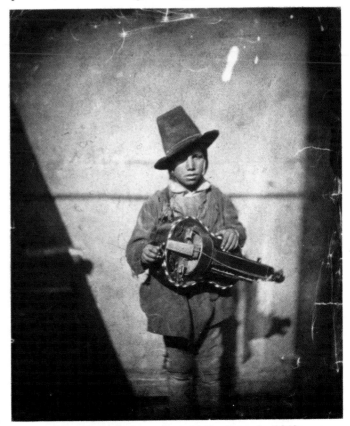

Probably Calvert Jones, *Boy with Hurdy-gurdy c.*1840s

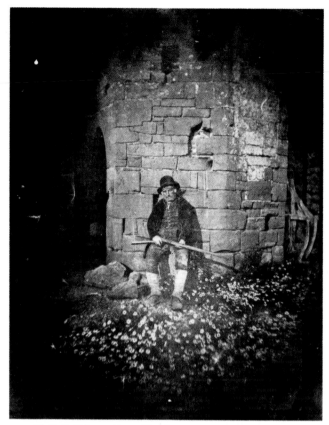

W. H. F. Talbot, *Above The Gamekeeper at Lacock Abbey.*

Below The Card-players.

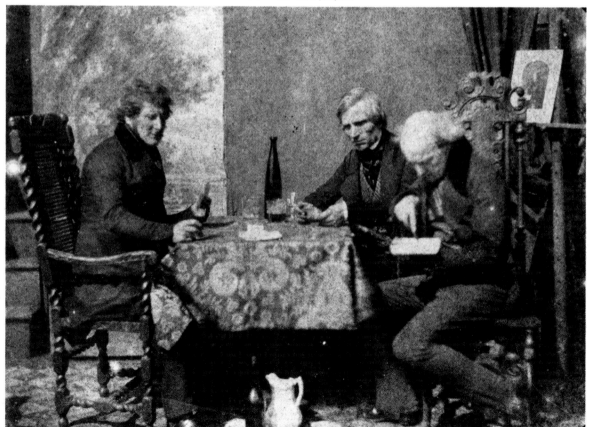

Lilliputian artist'. Talbot continued his experiments keeping in close touch with many brilliant men of scientific mind, such as Sir John Herschel, who was the first to use the phrase 'negative and positive'. No doubt much indebted to Herschel, Talbot produced the earliest negative, one inch square and dated 1835, of the oriel window in his house. This, the earliest photograph extant, can be seen today in the Science Museum in London, while much of Talbot's equipment (or replicas of the originals) and many important relics of his industry, knowledge and art are collected in the newly organized museum at Lacock Abbey.

Perhaps one of Talbot's least admirable qualities was a lack of generosity. He did not acknowledge his indebtedness to the Reverend Reade with whom he had useful conversations about his methods, or, more importantly, to Sir John Herschel, who can be considered the discoverer of hypo as a fixing agent. Talbot, we may surmise, was determined that it should be he who would reveal to the world that he had invented photography, so his shocked fury can be imagined when he read the news that a French theatre designer, Louis Daguerre, had announced a photographic process which he called the 'Daguerreotype'. Talbot at once proclaimed his own discoveries, presented his negatives and positives at the Royal Institution, and read a paper to the Royal Society giving his 'Some Account of the Art of Photogenic Drawing; or the Process by which Nature's Objects May be Made to Delineate Themselves without the Aid of the Artist's Pencil'. Talbot's discovery was more important than that of Daguerre – for he could produce any number of prints from a single negative, while each daguerreotype was unique. Admittedly the daguerreotype, formed on copper plate, gave a clearer image, and with none of the mottled effects of Talbot's paper prints. However, Talbot continued to refine his process and evolved what he named the calotype, and

it was this process that was adopted by the renowned team of Hill and Adamson, who produced some of the most beautiful photographs ever taken.

Many of Fox Talbot's own photographs were published in *The Pencil of Nature* in 1844. Not only have they historical importance, but they possess a quiet beauty that raises them above the quality of mere documents. His Chardin-like still-lifes show little more than a broom in a doorway and a ladder leading to a loft, and demonstrate that Talbot knew how to compose a picture as well as how to show what the camera was capable of. Most of Talbot's pictures were taken at or near his home: he photographed a favourite tree, his own Egyptian relics, his breakfast table, a toy train, a fire, candelabra, and the beautifully tooled volumes seen on his library shelves. He developed a delightful way of making a photographic inventory of his possessions, often seen in three tiers: his china, silver and glass collection. We can see these photographs alongside the originals at Lacock. He also made portraits of his extremely plain wife and daughter, and their pretty hats, bonnets and ribbon hair-trimmings. He photographed his gamekeeper, his neighbours, a boy with a barrel-organ, and all the members of his family – including his half-sister Horatia (of the duck-billed nose) playing a harp. A photograph of two unknown men playing chess, one wearing a romantic topper, is comparable to the work of Hill and Adamson.

William Fox Talbot, according to the likeness taken of him in later life, appears as a man of somewhat stolid, porcine appearance with intensely piercing, lidless eyes that sloped downwards; his expression conveys little of the artist. Being a shrewd man of vision he saw the vast future of photography and took out patents on his work. He no doubt felt a glow of satisfaction at the knowledge that he was the father of photography – as so many millions know it today.

W. H. F. Talbot, *Bonnets.*

Hippolyte Bayard

1801–87

H. Bayard, *La petite boudeuse au bouquet.*

H. Bayard, *The Overturned Pot*, 1847.

Born in Breteuil-sur-Noye, France. After moving to Paris worked as a clerk at the Ministry of Finance. Having long been interested in the chemical action of light, had been doing experiments with the effects of light on sensitized paper since 1837. Upon learning of Daguerre's invention (but not knowing the details) he quickly worked on his own experiments and within sixteen days produced first direct positives on paper made in the camera, 20 March 1839. Bayard's achievement was remarkable as he had little time for experimentation and did not have much money to purchase equipment or chemicals. On 24 June 1839, two months before Daguerre explained his technique, he displayed thirty of his photographs and thus deserves the honour of being the first person in the world to hold a photographic exhibition. Publications: *Bayard* by Lo Duca, 1943; *Hippolyte Bayard, ein Erfinder der Photographie* (exhibition catalogue, Essen) by O. Steinert and P. Armant, 1960.

An ill-paid civil servant, Bayard can be said to be one of the inventors of photography in France. Bayard's 'nature printings' were the result of an entirely new technique – that of printing on paper without a negative. His methods were published in 1840 and after 1842 he took remarkable calotype photographs based on Fox Talbot's theories. Bayard explained his process: 'Ordinary letter paper having been prepared following Mr Talbot's method and blackened by light, I soak it for some seconds in a solution of potassium iodide, then laying the paper upon a slate, I place it in a camera obscura. When the

image is formed, I put the paper in a solution of hyposulphate of soda and then in pure warm water, and dry it in the dark.' Bayard's process was better suited than Daguerre's for travellers since it was easier and more compact. His sensitized paper could be kept for weeks.

In March 1839 Bayard showed some examples of his invention to François Dominique Arago, a distinguished physicist and astronomer. Arago, a friend and sponsor of Daguerre, knew that the announcement of a second process would minimize the effect of Daguerre's discovery, and without giving the reason, begged Bayard to postpone the publication of his method. Arago then gave official status to Daguerre's invention by announcing the discovery to the Académie des Sciences. Honours and praise were heaped on Daguerre. The government granted a pension of 6,000 francs to Daguerre and 4,000 francs to Niepce's son.

In the controversy that occurred in 1840 concerning the priority in producing direct-positive photographs it was particularly unfair that Arago did not mention that Bayard had previously shown direct-positive photographs. In order to placate Bayard, Arago probably influenced the Minister of the Interior to give 600 francs towards buying Bayard a better

H. Bayard, *The Hat*.

camera and lens and to subsidize further experiments. However, Bayard, suffering from a sense of injustice, took a photograph of himself posed as a corpse in a morgue. He had supposedly drowned himself as a result of the neglect shown to him by the government and the public, and this was certainly the earliest use of photography as propaganda.

Bayard's prints of speckled feathers, checked materials, and old prints, placed on sensitized paper, are subtle, delicate, and highly personal. His studies of windmills, his garden, and still-lifes of plaster casts of Greek and Roman sculpture are in their own charming way quite perfect. He was adept at arranging plaques against a background of bobble-fringed drapery, and in his attic (1846) he recorded an extraordinary composition, beautifully spaced, of bedcover, bottles, crates and figurines. Bayard enjoyed making delightful self-portraits wearing a smoking cap and striped waistcoat as he posed in his vine-covered doorway, or, in old gardening-overall, sitting on a bench mending wooden implements. His studies of the barricades in the 1848 Revolution are historically important.

In Hippolyte Bayard's photographs a sense of scale is an important factor, and his sensitivity is readily recognizable. According to Minor White, his scenes and landscapes are suffused with an 'atmospheric luminosity'.

Although he was not acclaimed, his work was appreciated late in his life. He was proud to become a founder member of the Société Française de Photographie, which possesses six hundred of his photographs – not all, however, made by his direct-positive technique, but also by the calotype and albumen-on-glass and collodion processes.

David Octavius Hill and Robert Adamson

1802–70 and 1821–48

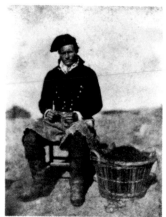

D. O. Hill and
R. Adamson,
Newhaven Fisherman,
June 1845.

David Octavius Hill was born in Perth, Scotland. The son of a publisher and bookseller, attended Perth Academy and probably School of Design, Edinburgh. Practised lithography and was a founder and secretary of Royal Scottish Academy, 1830–69. In 1830s involved in book-illustration and landscape-painting. Collected and arranged the annual RSA exhibitions to which he contributed paintings and, in 1844, 1845 and 1846, calotypes. After autumn of 1848 abandoned photography except once in the 1850s and between 1860 and 1862 when he collaborated with the Glasgow photographer A. McGlashan using wet plates. In 1866 *The Disruption Picture* was completed and, with F. C. Annan using a special camera, Adamson produced facsimiles of the picture for sale throughout the Free Church of Scotland.

Robert Adamson was the son of a farmer at Burnside near St Andrews. Too delicate to pursue chosen career as an engineer, learned the calotype process from his brother John in 1841–2. Began doing commercial photography early in 1843. Between May and August 1843 established a partnership with D. O. Hill. In the autumn of 1847 became critically ill and died the following year.

Exhibitions include: Museum Folkwang, Essen, 1963; Scottish Arts Gallery, Edinburgh, 1970 (and travelled); National Portrait Gallery, London, 1973. Collections: Scottish National Portrait Gallery, Edinburgh; Edinburgh Photographic Society; National Library of Scotland, Edinburgh; Glasgow Art Gallery and Museum; Royal Scottish Museum, Edinburgh; Glasgow University Library; National Portrait Gallery, London; Victoria and Albert Museum, London; Science Museum, London; Royal Photographic Society, London. Books: *Calotypes by D. O. Hill and R. Adamson* by Andrew Elliot, 1928; *David Octavius Hill* by Heinrich Schwartz, 1931; *David Octavius Hill* by Heinrich Nickel, 1960; *A Centenary Exhibition of the Work of David Octavius Hill and Robert Adamson* catalogue, by Katherine Michaelson, 1970; *Sun Pictures: the Hill–Adamson Calotypes* by David Bruce, 1973; *Hill and Adamson Photographs* by Graham Ovenden and Marina Henderson, 1973.

David Octavius Hill, a second-rate painter in Edinburgh whose landscapes were shown in the Royal Academy, was commis-

sioned in 1843 to fill a huge canvas with the heads of 474 ministers of the Church of Scotland. This monster work was to commemorate the famous Assembly at which Scotland broke free of the established church. To help him with this vast project, Hill turned to photography and to the young engineer, Robert Adamson. Together they experimented with a camera and discovered that, by giving a long exposure, and if their sitter remained completely still as he sat propped up outdoors, an excellent likeness could be registered which would come in very useful in the painting.

The collaboration of Hill and Adamson has done more than any other photographic venture to make the largest number of people realize that photography could acquire the dignity of an art. The glorious revelation came in the form of a series of people seen as if in a still life: carefully arranged studies of characters who seemed to realize the seriousness of the event – for their lives were here being perpetuated.

Hill and Adamson used the Talbotype or calotype process. The inventor, Henry Fox Talbot, had been in close touch with Sir David Brewster, a friend of Hill, since 1835 when Talbot had succeeded in reproducing accurate representations of architectural details of his own house. Hill now adapted the process to artistic ends and created the first, and some say the definitive, masterpieces of photographic portraiture. Hill, the mediocre painter, was the artistic director of the partnership, yet he would not have gone far without the technical skill of Adamson.

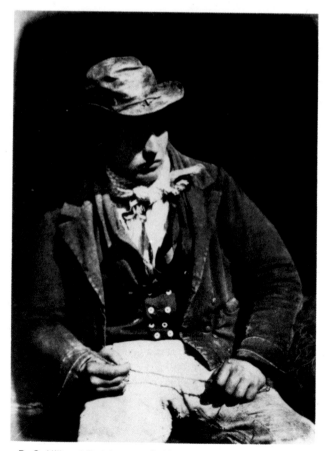

D. O. Hill and R. Adamson, *Baiting the Line*, June 1845.

Robert Adamson has been much underestimated: he was the quiet gentleman who remained behind the camera (while Hill often appeared in the compositions), and was responsible for the exposures, and for developing and printing the plates. Hill, spurred on by success, enlarged the range of sitters to include many of the great characters and worthies of Edinburgh, all of whom were delighted. Word spread of the exactness of the likenesses and soon all Scottish society came demanding to be featured in these process-prints. Hill and Adamson's artistic conception, masterly sense of form, instinct for bold and simple composition, and the powerful characterization, were all praised. Fifteen hundred prints resulted; many *chefs-d'oeuvre*. These portraits are vigorously strong and full of fresh air – a combination of healthy rusticity and scholarly learning. In fact, they are as truly Scots in character as their sitters.

In an attempt to give an effect of 'indoor' compositions Hill brought outside to the front of his house where the light was best, pedestals, tables, books, draperies and marble busts. The pictures he took there prove that he had a close knowledge of the paintings of Ter Borch, Vermeer, Gainsborough, Lawrence and Raeburn, and also that he knew how to utilize to his advantage the poses of fashion-plates of the day; these portraits have more than just the non-committal quality of snapshots; they are dedicated studies and have their own particular point.

Hill and Adamson did not confine themselves to portraying the cultured and professional classes. They carted their heavy paraphernalia out to nearby villages and photographed the seashore and the native dwellings of Newhaven. They devised a series of pictures of the sailors in their hard oilskin hats and tarry trousers looking like relics of Nelson's navy. In one exposure a young fisherman holds casually, as if in a dream, a piece of string; with his legs wide apart, and his sulky mouth lit by the sun, he looks like a Bernini sculpture and yet it is extremely modern in composition and pose.

The architectural photographs are masterly experiments with refraction. The quality of the stonework in Greyfriars churchyard has never been better conveyed, or distant roofs seen with greater depth of focus. Wherever personages – perhaps children asleep – adorn the compositions, they somehow give the human form an extraordinary significance and poignance.

Robert Adamson was hoping to exploit the technique of calotypes on a large commercial scale when he discovered that the prints quickly faded unless preserved in albums or closed boxes. This drastically reduced their value, and may have been the reason why Hill gradually gave up his calotyping and was forced to retire from photography when, in 1848, at the age of twenty-eight, Adamson died. It is true to say that it is not as a painter that Hill will be remembered, but for the artistry shown in the remarkable photographic partnership which had lasted only five years.

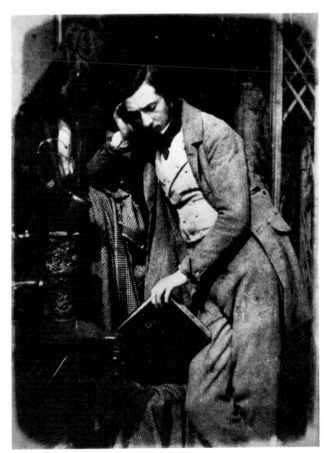 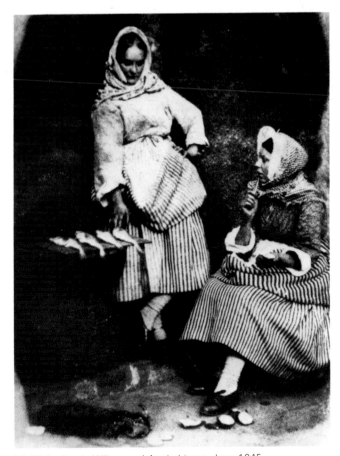

D. O. Hill and R. Adamson, *Above, left James Drummond, ARSA. Right Jeanie Wilson and Annie Linton,* June 1845.

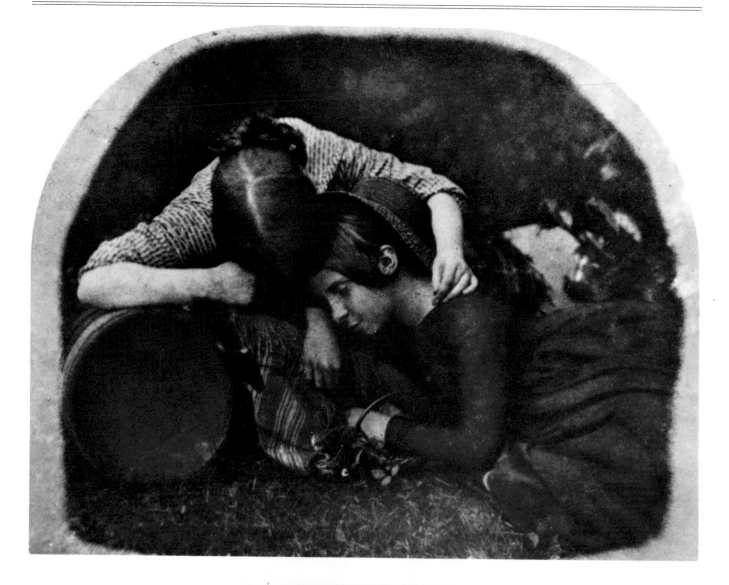

D. O. Hill and R. Adamson, *Above, top Miss Margaret McClandish and her Sister. Bottom Mrs Marian Murray.*

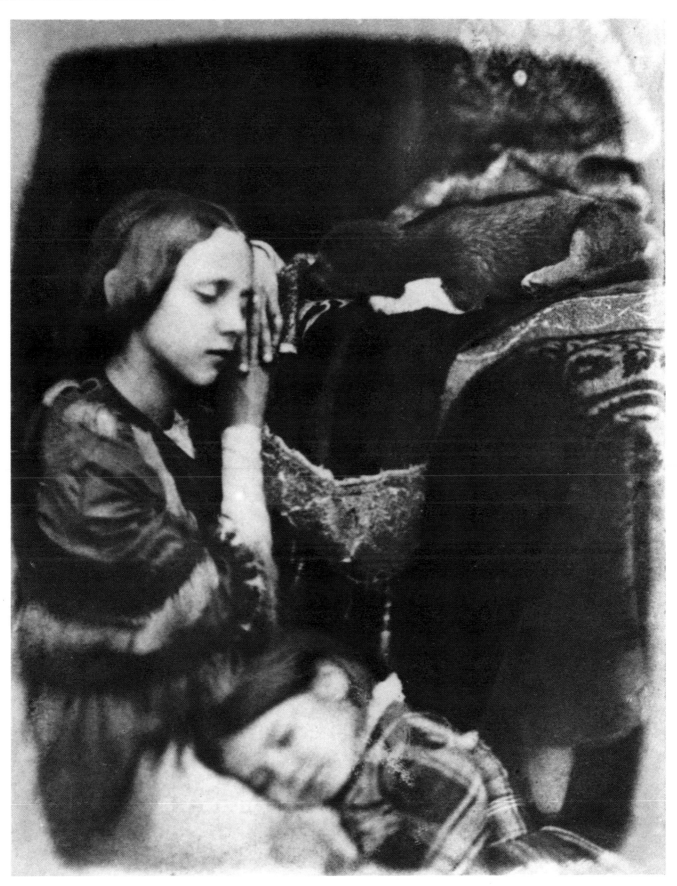

D. O. Hill and R. Adamson, *The Three Sleepers.*

Antoine-François-Jean Claudet

1798–1867

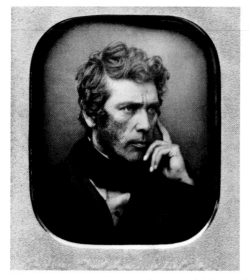

A. F. J. Claudet, Daguerrotype of Andrew Pritchard, 1843.

Albert Sands Southworth and Josiah Johnson Hawes

1811–94 and 1808–1901

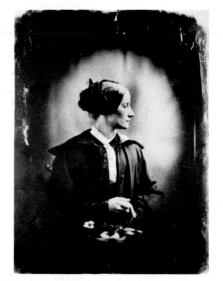

A. S. Southworth and J. J. Hawes, Daguerreotype.

Born in Lyons, France. At age of twenty-one, entered the banking business of his uncle. A few years later became director of a firm of glass-makers at Choisy-le-Roi. Opened a warehouse at High Holborn in London selling sheet glass and domed glass shades, 1829. Took George Houghton as a partner, 1837. Learned the daguerreotype process from the inventor and purchased a licence to operate in England, 1839. Read paper both at Royal Society and at the Académie des Sciences proposing that chlorine should be used as well as iodine to sensitize the silvered plates, June 1841. When the daguerreotype process was first announced the exposures were from fifteen to thirty minutes, making portraiture impossible; Claudet was one of the first to reduce the exposure-time. Opened portrait studio in Adelaide Street just behind St Martin-in-the-Fields, 1841. Took out patents covering the use of red lighting in the darkroom, the use of artificial lighting for portraiture, and of painted backgrounds, 1841. Signed an agreement with W.H. Fox Talbot to practise the calotype process in his portrait studio, 1844. Invented focimeter (used to test the degree of achromatism in lenses), 1844; photographometer (device for measuring the sensitivity of a daguerreotype plate), 1848. Sent some stereo-daguerreotypes of the Great Exhibition at Crystal Palace, 1851 to Emperor of Russia; received a diamond ring in appreciation. Moved premises to Regent Street, 1851; used calotype and wet-collodion process as well as daguerreotype. Patented a device which by using a shutter alternately in front of each eyepiece of a viewer in which there was placed something similar to a stereo-daguerreotype, the illusion of movement was created, 1853. Invented many things related to the stereoscope. Was the first person to take daguerreotypes in England. In 1863 the Emperor of France made him Chevalier of the Légion d'Honneur.

'Stereo-daguerreotypes that have survived show Claudet's skilled use of painted backgrounds, of curtained dummy windows. Several of these examples were hand-coloured. Colouring was applied very carefully with dry colour mixed with finely powdered gum, for the daguerreotype image is very delicate. Breathing on the plate was sufficient to soften the gum and fix the colour.'
(From Arthur T. Gill, 'Antoine-François-Jean Claudet 1798–1867', in the *Historical Group Newsletter* of the Royal Photographic Society, London, 1973)

Albert S. Southworth was born in West Fairlee, Vermont. Attended Phillips Academy, Andover, Massachusetts. A small-town pharmacist, saw first daguerreotype in 1840. Determined to learn process, bought a camera from Samuel F. B. Morse. Opened daguerreotype studio with Joseph Pennell in 1840; moved to Boston, 1841. Sent twenty-two daguerreotypes to third exhibition of Massachusetts Charitable Mechanic Association, 1841.

Josiah J. Hawes was born in Crawford, New Hampshire. Apprenticed to a carpenter and did oil painting in spare time. Learned daguerreotypy, 1840; joined Southworth as a partner, 1843. Firm not called 'Southworth & Hawes' until Pennell's retirement in 1845. During 1840s and 1850s not only operated gallery but sold daguerreotype supplies and taught process. Pioneered stereo-photography. In the 1860s and 1870s documented the city of Boston on wet-plate apparatus.

Collections: Metropolitan Museum of Art, New York; Boston Athenaeum; Holman's Print Shop, Inc.; Bostonian Society; Boston Public Library; International Museum of Photography, Rochester, New York. Publication: *The Hawes–Stokes Collection of American Daguerreotypes by Albert Sands Southworth and Josiah Johnson Hawes; a catalogue* by I. N. Stokes, 1939.

The Boston photographers Southworth and Hawes are considered by many the finest and most sensitive American practitioners of the daguerreotype. They went into partnership in 1843 and soon were photographing such notables as Daniel Webster, Charles Sumner, Louis Kossuth, Dorothea Dix, Oliver Wendell Holmes, Longfellow, Jenny Lind and her lover Otto Goldschmidt. Then, when competition among daguerreotypists was so keen, a photographer's clientele was often used as a measuring-stick of competence, skill and creativity. Southworth and Hawes's fame rests principally on their outstanding successes in studio portraiture. They are recognized, also, as being among the first to cut the time of exposure sufficiently to take casual scenes in natural environments. Of their work the editors of the Time–Life book *Great Photographers* say; 'They made the camera capture such unexpected and fleeting moments as the breeze riffling the hair of a stern and unyielding clergyman and a baby wriggling in her mother's arms, achieving an informality and depth of character that were novel at the time.' GB

Carl Ferdinand Stelzner

1805–94

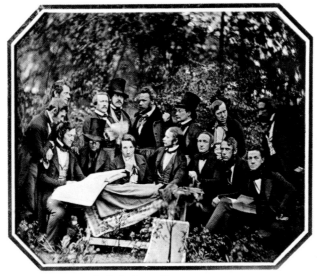

C. F. Stelzner, Daguerreotype.

German. Studied under Isabey and other well-known artists in Paris. Originally a miniature-painter. Learned daguerreotype process in Paris. Collaborated for seven months in a specially built glass-house in Hamburg with Hermann Biow, 1842. Together they took a large number of daguerreotypes of the ruins resulting from great Hamburg fire of 1842. His portraits were among the best done by daguerreotype process; they display great sense of composition, awareness of background and props, and naturalness in pose and expression. Went blind from fumes of silver iodide and mercury used in coating his plates. Collection: Staatliche Landesbildstelle, Hamburg. GB

Henri Le Secq

1818–82

In 1851 the French government used photography for official purposes by setting up an agency concerned with the preservation of ancient buildings. They assigned five photographers to do a thorough survey of archaeological monuments: Le Secq, Bayard, Baldus, Le Gray and Mestral. In the course of this work Le Secq recorded the cathedrals of Strasburg, Rheims and Chartres. An artist of rare delicacy, some of his strange 'garden scenes' have overtones of Bill Brandt – an urn, a ladder and a builder's implement seen against a lilac tree. His 'rustic scene', which seems like half a stereoscopic 'double', is curiously enigmatic, and the tree is like part of a stage setting. His fantasy still-lifes are very poetical – and his dusty, grainy flower-arrangements are the French equivalent of Roger Fenton's work in this genre.

H. Le Secq, *Rustic Scene*, c. 1853.

Roger Fenton

1819–69

Roger Fenton, *Still life.*

Born in Heywood, Lancashire. The son of a wealthy land and cotton-mill owner, received MA from University College, London. Studied painting with Paul Delaroche in Paris. Returned to London and studied law; worked as solicitor, 1852–4. Was one of twelve amateur calotypists to form Photographic Club, 1847. Helped found Photographic Society and became its first honorary secretary, 1853. Professional photographer, c. 1854–62. Returned to law profession, 1862–9. Special subjects: landscape, architecture, still life. Cameras: four of different sizes, including stereo; used wet plates. Exhibitions include: Royal Photographic Society, London, 1972. Collections: Royal Photographic Society; Science Museum, London; Victoria and Albert Museum, London; Stoneyhurst College; Royal Library, Windsor; Gernsheim Collection, University of Texas; Liverpool City Libraries; Manchester Central Library; Cambridge University Library. Publications: *The Conway in the Stereoscope* by J. B. Davidson, 1860; *Ruined Abbeys and Castles of Great Britain and Ireland* by William and Mary Howitt, 1862 and 1864; *Stereoscopic Magazine*, from 1858–; many through Photogalvanographic Co. for which he was manager of photographic department and chief photographer. Book: *Roger Fenton of Crimble Hall* by J. Hannavy, 1974.

Fenton embraced photography with such verve that he abandoned his career in the law. He excelled at making pictures of English cathedrals and ruins, and utilized sunlight and shadow to great effect. He went to Russia in 1852 to make photographs of a suspension bridge that was being built over the Dnieper, and took views of Kiev, St Petersburg and Moscow. On his return to England, Fenton was summoned by Queen Victoria to record intimate domestic scenes of the royal family. His large prints were received with awe and wonder. This association with royalty continued for many years. He photographed a mammoth number of art treasures in the British Museum. His exuberant still lifes of fruit and flowers are

Roger Fenton, *Still life.*

Roger Fenton, *Highland Gillies at Balmoral.*

unequalled in texture, richness and beauty of composition, and remind one less of Fantin-Latour than of Courbet.

An expedition by Fenton to the Crimea was made under the Queen's patronage, and he had letters of introduction written by the Prince. He arrived at Balaclava in 1855 and took nearly four hundred photographs of the war. Fenton's pictures show none of the horrors and ravages of battle: Victorian taste would have been offended if the bloodshed and violence had been depicted starkly.

In 1862, at the height of his success, Fenton gave up photography to return to the law. Some of his negatives were bought up by Francis Frith, the photographer and print-seller in Reigate, who also published at least two folio volumes of his work.

Roger Fenton, *The Terrace and Park at Harewood House,* 1861.

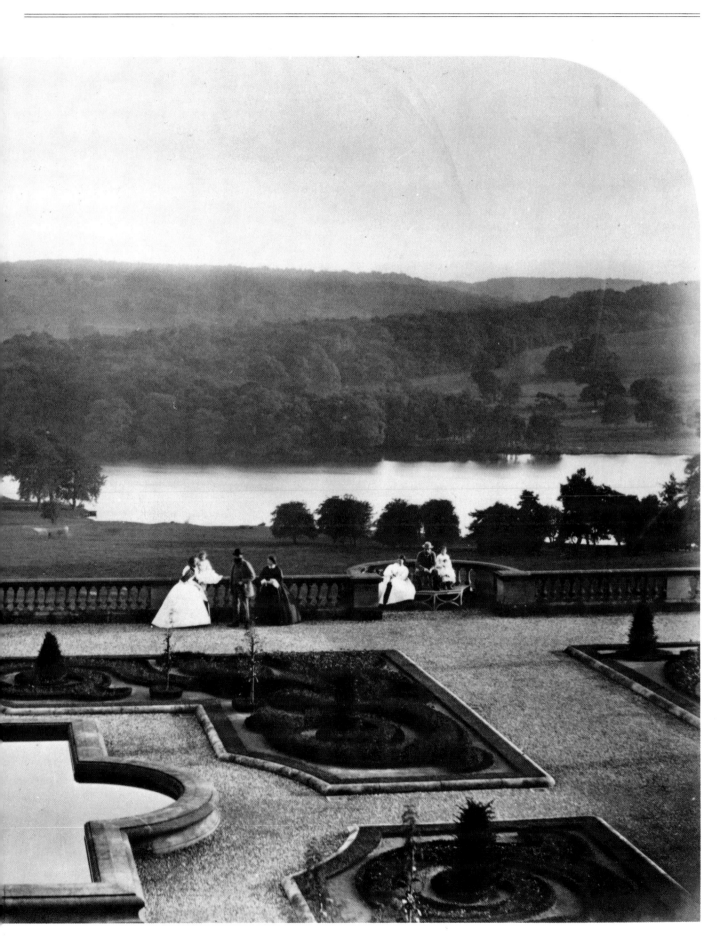

Hugh Welch Diamond

1809–86

H. W. Diamond,
Mental Patient,
c. 1852.

Born in Kent. Educated at Grammar School, Norwich, and admitted to Royal College of Surgeons as an articled pupil, 1824. After obtaining his qualification was appointed house surgeon to the West Kent Infirmary at Maidstone. Relinquished post in order to take up private practice in Soho, then one of the most fashionable areas of London. A member of Board of Health, distinguished himself in his activities during cholera outbreak of 1832. Decided to specialize in mental disease, appointed superintendent of women's department of Surrey County Asylum, 1848. Between then and 1858 when he resigned the post, used photography in the direct treatment of mental patients. Secretary of Photo-graphic Society and editor of its Journal, 1848–58. Secured the lease of the old mansion, Twickenham House, where he treated but did not photograph his private patients, from 1858. (Felt to photograph in a public institution was permissible; in a private one it was not.) Appointed juror for England at the International Exhibition, 1867. Collections: Royal Society of Medicine; Norwich County Record Office; Norwich City Library; Royal Photographic Society, London.

Dr Diamond was a very early worker in photography and probably the first person to use the camera to record the faces and expressions of mental patients. It is a terribly emotional experience to look at these women patients as they appear frozen forever on the faded salted paper. In photography, the viewer goes straight into the picture. Thus, when looking at Diamond's portraits we feel we are with these patients. To feel such immediacy with people who lived over 120 years ago is unnerving enough, but to sense their lunacy as well is quite overpowering. Dr Diamond's photographs are unique in the effect they have on anyone who looks on them. GB

Philip Henry Delamotte

1820–89

P. H. Delamotte, *The Open Colonnade, Crystal Palace,* 1855.

An Englishman, and professor of drawing at King's College, London, Delamotte was an early calotypist. He made an arrangement with Talbot to take collodion photographs and was commissioned by directors of Crystal Palace Co. to take photographs of the works in progress during rebuilding of the Crystal Palace in Sydenham. Delamotte documented thoroughly and imaginatively the erection of the Crystal Palace, from the levelling of the site in 1851 to the opening ceremony conducted by the Queen on 10 June 1854. Every week Delamotte took the photographs and the complete work, published in two volumes entitled *Photographic Views of the Progress of the Crystal Palace, Sydenham, taken during the progress of the works, by desire of the Directors, 1855,* is a magnificent achievement and a superb ex-ample of how faithfully a wet-plate photographer could docu-ment events. The *Photographic Journal* of 21 February 1857 remarked, 'The specimens of Mr Delamotte's art are highly deserving of all that commendation which has been so freely and justly bestowed upon them.' Delamotte published numer-ous stereo-views of the Crystal Palace and its exhibits. Collection: County Hall Members' Library, London. GB

Charles Nègre

1820–80

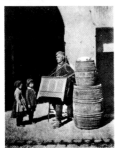

C. Nègre, *Organ-Grinder,* 1852.

A painter and pupil of Ingres and Delaroche, Nègre began photographing in 1851. He was born in Grasse, and left photographs of his native province that would be difficult to surpass even today. A *flâneur* photographer, he roamed the streets as Cartier-Bresson does today, taking pictures of bizarre types and odd encounters. Nègre made a series of working-class people at their various trades – the water-seller, and a child giving a piece of money to an organ-grinder – but his most handsome work was his report on the Imperial Asylum at Vincennes, one of the charitable institutions founded by Napoleon III for the care of disabled workmen. As Frances Benjamin Johnston was to do at the Hampton Institute twenty years later, he made extraordinary, bewitching pictures – of nuns, and young boys, and all types tending their patients with care and devotion. Although the lighting may have been poor, Nègre, with the use of small plates and a relatively wide lens, produced dramatic results. Nègre intended to use photographs as studies for his paintings, but on their own merit they can be judged as exquisite works of art. He also succeeded with heliogravure, the collotype process and photogalvanography.

John Jabez Mayall

1810–1901

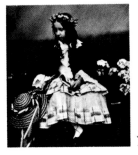

J. J. Mayall, *Princess Helena,* 1855.

John Jabez Mayall was an American from Philadelphia who lectured in chemistry and ran a daguerreotype studio there from 1842. He arrived in London in 1846 and managed the studio of Antoine Claudet, a Frenchman who had bought the first license from Louis Daguerre to practise daguerreotypy in England. Mayall did not stay long with Claudet, as he opened his own studio in April 1847, called the American Daguerreotype Institution. He became very successful as his daguerreotypes, like all American ones, had a greater polish and clarity than the English products.

Mayall soon became one of the leading portrait photographers using both albumen-on-glass and wet-collodion negatives. Looking through the *Illustrated London News* and the *Illustrated Times* of the day, one finds hundreds of engravings of prominent individuals based upon photographs by Mayall. His *carte-de-visite* business earned him £12,000 a year, a figure that put him ahead of all other English professional photographers. The output of his establishment was said to exceed half a million *cartes* a year and the royalties paid to him for his photographs of the royal family exceeded £35,000.

Gustave Le Gray

1820–82

G. Le Gray,

French. An artist, changed from painting to photography around 1848. Opened a portrait studio in the Madeleine district of Paris. Became known for his landscapes, seascapes and architectural views, Initiated 'combination printing'. A teacher of photography to most of the well-known photographers of his day. Invented wax-paper process, 1851; this was most popular paper process for landscapes and architecture. Books: *A Practical Treatise on Photography*, 1850. He is best known for his seascapes printed with two negatives, one a cloud and the other the scene. A sensation was created when his photographs were exhibited in London. *La Lumière* declared, 'This is the event of the year.'

Felice Beato and James Robertson

(no dates known)

F. Beato, *Kamakura, Japan.*

James Robertson, an Englishman who had designed medals in the 1830s, was appointed superintendent and chief engraver of the Imperial Mint at Constantinople in about 1850. Robertson met Felice A. Beato, a Venetian by birth and a naturalized British subject, in Malta in 1850 and they began a close association. They first photographed in Malta in calotype and then travelled to Egypt and Athens, photographing by the wet-collodion process. In the 1850s Robertson published views of Constantinople, Malta and Athens. He went to the Crimea in September 1855, immediately after the fall of Sebastopol. His powerful images of the Russian batteries, the English and French camps and entrenchments, and the town of Sebastopol form a continuation of Roger Fenton's documentation of the war. When he returned from the Crimea he joined Beato, who was on his way to India. They stopped in Palestine in 1857 in order to photograph. Upon arriving in India, the two men photographed the aftermath of the Indian Mutiny of 1858.

After documenting the destruction and despair caused by the uprising, Beato joined the Anglo-French campaign against China and was able to record some of the major events that occurred during the Opium War in 1860. Robertson remained in India and became a partner of Shepherd (of the photographic firm founded in 1843) and took many photographs of soldiers in the British army. In 1862 Beato went to Japan and spent many years there photographing Japanese officials, peasants and ordinary families as well as palaces, towns, temples and the countryside. He did extremely fine panoramas of Japanese landscapes, as Robertson had done elsewhere in the 1850s. Processes: calotype, albumen-on-glass, wet-collodion. Collections: Indian Record Office, London; Victoria and Albert Museum, London; National Army Museum, London; Imperial War Museum, London. GB

Henry Peach Robinson

1830–1901

Born in Ludlow, Shropshire. Bookshop assistant in Leamington; studied art and contributed articles and sketches to *Journal of the Archaeological Society* and *Illustrated London News*. Etching, sculpture and literature occupied much time, painting principal interest. Became interested in photography, 1852; opened portrait studio in Leamington, 1857. Resolved 'to produce every year at least one picture with the sole object of showing the pictorial capacity of the photographic art'; photographs exhibited annually at Photographic Society of London. Temporary retirement, 1875. Worked in partnership with N. K. Cherrill in Tunbridge Wells from 1868; built 'Great Hall Studio' there, 1878. Retired from business, 1888. Honorary Fellow, Royal Photographic Society, 1900. Founder member of Linked Ring, 1892. Received over 100 medals from various sources, 1860–90. Process: wet-plate; albumen and platinum prints; specialist in combination printing. Major collection: Royal Photographic Society, London. Books include: *Pictorial Effect in Photography,* 1869; *Picture-making by Photography,* 1884; *The Studio and what to do in it,* 1885; *The Art and Practice of Silver Printing*, with Sir W. de W. Abney, 2nd ed. 1888; *Photography as a Business,* 1890; *The Elements of a Pictorial Photograph,* 1896.

Robinson was probably the most influential voice in nineteenth-century photography; not only was he a consistent producer of images that startled his public, but he was a founder of the Linked Ring group of earnest photographers who were the English equivalent of the Secessionists in America.

Robinson trained as a painter in the Pre-Raphaelite vein, and had a canvas exhibited in 1852 at the Royal Academy. When he was introduced to camera picture-making he became an immediate enthusiast.

He was intent on telling a story with his camera, and in doing so joined portions of negatives together. The dividing lines were scarcely visible, and his *Dawn and Sunset*, where we see youth and old age represented in a cottage interior, was totally convincing. *Fading Away*, his masterpiece, and the first photograph he exhibited, was made with five negatives; *Sleep,* with moonlight on the sea outside a mullioned window, with perhaps even more. In the 1860s his montage of the Lady of Shalott – a very pregnant Lady of Shalott – was as near to Millais, with its willow-trees and water-lilies, as fake photography could make it. Robinson's creations show that the early lenses were extremely sharp, even if they necessitated long exposure.

Robinson theorized and was articulate about his art-philosophy and of what photographic art consisted. He was ruthlessly doctrinaire, telling us that ten per cent of the picture must be lit in a certain way, leading figures so many inches from the margin, a line of emphasis to be off-centre. Robinson published eleven volumes on photography. His text-books were bibles for camera enthusiasts for at least twenty years. His guidelines for photographers, based on the standard art system of the Royal Academy, showed that his principles were the same as in nineteenth-century painting – oneness of purpose, a story and thought, the unity of line, light and shade, subordination of superfluous material to help emphasize the main meaning of the picture, a sense of what is appropriate to the entire picture.

Certainly Robinson succeeded in producing some quaint pictures of remarkable technical achievement and treacly sentimentality which appealed greatly to certain Victorian tastes.

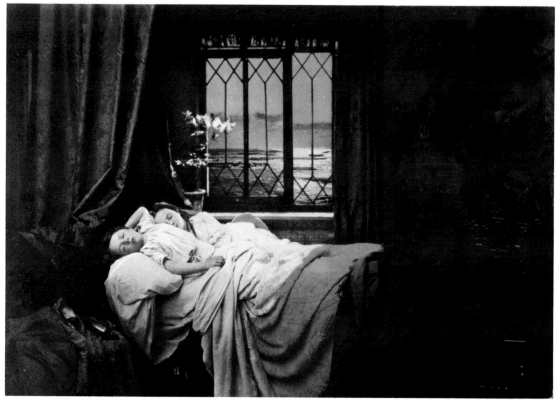

H. P. Robinson, *Sleep*, 1867.

Oscar Gustave Rejlander

1813–75

O. G. Rejlander, *Gustave Doré*, 1860.

Probably born in Sweden. Studied painting in Rome where he worked as a portraitist, lithographer and copyist. By 1841 was living in Lincoln; by 1846 in Wolverhampton. Learned photography from Nicholas Henneman, 1853. Early experimenter with lighting and multiple printing. First combination print exhibited 1855; *Two Ways of Life* exhibited at Manchester Art Treasures Exhibition, 1857. Special subjects: portraiture, studies for artists, composite photographs. Process: wet-collodion. Major exhibition: London (about 400 prints), 1889. Collections: Bäckström Collection, Stockholm; Edinburgh Photographic Society; Royal Photographic Society, London; International Museum of Photography, Rochester, New York; Gernsheim Collection, University of Texas; Kodak Museum, Harrow. Books: *The Expression of the Emotions in Man and Animals* by Charles Darwin, 1872; *Father of Art Photography: O. G. Rejlander* by Edgar Yoxall Jones, 1973.

A painter by inclination, Rejlander made a living in Rome by copying old masters. When he married an Englishwoman he came to live in England as a portrait-painter. After using photography in order to help him with his likenesses, he decided to give up painting altogether and to supply useful photographs to other painters.

Rejlander then experimented in using many negatives in the same picture: an old cottager smoked a pipe against the background of an added haystack which, in turn, gave on to a 'made-up' country scene. Encouraged by success, he would look from his window for suitable subjects to include in his 'Every Photograph Tells a Story' series. As well as his friends, he corralled the muffin-man, the pot-man from the Darlington Arms, the laundry-women with their baskets. He accosted strangers in the streets, if he considered them photogenic, and 'directed' them in his home-made scenes. One photograph-montage, no longer in existence, showed a maid and a man-servant 'making warm love' outside the back door of the kitchen, while, from the various windows the entire family, including the children, watched 'the culprits'. 'To balance the composition, a rocking horse was put to admirable use!'

Rejlander continued to emulate painting in photographic terms by using more and more negatives, a process that was incredibly laborious and time-consuming. He was partial to allegory, and soon his great 'cartoon' began to take shape. *The Two Ways of Life* was made from over thirty negatives in which sixteen nude or semi-nude figures were used; it was this fantasia which brought him lasting fame. When first seen, it was

considered 'indelicate' and Scotland rejected it; but, when the Manchester Art Treasures Exhibition showed it, Queen Victoria, always interested in photography, bought a copy to give to the Prince Consort who proudly displayed it at Windsor. Later, other examples were shown throughout the United States and the continent.

Rejlander continued to make his 'assemblages', but he was never a master technician and, tired of criticism, 'cavil and misrepresentation', he gave up composite photography for landscape and illustrations for Charles Darwin's *The Expression of the Emotions in Man and Animals* (1872). He photographed *Indignation, Disgust, Surprise, Helplessness,* and in order to illustrate *Mental Distress* he depicted a child howling his head off. This picture became a freak success; sixty thousand copies and a vast quantity of *cartes-de-visite,* were sold and many more pirated by dishonest firms. Rejlander was not proud of 'Jinx's Baby', as this picture came to be known; 'but,' said its creator, 'it paid the bills.' Rejlander was always short of money.

In London, Rejlander experimented in his studio with lighting in order to 'accentuate texture and outline'. He was of the opinion that 'solidity and force would be secured if all the light which had no part in the formation of a photographic image could be either shut off or shut out from the room'. At first he experimented with a tunnel of screens in front of the lens, and later with telescopic tunnels whose interiors were painted black.

He made himself a studio in 'a dark, tapering passage' in which he set his camera, with the sitter being lit with what we would now term spotlighting from the top and side. Edward Burne-Jones used his photograph *Truly Thankful* for one of his paintings, and Gustave Doré posed on a chaise-longue: the result was praised by the etcher, but criticized for its poor technique by photographers. He made portraits using 'concentrated' daylight, that were near to candid studies in which he did his best to eliminate the 'Sunday best' formal pose of most photographers. He also indulged in his taste for grossly exaggerated character-studies or comic pictures.

Rejlander's slightly whimsical humour and his sentimentality were evident in some of the captions to the pictures: *What Ails Amy?, Is It True?, Tatters, Did She?, Hard Times, I Pays, Nothing Left to Pawn, Longing for Home.*

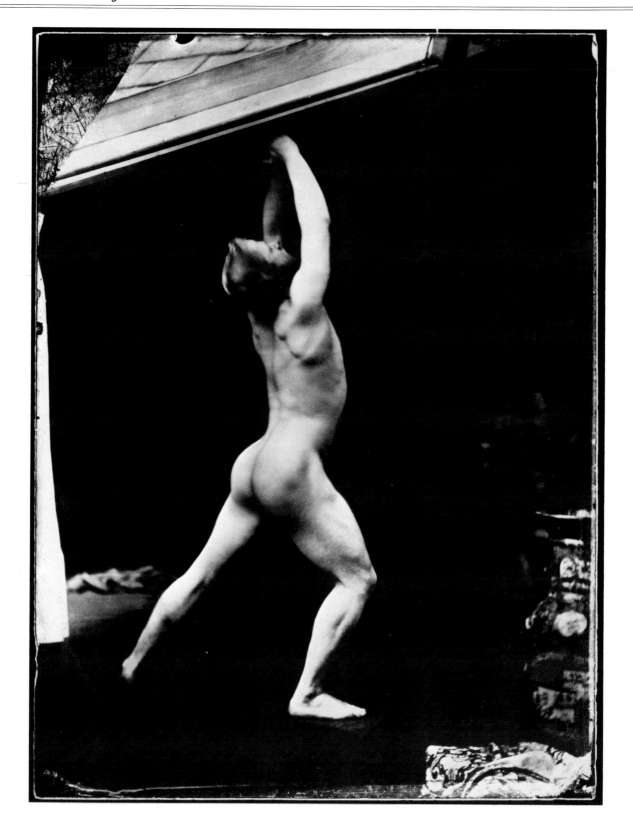

O. G. Rejlander, Artist's study.

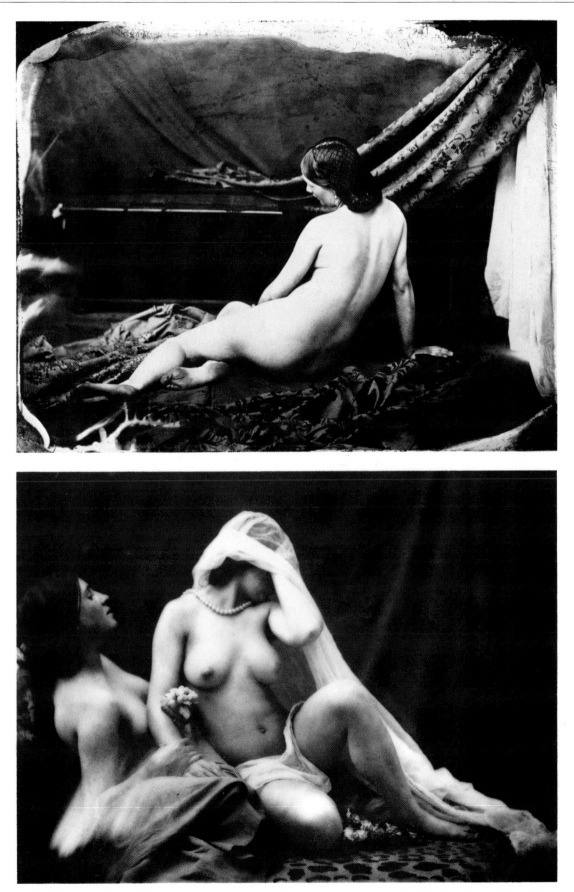

O. G. Rejlander, *Top* Artist's study. *Bottom* From one of the original negatives used in *The Two Ways of Life*, 1857.

Charles Lutwidge Dodgson (Lewis Carroll)

1832–98

Lewis Carroll, *The Elopement, Alice Jane Donkin*: a composite photograph taken at Barmby Moor, 1862.

Born in Daresbury, Cheshire. Educated at Rugby and Christ Church, Oxford, 1846–50. Took up residence at Christ Church, 1851, and lived there until death. First became interested in photography, 1855; bought photographic outfit and took first pictures, 1856. Became mathematics lecturer and first used pseudonym 'Lewis Carroll', 1856. Finished *Hiawatha's Photographing*, first published in *The Train*, December 1857. Showed four photographs at fifth exhibition of Photographic Society of London, 1858. Rented Badcock's yard, Oxford, for photographing, 1863. Constructed a glass studio over his rooms at Christ Church, 1872. Stopped photographing about 1880. Equipment: wet-plate. Collections: Parrish Collection, Princeton, New Jersey; Gernsheim Collection, University of Texas; private collections.

The Reverend Charles Dodgson, of Christ Church, Oxford, the author of *Alice in Wonderland* and *Alice through the Looking-glass*, was a lion-hunter and pursued celebrities with his camera. His portraits of men were straightforward and he was sensitive to the background he used. He most enjoyed photographing little girls in fancy-dress costume. His favourite sitter was Alice Liddell, the original 'Alice', and his photographs of her with her sisters showed his natural sense of composition. Criticism was levelled at Carroll for photographing little girls in the nude. Much of his work was looked upon with a certain 'knowing' disapproval, and after his death many of the offending negatives were burnt. This is particularly sad since he was surely the best photographer of children in the nineteenth century. Unlike Julia Margaret Cameron (who photographed Alice Liddell when she had grown to be a somewhat stringy, rangy adult), Lewis Carroll could arrange groups of young people with exquisite grace and naturalness.

Lady Hawarden

1822–65

Lady Hawarden, born Clementine Elphinstone at Cumberweald House, near Glasgow, married Cornwallis Maud, fourth Viscount Hawarden. Her mother was Spanish (which perhaps accounts for the slightly Mediterranean look of her daughters' piercing dark eyes and straight black hair).

Lady Hawarden was more than a brilliant amateur. She had a strongly individual attitude towards picture-making. With such a bold attack, uncluttered line and obliteration of all extraneous detail, her work might be that of a man.

She worked in her sparsely furnished London house with the light coming from the tall windows from which she pulled back the muslin curtains. Lady Hawarden was particularly good with children and young girls in Alice-in-Wonderland fashions of crinoline skirts and tiny buttoned boots. The charm of these sometimes poignant and always poetical studies was enhanced when she used the stereoscopic camera, and we see her delightful images in double.

Lady Hawarden was influenced by the Pre-Raphaelite movement, and some of her compositions in this vein were quite unlike the work of Julia Margaret Cameron, although she used similar subjects and technique. More adept at grouping and general composition than Mrs Cameron, she seldom photographed only the sitter's head but, taking full advantage of the sweeping skirts of the period, made highly romantic conversation-pieces on terraces and balconies.

Lady Hawarden joined the Photographic Society in 1863 where her work won her much admiration from Lewis Carroll, and others, as well as several prizes. In July 1864 she collected £50 by taking portraits in one afternoon at a fête in aid of the Female Schools of Art. Six months later she died.

Lady Hawarden, Two untitled photographs.

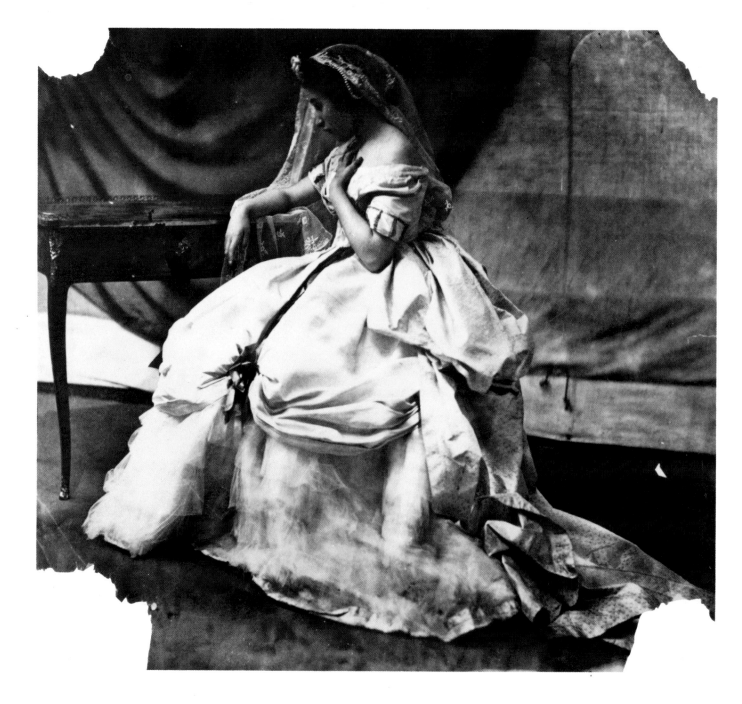

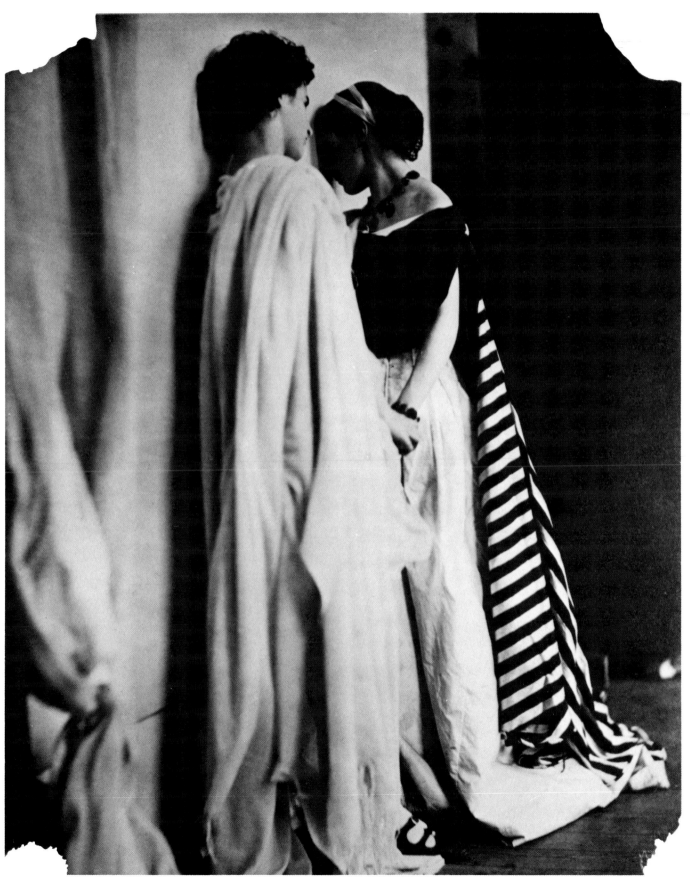
Lady Hawarden, Untitled photograph.

Camille Silvy

b. 1835–?

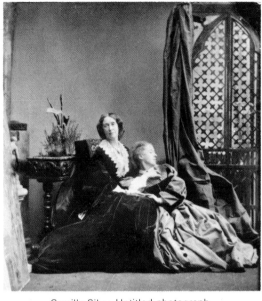

Camille Silvy, Untitled photograph.

Silvy was a French aristocrat with an imposing ancestral château in the grounds of which he enjoyed taking photographs with an amateur's camera. Surprisingly, he decided to come to England where, in the 1860s, *cartes-de-visite* were 'all the rage', to open a portrait studio in Porchester Terrace. These little portraits, used as greetings, were generally taken in full length with an elaborately fanciful background and suitable props arranged around the sitters. This fashion gave Silvy his opportunity to show not only his impeccable taste, but also his skill at portraying his subjects at their most characteristic and, without the stigma of retouching, to present them at their best advantage.

The work of this highly successful artist has an unfailing charm. Its tone-values, compositions, the natural freedom of the poses make him the Gainsborough of commercial photographers.

M. Silvy photographed the entire British Royal family and most of the celebrities of the day. He seldom duplicated backgrounds, though once he slipped up by featuring Sir Edward Cust in the kitchen setting for Mme Patti in Rossini's *La Gazza Ladra*. M. Silvy posed the tall Miss Moncrieffe, later to become the renowned beauty Georgiana, Lady Dudley, with her minute head, its exaggeratedly swanlike neck, in a woodland glade; Princess Alice went into a painted conservatory, little boys in tall hats propped themselves against ornamental vases or were depicted in gothic libraries, a rowing-boat, or among the rigging of a pirate galleon. Ballet-dancers were made to look as gossamer-light as they did in the engravings of Chalon and Brandard, perched like birds on a balustrade. M. Silvy obviously derived enjoyment from posing Mme Musurus, the enormously rotund wife of the Turkish ambassador: he placed her in a setting of rhomboids, bobbled pouffe chair, looped curtains and fat gloxinia. Other Silvy masterpieces are Miss Haywood in bridal coronet, and Miss Bryden in her black velvet crinoline with a folding parasol over her shoulder.

Although Camille Silvy was the undoubted and unchallenged *maître* of the *cartes-de-visite*, some provincial practitioners managed to produce a few isolated bull's-eyes enhanced by the elaborate costumes of the period.

M. Adolphe Beau, himself to become a renowned recorder of his palmy time, had once acted as an assistant to M. Silvy, and inherited his master's collection of negatives. At the end of his life, Beau wrote:
'In reply to your appeal to my memory I send you herewith, *currente calamo*, what I can gather from the corners of my brain, after such a lapse of time:

Perhaps I might be allowed to mention my having been one of the pioneers of photography in this country. There were indeed very few photographers in London at the time when with Silvy, I introduced the full length *cartes-de-visite*. We thought the best plan for the purpose was to produce at first a series of theatrical portraits, thus enabling the public to judge what they would be like as regards likeness and artistic treatment. Therefore the studio of Porchester Terrace became the rendezvous of the most eminent of the profession. Later on, in my studio in Regent Street, I followed in the same strain, and I possess a most important and unique collection of the first dramatic portraits of the period. It is a very remarkable fact that most actors, when finding themselves in broad daylight, seemed, as it were, quite *dépaysés* and to have lost the actual remembrance of their exact poses and expressions before the footlights, and I had often to quote the words to promote the attitude.'

M. Silvy appears briefly in only a few books of reference, and the mystery of his personality is unfathomable.

When the *cartes-de-visite* fashion faded, M. Silvy retired to his ancestral château, but later returned to England as consul at Exeter.

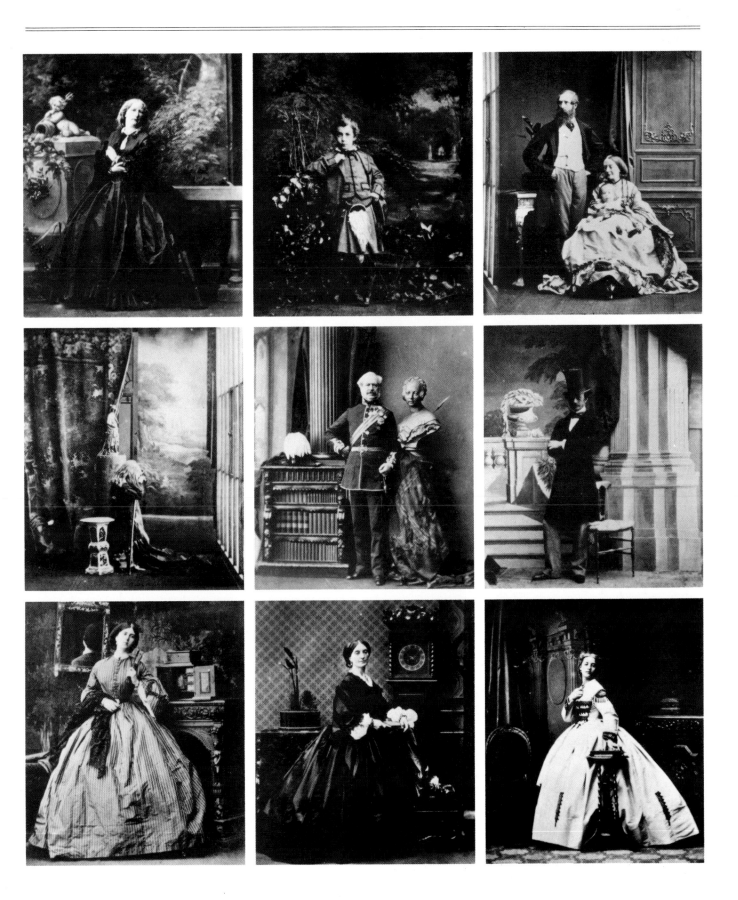

Camille Silvy, *Cartes-de-visite* photographs.

Mathew B. Brady

1823–96

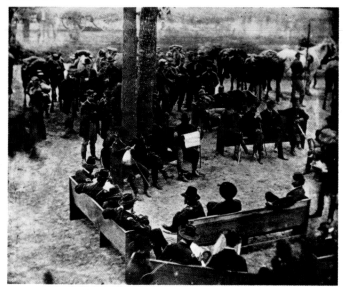

Mathew B. Brady, *General Grant's Council of War in a Field near Massaponax Church, Virginia, 21 May 1864.*

Born near Lake George, New York. Of Irish descent, received instruction in art from William Page, a friend of Samuel F. B. Morse, an early experimenter with daguerreotypy. Learned how to make daguerreotypes from Morse, J. W. Draper and Professor Doremus. Opened first studio in New York City, 1844. Conceived idea of photographing all the distinguished and notable people of his day, 1845; to secure the survival of his images, copied all his daguerreotypes on to glass plates. Opened second gallery in Washington, DC, 1858; opened third gallery in New York, 1860. Was the first photographer on the scene to record the American Civil War, 1861–5; directed his extensive staff of photographers from his headquarters in Washington. After war gave one set of his negatives to principal creditor, E. and H. T. Anthony & Co. and tried to sell second set. Sold all his property and New York galleries to pay creditors; kept Washington gallery. Cameras: daguerreotype and wet-plate. Major collections: Library of Congress, Washington, DC; National Archives, Washington, DC. Books include: *Gallery of Illustrious Americans* with C. Edwards Lester, 1850; *Mr Lincoln's Camera Man*, Mathew B. Brady by R. Meredith, 1946; *Mathew Brady, Historian with a Camera* by J. D. Horan, 1955.

Mathew B. Brady (no one ever found out what the 'B' stood for) became famous as Mr Lincoln's cameraman. This odd-looking Irishman with a long, strange nose, topped by pince-nez, straggling thin pointed beard and unruly curls, photographed the President before his inauguration – Mrs Lincoln very grand in floral wreath and flowered crinoline – and all through his term of office until the shooting in the box at Ford's Theater.

His earliest photographs, made for whimsical *cartes-de-visite* were of parakeets and budgerigars at play; but he discovered straight portraiture to be more remunerative and soon he was photographing all the celebrities of the day: Walt Whitman, Jennie Lind 'The Swedish Nightingale', and Finias Taylor Barnum, the showman and founder of a circus, 'The Greatest Show on Earth'. Brady's highly gilded 'baroque' studio on Broadway, resplendent with chandeliers and palms, displayed 'Imperials' (the name was his invention for life-size photographs – often tinted) around the velvet-hung walls. These rather wooden and self-conscious but illustrious personages

comprised royalty and congressmen, senators and actors. So great was Brady's renown that he opened studios in Washington and other cities.

In 1861, seventeen years after the opening of his first studio, Brady found himself on a wagon *en route* to photograph a war. He presented an odd sight in his white linen duster and extraordinary straw hat, with his 'water melon' wagon (his travelling darkroom), and three days' rations, as he joined General MacDowell's army in the march on Centerville, Virginia, the reported position of the Confederate army. Brady decided at the onset of the war to make a thoroughly comprehensive visual record. He hoped eventually to obtain financial support from the government for this venture, but went ahead on his own employing some twenty photographers and investing $100,000 in outfitting and training them.

It was more Brady's organizational abilities and bravery in the face of danger than his artistic talent that are remembered with respect today. Brady and his staff photographed everything to be seen; General Sherman, General Grant and Robert E. Lee, an army storekeeper's tent and the entrance to the National Cemetery at Gettysburg. In one group, taken just before the Battle of the Wilderness, we see Brady leaning against a tree, extremely nonchalant in his picturesque clothes, large hat and long hair.

It is often difficult to know which photographs were taken by Brady himself, and which by his assistants, for he stamped his name on all of them. The clause in the contract whereby Brady insisted that all pictures should be credited to him was the reason for Alexander Gardner, who seems to have been responsible for many of the best pictures, leaving the enterprise and starting up on his own.

Of the photographs that we know were taken by Brady, *General Grant's Council of War in a Field near Massaponax Church, Virginia,* is exceptionally fine. Under the trees, sitting on pews, the officers are gathered to discuss the disastrous situation – for the Union troops' losses that day had been heavy. Grant is bending over the bench looking over another general's shoulder at a map in the general's lap. The orderlies, the ambulances and the baggage-wagons in the background build up an interesting composition. This shot, together with a few others taken with a stereoscopic camera, are historical documents of the greatest importance and, without his knowing it, they have brought Brady lasting fame.

Long after the war Mathew Brady remained confident that eventually the government would purchase his negatives, but he was wrong; once the hostilities had ended the public did not wish to see the brutality of war.

Unable to pay for even the storage of his pictures Brady put them up for auction, and the United States War Department purchased the collection from the storage company for less than $3,000. President Garfield appealed in the House of Representatives for help for this man who, for twenty-five years of his life, had been doing genuine service to the community. Although $25,000 was finally voted to Brady, he was too far in debt for this to be of lasting benefit. He died in the poor ward of a New York hospital.

Alexander Gardner

1821–82

Born in Paisley, Scotland. Trained in physics and chemistry. Went with family to United States to settle in socialist community in Iowa, 1856, but because of an epidemic there went to New York City. An accomplished photographer, hired by Mathew Brady. Opened photographic gallery in Washington for Brady, 1858. Started to photograph American Civil War for Brady but split with his employer because of differences of opinion about copyright. Became official photographer to the Army of the Potomac. Opened own gallery in Washington, DC, 1863. Went to Kansas as official photographer for Union Pacific Railroad, 1867. Photographed Indian delegates to Congress for Office of Indian Affairs, 1867–80. Made 'rogues' gallery' for Washington police, 1873. Process: wet-collodion. Collections: Library of Congress, Washington, DC; National Archives, Washington, DC; British Museum, London, etc. Books: *Gardner's Photographic Sketch Book of the (Civil) War,* 1866 (reprinted 1959).

Alexander Gardner came of a middle-class church family. At fourteen he was apprenticed to a jeweller and this may have given him the dexterity which proved to be so useful in the delicate task of preparing wet plates. His interests were social welfare, literature, astronomy and optics. His involvement with chemistry led him to photography in the 1840s and 1850s. But it was photography as an art-form rather than as a craft that he embraced.

When Gardner brought his family from Scotland to America, Mathew Brady, recognizing Gardner's superior knowledge of photography, based on his study of physics and chemistry, had found at last someone to manage his branch portrait-gallery in Washington. Gardner invested his savings and busied himself with experiments in lighting by electricity. Soon he had constructed a crude machine by which he was making photographs with artificial light in the Brady Gallery.

Alexander Gardner was for seven years Mathew Brady's right-hand man. He was the wet-plate photography expert and during the Civil War was responsible for preparing the delicate plates in the horse-drawn 'darkroom' on the battlefield and rushing them to the nearby camera where for perhaps ten seconds they were exposed before being returned immediately to the tent for development. Later Gardner held an independent position as photographer to the Army of the Potomac and pinpointed all the important scenes and incidents that go to make up the history of the Civil War. He was certainly responsible for some of the most evocative and macabre pictures taken during the war – bits of limbs, clothing, Confederate soldiers dead in the trenches at Fort Mahone, and a dead boy lying in the road near Friedrichsberg. His dramatic representations of the Lincoln conspirators, and of their actual hanging, are of great historical value.

Gardner was a quiet, dour, intelligent man who wished to make his name famous in history, and for this reason he refused to continue as one of a staff of anonymous photographers working under the Brady signature. He published a book of his own photographs called *Gardner's Photographic Sketch Book of the War.* Gardner wrote for the book a brisk, vital and journalistic text which showed him personally and emotionally involved with a strong partisan attitude. The book, though today of great value and a rarity, did not succeed, for by the time it appeared the war was over and it aroused too many painful memories.

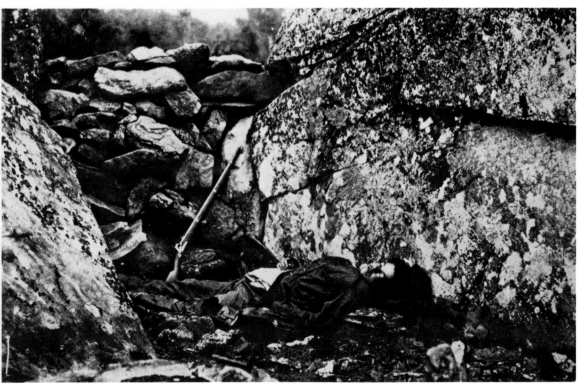

Alexander Gardner, *Death of a Rebel Sniper, Gettysburg, 5 July 1863.*

Julia Margaret Cameron

1815–79

Julia M. Cameron, *Thomas Carlyle*, 1867.

English, born in Calcutta, the daughter of James Pattle, high official in Bengal Civil Service. Educated in France and England. Married Charles Hay Cameron, 1838. Came to England, 1848; moved to Freshwater, Isle of Wight, 1859. Given camera and wet-collodion equipment by daughter and son-in-law, 1864. Finest portraits done between 1866 and 1870; illustrations to poetry including Tennyson's *Idylls of the King*, 1870–5. Left for Ceylon, 1875. Returned briefly to England, 1878. Photographed native types in Ceylon. Exhibitions: Museum of Modern Art, New York, 1949; Leighton House, London, 1971; Royal Photographic Society, London, 1973; Major collections: Royal Photographic Society, London; Victoria and Albert Museum, London. Books: *Alfred, Lord Tennyson and His Friends*, 1893; *Victorian Photographs of Famous Men and Fair Women* with introduction by Virginia Woolf and Roger Fry, 1926 (reprinted, 1973); *Julia Margaret Cameron* by Helmut Gernsheim, 1948; *Julia Margaret Cameron – A Victorian Family Portrait* by Brian Hill, 1973.

Julia Margaret Cameron was the ugly duckling of the seven Calcutta-born Pattle sisters who were famous for their beauty and made brilliant marriages. The eldest married Lord Somers (who was to take beautiful photographs of Julia Margaret's five sons); the youngest, limpid-eyed and swan-necked, was destined to become the great-aunt of Virginia Woolf.

Julia Margaret was squat, with a wart at the left side of her nose, and wore her black hair in the very difficult fashion of the time (parted in the centre, flat down over the ears, like Giselle). However, whatever she lacked in looks she more than made up for in vitality. Her bubbling exuberance endeared her to Charles Hay Cameron, the fourth member of the Council of

India, a Benthamite jurist and philosopher of remarkable learning and ability, who owned a large estate in Ceylon, and asked for her plump hand. Although he was forty-four – twice her age – Julia Margaret accepted with wild delight. She was agitating company: outspoken, candid, caustic and despotic; iron-willed and hypnotic. Moreover, she was determined to express herself in every sort of way. Not only did she 'queen it' over local Indian society, but she became a poetess, translated from the German, and started a novel which her friends dreaded having to read.

When the Camerons came to settle in England and took up residence with their children in Putney, Julia Margaret would not be squeezed into conformity, and did not attempt to hide her contempt for the ways of conventional society. She became impossibly high-handed in her behaviour towards her English acquaintances. She had the power of loving and the determination to be loved; but she was neither loved by, nor did she love, her suburban neighbours.

Then the Camerons decided to live in the Isle of Wight. They reconverted two honeysuckle- and rose-covered cottages with sunny bow-windows in Freshwater. Here were people who gave Julia Margaret all the intellectual stimulus she craved. The Poet Laureate Alfred, Lord Tennyson, wrapped in a heavy cloak with a broad-rimmed hat, brought Longfellow and others over from Faringford to Dimbola, the Cameron house, named after one of Mr Cameron's estates in Ceylon. The Briary was shared by Watts, the painter, his newly-wed wife, Ellen Terry, and the Prinseps (she a sister of Julia Margaret, celebrated for her salon and her cook). At the Terrace House was Horatio Tennyson, the poet's younger brother. Visitors included Browning, Herschel and Darwin; and Amy Thackeray, the novelist's daughter, on a visit to forget her father's recent death, quotes 'a poor Miss Stephens' as saying: 'Everybody is either a genius or a poet or a painter or peculiar in some way. Is there nobody commonplace ?'

The local people at first were startled to see Julia Margaret driving in her 'donkey chaise' or pacing the beach even in the stormiest weather. She enjoyed giving presents, and upon the most unsuitable people in the village would bestow Indian shawls, turquoises or ivory elephants. They were startled at her lack of selfconsciousness. There was talk of how once when a favourite preacher was about to deliver a sermon, she climbed into the gallery to be as near as possible to the pulpit. When her favourite climbed the pulpit stairs and his head was so near her that she could almost have touched it, she learnt forward and blew him kisses until the abashed man sank to his knees and buried his face in the pulpit cushions.

Soon Julia Margaret was making a great stir. She was seen rushing to the station, bareheaded (even in the summer wearing red velvet crinolines with trailing draperies) at the same time stirring the sugar in a cup of tea. It was said of her that she 'makes the house shake whenever she enters'.

When her daughter gave her a present of a large box camera, Julia Margaret found, at the age of fifty, her real life's work. She turned a coal-house into a darkroom for developing her 10 × 15 inch plates, and made a glazed fowl-house into a day-

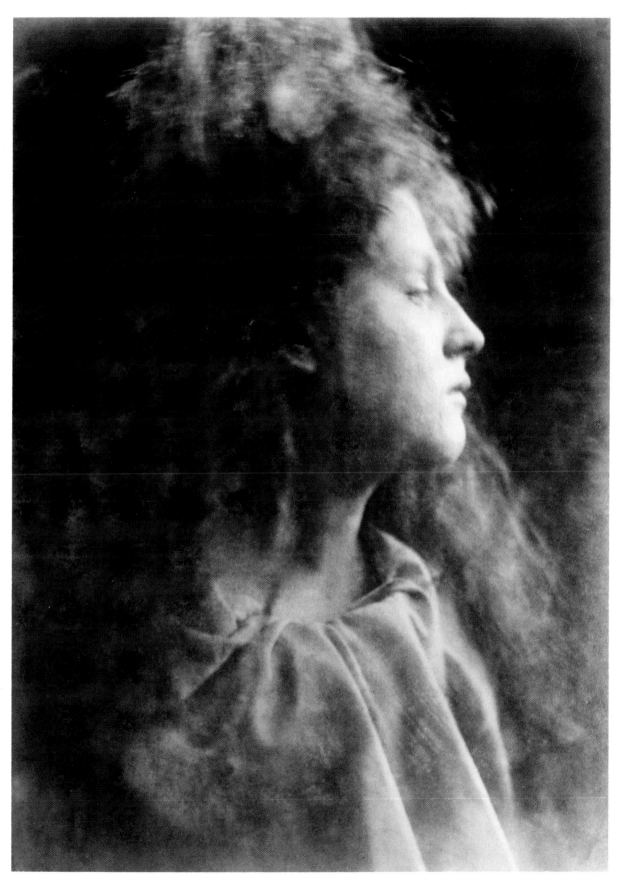

Julia M. Cameron, *Mary Hillier*, 1869.

Julia Margaret Cameron

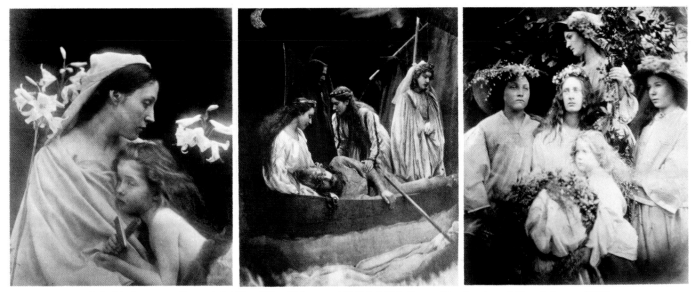

Julia M. Cameron, *Above, left Lilies (Miss Philpot and Child)*, 1869. *Centre The Passing of King Arthur, c.* 1879.
Right Rosebud Garden of Girls, 1868.

light studio. Instead of chickens, she wrote, 'the humble little erection' was to become 'immortalized by poets, prophets, painters and lovely maidens'. She wrote: 'I did not know where to place my dark box, how to focus my sitter, and my first picture I effaced, to my consternation, by rubbing my hand over the filmy side of the glass.' The ruined picture was of a farmer from Freshwater who, to Julia Margaret, resembled Bolingbroke, and to whom she paid half-a-crown an hour. She worked 'fruitlessly but not hopelessly', for the difficulty of her pursuit made her triumph all the greater. In her darkroom there was no running water, and she had to run to the well nine times for fresh water to wash each batch of negatives. She rinsed her prints by flushing them in the lavatory pan. Sometimes she was locked up in her untidy and uncomfortable studio for hours on end, occasionally in despair. Eventually, after spending a great deal of money and many hours in abortive experiments, and wasting hundreds of plates, Mrs Cameron succeeded.

Sitting to Julia Margaret was a serious affair not to be dismissed lightly. Her sitters came at her summons; they trembled – or would have trembled had they dared – when the round black eye of the camera was turned upon them and they were forbidden to move for several minutes while the cap was off the lens.

When trying to photograph a group of children 'a splutter of laughter' ruined her picture. She realized she had been too ambitious. She singled out one child and treated her to a lecture on the waste of her chemicals and of her strength if she were to budge during the exposure. The lecture worked, and Mrs Cameron wrote under the photograph, 'Annie, my first success, 1864'. She was in transports of delight; she printed, toned, fixed and framed the picture and presented it to the child's father that same day.

Many early Victorian 'portrait' photographers soon learnt too much about what photography can do. They became over-familiar with its limitations: they learnt how to 'light a face',

and where to place the nose shadows. Part of Mrs Cameron's power came from the fact that she was totally ignorant of the camera's eye, and she saw the world with a wide-eyed wonder and a marvellous purity. That she did not know what kind of a person was photogenic only gave her complete freedom to express herself. Quite a number of her women sitters were the prognathous-jawed, 'butch' matrons with good bones, whom the Victorians admired. But Mrs Cameron saw these Boadiceas only as human beings, and she succeeded in giving them nobility. With men she was even more in her element. Her portrait of someone with as sensitive and poetical an appearance as that of Mr Frank Charteris – who was to commit suicide so young in life – evoked mystery.

From the first Mrs Cameron was quite certain of what she wanted from photography. She could not indulge in flattery: she would show the character of her subject. Her pictures need not possess technical perfection, and indeed she intentionally put the camera slightly out of focus in order to command supremacy over the mechanism at her disposal. Unlike the fashionable, tiny *cartes-de-visite* of Silvy, Julia Margaret's prints were enormous, and consisted almost entirely of the sitter's head. They were quite sensational and in advance of anything of her time. She learnt to direct the available light in order to get a likeness-in-depth; the more difficulties she came across the more determined she was to overcome them. It was fortunate that Julia Margaret did not have to think about money, for she was extremely lavish and generous in giving her photographs as presents to her friends – in fact, to anybody who would receive them. She distributed huge mounted prints to the railway porters, and set up a permanent exhibition in a waiting-room at Freshwater station.

Julia Margaret waited three years before she considered she had mastered the medium of photography sufficiently to be worthy to photograph Tennyson. Then she badgered him for sittings until she created what she called her 'immortal head – a fit representation of Isaiah or of Jeremiah', which the Poet

Laureate himself called 'the dirty monk'. The great man eventually became impatient when requested once more to come over for another session with this pest, whom he considered a poor photographer. 'She gives me bags under the eyes!' the poet complained. 'But,' shouted Julia Margaret, 'he has got bags under his eyes!' There is a story that, when Garibaldi visited Tennyson, Mrs Cameron was so anxious to see him that she took up her position by the door. When Garibaldi saw this strange-looking woman, holding her arms above her head, he mistook her for a begging peasant and threw her a handful of coins.

Before Herschel became perhaps her most successful subject, she made the great scientist wash his white hair so that it should stand out like a halo. Carlyle posed for Julia Margaret in London, for a portrait in which she aimed to 'show the greatness of the inner and give a likeness of the outer man'; the seventeen-year-old Ellen Terry swooned against a regency wallpaper in her bathroom; Alice Liddell, the original Alice in Wonderland, now grown to womanhood, was placed against a background of hydrangeas. These portraits exude a great intensity and robustness, and they were a revelation of character, with a flowing line of movement throughout their whole structure, and a naturally felicitous organization of forms.

When working in her studio, a nondescript curtain which often would not stretch quite wide enough was her background: and sometimes her improvizations were quite crude. The boatman, as King Arthur, was obviously wearing a helmet made of cardboard, and Guinevere looked very uncomfortable wrapped in carriage-rugs. But the tone-values of their faces were registered with a remarkable truthfulness, even when judged by present-day standards. Mary Hillier, a maidservant in the Cameron household, who had placid features which rendered her a most suitable sitter, was obliged again and again to portray a vaguely 'Italianate' Mother Mary holding a della Robbia-like Infant. At last, however, she exchanged the work as a model for marriage to a wealthy man with whom she settled in Ceylon.

Poor Mr Cameron! Ignoring most forms of domesticity, his

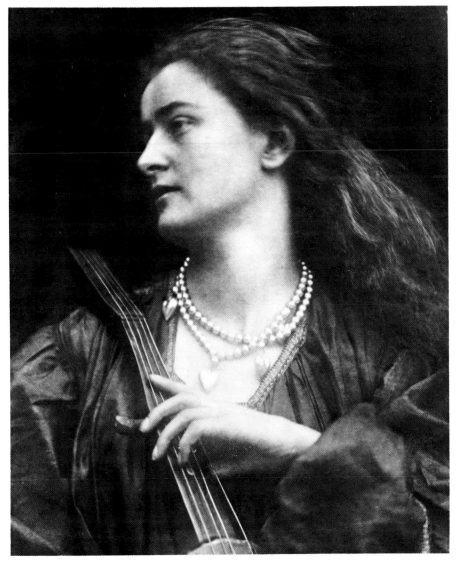

Julia M. Cameron, *And Enid Sang*, 1870.

wife would even prevent the servants from continuing their household chores by dressing them up in medieval costumes, and he would have to answer the doorbell while the parlour-maid was posing as Miranda. He would wait patiently for his lunch, then when hunger drove him to the table without his wife, she would rush in, smelling of chemicals and her hands stained brown, to drip indelible drops of nitrate of silver over his clothes and the table linen as she held up the 'fresh glory'. Despite such inconvenience her husband encouraged her enthusiasm, then she rushed off to inflict further miseries on her captive sitters as they sat for hours on end to do her bidding. It is small wonder that Mr Cameron spent more and more of his time in his bedroom, wearing a blue Eastern kaftan and reading the Greek poets. By degrees he became a recluse – a semi-invalid who seldom got out of his bed. Julia Margaret's sister and nephews next door would be visited by her with three maids carrying a huge box of photographs which they would have to peruse and analyse with their perpetrator by the hour. The light in Mrs Cameron's own room would burn till dawn as she 'sat up over her soaking photographs'. Inspired by Watts's paintings she made allegorical compositions and only occasionally did she totter over into the abyss of the ridiculous: her *Rosebud Garden of Girls* could have been saved by better grouping and sense of composition.

In her illustrations for *The Idylls of the King* the amateur-theatrical quality of her improvizations was overcome by the sincerity that she gave to the work. Tennyson, when describing his Lancelot, said: 'I want a face well worn with evil passion.' On seeing Cardinal Vaughan (to whom she was a complete stranger), Julia Margaret cried: 'Alfred, I have found your Lancelot!'

Tennyson, like so many others, treated her as an amateur and when the large prints she finished for illustrations appeared in small-format woodcuts (and without payment) she moaned: 'I have taken two hundred and forty-five plates to get twelve successes!' In order to show the work as she wished, she paid for a vast *édition de luxe* by cutting off a slice of her husband's estate in Ceylon. Roger Fry called these *Idylls* 'arty'; but are

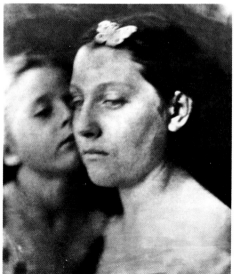

Julia M.
Cameron,
Untitled
photograph.

they any more ridiculous than many of the paintings of Rossetti and the Pre-Raphaelite school?

Julia Margaret did not hold with 'hiding her light under a bushel' and boldly sent off her prints to various exhibitions, even if she had dropped and broken her glass plate and the prints were either scratched or torn. When 'unenlightened' critics wrote of her smudges, indifferent bungling pupil's work, slovenly manipulation or her contempt for the very proprieties of photography, Julia Margaret's bile over-flowed. She was furious when she did not receive from the Photographic Society a prize for a head of Sir Henry Taylor of the huge flowing beard and moustache; she proudly described the light as 'illuminating the countenance in a way that cannot be des-cribed'. But when her work was praised, her heart 'leapt up like a rainbow in the sky'.

Julia Margaret's monomania earned her the dislike of Edward Lear, who complained of the odious incense and ornamental trash in her house. H. P. Robinson, the 'most bemedalled photo-grapher of his day', heaped scorn on her for her 'badly defined' work. Her innate arrogance rose to the surface when she received this letter:

'Miss Lydia Louisa Summerhouse Donkins informs Mrs Cameron that she wishes to sit to her for her photograph. Miss Lydia Louisa Summerhouse Donkins is a Carriage person, and, therefore, could assure Mrs Cameron that she would arrive with her dress uncrumpled. Should Miss Lydia Louisa Summerhouse Donkins be satisfied with her picture, Miss Lydia Louisa Summerhouse Donkins has a friend who is *also* a Carriage person who would *also* wish to have her likeness taken.'

Julia Cameron wrote: 'I answered Miss Lydia Louisa Summerhouse Donkins that Mrs Cameron, not being a profes-sional photographer, regretted that she was not able to 'take her likeness', but that had Mrs Cameron been able to do so she would have very much preferred having her dress crumpled.' Weary of his bedroom, Mr Cameron eventually felt the call of Ceylon. His sons were there, and a daughter had died leaving her family living and working there. Life was less expensive in the East. He wished to look after his estates on the island, to which he had given a code of legal procedure. It was decided to leave Dimbola.

'The pleasant days at Freshwater [Amy Thackeray wrote] ended in a way with the Camerons' departure for Ceylon. Their leave-taking will long be remembered. The piles of luggage were fantastic with bales of trinkets, glass and boxes of all manner of junk for presents, plus two coffins and a cow. Mr Cameron, with shaggy white hair falling over his shoulders, was peering through his spectacles and holding in one hand his carved ivory cane, while in the other was the pink rose which Lady Tennyson had given him when he and Margaret Cameron stopped to say goodbye at Faringford. Mrs Cameron with a thousand preoccupations and her faithful maid, Eileen, appeared valiant and grave.'

Julia Margaret's new home was perched four hundred feet above the level of the sea and was surrounded by mango, casuarina, breadfruit, and coconut trees. Her pets were grey monkeys, squirrels, rabbits, a mynah bird and a beautiful tame

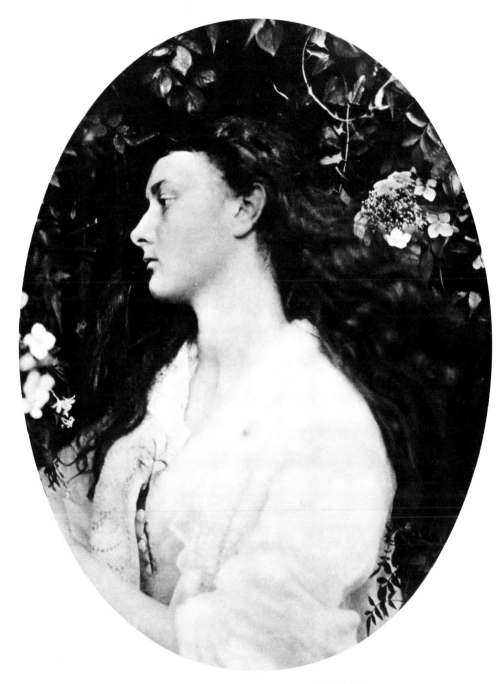

Julia M. Cameron, *Alethea* (*Alice Liddell*), 1872.

stag. With a lace veil on her head and still wearing flowing draperies she continued her torturing of photographic subjects – now mostly the natives – in a temperature of 96 degrees. She admired the back of one young man as being 'absolutely superb' and insisted upon her son retaining him as a gardener although there was no such thing as a garden. Even experienced travellers to the tropics found her oddities 'refreshing'. Here at Kalutura in her house with mud walls and filled with photographs she was perfectly content; birds flew in and out of the doorways and windows.

It was in the early 1920s that interest revived in Julia Margaret's photography. This was due to the enthusiasm of her great-niece Virginia Woolf, and the whole Bloomsbury set. In a monograph of her great-aunt's photographs published by the Hogarth Press, Virginia Woolf wrote in high praise of the portraits, including those of her mother, Mrs Herbert Duckworth, later Mrs Leslie Stephen. In 1935 she wrote a play, *Freshwater*, a comedy in three acts about the life of Julia Margaret and her friends on the Isle of Wight. This was given its first performance at No. 8 Fitzroy Square. Vanessa Bell played the part of Mrs Cameron, Leonard Woolf that of the benighted Mr Cameron, Julian Bell was Lord Tennyson, and G. F. Watts was portrayed by Duncan Grant. Mr Quentin Bell in his wonderful biography writes that the performance was somewhat marred by his father Clive and his Uncle Cory who 'laughed so long and so big that the dialogue was practically inaudible'.

Nadar

1820–1910

Nadar, *Franz Liszt*, 1886.

Born in Paris. Real name Gaspard Félix Tournachon. Spent youth in Paris and Lyons where he studied medicine. Moved to Paris, 1842; a Republican, took part in 1848 revolution. Founded *La Revue Comique*, 1849. Became interested in photography about 1849 and with his brother opened portrait studio, 1853. Conceived and patented idea of taking photographs from balloons for surveying and map-making, 1855. Began experiments with artificial light on which he reported to Société Française de Photographie three years later, 1858. Commander of Balloon Corps during Paris Commune, 1870–1. Retired from photography, 1886. Founded magazine *Paris Photographe*, 1891. Process: wet-collodion negatives, often 18 × 24 cm or *carte-de-visite* size; albumen prints. Major collection: Bibliothèque Nationale, Paris. Books include: *Panthéon Nadar*, 1854; *Quand j'étais étudiant*, 1858; *Galerie des Contemporains*, 1870; *Quand j'étais photographe*, 1899.

Nadar, cartoonist, lithographer, writer and photographer, decided at the age of twenty to settle in Paris in order to write, draw and make cartoons for periodicals. His biting caricatures earned him the soubriquet *Tourne à dard* (*dard* = sting). He abbreviated *Tourne à dard* to 'Nadard', and later to 'Nadar'.

He became interested in photography and started taking pictures of the Paris catacombs and sewers with artificial light. Together with his brother Adrien, he opened a studio in the rue Saint-Lazare which was to become the meeting-place of the flourishing celebrities of the Second and Third Republics. It was here that the Impressionists were given their first exhibition. Monet wrote: 'Nadar, the great Nadar, who is as good as bread, gave us this place.' Ingres would often send his sitters to Nadar for a preliminary study.

Nadar was a practical man and he kept albums which were a record of all his sittings. These are full of suprises, for we discover that his earliest work consisted less of portraiture than of making 'fanciful pictures' for stereoscopic cameras and *cartes-de-visite*. They involved many bizarre personages:

dames aux camélias in fake ballrooms, Dickensian pickpockets in posed situations, as well as quaint *al fresco* scenes of picnickers and families playing at haymaking. Nadar also enjoyed focusing his lens upon freaks, laundresses, Spanish dancers, boxers and acrobats.

At first Nadar's portrayals followed the approach of the daguerrotypists. Wherever possible he utilized full sunlight, but his habit of side-lighting a face was acclaimed as an outlandish novelty. Certainly such perfection of detail, skin-tones and revelation of character had never been seen before. These strong direct portraits are masterpieces. Nadar allowed his subjects to choose their own postures and gestures, but seldom included their hands even in his half-length portraits.

Small wonder that it was not long before everyone of importance in Paris wished to be depicted by him. Although the Emperor was not among his sitters, Nadar took in his stride such diverse personalities as Louis Philippe, Gustave Doré, Delacroix, Théophile Gautier, Dumas, Rossini, Berlioz, Balzac, Liszt (warts and all), and Daumier. George Sand and the young Sarah Bernhardt were flattered to be exceptions to Nadar's rule not to photograph women. He was the first to instigate the 'photograph interview' when he interrogated the shock-haired scientist Chevreul on his hundredth birthday.

Nadar's professional work comprised only a small part of his output: he was a 'snapshotter' of considerable talent. In later years he took up ballooning and photographed Paris from the air, having to coat his wet plate while in the balloon. He was the world's first to photograph underground and from the sky. Nadar wrote of his experiences in *Les Mémoires du géant*, illustrated with caricatures by Daumier. Always a strong Republican, Nadar refused the request of Napoleon III to put his balloon photography to the service of the French army.

Antoine Samuel Adam-Salomon

1811–81

A. S. Adam-Salomon, *Self-portrait.*

French. A Parisian sculptor, took up photography in 1858 but devoted only two hours a day to it. A successful artist, charged high prices for his photographs which were of exceptionally high quality. In the Paris Exhibition of 1867 his portraits were considered the finest displayed. *The Times* reported of his work, 'the finest photographic portraits in the world'. He draped sitters in velvet and posed them like a Rembrandt painting. In trying to raise photography to an art was applauded by H. P. Robinson in *Pictorial Effect in Photography*, 1869. P. H. Emerson dedicated *Naturalistic Photography*, 1880, to him. Due to failing eyesight, gave up photography in the 1870s. Reproductions of photographs appear in the seven volumes of *Galerie des Contemporains*.

Etienne Carjat

1828–1906

E. Carjat, *Rossini, c.* 1865.

French. Editor of *Le Boulevard*, 1862–3. A writer and caricaturist, took portraits in his studio on a part-time basis between 1855 and 1875. Contributed to *Galerie des Contemporains*. Collections: Bibliothèque Nationale, Paris; International Museum of Photography, Rochester, New York; British Museum, London.

William Henry Jackson

1843–1942

America bred many photographers yearning to explore the great 'wild west'. Among the most colourful and fascinating was William Henry Jackson, born in Keesville, New York, a veteran of the Civil War, and called by many 'the grand old man of the National Parks'.

In 1866 he left Vermont where he had been a photographer's apprentice and went west with a Mormon wagon-train as bull-whacker driving an ox team. In 1868 he started a photographic business in Omaha, Nebraska and in addition to his commercial work, travelled in the surrounding areas photographing chiefly the local Indians.

In 1869 Jackson went on a photographic tour along the newly completed Union Pacific Railway. It was during this time that he met Dr F. V. Hayden. Hayden asked Jackson to accompany him on his 1870 survey and from then until 1879 Jackson was official photographer of the United States Geological Survey Territories. In 1871 he photographed in the Yellowstone region, in 1872 in the Grand Tetons, in 1873 in what is now the Rocky Mountain National Park (climbing many of the peaks to get good panoramic views), in 1874 around south west Colorado, and in 1875 he went into the San Juan Mountains of Colorado with a camera that took 20 × 24 inch wet-plate glass negatives. Many of these areas, such as Yellowstone, had never been photographed before. Jackson's

photographs of the West served to validate all the tales that were told of the natural wonders that exist in North America. The photographs not only amazed the average American; they so impressed the members of the United States Congress that they set apart the Yellowstone region as a national park.

Around 1874 Jackson set up the Jackson Photograph & Publishing Co. in Denver and produced stereo-cards for home viewing from the photographs he took while travelling around America on horseback with a pack-horse to carry his mammoth amount of equipment. Between 1894 and 1896 Jackson travelled around the world as photographer for *Harper's Weekly*. Knowing that Jackson travelled half-way across Siberia and at the age of ninety-two was commissioned to do a series of murals for a new building of the Department of the Interior gives a clue to the incredible stamina of the man who lived such an active, adventurous and creative existence.

Camera: in early years stereoscopic, 5 × 8 inch, 11 × 14 inch and 20 × 24 inch wet-plate cameras without shutters; in later years dry-plate cameras. Collections: National Archives, Washington, DC; Library of Congress, Washington, DC; Denver Public Library, Colorado; International Museum of Photography, Rochester, New York. Books include: *Time Exposure*, 1940; *Picture Maker of the Old West; William Henry Jackson* by C. S. Jackson, 1947. GB

Charles Marville

1816–c. 1879

Charles Marville, *Tearing down of the Avenue de l'Opéra, c. 1865.*

He was a prolific photographer of architecture, particularly religious buildings and their treasures in the 1850s. He also documented the streets of Paris in 1865, before the great changes in the city brought about by Napoleon III and Baron Haussmann. Marville preferred taking his pictures on a rainy day so that he could emphasize the texture of the stone walls and cobbled streets, typical of the old Paris of Balzac and Hugo.

Marville achieved documentary perfection with his precise rendition of materials, perfection of perspectives and forms, and luminous shadows. He was an enthusiastic worker for an agency called the Commission for Monumental Historical Monuments which endeavoured to preserve ancient buildings, and his work is a personal statement about the city he knew so well before it was lost forever. GB

Timothy H. O'Sullivan

1840–82

Born in New York City. Learned photography in Mathew Brady's New York gallery. Worked for Alexander Gardner for over seven years in Washington and on many fronts during American Civil War. Twice had camera knocked down by shell fragments. Official photographer on United States Geological Exploration of the fortieth parallel under Clarence King, photographing Humbolt Sink and Rockies, 1867–9. At Virginia City, Nevada, photographed hundreds of feet underground using magnesium powder ignited in an open tray at Comstock Lode mines. Went to Panama on Darien Expedition, 1870. Joined Lieutenant Wheeler's survey west of 100th meridian; faced starvation when some of the expedition's boats capsized on Colorado River; made 300 negatives but few survived trip back to Washington, 1871. Continued doing surveys with Wheeler of the West, 1873–4. On recommendation of Brady and Gardner appointed chief photographer for Treasury Department, 1880. Died of tuberculosis. Cameras: wet-plate. Collections: National Archives, Washington, DC; Library of Congress, Washington, DC; New York Historical Society; Art Institute of Chicago; International Museum of Photography, Rochester, New York; New York Public Library's Rare Book Room. Books: *Timothy*

O'Sullivan America's Forgotten Photographer by James D. Horan, 1966; *T. H. O'Sullivan, Photographer* by Beaumont and Nancy Newhall, 1966.

'The O'Sullivan photographs opened wide a new world for me. Here were perceptive images, well-composed, of high technical quality, and definitely suggesting a creative personality

'Perhaps O'Sullivan's finest photograph is his superb view of the Canyon de Chelly, Arizona, an image of great power and revelation. The limitations of the old wet plates were severe, but their color-blindness (they were sensitive only to the blue region of the spectrum) was most favorable to the rendition of the red rock of the Southwest. . . .

'O'Sullivan's work has a very important place in the history of the world's best photography.'
('An Appreciation' by Ansel Adams in *T. H. O'Sullivan, Photographer,* by Beaumont and Nancy Newhall, 1966.)

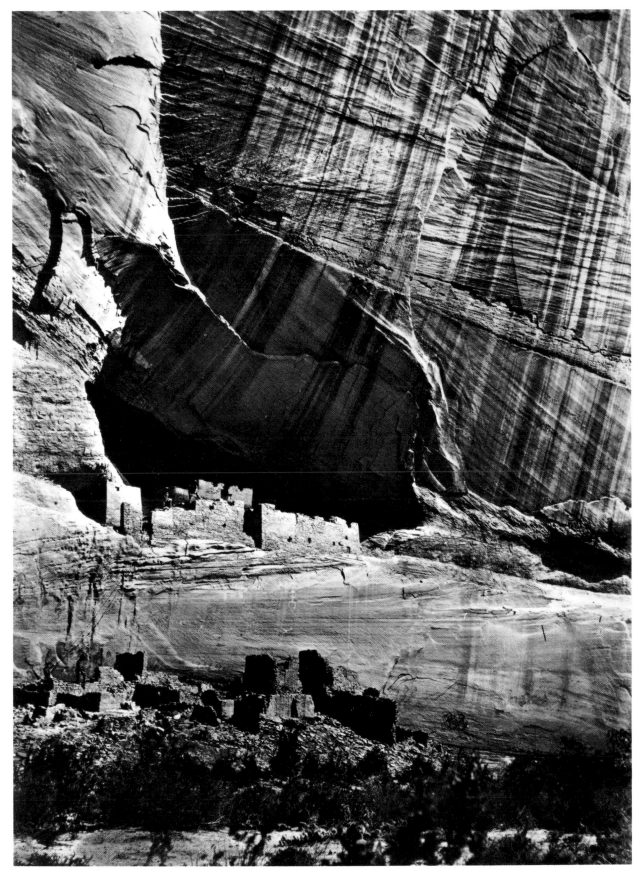

T. H. O'Sullivan, *Canyon de Chelly, Arizona*, 1873.

George Washington Wilson

1823–93

G. Washington Wilson, *Queen Victoria and John Brown*, 1857.

William Notman

1826–91

William Notman, *Bakeoven in the Château de Ramezay, Montreal.*

From Aberdeen, Scotland. Best known internationally for his views of Scottish cities, castles, cathedrals, seascapes, and lake and mountain scenes. A popular portrait photographer, appointed Photographer to Her Majesty in Scotland in 1860. Interior views of cathedrals unequalled in the period. Became famous for his 'instantaneous views' (less than one second); referred not only to time of exposure but also to subject matter; i.e., peopled streets, boats under sail, etc. Built up over 1700 views which he sold as prints, stereos and lantern slides. In the 1880s 'G.W.W.' was the world's largest publisher of photographic views; principal competitors were Francis Frith and James Valentine (1815–80). Process: wet-plate, albumen prints.

George Washington Wilson was the first photographer to take photographs of Queen Victoria and her family in Scotland. His first Royal commission in September 1854 was to photograph Balmoral Castle. The following year he was called upon to take a picture of the family group on the day Prince Frederick William of Prussia proposed to the Princess Royal. In *Queen Victoria, A Biography in Word and Picture,* Helmut and Alison Gernsheim tell a story about the day Wilson came to take the above photograph and an incident that transpired a few days later:

'On account of dull weather the exposure was rather long, and on developing the negative in his dark-tent Wilson found that the Queen had moved slightly. She seemed somewhat put out on hearing this, but sat for another picture with better results. A day or two later the Queen and the Prince happened to ride past on their ponies as Wilson was focusing his camera on the mountain Lochnagar. Stopping to enquire whether he had been successful, the Queen jokingly added before Wilson had time to reply, "If not, you must not blame your sitter this time, for Lochnagar keeps very still and does not fidget."'

'G. W. W.' was summoned to Balmoral Castle many, many times and was one of the Queen's favourite photographers. Even though Wilson was 'commercial', his vision was sharp and his views always seem to be taken from the precise point to give maximum atmosphere and clarity to his subjects.

Born in Renfrewshire, Scotland. Moved to Montreal in 1856. Opened temporary portrait studio to bring in extra money during winter months, 1856. Eventually had photographic establishments in Halifax, Toronto, Ottawa, Montreal and branches in New York, Boston, Albany and Newport, Rhode Island. Two sons, William McFarlane and Charles, helped father in the business and took over after his death. Made large composite photograph for Paris World Fair at the request of Canadian government, 1878. Special subjects: portraits and landscapes; photographs of Canadian folk-life. From 1859 made stereoscopic views. Processes: daguerreotypes, ambrotypes and wet-collodion negatives; albumen prints until 1890, then platinum prints. Collection: McCord Museum, McGill University, Montreal. Books include: *Photographic Selections* vol. 1, 1863; second series, 1865; *Sports pastimes and pursuits of Canada, photographed from nature,* nd; *Royal Society of Canada,* with son, 1891; *Portrait of a Period: A Collection of Notman Photographs 1856 to 1915,* edited by J. Russell Harper and Stanley Triggs, 1967.

Louis-Auguste and Auguste-Rosalie Bisson

1814–1876 and 1826–1900

Two of the leading photographers in France until they retired in about 1865. Opened a daguerreotype portrait studio in Paris, 1841. The Société d'Encouragement pour l'Industrie Nationale awarded them a medal for a daguerreotype reputed to measure 'nearly one metre', 1842. With the assistance of a financial backer, moved studio to Madeleine district; studio served as meeting-place for the well-known authors and artists of the day. Daguerreotyped all the members of Chamber of Deputies and Senate; portraits published as lithographs. Never known to have used calotype process; extremely adept at wet-collodion. The brothers were the leading architectural photographers of their day, taking views on 15 × 18-inch wet plates. Accompanied the Empress Eugénie and Napoleon III from Paris to Switzerland and took wonderful views of the Alps, 1860. Auguste photographed the summit of Mont Blanc, 1861. Collections: Bibliothèque Nationale, Paris; Victoria and Albert Museum, London. Publications include: *L'Oeuvre de Rembrandt reproduit par la photographie, décrit et commenté par M. Charles Blanc,* 1854–8; *Oeuvre d'Albert Dürer photographié,* 1854.

Francis Frith

1822–98

Francis Frith, *Oxford Ferry, Marston Mesopotamia.*

Samuel Bourne

1834–1912

Samuel Bourne, *Front of Oakover, Simla, c. 1867.*

Born in Chesterfield, Derbyshire. From a Quaker family, attended Ackworth School and Quaker Camp Hill School in Birmingham, *c.* 1828–34. Apprenticed to Sheffield cutlery firm, 1838–43. Began wholesale grocery business in Liverpool; cornered Greek raisin crop, 1845–56. Established printing firm and photographed, 1850–6. First trip to Egypt, 1856; second to Egypt and Palestine, 1857–8; third trip up the Nile, 1859–60. Started photographic and printing-works in Reigate, 1859; active in business until about 1885. Special subjects: landscapes of the Middle East and rural England. Cameras: on Nile expeditions, three of different sizes – standard studio using 8 × 10-inch wet-collodion glass plates, a stereoscopic mahogany camera using glass plates of 16 × 20 inches; in England, 8 × 12-inch glass plates and 8 × 6-inch format. Collections: Louis Rothman Collection of Victorian Photographs by Francis Frith; numerous local history libraries. Books include: *Memorials of Cambridge,* 1858; *Cairo, Sinai, Jerusalem and the Pyramids of Egypt* and *Egypt and Palestine,* 1860; *The Holy Bible* and *Egypt, Nubia and Ethiopia,* 1862; *The Gossiping Photographer on the Rhine* and *The Gossiping Photographer at Hastings,* 1864; *Hyperion* by Henry W. Longfellow, 1865.

His was an adventurous life; he was shipwrecked and robbed by bandits, and a leopard carried off a lion from outside his tent.

Between 1856 and 1860 Francis Frith made three expeditions to Egypt and the Near East and photographed everything that interested him. His views of Philae and Luxor are as good as anything Walker Evans did in New York a hundred years later. He also travelled in Greece, Turkey and other parts of Europe.

Of a retiring nature, Frith backed away from the public recognition that could have been his. He published religious works and several volumes of photographs of his travels, a book of verse, and an edition of the Bible illustrated with some of his photographs. But it was his photographs taken throughout England that inspired him to found a great postcard enterprise. He built up an unique record of the nineteenth century. The firm of F. Frith & Co., in Reigate, is remembered today as one of the largest publishers of picture postcards in the world.

Samuel Bourne, a Nottingham photographer, arrived in Simla in 1861 and joined a Mr Shepherd in the photographic business. Bourne was an extraordinary individual and a truly magnificent photographer. His work has a timeless perfection and although he was well aware of the limitations of nineteenth-century photography, his work is not often equalled today. Known as one of the most outstanding landscape photographers of his time, he displayed great sensitivity when photographing natives such as the Todas or Tibetans. All his prints, whether they were taken in the studio or thousands of miles out in the wilderness, are crystal-clear and with a full range of tones.

A wet-plate photographer, Bourne made three expeditions to the Himalayas. The first, in 1863, lasted ten weeks. The second, which he embarked on the following year, lasted nine months and resulted in his taking five hundred negatives. In order to take so many photographs, he had to employ fifty-four coolies and servants to carry his wet-plate apparatus, chemicals and provisions. In 1866 he and his sixty coolies reached the Manirung Pass (18,600 feet) and it was not until 1880 that this record for high-altitude photography was surpassed.

Obviously terribly lonely when on these Himalayan trips (most of the time there was no one with him who spoke English), Bourne wrote articles for the *British Journal of Photography* describing his adventures. They make fascinating reading and vividly explain the problems confronting the nineteenth-century photographer.

Upon returning to Nottingham, Bourne established S. Bourne & Co., a cotton and doubling business. He married at the age of forty-five and when his son reached twenty-one, Samuel retired to paint watercolours of woods and landscapes. Collections: India Record Office, London; Royal Photographic Society, London; Royal Geographical Society, London. GB

Adolphe Braun

1811–77

Adolphe Braun, *The Imperial Court at Fontainebleau in 1860*; the Emperor and the Prince Imperial are in the small boat.

Perhaps one of the best still-life photographers in the 1850s and 1860s. A designer in a French cloth-manufacturing house, he sometimes used his photographs as the basis of his designs. His huge group of the Court of Napoleon III at Fontainebleau in 1860, his idyllic *The Garden* and the *Poet of Marseilles* are his outstanding achievements.

John Thomson

1837–1921

Born in Edinburgh, Scotland. Studied chemistry at Edinburgh University. Travelled to Ceylon, 1862; returned home soon due to illness. Spent nearly five years in Far East, 1865–c. 1870. Fellow of Royal Geographical Society for fifty-five years; instructed members in photography. Professional photographer in London, with a studio in Grosvenor Street. Translated Gaston Tissandier's *Les Merveilles de la photographie* into English, 1876. With Adolphe Smith writing most of the text, brought out monthly publication entitled *Street Life of London* priced at 1s 6d portraying the life of the working class, 1877. Photographed on Cyprus immediately after England took over the island, 1878. Camera: wet-plate. Major collection: Royal Geographical Society, London. Books: *The Antiquities of Cambodia*, 1867; *Illustrations of China and its people*, 4 vols., 1873–4; *The Straits of Malacca, Indo-China, and China*, 1875; *Through Cyprus with the Camera in the Autumn of 1878*, 2 vols., 1879; *Street Incidents* with Adolphe Smith, 1881; *Through China with a Camera*, 1898.

One of the earliest social documentary photographers, John Thomson was a great traveller who recorded the characteristic features of the countries and people that he visited in the Far East. An opium addict, he went in the 1860s to China. He always seemed to be able to look objectively at the isolated social conditions, with which he was deeply concerned. In China not only did he register the local customs, the landscape and the food, but somehow he was able even to give an indication of the climate.

John Thomson worked in London in a professional studio, but his most interesting pictures were taken outdoors showing the life of the working classes in their own surroundings.

Thomson, unlike Paul Martin, seldom took his sitters unaware. He made them stand still while assuming as natural poses as possible. The photographs have a painterly quality; often the dark sky is as if on a theatrical backdrop with vistas of slum buildings. *The Old Clothes Shop* has, without being pretentious, a Rembrandtesque air, and there is something extraordinarily moving in some of the straightforward portraits such as *Tickets*, the card-dealer.

Thomson's beautiful, poignant publications entitled *Street Life of London* were a breakthrough in observation, for in mid-Victorian times it was not the rule that photographers should point their cameras at overt social problems. The working-class dilemma was not something to be looked at either with the naked eye or the camera-lens. Thomson had deep sympathy and pity as well as admiration for the people he portrayed.

John Thomson, *The home of Mr Yang* (*a gentleman enormously rich and holding an official rank in Peking*), *c.* 1870.

John Thomson, *Old Furniture, c.* 1876.

John Thomson, *A Hong Kong Artist, c.* 1870.

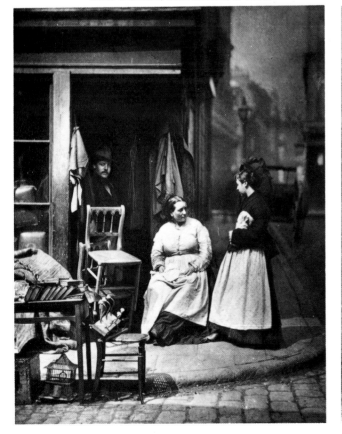

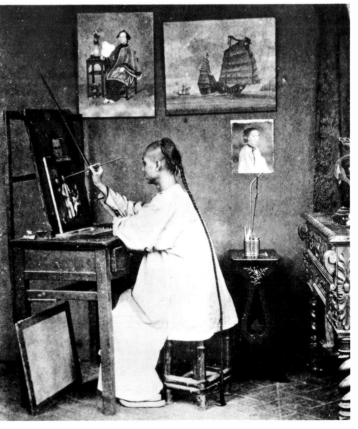

Eadweard Muybridge

1830–1904

Born in Kingston-upon-Thames. Attended Queen Elizabeth's Free Grammar School, Kingston. First employment was in family trade of stationers and paper-makers in London. Left for United States *c.* 1851; first jobs were as a commission merchant for London Printing and Publishing Co. and as an agent for Johnson, Fry & Co. overseeing importing, sale and distribution of books. Learned photography from the New York daguerreotypist Silas Selleck in early 1850s. Opened bookstore in San Francisco, 1855. After recuperating in England from a serious stagecoach accident, produced some two thousand photographs of American far west, *c.* 1868–73; until 1872 all photographs were signed with pseudonym 'Helios'. Between 1872 and 1877 took photographs of Leland Stanford's horse Occident to prove that at some point a horse trotting at top speed has all four feet off the ground. Photographed the Modoc War, 1873. Shot and killed his wife's lover, 1874. Photographed in Central America and Isthmus of Panama, 1875–6. Filed letters patent on a 'Method and Apparatus for Photographing

Objects in Motion', 1878. Took hundreds of instantaneous pictures for Stanford, using twenty-four cameras, of horses, dogs, cows, athletes, etc., 1879. First introduced his zoöpraxiscope, device for animating and projecting his motion photographs, 1879. Worked with Étienne-Jules Marey in Paris, 1881. Lectured before Royal Institution and Royal Academy, London, 1882. Engaged as a public speaker in America on animal locomotion, 1882–4. Invited to carry out camera research at University of Pennsylvania where he produced some 100,000 photographs of animals and humans in motion, 1884–5. Returned to England and lectured throughout British Isles, 1894–6. Processes: wet-plate and dry-plate. Major exhibition: Stanford University Museum of Art, 1972. Major collections: Kingston Borough Library; Science Museum, London; Stanford University, California. Books include: *The Attitudes of Animals in Motion*, 1881; *Animal Locomotion*, 1887; *Eadweard Muybridge: The Stanford Years, 1872–1882* (exhibition catalogue), with introduction by Anita Ventura Mozley, 1972.

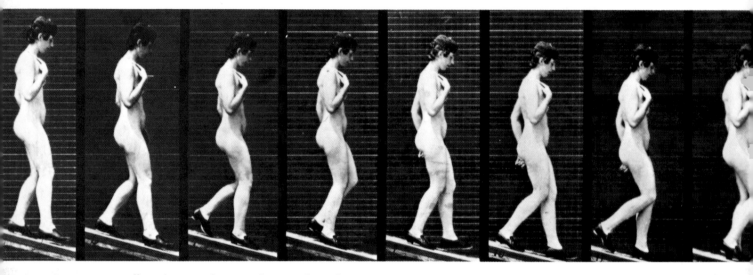

Inventor, traveller, photographer, murderer, Eadweard Muybridge enjoyed changing his names. Edward became Eadweard and his surname evolved from Muggeridge. At an early age he emigrated to New York, subsequently moving to the west coast of America where at first, with plates measuring 16 by 20½ inches or with stereo cameras, he made photographic surveys for the firm of Thomas Houseworth. The pearl-like delicacy of the clouds, the fine filigree of the pine-trees on the distant peaks of Yowigi and Piwack – and other parts of the Grand Canyon – have as much richness of tone as any landscapes in painting, engraving or other graphic medium and are as technically remarkable as anything achieved by Walker

Evans, Edward Weston and Ansel Adams a century later.

Muybridge was later engaged by the War Department to take views along the west coast, and to document Californian life. Muybridge's conceptions of the Yosemite Valley, which he created on whole plate and stereo glass plates, brought him into prominence in 1868. When America acquired Alaska from Russia, Muybridge accompanied General Halleck to take views of the military ports and harbours. In 1872, Muybridge spent six months depicting the Yosemite, taking with him a line of pack mules to carry his provisions and photographic supplies which included 20 by 24 inch glass negatives.

Muybridge married a girl much younger than himself and,

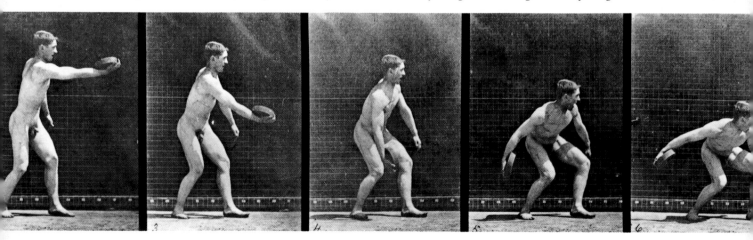

This page and opposite Eadweard Muybridge. Details from human motion studies.

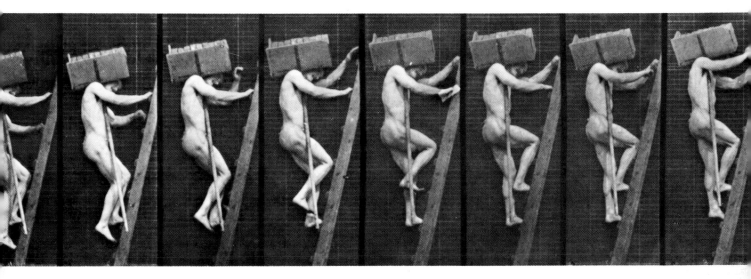

when returning from taking pictures of the Modoc Indian war in the autumn of 1874, discovered that his wife had taken a lover. Muybridge shot him dead. Muybridge was charged with murder, but released a few months later.

Later he went to the west coast of Central America, finding subjects that had never before been recorded with the camera: the ruins of Panama, life in Indian villages. These photographs brought him a reward of $50,000 and further acclaim. But Muybridge's greatest enthusiasm was to show photographically all aspects of movement. In answer to the question about a galloping horse, 'Has at any moment the animal all four feet off the ground?' Muybridge in 1872 was able to bring out his wet plates and prove that the answer was in the affirmative; with the use of as many as twelve, or even twenty-four, cameras

with thin threads placed across the path of an oncoming horse, so that the various shutters should be set off as the horse passed, he was able to alter the concepts of the 'rocking-horse' gallop – which even the great painter Stubbs had failed to recognize as being untrue to nature. He took a succession of pictures of a woman rising from a chair, men jumping and greyhound-coursing.

His nudes seen against a void in unexpected and often rude attitudes have enormously influenced the painter Francis Bacon, and his experiments with movement paved the way to cinema photography.

In 1900 he returned home to Kingston-upon-Thames where he died four years later, leaving eleven volumes of 781 photo-engravings illustrating two thousand moving people and animals.

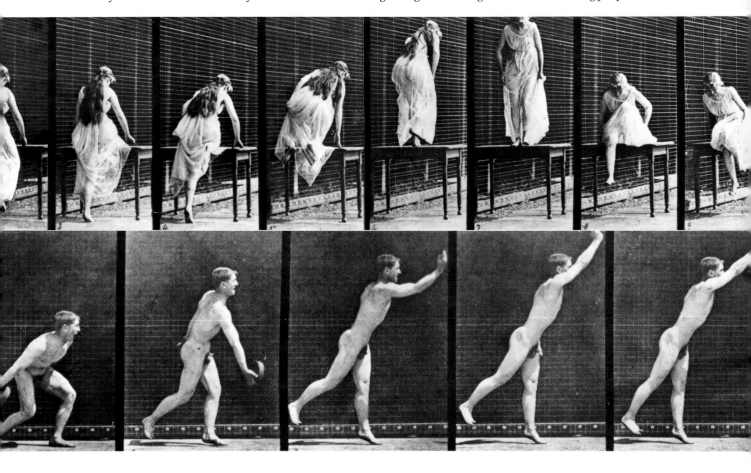

Frank Meadow Sutcliffe

1853–1941

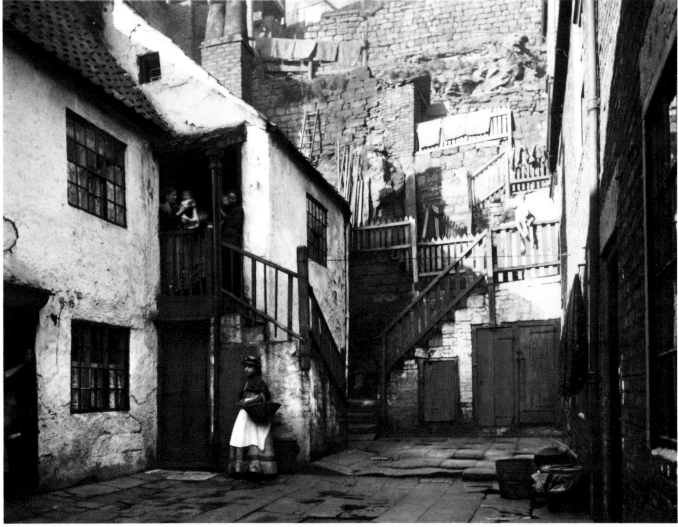

Frank Meadow Sutcliffe, *Barry's Square, the Crag, Whitby.*

Born in Headingly, Leeds. His father Tom was a painter, etcher, lithographer, printer and amateur photographer. Family moved to Whitby, Yorkshire, 1871; took up photography. After marriage to Eliza Duck, unable to find suitable studio in Whitby, moved to Tunbridge Wells. Competition being too great, returned to Whitby, 1875. Found place suitable to convert into studio; established himself as a professional portrait photographer. A persistent exhibitor, between 1881 and 1905 won sixty-two medals at international exhibitions. Had arrangement with Kodak to try out all their latest model cameras; Kodak had option of using any picture he had taken with their apparatus for their own purposes. After death of Horsley Hinton wrote 'Photography Notes' for *Yorkshire Weekly Post*, 1908–c. 1930. Contributed articles to *Amateur Photographer* and non-photographic magazines. Asked by council of the Whitby Literary and Philosophical Society to become curator of Whitby Gallery and Museum, 1923. Held this position from the age of seventy to eighty-seven. Special subjects: landscape and genre. Process: wet-plate until 1880s; dry-plate afterwards. Award: Honorary Fellow, Royal Photographic Society, 1935. Exhibitions: Sutcliffe Gallery, Whitby, Yorkshire (permanent); Impressions Gallery, York, 1972. Collections: Whitby Literary and Philosophical Society; Royal Photographic Society, London.

Sutcliffe photographed English rural life with great warmth and delicacy. He admired the people who earned their livelihood from the land and from the sea, and he used the albumen and carbon process to show, in particular, his love of Whitby, the people and the place. He was professionally a fine portrait photographer who won medals for his exhibits, but it was for his landscapes and genre photographs that he was lauded. Especially fine are his natural shots (difficult to achieve in the slow technique of wet plates which he first used) of the Whitby fishermen in their protective clothing, and the seashore women, likewise in protective clothing. When his *Water Rats* – a crowd of little boys in a rowing-boat, jumping in and out of the sea without any clothes on – was publicly exhibited, Sutcliffe was excommunicated from the church for depraving women and children. However, eventually he overcame this disapproval, did experimental work for Kodak and took momentous pictures as a result of waiting for hours to find people pass by 'in natural order'.

Although masterly at catching what seemed to be the impromptu, he somehow imposed himself on the photograph. A life passionately devoted to photography ended at the age of eighty-seven.

George Davison

1856–1930

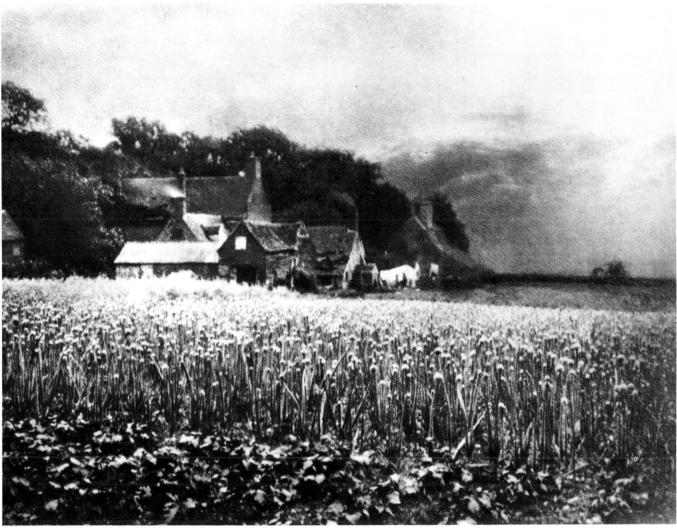

George Davison, *The Onion Field, Mersea Island, Essex*, 1890.

English. Listed in Articles of Association as a subscriber with twenty-five preference shares in the Eastman Photographic Materials Co. Ltd., November, 1889. Entered the company as a director and assistant manager, 1897. A director of newly formed Kodak Ltd, 1898–1901; appointed managing director of company, March 1901. Resigned post, December 1907; resigned directorships in Cadett & Neall and Kodak GmbH Berlin, 1908. Board member of Eastman Kodak Co., 1907–13; not re-elected because of trouble in 1912 over his association with the anarchist movement. Carried on his support to anarchists, communists, 'freethinkers', etc. from his residence in Harlech, North Wales. Connected with pacifist movement during First World War; his activities discussed in House of Commons on 11 December 1917. Special subjects: strange, disquieting landscapes and straight genre pictures. Cameras and processes: varied Kodak cameras and films, occasionally used pinhole camera; photogravure and bromide prints. Exhibitions: Annual London Salon, 1892 to First World War; Kodak Museum, Harrow, 1972. Collections: Kodak Museum; Royal Photographic Society, London.

Originally a civil servant, George Davison became a leader among early pictorial photographers. His impressionistic prints were picturesque and moody, with a fine composition. His subjects were mostly rural – labourers, horses and carts,

ploughed fields – but he was particularly successful with a romanticized view of Harlech Castle. *The Onion Field*, made with a pinhole camera, brought him into great renown with the Camera Club and the Photographic Salon. In 1892 he became a founder member of the Linked Ring, and he excelled in photogravure prints, which he distributed as Christmas cards. In 1901 Davison was appointed managing director of the newly formed Kodak Ltd, which represented the interests of the American company in Europe. He held this position until 1912. He became interested in promoting a magazine devoted to anarchist doctrines and was looked upon with great suspicion.

Davison was eventually called upon to resign from his directorship of the board of Eastman Kodak Co. As he had invested heavily in Kodak shares, he left the company as a man of colossal wealth. He built himself a palatial mansion in Wales which appears to have become the headquarters of any subversive organization which could enlist his financial aid.

Davison, a schizophrenic character, had also a split personality as a photographer, one side taking an idealized view of nature, and the other seeing life with the clear, sharp eye of the reporter.

Peter Henry Emerson

1856–1936

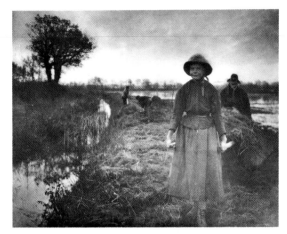

P. H. Emerson, *Poling the Marsh Hay, c.* 1885

Born in Cuba; English. Father American, mother Cornish. Went to school in Massachusetts during time of American Civil War. In England, attended Cranleigh School, King's College Hospital, London, and Clare College, Cambridge. Abandoned medical career for one as descriptive writer and photographer of the Norfolk Broads. Started exhibiting photographs and winning prizes and medals, 1885. Elected to the council of the Royal Photographic Society, London, 1886. Began awarding 'Emerson medals' in 1925 (some posthumously) to Hill and Adamson, Bayard, J. M. Cameron, Nadar, Craig Annan, Brassai. Made only platinum and photogravure prints. Award: progress medal of Royal Photographic Society, 1895. Exhibitions: Royal Photographic Society, 1900; Arts Council of Great Britain travelling exhibition, 1974. Books include: *Life and Landscape on the Norfolk Broads*, with T. F. Goodall, 1886; *Pictures of East Anglian Life*, 1888; *Naturalistic Photography*, 1889; *The Death of Naturalistic Photography*, 1890; *Wild Life on a Tidal Water*, with T. F. Goodall, 1890; *Birds, Beasts and Fishes of the Norfolk Broadland*, with photographs by T. A. Cotton, *c.* 1894; *Marsh Leaves*, 1895; *P. H. Emerson: Photographer of Norfolk* by Peter Turner, 1974.

Related to Ralph Waldo Emerson, Emerson inherited money from his father, a rich plantation-owner in Cuba. When his

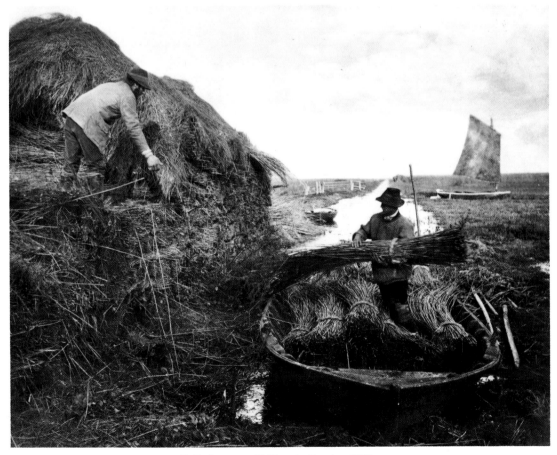

P. H. Emerson, *Ricking the Reed, c.* 1885.

father died Emerson, aged thirteen, moved with his English mother to England, where he was educated and trained as a physician before he passionately took up photography.

A print that Stieglitz made in 1887 while on a trip to Italy was sent in to a competition organized by the English journal, *Amateur Photographer*. It was for this print that Emerson awarded Steiglitz his first international medal. In the following year Emerson wrote asking Stieglitz to translate his *Naturalistic Photography* into German. Although Stieglitz agreed it was never published. This, however, was the beginning of a long exchange of ideas through letters and pamphlets.

Emerson's photographs are all to do with nature and simple subjects such as a fisherman at home, duck-shooting, hay-gathering, dame schools, farmers' wives and children, river scenes and straight landscape. His book of life and landscapes on the Norfolk Broads in 1886 is a quite splendid example of straightforward sharp photography. But he then changed his point of view, and expounded his theory that the eye sees most sharply in the centre of the field of vision, and that objects on the periphery of the eye are progressively less defined. He considered that nothing in nature had sharp outlines and turned to the great painters of his day, Turner, Whistler and the French Impressionists, to confirm his observations. He then proceeded to take pictures with only certain areas in focus: for instance, when making a picture of a boy sitting by a gorse-bush, it is the gorse and not the boy's head that is sharp in focus. Emerson considered that in this way he was taking pictures that corresponded to natural vision.

In 1889 Emerson published *Naturalistic Photography*, which was to become a bible to many photographers, the chapters ranging through such subjects as 'Naturalism in Pictorial and Glyptic Art', 'Camera and Tripod', 'Studio and Furniture', 'Hints on Art'. A year after the publication Whistler convinced Emerson that 'he was confusing art with nature'. Emerson published a black-bordered pamphlet entitled *Death of Naturalistic Photography, a Renunciation*. In this he stated categorically that he recognized the inherent limitations of photography. Furthermore, photography was only confessing its weaknesses when it indulged in the alteration of tonal values, false emphasis to certain areas of the picture, and the use of soft focus and special effects.

Emerson, in his aggressive, dogmatic style, encouraged photographers to see their medium as an independent art-form with its own rules. He remained always photography's advocate, encouraging the young with letters, medals and prizes.

Emerson can be said to be another of photography's many eccentrics. Some of his activities, apart from those connected with the camera, were writing detective stories, a theory of genetics and rules for amateur billiard-players. He was a vain and probably unlikeable character, a prolific writer, prejudiced and highly opinionated, often strong in his unstinting distaste of certain other photographers.

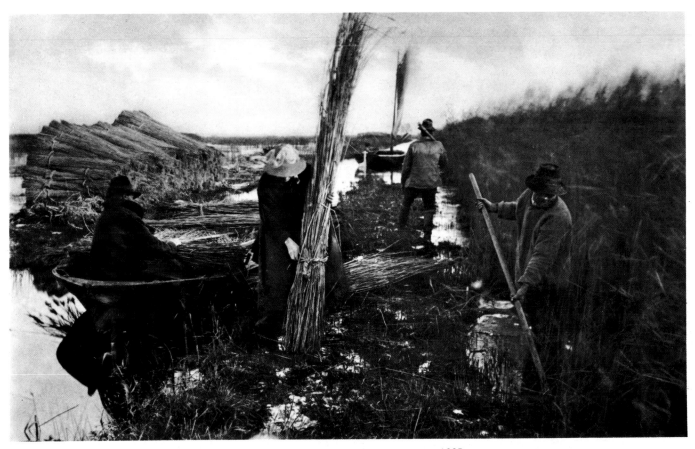

P. H. Emerson, *During the Reed-Harvest, c.* 1885.

Count Giuseppe Primoli

1851–1927

Count Giuseppe Primoli, *Above, left Princess Mathilde Bonaparte with two Ladies-in-Waiting,* 1888.
Centre Portrait Study, c. 1890. *Right Edgar Degas Coming out of a Pissoir,* 1889.

Italian. Related to Napoleon through his mother, Carlotta, whose two grandfathers were brothers of the Emperor. Family moved from Italy to Paris, 1853; remained there until beginning of Franco-Prussian War. Accompanied Empress Eugénie to Egypt for opening of Suez Canal, 1869. Through his aunt, Princess Mathilde, met most of the famous writers, musicians and artists of his time. Learned photography before 1888. Travelled widely throughout Europe photographing sovereigns and their courts at play and at work, *c.* 1888–91. Primoli family ruined financially, 1893. Giuseppe lived and photographed with his brother Luigi until 1911; most of Luigi's photographic material disappeared when he died in 1925. Estimated that the Count exposed 20,000–30,000 plates in his lifetime; only 12,575 were found in his apartment at the time of his death. Cameras: Kinégraphe, reflex camera with 8 × 9 cm plates and possibly Traveller. Major collection: Fondazione Primoli, Rome.

Very soon after Daguerre's invention was announced there was a great demand by artists and tourists for photographs of paintings, sculptures and famous buildings; thus, particularly in Italy, photography was used for quick recording. However, the advent of the dry plate around 1880 encouraged more people to take up photography, including Giuseppe Napoleone Primoli and his brother, Luigi, who became so dedicated to the new medium that, in three years, they exposed three thousand glass plates.

Giuseppe, an extremely ugly but dandified Roman aristocrat and direct descendant of Napoleon, depicted the high court life with an amateur's camera but a most unusual eye. From a low angle he took a remarkable snapshot of the plain Princess Mathilde Bonaparte with her *dame d'honneur* in court dress. He photographed every aspect of the wedding of Victor Emmanuel of Naples to the Princess Helena of Montenegro: the male guests with huge flowing white moustaches and ladies well-upholstered in their Knossos-stiff dresses, the spectators crowding the doorways and climbing

on lamps and on to window-ledges. In fact, doorways play a large part in the Count's evocations. He gives an empty wall an air of mystery by the inclusion of a door: for instance, Empress Eugénie going through a church door to pray, ladies buying flowers outside the church door. One of the strangest pictures is of a spectacled and obviously disapproving spinster raising her skirts as she stared in disgust at the actress Réjane with a group of men, including Degas the painter, coming out of a doorway. Another shows an elegantly dressed man going through the swing doors of a *pissoir* while another comes out.

Primoli photographed everything from disasters to beggars, circus artists to society. He capriciously presents us with La Duse in a gondola, seeming like just another Italian beggar-woman. He shows peasants, be-shawled, swaying up the church steps to mass and appearing like grand personages. Occasionally the Count allows himself an elaborate joke, dressing his sitters in classical costume, and in one of his few contrived set-pieces, he stages a romantic scene of Marie d'Annunzio with her son, Mario, at a window of the Palazzo Primoli in Rome in 1881. But most of his shots are quite candid: Sarah Bernhardt slumped in a chair, Buffalo Bill at the circus and the amazon, Annie Oakley, on a bucking bronco. However he is at his most skilful in his street scenes, his glimpses of military occasions, of the races, of horsemen, and the elegant life of clubmen.

After the *coup d'état* and the proclamation of the Second Empire Giuseppe left Rome for Paris, where he became part of the literary milieu that centred around Théophile Gautier, Alexandre Dumas, Guy de Maupassant, Gounod and the Goncourt brothers. The Count would have liked to be considered a *littérateur* himself, and his letters and aphorisms definitely show a talent and sharp eye, especially when directed towards the disintegration of the Italian aristocracy.

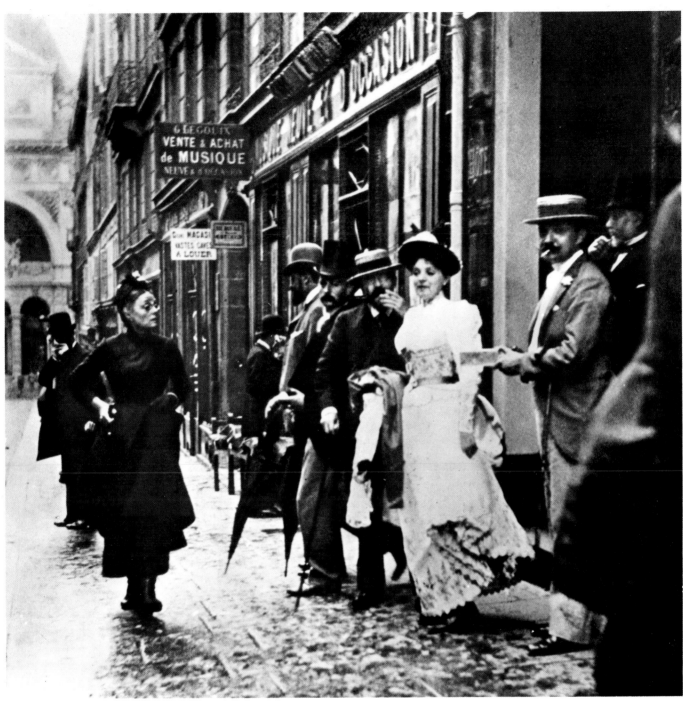

Count Giuseppe Primoli, *Réjane and Admirers*, 1889.

Primoli's pictures – and I have never seen an original print – have the same strong blacks and whites as a woodcut. He does not go in for gradation of tone, but this gives the drama that the work of later photographers of his ilk lacks.

The Count portrayed the life of Naples, Venice, Rome, Paris, Turin, giving these cities their own essential individuality; alleyways with washing hanging out – banal but transcended by the refreshing individuality of the Count's eye – and most personal of all, the indeterminate groups of people clustered together laughing, talking, not knowing they are being taken.

They are looking ridiculous, looking charming, looking elegant, looking poor, looking alive. Count Primoli's output – a comely cornucopia – was an important contribution to photography.

A Primoli Foundation in Rome collected over twelve thousand plates, but it is impossible to distinguish the early works of Luigi, his brother, who gave up photography after a short while, from those of Giuseppe. The brothers worked with several 9 by 12 centimetre cameras, which were purchased from Paul Nadar, the son of Félix, in Paris.

83

Thomas Eakins

1844–1916

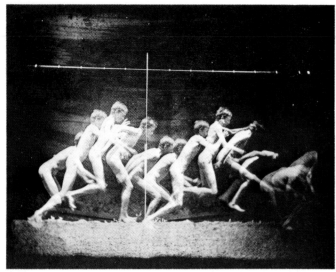

Thomas Eakins, Motion photograph, 1885.

Born in Philadelphia. Graduated from Central High School, 1861; attended classes at Pennsylvania Academy of Fine Arts and Philadelphia Sketch Club. Studied under Jean-Léon Gérôme at École des Beaux-Arts, Paris, 1866–9. Taught at Pennsylvania Academy of Fine Arts, 1876–c. 1886 and at Philadelphia Art Students' League. First dated photograph, 1880; made clear distinction between 'photographs' and 'photographic studies'. Used lantern slides of Muybridge's horse in motion-studies in lectures, from 1883. Demonstrated to Photographic Society of Philadelphia an apparatus he devised for taking very short exposures, 1883. Dismissed from the Academy, went to Dakota, 1887. Special subjects: family, pets, students and motion work. Equipment: 4 × 5 inch American optical box camera, a number of lenses and accessories, solar camera and Marey Wheel purchased in October 1884. Exhibitions: *History of a Jump*, Photographic Society of America, 1886; Pennsylvania Academy of Fine Arts, 1969. Collections: Philadelphia Museum of Art; Metropolitan Museum of Art, New York; private collections. Books include: *The Photographs of Thomas Eakins* Gordon Hendricks, 1972.

Eakins is considered by many to be America's best painter. Perhaps more than anyone else he used photographs as a guide in his ceaseless effort to capture the 'instant' moment of action, to preserve what should be ephemeral, to make public what is normally considered private. Eakins was not averse to admitting his indebtedness to photography at a time when it was thought quite wrong for a painter to seek this aid; in fact, he was severely criticized for confusing the two media.

Lincoln Kirstein, in an essay on Eakins and Whitman, remarks that 'the painter re-creates the world, the photographer spies on it'. He tells how Eakins used the camera to make fresh convictions and attain corrective precision, being of the opinion that two eyes are better than one. In some instances Eakins used his brush to copy every detail from a photographic print that he had made. In reproduction it is sometimes difficult to distinguish his portraits from his photographs as, for example, in a picture of a surgical operation.

With a 4 by 5 inch box camera Eakins took views of the neighbouring countryside, snapshots of his wife, who was a painter, his nephews and nieces, and his cat-filled house. His most renowned sitter was his friend, Walt Whitman, who said of Eakins's photographic work that it was 'not a remaking of life, but life shown as it is'.

As a member of the Pennsylvania Academy of Fine Arts, Eakins for many years gave lectures and often photographed his classes. He also tried to arrest movement with the camera. Not content with taking nine successive shots of a boy vaulting, he then achieved twenty exposures on the same plate of a man jumping. Unlike his friend Muybridge, Eakins separated the stages of action in his motion studies by stacking his photographs, like playing cards, one on top of the other. It was a step towards the series of pictures rapidly replacing each other on one spot, which was the beginning of cinematography.

Frances Benjamin Johnston

1864–1952

Born in Grafton, West Virginia. Educated at Notre-Dame Convent, Maryland. In 1883 went to Paris for two years to study drawing and painting at the Académie Julien. Learned photography from Professor Thomas William Smillie, director, Division of Photography, Smithsonian Institution. Opened studio in Washington, DC, 1890. Awards: Grand Prix medal at Third International Photographic Congress, Paris; honorary member, American Institute of Architects, 1945. Collections: Library of Congress, Washington, DC; Museum of Modern Art, New York. Book: *The Hampton Album*, 1966.

Miss Johnston was born in 1864, and early in life decided to take up photography. She wrote for advice about equipment and methods to George Eastman in Rochester, and then started on a career of intense activity which continued through two world wars and ended only with her death.

She enjoyed an exalted social position which helped her to enter the White House under the administrations of Cleveland, Harrison, McKinley, Teddy Roosevelt and Taft, and this was of great help to her. She was particularly close to Mrs

Roosevelt, and her grand friends and their husbands came to pose in Miss Johnston's studio with its enormous northern skylight and decorations typical of a bohemian life-style, with a plaster cast of the Venus de Milo, Parisian posters and oriental bric-à-brac.

Miss Johnston considered herself on equal terms with male photographers and soon was as highly paid as any. She started to take her heavy, bulky camera out of her studio to photograph architecture of all sorts, including the newly built mansions – both inside and out – of the rich.

But Miss Johnston was not only interested in affluence: she became something of a news recorder. She made a tour of the Pennsylvania coalfields in which she showed that the miners' children were neat, clean and fresh-faced in spite of the filth in which their fathers lived, and she published *What a Woman can do with a Camera, Day at Niagara*, and *President Roosevelt's Children*.

Frances Benjamin Johnston

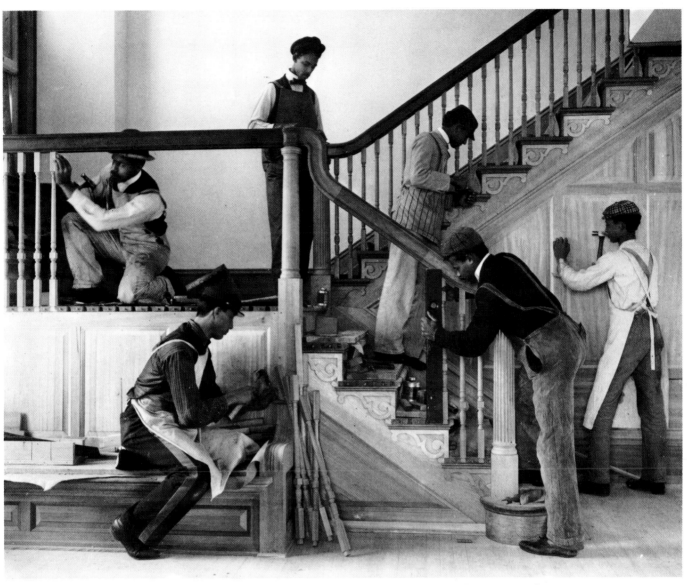

Frances Benjamin Johnston, *Stairway of Treasurer's Residence and Students at work.*

In the era of reconstruction after the Civil War the Hampton Institute began training selected black and American Indian youth in agriculture, domestic work, arts and crafts, so that they might gain respect for labour by replacing stupid drudgery with skilled hands. Frances Johnston came to Hampton in early December 1899, and was at once so impressed by all she saw that she became determined to make known through her photography the devotion and sweetness of the pupils and staff and their achievement. She wanted it to be seen as a uniquely symbolic social and educational triumph for her country.

The quality of the photographs is silvery-smooth, gradual, gentle, the detail impeccable. You have only to compare her *The Old Folks at Home* with the work of the Englishman H. P. Robinson to see what an unsentimental artist Miss Frances Johnston was. Her reportage is a straightforward recording of this community with its black population in their varied uniforms for work or play, with every member of the Indian orchestra or football teams seemingly so pious and serious. Even the children are given a sense of solemnity. They continue to remain in place for the pictures that tell the story: *A Class Judging Swine, Experiments with Plants and Soil, Studying the Seed, Arithmetic Measuring and Pacing, Geography – Lesson on Land Formation on the Beach of Old Point, Field Work in Sketching* (a lovely group of dark ladies in pelisses sketching a cow), *Class in American History with Sioux Indians in Full Rig* and (a great assemblage of tiny tots) *Saluting the Flag.* Her work here shows an articulate, humane understanding of, and sympathy for, the condition of personality. It is today a delightful evocation of a Victorian past.

Miss Johnston was a strong, unbrookable character. She enjoyed being the centre of attraction, she adored flattery. Not unnaturally, she was proud of her accomplishment both as a woman and as an artist.

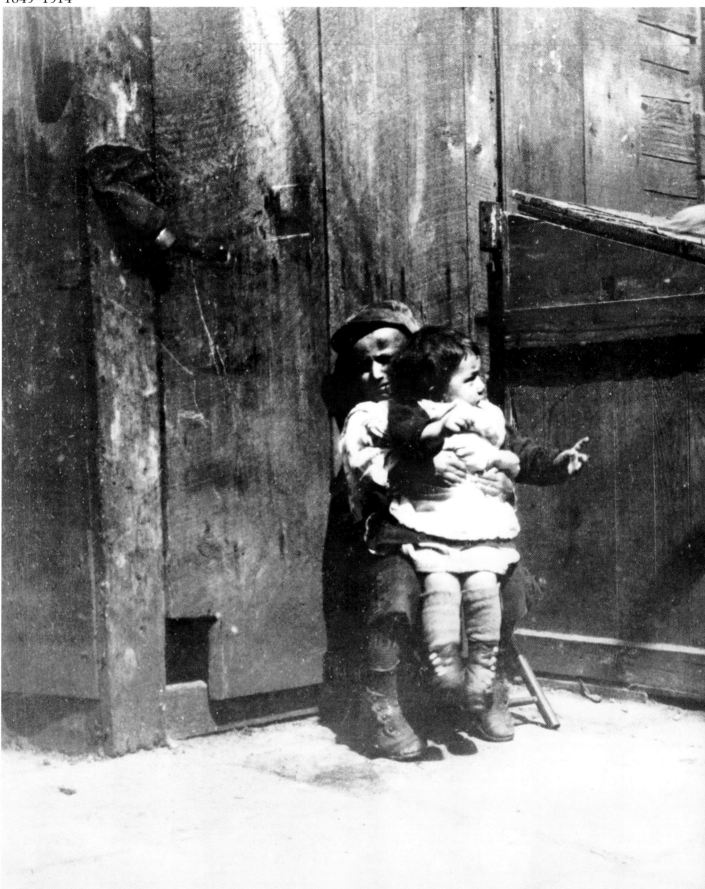

Born in Ribe, Denmark. First introduced to journalism as a child helping father, a teacher in a Latin school, to prepare copy for weekly paper. Four years spent as an apprentice to a carpenter in Copenhagen. Hoping to make this his career in United States, left Denmark, 1870. Upon arriving spent more than three years often destitute, homeless, jobless, and at times suicidal; finally found employment with a news association in New York. Police reporter for New York *Tribune* and Associated Press Bureau, 1877–88. His daily stories in *Tribune* criticizing social conditions helped bring about the appointment of a Tenement House Commission, 1884. Began working for *Evening Sun* about 1888. Offered high public office many times by Theodore Roosevelt when he was Governor and President; always refused saying he was too busy to enter politics. Stricken with heart disease, 1904; continued energetic career as writer and lecturer until death. Equipment: 'Detective' camera and for artificial light, a frying pan to ignite the flashlights; cartridges fired from a revolver (twice set fire to the places he visited, once to his own clothes, and once almost blinded himself). Major collection: Museum of the City of New York. Books: *How the Other Half Lives,* 1890 (reprinted 1971); *The Children of the Poor,* 1892; *Out of Mulberry Street,* 1898; *The Making of an American,* 1901; *Children of the Tenements,* 1903.

Riis, a Dane, who arrived in New York at a very early age, was so horrified by the poverty and squalor of the lives of the immigrants eking out the barest existence that he used his camera as a means of propaganda. He trained his flashlights on to Jews, Italians, and Indians living in appalling tenements, without furniture, with perhaps one communal wash-basin, and the only bathtub wedged between an outer wall and that of the neighbouring block. He photographed the inhabitants in their basements, or in alley-ways squatting on barrels, tins or mattresses. He flashed down-and-outs in the police station lodging-rooms, boarders in a seven-cent lodging-house, and 'Happy Jack's Canvas Palace' where the inmates lay on strips of canvas stretched in rows from wooden beams.

Riis diligently immortalized little street arabs asleep in corners of Mulberry Street, the 'Home Sweat' shops, the rag-pickers, the men in the communal shower-bath, the inhabitants on Ellis and Shelton Islands and the wasp-striped inmates of the Penitentiary on Blackwell Island.

Riis had no pretensions about being an artist in charge of a camera, and it is astonishing that out of so many thousands of pictures only one or two have even a 'picturesque' quality. But he succeeded in doing what he set out to do. These documents are so haunting that when they were collected in Riis's books, *Battle with the Slum* and *How the Other Half Lives,* a great effort was made to better the lot of these destitutes.

In the 1920s, Jessie Tarbot Beales continued in Riis's footsteps. She, too, was responsible for much remarkable propaganda work and must be given ample credit for improving social conditions. More skilfully trained with her camera than Riis, she set about, with disgust yet fervour, to photograph every aspect of the misery of the 'down-and-out'. Her records, never sentimental but often dramatic, are a terrible indictment of man's cruelty to man.

J. A. Riis, *Minding the Baby, Gotham Court.*

John Benjamin Stone

1836–1914

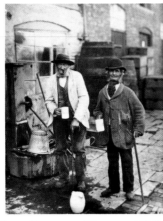

J. B. Stone, *Sippers and Toppers at Bidford Mop.*

Born in Birmingham, England. Educated at King Edward VI's Grammar School, Birmingham. Became a fellow director with his father of Stone, Faundry & Stone, glass-makers. Elected to Birmingham Town Council, 1869; president of Birmingham Conservative Association, 1874-80. Fellow of Geological Society, 1863; Geographical Society, 1886; Linnean Society, 1887; Royal Astronomical Society, 1894; Royal Photographic Society, 1905; Society of Antiquaries, 1905. President of Birmingham Photographic Society, 1889–98. Knighthood conferred by Queen Victoria, 1892. Member of Parliament for East Birmingham, 1895–1909. Instituted National Photographic Record, 1897 (dissolved 1910). Work exhibited Royal Photographic Society, London, 1900 (photographs from the National Photographic Record Association); South Kensington Museum, 1901; Imperial Institute, London, 1902. Major collections: British Museum, London; Birmingham Public Library. Books include: *History of Litchfield Cathedral*, 1869, *Summer Holiday in Spain*, 1877; *Traveller's Joy* (play), 1883, *Children in Norway*, 1884, *On the Great Highway*, 1892; *Sir Benjamin Stone's Pictures* (2 vols.), 1906; *Customs and Faces: Photographs by Sir Benjamin Stone* by Bill Jay, 1972.

Sir Benjamin Stone joined the family business of glass-manufacturing, but had acquired the hobby of collecting photographs before becoming what he determined to be considered – a history photographer.

As an old man Sir Benjamin was rather portly, with white mutton-chop whiskers; obviously someone not to be tampered with. He was a Member of Parliament for Birmingham and thus he photographed fellow Members and visitors on the terraces of the Houses of Parliament. In fact he photographed every sort of character, and every sort of worker. He documented all aspects of life in the English countryside; the charcoal-burners, the 'Oak Apple' processions and morris-dancers, and the yew-trees in the churchyard at Painswick. His direct reporting of peculiar folk and traditional scenes are all the stronger for the reverence with which he treats them.

He travelled everywhere, even to Brazil, to take observations of a solar eclipse. Altogether he made 25,000 pristine prints, which have survived. During his lifetime Sir Benjamin must have spent over £100,000 on photography. He has made an astonishing record of everyday life in Victorian England; some pictures are in the British Museum, but, alas, not easily obtainable at the moment.

James Craig Annan

1864–1946

J. Craig Annan, *A Franciscan, Venice, c.* 1895.

Born in Hamilton, Scotland. Son of Thomas Annan (1829–87), photographer. Studied chemistry and natural philosophy learnt photogravure process, then worked in his father's studio. Professional portrait photographer. About 1890 re-photographed the calotypes of Hill and Adamson and made photogravure prints of them. Exhibitor in the salon of Linked Ring, 1893–1908. Elected member of Linked Ring, 1894. Award: Honorary Fellowship, Royal Photographic Society, London, 1924. Work reproduced in *Camera Work*, VIII, XIX, XXVI, XXXII, XLV (1901, 1907, 1909, 1910, 1914). Portfolio: *Venice and Lombardy: A Series of Original Photogravures* (limited edition of 75), 1898. Collections include: Royal Photographic Society, London.

James Craig Annan's father was a professional photographer and friend of David Octavius Hill and other painters in Edinburgh. In 1883 J. C. Annan went to Vienna to study the newly perfected art of photogravure from its inventor, Karl Klíč. On his return he became its foremost British exponent. His many gravure prints from the Hill and Adamson negatives were responsible for a renewed interest in them.

When the Linked Ring exhibited his *Miss Burnet* in 1893, he became recognized as a leading professional photographer; he also made beautiful compositions with people in natural settings, of theatrically lit alley-ways hung with romantic-looking washing and peopled with figures in tall stove-pipe hats or little urchins squatting like sphinxes.

Frederick Henry Evans

1853–1945

English. Early career as bookseller with shop in Queen Street, Cheapside, London. Got Aubrey Beardsley his first artistic assignment, 1892. Retired from bookselling to devote himself to photography, 1898. Elected Fellow of Linked Ring, 1900. Designed and hung Photographic Salon of Linked Ring, 1902–5. Published six articles on architectural photography in *Amateur Photographer*, 1904. Played pianola at the opening of his one-man exhibition at Camera Club, London, 1904. Became a professional photographer on accepting assignments from *Country Life*, 1905. Regular contributor to *Camera Work*, 1904–7. Photographed extensively in Westminster Cathedral, 1911. Privately published Blake's illustrations to Vergil, 1921; Hans Holbein's *Dance of Death* wood-cuts, 1913; E. FitzGerald's translation of *Rubáiyát of Omar Khayyám*, 1914; *Grotesques* by Aubrey Beardsley, 1919. Camera and film: large (glass) plate camera, Christoid film, platinum or photogravure prints. Awards: Honorary Fellow, Royal Photographic Society, 1928. Major exhibitions include: Architectural Club of Boston, Massachusetts, 1897; Royal Photographic Society, London, 1900, 1922, 1944, 1972; Little Galleries of the Photo-Secession, 1906; International Museum of Photography, Rochester, New York, 1964; etc. Collections: Royal Photographic Society, London; International Museum of Photography, Library of Congress, Washington, DC. Publications include: *Camera Work*, vol. IV, 1904; *Frederick H. Evans* by Beaumont Newhall, 1964.

Evans's bookshop in Queen Street was frequented by Bernard Shaw and William Morris and a young insurance clerk, named Aubrey Beardsley, who swopped books for his drawings. In his spare time Evans experimented with a camera obscura and enjoyed optical and mechanical mysteries. His photographic experiments made him unpopular, since they surrounded him with the aura of black magic and often the chemicals he used made his clothes smell obnoxiously.

Eventually Evans decided to 'put photography to the service of art', and retired 'sick' from his bookshop, although, according to Shaw, his illness never prevented him from doing anything he really wanted, 'and the things he wanted to do would have worn out a navvy in three weeks'.

Evans's greatest forte was the photographing of ancient architecture, though he said his interest was less in the antiquarian aspects than in the visual. He wrote that his chief aim was to try for such effects of light and shade that give the feeling that one is in an interior and that it is full of air and space. By degrees Evans succeeded in portraying many of the cathedrals of England and the châteaux of France. In his compositions he was often influenced by Turner's small watercolours, containing such a superb sense of 'height, light, bigness, atmosphere and grandeur'. Evans had a keen eye and noticed with delight the textures of weathered walls, the waves on old, worn stone steps. He was a man of inordinate patience and sometimes waited for months on end for correct conditions of balance of light. He took impeccable care in achieving his results and on one occasion, in order to get an uncluttered effect, demanded that the dean of a cathedral should take away

F. H. Evans, *Kelmscott Manor,* 1896.

a hundred pews at an appointed hour. The dean acceded.

At this time many photographers were experimenting with pigments to give surface-interest to their prints, and make 'art' by dint of bromoil or gum bichromate processes. But Evans was of the opinion that it was the negative which possessed the decisive merit and not the 'dodged' print. Evans was essentially a 'pure' photographer, and never reduced or intensified or retouched his double-coated plates. He excelled in the tone qualities and printed on platinum paper which, when it became difficult to find and the cost mounted, influenced him to give up photography and again to 'retire'. Of the few portraits that he took, the young Beardsley, with long cheese-stick fingers to his upturned hatchet profile, is in every photographic anthology.

Eugène Atget

1857–1927

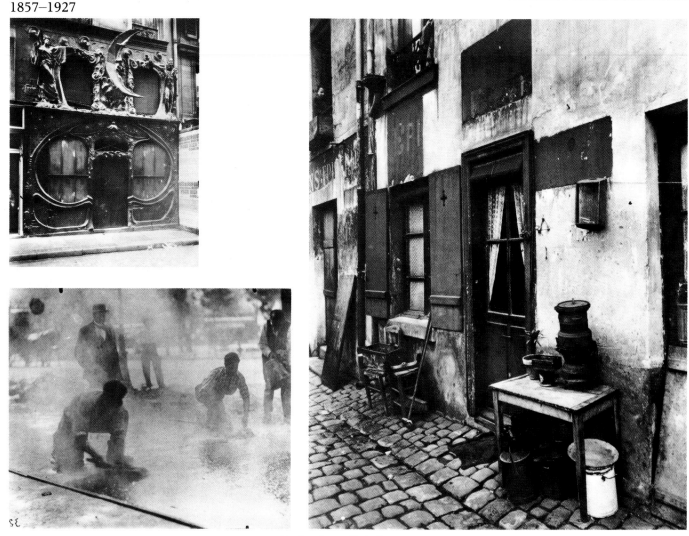

Eugène Atget, *Paris Scenes.*

Born in Libourne, near Bordeaux, France. After being a sailor, actor, painter, turned to photography at the age of forty-one. Photographed subjects that would be useful to artists. The French society Les Monuments Historiques bought from him all photographs relating to the history of Paris. In 1921, commissioned to photograph the brothels of Paris. Equipment: 18 × 24 cm. bellows camera, set of rectilinear lenses, wooden tripod, few plate-holders. Made gold-toned prints. Major exhibition: Museum of Modern Art, New York, 1969. Major collections: Bibliothèque Nationale, Paris; Museum of Modern Art, New York; International Museum of Photography, Rochester, New York; Metropolitan Museum of Art, New York. Books: *A Vision of Paris*, 1963; *The World of Atget*, text and editing by Berenice Abbott, 1964; *Les Métamorphoses de Paris,* 1967 and *les Métamorphoses de la Banlieue Parisienne,* 1969 by Evan Christ.

Atget's financial position was so low that all his life he continued to photograph with only a few plate-holders for his 18 × 24 cm. bellows camera. His equipment was of the most rudimentary – a set of rectilinear lenses and a wooden tripod – yet with this he gave us the best window we have for looking at life in Paris from 1900 to 1925. Atget consorted with no other photographer, and had no patience with gum prints or hazy photographs that imitated paintings. Almost everything in God's daylight and man's artificial light was to be photographed and filed in orderly catalogues for sale in his upstairs studio in the Quai Bourbon, above his modest sign *Documents pour Artistes*. The photographic subjects that he considered would be of use to painters were parks, gardens, woods and architectural detail of houses, both inside and out.

But many of Atget's photographs are more than just documents. He has distilled poignant beauty out of the poor, dark streets. His kerbside sellers are tremendous characters, his prostitutes have a terrifying reality and yet possess a rorty gaiety, his travelling circus is full of a strange *poésie*. He was good with shop windows and other reflections: his *Corset Shop* is a little gem. Atget's remarkable eye, industry and innate sense of pathos have made him one of France's comparatively few great photographers.

Paul Martin

1864–1944

Born in Herbeuville, France; British resident. Lived in Paris in dire poverty during Commune, 1870–1. Family moved to London, 1872; attended English school, 1873–8. Continued schooling at École Gosserez, Châlons-sur-Marne, France, 1878–80. Apprenticed to an English wood-engraver, 1880–3. Took up photography as a hobby, 1884. Began series of scenes of London by gaslight, 1895. Opened photographic studio with H.G.Dorrett, 1899. Photographed Queen Victoria's funeral, 1901; coronation of Edward VII, 1902. Developed self-focusing enlarger, 1921–2. Closed down business with Dorrett, 1926. Wrote articles for journals, gave lectures and slide shows, 1934–8. Cameras: Facile, whole-plate home-made half-plate. Exhibitions: 'London by Gaslight', Royal Photographic Society, London 1896; Wimbledon Camera Club, 1929; Century of Photography Exhibition, Victoria and Albert Museum, London, 1938. Collections: Gernsheim Collection, University of Texas; Kodak Museum, Harrow; Radio Times Hulton Picture Library, London; Royal Photographic Society, London; Victoria and Albert Museum, London; private collection. Books: *Victorian Snapshots*, 1939; *Victorian Candid Camera* by Bill Jay, 1973.

In his lifetime Paul Martin received scant recognition: little was known of him except that he worked hard for a very long period, earning his living by churning out commercial portraits in his Westbourne Terrace studio; his most profitable sideline was the production of button badges containing portraits of popular generals and heroes of the First World War. At weekends he loved nothing more than to take long walks in the countryside snapping his fellow human beings at work, at leisure and at play: and he enjoyed documenting the historical events of the day – the Jubilee celebrations of Queen Victoria, and the great frost of 1895. He also took loving views of Cornwall, Brittany and Switzerland. But this delightful, quiet and gentle individual was more of an artist than he ever imagined, and the snapshots that he took purely for his own pleasure eventually gained him a place in history. These were the pictures that Martin took with his camera wrapped in brown paper and held under one arm in order to prevent his subjects spotting the photographer and becoming self-conscious.

With his curiosity about people, and sympathy for their foibles, he might be called the Charles Dickens of the lens. Martin never lost his sense of surprise in what that object was able to record. He could even make it convey the pure lyricism of a very simple, ordinary-looking dwelling with its windows and wooden gate overgrown with summer foliage. He never became blasé about the actuality. He did not wish, as did his more pretentious contemporaries, to make by extraneous means, 'fake' paintings with the camera. He was content to record what he saw and what pleased him, and his snapshots have more significance than much of the work by the so-called 'concerned' photographers of today.

Martin's agent could not find means of bringing him commissions, and seems only to have had a depressing effect upon this sensitive artist. Martin occasionally sold his negatives to the Press, but they were seldom used in his lifetime. When eventually these prints became well-known examples of Victorian photography, they were reprinted crudely without the carefully modulated tones of the originals, even the composition being changed by Fleet Street demands. Although

with his extraordinary mechanical and engineering talents, Martin succeeded in improving much of the photographic apparatuses that were on the market, this commercial bonus never brought him in money. Dishonest and grasping manufacturers exploited Martin's inventions to their exclusive advantage, and some are still thriving on his genius. By speeding up his equipment and capturing the fleeting instant, he became the precursor of the 'flash' photographers. Today we take for granted that, whenever we wish to record the fly in amber, it is merely a question of pressing a shutter; yet few of today's snapshot photographers realize their debt to Paul Martin.

During his last years Martin became dispirited. His snapshots, which he felt to be his main contribution, were decried as 'non-artistic'. In an effort to be taken seriously he started to work more in the vein of a deliberate 'camera-artist', who used soft forms effects and pigmental papers, but as a pictorial photographer his work was mediocre. Yet it was these 'aesthetic' works that were accepted for exhibition and brought him invitations to lecture to amateurs. His pictures of sunsets and the play of light on water, printed on blue-tinted or coarse-textured paper, were too controlled and self-conscious; his sense of spontaneity was missing.

Paul Martin eventually gave up hope that his life's work was of any interest to others, and when, in his last years, Helmut Gernsheim and other discriminating collectors began to call upon him with requests for his snapshots, he gave away his remaining negatives, grateful that anyone should show a sparkle of interest. He was now content to potter about looking after his prized collection of fuschias. It is significant that he should have dwindled on in a state of semi-poverty two years after he was presumed dead.

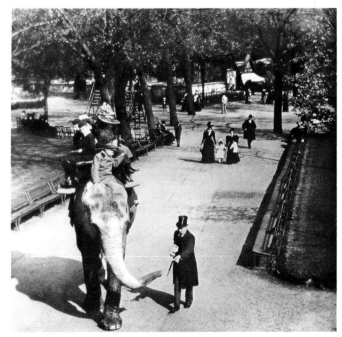

Paul Martin, *The Zoo, Regent's Park*, 1905.

Robert Demachy

1859–1936

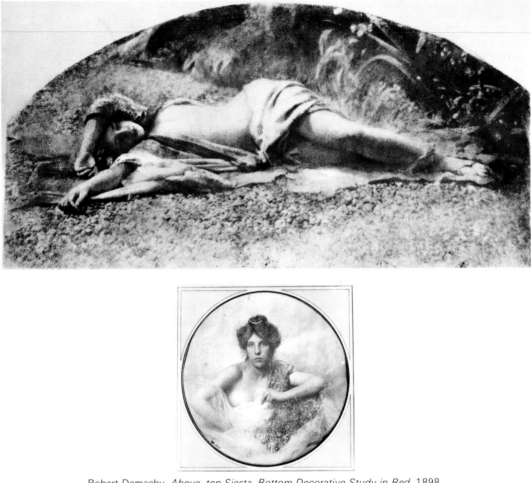

Robert Demachy, *Above, top Siesta. Bottom Decorative Study in Red,* 1898.

French. From 1892 devoted time to photography. Wrote five books and over a thousand articles on the aesthetic and technical aspects of photography. Photographs and writings reproduced in *Camera Work* V, VII, XI, XVI, XVIII, XIX (1904–7). Award: Honorary Fellow, Royal Photographic Society, 1905. Exhibitions include: Royal Photographic Society, London, 1973. Collections: Bibliothèque Nationale, Paris; Royal Photographic Society. Books include: *How to Make Oil Prints – The Rawlins Process,* 1905; *Les Procédés d'Art en Photographie,* with C. Puyo, 1906; *How to Make Oil and Bromoil Prints,* with C. H. Hewitt, 1908; *Le Report des épreuves à l'huile,* 1912; *How to Make Oil and Bromoil Prints in Monochrome and Colour* (5th ed), 1914.

As a youth Robert Demachy was interested in music and fast cars. Later he became a banker, literary expert, amateur artist and photographer. He married an American related to Franklin Roosevelt, after which he spent most of his time photographing and developing his theories on art photography. Under the influence of Degas and the Impressionists he took up manipulative photography. He concocted oil and gum photographs, and expounded his views that photography could not be a work of art unless a great deal of work was done to the plate after it had been exposed in order to 'interpret' the scene. In opposition to pure photography he tried to 'endow' a print with the maximum plastic effect. He said that 'a work of art must be a transcription, not a copy of nature, and must show the artist's interpretation'.

Demachy was convinced that the picture should be built up detail by detail, that certain areas should be held back, and others accentuated. Accordingly he used every sort of aid: gum bichromate, oil transfers and scratching of the gelatine; the result might have been an etching, woodcut or painting. So much handwork has gone into his prints that it is impossible to see the camera's eye through the surface retouching. Demachy was of the opinion that it was necessary to have an idea in the mind as to what a work of art looked like, then, having taken the photograph, to add the 'art work'. The moment came when he recognized he had created his masterpiece. Sometimes entirely different 'works of art' came off the same negative. The dancers in Demachy's imitation etchings have, with their tutus and *brioche* hair-dos, little grace or *élan*, for he has not been able to eliminate a Victorian dowdiness which Degas so elegantly overcame in his ballet figures.

However, Demachy made a big name for himself internationally, particularly as a worker and lecturer on photography. He wrote a great deal about his theories on camera-work and, with Puyo, formed the Photo Club of Paris which had links with other Secessionist movements in photography.

Fred Holland Day

1864–1933

Fred Holland Day, *The Prodigal*, 1909.

Born in Norwood, Massachusetts. Educated at Chauncy Hall (private school in Boston). Of independent means, inherited wealth from his father, a leather merchant. A book-publisher, founded firm of Copeland & Day, 1888; published Aubrey Beardsley's sketches and Alice Brown's poems, etc. Was the first to recognize Keats and spent years in arduous publicity to acquaint the literary world with the poet's work. Process: mostly platinum. Exhibitions: Royal Photographic Society, London, 1900 and 1972. Collections include: Royal Photographic Society; Library of Congress, Washington, DC.

Even by Boston standards Holland Day was extremely well off, but he was an enlightened man who spent much of his fortune on altruistic schemes, and through his charity work was in close contact with many immigrants, mainly Chinese and blacks, whom he treated with an unaccustomed friendliness that was adversely remarked upon. In fact, from his early days, Holland Day expressed an individuality of thought and action that was never understood by the majority of Bostonians, who considered him eccentric.

Holland Day dressed like an aesthete (Steichen photographed him in a huge beret, and at home he often wore the Arab burnous) and was much influenced by the Decadent movement in Europe. He was a great friend of such people as John Lane, the publisher, William Morris and Oscar Wilde. He made a fine collection of Keats's letters, manuscripts and first editions that became the finest harvest of Keatsiana in existence.

With Professor Copeland of Harvard, an intimate friend, he started a publishing business, Copeland and Day, and produced *The Chap Book* and other volumes illustrated by Aubrey Beardsley; his publications are acknowledged to be of the finest quality only comparable to the best made in Europe.

Holland Day, who was remarkably talented in a variety of ways, dabbled in painting: he surprised his friends when his *Girl in a Gainsborough Hat* was sold in thousands of art-stores and swept the country. Quite suddenly the popular artist turned his talents to photography. He bought a specially uncorrected lens, made in Boston by the firm of Pinkham and

Smith, which produced a sharp image but with a halo around the highlights. With ardour he proceeded to take his friends to neighbouring woods to pose as mythological figures, in all sorts of unconventional gear. When friends were unavailable he cajoled his servants to pose for him.

Holland Day made a series of photographs illustrating the legend of Orpheus, with titles such as *The Vision* and *The Return to Earth*. Beacon Hill society was given a glimpse of full frontal nudity: the lorgnettes quivered. When Holland Day photographed his black chauffeur in very circumspect naked studies, he was totally condemned. Undaunted, Day enlarged his photographic output with unquenchable zest. The conviction with which he worked spared him from seeming pretentious, and the titles of his pictures tell of the taste of the man and the period: *Negro with Hat, Youthful Bacchus in the Glade, Girl in Arabian Clothes, Nudes in Wood, Boy with Bow and Arrow* and *Motherhood*.

Holland Day wandered around his incense-filled rooms with, according to a local paper, 'their massive furniture and bric-à-brac of foreign manufacture', in long Turkish robes – his imagination afire – concocting new photographic schemes which became more and more audacious. Suddenly, in order to prove conclusively that photography could compete on equal terms with painting, and although he was not religious *per se*, he decided to illustrate the seven last days of Christ. Holland Day set about the task with dynamic fever. He was determined to be accurate in every detail: he had sandals made by special craftsmen and clothes of stuffs from the Middle East; he searched the environs of Boston to find a place that might have the natural features of Calvary, and he considered he had found the correct location at Norwood; the models who were to form a group at the foot of the cross were chosen and clothed with the greatest care. Finally he decided that none other than he himself should pose as Christ: to this purpose he starved himself for a year and allowed his hair to grow to his shoulders.

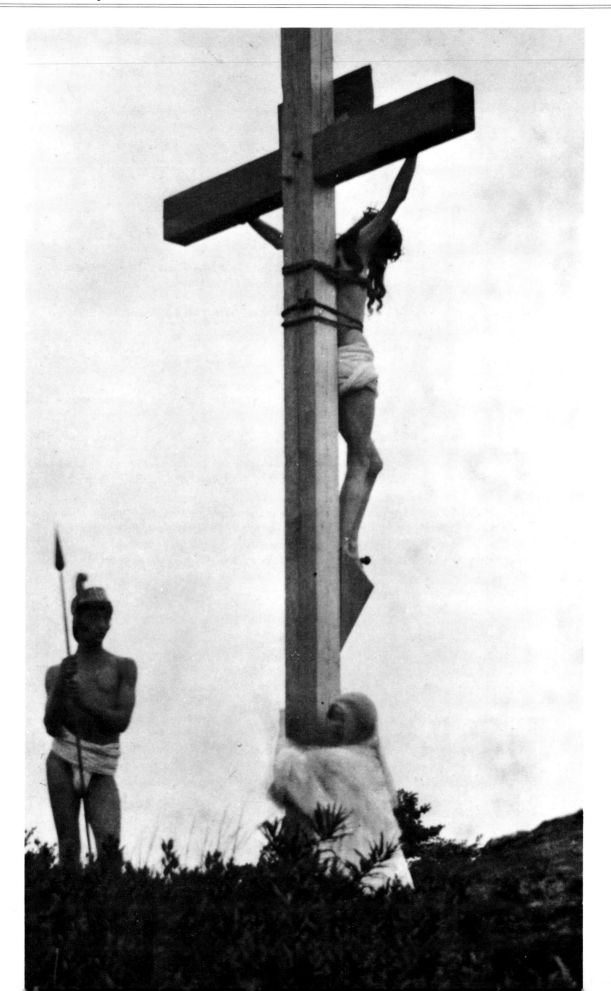

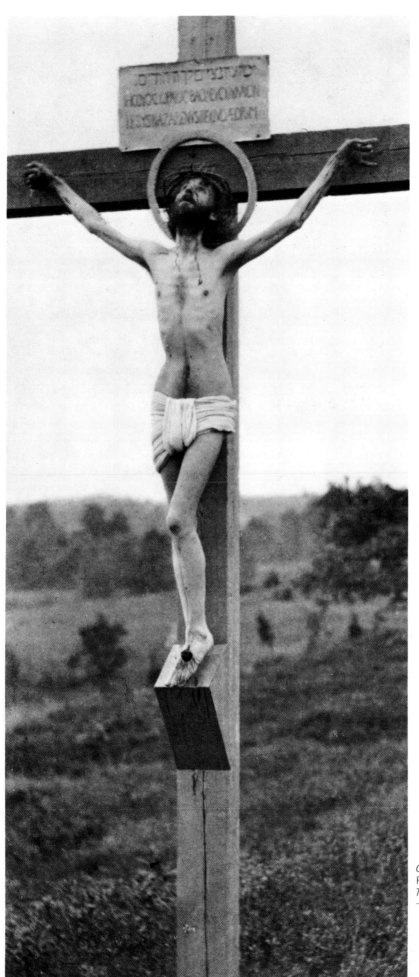

Opposite and left
Fred Holland Day,
The Crucifixion, 1898.

Fred Holland Day

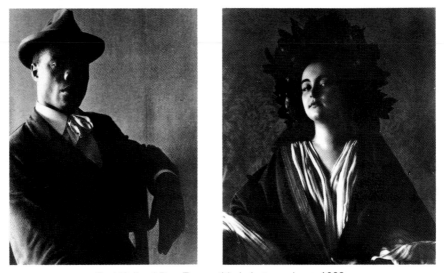

Fred Holland Day, Two untitled photographs, c. 1900.

On the appointed day the photography started. For a period of three summer months hundreds of negatives were exposed of the Bostonians who had been selected to represent Nicodemus, Joseph of Arimathea, the three Marys, St John the Divine, soldiers, guards and Jews. The cameras focused special attention on the fakir-thin Mr Day running the gamut of every emotion on the day of the crucifixion; the two thieves already on high, Mr Holland Day, crowned with thorns from which carefully painted drops of blood fell on his forehead, and wearing a beautifully draped loin cloth, stepped out of his motorcar to be stretched upon the cross. His body was beautifully trim, his hair and beard silken. The cameras clicked. Holland Day was seen in full-length and in close-up: the Guido Reni agony on his face was most realistic and awe-inspiring. A mood of great reverence was felt by all.

When the results – printed on terracotta-coloured paper vignetted at the edges – were secretly shown to a few privileged friends, the response was enthusiastic. Steichen even wrote: 'Few paintings contain as much that is spiritual and sacred in them.' Nevertheless Holland Day, hurt by so much opposition in his native town, refused to let Boston have the first public view of his great *oeuvre*. London, Berlin and Vienna were favoured. Result: sensational praise. When, at last, Boston was given a public view the cries were of: 'Sacrilege!' However, the *Boston Herald* on 17 January 1899 had headlines: 'Mr F. H. Day finds a new and important work for the camera. Picture completed without marring either the meaning or spirit of the subject.'

When Day became friends with a fellow amateur photographer, his distant cousin, Alvin Langdon Coburn, the younger man wrote: 'To be in the company of this intellectual and artistic man was an education in itself, and it was thus that I really began my career as a photographer.' Together the two travelled in Europe, visited all the well-known photographers, and fought to see that photography should be considered an art-form. To this end Holland Day was in sympathy with Stieglitz and the Secession group, but these two men were both too strong in character to get along together. They were obviously competing with one another for leadership among American photographers and when, in 1900, Day decided to take an enormous photographic exhibition to London, to be called 'The New School of American Pictorial Photography', Stieglitz refused to have his photographs included. However, the exhibition, which was held at the Royal Photographic Society, and consisted of 375 photographs, contained 103 of Day's pictures. It created a furore.

In November 1904 Holland Day's great collection of photographic prints and negatives went up in an apocalyptic conflagration. Little remained of all his efforts, and the rare prints which have survived have become prized possessions in museums. The loss was disastrous for it put an end to Holland Day's career of photography as an art-form.

His boyhood love of all things that were antique and of historic interest inspired him in a new lease of life. He gave up his publishing firm, and decided to move back to Norwood, Massachusetts, where he was born, to a house he would build for himself. He hired a horse and wagon and toured the state of Maine to look among the abandoned farms for old colonial doors, floorboards of unusual width or original mantelpieces, fire-irons, old iron pots from chimney places, and other such oddments which are now generally accepted as beautiful. Holland Day stacked a barn with the loot that he had found or bought for almost nothing Then he chartered a schooner, filled it with all his newly acquired possessions, and sailed for Southport. Having bought a rocky island off the coast, Day found a carpenter who could follow his instructions and understand the effect that he wished to create. Thus he built himself a house that he considered fitted the landscape. The dining-room walls were made entirely of the old doors he had found and the design and general layout were original. While it followed a definite plan of fantastic thought apart from the architecture of the day, it was said by the *cognoscenti* to be entrancing.

Day was said to have amazing insight and intuitive judgement in accurately analysing both local affairs and general trends. He continued to be interested in many varied aspects of life. A man of great courage and a temperament appreciative of artistic endeavour, he was not understood in his time except by the most brilliant minds in Europe and America, literary figures and artists. His critics were naturally surprised by Day's major idiosyncrasy when, in 1917, he took to his bed and remained there for over sixteen years.

It was to Julius Tuttle, the closest of his little coterie of friends and one of the executors of his estate, that Holland Day, before he died in 1933, confided that he wished his collection of Keatsiana to be secretly donated to the poet's house and museum in Hampstead. But Fred Edgecombe, the curator of the Keats museum, staggered by the importance of the priceless gift, begged that the name of the donor should be published in England.

F. Holland Day, who was privileged to live his life exactly the way he wished, availed himself of that rare opportunity to the full. The old bachelor, the last representative of a wealthy and prominent family, was buried, as he wished, in a simple service. Apart from the growing interest in him as a legendary figure, and for a legacy of the most beautifully produced books ever to be made in America and a few excellent photographs that survived the fire, he will always be acknowledged for the success of his campaign to make photography recognized as an art.

Heinrich Kühn

1866–1944

Heinrich Kühn, *Portrait of a Girl.*

Born in Dresden. Studied science and medicine at Innsbruck. Met Hans Watzek and Hugo Henneberg at Vienna Camera Club (founded 31 March 1887) and together they formed the Viennese Triforlium. From 1897 produced multilayer portraits and landscapes in gum bichromate; towards end of century turned to oil printing. During 1920s advised previsualization, the making of a perfect negative, and avoiding any manipulation of the print. Contributed to *Photographischen Rundschau* and *Das Deutsche Lichtbild*. Work published in *Camera Work*, XIII and XXXIII (1906, 1911). Article: *Image*, vol. 1A, nos. 5–6, Dec. 1971.

Heinrich Kühn was one of the leaders of the Austro-German Secessionist movement in photography. Together with Professor Hans Watzek and his good friend Hugo Henneberg, Kühn championed in his homeland the cause of the international movement in photography, called by some 'pictorialism', by some 'impressionistic photography' and by some the 'aesthetic movement'.

'His pictures clearly show the result of his special methods. The proportion of the light and color-values is frequently so truly reproduced that we feel the sensation of color. . . . His work includes genre pictures, street-scenes, still life, portraits, color-experiments, etc. etc. Taken all in all, Kühn is the most diligent and competent of the German–Austrian pictorialists; and the success of an exhibition has frequently been decided by his participation or non-participation.'

(F. Mathies-Masuren in *Camera Work*, XIII, No. 13, 1906) GB

Alfred Stieglitz

1864–1946

Born in Hoboken, New Jersey. Attended Charlier Institute, Grammar School No. 55, College of the City of New York, 1871–81; Real-gymnasium, Karlsruhe, Germany, 1881. Began study of mechanical engineering at University of Berlin but switched to photochemistry, 1882–90. Made first prints, 1883; sent first prints to competition, 1886. English and German photographic periodicals start reproducing work, 1887. Returned to New York; entered photo-engraving business, 1890. Editorial contributions followed by editorship of *American Amateur Photographer*. Unanimously elected to Linked Ring, 1894. Withdrew from business, 1895; founded and edited *Camera Notes*, an organ of Camera Club of New York, 1897. Resigned from *Camera Notes*, founded Photo-Secession, 1902. Published and edited *Camera Work*, 1903–17. Ran Little Galleries of Photo-Secession at 291 Fifth Avenue, New York, 1905–17. Organized International Exhibition of Pictorial Photography at Albright Art Gallery, Buffalo, New York, 1910. Began the series of photographs of Georgia O'Keeffe, 1917. Director Intimate Gallery, 1925–9; An American Place, 1929–46. Stopped photographing, 1937. Awards include: progress medal of Royal Photographic Society, London, 1924. Exhibitions include: Camera Club of New York, 1899; '291', New York, 1913; one-man shows at Anderson Galleries, New York, 1921–4; Museum of Modern Art, New York, 1947. Collections: Metropolitan Museum of Art, New York; Museum of Fine Arts, Boston; Museum of Modern Art, New York; Royal Photographic Society. Books: *America and Alfred Stieglitz. A Collective Portrait* edited by Waldo Frank, Lewis Mumford, Dorothy Norman and Harold Rugg, 1934; *Tributes – In Memoriam*, with Stieglitz Memorial Portfolio edited by Dorothy Norman, 1947; *Photo-Secession* by Robert Doty, 1960; *Alfred Stieglitz: Photographer* by Doris Bry, 1965; *Alfred Stieglitz: An American Seer* by Dorothy Norman, 1973.

'I was born in Hoboken. I am an American. Photography is my passion. The search for truth my obsession.' Thus wrote Stieglitz of himself. It was Emerson, one of the strongest influences of the naturalistic school of photography, who first recognized the talent of the young Stieglitz and gave him his first prize. Stieglitz had always a strong feeling for the natural elements, and it was this that led him to photograph spring showers and wintry blusters. He said that by photographing clouds he could put down his philosophy of life and translate into photography his stored-up energy, memory, will and impulses. 'When I see something that serves as an "equivalent" for me of what I am experiencing myself, then I feel compelled to set down a picture of it as an honest statement – which statement may be said to represent my feelings about life.'

Stieglitz had a remarkable talent for conveying these feelings through his pictures. He could, by looking at them, 'feel' the snow or cloud-formation; he could 'feel' the energy in crossed hands or legs. By showing the veins and wrinkles in a workman's hands, or a woman's finger with a thimble upon it, he was able to recreate the intensity that was in him. It was Stieglitz's opinion – thought to be quite revolutionary at the time – that a work, whether that of a painter, pastrycook, musician, sculptor or photographer, should be judged on its own merit and only in terms of itself.

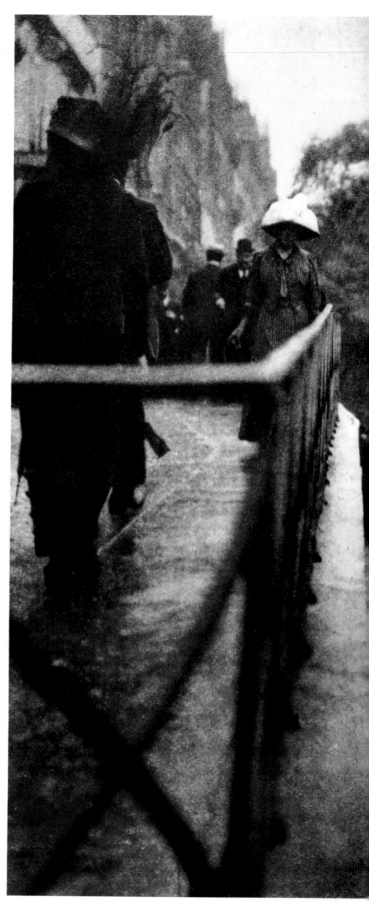

Alfred Stieglitz, *Paris*, 1911.

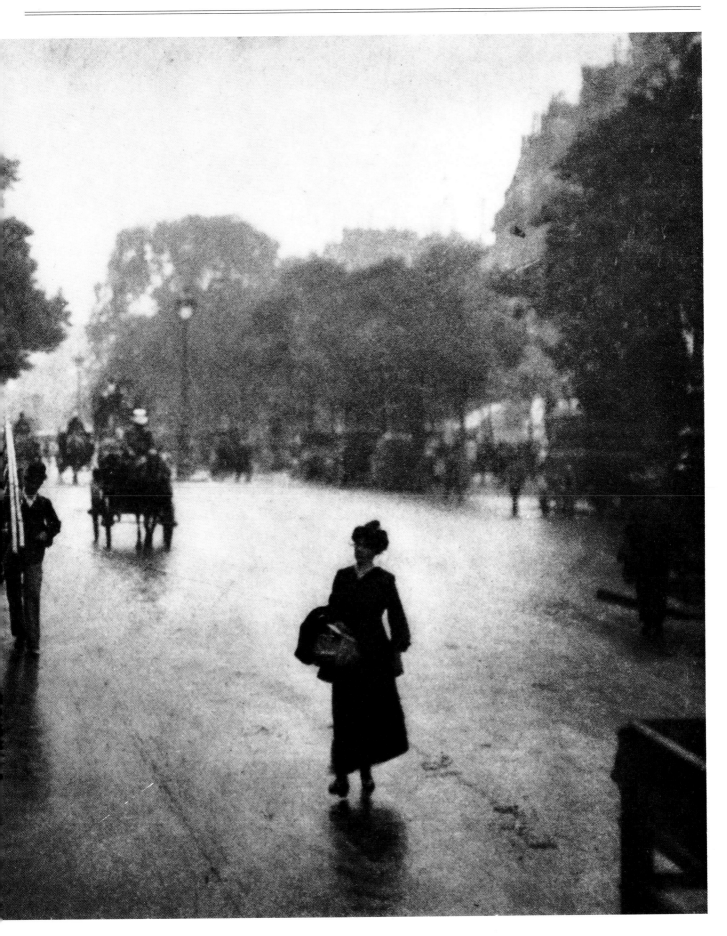

Alfred Stieglitz

Alfred Stieglitz, *The Flat Iron Building,* 1903.

In order to capture a mood rather than a happening, he would stand for days on a traffic island! His exposures of city streets and railway-yards at night were wistful and sensitive revelations of beauty, and were entirely new. He was a pioneer and, through writings and exhibitions, he fought all his life to foster the spirit which animates true explorers and creators in the arts.

At first Stieglitz only photographed 'in small', his prints being less than the size of a playing card, but they were mounted on a large sheet of buff or brown crinkly paper. Since he would not allow his pictures to be enlarged even in reproduction in magazines, he at first received less acclaim than more worldly photographers.

His early exhibitions showed pictures that were the result of much manipulative work so much admired by his friend, Joseph Keiley, but he abandoned the purely 'romantic' and elemental, and became more concerned with abstraction. With sharp perception he portrayed the austere geometry of New York. Stieglitz acknowledged the use of photography for capturing reality, but insisted that his work should be judged not by its subject-matter, but by its spirit. Thus he was able to accept modernism years before his time, and his black-and-white designs became like Cubist paintings. He was obviously influenced by Picasso, Matisse, Braque, Picabia and many others whom he was the first to introduce to New York. He was

responsible for the wide acceptance of primitive African sculpture in Manhattan.

Even if the German Stieglitz had not produced strikingly new pictures of horse-carriages ploughing through the slush of Fifth Avenue, a wet day in Paris, or of his stark, empty studio or landing filled only with dramatic light, he would still be considered a vital figure in American photography. For it is as a force and influence that he is significant. Together with his rival, Fred Holland Day, he was largely responsible for 'legitimizing' photography.

Stieglitz's crusade to make the camera something other than a means of transcription had begun in 1885; but it was as the editor of *Camera Work,* one of the most beautiful of all photographic magazines, that the real foundations were laid.

During a blizzard on a night in 1902, Stieglitz had delivered a christening speech to the guests at the first Photo-Secession exhibition (an equivalent of the Secessionist movement in painting in Munich) at the National Arts Club in New York. He declared the purpose of the group was, above all, to dignify that profession which until recently had been looked upon as a trade. The success of the evening made history. The Photo-Secessionists moved to a gallery at 291 Fifth Avenue ('291' became the name of his pioneer group) where the clean white walls formed the background for a series of exhibitions that made the club the centre of art in America. '291' was soon the

Alfred Stieglitz, *Above, left Winter–Fifth Avenue,* 1893. *Right The New York Central Docks,* 1904.

vortex of 'discussion and rages', the focal point of a peaceful rebellion against the mechanical age.

The number of his disciples increased and when Stieglitz went for walks with aspiring young enthusiasts such as Paul Strand, friends joined him on the way so that when he eventually arrived at a small Chinese restaurant there might be as many as a dozen at his table.

The First World War put an end to the career of *Camera Work*, the Photo-Secession Galleries and the '291' group. Stieglitz, who remained pro-German, poured his creative activity into his own photographic interests. He was one of the first collectors of photography and he spent as much as he could afford on buying early prints. He also received with enthusiasm the gifts of his photographer friends whose work interested him.

As his second wife this serious, parroty little man married the painter Georgia O'Keeffe, a bony greyhound of exceptional beauty, and for twenty-seven years Stieglitz made thousands of portraits of her. Nor were the portraits confined to her beautiful face: as well as the enigmatic, mysterious expressions in her eyes he photographed details of her neck, her feet, her torso, and above all her hands, which he showed in repose, sewing and doing the daily tasks of a housewife: no more comprehensive or intimate photographic essay has ever been made of one human being.

It is almost impossible to single out, from the vast bulk, prints in which Stieglitz reached his highest peak; just one exposure cannot convince us of the integrity and individual attitude towards his subject. Yet superlative are *The Steerage Immigrants, Paris*, a black-and-white clapboard house on Lake George, strangely like a Spanish ballet setting by Picasso, and the abstract designs composed of Manhattan walls, all identical in shape, yet varied in their texture and light.

From 1902 until the time of his death, Stieglitz was the very centre of photographical activity in the United States. He taught, he lectured, he wrote; his influence was incalculable. Perhaps today some may consider his writings to be heavy and selfconsciously mystical, yet much is still valid. He was always curious to know what was going on at the back of people's minds. He sympathized with all who looked around them with a fresh eye at whatever subject they chose. To him it was the photographic experience that gave him greater understanding.

Stieglitz's vast photographic collection had cost him approximately $15,000 and on an impulse he gave it to the Metropolitan Museum. John MacKendry, the brilliant young Curator of Prints has written 'During the forty-one years since the first of the seven extraordinary Stieglitz gifts almost five thousand photographs have come to the Museum. It would be virtually impossible to form a comparable collection today, for much of the material in it is unique. . . .'

Gertrude Käsebier

1852–1934

Born Gertrude Stanton in Des Moines, Iowa. Crossed the plains to Leadville, Colorado in covered wagon, 1852. Attended Morovian College for Women, Bethlem, Pennsylvania. Married Eduard Käsebier, from Wiesbaden, Germany, and raised three children, 1874–88. Studied painting at Pratt Institute, Brooklyn and casually started photographing, 1888–93. Opened studio in Paris, 1894; studied with photographic chemist in Germany, 1897. Opened New York studio, 1897. Jury member of second Philadelphia Salon, 1899. First woman to be elected to Linked Ring, 1900. A founder and council member of Photo-Secession, 1902. Ousted from Photo-Secession, 1910. Formed the group Pictorial Photographers of America with Clarence White and Alvin Langdon Coburn, 1916. Exhibitions: Camera Club of New York, 1898; Philadelphia Salon, 1898; 'New School of American Photography', Royal Photographic Society, London, 1900; Albright Art Gallery's International Exhibition of Pictorial Photography, Buffalo, New York, 1910; Brooklyn Institute of Arts and Sciences, New York, 1929. Collections: Museum of Modern Art, New York; Library of Congress, Washington, DC; Royal Photographic Society, London. Photographs reproduced in *Camera Work* I and X (1903, 1905).

A painter who took up photography in middle age, she successfully opened a studio on Fifth Avenue, New York. Her work shows great charm of invention and is full of surprise and delight. She renewed herself with a perpetual freshness of conception, and a creativeness that pervades all the elements of her pictures. She has special qualities of light, shade, tone and texture. She is a deep-dyed romanticist, and refused to remain with the Stieglitz group when the great master proclaimed himself an advocate of the unmanipulated straight-from-the-shoulder style of photography.

Gertrude Käsebier wrote:

'I am now a mother and grandmother. My children and their children have been my closest thoughts, but from the first days of dawning individuality, I have longed increasingly to make pictures of people . . . to make likenesses that are biographies, to bring out in each photograph the essential personality that is variously called temperament, soul, humanity. I had no conveniences for work, no darkroom, no running water in the house. Owing to the long twilight, I could not begin developing before ten o'clock. I had to carry my wet plates down to the river to be washed. My way was through a darkness so dense I could not see a step before me. It was often two o'clock in the morning, or almost dawn, when I had finished. I could not avoid draggled skirts and wet feet. More than one friend predicted I would get my death.'

Gertrude Käsebier, *The Sketch*.

Clarence H. White

1871–1925

Born in Ohio. A book-keeper, took his first photographs about 1894. Exhibited at First Philadelphia Salon, 1898. Stieglitz, impressed by his work, proposed name for honorary membership of New York Camera Club. By 1899 had achieved an international reputation, having exhibited in Boston, Dresden, London, New York, Paris, Turin, Vienna. Founder member of Photo-Secession, 1902. Moved to New York and became lecturer on photography at Teacher's College of Columbia University, 1906. Founded Clarence H. White School of Photography, 1910. First president of Pictorial Photographers of America, 1916. Prints mostly platinum. Work reproduced in *Camera Work* III, IX, XXIII, XXVII, XXXII (1903, 1905, 1908–10). Exhibition: Museum of Modern Art, New York, 1971. Collections: Museum of Modern Art; International Museum of Photography, Rochester, New York; Library of Congress, Washington, DC; Metropolitan Museum of Art, New York; Royal Photographic Society, London.

Clarence White was influenced by oriental art and also by the early Impressionists in Europe. But, living as he did in Ohio, he felt out of touch with events in the world of photography. However, he was impressed by the *Camera Notes* of Stieglitz, and became a member of the Secessionist group. In many of the series of scantily draped ladies seen against sunlit trees he used as a prop a crystal ball, the symbol of the Photo-Secession.

Clarence White, a sad, charming, mule-faced man, was self-taught, and even his earliest pictures show a point of view that was distinctly his own. His pictures are typical of the intimate style of American impressionism with its simple scenes, the female members of the family reading or playing blind-man's-buff, or dressed as allegorical and mystical figures seen in moments of reverie or solitude in a hazy landscape. Some of his images have an affinity with early Sargent, Whistler or Wilson Steer paintings.

Although White never used artifical light and was little attracted by artifice in any form, he was perhaps a precursor of the Baron de Meyer. He enjoyed the back-lighting effects of sun through apple-blossom, and maidens in nightgowns or other long-flowing garments pausing in alarm and *contre-jour* at the approach of some fearful footsteps. White's pictures are composed in an original and delightful manner, extremely feminine and romantic.

White contended that good photography relied upon concentration and planning, and by the continued use of the same subjects he was able to come to a deeper understanding of their intrinsic emotions.

Later in life, Clarence White became an international figure

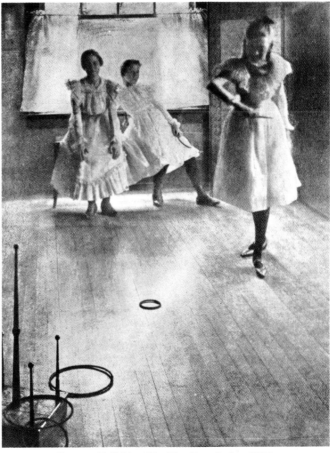

Clarence H. White, *The Ring Toss*, before 1903.

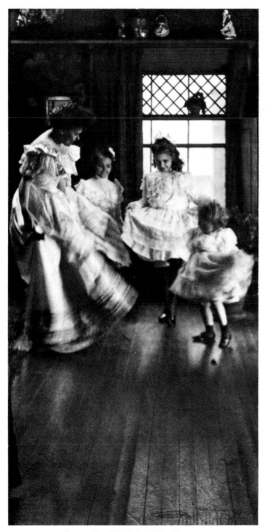

Gertrude Käsebier, *The Dance*.

as a great teacher of photography and lecturer at Columbia University. He also made some urban landscape photographs that anticipated the trend of American photography in the 1920s and 1930s. He died while leading a student tour in Mexico.

Lewis W. Hine

1874–1940

Born in Oshkosh, Wisconsin. After a succession of jobs as a labourer, began taking extension courses and became interested in art. Encouraged by friend and teacher Frank A. Manny to follow a teaching career, enrolled in University of Chicago, *c.* 1898. Taught science at Ethical Culture School, New York, where Manny was principal, 1901–8. Studied sociology at Columbia and New York Universities; received master's degree in teaching from the latter, 1905. A self-taught photographer, his first great photo series was on immigrants at Ellis Island, 1905. Published first illustrated article on social conditions, 1908; attracted attention of editor of magazine *Charities and the Commons,* who gave him a job as staff photographer. Early photographic investigations concerned the atrocious living conditions of the immigrant labourers on the New York State Barge Canal and the growing slums of Chicago and Washington. After first set of photographs of child labour appeared in *The Survey,* appointed staff photographer for National Child Labor Committee until the thirties. Having gathered information concerning each photograph, the pictures were used to illustrate booklets, posters, magazines and as source material for films. Photographed in Europe and Balkans during First World War. Chief photographer for National Research Project of the Works Progress Administration, 1936. Cameras: 5 × 7 inch view camera, magnesium powder for night flashes; later used 4 × 5 inch Graflex; used both glass plates and film. Exhibitions include: Civic Art Club, New York, 1920; Riverside Museum, New York, 1939; Des Moines Fine Arts Association Gallery, Iowa, 1939; Lewis W. Hine travelling exhibition organized by International Museum of Photography, Rochester, New York. Collections: International Museum of Photography Library of Congress, Washington, DC; Exchange National Bank of Chicago; Hine Collection, Local History and Genealogy Division Room, New York Public Library; Tennessee Valley Authority Graphics Department; Prints and Photographs Division of National Archives. Books: *Men at Work: Photographic Studies of Modern Men and Machines,* 1932; *Through the Threads: An Interpretation of the Creation of Beautiful Fabrics,* 1933. *Lewis W. Hine and the American Social Conscience* by Judith Mara Gutman, 1967.

Lewis Hine did not start taking photographs until he was thirty-seven years old when he was asked to double as a photographer and a private school teacher. When still an amateur he photographed the impoverished immigrants at Ellis Island, New York, and this was the beginning of his use of a camera as a method of showing the worst of the social ills and the plight of the underprivileged brought on by the early effects of industrialization upon urban life. His studies in sociology were greeted with enthusiasm and Hine was encouraged to give up teaching at the Ethical Culture School to make

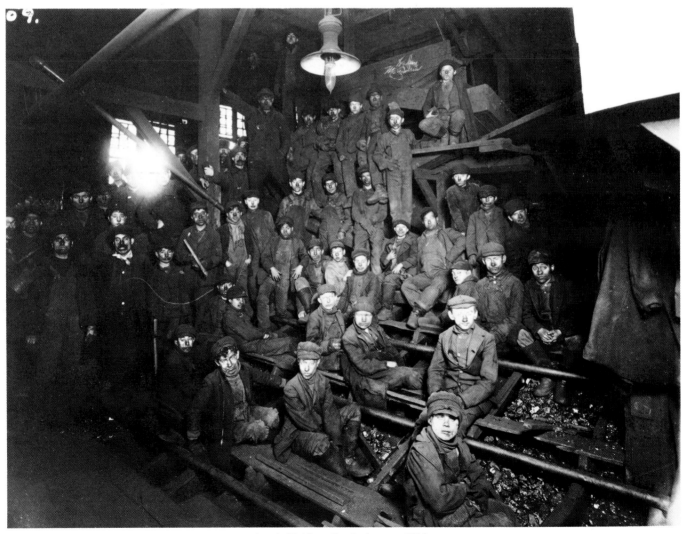

Lewis W. Hine, *Breakerboys, c.* 1911.

'documents of injustices,' for *Charities and the Commons*.

Lewis Hine drew attention to the terrible conditions of the Pittsburgh miners, the Negroes in Washington, the tenement-dwellers using the one communal tap, the under-nourished or tubercular children wrapped up to fight their disease on a snowy Manhattan rooftop. In his investigations of the lives of the poverty-stricken, Hine was particularly appalled by the fact that children from the ages of six to fourteen were forced to do menial work in factories, and were often made to operate dangerous machinery in squalid and insanitary surroundings. As well as producing pictures that were a powerful indictment of child labour he also gathered the information to heighten the effect with startling captions. 'Let the children grow,' he proclaimed as he made eloquent, penetrating, moving state-ments: a group of black coal-covered little boys, *The Breaker Boys, The Glass Boys* (Virginia in 1911), and the young girls working in the cotton-mills of Carolina. His *Girl with Dying Father* in a New York tenement is without horror but stabs us to the heart.

Hine was sent by the Red Cross to Europe to record its activities in the First World War, and later in the Balkans he documented the effects of war. On his return to New York he concentrated on people at the machines, the effort made by the emergency reliefs, rural nursing, and many health programmes, in an attempt to interpret the 'dignity of labour'. His book *Men at Work* showed the Empire State Building in course of construction.

Hine wrote: 'I wanted to show the things that had to be corrected: I wanted to show the things that had to be appreciated.'

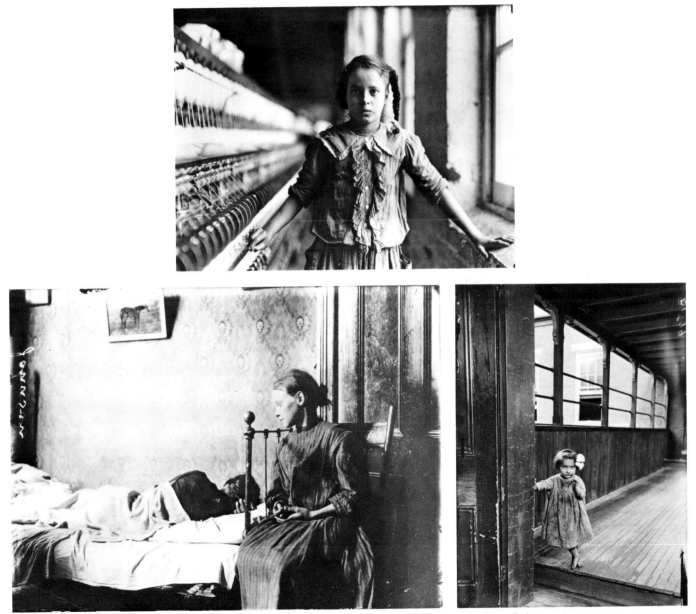

Lewis W. Hine *Above, top Textile Mill*, 1908. *Bottom, left Girl with Dying Father. Right Little Orphan Annie, near Pittsburgh*, 1908.

Baron Gayne de Meyer

1868–1946

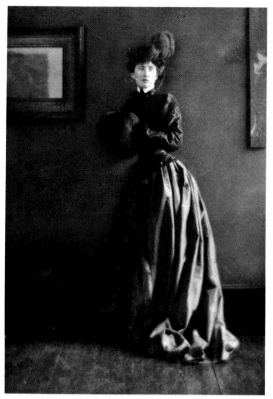

De Meyer, the Debussy of the camera, has not been placed high enough in the hierarchy of photographers. Yet few have had greater influence on the picture-making of today than this somewhat affected but true artist.

Born Demeyer Watson, of a French father and Scottish mother, he was brought up in Saxony, with a considerable amount of money to spend. Coming to London he married a formidable and mysterious lady, said to be the daughter of either King Edward VII or Kaiser Wilhelm. King Edward was delighted at the marriage and suggested that the King of Saxony should ennoble the young man. This was arranged; Mr Watson became Baron de Meyer and his ornamental wife was much admired in the royal box at Westminster Abbey. From then on the Baron Gayne de Meyer and his wife entertained extravagantly in a London house exotically decorated.

De Meyer's earliest photographs were taken under the influence of Stieglitz, with emphasis on sombre shadows and a somewhat aesthetic-looking subject emerging from a dark and fog-bound gloom. His portrait of the first Mrs Stieglitz is typical of this school. He also took pictures of fruit, picturesque peasants and Moorish native girls that were banal in the extreme. Then suddenly de Meyer found himself: the sun shone for him – and not only the sun, but the moon and all the stars. He used artificial light to make an aurora borealis. He discovered a soft-focus yet pinpoint-sharp lens which gave the required extra sparkle to shiny surfaces. His whites and silvers became dazzling, and the subtlety of his grey tones masterly. He invented a new universe: a high-key world of water

sparkling with sunshine, of moonlight and candlelight, of water-lilies in glass bowls, of tissues and gauzes, of pearly lustre and dazzling sundrops filtered through blossoming branches. He was able to reproduce the mystery of a Whistlerian nocturne by means of the camera.

When the Baron deigned to photograph professionally exclusiveness was his hallmark. It was a status symbol to stand against his barrage of back-lighting. The sitters were allowed only one single copy of their favourite poses. De Meyer seemed to live and work with consummate ease. It is difficult to turn out a flow of romantic photographs, yet he managed to sprinkle upon the most unprepossessing subject – such as Dame Nellie Melba – a little stardust. He was not afraid to reveal too little of his subjects, and sometimes as a portrait he produced just a blank outline.

De Meyer's lens played extraordinary tricks, with his lights reflecting in the *parquet de Versailles*, or seen through a vase of lilies or a champagne-glass. He enjoyed photographing in Louis Quinze rooms, especially if the *boiseries* were picked out in silver, and was delighted with all the exuberances of Art Deco. He made grottoes of small flowers and sprayed them with artificial dew. He liked the sheen on satin, or the cobweb texture of metal 'lace'. To obtain a more blinding gloss on a floor, he spilt buckets of water on the marble. Just as young photographers today take snaps right in the face of the sinking sun, so de Meyer tried to blind his lens, and the edges of his 10 × 8 inch plates became a firework display of refractions and dazzle.

De Meyer became the favourite photographer of Condé Nast for *Vogue*, who employed him not only for post-First World War fashion pictures, but for portraits of stage, screen and society personalities. He was never interested in portraying 'character'; rather did he aim to make his subjects into impersonal mannequin dolls or china figurines: he would pose them with their faces in a shadowless light and their bodies in poses suggestive of nonchalant extravagance and idly fantasy. None were penetrating likenesses, but they all had a quicksilver brilliance.

De Meyer's methods of light influenced Hollywood in its first days of sophistication as seen in Elinor Glyn films. His influence continued through the time of Marlene Dietrich till that of Korda. It reappeared in *Elvira Madigan*, and cameramen throughout the world who have never heard the name of de Meyer still employ his ruses of nebulous light, *profils perdus* and skeins of hair back-lit to appear like spiders' webs.

When de Meyer moved from *Vogue* to *Harper's Bazaar* whole issues of that magazine were created by him, and he wrote fitting and sensible articles to accompany his photographs.

When, after the Second World War, he begged to be taken back into the *Vogue* fold, the prodigal was rejected. Alone, unappreciated, poor and depressed, he emigrated to southern California where he made some splendid portraits of men. But at the age of seventy-seven, having survived for seven years in that culturally arid desert, he died. The *Los Angeles Times* in an obituary two inches long omitted any mention of his photography and inaccurately described him as a writer and a native of Paris. He was buried at – of all unsuitable places – Forest Lawn.

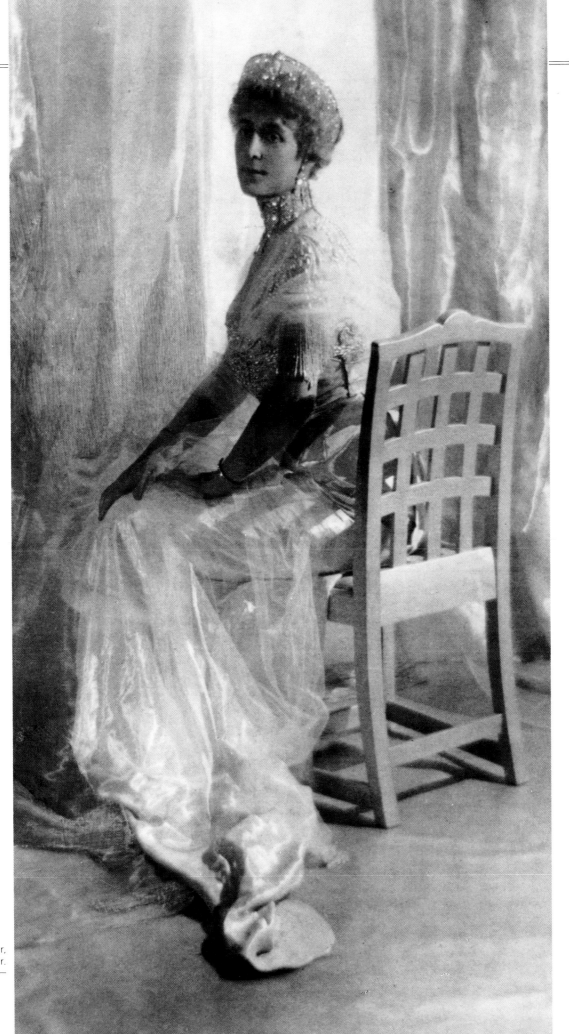

De Meyer,
Unknown sitter.

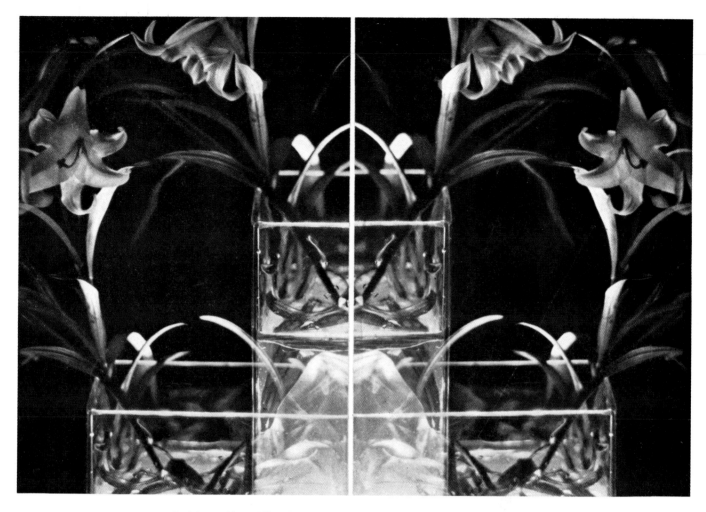

De Meyer. *Above Lilies. Below, left Hydrangea, c.* 1908. *Right Hoytie Wiborg.*

De Meyer, Untitled photograph.

Edward Jean Steichen

1879–1973

E. J. Steichen, *Rodin—Le Penseur*, 1902.

Born in Luxembourg; US citizen. Family moved to Hancock, Michigan, 1881; to Milwaukee, 1889. When formal education ended at fifteen, began apprenticeship in a Milwaukee lithographing company and used photography as a basis for his poster designs, 1894–8. After contributing to exhibitions in US and Europe from 1899, helped found Photo-Secession, 1902 and designed cover of its quarterly, *Camera Work*. With Alfred Stieglitz established Photo-Secession Galleries at 291 Fifth Avenue, New York, and designed galleries and installations, 1905. Returned to New York after living and painting in Paris, 1914; volunteered and was commissioned First Lieutenant in American army, 1917; retired Lieutenant-Colonel, 1919. Renounced painting and burned his canvasses, 1922. Chief photographer for Condé Nast Publications, work appeared in *Vogue* and *Vanity Fair*, 1923–38. Commissioned Lieutenant-Commander, USNR, 1942; named director of American Navy Photographic Institute and placed in command of all Navy combat photography, 1945–6. Director of Photography of Museum of Modern Art, New York, 1947–62. Prepared exhibition 'Family of Man', 1952–5; throughout career organized over fifty other exhibitions including 'The Bitter Years', 1962. Processes: palladium, platinum, gum bichromate, pigment, autochromes, bromide, etc. Awards include: German Prize for Cultural Achievement in Photography from Photographic Society of Germany, 1960; Silver Process Medal, Royal Photographic Society, London, 1961; Presidential Medal of Freedom, 1963; Selected exhibitions: La Maison des Artistes, Paris, 1902; Photo-Secession Galleries, 1906, 1908, 1909; Montross Gallery, New York, 1910. 'Mural by American Painters and Photographers', Museum of Modern Art, New York, 1932; 'Steichen the Photographer', Museum of Modern Art, 1961. Major collections: Museum of Modern Art, New York; Metropolitan Museum of Art, New York, Royal Photographic Society, London. Books include: *The Steichen Book* (Steichen Number and Special Steichen Supplement to *Camera Work*), 1906; *Steichen The Photographer* by Carl Sandburg, 1929; *The First Picture Book: Everyday Things for Babies* with Mary Steichen Martin, 1930; *US Navy War Photographs: Pearl Harbour to Tokyo* (editor), 1946.

Edward Steichen was born of peasant stock in the Duchy of Luxembourg. His mother considered that her son would have a greater chance in life in the midwest of America, and in 1889 the family moved to Milwaukee. Here the young Steichen studied painting which he intended to make his life's work, and joined the Art Students' League. When, a few years later, his father gave him a camera, the local photographer was badgered to teach the young enthusiast his trade.

Already, at a tender age, Steichen said he liked to take pictures that were 'useful'. He photographed 'details' of the countryside and sold his pictures of pigs for posters. But with the intent to create 'art' through the lens of the camera, he succeeded in producing dark, foggy pictures that were in the vein of fashionable romanticism.

In 1902, at the age of twenty-one, Steichen, like so many aspiring photographers, came under the salutary influence of Stieglitz's forceful vision. Arriving in New York, he visited the founder of the Secession group, at his Camera Club. Stieglitz encouraged the rather cocky young man by buying his photographs.

Steichen went to Paris and continued his painting. He made a series of sketches along the Seine, and exhibited a portrait of Holland Day at the Salon des Beaux-Arts. Holland Day was the organizer of the exhibition in London, which had created such a sensation, of the New School of American (Pictorial) Photography, which had included a number of Steichen's pictures.

Steichen's friendship with Rodin gave him superlative opportunities of which he took full advantage and produced probably his finest pictures of all. Steichen made memorable pigment prints at Longchamps of *Women at the Steeplechases*. Back in New York, and strongly influenced by Stieglitz, he took impressionist pictures of Brooklyn Bridge and the 'flat-iron' building. His portraits were too often heavily 'doctored': a self-portrait (wearing Holland Day's cravat) might have been an etching or a lithograph. The more straightforward renderings were the best: bottlenosed Mr J. P. Morgan, who was incensed when he saw his unretouched print, fox-like Richard Strauss, *Stieglitz and Kitty* (like an early Sargent), and the fabulous Mrs Philip Lydig, prune eyes a-goggle over a dying cyclamen.

At this time a self-conscious artistry tended to ruin Steichen's work and his nudes are nothing. But the photographer had no misgivings. He was consciously setting out to achieve immortality. When in 1911 he photographed fashion models for *Art and Decoration*, and later the *Sketch*, he stated, quite mistakenly (for de Meyer had preceded him brilliantly in this field), that they were probably the first serious fashion photographs ever.

After the sinking of the *Lusitania*, Steichen immediately joined the photographic section of the Signal Corps. When the war was over he returned to France where he 'wore himself to a frazzle' trying to educate himself in order to find his real path of self-expression. Then, in an improvised studio, he took the most elaborate measures to photograph the value, scale and weight of an apple. He made a thousand negatives of a white cup and saucer. Then he made a bonfire of all his paintings.

Steichen had long since taken off his soft-focus lens and concentrated on the photographing in needle-sharp close-ups of

foxgloves, household utensils, earthenware flowerpots and vegetables. But his 'significant details' lack the strength and drama of Stieglitz, and certainly cannot be compared in intensity to the work of Ansel Adams or Walker Evans.

It was a great notion to photograph Isadora Duncan at the Parthenon (although it is strange to discover how much re-touching he has seen fit to give these stones); but while on the Acropolis, Steichen went too far with Teresa Duncan, and his *Wind Fire* is funny-hideous. It was also a good idea to make Gordon Craig climb to a rooftop so that Nôtre Dame could be used as a stage backcloth behind him.

Steichen, a tall bony man with brilliant little eyes, a beaky nose, the ever-ready smile of the deaf, and a penchant for sweeping statements, became the best known photographer of his day. He did not possess a lightness of touch or much sparkle or humour, and it may well be that these failings have aided, rather than detracted from the reverence with which he was treated.

As a result of Frank Crowninshield's publishing in *Vanity Fair* Steichen's likeness with the caption that here was 'the world's best portrait photographer', Steichen cannily enough saw to it that he was also the highest paid. Crowninshield, that most darling, gentle and brilliant editor, induced Condé Nast to employ Steichen as his star photographer.

At the first sitting arranged to take place in Condé Nast's sophisticated apartment, Steichen was at a loss when asked by the *Vogue* electricians which, from a battery of Klieglights, banked in a corner, he would use. Steichen had heretofore used only daylight for his pictures. Tentatively he supplemented the light coming through a window with one light. By degrees, in his Condé Nast photography he used more and more lights. In fact, the 'high and low' cross-lighting may have added to the somewhat waxen sheen of his later photographs.

Steichen, who unaccountably insisted upon being referred to as 'Colonel Steichen', was sent to Europe to photograph the great names of the day. The politicians, fashionable play-wrights and other writers were seen for the first time as human beings.

Steichen also brought fresh air into *Vogue* with fashion photographs. 'Taste' was never the Colonel's strong point, and he was unfortunate in his use of props, so that the help that he was given by the incredibly intuitive Carmel Snow was inestimable. Not only did she choose the pick of Vionnet and other Paris clothes, the salient features of which she taught him, but she provided, in Marian Moorehouse, the best of all models.

Condé Nast was the springboard for Steichen to leap into the even more highly paid realms of commercial and advertising photography. For a firm of silk-manufacturers he grouped sugar-cubes, mothballs, carpet-tacks, spectacles, beans and thread: they may have been effective as yardage, but his dazzlingly lit *Boxes of Matches and Matchsticks* stands on its own as an abstract 'still'. His compositions for Jergen's Lotion, Kodak and other firms, in which he attempted to 'introduce naturalism', were proclaimed to be milestones. But somehow these and his *Homeless Women* were selfconsciously monumental.

In 1938, his earnings cleverly invested, Steichen closed his studio and retired to grow delphiniums. But with the declaration of war the erstwhile colonel became a lieutenant-commander of the USNR. He photographed the naval aspects of the war and did aerial photography in America, Britain and Germany. He was covered with praise, diplomas and rewards. With the cessation of hostilities he became in 1947 the director of the photograph section of the Museum of Modern Art in New York.

In 1952 he embarked upon a three-year undertaking to compile a great exhibition of the best photographers, to be called 'The Family of Man', the title of which was taken from a speech by Abraham Lincoln. In his quest he visited twenty-nine cities in eleven European countries. The exhibition, showing a preponderance of poverty-stricken scenes among the coloured races, proved to be his greatest achievement; it was viewed by over nine million people in sixty-nine countries and sold millions of copies in book form.

Steichen, 'the dean of American photographers', was for over seventy years a serious, earnest practitioner of the camera. Some of his early work survives the test of time. But he was never an innovator; his later work is completely lacking in interest, and his reputation has been grossly over-estimated.

On his eighty-second birthday Steichen was honoured in the United States as few have been during their lifetime. He died on the eve of his ninety-fourth birthday, and a new wing of the Modern Art Museum is about to be named after him. Stieglitz has received less due.

E. J. Steichen, *The Photographer's Best Model, George Bernard Shaw.*

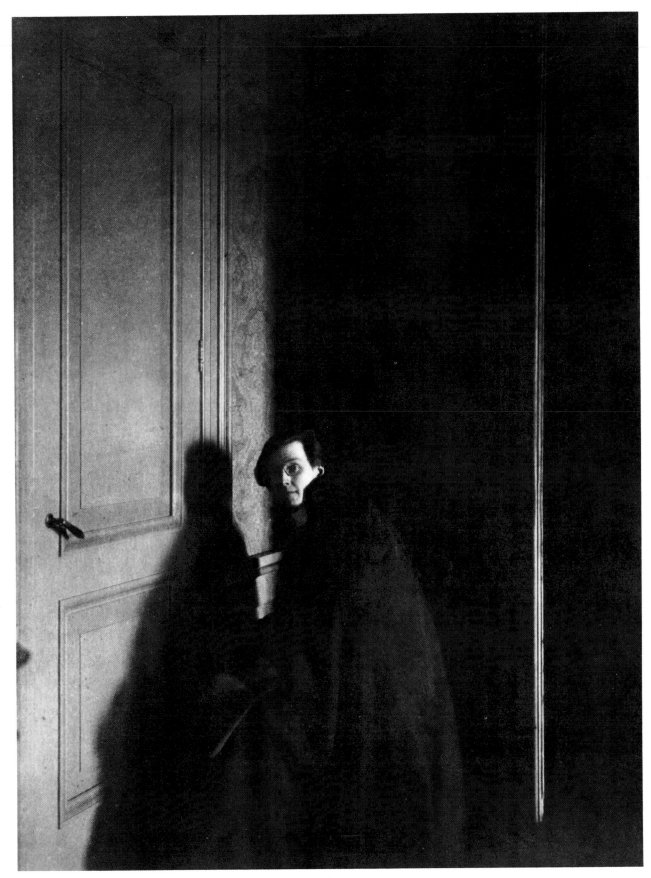

E. J. Steichen, *E. Gordon Craig.*

Alvin Langdon Coburn

1882–1966

Alvin Langdon Coburn, *Above, left Mark Twain, c.* 1910. *Right Regent's Canal, London, c.* 1905.

Born in Boston, Massachusetts. Moved to California soon after his father's death in 1889. Received first camera, a 5 × 4 inch Kodak box camera, when he was eight. Met his cousin Fred Holland Day whose influence led him to become a photographer, 1898. Travelled to England with mother and F. H. Day. Assisted Day in setting up and contributed to the exhibition the New School of American Pictorial Photography, held in October 1900 at Royal Photographic Society, London. Opened studio on Fifth Avenue, New York, in order to display his photographs, 1902. Worked for one year in Gertrude Käsebier's New York studio, *c.* 1903. Elected member of Photo-Secession, 1902; elected member of Linked Ring, 1903. Photographed in London, 1904–12. Produced the photogravure illustrations for his books; 83 plates and over 40,000 prints were made for these publications. Photographed in California and the Grand Canyon, 1910–11. Photographed in New York, 1912. Left America permanently with his bride, 1912. Made a 'vortoscope' based on principles of a kaleidoscope (composed of three mirrors fastened together in the form of a triangle), 1916; photographed with it, 1917. Built home in Harlech, North Wales in 1918 and lived there for thirty years. Became British subject, 1932. Moved to Colwyn Bay, 1945. Spent winters in Madeira where he once again photographed, 1966–7. Camera: used a 10 × 8 inch stand camera in early years of twentieth century. Award: Honorary Fellowship, Royal Photographic Society, London, 1931. Exhibitions include: Little Galleries of Photo-Secession, New York, 1907 and 1909; Royal Photographic Society, London, 1906, 1957, 1973; Collections: Royal Photographic Society; International Museum of Photography, Rochester, New York. Books include: *The Blue Grass Cook Book* by Minnie Fox, 1904; *London*, 1909; *New York*, 1910; *The Door in the Wall and Other Stories* by H. G. Wells, 1911; *The Cloud* by Percy Bysshe Shelley, 1912; *Men of Mark*, 1913; *London* by G. K. Chesterton, 1914; *The Book of Harlech*, 1920; *More Men of Mark*, 1932; *Edinburgh, Picturesque Notes* by Robert Louis Stevenson, 1954; *Alvin Langdon Coburn* by Nancy Newhall (portfolio), 1962; *Alvin Langdon Coburn, Photographer* (an autobiography) edited by Helmut and Alison Gernsheim, 1966.

Like his distant cousin F. Holland Day, Alvin Langdon Coburn was born in Boston. The son of a rich shirt-manufacturer he was fortunate enough to be able to indulge his tastes for music, art and photography, at an early age. Coburn became a friend of Stieglitz, and joined the Photo-Secessionists. When Coburn visited London he took soft-focus pictures of the Thames Embankment, the lions in Trafalgar Square and the Tower of London, in all of which smoke, fog and sunlight created self-consciously eerie, Whistlerian effects. Coburn's 'Post-Impressionist' gum-platinum pictures, or prints on rough cream paper with serrated edges or printed on photogravure, were praised by Bernard Shaw who wrote that 'Coburn's work always sets out to convey a mood and not to impart information'. Coburn was convinced that photography could achieve much of the depth of perception of a painting, and the painting that impressed him most was Japanese.

Because he wished to meet the artistic men of his day, Coburn wrote to such people as Mark Twain, Yeats, George Moore, Max Beerbohm, John Masefield, Arnold Bennett, Roger Fry, Matisse, Chesterton, George Meredith and Bernard Shaw, asking them to sit him for a book to be called *Men of Mark*.

Coburn's portraits, long out of fashion, are now back in favour for they are the unpretentious and true evocations of his illustrious sitters.

Later in life, under the influence of Ezra Pound's and Wyndham Lewis's theories on Vorticism, Coburn made a series of 'vortographs' taken with a kaleidoscopic prism-lens. He felt he had taken on a new lease of life and he rallied other photographers to 'Wake up! Do something outrageously bad if you like, but let it be freshly seen. Don't go fishing out old photographs and making feeble prints of them or photography will stagnate!'

Coburn enthusiastically formed an exhibition of abstract photography which included no work in which the subject matter was the all-important element. He cried: 'I do not think we have even begun to realize the possibilities of the camera!'

Religion and matters of the spirit had always played a large part in Coburn's life, and in old age he became a recluse–mystic, hiding himself in North Wales.

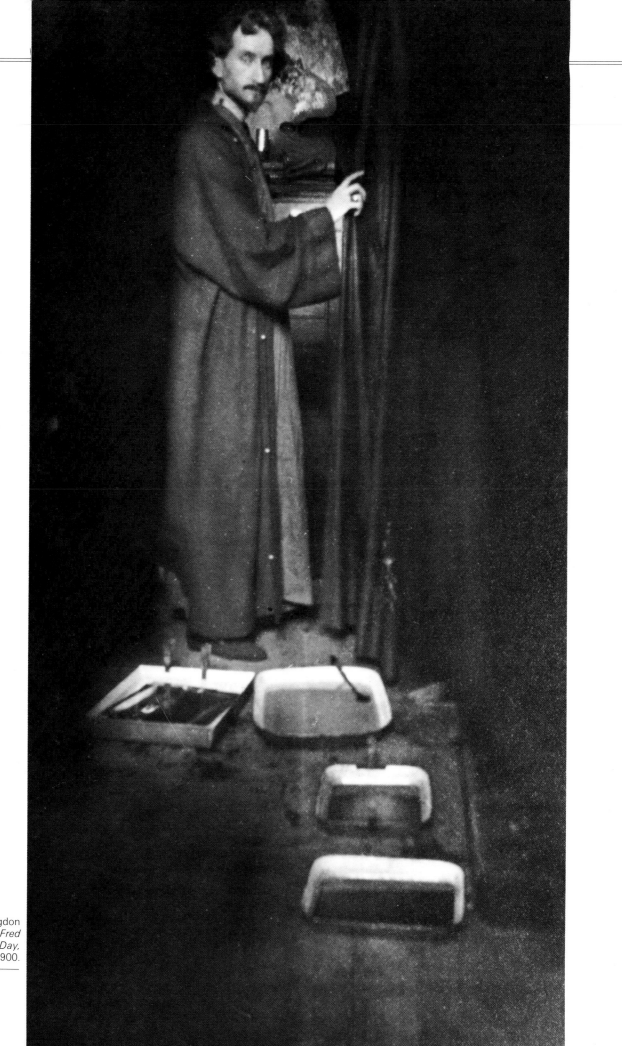

Alvin Langdon
Coburn, *Fred
Holland Day*,
1900.

114

Malcolm Arbuthnot

1874–1967

English. Married to a Kodak heiress, had studio at 43–4 New Bond Street, London, 1914–26. After First World War took many photographs for *London Illustrated News* and made film entitled *London's Leading Photographer*. Photographed for Goupil Galleries, London. One of original signatories of Wyndam Lewis's Vorticist manifesto *Blast*. Photographed actors and actresses, the Gaiety Girls and the entire chorus of the London Hippodrome. Moved to Jersey in 1930. Having learned painting from William Nicholson, devoted his later life to it. Collection: Royal Photographic Society, London.

It would not be surprising if Malcolm Arbuthnot was considered merely a commercial photographer of little artistic invention, for much of the output from his Bond Street studio bordered on the banal. But in fact he was a serious artist whose early shot of the simian-featured William Nicholson was exceptional even among the multitude of photographs of that most *photogénique* of painters. Yet Arbuthnot's commercial work had a controlled tonality and unusual tenderness of approach that was quite delightful. Likewise in the manner in which he allowed props to appear in his pictures he showed undeniable taste.

Unfortunately, even before such things became a wartime occurrence, all Malcolm Arbuthnot's negatives were destroyed in a fire in Bond Street, and, discouraged by the great loss, he quit photography.

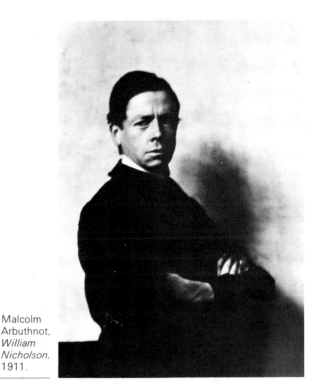

Malcolm Arbuthnot, *William Nicholson*, 1911.

Pirie MacDonald

1867–1942

Born in Chicago, Illinois. Left school at eleven; apprenticeship with Forshew Studio, Hudson, New York, from 1883. Opened studio in Albany, New York, 1889; New York City, 1900. Photographed 70,000 men in sixty years. First president of Oval Table Society of New York. Collections: New York Historical Society; Royal Photographic Society.

A gruff, humourless 'old master' brilliantly successful in New York in the 1920s and 1930s, MacDonald was renowned for his soft-focus *Portraits of Men*. The headshots, seen in a foggy haze, are lit with the same gleam on hair, or cheekbone, while the sitters remain completely static and lifeless in expression.

MacDonald was convinced of the validity of his work, and with tireless enthusiasm tried to prove that here was commercial photography at its most respectable. His belief was entirely endorsed by his illustrious sitters – celebrities all – who ranged from financiers, bishops, congressmen, corporation officials and automobile-manufacturers to the presidents of the Radio Corporation of America, Marshall Field and Firestone Tyre and Rubber Company, bankers and manufacturers, the president of the American Telephone and Telegraph Company, Cornelius Vanderbilt, President Wilson and Lord Duveen.

Pirie MacDonald, *Captain Jack Crawford, one of the Custer Scouts*, 1915.

MacDonald decreed that on his death all his negatives should be destroyed, but left five hundred *Portraits of Men* to the New York Historical Museum. The prints, already yellow, are quickly fading.

Jacques-Henri Lartigue

1894–1986

J. H. Lartigue, *Paris—At the Races*.

Born near Paris. Received first camera, 1901. Received formal art training at the Academie Julien. By the end of First World War was devoted to painting. Major exhibition of paintings held at Galerie Charpentier, 1939. Special subjects in photography: family and friends; cars, aeroplanes, sports, 'fancy' clothes. Cameras: all sorts, from view camera to hand camera to 35 mm. Exhibitions: Museum of Modern Art, New York, 1963; Photographers' Gallery, London, 1971. Collections include: Museum of Modern Art, New York. Books: *The Photographs of Jacques-Henri Lartigue*, 1963; *Diary of a Century* with Richard Avedon, 1970.

Lartigue's photographs were known, until recent years, only to his family and friends. Then a handful of people spotted the exceptional quality of those snapshots of movement made before the First World War which appeared in magazines of esoteric interest. They showed early aeroplanes, a woman jumping down a flight of steps, and fat women in hobble skirts hurrying along in the Bois de Boulogne.

Lartigue is a painter, and it is by his canvases that he has earned his living. But when his adolescent shots were exhibited for the first time in 1962 their extraordinary contemporary aptness was at once widely appreciated. They had such sense of speed and unvarnished reality.

One or two rather quaint little albums of his work appeared presenting these pictures as period pieces. But when the brilliant, energetic and resourceful Richard Avedon gathered the best of Lartigue's work into a magnificent super-*café-filtre* table-book, a great number of people discovered that some of the most influential photographs of this century were taken by a mere boy. For in this book Avedon published all the facts about how these pictures were taken, and we were even given extracts from the diary of the young embryonic photographer. We learnt that at an early stage Lartigue possessed an avid interest in all aspects of the life around him; he felt he must document everything; he tried to capture impressions by making diagrams and tracings, by drawing and painting. In his

diary he described how he filled each day – and these notes show him to have had, even then, a strange and original mind and an uncommon gift for self-expression with the pen. His father, well-to-do and able to indulge his interests in all the latest innovations, was an enthusiastic amateur photographer.

When the son reached the age of seven he found himself the possessor of a wonderful polished-wood photographic apparatus. Henri never stopped photographing his friends, his adored and admired elder brother, his uncles and cousins, who seemed to spend their days playing games.

From the first Henri attempted to catch the feeling of movement. So much was happening in the world, what with experiments with speed and flight. Henri was always in the centre of all this fun and festivity. He watched the auto-cars on the race tracks, the first attempts at flight in gliders, aeroplanes and dirigibles.

Seeing Lartigue's pictures of grand *cocottes* at the races one realizes what women of that Edwardian era really looked like in their pencil-tight skirts, long corsets which made their posteriors protrude, odd-shaped shoes of a softer leather than we use today, and vast feathered hats. These are unlike any other that were taken at that time. They are final statements. Yet in some of these pictures the fashions of the moment make way for emotion. For example, the disappointment on the faces of the men in their Gelot hats, with the lady, her plumage and finery forgotten, biting her lip when the wrong horse wins and she sees her money going down the drain.

Lartigue's early colour photographs are almost equally remarkable, for either through lack of technique or of his own volition, they are sparing in their use of colour, and many are like 'nocturnes' in blue, or grey and rose.

Although Henri Lartigue's work is nearest to that of the Italian, Count Primoli, who in addition to taking some remarkable aesthetically inclined studio portraits also made some fine candid shots of the life of the 1880s and 1890s, it is doubtful if the young Henri ever saw the work of the Roman photographer. Lartigue was influenced by nobody. He contrived nothing. He was not interested in creating with the lens anything artistic. He did not attempt to make his snapshots look like paintings. He was content merely to catch the fleeting moment in a direct manner. His aim was that the picture should come out clearly; it is this utter straightforwardness that gives his work an abiding quality, a quality that by its total reality often becomes mysterious and weird.

Lartigue's earliest pictures have acquired historical meaning. *My Secret Garden* is a lasting evocation of childhood tenderness and love. The picture of his mother's friends at Étretat with a background of villas, boats and downland is as atmospheric as any Post-Impressionist painting. His uncles enjoying a pillow-fight on a pole above water is wonderfully hilarious. The flashes of motor-racing are as violent today as they must have been when first seen.

Lartigue's shot of the legendary Gaby Deslys, the lady for whom King Manuel of Portugal is said to have lost his throne, is the earliest stage photograph I have seen portraying a performer as she must have appeared to the audience, showing the

J. H. Lartigue, *Above, top 'Bichonade'—the Cousin,* 1905.
Bottom The Diving of Cousin Jean, 1912.

painted canvas scenery under stage lighting in true relation to the singer – and very pretty it is, in its Bonnard way. Moreover, this demonstrates quite vividly the kind of appeal that she must have possessed: very unlike the image evident in the studio portraits of her time.

So it is with others whom we have only known from stereotyped likenesses. Yvonne Printemps suddenly springs to life; she is like a piece of fruit at the peak of its succulent perfection: big-nosed, big-mouthed with glorious pearls for teeth, and an animal healthiness and vitality. And here is everything we could know about Lartigue's father-in-law, the composer André Messager, a director at the Paris Opéra, as he sits back so delightful and delighted in the company of his adored and adoring little grandson, Dani. Papi Messager is also seen in a moving, completely un-macabre photograph, lying on his deathbed fully clothed in a black suit surrounded by huge cart-wheel bunches of Parma violets.

Lartigue's impressions of his first wife in her last month of pregnancy and later, after the birth of her second child, so soon to die, have the beautiful scent of domestic tenderness.

Among his later photographs, there are those of Lartigue's parents, shrunk with age, dressed neatly against the cold of a Paris winter, standing, he with his stick, she with her arm through his, in a typical street with the *Tabac* at the corner. They seem suffused with sadness for perhaps they, like their son, must have known that these were to be the last photographs taken of them by their devoted son.

Lartigue's photographs are like his diaries, of which he wrote, 'It is personal and I have to be completely honest with myself.' As Avedon wrote, these pictures show no moment that was not a private one.

Lartigue is a natty, wiry and resilient man, with tall, exceptionally lithe figure and white hair fashionably coiffed. With gusto he paints, photographs and entertains his friends to delicious meals cooked by his third wife, Florette, whom he photographs continuously and describes as 'unspoiled by growing up, natural, beautiful in the morning'.

Although he is pleased that his photographs have met with such recognition that his rooms, filled with old albums, cameras and photographic equipment, are the Mecca of hungry editors and journalists, Lartigue is determined that it is as a contemporary painter that he will eventually be appreciated.

John B. B. Wellington

1858–1939

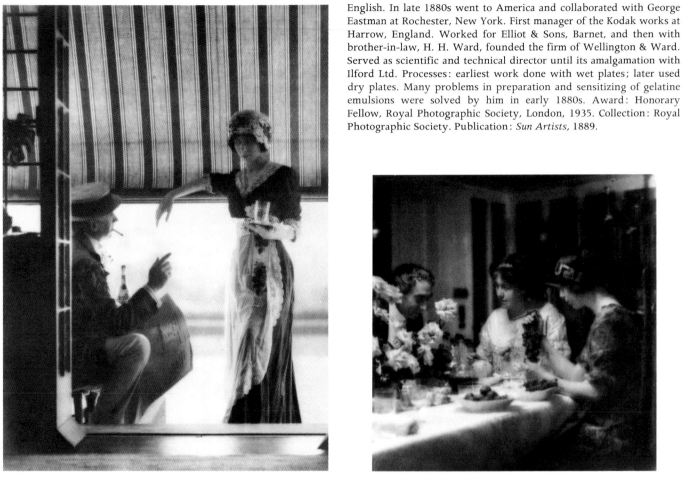

English. In late 1880s went to America and collaborated with George Eastman at Rochester, New York. First manager of the Kodak works at Harrow, England. Worked for Elliot & Sons, Barnet, and then with brother-in-law, H. H. Ward, founded the firm of Wellington & Ward. Served as scientific and technical director until its amalgamation with Ilford Ltd. Processes: earliest work done with wet plates; later used dry plates. Many problems in preparation and sensitizing of gelatine emulsions were solved by him in early 1880s. Award: Honorary Fellow, Royal Photographic Society, London, 1935. Collection: Royal Photographic Society. Publication: *Sun Artists,* 1889.

J. B. B. Wellington, *Left Cooling Moments,* 1925. *Above Dessert, c.* 1917.

J. J. B. Wellington's major activities were in the technical and industrial aspects of the photographic business. But he spent a considerable time taking photographs for his own pleasure. His work has a particular charm of its own, epitomizing the delights of the leisured classes of the Edwardian period. His use of ordinary electric light gave his glimpses of dinner-parties and other scenes of gaiety a verisimilitude that was never found in the fashion plates or advertisements. Wellington gave a true vision of the tastes and modes of the time: this, indeed, was how the supper-table was lit with pink-shaded candles and was adorned with carnations and maidenhair fern; this was how ladies, with large *brioche* hair-dos and chignons, ate their grapes from the silver bowl; this was how the men behaved when drinking champagne in their dinner-jackets or tail-coats, or lounged in their 'blazers' on the balcony of the cricket pavilion, or enjoyed the lazy relaxation at the river clubs and house-boats at Henley-on-Thames. Wellington knew how to make delightful compositions with figures seen as part of a geometric pattern against sunlit striped awnings.

Frank Eugene

1865–1936

Born in New York. Studied at City College, New York; originally a tapestry-designer. Left United States in 1886 and attended Bayrische Akademie der Bildenden Kunste (Bavarian Academy of Graphic Arts) in Munich. At some time he dropped his family name of Smith. Subject lecturer at Lehr- und Versuchsanstalt für Photographie (Teaching and Research Institute for Photography) in Munich, 1907 onwards. On council of Photo-Secession. Photographs reproduced in *Camera Work* v, xxv, xxx, xxxi, xlviii (1904, 1909, 1910, 1916).

'This talented worker, as everyone knows, etches with a needle upon his negatives, and while not all the results obtained may be by some considered "pure photography", they are by all acknowledged to be of great beauty and merit.'

('American Photographers in London' by A. L. Coburn, *Photo-Era*, January 1901) GB

Frank Eugene, *Nude.*

Frank Eugene, *Left to right* Frank Eugene, Alfred Stieglitz, Heinrich Kühn and Edward Steichen.

Richard Polak

1870–1957

From Rotterdam, Holland. Started photographic career in 1912. From June 1913, started to exhibit photographs in London. Studied technique for six weeks with Berlin photographer Karl Schenker, 1913. Gave up photography for health reasons; went to live in Switzerland, 1915. Member of London Salon of Photography, 1915. Process: platinum prints. Exhibitions: 'Amateur Photographer', Little Gallery, London, 1915. Collection: Royal Photographic Society, London. Portfolio: *Photographs from Life in Old Dutch Costume,* introduction by F. J. Mortimer, 1923.

Polak wanted to bring the past alive. His intention was to create works of art by making photographic imitations of the work of Vermeer, Steen, Ter Borch, De Hooch and Metsu. He discovered, in an old part of Rotterdam, a room on a top floor that had to be entered through a trap door. Polak liked its beams and whitewashed walls which he felt would make splendid backgrounds for his recreations. He bought the home and filled it with seventeenth-century furniture collected from antique-shops. As suitable props he bought maps, candelabra and musical instruments. The women in his photographs made their own voluminous clothing according to Polak's instructions and the men's doublets and feathered hats were concocted by theatrical costumiers. However, Polak's photographs are bewitching today because they are completely mistaken in their intention and unsuccessful as the genuine article. As in most theatrical ventures, no matter how painstaking or brilliant the effort, the contemporary always predominates. However expert a designer may be, it is almost impossible for him to endow his models with the understanding of the essence of an earlier record. In Polak's pastiches the men's moustaches and the ladies' hair-dos are undeniably late Victorian. However, the quaint results have a pleasant oddness.

Richard Polak, *The Artist and his Model,* 1914.

Alexander Keighley

1861–1947

Alexander Keighley, *The Great Bridge, Ronda.*

Born in Keighley, Yorkshire. First sent to dame school, then Old Grammar School. Offered a scholarship to School of Mines (now Royal College of Science) and took a course under T. H. Huxley. Was a director of Sugden Keighley & Co., a worsted-manufacturing concern, until 1932; leisure time spent painting and photographing. Most photographs taken outside England while on holidays. Travelled in South Africa as an ambassador carrying greetings from British photographic organizations, 1938–9. Member and president of Bradford Photographic Society. Equipment: first used whole-plate and 10 × 12-inch plate cameras, later quarter-plate box camera; made albumen, platinum and finally exclusively carbon prints; often enlarged pictures up to 24 × 30 inches. Award: Honorary Fellow, Royal Photographic Society, London, 1924. Exhibitions: New York Camera Club, 1920; Washington, DC, 1923; Chicago, 1930; Paris, 1933; Rochester, New York; Vienna; Hampshire House, London; and many others between 1923 and 1941; Bradford Art Gallery, 1943. Collection: Royal Photographic Society. Book: *Alexander Keighley: A Memorial,* produced by Pictorial Group of Royal Photographic Society, 1947.

As a boy Alexander Keighley studied science, but he always yearned to be an artist and reluctantly entered into the business of his father, a wealthy Yorkshireman. When Keighley discovered photography he gave up his share in family activities and it was fortunate that when he went on a photographic expedition he was able to take servants with him to help him with his heavy photographic equipment. When he started to make 'camera-paintings' he knew his existence was justified.

Keighley was a founder member of the Linked Ring which had the prime objective of attempting to make photography recognized as a serious art-form.

Keighley pronounced that it was a mistake for the photographer to borrow from other related forms of art such as engraving, paintings done in body colour, or drawings with charcoal or pencil. But he then went ahead and broke all his

Alexander Keighley, *The Vineyard, c.* 1904.

own rules. His carbon-prints are so heavily retouched and far from being the direct result of a negative printing, that it is impossible, at first sight, not to confuse them with reproductions of those popular calendar paintings with titles like *The Garden of Sleep* or *The Isle of the Dead* which were so popular at the turn of the century.

Keighley's achievements were the result of great knowledge of stump-work, stipple and spray. With a master's authority he made use of chalk, charcoal, crayon, pencil and aquarelle. To his photographic landscapes he added, 'to taste', foliage, trees, clouds, sheep, and even mythological figures. There was no trick of the trade that Keighley did not enjoy. His masterpiece complete, he varnished it. When exhibited to the public, astonishment was mixed with aesthetic admiration. His work was seen everywhere and, unlike most, Keighley's picture-photographs gain in reproduction.

For fifty years or more he achieved the feat of producing five or six of these pictures per annum. The titles tell the story: *The Rest is Silence, Fantasy, Ali Baba's Cave, Service Time, The Old Cloister, The Inner Gate, A Spring Idyll*. When, in 1901, he exhibited *The White Sail* and *Grace before Meat* he was acknowledged as the leader of British pictorial photography.

Keighley deserved his resounding success: he had an uncanny gift for chiaroscuro. Somehow he always managed to find a sunlit, white-robed figure to pass in front of a dark cypress tree, or a silhouetted form to be shown up by contrast at the right moment crossing a bridge. With uncanny instinct

he persuaded the sheepfold to move against the graceful silver birches of the Corotesque springtime background. Keighley was able to make donkeys and peacocks (in *My Lady's Garden*), and even flying birds, do his bidding.

Keighley propounded his theories: 'No outline should be definite, everything must be soft: no sharp-focusing.' Like that of many of the Edwardian photographers one feels that Keighley's life must have been, to use a word then fashionable, 'satisfying' in the extreme.

Alexander Keighley, *My Lady's Garden*, 1899.

121

Adam Clark Vroman

1856–1916

Born in La Salle, Illinois. Employed by Chicago, Burlington and Quincy Railroad as ticket-seller, operator, dispatcher, agent, 1874–92. Began to make landscape photographs, moved to Pasadena, California, 1892. Opened bookstore with J. S. Glasscock in Pasadena, 1894. First visit to Hopi village, 1895; photographic visits to Indian villages each year until 1904. Spent seven weeks in Rio Grande photographing missions, a special assignment from Dr F. W. Hodge, 1899. Joined Museum-Gates Expedition to photograph archaeological digs in Navaho country, 1901. Special subjects: documentation of Indians of south-west United States, Yosemite Valley, California Missions. Cameras: view and hand view cameras using $6\frac{1}{2} \times 8\frac{1}{2}$ inch dry (glass) plates; platinum prints. Exhibitions: 'A. C. Vroman – photographs of Yosemite and of the California Missions', Natural History Museum of Los Angeles County, 1958; Vroman Gallery, Indians of the Southwest, Natural History Museum of Los Angeles County, 1960–73. Collections: Natural History Museum of Los Angeles County; The Southwest Museum, Los Angeles; Pasadena Public Library. Books: *Ramona*, by Helen Hunt Jackson, *Photographer of the Southwest, Adam Clark Vroman, 1856–1916* edited by Ruth I. Mahood 1961; *Dwellers at the Source, Southwestern Indian Photographs of A. C. Vroman, 1895–1904*, by William Webb and Robert A. Weinstein, 1973.

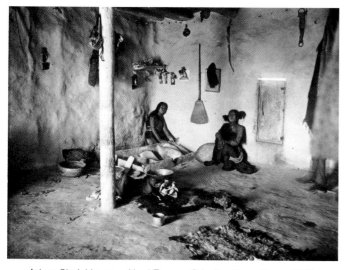

Adam Clark Vroman, *Hopi Towns, Grinding Corn, Tewa*, 1895.

Ansel Adams, the great landscape photographer of the American West, has said of the photographs of Adam Clark Vroman that 'They are invaluable as documents and rewarding as impressions of long-vanished times and places. Because of their simplicity and directness some reach extraordinary heights of convincing content. . . . There are no obvious efforts to create subjective effects – but much magic is there, inherent in both subject and image because of the honest selectivity of the photographer's eye and mind.'

Vroman made friends with the Indians and cared sufficiently about them to try and show through his photographs the uniqueness of each individual he asked to stand before his camera. His concern for the Indian was far-reaching; he strove through his photography to show the homes, the handicrafts, the rituals of the Indians. Unlike the hundreds of other photographers of his day, he did not take 'happy snaps of Injuns' but made thoughtful and concerned studies of a vanishing people and life-style. GB

Edward S. Curtis

1868–1952

Born in Wisconsin. Family moved west to Seattle; started to photograph American Indians, 1896. To help earn a living, bought an interest in a small studio. Not until he met George Grinnell, a prominent Indianologist, did his work have real purpose. Special subject: an intimate record of the North American Indian, tribe by tribe. Cameras: 14 × 7 inch view, later on 11 × 14 inch and finally 6 × 8 inch reflex; nearly all photographs taken on glass plates. Exhibitions: Pierpont Morgan Library, New York, 1970; Philadelphia Museum of Art, 1972. Collections include: Pierpont Morgan Library; Philadelphia Museum of Art, British Museum, London. Books: *The North American Indian*, twenty volumes of text and illustration, 1907–30; *The North American Indians: A Selection of Photographs by Edward S. Curtis*, introduction by Joseph Epes Brown, 1972; *Portraits from North American Indian Life*, 1973.

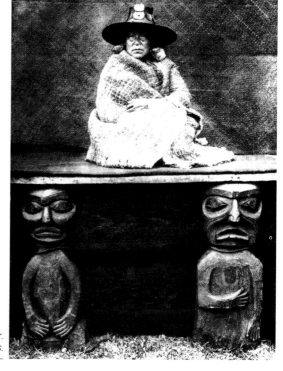

Right Edward S. Curtis, *Kwakiutl, Nakoaktok Chief's Daughter*.
Opposite Hopi, *Watching the Dancers*.

Edward S. Curtis

Edward S. Curtis, son of a minister in the United Brethren church in Wisconsin, became renowned as a humanist and pioneer photographer. Curtis was one of the few white men in the nineteenth century to be affectionately concerned with the predicament of the North American Indian. When he and his family moved to Seattle, young Curtis set up a photographic studio of his own. On discovering that Sioux Indians were living on a nearby reservation at Puget Sound, Curtis found the subjects by which his name is remembered. By the time Curtis started his work, the white settlers in the West had successfully decimated the defeated Indians with appalling brutality at Wounded Knee. General Sherman had boasted: 'The only good Indian is a dead Indian.'

When Curtis heard the Indians' story of the Custer massacre he was appalled, and was shocked to see the missionaries systematically trying to obliterate all traces of 'godlessness' in the Indians who, in fact, were a people with particularly strong religious awareness; the attempts by the missionaries to destroy all sacred habits, customs and ceremonies of the Indians distressed him.

Curtis started to photograph the Indians, tribe by tribe, as

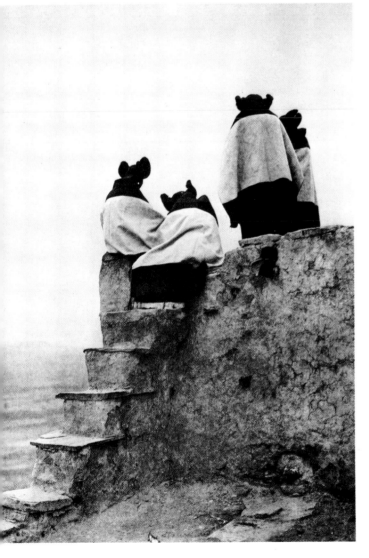

they lived, herded into reservations. The Indians accepted him because he was devoted and honest in his work. He began to sell his straightforward, well lit and technically perfect photographs.

In 1899 Edward H. Harriman, the railway millionaire, contracted Curtis to become part of a large group of ethnographers, biologists and anthropologists who were to make an expedition to Alaska. Here, for the first time, Curtis came in contact with the Eskimo Indians. They were, he wrote, 'healthy as a rule, and exceptionally happy because they have been little affected by contact with civilization'. From 1900 Curtis spent four years among the tribes west of the Mississippi. On his return his photographs were received with enormous enthusiasm, and he was invited to the White House to photograph the legendary Apache Chief Geronimo and a party of visiting Indians. J. Pierpont Morgan then advanced the sum of $75,000, payable over five years, in order that Curtis's prints should be incorporated in a set of books, 'the handsomest ever published'. The bulk of Curtis's prints are to be found in the Morgan Library today.

Curtis admitted that his life work had 'not been an easy one'. The hazards and difficulties of his expeditions were almost overwhelming. Travelling by wagon or pack-horse, loaded down with the cumbersome photographic equipment in broiling desert heat or arctic cold of winter, finding himself in floods or sandstorms, he must have been tried to the utmost. But he was rewarded when he succeeded in breaking down the resistance of reserve and hostility of a people who had so much reason to feel suspicious of the white man.

As a result of the recent emphasis on the American Indian situation and of increased guilt and sympathy towards them, and also perhaps due to a nostalgia for the old pioneering days, Curtis's work has come out of eclipse. Some of the faces he chose to portray are almost unbelievably striking in their boniness, gaunt nobility, and age shown in wrinkles that resemble the cracked earth of a desert drought. Some of the young women, with the elaborate hair-styles like double conch shells that indicate their virginity, are compelling, especially when they are seen praying by the smooth rocks of a still lake. The captions to some of his most remarkable pictures read: 'Dancing to restore an Eclipsed Moon'; 'Black Belly – Cheyenne'; 'Profile – Chaiwa-Tewa' (showing in close-up a stunning hair-style); 'A Piegan Dandy', with birdlike coiffure, beads, feathers and white-dotted skin; 'Placating the Spirit of a Slain Eagle – Assiniboin', a large-nippled man with pigtails; 'Watching for the Signal – Nez Percé', two naked men bareback on horses with flares against a night sky; 'Carved Posts at Alert Bay', with Art Deco bird-carvings house-tall; and 'In a Piegan Lodge'.

In the introduction to his book, Curtis describes it as 'a personal study of a people who are rapidly losing the traces of the aboriginal character and who are destined to become assimilated with the "superior race"'. He was horrified by the fact that 'the treatment accorded the Indians by those who lay claim to civilization and Christianity has in many cases been worse than criminal'.

J. Dudley Johnston

1868–1955

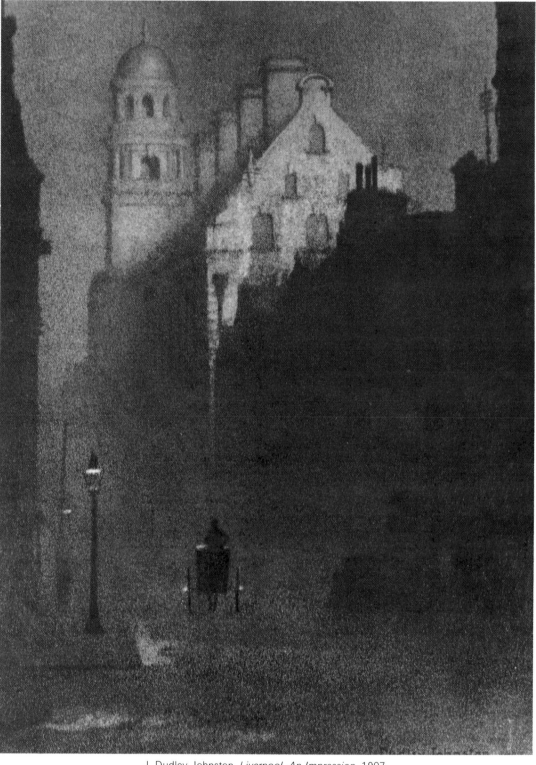

J. Dudley Johnston, *Liverpool—An Impression*, 1907.

Born in Liverpool. Commercial career in Liverpool, 1883–1911. Studied art and music; director of Liverpool Philharmonic Society, 1911. Instead of making watercolours on a trip to Norway, acquired a camera, 1893. Member of Liverpool Photographic Association, 1904; President, 1901–11. Moved to London, 1912. Joined Royal Photographic Society, 1907; president, 1923–5 and 1929–31. Regular exhibitor, photographic juror and writer on photography. Honorary curator of Royal Photographic Society Collection, from 1925. Special subjects: landscapes and cityscapes. Process: gum bichromate and platinum prints; lantern slides made in thiocarbamide (of which he was an acknowledged master). Awards: honorary Fellow, Royal Photographic Society, 1925; OBE for services to photography, 1947.

Joseph Byron and Percy Claude Byron

1846–1922 and 1879–1959

Joseph Byron, born in England, was a third-generation photographer. His grandfather had founded a photographic firm in Nottingham in 1844 under the family name of Clayton. Later, the name was legally changed. Joseph did advertising and *carte-de-visite* photographs. He also interpreted the news for the *Graphic* (of London), preparing and developing his wet plates in a hansom cab. Before emigrating to America in 1888 he undertook a documentation of coal mines for the British government.

Joseph Byron had five children; it was his son Percy (born in Nottingham; became US citizen, 1922) who was to become his photographic partner, although at times his other son and three daughters were actively engaged in the family business. Joseph had taught Percy to photograph by the time he was eleven; at fourteen he had sold his first photograph to the *World*.

In 1891 Joseph Byron pioneered stage photography. He and his son also photographed news events, banquets and balls, weddings, funerals, parades, people, buildings, hospitals, hotels, parks, etc. Percy photographed the Spanish–American War (1898) for the *Journal*.

In 1942 the ninety-eight-year-old five-generation firm closed.

Several generations of the Byron family contributed to making a fascinating record of life throughout the United States. The best work stretched from the 1890s to the beginning of the First World War. These factual representations were primarily of importance for pin-pointing a certain event or scene, and they have achieved, by their unpretentiousness and directness, a lasting interest. There are groups of the Daughters of the American Revolution, policemen patrolling the Brooklyn trolley-strike, scenes in City Hall, at political meetings, Coney Island, and in operating theatres. We see immigrants in the steerage of ss *Pentland* of the Red Star Line coming to the new land in 1893, scenes in a Turkish bath, or of the shirt-waist strike in 1909, and a slum-life as terrible as anything engraved by Gustave Doré.

No one will claim that these generations of the Byron family performed any great service in the cause of art, but they made a vast, valuable and fascinating document of their times.

Byron, *Madison Square, looking south from about 24th Street*, 1901.

Charles Puyo

1857–1933

Charles Puyo, Montmartre, *c.* 1900.

French. Took up photography about 1885 during final years of his tenure as an artillery officer in French army. Member of Photo-Club of Paris, helped form French Salon in 1894 with Robert Demachy, René Le Bègue and Maurice Bucquet. After retirement from army in 1902 devoted himself to photography. Photographs reproduced in *Camera Work*, XVI (1906). Processes: gum bichromate and oil transfer. Collections include: Société Française de Photographie. Books: *Notes sur la photographie artistique* 1896; *Les Procédés d'art en photographie*, with Robert Demachy, 1906.

Léonard Misonne

1870–1943

Born in Gilly (Charleroi), Belgium. After studying classics at Jesuit College in Charleroi, gained a diploma of engineering from University of Louvain, 1895. Never practised engineering, preferred painting, photography and the piano. Gave up other occupations for photography, 1896. Worldwide reputation, contributed to every important photographic exhibition, 1896–1940. Special subject: 'atmospheric' landscapes. Processes: gum bichromate, carbon, flou-net, bromoil, oil prints, Fresson, bromide. Collections include: Het Sterckshof, Deurne, Antwerp, Belgium; Museum Agfa-Gevaert, Leverkusen; family of L. Misonne, Charleroi. Books include: *Tableaux photographiques*, 1927; *Twenty-four photographs*, 1934; *Introduction à l'oeuvre photographique de Léonard Misonne* by Maurice Misonne (1971).

Leonard Misonne, *After the Rain*, 1935.

Horace W. Nicholls

1867–1941

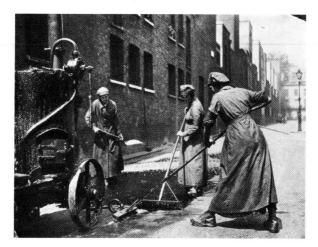

H. W. Nicholls, *Above Tar Spraying London Streets*, 1917–18.
H. W. Nicholls, *Opposite Derby Day; Top left c.* 1907;
right c. 1910; *bottom* 1914.

Born in Cambridge, England. Father Arthur Nicholls, a painter in watercolours and oils, was a pioneer photographer. Attended school in Sandown, Isle of Wight. Apprenticed to a chemist and/or photographer in Huddersfield, *c.* 1884–6. Served as an assistant photographer in Chile, *c.* 1886–9. Worked at Cartland's Photographic Studio opposite Windsor Castle, 1889–92. Occasionally summoned by Queen Victoria to give instruction in photography to her guests. Took up post in studio of a Mr Goch in Johannesburg, 1892; returned to England briefly to be married, 1893. Photographed the Boer War. Returned to England permanently, 1902; went on a country-wide illustrated lecture-tour under patronage of HRH Princess Alice. Established himself as freelance photographer with premises in Ealing, London. During First World War enlisted in Artists' Rifles but was not sent overseas. Worked for Department of Information as 'official photographer for Great Britain', 1917–18. On staff of Imperial War Museum at Crystal Palace as a photographic expert in charge of darkroom and war-negative records, 1919–32; worked concurrently as a freelance photographer. Photographs published in national daily newspapers and in *Tatler, Bystander, Illustrated London News, Sporting and Dramatic,* etc. Special subject: photo-journalism. Cameras: during Boer War, 'N & G'; Nidia, half-plate box camera with Zeiss Tessar lenses; Newman; Baby Sybil during the 1920s; Leica 35 mm during the 1930s. Film: Wistona. Collections: Royal Photographic Society, London; Imperial War Museum, London. Book: *Uitlanders and Colonists Who Fought for the Flag 1899–1900,* privately published, 1902.

Horace Walter Nicholls, a name unfamiliar to even the cognoscenti of photo-history, yet one of Britain's most remarkable photographers. He will be remembered for two enduring bodies of work: depicting the Edwardians at their seasonal sporting events and capturing the image of British women the moment in history that they walked out of the home and into the workplace.

Nicholls was a full-time freelance photo-journalist. During his lifetime he concentrated on diverse themes. When he was in South Africa he took photographs of black diamond-miners stripped naked and subjected to humiliating searches for loot. In England he was fascinated by the middle- and upper-class Edwardians at leisure in their splendid attire. His charming,

witty and subtle portraits at Henley, Derby Day and Ascot combine to make one of the great photographic essays of all time. Dress, stance, food and drink, expression, textures and idiosyncrasies were all important in Nicholls's documentation. His social consciousness required him to portray the relationship between the working-class people and the gipsies present at these events with those who were able to 'over-indulge'. Often he could not capture the contrasts on one negative. For Nicholls this meant employing a pair ot scissors. He would cut up his prints and paste image upon image in order to make the statement *he* felt was closest to the reality he saw. (We must remember he was using glass plates with slow emulsions and a camera without interchangeable lenses.)

Historic events in Johannesburg in 1896 turned Nicholls into a photo-journalist. The Boer War made his reputation.

If his coverage of the Boer War was unusual, his documentation of the First World War was unique. Having enlisted in the army, he was refused permission to be sent on overseas duty and was transferred to the Department of Information in August 1917. As a photographer on the home front, he showed vividly how a country functions during wartime. He made a beautiful set of photographs entitled *Women at War* which show women fulfilling the jobs held by their husbands, fathers and sons. They are wonderful portraits, simple and strong. His other photographs from this period show such scenes as children making clothing, a royal chef preparing 'patriotic' Christmas pudding, wounded soldiers in wheelchairs outside Oxford colleges, munitions workers, raid-shocked girls working in a laundry, emaciated British prisoners-of-war, and American troops passing through Winchester.

Nicholls's great talent lay in his ability to construct 'story-telling' images and his foresight in knowing the historically significant. His photographs combine atmosphere and information: they are among the finest visual documents of his time and place. He was a sociologist, historian and artist and should be remembered as such. GB

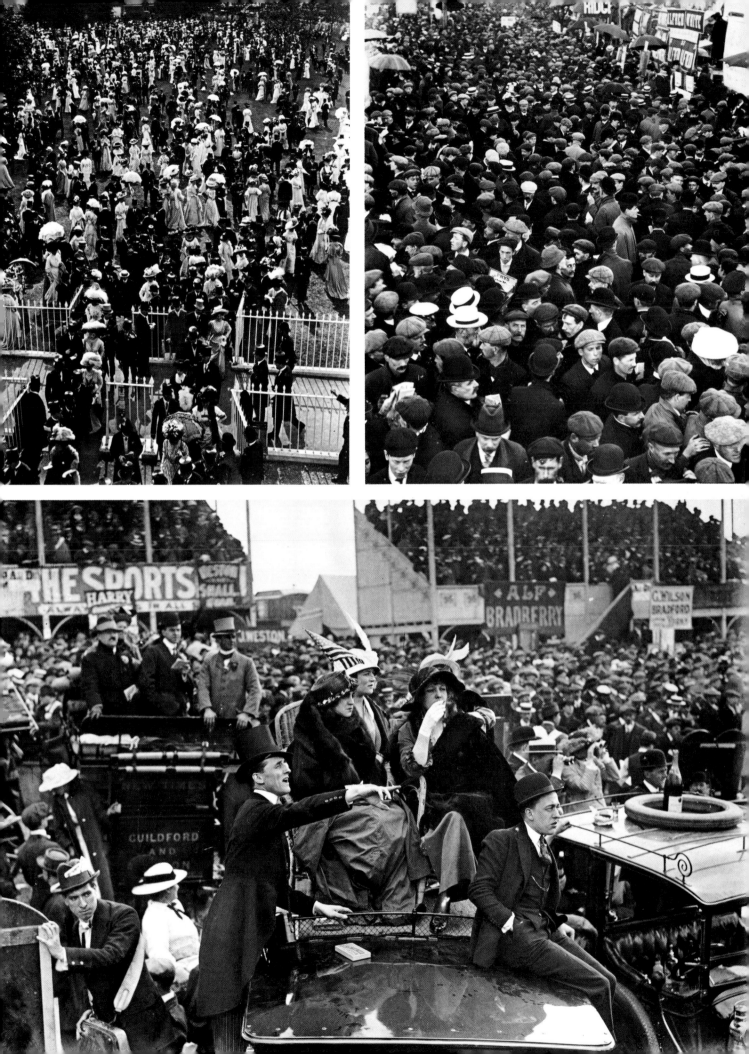

Opposite, top A reproduction of the *diaphanie* first shown by L. Ducos du Hauron on 7 May 1869.
Bottom A heliochrome by L. Ducos du Hauron, 1879.
Pages 130–31 Jacques-Henri Lartigue, *Bibi in the New Restaurant of Eden Roc, Cap d'Antibes,* 1920.
Page 132 Erwin Blumenfeld, Untitled photograph.
Page 133 Roman Vishniac, *Protein.*
Page 134 George Silk, *Riding the Wild Waves, Sunset Beach.*
Page 135 Lennart Nilsson, *Eighteen-Week-Old Embryo.*
Page 136 David Buckland, Untitled photograph, *c.* 1973.

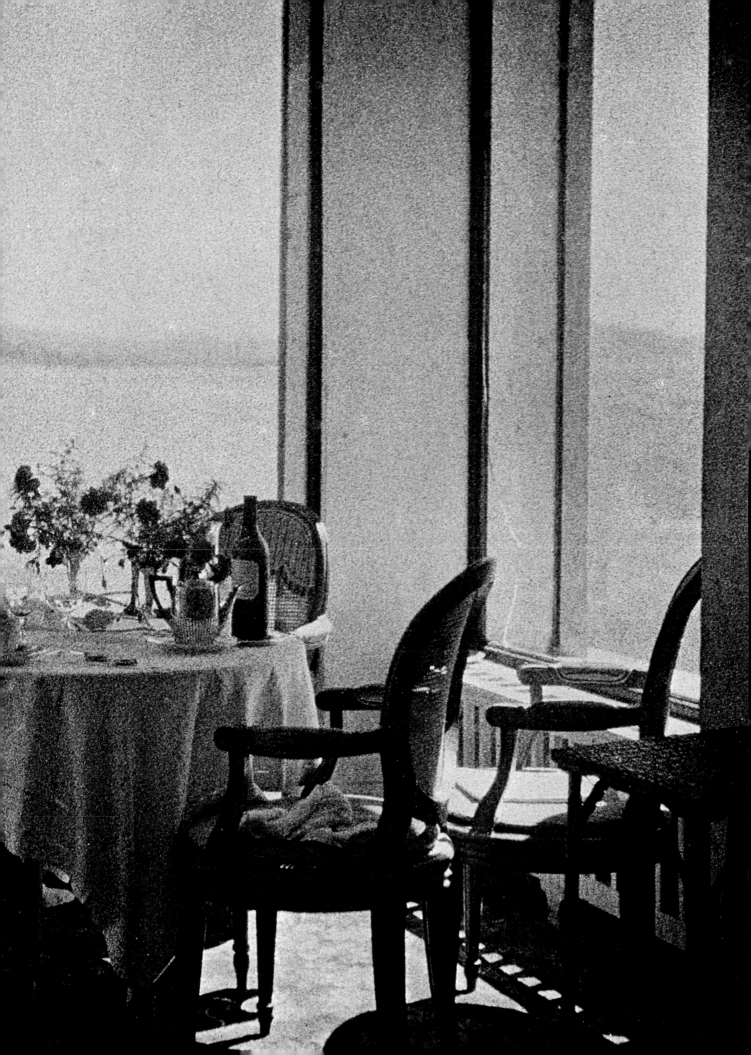

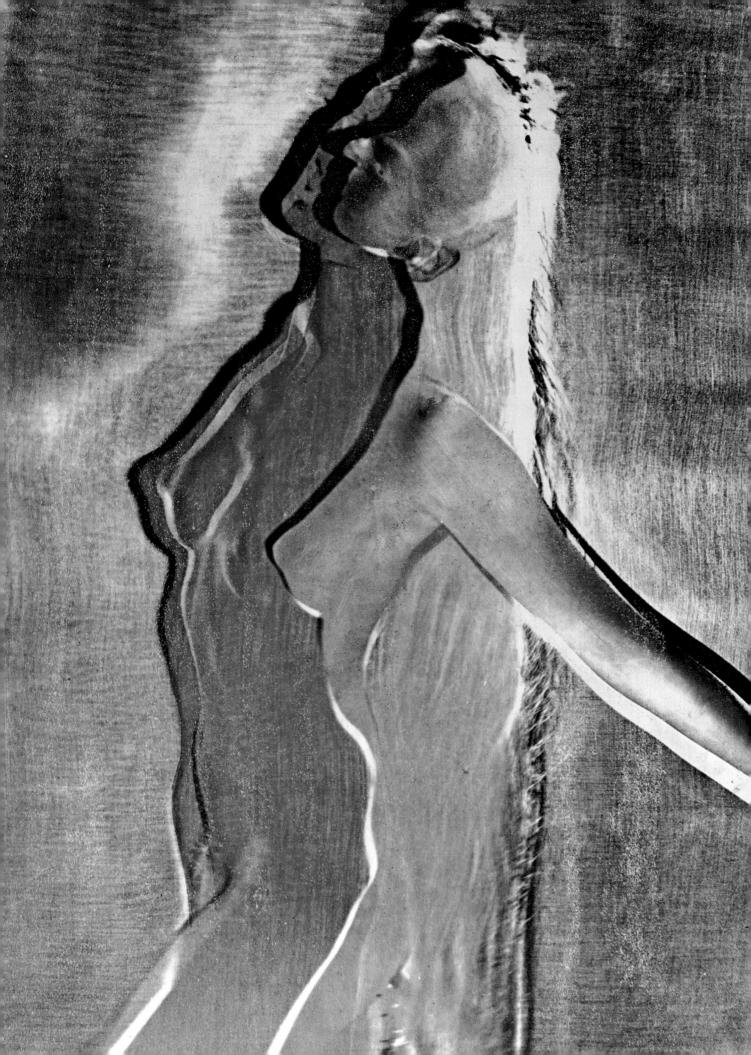

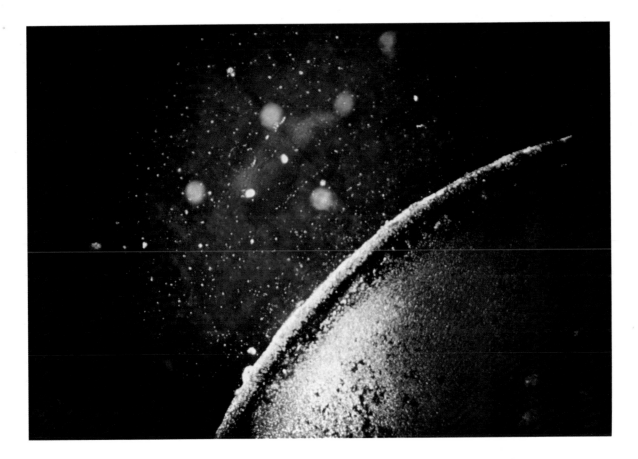

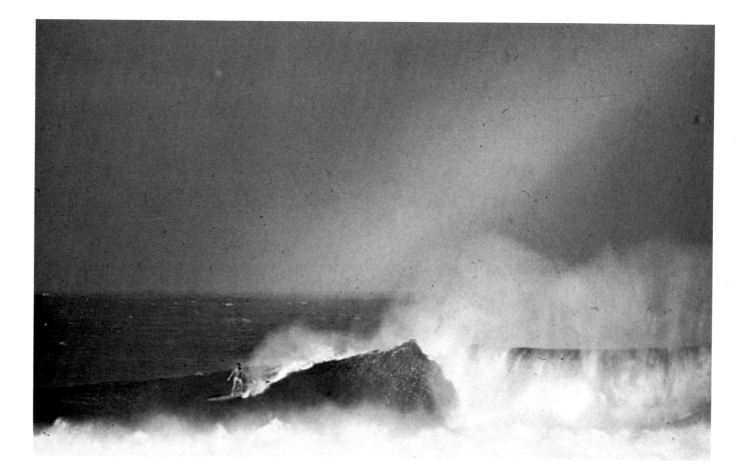

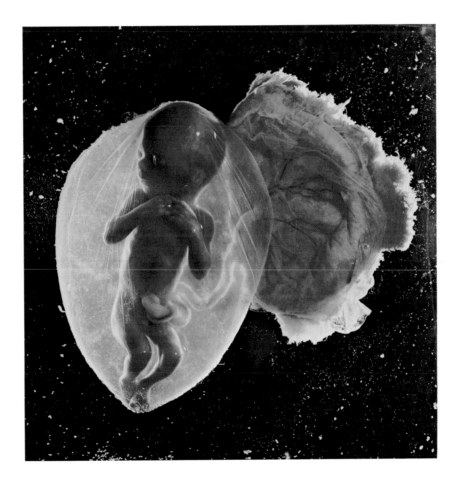

Page 128 Louis Ducos du Hauron (see page 302).

Pages 130–1 Jacques-Henri Lartigue (see page 116).

Page 132 Erwin Blumenfeld (see page 159).

Page 133 Roman Vishniac (see page 164).

Page 134 George Silk (see page 256).

Page 135 Lennart Nilsson (see page 210).

Page 136 David Buckland (b. 1949).

Page 217 Larry Burrows (see page 216).

Page 118–9 Georg Gerster (see page 225).

Page 221 Ernst Haas (see page 249).

Pages 222–3 André Martin (b. 1928).
Born in Normandy, France. First began working as a cinematographer but soon turned to freelance still photography. After travelling through Africa, Asia and Europe, illustrated books on Indonesia, Sicily, Southern Italy and Andalusia. In 1960 began a collaboration with Delpire for publicity and book illustration.

Emil Otto Hoppé

1878–1972

E. O. Hoppé, *John Lavery R.A. and his Wife Hazel, c.* 1926.

Born in Munich. Educated in Paris and Vienna; first profession, banking. Learned photography in London; studios in southwest London, Baker Street, and South Kensington. A founder member of The London Salon of Photography. Official British representative with Sir Benjamin Stone to the International Exhibition at Dresden, 1909. First one-man show, Goupil Galleries, London (introduction to catalogue written by John Galsworthy). Held exhibitions in his studio of the work of stage designers, artists, etc. Special subjects: portraiture, landscape, and illustrating poems and short stories with photographs. Collections: Mansell Collection, London; Kodak Museum, England; Royal Photographic Society. Books: *Taken from Life* with John D. Beresford, 1922; *The Book of Fair Women* with R. King, 1922; *In Gipsy Camp and Royal Palace: Wanderings in Rumania*, 1924; *London Types Taken from Life* by William P. Ridge, 1926; *Picturesque Great Britain: The Architecture and the Landscape*, 1927; *The Fifth Continent*, 1931; *Round the World with a Camera*, 1934; *The Image of London*, 1935; *Camera on Victorian London*, 1936; *The London of George VI*, 1937; *Hundred Thousand Exposures – The Success of a Photographer*, 1945.

It is hard to imagine what a delightful impression the photographs of E. O. Hoppé made fifty years ago. At that time a commercial London photographer could hardly be credited with artistic tastes; Hoppé was unique in that his work showed him to be a man of rarefied politeness, of cultured background and a collector of distinction. If he allowed any props to appear in his compositions they were always in a restrained taste yet of dramatic value, and his prints had a unique richness of tone and velvety softness of texture.

Hoppé created an aura of exclusive aestheticism around himself; he did not encourage 'anybody' to be photographed by him. If some rather grand woman came to his studio she had to obey him: she could not demur if he wished to transform her into a Portia or Guinevere, or to ask her to be photographed opening a jewelled casket, or fondling a jade figurine.

Using a reflex camera (which was independent of a black cloth, but had the minor disadvantage of emitting an alarming click each time a plate dropped for the exposure) Hoppé demonstrated that it was possible to take 'camera portraits' without ruffling his hair.

Hoppé's aim was not so much to strike an effect as to give a truthful rendering of his subjects, and his chief interest was to watch the unconscious resistance of his sitter being broken down. The 'thawing process' was his greatest enthusiasm.

The Ladies Lavery and Oxford and the Baroness d'Erlanger were among Hoppé's most enthusiastic artistic supporters, and they acted as 'whippers-in' of interesting figures from the 'half-worlds' of society and the intelligentsia.

Hoppé could be sadistic: occasionally he permitted his illustrious victims a quick look at the one definitive proof resulting from the long sitting. Even the dancer Pavlova, known for being difficult, found her tears and screams were in vain when Hoppé refused to show her the proofs. 'If I do not like your pictures how could they be good?' Pavlova eventually agreed it would only upset her even more were she to see herself not looking at her best. Thereupon she agreed to sit again, and did so many times, though often in very ugly hats.

Looking at Hoppé's photographs of the leading beauties of the First World War one wonders how it was that they created so great a stir. But one forgets that any slight deviation from the conventional caused a storm. For a well-known society beauty merely to raise her chin just that little bit higher, to elongate her neck, or to lift her arms to a brass tray behind her head, was sensational. Any handsome woman with a scarf wound straight across her bosom, and wearing an oriental headdress like a lampshade that Hanover Square decreed must fall to the tip of the sitter's nose, would feel convinced that if she merely turned her head *en profil,* with her hands in a stiff 'Egyptian' pose, she was the reincarnation of Cleopatra. Hoppé's restrained taste rose above such makeshift travesties.

Hoppé's black-and-white Beardsley-ish drawings sometimes appeared in magazines in the same issues as his photographs, a testimony to his industriousness.

Hoppé was quite a traveller and took photographs wherever he went. Some of them today appear trite and banal, and show little more personality than those of clever amateurs. But those of a West African tailor's store, of giant engines in factories, coiled ropes on a boat, awnings in rows, New York's Grand Central Station, and the inevitable Brooklyn Bridge are striking even today.

Although over-retouched (according to our present day tastes), many of Hoppé's portraits remain valid. Outstanding are the severe Victorian landlady Alice Meynell, that formidable character Dame Ethel Smythe, Bernard Shaw (of course), sensitive and appealing Thomas Hardy, and Jacob Epstein.

Arnold Genthe

1869–1942

Born in Berlin; US citizen. Attended the universities of Berlin and Jena, where he received his doctorate in 1894. A highly qualified philologist, had mastered eight ancient and modern languages before coming to San Francisco in 1895 as a tutor for some young German counts. Worked as a professional portrait photographer in San Francisco until 1911; moved to New York City. Always interested in colour photography; his autochromes of celebrities were the first to be published in an American magazine. Collection: California Palace of the Legion of Honor, San Francisco. Books: *Deutsches Slang; De Lucani Codice Erlangensi; Letters of Hegel to Goethe; Rebellion in Photography; Old Chinatown; The Book of the Dance; Japanese Prints; Impressions of Old New Orleans; As I Remember,* 1939.

In the San Francisco earthquake Genthe lost all his possessions, but was fortunate enough to borrow a camera, and he took three extraordinary photographs of the burning city. One of these is of abiding quality; it will be represented in every important collection.

Genthe conscientiously took his camera wherever he went. He travelled a great deal in Germany, where his compositions looking across the Rhine from Cologne are cloudy and beautiful. His landscapes in South America (particularly those taken around the volcano in Antigua), the inland sea of Japan, and the wall in Kyoto and other scenes pre-dating the age of chromium and plastic, have now acquired a nostalgia that fills us with charmed wonderment.

A delightful grey-white-haired, guttural gentleman with a cold in the nose and a protruding lower lip, Genthe was the personification of the 'artistic portraitist'. His lens was aimed at many renowned people of his day: John Galsworthy, John Barrymore, Toscanini, Gerhardt Hauptman, Paderewski, Mary Pickford, A. W. Mellon and President Woodrow Wilson. Many of these studies are only interesting as period-pieces, but immutable are his profiles of Duse and Garbo. Genthe was fortunate to catch the young Garbo, with her swan-neck thrust back, on her way to her fate in Hollywood. Genthe's lighting and studio facilities were inadequate for action pictures, but he was interested in all forms of the dance, and somehow contrived to take some beautiful groups of classical dancers. Isadora Duncan was one of his favourite subjects, and he succeeded in bringing about what he described as 'a miracle' when he pinned Pavlova in movement. This picture is a true evocation of her spirit.

His book, *As I Remember* (1939), gives his lifetime's work. His so-called 'modern torso' and Isadora Duncan dancers are excellent of their sort, though *The Book of the Dance*, illustrated with *andante, allegro,* and *allegretto,* is sadly out of context today.

Arnold Genthe, *Above, left Eleonara Duse.* Right *Greta Garbo,* 1925.

August Sander

1876–1964

Born in Herdorf-an-der-Sieg, Germany. Began career as a miner; first contact with photography at age of sixteen. Devoted all his free time to photography until 1896 when he left the mine to do military service. While in the army received encouragement from a local photographer in Trier. Spent some time at Academy of Painting, Dresden, before setting up a studio with a partner in Linz, 1902. Started making colour photographs, c. 1904. Studio in Cologne, 1910–14; considered to be one of Germany's finest photographers. Economic recession during First World War forced him to become an itinerant photographer; began project to portray the German people in their entirety. Progress was slow due to hounding by the Gestapo (Sander a committed Social Democrat, son a communist). First camera: 13 × 18 cm with Aplanat lens (smallest plate camera available). Awards include: honorary member, DGPh (German Photographic Society), 1958; DGPh Cultural Award, 1961. Major collections: Cologne Museum; Photogalerie Wilde, Cologne; family. Major exhibitions: 'People of the Twentieth Century', Cologne, 1927. Photokina, Cologne, 1951; 'August Sander – Personalities of his Time', DGPh House, 1959; Museum of Modern Art, New York, 1969. Books: *Face of Our Time*, 1936; *German Country, German People*, 1936 and 1939; *August Sander, Photographer Extraordinary*, with biography by Gunther Sander, 1973.

At sixteen years old August Sander started taking photographs of his family, and later of his fellow conscripts in Kaiser Wilhelm's army. With the defeat of Germany he turned his camera-eye on to the faces of average people – a nun, a street-cleaner, a clerk. Sander not only created a likeness, but with an uncanny penetration he captured the underlying character of his subject.

At first glance Sander's gallery may strike us with its naïve gaucherie, but the stiff manner in which he shows the butcher, baker and candlestick-maker, usually in the doorways of their lairs or against a plain grey wall by a window, is without pretention or artifice. By degrees Sander casts a spell.

Sander was as remote from current tendencies and fashionable trends as anyone working in Germany between the two wars. If he photographed the blind children, the unemployed, cretins and cripples, it was with a gentleness and benign sympathy – unlike Diane Arbus, whose work was doubtless influenced by him. Penn was taught by Sander, and many young photographers of the 1960s have been more in his shade than they are aware.

Sander had the intention of publishing what he called 'People of the Twentieth Century' in a consecutive series of forty-five portfolios, but, although there was no possible reason for considering them 'anti-social' the Nazis confiscated those books that had appeared and destroyed all the blocks. Fortunately, Sander had managed to preserve his negatives and we are richer for extraordinary, often horrendous, portraits of Cologne personalities: particularly unlovable in his aggression is the *Student Teacher* with his high boots and dangerous dog, and the drunkenness of the fancy-dress ball at the *Artists' Carnival*. His intellectual young ladies of Berlin before the First World War are as essentially of their epoch as a Modigliani portrait: the Eton-cropped wife of the painter, Peter Abalen, stands with knees inward and slightly bent, with toes turned in, in the favourite attitude of Nijinsky or Adolf Bolm, and the tenor, Leonardo Aramesco, places his beautiful hands with arched wrists in the manner of the early Greta Garbo on her way to Hollywood.

When the war was over, Sander, having experienced the savagery of the SS guards, felt himself too old to meet his own demanding standards. Although he took likenesses of the odd-looking personages in the small town of Westerwald, he gave up portraiture and took to romantic but odd landscapes. Through the pictures of convoluted woods he demonstrated the torture of his own mind.

Doris Ulmann

1884–1934

Born in New York City. Attended School of Ethical Culture and Columbia University. Studied photography with Clarence H. White. When photographing in Appalachian Region she travelled with John Jacob Niles, discoverer of mountain folk-ballad. Cameras: 8 × 10 inch and $6\frac{1}{2} \times 8\frac{1}{2}$ inch (glass) plate camera without shutters. Collections: Berea College, Kentucky; University of Oregon Library; John Jacob Niles. Books include: *Portraits of the Medical Faculty of the Johns Hopkins University*, 1922; *A Portrait Gallery of American Editors*, 1925; *The Appalachian Photographs of Doris Ulmann* with an introduction by John Jacob Niles, 1971.

When admiring the strong, straightforward photographs of the uneducated poorest white people in the deep south of the United States in the late 1920s and early 1930s, it must come as a surprise that they were the work of a very frail, but wealthy lady. Doris Ulmann was immaculate in white dresses that were sent to the laundry each day even when she photographed the share-croppers and other who worked with their hands for a meagre living in the backwoods of Kentucky.

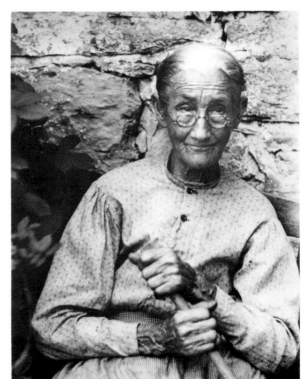

Doris Ulma
Unidentifie
sitter.

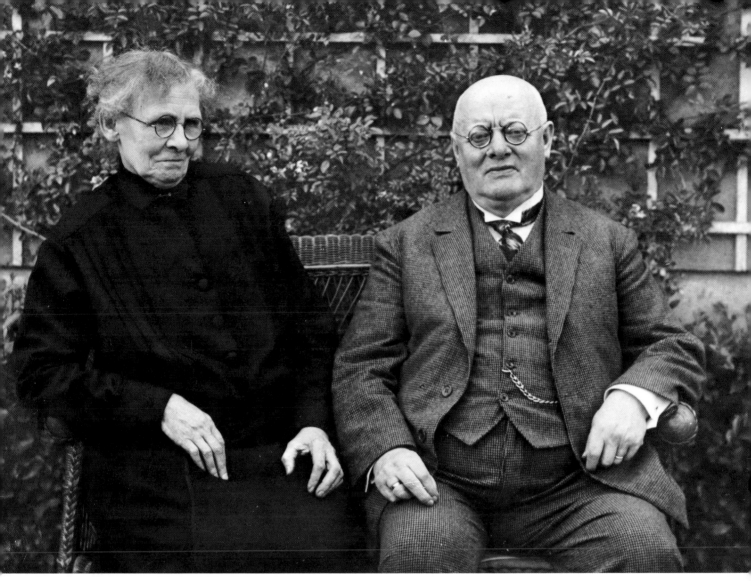

August Sander, *Smalltown Man and Wife* (the parents of the writer Ludwig Mathar), 1928.

Doris Ulmann was a distinguished type of American: aristocratic, autocratic, sensible. She was well educated, widely travelled, and could speak German, French and Italian. She had no patience with pretence and stupidity, but admired native intelligence and people to whom she referred as 'genuine'. Living with the utmost refinement in an apartment at 1000 Park Avenue in New York, she was cared for by a bevy of servants.

Doris Ulmann despised the use of simple snapshot photography. The elaborate preparations of setting up her equipment added to the difficulties of her undertaking. Jonathan Williams quoted her in the preface to *The Appalachian Photographs of Doris Ulmann*: 'They all want to go and dress up. It is not an easy task to induce a farmer's wife to have her picture taken in her kitchen peeling potatoes.' Her intention was to show the character differences in the lined and ravaged faces of the maker of dolls, the loggers and the moonshiners. Sometimes her camera seems to dominate the sitter as he stands in the doorway of his shack, while she succeeds in overcoming

the selfconsciousness of others – the old wood-carver, basket-weaver, or aged crone – as they look into the lens direct, detached and without apologies. Most of Miss Ulmann's models have strong, good, well based faces. Often their hands are gnarled, but they are bold and forceful. Doris Ulmann was fascinated by the way these people lived. She made no concession to them nor did they to her. Wearing fashionable hats, and always in gloves, she stalked her prey in a 1920s slouch. She found some marvellous faces: an unknown preacher with his Bible in a box, a fiddler and a fireman, and she presented them just as she found them.

When on her travels she would take two adjoining hotel rooms, one for sleeping and the other as a darkroom. Here she worked meticulously in every technical aspect of her work, for she did not trust others to do her developing, and she always mixed her own chemicals.

In New York she photographed doctors, lawyers, judges, scientists and musicians. She admired these people for having experienced so much and lived so intensely.

Alexander Rodchenko

1891–1956

Alexander Rodchenko, Untitled photograph, 1930.

Born in St Petersburg. Family moved to Kazan, 1902; entered Kazan School of Art, 1910. Spent short time at Stroganov School of Art, Moscow, 1914. After February revolution, 1917, made Director of Museum Bureau and Purchasing Fund by Bolshevik Government, 1918. Joined 'Inkhuk', Institute of Artistic Culture, 1920. Taught at Stroganov School of Applied Art, renamed Higher Technical-Artistic Studios (Vkhutemas), 1920–30. Designed and did layout for Mayakovsky's poetry during post-Revolutionary period. First printed photomontage illustrated Mayakovsky's anthology of poems *About This*, 1923. During 1920s designer for documentary and propaganda films; said to have 'given up painting', 1921. Worked closely with Mayakovsky on *Lef*, organ of Constructivist artists, 1923–5; and then under new title of *Novii Lef*, 1927–8. His creative photographs, many employing typical Constructivist low-angle shot, published regularly in *Lef* in 1920s; in *USSR in Construction* in 1930s. Photo-essays include 'Red Army Manoeuvres', 'The First of May in Moscow', 'Street Traditions', 'Shatura Power Station', 'Baltic Sea Canal'. Gave up photo-reportage, 1942. Camera: Leica with one lens in 1930s. Major exhibitions: Paris International Exhibition of Decorative Art, 1925; Cinema Posters, Moscow, 1926; Theatrical Art, New York, 1926; public photographic exhibition by ODKS, Society of Friends of Soviet Cinema, 1927; 'Ten Years of Soviet Photographers', Russia, 1928; international photographic exhibitions, 1928, 1929. Book: *Towards Model Social Provision of Necessities* (with photographs and photomontages), 1931.

Hans Finsler

1891–1972

Born in Zürich. Studied architecture in Munich; became acquainted with modern art under the influence of Fritz Burger. During First World War studied art history; gained insight into perception and analysis of pictures from Heinrich Wölfflin. Appointed librarian and art history teacher, School of Arts and Crafts, Burg Giebichenstein, Halle, Germany, 1922. Never studied photography yet taught it. Created a school of photography in Zürich; his pupils included Bischof, Schulthess, Staub, Burri. President of Swiss Werkbund for many years; involved with problems relating to environment and design. Special subject: 'object' photography. Major exhibitions: Germand Werkbund, 1927; Balerie 58, Rapperswil, Switzerland, 1969; IBM Gallery, New York, 1970. Publications include: *foto-auge* (*photo-eye*) by Franz Roh and Jan Tschichold, 1929; *Du*, March 1964; *30 Aufnahmen aus den zwanziger Jahren* (*30 Photographs from the twenties*), 1970; *My Way to Photography*, 1971.

Hans Finsler was the purest of photographers. He made his statements with the most direct basic means. He was essentially a philosopher who already in the 1920s was a pioneer of photographic psychology. He built his theories of stillness and motion on the effect of high light and shadow by photographing the simplest shapes such as an egg, and contrasting, with amazing drama, his negative with the positive print.

Finsler's book, *My Way to Photography*, is filled with elementary forms such as an arrangement of studio lights which appear as abstract shapes; an electric light bulb and its shadow, eggs and portions of eggs (Finsler considered detail to be part of the very essence of photography) and of porcelain bowls. He also took straight shots of what he called 'existing objects' – the hull of a ship or its screw, the ventilators of the *Bremen*, and the 'structures' of an outgoing tide with its naturally formed chiselled banks of sand. Finsler made many landscape experiments with the bridge as being symptomatic of man conquering nature, and he also pointed out the destruction of nature by man – using as an example the Browncoal mines. He made something unusual of a wharf at night.

Finsler wrote: 'The laws of things that can be made visible in photography are combined in a photograph with the laws of photography.

'Photography can bring into existence secondary, unimportant and non-visible objects, as well as those objects which are considered worthy of being photographed.

'We orient ourselves by eyesight which, unlike the photograph, is bound to time and space, to the 'here and now', which is always connected with a personal relationship. For us, it is the objective picture of the world whose objects we ourselves are. The photograph is an image, that is, an exemplification, unreal and deliberate. It not only differs from our optical impression in its origin but can also be manipulated, made unreal and alien.'

Francis Bruguière

1879–1945

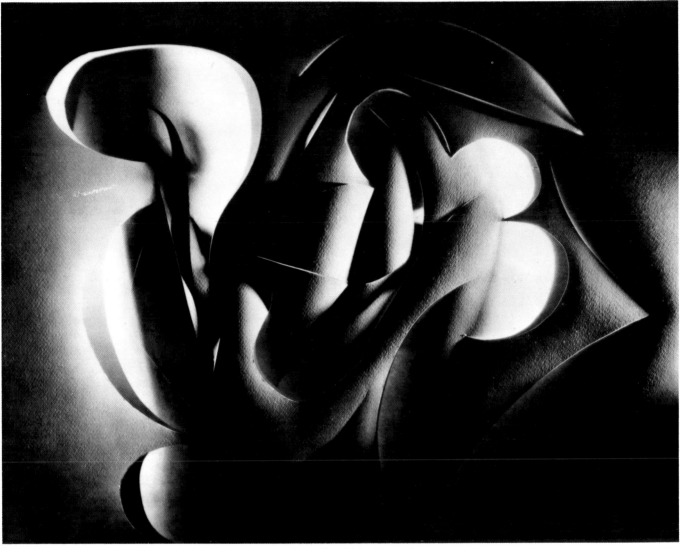

Francis Bruguière, *Light Abstraction.*

Born in San Francisco. Studied painting in Europe. Went to New York, 1905; met Alfred Stieglitz at '291' and became member of Photo-Secession. Studied photography under Frank Eugene. To San Francisco, early 1900s; returned to New York and opened studio, 1919. Became well known for photographs of Theatre Guild Productions using stage lighting. Worked with Lee Simonson and Robert Edmund Jones on stage settings requiring special lighting effects. Worked in collaboration with Norman Bel Geddes on his book of stage design for Dante's *Divine Comedy* (foreword by Max Reinhardt), 1924. Produced and photographed the film *The Way* with Rosalinde Fuller and Sebastian Droste, 1925. Began light abstractions, 1926. Made film *Light Rhythms* in collaboration with Oswell Blakeston, 1930. Did multiple exposures of skyscrapers in New York while writing a 'Pseudomorphic Film' of his impressions of Manhattan during the Depression and Prohibition for publication in *Close-Up*, 1930. Produced photographic murals for British pavilion at Paris Exhibition, 1937. Concentrated on painting and sculpture until his death. Special subject: light abstractions. Exhibitions: 'International Exhibition of Pictorial Photography', Albright Art Gallery, Buffalo, New York, 1910; Art Center, New York, 1927; Der Sturm Galleries, Berlin, 1928; 'Film und Foto', Deutsche Werkbund, Stuttgart, 1929; Focal Press of London memorial exhibition, 1949; 'A Quest for Light', International Museum of Photography, Rochester, New York, 1959. Collections: International Museum of Photography, Rochester. Books: *San Francisco*, 1918; *Photographs and Paintings by Francis Bruguière* (catalogue), 1927; *Beyond This Point* by Lance Sieveking, 1929; *Few Are Chosen* by Oswell Blakeston, 1932.

Bruguière, a quiet, reserved man with flames of white hair and a codfish mouth, was a celebrity in the Bloomsbury world of London in the 1920s. Always somewhat mysterious, he was a very private face in a private room. He enjoyed the encouragement given to his photographic experiments. As early as 1912 Bruguière was making deliberate experiments in abstract photography and was probably the first to do so. He hung scrolls or curved sheets of paper and photographed them in one dramatic lamp; the result was pure abstraction. Bruguière also placed oddly assorted objects on to sensitized paper, somewhat in the manner of Fox Talbot.

The photographs that Bruguière took of people he admired looked like 'stills' for some *avant-garde* German film. Having caked his sitter in clown-like make-up, he would then excavate the pores, crevices and cracks of the physiognomy that cruelly could be seen through the crust of the mask.

143

Man Ray

1890–1976

Born in Philadelphia, Pennsylvania. Studied architectural drawing and engineering in high school; attended Academy of Art, New York, 1908–12. First jobs in layout, lettering, typography; drew and painted in free time. Member of proto-Dada group in New York, 1920. Moved to Paris and made first 'rayogram', 1921; worked as a professional fashion and portrait photographer. Made contribution to Surrealism with films *Emak-Bakia* and *Etoile de Mer* and with creative solarizations and darkroom experiments, 1926–9. Lived in Hollywood and did fashion photography, painting, teaching and lecturing, 1940–50. Returned to Paris, 1950; concentrated on painting and personal photography. Methods used: solarization, granulation, photogram, relief, negative print, distortion, blurred design. Awards: gold medal, Foto Bienniale, Venice, 1961; DGPh Cultural Award (German Photographic Society), 1966. Exhibitions: Galerie Daniel, New York, 1915; Photokina, Cologne, 1960; Bibliothèque Nationale, Paris, 1962. Books include: *Les champs délicieux*, 1922; *Man Ray* by G. Ribemonte-Dessaignes, 1924; *Revolving Doors, 1916–1917*, 1926; *La photographie n'est pas l'art,* 1937; *To Be Continued Unnoticed,* 1948; *Alphabet for Adults,* 1948; *Portraits*, 1963; *Self-Portrait*, 1963; *Man Ray: 12 Photographs 1921–1928*, 1963.

Man Ray is American. Like almost all American photographers of the last generation, he was inspired by Alfred Stieglitz. He became a frequent visitor at '291' during its revolutionary exhibitions of early twentieth-century artists and sources. Man Ray initially started using a camera to make copies of his paintings, but soon found photography offered him a greater range of creative possibilities. He became a member of the proto-Dada group which included Marcel Duchamp and Francis Picabia. He began working in collage and constructions.

In 1921 he went to Paris where he joined the Dada group, and had immediate success with his first exhibition of paintings, photographs and 'rayograms', and he showed a film, *Le Retour de la Raison,* hastily assembled overnight out of experimental clips and 'rayograms' of pins and drawing-pins.

Perhaps in the past I was not totally convinced that the lack of architectural solidity in Man Ray's photographs was compensated for by superficial aids, trick printing, elongation

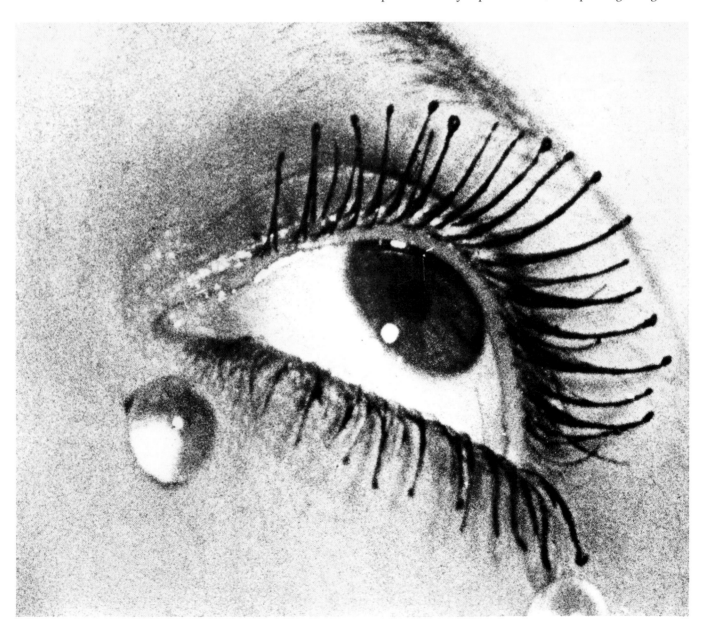

by special lenses or the 'solarization' of negatives. Today, looking back, his work has acquired a validity which I was not able to recognize. I see now that his pictures of the Paris of the 1930s – of Barbette, the female impersonator and trapeze artist, and of James Joyce – project a unique point of view. His young Braque, Matisse, Léger, Miro, Giacometti and Picasso are valuable documents, for it is mostly as venerated 'old masters' that they have become familiar. Many of Man Ray's surrealistic compositions – a plaster cast of Venus reflected in shaving mirrors, a naked lady unaccountably involved in a printing-machine with black oil on her arms, his nudes tangled in children's hoops, and the Art Deco interiors – are absurdly dated.

But successful in combating the subsequent changes in taste are his prints of the boyish, flaxen-shingled Lee Miller, his pupil, herself to become an excellent photographer; Kiki of Montmartre, naked but for a turban and *'le violin d'Ingres'* painted on her back; the nun from *The Miracle* portrayed by Lady Diana Manners and taken in collaboration with Curtis Moffat; a limpid aquamarine head of Max Ernst; a solarized Anna de Noailles; a swooning Marie-Laure; Nancy Cunard with her kohl-rimmed eyes and bracelets of African ivory; a self-portrait, seemingly printed on bark, like a head from a Greek sarcophagus; and his own mascara'd eye with tear-drops.

Man Ray is more than a photographer employing all available means, techniques and materials.
He wrote:
'I want to enjoy myself – my aims are both the pursuit of liberty and the pursuit of pleasure. And, like all young people, I have a strong revolutionary instinct in me. In whatever forms my work is finally presented, by a drawing, a painting, a photograph, or by the object itself in its original materials, it is designed to amuse, bewilder, annoy or to inspire reflections, but never to arouse admiration through any technical excellence usually sought for in works of art. The streets are full of admirable craftsmen, but so few practical dreamers.'

an Ray, *Eye with Tear,* 1934.

Herbert Bayer
1900–1985

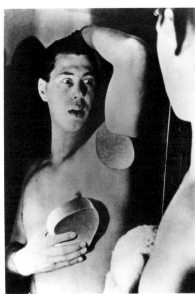

Herbert Bayer, *Self-portrait.*

Born in Haag, Austria. Military service, 1917–18. Apprentice in George Schmidthammer's studio for architecture and decorative arts, Linz, 1919. Assistant to architect Emanuel Margold, Darmstadt, Germany, 1920. Studied mural painting under Kandinsky at the Bauhaus, Weimar, 1921–3; created 'universal' alphabet. Earned living as a house-painter, 1923–4. Master at Bauhaus, Dessau; taught typography and graphic design, 1925–8. Active as a painter, photographer, graphic designer and exhibition architect, Berlin, 1928–38; director of Dorland Studio, Berlin; Art Director, *Vogue*, Berlin 1929–30. With Walter Gropius, László Moholy-Nagy, Marcel Breuer designed exhibition *'Deutscher Werkbund'*, Grand Palais, Paris, 1930. Exhibition designer, New York, 1938–46. Designed 'Bauhaus 1919–1928', Museum of Modern Art, New York, 1938 and 'Road to Victory', Museum of Modern Art, 1942; etc. Design consultant and, from 1956, chairman of Department of Design, Container Corporation of America, 1946–67. Designed exhibition '50 Years Bauhaus' which travelled to major centres in Europe, North and South America, Japan, 1967–71. Designed highway sculpture 'Articulated Wall' for Olympic Games, Mexico City, 1968. Special subject: photomontage. Cameras: Leica, Pentax, Contax D. Major exhibitions: Kunstverein, Salzburg, 1936; London Gallery, London, 1937; Yale University, New Haven, 1940; 'The Way Beyond Art', ten universities and museums in US, 1947–9; Kunstkabinett Klihm, Munich, 1954 and 1967; '33 Years of Herbert Bayer's Work', six museums in Europe, 1956–7; Städtische Kunsthalle, Düsseldorf, 1960; Andrew Morris Gallery, New York, 1963; Byron Gallery, New York, 1965; Marlborough New London Gallery, London, 1968; Marlborough Gallery, New York, 1971. Collections: Victoria and Albert Museum, London; Museum of Modern Art, New York. Books include: *Bauhaus 1919–1928*, editor with Ise and Walter Gropius, 1938; *World Geographic Atlas*, 1953; *The Way Beyond Art, The Work of Herbert Bayer* by Alexander Dorner, 1947; *Book of Drawings*, 1961; *Herbert Bayer – Painter, Designer, Architect*, 1967.

An Austrian student of painting, Bayer worked under Kandinsky in Vienna, later moving to the Bauhaus School at Dessau. He probably explored the uses of photography as a means of expression even more thoroughly than did John Heartfield. He is a personification of the tastes of the 1920s and 1930s, and his ingenious collages were much admired.

Today he lives in Colorado and is still working as a photographer, but also carries on the activities of architect, designer, painter and sculptor.

André Kertész

1894–1985

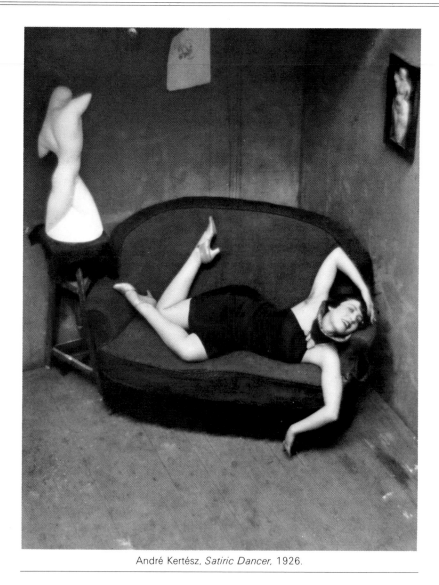

André Kertész, *Satiric Dancer*, 1926.

Born in Budapest; US citizen. Completed studies at Academy of Commerce and began work at Budapest Stock Exchange, 1912. During First World War served in army in Central Europe and Balkans. Started as a freelance photographer in Paris, 1925; worked for publications such as *Frankfurter Illustrierte, UHU, Berliner Illustrierte, Nazionale di Firenze, The Times, Vu, Art et Médecine*. Left for New York with one-year contract with Keystone Studios, 1936. Worked for American fashion magazines and journals of interior décor; contracted to Condé Nast Publications, 1949–62. Cameras: plate cameras and Leica. Exhibitions include: Sacre du Printemps Gallery, Paris, 1927; Julien Levy Gallery, New York, 1937; Art Institute of Chicago, 1946; Long Island University, 1962; Bibliothèque Nationale, Paris, 1963; Museum of Modern Art, New York, 1964; Photographers' Gallery, London, 1972. Books include: Jaboune, *Enfants*, 1933; Pierre Mac Orlan, *Paris vu par André Kertész*, 1933; Jaboune, *Nos amis les bêtes*, 1936; Pierre Hammp, *Les Cathédrales du vin*, 1937; *André Kertész: Sixty Years of Photography 1912–1972*, 1972.

André Kertész, born of a rich Hungarian banking family, refused to go in for finance and, much to the disapproval of his parents, became interested in photography. Early on he was committed for life to the medium to which he has given much wit and enjoyment.

Kertész responded sharply to the wandering minutiae in Hungarian streets. He was always awaiting the unfamiliar and, using different angles, presented odd compositions, often with the heads and feet of his subjects cut off. Looking from a high window, he saw the patterns of other windows below, of passers-by under vast Dubonnet advertisements, or arrows of the traffic signals making extraordinary, dramatic gestures.

Kertész had no pretentions about his contribution to photography, and those brilliant 'interiors' for which he was renowned, taken for the Condé Nast publications, are not among those he chose to put into his book, *André Kertész: Sixty Years of Photography*. His best pictures are probably of the 1914 war in Hungary, at which time he was shot through the heart but recovered.

Kertész has made interesting distortions of the nude body, but most typical of his unusual eye are his pictures illustrating the drama of a fallen horse, of a wooden statue of Thomas Jefferson lying on the floor in a museum with four bandy legs above it, *Broken Bench in a New York Park, The Disappearing Act,* and the three shorn *Sheep* which combine tenderness with amusement.

George Hoyningen-Huene

1900–68

Born in St Petersburg; US citizen. Father was Baron Barthold von Hoyningen-Huene, chief equerry to the Tsar; mother was an American, the daughter of the Honorable Van Ness Lothrop, Minister Plenipotentiary to the Court of Alexander III. During Russian Revolution fled to Sweden and later French Riviera. After fighting in counter-revolution, began working as a sketch artist in sister's dressmaking establishment. Studied with the Cubist painter André Lhote. Began work for *Vogue*, 1925; soon became its chief Paris photographer. Left Paris to work for *Harper's Bazaar*, New York, 1935. Came to Hollywood, 1946; taught photography at Art Center School. Colour-consultant to George Cukor on a long series of films. Special subjects: fashion, portraits, travel. Cameras: 8 × 10 inch studio, Rolleiflex (?). Exhibitions: Los Angeles County Museum of Art, 1970. Books: *Hellas*, 1943; *Egypt*, 1943; *Baalbek, Palmyra*.

Born a Baltic baron, Huene became essentially French in character, and it was in Paris in the 1930s that his photographs were received with such raptures.

Condé Nast employed Huene to work on *Vogue*. Nast was a gentleman who had very strong ideas about what was distinguished and what was 'beyond the pale'. He instituted rules about the photography he would ennoble in the pages of his magazines. He did not permit a large head – that was for movie 'stills'. He would not publish 'high-key' pictures: every block had to be meticulously sharp and technically perfect. He would not allow his staff the use of hand-held cameras. Although few photographs in colour were used, he wished to achieve a dark, rich Rembrandtesque effect of light and shadows. Huene, who became one of his greatest stars, used to do an hilarious imitation of Nast holding up a black-and-white print by his 'sun and moon', Steichen: 'Now what we want is colour. And this has colour. Rich colour!'

Influenced originally by Steichen, Huene used his master's spotlight schemes to achieve many an artificial fantasy: Huene enjoyed with a grand relish the current frivolities in fashion and decoration. He brought into play giant sculptured heads and hands, details from the Parthenon and Moorish fretwork. Huene's society beauty sitters often became an excuse for a riotous décor of baroque scrolls, pampas grass and Greek plaster casts. It is amazing how some of the more conventional ladies submitted to his varying enthusiasms, even allowing themselves to endure the humiliation of being disguised under a heavy make-up with the dark yellow complexion and black lips of Hollywood studios.

He was the first to photograph fashion models from above lying on the floor with their draperies arranged to look like flying figures on a frieze.

Another aspect of Huene's wit and irreverence was his ability to impersonate and to 'take the mickey' out of other photographers by making pictures in their idiom. One of his most successful essays was a spread in *Vanity Fair* of Natascha Paley, unrecognizable as the same person when photographed in the romantic manner of David Octavius Hill, the warts-and-all-reality of the German Lerski, solarized by Man Ray, or seen as one of the pretty-pretty, characterless ladies in artificial-flower grottoes of Beaton's early photographs. In 1940 he created pages of fashions taken in the style of de Meyer's sequin dazzle of the 1920s. When the situation demanded it, Huene, fundamentally a serious, even melancholy person, knew how to show the serious side of his sitters. He was particularly successful with Bourdelle, Pabst, Cocteau and Derain.

When Huene went to Hollywood to photograph a series of movie stars, life on the West Coast became a glorious revelation to him. Although he went to Spain to compile books on its architecture, he became obsessed by some misbegotten theory that, culturally, Europe was dead, and he gave up his own life-enhancing work to teach photography to Los Angeles students. In a cursory way, he continued to take photographs, but he wasted much time working on an unpublished book showing all the more boresome aspects of a film studio, including portraits of technicians and executives at their desks.

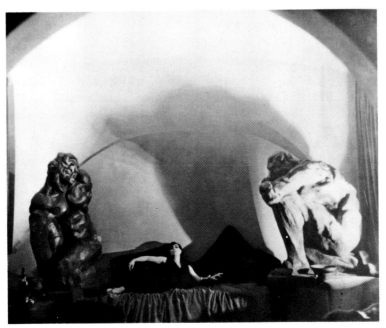

George Hoyningen-Huene,
*Marchesa Sommi
Picenardi*, 1933.

Curtis Moffat

1887–1949

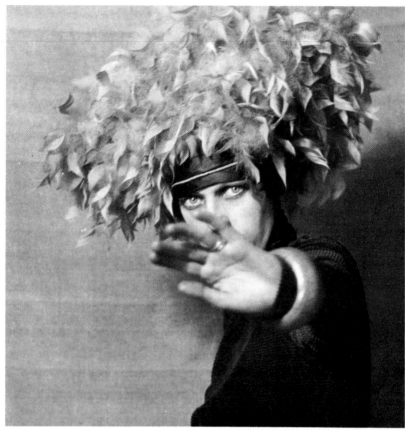

Curtis Moffat, Untitled photograph.

Born in New York. Became interested in photography at an early age; set up own darkroom at age of nine. Received early art training in New York, 1913–14; further training, Paris. After First World War entered professional photography in Paris; collaborated with Man Ray, 1923. Opened studio in London, 1925. Returned to New York to do portrait photography, 1927. During later life concerned with decorative and commercial arts. Speical subject: abstraction and colour. Exhibitions include: Bond Street Galleries, London, 1925; 'Curtis Moffat and Olivia Wyndham', Brook Street Galleries, London, 1926; Mayor Gallery, London and Chicago Camera Club, (colour photographs), 1935; Museum of Modern Art, New York, 1937; 'Photography 1839–1937', English touring exhibition, 1938.

A gentle, quiet, easy-going man with velvet eyes and enormous charm, Curtis Moffat was, in the early 1920s, the most Europeanized of Americans. He seemed to be only 'at home' in the quietness of his book-filled rooms where the talk, food and wine were always good. But appearances are deceptive; in fact, he was the centre of enormous creative artistic activity.

Not only did Curtis Moffat run an *avant-garde* picture gallery in collaboration with Freddy May, but he was a talented painter himself, mostly of still lifes done under the Braque–Chirico influence, and he filled the nobly proportioned rooms of a huge house, 4 Fitzroy Square, with his collections of Chinese objects and African sculpture.

Financed by the young Jock Whitney, he started an interior decorating firm, Curtis Moffat, Inc., designed tubular chairs, commissioned Wyndham Lewis to design door panels, and

brought McKnight Kauffer and Marian Down from America to design textiles and carpets.

Curtis Moffat had collaborated with Man Ray in Paris and made interesting Dada compositions by placing various objects on sensitized paper (under the influence of Picasso but in the manner of Wedgwood). His 'camera-less' photographs often made everyday objects into something mysterious. Then, on the top floor of 4 Fitzroy Square, Curtis Moffat started to take photographs on his own. He was an early adventurer into the realms of colour photography. Some of his abstractions and still-lifes are worthy to be reckoned with the best. When Curtis Moffat, in a gentle and delightfully casual manner, started to take portraits of his friends and publish the more celebrated of them in weekly magazines, it was a significant moment. The works that he had done with such apparent vagueness were sensationally original. Their influence was far-reaching.

His prints were made on low-key papers and were of a silvery grey fogginess. The cropped heads were monumental and were mounted on coloured or gold and silver papers and framed to become at least a yard in height. Among his compelling portraits were those of his first wife, Iris Tree, the shorn, corn-coloured hair, looking like a startled saint, the Sitwells, the young poet Aragon and his current love, Nancy Cunard, Phyllis de Janzé, Augustus John, Lady Diana Cooper and many other decorative people who, in the 1920s and 1930s, helped to make London a centre of creative excitement.

148

Brassai

1899–1984

Born in Brassov, Transylvania; French. Real name Gyula Halász. Studied painting at École des Beaux-Arts, Budapest and the Art Academy, Berlin. Journalist in Paris from 1924, turned to photography after a discussion with his friend André Kertész, *c*. 1929. During the Occupation, encouraged by Picasso, took up drawing again. Worked for *Harper's Bazaar*, 1945–65. Executed photographic décors for the ballet *Le Rendez-Vous* and for the play *En Passant*. Presently doing sculpture. Cameras: Leica, Voigtländer, Rolleiflex. Exhibitions include: 'Graffiti', 1956 and a retrospective, 1968, Museum of Modern Art, New York. Books include: *Paris de Nuit*, 1933; *Voluptés de Paris*, 1935; *Trente dessins*, 1946; *Les Sculptures de Picasso*, 1948; *Camera in Paris*, 1949; *Seville en fête*, 1954; *Graffiti*, 1960; *Brassai* (catalogue Bibliothèque Nationale), 1965; *Picasso and Company*, 1967; *Brassai* with an introduction by Lawrence Durrell, 1968.

Brassai was born in Hungary. He began life as an abstract painter and sculptor in Budapest and Berlin. His work showed brilliant promise and his draughtsmanship was likewise of a high calibre. Under the influence of his friend, André Kertész, Brassai took to photography late in life. He started as a photojournalist with a penchant for the night life of Paris, and showed a taste for the ambiguous, the strange and depraved. A photograph of two tough youths in caps, with broken noses and bright eyes and ready for anything, was named *Two Hoodlums* and became famous for its combination of excitement, sexuality and menace. Seen in what, today, appears somewhat selfconsciously dramatic lighting are Miró, Max Ernst, Braque and Man Ray. His early Picasso, sitting by the Brontosaurus stove, is likewise a milestone. Brassai never interested himself in making 'the print beautiful', but used routine 'glossies'. He said: 'I invent nothing, I imagine everything.'
Brassai has written:
'The photographer has respect for his subject, amounting almost to religious veneration; keenness of powers of observation; patience and hawk-like speed in swooping on his pray; impulsiveness; preference for the human race and indifference to mere faces of reality; spurning of colour and the enjoyment derived from the restraint and sobriety of black upon white; and, finally, desire to get beyond the anecdotal and to promote subjects to the dignity of types.'

Although Brassai's photographs appear somewhat less startling with the years, his work has not become dated. In fact, this little man with the humorous twinkle and crushed-up, grey, crustacean face, whom Henry Miller once called the 'eye of Paris', was, in a way, an inventor of the 1920s.

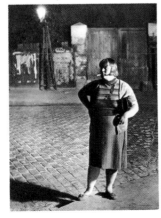

Brassai *La belle de nuit*, 1933.

Berenice Abbott

b. 1898

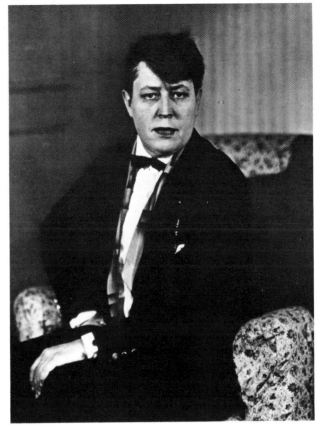

Berenice Abbott, *Jane Heap*.

Born in Ohio. Originally a sculptor, studied in Berlin and in Paris with Bourdelle and Brancusi. Became an assistant to Man Ray in 1923 and later opened her own Paris studio. Devoted much energy to saving the photographs of Eugène Atget after his death, and bringing them to world attention. Photographed New York City in the 1930s under the auspices of the Federal Art Project. Devoted to scientific and experimental photography from the 1940s onwards. Major exhibitions: 'Portraits photographiques', Paris, 1926; 'Photographs of New York City', 1934–5, and 'Changing New York', 1937, at Museum of the City of New York; Art Institute of Chicago, 1951; 'Science Photographs' at Smithsonian Institution, Washington, DC and circulated, 1960; Museum of Modern Art, New York, 1970. Books include: *Changing New York* by Elizabeth McCausland, 1939; *A Guide to Better Photography*, 1941; *Magnet* by E. G. Valens, 1964; *Motion* by E. G. Valens, 1965; *A Portrait of Maine* by Chenoweth Hall, 1968; *The Attractive Universe* by E. G. Valens, 1969.

Born in Ohio, she emigrated early on to France where she became a pupil of Man Ray. Her straightforward renderings of other expatriates are her most lasting contribution. Of the Paris celebrities she photographed between 1923 and 1925, Fougita, Cocteau, Djuna Barnes and Atget are among her best. She has left an interesting collection of those on the fringes of art and society in this most productive but nevertheless often decried period.

Her New York and Brooklyn shots are less successful than her portraits, and it is interesting that she eliminated the human face wherever possible from her landscapes.

Rudolf Koppitz

1884–1936

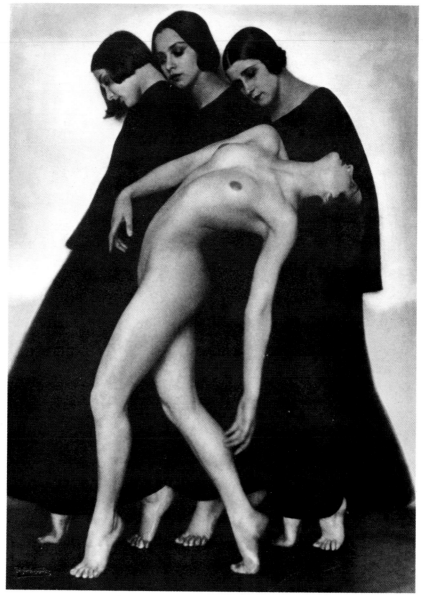

Rudolf Koppitz, *Movement Study*, 1926.

Austrian. A professor of photography, taught for twenty years at Graphischen Lehr- und Versuchsanstalt, Vienna. Worked in a simple studio with a north light; white curtains controlled daylight. Kitchen served as darkroom, wife did retouching on the back of his glass plates. A greatly respected photographer, taught private students at his home. A frequent international exhibitor, photographs used as book-illustrations and as postcards. Special subjects: landscapes, portraits, country life. Cameras: whole-plate for portraits, Rolleiflex for landscapes. Processes: gum bichromate, bromoil and most especially bromoil transfer, all done on ivory paper. Collections include Royal Photographic Society, London. Book: *Rudolf Koppitz*, 1937.

At the time of his death, Austrians called Professor Rudolf Koppitz 'the Master of the Camera'. A brilliant worker in bromoil transfer, it is as an image-maker that his importance rests. His photographs from the 1920s and 1930s were fascinating in perspective and in the use of symbols. His images linger in one's mind because of their unfamiliarity. Koppitz fits into no category. At a time when much of pictorial photography was banal, Koppitz's images were psychologically provocative. He created illusions; he related equally to mythology and reality. He sought to stimulate the complacent viewer into a new way of seeing; he photographed oxen from below, peasants full-frame from the back, heads cropped at the most surprising (for his time) places. He manipulated his prints until he felt he had obtained the correct aesthetic balance. In his most famous photograph, *Bewegungsstudie*, showing four women, one naked and three draped in black, one foot is drawn in entirely by the hand of his wife. Koppitz's photographs were extremely popular in his time but it is ironic that now, when we are ready to probe for deeper meanings, the photographs of Professor Rudolf Koppitz are hardly ever seen. GB

150

František Drtikol

1883–1961

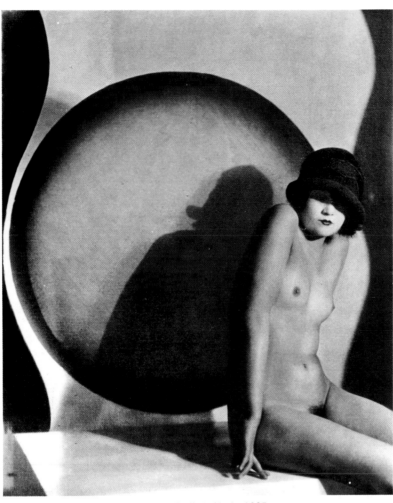

František Drtikol, *Nude*, 1925.

Born in Pribram, Czechoslovakia. Began career as an apprentice in a portrait studio in Pribram. Studied at Lehr- und Versuchsanstalt für Photographie (Teaching and Research Institute for Photography), Munich; student of G. H. Emmerich and Hans Spürl who taught Jugendstil, or Art Nouveau, 1901–3. Upon returning to Czechoslovakia, worked in several studios before doing military service. Afterwards sold prints through Prague Co-operative Artel and lectured to amateur and professional photographers. Ran his own studio in Prague; famous for portraits of writers and artists. Gave up photography entirely for painting, 1935. Special subject: the nude. Major exhibitions: Museum of Decorative Arts, Prague, 1972–3; Salone internazionale cine foto ottica, Milan, 1973; Photographers' Gallery and Royal Photographic Society, London, 1974. Collection: Museum of Decorative Arts, Prague. Books: *Prague Courts and Backyards*, with Augustin Skarda, 1911; *Les nus de Drtikol* edited by A. Calavas, 1929; *Zena na svetle* (*Women in Light*), 1940.

Drtikol lived and worked in Prague where he became one of the most revered of the 'misty-muzzy' photographers of the First World War period. He gave complimentary sittings to the usual celebrities, and his landscape work with Augustin Skarda, the editor of the photographic magazine *Photographic Horizon*, resulted in the book *Prague Courts and Backyards*. Drtikol's enthusiasm for photographing the female nude brooked no obstacles; even the fact that most of his models

appeared angry at posturing for him did not deter him. These frowzy women with untidy coiffures and crumpled buttermuslin draperies sometimes assumed classical dance positions in the Art Nouveau or more starkly 'functionalistic' balletic poses. The 'modernistic' effect was accentuated by his use of an arc-lamp that cast hard shadows. Typical of this phase are his portraits: particularly amusing are the earliest aviators in their helmets with large moustaches, obviously eminent men feverishly smoking pipes, and the 'auto-portrait' of a greedy-eyed, bullocky young man with a cigaroo. Drtikol's abiding interest was in the live female nude, though sometimes he substituted it with Art Deco-ish figurines.

In the 1920s Drtikol subjected his ladies to harsher arrangements of light and form; with these strange and somewhat ludicrous concoctions he was said to have influenced the Bauhaus movement. In the 1930s he painted cubistic backgrounds for his nude ladies, who wore Michael Arlen 'Green Hat' cloches low over their thinly pencilled eyebrows. These exercises may have fired him to turn his activities to painting and to abandoning all forms of photography. Later in life Drtikol became exclusively interested in meditation and Indian and Chinese philosophy.

Hugo Erfurth

1874–1948

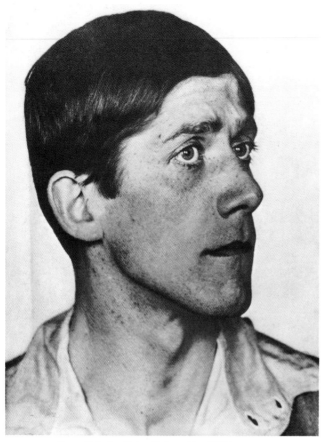

Hugo Erfurth, *Oskar Kokoschka*, 1927.

Born in Halle, Germany. Received his professional training in Atelier Hoffert in Dresden. After having achieved master's status he secured a place in studio of the court photographer Schroder. Designed a special photography section at Great Dresden Exhibition, 1904. Taught a class in photography in college of book-production in Leipzig under Professor Tiemann until outbreak of First World War. His Dresden studio was the meeting-place of artists and other notables in the 1920s. Founder and president for many years of the Gesellschaft Deutscher Lichtbilder (Society of German Photographers), 1919 onwards. Moved to Cologne from Dresden, 1934. Picture archive destroyed in night of bombing, 1943; large part of work survived in a bank safe. Moved to Gaienhofen on Bodensee and continued to photograph until death. Special subjects: portraits of the leading personalities in the worlds of art, letters and politics. Process: gum bichromate and oil pigment. Major exhibition: Photokina, Cologne, 1951. Collection: L. Fritz Gruber, Cologne. Books include: *Hugo Erfurth Sechsunddreissig Künstlerbildnisse*, with remarks by Hermann Schardt, Otto Steinert and J. A. Schmoll, 1960.

For the first thirty years of this century the name of Hugo Erfurth was almost synonymous with great German photographic portraiture. He is best-known for his portraits of male artists and other notables. He worked fervently to capture the character of his sitter.

He chose to produce his photographs as costly oil-pigment prints which helped him achieve the bold linear outlines and the flattish texture he so loved. His work cannot be judged in reproduction. The graininess, colour and surface quality of the original Erfurth print add enormously to the overall appreciation of the work. GB

Martin Munkacsi

1896–1963

Born in Kolozsvar, Hungary. After changing schools many times, learned the trade of a house-painter. At age of seventeen went to Budapest; following year became sports reporter for the important publication *Zz Est*. First introduction to news photography came in 1923; photographed men fighting and his picture served to decide the fate of a falsely accused man. Became a photo-journalist; one year after entering the field was Hungary's highest-paid photographer. Under three-year contract to Ullstein Verlag, Berlin, from 1927. Work published in *Biz, Dame, Studio* (London). Under assignment for *Berliner Illustrierte Zeitung*, flew around the world on airship *Graf Zeppelin*. With the rise of Nazism, renewed former contacts with Hearst Press and moved to United States. Photographed for *Harper's Bazaar, Town and Country, Good Housekeeping, Pictorial Review*; took pictures of people in the arts, politics, high society as well as fashion and personal subjects. Started collaboration with *Life* with first issue, 1936. Did series 'How America Lives' for *Ladies' Home Journal*. In 1941 thought to be America's highest-paid photographer and the world's most famous photographer of women. Special subjects: photo-journalism, nudes, fashion. Books: *Fool's Apprentice*, 1945; *Nudes*, 1951.

A jovial Hungarian Jew, Martin Munkacsi was, at an early age, known by fellow newsmen as a sort of 'stunt man'. With his miniature camera he was to be seen defying water, fire, or even brimstone in order to get a unique angle. Little wonder that he was spotted by Ullstein and soon took over the German press. Little wonder, too, that with his push and daring he should be hired for an enormous fee to go to the United States to work for the Hearst Press. But Munkacsi was soon disappointed; Hearst decided to make the photo-reporter into a fashion photographer. Although he brought a sense of everyday reality that had been lacking in this particular genre, and at *Harper's Bazaar* gave a healthy energy to the pages by bringing his models from the confines of a studio out into Central Park, he was not 'happy in his work'. He complained of those 'plastic rocks, fake trees, and stupid-looking frozen models'. To achieve ever more startling results he made his pampered little models, who had seldom been out-of-doors, do all sorts of feats of daring. He challenged them to leap over pools, boulders, girders, fences. He originated alfresco fashion photography. In a vast studio in Tudor City he made bizarre studies of naked women; he experimented with elongation which he felt brought his nudes into the domain of serious art.

Munkacsi, a man of great drive, wrote a novel, lectured, formed an art collection. He was a motor-cycle racer, footballer and a bohemian spendthrift; he painted and was an expert on antiques. The path of his success soared ever upwards: he worked for King Features, for Henry Ford, Reynolds Company, and television films.

Then slowly he slipped. He lost his studio, his wife and his commissions. Nearing the end, he took wedding and baby pictures. He suffered a heart-attack and, before he was fully recovered, went to see his fellow countrymen playing in a soccer match. Another heart-attack followed. He died before any hospital would take him in.

Munkacsi today is remembered as one of the first major photo-journalists, and an innovator in fashion photography. What he has bequeathed to us is important. Among the thousands of remarkable photographs the white animals are particularly memorable.

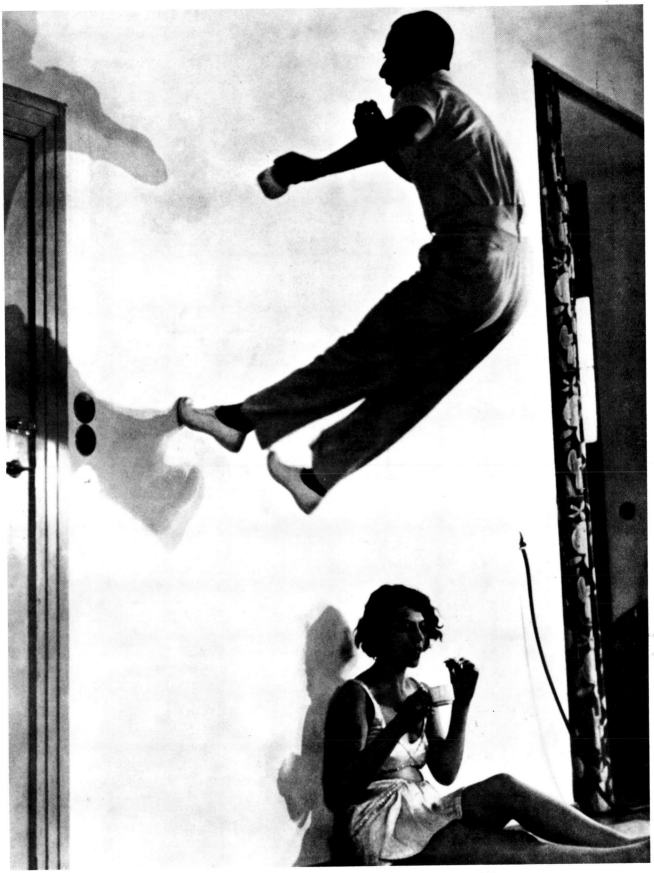

Martin Munkacsi, *Someone at Breakfast*, from *Deutsche Lichtbild*, 1936.

László Moholy-Nagy

1895–1946

Born in Borsod, Hungary; US citizen. Studied law but without receiving a qualification at University of Budapest, 1915. Co-founder of review *Jelenkor* and member of Hungarian art group MA, 1916. First photographs and arrival in Berlin, 1920. Master at Staatliche Bauhaus, Weimar and Dessau, 1923–8. Co-founder and editor of international art review *i 10*, Amsterdam, 1926. While in Berlin experimented with new materials: Galalith, Trolith, Cellon, Rhodoid, Plexiglas, aluminium, etc.; did typographical work; theatre-settings, 1928–31. Abstract film *Light Display, Black and White and Grey*, 1930. After fleeing from Fascism to Holland, arrived in London, 1935. Made film *Lobsters*, one of the ten best films of 1936, special effects for H. G. Wells's film *Things to Come*. Offered and accepted directorship of New Bauhaus in Chicago, 1937. Exhibitions: Guggenheim Museum, New York; London shows, 1935–7; 'Photo Eye of the Twenties', Museum of Modern Art, New York, 1970; Moholy-Nagy retrospective, USA, 1970. Books include: *Horizont* (1921); with L. Kassák, *Buch Neuer Künstler*, 1922; co-editor with Walter Gropius of the fourteen Bauhaus books, 1923–8; *Malerei-Fotografie-Film*, 1925 (translated as *Painting, Photography, Film*, 1969); *Die Bühne im Bauhaus* with Oskar Schlemmer, 1925; *Von Material zur Architektur*, 1929 (translated as *The New Vision*, 1930); *Fototek*, 1929; *Telehor*, 1936; *The Streetmarket of London* with Mary Benedetta, 1936; *Eton Portrait* with Bernard Ferguson, 1936; *Oxford University Chest* with John Betjeman, 1937; *Vision in Motion*, 1947; *Moholy-Nagy, Marginal Notes* by Lucia Moholy, 1972.

Moholy-Nagy was born in the Hungarian countryside, and when still a youth published poetry in small-town magazines. Later while studying law, he gave time to writing and painting. Such delightful activities were curtailed when he was called into the Austro-Hungarian army and sent to the Russian front. Here he was wounded. Recuperating, he started painting seriously and in Berlin became a co-founder of the Constructivist movement. This led him to take on the co-editorship of an anthology of modern art, and a prophetic manifesto entitled 'The Dynamic Constructive System of Forces'. By the 1920s Moholy-Nagy was well known in European *avant garde* circles. His earliest reputation came from his abstract paintings and the photographs without a camera which he called 'Photograms', the result of flashing a light on ordinary everyday objects placed on sensitized paper. He wrote 'The Photogram or Cameraless Record Produced by Light; the photogram embodies the unique nature of the photographic process and is the real key to photography. It allows us to capture the patterned interplay of light on a sheet of sensitized paper without recourse to any apparatus. . . . The Photogram opens up perspectives of the hitherto wholly unknown morphosis governed by optical laws peculiar to itself. It is the most completely dematerialized medium which the new vision commands.' As a 'straight' photographer Moholy-Nagy was adept at making extraordinary designs and patterns out of the usual.

Moholy-Nagy collaborated with Edwin Piscator's theatre and the Berlin State Opera and made films, both representational and abstract.

Walter Gropius, founder of the Bauhaus school, invited Moholy-Nagy to Weimar to teach the basic foundation course in photography, and together they collaborated on many Bauhaus books. Eventually Fascism drove Moholy-Nagy to Holland and thence to London. From Hampstead he organized a Courtauld exhibition and worked in interior design. In 1941

he joined the American Abstract Artists and developed his 'space-modulator conception' into three-dimensional sculpture. He started to write his summaries of ideas in *Vision in Motion* which was published posthumously after his premature death from leukaemia in 1946.

Moholy-Nagy was much concerned about changing photography from what he considered a reproductive technique to a productive medium.

In a book published in 1970 Richard Kostelanetz writes, 'Moholy-Nagy continues to live in contemporary art, although the record tells us that he died over two decades ago, for he is the only artist born before 1900 whose work, ideas and example remain variously relevant in this era of light-shadows, sculptural medium and abstract films, non-representational photography, radically diverse book layouts, streamlined industrial design, artistic environments and 'mixed-means' theatre. Not only did Moholy-Nagy's writings and ideas espouse most of these distinctly contemporary forms, he literally worked in most of them, three, four or five decades ago.'

Andreas Feininger

b. 1906

Andreas Feininger, *Nautilus Shell.*

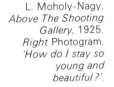

L. Moholy-Nagy,
*Above The Shooting
Gallery,* 1925.
Right Photogram.
'How do I stay so
young and
beautiful?'.

Born in Paris; US citizen. Attended Bauhaus in Weimar, Germany 1922–5; became a cabinet-maker. Attended technical schools in Weimar and Zerbst, Germany, to become an architect, 1925–8; developed interest in photography and taught himself basics of photo-technology. Worked as an architect in Germany, 1929–31; for Le Corbusier in Paris, 1932–3. Worked as an architectural and industrial photographer in Sweden, 1936–9; built first super-telephoto camera. Moved to New York, 1939. Worked as a photo-journalist for Black Star Picture Agency, 1940–1; full-time staff photographer for *Life*, 1943–62. Special subjects: nature photography, close-up and tele-photography. Cameras: $2\frac{1}{4} \times 2\frac{1}{4}$ inch and 4×5 inch. Major exhibitions: 'The Anatomy of Nature', American Museum of Natural History, New York; Smithsonian Institution, Washington, DC, etc., 1957; Heinz Held Gallerie, Cologne, 1961; 'The World through my Eyes', Smithsonian Institution, 1963; 'New York in Farbe', Deutsche Gesellschaft für Photographie, 1965; Oakland Museum, California, 1970; 'Shells', American Museum of Natural History, 1972. Collections: Metropolitan Museum of Art, New York; Museum of Modern Art, New York; Smithsonian Institution; International Museum of Photography, Rochester, New York; Museum of the City of New York; Newark Museum, New Jersey; Carpenter Center for the Visual Arts, Harvard University; City Library, Springfield, Massachusetts. Books include: *The Complete Photographer*, 1965; *Trees*, 1968; *Basic Color Photography*, 1972; *Shells*, 1972; *Photographic Seeing*, 1973.

Born in Paris, the son of Lyonel, a great painter and composer, Andreas Feininger is one of the most scholarly photographers and applies his knowledge of photographic techniques to his highly controlled cityscapes. These were mostly taken with a telephoto lens in order to remove extraneous material in the foreground.

At first he was apprenticed to a cabinet-maker; then he worked in Corbusier's studio in Paris in 1932. In Sweden he decided to give up architecture and produced many articles of photography in photo manuals and picture-books. In 1939 he went to New York where he has written over twenty-one books. Feininger's *Complete Photographer* was published in 1965 but he considered *Forms of Nature and Life* (1966) his best book.

Imogen Cunningham

1883–1976

Imogen Cunningham, *Two Callas*, before 1929.

Born in Portland, Oregon. Studied chemistry at the University of Washington. After graduation took at job at the Curtis Studio, Seattle, Washington, and printed hundreds of Edward S. Curtis's negatives of Indians on to platinum paper, 1907–9. Received a national scholarship enabling her to study photographic chemistry at the Technische Hochschule, Dresden. Opened portrait studio in Seattle, 1910. A member of Group f/64, 1932–5. Did occasional assignments for *Vanity Fair*, 1931–6. Professional portrait photographer in San Francisco, from 1947. Teaches at San Francisco Art Institute and lectures at different Californian colleges. Special subjects: people and plants. Cameras: 10 × 8 inch, $2\frac{1}{4} \times 2\frac{1}{4}$ inch. Guggenheim fellowship, 1970. Major exhibitions: Brooklyn Institute of Arts and Sciences, 1912; Los Angeles County Museum, 1932; Cincinnati Museum of Art, 1956; International Museum of Photography, Rochester, New York, 1961; Art Institute of Chicago, 1964; Standford University, California, 1967; Siembab Gallery, Boston, 1969; 'Women, Cameras, and Images I', Smithsonian Institution, Washington, DC, 1968–9; Phoenix College Library Gallery, Arizona, 1969; Witkin Gallery, New York, 1973. Collections: International Museum of Photography; Museum of Modern Art, New York; Oakland Museum; Exchange National Bank, Chicago; Library of Congress, Smithsonian Institution, Washington, DC. Books: *Imogen Cunningham: Photographs*, with introduction by Margery Mann, 1970; *Aperture*, vol. 11, no. 4, 1964.

The work of the ninety-year-old photographer Imogen Cunningham is greatly respected in America. At first she studied in Germany as a chemist. Then, inspired initially by Gertrude Käsebier, she started on a photographic career. Her work was of the soft-forms, romantic-impressionist type. In 1910 she moved from Dresden to Seattle where she opened a Studio for Portraits. She also made 'problem pictures' with titles like *Eve Repentant* and *The Wind*. Married to an etcher in 1915, her photography became directed towards the flowers and plants in her garden when she had to remain at home looking after her family. Later, divorced from her husband,

and when her children were grown up, she again turned to portraiture; but it is her nudes and her horticultural and nature studies that are especially fine, particularly the *Negative of a Snake* made in 1921, and her *Crab Nets* which are as delicate as lace. Her output had taken on a new realism with sharp focus, and she became a member of Group f/64 which was formed around Willard Van Dyke, who explained his theory: 'The quality of art in perception and execution was the main concern executed in clean, simple form.' Other members of the influential group were Edward Weston, Ansel Adams, Henry Swift, John Paul Edwards and Sonya Noskowiak. Late in life Imogen Cunningham made a salient picture of herself, mirrored in a squalid shop in Geary Street, San Francisco. She saw herself as a humorous and whimsical old character.

Imogen Cunningham's work veered more and more towards plants and natural forms to which she gives sexual significance. *The Black Lily* (*vertical*), and *The Black Lily* (*horizontal*), tell their own story. *The Rubber Plant* conveys great sensuality, as do her *Magnolia Bud*, *The Two Callas* and even *The Magnolia Blossoms*.

Recently Imogen Cunningham said: 'I've lived so long, and played with photography so long, that people are curious about what makes me tick. I suppose, by the time most people are my age, they have made it. Maybe it's the lack of money that pushes me along. I've always worked for money, and I've always had fun doing it. People often marvel at me. "I don't know how you keep so busy," they say.' '*Keep* busy,' she repeats. 'I don't *keep* busy. I *am* busy.'

Miss Cunningham's fame is partly academic, and derives from the hundreds of thousands of those who have benefited from her teaching.

Edward Weston

1886–1958

Born in Highland Park, Illinois. Took first photographs, 1902. Went to California on holiday and stayed, 1906. Married Flora May Chandler, 1909; four sons born: Chandler, 1910; Brett, 1911; Neil, 1914; Cole, 1919. Opened own portrait studio, Tropico (now Glendale), California, 1911. Studio in Mexico City, 1923–5; returned to San Francisco for six months. Photographed with Tina Modotti and Brett throughout Mexico, 1926. Opened studio in Carmel, 1928. With Ansel Adams and Willard Van Dyke formed Group f/64, 1932. Married Charis Wilson, 1938. Worked in colour while on location with Willard Van Dyke for film *An American Photographer*, 1947. Stricken with Parkinson's disease, made last photographs on Point Lobos, 1948. With Brett's help, published *50th Anniversary Portfolio*, 1955. Through the generosity of a friend, was able to choose some 800 negatives he considered to be his best work and supervised Brett in making eight sets, 1955–6. Special subjects: close-ups of natural forms, landscapes, portraits. Camera: 10 × 8 inch view. Awards: first Guggenheim fellowship, 1937; extended, 1938. Exhibitions include: Mexico City, 1923 and 1924; major retrospective, Museum of Modern Art, New York, 1946, and in Paris, 1950. Major collections: Guadalajara State Museum; Los Angeles Public Library; Museum of Modern Art; International Museum of Photography, Rochester, New York. Books: *California and the West* by C. W. Weston, 1940; special edition of *Leaves of Grass* by Walt Whitman, 1941; *My Camera on Point Lobos*, 1950; *The Day-books of Edward Weston*, vol. I 1962, vol. II, 1966.

In 1900 there was in America a division between the east and west coast photographers. On the east coast they were interested in defining the atmosphere of the cities, the streets and interiors: the west coast practitioners were nearer to nature with a greater sense of country values.

Edward Weston, *Bedpan*, 1930.

In the latter category was Edward Weston, who was to become one of the most important and readily acclaimed of all American artists of the camera. Known as 'the Californian photographer', he was born in Illinois of a long line of New England preachers, teachers and doctors. His grandfather was a poet and a Black Republican who founded a seminary for girls in Illinois.

At the beginning of his great career, Weston retouched, out of all recognition from the original, his soft-focus oil prints. *The Excavators*, done in 1908, is more painting than photography. But after seeing a modern art exhibition around 1915 and meeting Stieglitz, Strand and Sheeler in New York in 1922, his work changed to pin-sharp, unretouched pictures, and America found her great master photographer.

Weston was so poor at first that he could not waste paper or chemicals, and so had to become proficient in all the technicalities of developing and exposure. It was, in fact, through his poverty, and not being able to afford to use more than two sheets of paper on any one negative, that he became the greatest perfectionist of his day. He acquired a complete, almost incredible mastery over tone-values and detail that has made him an idol of many generations of American photographers.

Using an 8 × 10 inch camera, Weston worked in isolation, but he carried his single-mindedness into his own personal life.

Even as a frail child, Weston instinctively fasted – as he did all his life – and tended towards being a vegetarian. He treated sunlight and cold water as medicines (he would rise around four in the morning and take a cold bath before writing his diary: 'My way of exploding.') In his 'daybooks' he poured out his bitterness and anguish.

At first Weston wanted to become, in turn, a track-star, a prize-fighter, then a painter, but photography became his passion when his father gave him a Bull's-eye camera. For three hideous years he earned his living as an errand-boy and salesman for Marshall Field in Chicago, but in his spare time he learned a photographer's trade. When he went to California and surveyed for railways he had saved enough to buy himself a postcard camera and went around ringing door-bells to suggest he should take – for a dollar a dozen – anything that was available: from babies to funerals.

Encouraged, he opened a portrait studio from whence he sailed forth, wearing a velvet cape and windsor tie, to take soft-focus, 'arty' pictures. He married and had four sons. Of his wife, the photographer Imogen Cunningham said, 'She was like an electric fan you could not turn off.' Divorce was followed by a marriage to another photographer.

That fame should come his way was never uppermost in his mind; he wished only for the respect of the friends whose opinion he valued.

Much of the drama of Edward Weston's work depends on his metallic technique; the same subject in the hands of lesser craftsmen would have little authority. If a wooden doorway Weston photographed were seen slightly out of focus by any Rolleiflex novice, it might have had no inherent drama, but Weston managed to photograph even the tasteless baroque

Edward Weston, *Shell*, 1927.

decorations on a Metro-Goldwyn-Mayer cinema set with such meticulous precision that they became objects of interest. When he turned his camera on to the blistered paint of an abandoned car in the sun of the Mohave desert, the wedding-cake houses of Mexico, or the graffiti on peeling walls, it is his extraordinary technique and purity of vision that makes the effect.

To judge Edward Weston's work by the reproductions in magazines is not to give it its full value. To look at his original prints, such as *Two Shells* or *Fungus* is a moving experience. In texture and definition, they are today as breathtaking as when first created in 1921.

Weston has always been aware of what he is doing in photography. There was never a question of the 'happy accident' upon which so many young photographers of the 1960s and 1970s hopefully rely.

In 1923 Weston went to Mexico in the company of the beautiful Tina Modotti. A rampageous communist, she became an admirable practitioner of the camera herself and, no doubt under the influence of Weston, made some strong close-ups of hands of peasants, a typewriter, roses, and the inevitable shots of breast-feeding. Her best are of wire telegraph poles and a sports stadium. In Mexico City Weston was accepted as their equal by such painters as Diego Rivera, Siqueiros, Orozco and others, who said that his photographs expressed the creator's deepest emotions and sensibilities.

Weston soon became disillusioned with his Mexican life. He smelled revolution in the air, and returned to California and the photography of shells, dunes and nudes. When, before a meal, he photographed a cabbage or cauliflower, a pepper or a lettuce intended for his lunch, a friend remarked that he ate his subjects.

The surprising exactitude with which Weston presented the physical texture of objects – a farm window, a piece of railing, or a makeshift doorway – would in itself make his prints appear outstanding. Yet they possessed something else that made them memorable. And this was a quality essential to any outstanding photographer – his ability to convince the viewer of his personal attitude to the subject. In Weston's case a stone or a bench could create an emotion in him by which he succeeded, with his passion, in making us see the world around us in his way.

In one of his daybooks he wrote: 'The camera should be for a recording of life, for rendering the very sustenance and quintessence of the thing itself, whether it be polished steel or palpitating flesh.' All his life Weston lived frugally, and for most of the time he was very short of money. He rarely laughed. He hated cities, motor-cars and noise, and found his ideal home in Carmel where, after suffering from Parkinson's disease for ten years, he died. His four sons took his ashes down to the cave on Point Lobos, where he had done some of his most lasting work, and scattered them into the sea.

In some ways Weston could be compared to a Renaissance painter, but, incongruously, he worked with a wooden mechanical instrument. In his vision he was ahead of his time, but in his aspirations and way of life he was remote from contemporary life.

Erwin Blumenfeld

1897–1969

Born in Berlin; US citizen. Educated in Berlin; started work as an apprentice dress designer. Went to live in Holland and opened a leather shop in Amsterdam. In spare time, took photographs. When he felt he could earn a living in photography moved to Paris. In the 1930s did experimental work for magazines such as *Verve*; staff of Paris *Vogue*, 1938. Emigrated to the United States; worked for Condé Nast Publications from 1944. Special subject: female figure. Camera: Linhof and 8 × 10 inch Deardorff view.

Erwin Blumenfeld, From a reproduction in *Verve*.

Erwin Blumenfeld was an intellectual who escaped from a German concentration camp and went to Paris to eke out an existence in Montparnasse. In a minute attic, he produced extraordinary original images of semi-nude women. Sometimes their draperies of butter-muslin were wetted to make them like Greek sculptures. Often they were reflected in contorting mirrors, seen through thick glass or looming behind only semi-transparent materials. Blumenfeld also experimented with lights, creating haunting effects on the human face; he used double reflectors. He was tireless in his inventiveness. By contrast, he gave his personal vision of a church tower, a springtime garden in France, a stone wall, and a park with iron chairs. Blumenfeld also took 'straight' details of Beauvais tapestry, which somehow he seemed to make his own.

Blumenfeld's work was not appreciated in London when he arrived to start a career as a fashion photographer. In the United States however, he was at once seized by rival editors. But Blumenfeld was never an easy character; he held too many unpopular opinions: his directness and honesty manifested themselves too blatantly, and he made enemies. He earned a great deal working with advertisers, and invested his earnings successfully.

Blumenfeld's last years were spent in writing, and had it not been for his great skill as a photographer he would doubtless have made a name as a cynic and an uncanny observer of life in its least pleasant aspects.

Erwin Blumenfeld, From a reproduction in *Verve*.

Richard Kearton and Cherry Kearton

1862–1928 and 1873–1940

Both born in Thwaite, Swaledale, Yorkshire and educated at village school and Birkbeck College; self-taught photographers. Richard's first job in London was with Cassell, publishers, c. 1883. Soon turned to writing on natural history and using his brother Cherry's and his own photographs as illustrations in articles and books. Gave thousands of lantern-slide lectures during his lifetime. Specialist subject: British birds, flora and fauna. Equipment: 5 × 4 inch field camera with 9 inch rectilinear lens and roller-blind shutter, glass plates; autochromes from c. 1912 used only to photograph landscapes, flowers and moths (very slow speed). Award: Offered knighthood, refused. Exhibitions: Two at Queen's Small Hall, London, between 1905 and 1914 with Cherry. Produced portfolio of twelve photographs and packets of six stereoscopic slides. Wrote and illustrated sixteen books which include: *Birds' Nests, Eggs, and Egg-Collecting*, 1890; *Our Bird Friends*, 1900; *Wild Nature's Ways*, 1903; *Wonders of Wild Nature*, 1915; *At Home with Wild Nature*, 1922. Books in collaboration with Cherry Kearton include: *British Birds' Nests*, 1895; *With Nature and a Camera*, 1897; *Keaton's Nature Pictures*, 2 vols, 1910.

Cherry joined his brother at Cassell, publishers, London. Collaborated with Richard on books and articles from 1892. Before 1905 began taking moving pictures; took cine pictures in Spencer's airship over London and of a common white-throat, 1905. Filmed big game in British East Africa, 1909. Made films in India, Burma, Borneo, Malaya, Canada and American Rockies; most popular were *Dassan* (about penguins) and *Tembi* (about crocodiles). Served in Legion of Frontiersmen during First World War in German East Africa; took aerial photographs. Special subject: animal life. Cameras include: half-plate, stereoscopic, reflex; telephoto lenses; invented a 'gun' camera. Produced five volumes in Library of Animal Friends. Books include: *Wild Life Across the World*, with introduction by Theodore Roosevelt, 1913; *In the Land of the Lion*, 1929; *Adventures with Animals and Men*, 1935; *My Woodland Home*, 1938.

Richard Kearton can be called the father of natural-history photographers. He had always been interested in birds and at the age of nine fell and dislocated his left hip while climbing a tree to watch a bird. For the rest of his life he had a lame leg six inches shorter than the other. By the time he was seventeen he was an expert sheep-farmer and first-class naturalist. Of the two brothers, both ornithologists and naturalists, he was the first to take bird photographs and to experiment with the 'hide'. He worked closely with his brother, Cherry, and in 1892 together they made a picture of a thrush's nest and eggs. Soon after Richard was twenty-one the brothers published an article concerned with natural history which contained probably the first photographic illustrations ever taken directly from wildlife.

Since Richard had observed that birds take little notice of other animals such as sheep, horses and cows, he reasoned that it should be possible to obtain photographs from inside a hollow, fake cow or horse. The ruse worked and he then proceeded to use other empty structures – such as tents and huts – with equal success.

Helmar Lerski

1871–1956

Born in Strasbourg; naturalized Swiss. Brought up in Zürich. Went to United States in 1893 and acted in German theatres around the country. Learned photography from his wife, 1911. Demonstrated his portrait technique at St Louis convention of Photographers' Association of America, 1913. Taught photography and German language at University of Texas, 1914. Worked as cameraman in Berlin film studio, 1915–29. Made documentary films and photographed in Palestine, 1931–48. Returned to Zürich, 1948. Equipment: first used 14 inch Heliar lens, then 11 inch Dagor; 18 × 24 cm or 24 × 30 cm view cameras using fine-grain plates. Exhibitions: Berlin, 1915; 'Film and Foto', Stuttgart, 1929. Collections: International Museum of Photography, Rochester, New York; Gernsheim Collection, University of Texas. Books: *Köpfe des Alltags*, 1931; *Verwandlungen durch Licht*, 1938; *Der Mensch – Mein Bruder*, 1957.

Helmar Lerski left Zürich at the age of twenty-two to become an actor in the United States. He took up photography by mistake when he snapped some pictures of his fellow actors in the studio of his wife, who was a professional photographer.

In 1915 he returned to Europe. For fourteen years he was a cameraman at the UFA studio in Berlin: among the films he shot were Paul Leni's *Waxworks* and Berthold Viertel's *The*

Helmar Lerski, From *Kopfe des Alltags*.

Adventure of a Ten-Mark Note. When sound came in, he left film production and returned to his portrait camera. Since his uncompromising realism repelled some sitters, he turned to the streets for models, and brought the style he originated back in Milwaukee to an extreme point. He placed his view camera two feet from the model, whose back was placed to the sun. He surrounded the face with mirrors and reflectors, sometimes as many as sixteen. To secure depth of field he was forced to stop down the lens to the limit; exposures ran to fifteen seconds. He printed by contact from unretouched negatives, and recorded exactly what he saw upon the ground glass.

In the early 1930s in Berlin, Lerski's close-up portraits were outstanding. Mostly of men, they were extremely vital and uncompromising; some had the appearance of fragments of Roman sculpture, a little debased, but all the more sexually alluring for that.

Erich Salomon

1886–1944

Born in Berlin. Deprived of nationality by Nuremberg laws. The son of a wealthy banker, early interests were in zoology and carpentry. Studied mechanical engineering and law at University of Munich; gained doctorate of law. A prisoner-of-war for four years during First World War. After various jobs, permanent employment in publicity department of Ullstein Verlag. First contact with photography, 1927. A pioneer of photo-journalism in Berlin, 1928–9; sold pictures to *Berliner Illustrierte* and other papers. Visited England, 1929; America, 1930, and was the first photographer to photograph in White House. Being Jewish, emigrated with family from Germany to Holland, 1934. Murdered with wife and second son in Auschwitz, 1944. Special subject: available-light reportage. Equipment: Ermanox fitted with f/2 lens taking glass plates, 4·5 × 6 cm; always used a tripod for half-second exposures. Later Er-Nox (f/8 lens); from 1932, Leica. Exhibitions: Royal Photographic Society, London, 1935, 1957, 1972; Photokina, Cologne, 1956, 1963; International Museum of Photography, Rochester, New York, 1958; Time-Life Building, New York, 1958; Library of Congress, Washington, DC, 1958. Collections: Museum of Modern Art, New York; Gernsheim Collection, University of Texas, Austin; International Museum of Photography; Peter Hunter, Amsterdam; L. Fritz Gruber, etc. Books: *Famous Contemporaries in Unguarded Moments*, 1931; *Portrait of an Age*, 1967.

Should photographers who take forbidden snapshots be encouraged? Occasionally we are pleased to see the result of their breach of the rules. A man named Arthur Barrett hid his camera in his top-hat, in which he had cut a hole for the lens, and when he went to the trials of suffragette leaders at Bow Street Magistrates' Court in London, managed to catch some expressive pictures. We are grateful to Barrett for the interesting glimpses of those odd heroines, Cristabel and Mrs Pankhurst and Mrs Drummond, in their fashionable hats. But hidden cameras have 'scooped' electric-chair death scenes and other horrors that are likely to turn the stomachs of the queasy, and the telescopic lens has made the lives of members of royal families less private than they might wish, and made it dangerous for Miss Garbo or Mrs Onassis to bathe in the nude.

Dr Erich Salomon, one of the founders of photo-journalism, had no need to hide his camera. He and other pioneers of photo-reporting in Germany were invited to important political and social functions, and were known as 'photographers in tails'. Salomon was the great master of the candid indoor shot, mainly on political subjects, but produced comparatively few 'photo-essays'. He took photographs at a murder trial in Berlin, and continued in more sophisticated circles. He was able to enter many a holy precinct in Paris and in London where he managed the best-ever likeness of Neville Chamberlain. Aristide Briand points a finger at the photographer who appeared at a secret conference where the Ministers of Foreign Affairs were gathered. He photographed Prime Minister Ramsay MacDonald explaining his theory of relativity to Albert Einstein at a reception in Berlin, and Einstein in turn explaining his hopes for the peace talks. His most remarkable, perhaps, is of Stanley Baldwin and Ramsay MacDonald, both with hand-cupped ear, looking harrassed and worn as they try to hear at a press conference. With his fast-trained lens Salomon was able to take historical records of political conferences, concerts, snob parties, and many occasions where a flashlight would have been considered unpardonable.

His great highlights showed his love of music – and his series of every sort of musician was obviously carried out with passion. He was also understanding with judges and court life, the League of Nations, the Geneva Conference and Germany in 1930. He brought back some vivid records of W. R. Hearst's Citizen Kane-like ranch in California, caught Queen Wilhelmina adjusting her tiara, and Lady Desborough, tremendously gracious, but somehow overdoing the jollity, in company with the elderly Miss Baba Brougham, whose hair had been tightly tonged by a too-zealous coiffeur.

The doctor's pictures were strikingly unusual and were composed with the flair of a painter. Dr Salomon achieved a valuable breakthrough with his reportages in evening light indoors; the quality was often opalescent. He could convey the soft glow from candles, the reflections from an illuminated music-stand or chandeliers. He showed us the effect that Princess Marina and other beauties created when seen under these flattering circumstances – surely in the way that great romantic writers described their heroines.

Although Salomon's work is better-known in Europe, it seems that in England and in the United States it has not been given its due appreciation.

Erich Salomon, *William Randolph Hearst reading despatches at his California ranch.*

Erich Salomon, *Above, left Lady Desborough and Miss Eleanor Brougham at a reception in the Dutch Embassy, London,* 1937. *Right Briand spotting Salomon at a banquet at the Quai d'Orsay which photographers were not allowed to attend,* 1931.

Erich Salomon, *Political conference at the home of the Dutch Premier, Dr Colijn* (centre) *on the occasion of the visit of Oswald Pirow from South Africa.*

Tim N. Gidal

b. 1909

Born in Munich. Studied history of art, law, economics, history at universities of Munich and Berlin, 1928–33. Began photo-reporting after picture-story 'Kumpels Meet in Stuttgart' was published in *Münchner Illustrierte Zeitung*, 1929. Special photo-correspondent in the Middle East for *Münchner Illustrierte* and for *Woche*, 1930. Worked as photo-journalist throughout Europe, 1931–6. Student at Basle University, Switzerland, 1933–5; received doctorate. Picture-reporter for British and American magazines and for Associated Press while living in Palestine, 1936–8. Invited by Stefan Lorant to join staff of *Picture Post*, 1938; with Kurt Hutton and Felix Man was one of the principal photo-journalists until 1940. Covered All-India Congress in Bombay for *Look* and *Picture Post*, 1940. Staff of *Parade*, British Eighth Army weekly picture magazine, 1942–5; one of two chief photo-reporters, rank of captain. Freelance researcher and *Life* consultant on history of photography and art stories; 1948–54; 'photo-archaeologist' on editorial staff of *Life*, 1954. Lecturer on history of photo-journalism at New School for Social Research, New York, 1954–6. Special subject: photo-journalism. Cameras: Ermanox, Leica, 4×4 inch Rolleiflex, Nikon. Illustrated and wrote with Sonia Gidal many books for 'My Village' series, Random House-Pantheon Books, New York, 1955–69. Other books include: *Everyone Lives in Communities; Modern Photojournalism: Origin and Evolution, 1910–1933*, 1973.

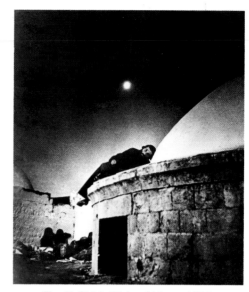

Tim N. Gidal, *Night of Meron*, 1935.

Roman Vishniac

b. 1897

Born in Pavlovsk, Russia; US citizen. Studied at Shanyavsky University, Moscow, gained doctorate in zoology, 1914–20; studies interrupted by solitary confinement in prison and being drafted into three armies – Tsarist, Kerensky and Soviet. Pioneered work in time-lapse cinemicroscopy. Course in medicine sponsored by government, 1917–20; left Russia after two escapes from firing squads of Tsarist army. Lived in Berlin until Second World War, did research in endocrinology and studied oriental art at University of Berlin; qualified for a degree but did not receive it due to being a Jew. Filmed and photographed Jews of eastern Europe, 1936–9. Concentration camp, Du Ruchard, Annot, France, 1940; arrived in America with family, 1941. Worked as a portrait photographer and photographic printer and did experiments in photomicroscopy, 1941–50. Developed principles of rationalistic philosophy, 1950–60. Developed many techniques in photomicroscopy, especially in lighting; made seven films, 1949–72. Special subject: universal environment. Exhibitions: Louvre Museum, Paris, 1939; Teacher's College, New York, 1941; 'Through the Looking Glass', IBM Gallery, New York, 1962; 'The Concerns of Roman Vishniac', Jewish Museum, New York, 1971; 'The Concerned Photographer 2', Israel Museum, Jerusalem, 1973; Photographers' Gallery, London, 1973. Books: *Polish Jews*, 1947; *Building Blocks of Life*, 1971; *The Concerned Photographer 2*, 1973.

Self-questioning began for Roman Vishniac when he was a boy in Tsarist Russia. He filled his room with his interests: plants, insects, fish and small animals. According to his own reckoning, Vishniac's first important photograph was taken when he was seven years old. It was a photomicrograph of a cockroach's legs that he made by attaching his camera-lens to a small microscope. He continued to use the microscope as an ingredient in his photographic studies. Later, when living in Berlin, he became painfully aware of Hitler's plans to eliminate Hebrewism. Unlike many of his creed, he did not choose to ignore the impending horror; but he decided on a four-year programme to photograph the doomed Jews of eastern Europe.

In 1938 Roman Vishniac travelled from the Baltic Sea to the

Carpathian mountains in order to document the Jewish population of Poland. The pictures of these exceptionally photogenic faces, some of them taken in snowstorms, are horrifying and an abiding reminder of man's cruelty. The last pictorial record of the life and character of these people before catastrophe exterminated them is haunting and tragic. Only a few of these pictures survive, alas, for many were destroyed or lost.

After several imprisonments Dr Vishniac escaped to Vichy-dominated France. Here he was placed for four months as a stateless person in a concentration camp. In 1940, with his family he left Europe for America, but the early years there were hard even in comparison to those in Germany and France.

He was not able to speak English, although he knew seven other languages. At one time he worked as a photographic printer, earning a few cents for each print on a 'piece' basis, in order to provide for his family. He also turned to freelance portraiture since he was unable to work as a photo-journalist. By 1942, he began to achieve some success with his experiments in photomicroscopy and eventually gave up portraiture. He expressed the opinion that 'everything made by human hands looks terrible under magnification – crude, rough and asymmetrical. But in nature, every aspect of life is fine. The more magnification that we can use, the more details are brought out, perfectly formed.'

Vishniac photographed a protein, a vitamin, and the digestive system of a simple organism whose existence is known *only* because of his photographs. He is a teacher who wishes to share his wealth of wisdom.

Vishniac once 'borrowed' swamp-water in order to immortalize its inhabitants; then for hours he looked for a similar place in order to return the creatures he had photographed. When asked why he took such pains, he replied: 'If I had

Roman Vishniac

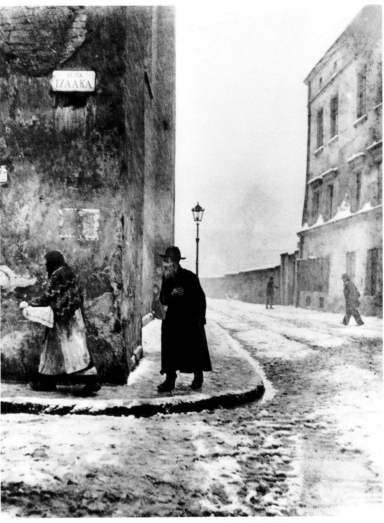

Roman Vishniac, *Cracow, Poland*, 1939.

returned them to the wrong place, I would have been guilty of disrupting family life, and that is a terrible thing to do. . . . It is no laughing matter.' Dr Roman Vishniac's slides of a world that was once invisible achieve the rarest of creative goals – a confirmation of beauty with learning.

Michael Edelson, in *Popular Photography*, wrote: 'His scientific experiments produce a contemporary form of beauty.' Vishniac's *Vitamin B* (32,000 times magnified) looks like a detail from a hypothetical Jackson Pollock painting in a *gamme* of Matisse's blues; his *Beta – Lipoprotein Found in Plasma* is like a fragment of a medieval stained-glass window or a design by Rouault; his *Fermentation of Yeast* (15,000 times magnified), and his *Eye of a Mosquito* (30 times magnified), are more beautiful than any designs for contemporary jewellery.

For most of his life Vishniac has worked in such diversified areas as medicine, biology, philosophy and art, though he believes that these man-made classifications are 'prejudices'. 'Everything that you think will be wrong in fifty years!' he has said. But then he explains: 'All our knowledge is constantly being changed. So as long as the human race exists, we will be wrong. If we know something to be true for 1971, will it be so for 1981 ? All,' he points out, 'is temporary knowledge.'

To Vishniac, 'there are photographs that are *not* photographic, and there are paintings that *are* photographic'. He is appalled by the current American fashion for 'photo-realism'. 'For me,' he has said, 'photographic vision and photographic interpretation mean much more than what the camera is doing. It is not important to ask, 'Is it done by the camera ? It is both wrong and weak to analyse photography, and *all* art for that matter, from the point of view of technique. Instead, we must start from the point of thinking.

'If you think we see with our eyes, you are wrong. It is with our brain. We do not hear with our ears, but with our brain; and we believe in God not with our soul, but also our brain.' And, to Vishniac, the brain is triggered by the idea that is carried by the image.

Today Vishniac, a seventy-seven-year-old man, bulky, bald, with benevolent brown eyes brimming with wisdom, holds degrees in biology, oriental art, zoology and medicine. He lives in West Side New York and still fills his rooms with plants, insects and small animals as well as paintings and rare books.

Walker Evans

1903–1975

Walker Evans, *Stables, Natchez, Mississippi*, 1935.

Born in St Louis, Missouri. Educated at Phillips Academy, Andover, Massachusetts, and Williams College, 1922–3; Sorbonne, Paris, 1926. Decided to become a photographer, 1928. Made 500 negatives and several sets of prints of African Negro art for distribution by General Education Board, to colleges and libraries. Worked for Farm Security Administration 1935–7. On staff of *Time* magazine as writer, 1943–5; staff writer and photographer on *Fortune* magazine, 1945–65. Professor at Yale University, from 1965. Award: Guggenheim fellowship, 1940. Exhibitions: Annual Exhibition of Contemporary American Photography, Philadelphia, 1930 and 1931; 'Photographs for Art and Industry', New York, 1931; Brooklyn Museum, New York, 1932; 'Photographs of Nineteenth-Century American Houses', Museum of Modern Art, New York, 1933; Pennsylvania Museum of Art, 1937; Museum of Modern Art, 1938 and 1971. Collections: Smith College; Wadsworth Athenaeum; Fogg Museum, Cambridge, Massachusetts; Museum of Modern Art; Metropolitan Museum of Art, New York. Books: *The Bridge* by Hart Crane, 1930; *The Crime of Cuba* by Carleton Beals, 1933; *American Photographs*, 1938; *Let us Now Praise Famous Men*, with James Agee, 1941; *Walker Evans*, 1971.

Walker Evans is an attractive, dark brown leathery man with black crew-cut hair and a narrow face of which the foxy nose is the most distinctive feature. It is also the most significant; its forward thrust is symptomatic of his inquisitiveness – of his quickness at sniffing things out, and being first on the scent.

Walker Evans made his first serious photographs in 1928 at the age of twenty-four. His decision to become a photographer was an act of protest against the conventionality of his 'well-to-do' parents who wanted him to take up some 'respectable' profession. His background and education in an elegant Chicago suburb were extremely proper. When his parents separated, he accompanied his mother to New York and, after working in the public library, went to Paris as an auditor at the Sorbonne. On his return to his country he became depressed by the materialistic society, and after a series of unsatisfactory jobs decided to become a professional photographer.

He disliked the two leading photographic 'aces' of the day: Stieglitz for his arty-craftiness, Steichen for his commercialism. Evans wanted to find some 'plain and common' form of photography, free from a personal handwriting, straightforward and unpretentious. From the first he showed an unusually discriminating eye for creative detail: a shabby coat hanging on a wall, a watering-can, a pair of pliers, some rubbish on a bed. He concentrated less on nature than on man-made objects and structures.

Walker Evans was fortunate in making friends who were excellent influences – Lincoln Kirstein, Muriel Draper, Hart Crane, and the painter Ben Shahn, with whom he lived for two years in Greenwich Village. Lincoln Kirstein inspired him to make documents of the early Victorian houses of New England and New

José Ortíz Echagüe

1886–1980

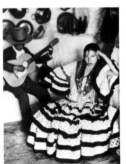

José Ortíz Echagüe, *Gipsies in the Albaicín*.

Born in Guadalajara, Spain. At age of twelve received a cheap box camera; passionate interest in photography continued from that time. Trained as an engineer at Academia de Ingenieros Militares de Guadalajara. In early 1900s became a balloon pilot and because of his hobby was made an officer in charge of photography. Commissioned as an aeroplane pilot, 1910. Founder and President of CASA, (aeronautical factory) and SEAT, (car-manufacturing company). Special subjects: the Spanish people, their customs and countryside. Process: Fresson (a pigment process rarely used) and his own process called 'carbondir', an abbreviation of direct-carbon. Awards include: Honorary Fellow of Royal Photographic Society, London, and Photographic Society of America. Collections include: Royal Photographic Society. Books: *España Tipos y Trajes*; *España Pueblos y Paisajes*.

Daniel Masclet

1892–1969

Daniel Masclet, *Du côté de la Maubert.*

Born in Blois, France. Father gave him drawing lessons, mother taught him Russian and English; never went to school. Started cello and violin lessons at the age of ten; at seventeen was a virtuoso cellist, considered to be second only to Pablo Casals. After returning from the First World War in 1919, met Robert Demachy who introduced him to Baron de Meyer, the first person he considered to be a 'great' photographer. Was de Meyer's assistant on *Harper's Bazaar* and did all the technical work for him, 1920–5. Worked for *Vogue* under Lucien Vogel, 1925–8. Exerted an influence on French photography as a writer, lecturer, teacher and photographer; founded a course in photographic aesthetics in Paris, 1949. Created the Salon of the 'Nude' and edited its album, 1933. Cameras: Linhof, Speed Graphic, Leica. Books: *The Countryside in Photographs*, 1946.

York as a way of preserving segments out of time itself. Truth was to be discovered – not constructed. Evans worked in bright sunlight, forcing the architectural details into utmost clarity. The focus was so sharpened that some of the houses seemed to exist in an airless atmosphere such as Edward Hopper suggests in his painting of similar objects.

Walker Evans, like many artists of the 1930s, wished to show the nobility of poverty. His canonization of what has been termed *le style de Chiffonier* was perhaps derived from Lenain, through Picasso (in his blue and rose periods) to the neo-romanticism of the tattered rags and travelling players of Tchelitchev, and of Christian Bérard in the ballet *Les Forains*. Evans himself endured poverty with great stoicism, which no doubt enabled him to feel fitted to become one of the 'Compassionate Camera' artists who were part of the United States Farm Security Administration. His book on the share-croppers in their settings, *Let Us Now Praise Famous Men*, compiled in conjunction with his friend, James Agee, was a documentary milestone.

Lincoln Kirstein, who collaborated with Walker Evans on three photographic books, and who gave an important collection of Evans's work to the Museum of Modern Art in New York, wrote: 'Many of the houses, neglected and despised, have disappeared in the short time since these photographs were made.' Evans's pictures had the quiet, static mobility of sculpture. Perhaps his work could be said to rest on two tenets: the acceptance of precise and literal photographic descriptions, and faith in the validity of his own intuitions.

When making a secretive series, *Riders on the Subway*, he gave up all means of photographic control for the camera was hidden under his top-coat. These pictures are his least successful. His work passed through many and various phases, but later in his career he returned to the documentary pictures of his early youth.

Walker Evans, with his quiet sense of leisure, his large, old-fashioned camera, has now become accepted as an 'old master'. His meticulous renderings – sometimes their clear, sharp lines appear as if etched with a needle – of wooden shacks in the harsh sunlight of the Middle West, the empty lots, the scabrous walls, cafés with Coca-Cola signs, the designs of subways and overhead railways, have all become American photographic history. Twice unsuccessfully married, addicted to work, he now spends his time teaching as well as practising photography. He lives in an old habitation, collecting early tobacconists' signs, lettering, postcards and matchboxes.

Manuel Alvarez Bravo

b. 1902

Born in Mexico City. Attended Catholic Brothers' school, 1908–14. Worked as a copy-clerk and studied accounting at night, 1915. Began working for Mexican Treasury Department, 1916. Studied painting and music at night at the Academia Nacional de Bellas Artes, 1918. Started photographic career with advice from German photographer Hugo Brehme. Met Tina Modotti, 1927; sent portfolio of prints to Edward Weston, 1929 (received favourably). Taught photography at the Escuela Central de Artes Plásticas while Diego Rivera was director, 1929–30. Left Treasury Department to become a freelance, specializing in the reproduction of painting and other art work, 1931. Regularly employed as photographer and cameraman at the Sindicato de Trabajadores de la Producción Cinematográfica de México, 1943–59. A founder, director and chief photographer, El Fondo Editorial de la Plástica Mexicana (Foundation of Mexican Plastic Arts), from 1959. Special subjects: Mexico and its people; their relationship to their land and to their heritage. Selected exhibitions: Galería de Exposiciones del Palacio de Bellas Artes, Mexico City, 1935; Hull House Art School, Chicago, 1936; Photo League Gallery, New York, 1942; 'Mexican Art Today', Philadelphia Museum of Art, 1943; Art Institute of Chicago, 1943. Collections: Pasadena Art Museum, California; Museum of Modern Art, New York; International Museum of Photography, Rochester, New York; Museum of Modern Art, Moscow; Bibliothèque Nationale, Paris. Publications include *Manuel Alvarez Bravo* by Luis Cardoza y Aragón, 1935; *Manuel Alvarez Bravo: Fotografías 1928–1968* (brochure), 1968.

'It requires an unusually sensitive artist to undertake the analysis of something as intimate as the mythology of his own culture. However, even with genius, such analysis is of little value unless it finds a means of expression. . . .

'Formed as he is by his culture, there is in his work an obvious absence of fear in daily existence. He courageously encounters the presence of death, be it direct or implied, at every opportunity. Life and death approach equality and are almost interchangeable.'
(Fred R. Parker, in *Manuel Alvarez Bravo*, 1971.)

Manuel Alvarez Bravo, *Los obstáculos*, 1939.

Dorothea Lange

1895–1965

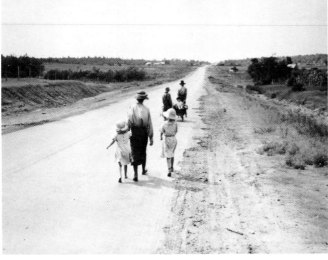

Dorothea Lange, *Homeless family, tenant farmers, Oklahoma*, 1936.

Born in Hoboken, New Jersey. Attended New York Training School for Teachers, 1914–17. Deciding on photography as a career, worked for a while with Arnold Genthe and studied under Clarence White at Columbia University, 1917–18. While setting off on a photographic trip around the world, her funds ran out and she settled in San Francisco. Opened portrait studio, 1919. Photographed for Paul S. Taylor's report on migrant labour for Californian State Emergency Relief Administration, 1935. Worked for Resettlement Administration (later known as Farm Security Administration), 1935–42; War Relocation Authority, 1941–3; Office of War Information, 1943–5. Covered formation meeting of United Nations for State Department, 1945. In 1950s contributed stories to *Life*; photographs reproduced in thousands of newspapers and magazines around the world. Award: Guggenheim fellowship, 1941 (gave it up to work for war effort). Selected exhibitions: Biblioteca Communale, Milan, 1961; 'The Bitter Years,' Museum of Modern Art, New York, 1962; 'The Compassionate Camera: Dustbowl Pictures', Victoria and Albert Museum, London, 1973. Collections: Oakland Museum, California; Library of Congress, Washington, DC. Books include: *An American Exodus: A Record of Human Erosion* with Paul Taylor, 1939 (reprinted 1969); *The American Country Woman*, 1967.

Dorothea Lange used her lens to make statements that were straightforward. 'Hands off!' she would shout – meaning that nothing must be changed or arranged for her picture-taking. The people she liked to photograph were certainly not the sort of people who would like to be arranged. The intention was to reveal the farmers and their wives as they were with all the signs of their hard life indelibly stamped on their faces and bodies. She did not flinch at the very fat-armed and bulging-bosomed young farmers' wives or the withered skin of the old.

Dorothea Lange has long been an institution in the United States. From the early pictures taken of her, she appears a somewhat self-satisfied, simpering spinster. In older age she became as rugged as her subjects: weatherbeaten, wrinkled, with boyishly cropped grey wire-hair.

The *summum* of her work is of people and things that have now become scarce or have almost entirely disappeared: she showed us part of the world that few others knew. She showed 'American Country Women' with an honesty that is unaccept-

able to those who feel there are limits to what a plain woman should be, and that although there is great merit to be found in the homespun, there is less in the cheap nylon-spun. One knows that Dorothea Lange is right in not baulking at portraying some of the ugly aspects of poverty, for ugliness has its fascination, and even, perversely enough, its own beauty; but their plainness is something that only a few artists have been able to utilize as subjects. Many of Dorothea Lange's 'Women of America' are merely plain.

In the early 1930s the American government, through the Farm Security Administration established by President Roosevelt, sent out a group of top photographers to make a reportage of the plight of the Mid-western farmers and their families. Because of a four-year drought and the takeover by big farming industries they had become destitute, and in desperation were driven out to seek a new life – perhaps as far away as California.

The project was the beginning of large-scale documentary photography in which there were no obligations to editor or sensation-loving public. There was no date-line. All the artists commissioned rose to the occasion with brilliance. It is interesting to see how varied were their results. The theme they portrayed was of exhaustion – exhaustion of the soil and of the people. Strangely, the effect was not so deeply depressing for, although they showed unsparingly the abject conditions of poverty, the pictures were testimonials of human dignity.

It was natural that Dorothea Lange should be one of the leaders of the expedition. Much of her direct reporting told the story of heart-rending poverty with a force that shocks one. She did not spare any sad detail. *The Migrant Mother* became her masterpiece and one of the best-known pictures of the century. It depicted a mother of seven at rest at a pea-pickers' camp. Two of her children are seen with heads turned away, perhaps in despair; the face of the woman is slightly out of focus, but the expression is haunting as she sits, hungry and desperate, doubting of the future in that bitterly cold March of 1936. Here, as in all her pictures, the human hand is of great interest and often beauty. The squatters in the bush are as poor as any character of Steinbeck, yet somehow Dorothea Lange produces distinction from their acceptance of their fate.

Dorothea Lange's 'Dustbowl' pictures are inspired by a journalistic sense, and they made quiet and terrible comment as she followed the émigrés – walking with a pram or a small barrow containing their worldly possessions – along the endless roads with the vast, high skyline above them. The émigrés continued on past abandoned farms on their way to look for jobs – past the vast poster of a man, leaning back in his comfortable seat, saying: 'Next Time Travel by Train, Southern Pacific'. Dorothea Lange's quick eye picked up the terrible abandoned rubbish, the cracked and parched earth, and the huge advertisement for Al G. Smith & Co. Ltd, with its glorious coloured idyll illustrating 'There's No Way Like the American Way – World's Highest Wages'. One Missouri farming family of five have been in their jalopy en route to the west for seven months.

There is no doubt that Lange had a real involvement, and also an affection and respect for the people she photographed.

Perhaps it is true to say that she went beyond portraiture to exploring social concern with her camera. She always tried to picture human beings as a part of their surroundings – as if they had roots somewhere – even if she was photographing people who were homeless and transitory. Lange also tried to convey a sense of time: 'Whatever I photograph, I try to show it as having its position in the past or in the present.'

Much depended on the meticulous technique of these Dustbowl photographers in showing us the bleak, low horizons, and potato-pickers – men with hats covered with holes. Occasionally a haunting scene, such as one or two by John Vachan, has little effect for it is slightly out of focus and, therefore, might be the work of any hurried press photographer.

Mae Burroughes, the wife of a cotton-cropper from Alabama, was depicted by Walker Evans with the cracks on her parched lips, the bald patch in her black strong hair, and the fluffy down around her chin. But the look of beauty in her eyes was transcendent.

Rothstein contributed a picture that is eternal. The painter, Ben Shahn, photographed raven-thin women with scraggy arms, and children of the Ozark mountains holding their dolls and kittens, sad-eyed and sad-mouthed: also cotton-picking children, with long bags hanging from their shoulders like deflated windsocks or pathetic court-trains. Carl Mydans worked near Lexington in Texas, using as his subjects outcasts hanging on to life by a thread in an abandoned hut. Russell Lee moved in close to show the hands of Mrs Andrew Oslemeyer, the wife of a homesteader, unbelievably cracked and worn like old boots.

The 'Compassionate Photographers' brought back historical documents. In comparison to anything that was being produced in England at that time they were milestones in the advance of photo-journalism. America is proud of the achievements and has made Dorothea Lange a national heroine.

Arthur Rothstein

1915–1985

American. Graduate of Columbia University. Joined Farm Security Administration, 1935–40. Staff photographer, *Look*, 1940; left shortly after to join Office of War Information and then army. Served as chief photographer for United Nations Relief and Rehabilitation Administration in China. Re-joined *Look* as technical director of photography, 1946; appointed director of photography, 1969. Became editor of *Infinity* magazine, 1971; visual aids consultant to US Environmental Protection Agency and American Iron and Steel Institute. Member of faculty of Graduate School of Journalism, Columbia University, from 1962. Developed the Xograph 3-D process over thirteen-year period. Regular columnist for *US Camera*. At present an associate editor of *Parade,* a Sunday newspaper magazine. A founder and former officer of American Society of Magazine Photographers. Exhibitions: Smithsonian Institution, Washington, DC; International Museum of Photography, New York; Museum of Modern Art, New York; Royal Photographic Society; Library of Congress, Washington, DC. Major collections: Library of Congress; Smithsonian Institution; Royal Photographic Society; International Museum of Photography; Museum of Modern Art. Books: *Creative Color*, 1963; *Photojournalism*, 1956; *Look at Us* with William Saroyan, 1967; *Color Photography Now,* 1970.

Dali, popes, 'Good Humour' men, Salvation Army workers, and the hooded members of the Ku-Klux-Klan, as well as many of the world's leading events and personalities. He documented the Quebec Conference at which the Second World War invasion of Europe was planned, the war in China, relief effort during the 1946 famine in China, and Cape Kennedy. Arthur Rothstein says of his work: 'The camera is the means by which I convey a meaning, a mood, or a sensation to others. I like to think of my efforts as primarily a form of communication.'

Arthur Rothstein made a masterpiece when he was sent out to document the plight of the farmers whose land had been devasted by drought. The most evocative of all the images of the 'Dustbowl' group is Rothstein's farmer and his small boys hurrying to their hut during a sandstorm in Cimarron in Oklahoma. We see them only in the semi-distance but, apart from its pictorial values, this fine picture seems to possess the germ that infected the paintings of Thomas Eakins and the more recent Philadelphian artist, Walter Stumpfig. Also great is a shot of the farmer without a job and without much hope for the future. His wife is obviously pregnant and her growing family share the general misery.

The 'Compassionate Photographers' brought back haunting evidence of the intense battle of man against nature at its cruellest, but none greater than Rothstein who, during the past years, has photographed space shots, baseball, rodeos, marching bands and cotton-picking. He has also included John Marin,

Arthur Rothstein, *Farmer and sons in dust storm, Cimarron County, Oklahoma,* 1936.

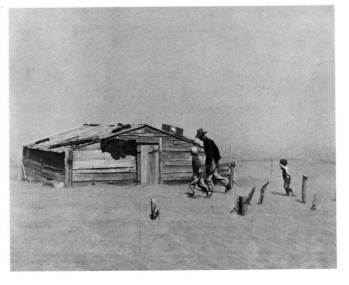

Maurice Beck

1886–1960

English. Attended Rugby School and then trained as an engineer. Apprenticed to Glasgow firm of shipbuilders. Went to Shanghai and served as secretary to the Chamber of Commerce; developed interest in photography. Opened studio in London with Helen MacGregor. Worked for Condé Nast Publications from 1922; for Shell Mex & BP Ltd from 1932. Commercial work included photography for London Transport, Rolls-Royce, etc. Special subjects: portraiture, fashion, theatre. Cameras: 7×5 inch, $3\frac{1}{4} \times 2\frac{1}{4}$ inch, $2\frac{1}{4}$ inch square, 35 mm; made his own half-plate wooden stand camera on a lathe. Exhibition: Piccadilly Hotel, London, 1923. Collections include: Royal Photographic Society.

A great variety of lenses were used in the late 1920s to portray the faces and styles of this most creative of periods. None succeeded in conveying the current attitudes better than Maurice Beck and Helen MacGregor. Maurice Adams Beck was an odd-looking figure with large horn-rimmed spectacles, black velvet jacket, a pullover tightly drawn over his large chest, grey flannel trousers and suede shoes, an Egyptian cigarette seldom out of his fingers. Although his conversation

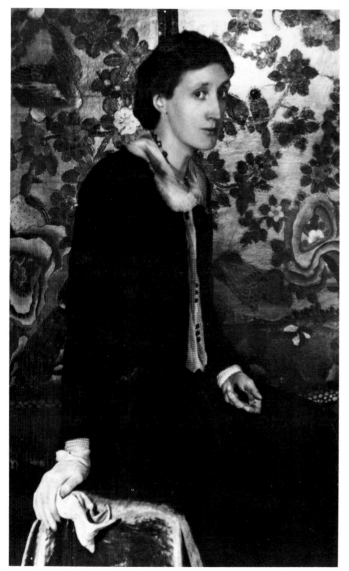

Maurice Beck and Helen MacGregor, *Virginia Woolf.*

was coarse in the extreme, his manners were likely to strike as impeccable. Beck, an old Rugbyian, was primarily an engineer, interested in racing-cars, some of which he built to his own design. As a photographer he had a strange originality but was underrated, partly because he would not admit his talents. One had the impression that he thought of himself as an 'old fake' and discouraged his friends, who affectionately nicknamed him 'Old Filthy', from taking his photographs seriously.

Helen MacGregor was small, Scottish and bun-faced, with a twinkle in her clear blue eyes. In middle age she dressed in homespun. This quiet but very determined little spinster and the rorty full-blooded Maurice Beck made an incongruous pair, but they worked together in great harmony in a Marylebone studio where they were the chief photographers for British *Vogue*. Neither of them had any great interest in fashion, nor, indeed, had their clever editor, Dorothy Todd, who wore black coats and skirts with a gardenia in her lapel and was interested in dresses only if they were made by the sister of Marie Laurencin or the great Poiret. But Miss Todd was interested in the world of the intelligentsia, as they were called at this time, and interesting people, such as Rebecca West, Cathleen Nesbitt, H. D. Maynard Keynes and Lopokova, T. S. Eliot, the Sitwells, Constant Lambert, and Dora Stroeva (who sang, in a deep bass voice, with a guitar, wearing a dinner jacket and a red chiffon scarf) came to the mews studio off New Cavendish Street.

There was always something insouciant about the lack of direction or rules with which Beck and MacGregor placed their lights: their haphazard effect often caused shadows with which other more professional photographers would have willingly dispensed. But for all their vagueness, the interesting results of the sittings were thrown onto a desk with an offhand assurance that what they had produced was interesting.

Exactly where Beck's influence began or MacGregor's talent took over is difficult to say. Only occasionally did they work on the same sitting, yet their pictures had a definite affinity and they both admired the young women who resembled young boys and the young men who looked like girls. It was a 'trade mark' that young sitters should be covered with oil in order to acquire a high polish before being photographed in the semi-nude.

Beck and MacGregor enjoyed all shiny things – the reflections from the polished table-tops, piano lids, or the various silver and gold screens that Beck had brought back from China, Hong Kong, where he spent several years.

Beck and MacGregor were never given the tribute of an album of their work, and their names have never been enrolled in the shrine of fame. But the pictures of Rudolph Valentino, who had the idea of making a film of Debussy's *L'Après-midi d'un faune* and posed in tights of mottled animal-skin, are alone worthy of perpetual interest. Of all the photographers to whom Virginia Woolf so readily sat, none has given us a finer version of that oddly beautiful and difficult woman than the 'odd' couple.

Herbert Lambert

c. 1881–1936

English. Father was Henry Lambert, a pioneer in camera portraiture. Succeeded father and brother in studio in Bath, 1900. A lecturer at Royal Photographic Society and Professional Photographic Association congresses. Managing director of Elliot & Fry, 1926–36. Book: *Studio Portrait Lighting,* 1930.

Herbert Lambert of Bath was a professional photographer of high quality carrying on his business in Milsom Street of that beautiful but dreadfully provincial city. In addition, he was for many years the manager of the successful London firm of Elliot and Fry, for whom he took many portraits.

Since Lambert was a man of wide cultural tastes, for whom music was a prime passion, it was not surprising that the musicians of his day, Elgar, Vaughan Williams, and the Dolmetsch family were his most successful subjects. His beautifully composed interiors, with Mrs Violet Gordon Woodhouse playing the harpsichord and Mr Rubio, the great cellist and friend of Casals, listening to this exquisite little genius, are typical of Lambert at his best. These rather 'Dutch School' black-and-whites are rare records of the musical milestone beautifully described by Osbert Sitwell in the last volume of his autobiography.

Lambert also photographed the available collection of Fox Talbot's fading prints and was a great collector of seventeenth- and eighteenth-century books.

Herbert Lambert came of a Quaker family, was cruelly imprisoned in the 1914 war for being a conscientious objector. But gossips invented scurrilous reports about him and rumoured the fantastic slander that Lambert practised black magic. There was no possible foundation for this except perhaps that Lambert produced strange sounds while making clavichords as a hobby.

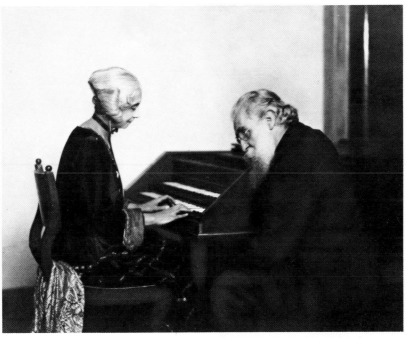

Herbert Lambert, *Mrs Violet Gordon Woodhouse at the Harpsichord.*

Lotte Meitner-Graf

?–1973

Born in Vienna. Studied at the Graphische Lehr- und Versuchsanstalt, Vienna, and later at Munich and Warsaw. Left Austria with her husband, Dr Walter Meitner, for England, 1938. During the war managed Fayer Studio, Grosvenor Street, London. From about 1953 ran her own studio; photographed celebrities and working people.

Lotte Meitner-Graf was the daughter of a distinguished Viennese lawyer and was married to a well-known chemist. She escaped from Hitler and, arriving in London, managed the firm of Fayer of Vienna, a studio, signing (by contract) all her photographs with Fayer's name.

When she escaped once more to her own studio on the top of a liftless building in Old Bond Street, her comely portrayals – sharp, and of a dark tonality – improved, as did the quality of her sitters. For Lotte Meitner-Graf was extremely intellectual and took pictures of Nobel prize-winners, scientists and musicians. Among her signal portraits, always carefully lit to bring out the sculptural planes of a face, are those of Albert Schweitzer, Klemperer, Artur Rubinstein, Menuhin, Marian Anderson, Nehru and Bertrand Russell. A meticulous artist, uncommercial and uncompromising, she made her own conception of nature; but it was the unretouched, unvarnished human face that brought out the best in her.

Charles Sheeler

1883–1965

Born in Philadelphia; Pennsylvania. Studied at School of Industrial Art, 1900–1903; studied painting under William M.Chase at Pennsylvania Academy of Fine Arts, 1903–6. Began to photograph professionally, 1912. Photographed works of art for Marius de Zayas's Modern Gallery, New York, 1916. Although earned living by doing freelance photography for magazines such as *Fortune*, copying works of art, and as staff photographer for Condé Nast, 1923–9, considered himself primarily a painter. After 1945 had no vocational connection with photography. Exhibitions: Modern Gallery (with Paul Strand and Morton Livingston Schamberg), 1917; 'Doylestown House Photographs', Modern Gallery, 1917; Museum of Modern Art, New York, 1939. Major collections: International Museum of Photography, Rochester, New York; Museum of Modern Art; Metropolitan Museum of Art, New York; Library of Congress, Washington, DC. Books include: *Egyptian Statues*, 1945; *Egyptian Statuettes*, 1945; *The Great King, King of Assyria*, 1946; 'Charles Sheeler, American Photographer' by Charles W.Millard III in *Contemporary Photographer*, VI, 1, 1967.

Charles Sheeler, unlike so many others, started professionally as a photographer and switched to painting. But as a young man he could not support himself with painting alone, so took up the photography of architecture and works of art as a means of subsistence which he felt would in no way conflict with, and might possibly assist, his work as a painter.

Sheeler made trips to New York, and like so many palmy photographers, he came under the influence of Alfred Stieglitz at the '291' studio. Sheeler's own photographic vision – which demanded all-over sharpness of texture – coincided with that of the acknowledged master.

Sheeler made photographs of the interior of his Doylestown house, which were among the first he exhibited, and which he wanted to show as a series. They are reflective studies of architecture and of quiet, almost empty interiors with perhaps only a window open to the night, or a chimneypiece without a fire as interest. But Sheeler preferred the countryside to urban centres and evoked with obvious delight the clear-cut farm buildings and the clean countryside.

Sheeler enjoyed taking pictures of barns, and his best-known photograph, called *Bucks County Barn* or *Side of a White Barn*, dates from 1915. He then started to take still-life and modern painting and sculpture, especially African and pre-Columbian.

Sheeler later started an assemblage of photographs of New York buildings taken from above and looking down, finding complex patterns of life and forms.

In 1921 he collaborated with Paul Strand on the film *Manahatta*, released under the title *New York the Magnificent*, basically a series of 'stills'. They were both involved in 'the abstract organization of reality'.

In 1923 Steichen was taken ill and Sheeler understudied for him at *Vogue* by doing portraiture and even fashions – an occupation that was to last eight years. Sheeler also did freelance advertising which led to one of his most important contributions. In 1927 he received a commission from the Ford Motor Company to document its River Ruge plant – not for advertising pictures but to serve as a creative visual document of an industry. He spent six weeks there, but only took thirty-two pictures.

In later years Sheeler turned more and more to painting, but with the outbreak of the Second World War he feared his canvases would not be sold, so reverted to photographing works of art for the Metropolitan Museum of Art as a staff photographer.

Charles Sheeler, *Williamsburg Stairwell*, 1935.

Barbara Morgan

b. 1900

Born Barbara Brooks Johnson in Buffalo, Kansas. Studied Art at University of California at Los Angeles, 1919–23. Married Willard D. Morgan, 1925. Taught design, landscape and woodcut, University of California at Los Angeles, 1925–30. Since 1935 has exhibited her photographs, paintings and graphics and contributed to various publications including *Aperture, Dance Magazine, Image, Magazine of Art*. Co-owner Morgan & Morgan, Inc., publishers, Hastings on Hudson, New York. Principal themes: photomontage, dance, people, nature, junk. Cameras: Leica, Rolleiflex, 4 × 5 inch, 5 × 7 and 8 × 10 inch view, etc. Award: American Institute of Graphic Arts Trade Book Clinic. Selected exhibitions: 'Dance Photograph Touring Exhibitions, I, II, III and IV', circulated to over 150 centres, 1940–3; World Youth Festival, Prague, 1947; 'Summer's Children', International Museum of Photography, Rochester, New York, 1955; Société Française de Photographie, Paris, 1964; 'Barbara Morgan: Women, Cameras, and Images IV', Smithsonian Institution, Washington, DC, 1970; Museum of Modern Art, New York, 1972; Collections: International Museum of Photography; Museum of Modern Art; Smithsonian Institution; Library of

Barbara Morgan

Congress, Washington, DC; Metropolitan Museum of Art, New York; Philadelphia Museum of Art; Princeton University Library; UCLA Library; National Portrait Gallery, Washington, DC; Lincoln Center of the Performing Arts, New York; Massachusetts Institute of Technology. Books: *Martha Graham: Sixteen Dances in Photographs*, 1941; *Prestini's Art in Wood* by Edgar Kaufmann, Jr., 1950; *Summer's Children*, 1951; *Barbara Morgan Monograph, 1972.*

Barbara Morgan is a woman with a voice full of pathos and warmth. Perhaps it reflects her true character – deep, humorous and highly civilized. In her long lifetime she has gained the recognition that she did not search for, yet so well deserves.

When, as a young child, Barbara Morgan's father told her that the world was full of continuous movement, created by never-still atoms, Barbara began her exploration. She watched the gestures of plants, and everything that contained living energy.

Later, Barbara Morgan became an abstract painter and went to live in California. When she married a photographer she helped him in his work, but after the birth of her children she could not find enough time to paint. Instead, while her children were asleep at night, she worked at photography. She explains that it was a traumatic experience to decide eventually that this was to be her life's work. She knew she must bring to it the same attitudes as towards her painting.

As in her canvases, the theme in her camera images always was that of intrinsic movement. She studied the drawings on the walls of the Lascaux caves and other prehistoric forms; she became interested in symbols and gestures, and from the Indian ritual dances she turned to the art of Martha Graham. For five years she concentrated on this expert interpreter of modern dance forms. She made her into a moth, molten wax, a cabbage-leaf and a blade of grass. Rather than combat the hazards of a theatre setting, she preferred the more intimate atmosphere of a studio the better to produce her previsualized notions of movement.

She wrote: 'Previsualization is the first essential of dance photography. The ecstatic gesture happens swiftly and is gone; unless the photographer previsions in order to fuse dance action, light and space simultaneously, there can be no significant dance picture.' Sometimes Barbara Morgan carries a picture, or the idea of a picture, in her mind for days or months, and only when she is 'full of the subject, ideas and treatment' does she elect to click the shutter.

When Barbara Morgan took a picture of a corn-leaf it is significant that she called it 'a corn-leaf rhythm'; an old tree-stump, showing the circles of its years of life, is likewise an essay in concentric movement. She gave a new aspect to an amaryllis bud and the amaryllis seed-pod, and made an innovation of the hairiness of a man's leg in contrast to the hairs on a leaf.

It is in these details of nature with which she embodies the spirit of growth or movement that her talent lies. Barbara Morgan reacts not to the surface motion, but to the 'invisible axis of the form'. In some of her montages – in yet another attempt to achieve a feeling of movement – she combines men marching along as if to a funeral, a photogram of a

Barbara Morgan, *Martha Graham, Ekstasis,* 1935.

flower with a vista of city buildings. Some of her collages may appear to the novice as too simplistic: but Barbara Morgan's output warrants and demands study, and it becomes clearer why she placed a leaf against a skyscraper, and one single giant shell upon a town. Still, the *Inner and Outer Man* – a silhouetted profile superimposed on a skull – remains baffling. Barbara Morgan excels at dance interpretations. They convey the taut intensity and coiled-spring force of balletic vitality. Somehow she manages to infuse them with a significance 'which could relate to some specific aspect of life'.

As a practising photographer Barbara Morgan's work is variable: she is good with a corn tassel through a broken windshield; her feelings for children are profound, but her pictures of them are trite. Her attempts to catch moods or gestures in her outdoor portraits are successful only with Gerald Heard with his long, wiry fingers, monkey-like Merce Cunningham, and white-haired Charles Sheeler, owlishly blinking behind his glasses, against his favourite tree.

But it is as an intellectual woman of the purest integrity and as lecturer of truth that she is a significant figure, not only to her own country, but to the world. Barbara Morgan feels that as we enter into an even more complex space age, it will be harder for the one-track mind to survive, and she sees the increasing need for photomontages of movement – and of the dance.

173

Robert Capa

1913–54

Born in Budapest; US citizen. Real name André Friedmann. Attended university in Berlin; began work as a photographic assistant, 1931. Moved to Paris as Nazis came to power, 1933. Photographed the Spanish Civil War, 1936. Reported on the Japanese invasion of China, 1938. Photographed the war in Europe as a correspondent for *Life* and other magazines, 1941–5. Helped found Magnum Photos and worked towards its growth, 1947–54. Recorded the struggles of Israeli independence, 1948–50. Killed by a landmine while on assignment in Indo-China, 1954. Selected exhibitions: 'On Picasso' with Gjon Mili, Museum of Modern Art, New York, 1952; 'Robert Capa – War Photographs', circulated in USA by Smithsonian Institution, Washington DC, 1960; 'Images of War', Smithsonian Institution, 1964; 'The Concerned Photographer', Riverside Museum, New York, 1967. Collections: Bibliothèque Nationale, Paris; International Museum of Photography, Rochester, New York; Metropolitan Museum of Art, New York; Museum of Modern Art; National Gallery of Art, Washington, DC; Riverside Museum; Smithsonian Institution. Books include: *Death in the Making*, 1937; *The Battle of Waterloo Road*, 1943; *Slightly out of Focus*, 1947; *The Russian Journal* with John Steinbeck, 1948; *Report on Israel* with Irwin Shaw, 1950; *Images of War*, 1964.

Robert Capa photographed five wars in eighteen years. He hated war, but felt it was impossible to stand aloof from events which were affecting the lives of humanity. The cruelty of man and the futility of war obsessed him. To turn the pages of *Images of War* is a harrowing experience. Only occasionally – as with *The Soldier and the Kitten* – was he sentimental. His portrait of John Christie, the founder of the Glyndebourne opera, being bitten by a pug is wonderful. Capa was not afraid to show bloodshed. His pictures possess an extraordinary vitality – if little pictorial quality.

He was a fighter rather than an artist with a camera, and as a fighting journalist he knew where the great news picture was to be found. He was with the troops in the water in the Normandy landings. He is quoted as saying, 'If your pictures aren't good enough, you aren't close enough.' He got in ever closer to the fray until he paid with his life for his courage.

Robert Capa, *Spain*, 1936.

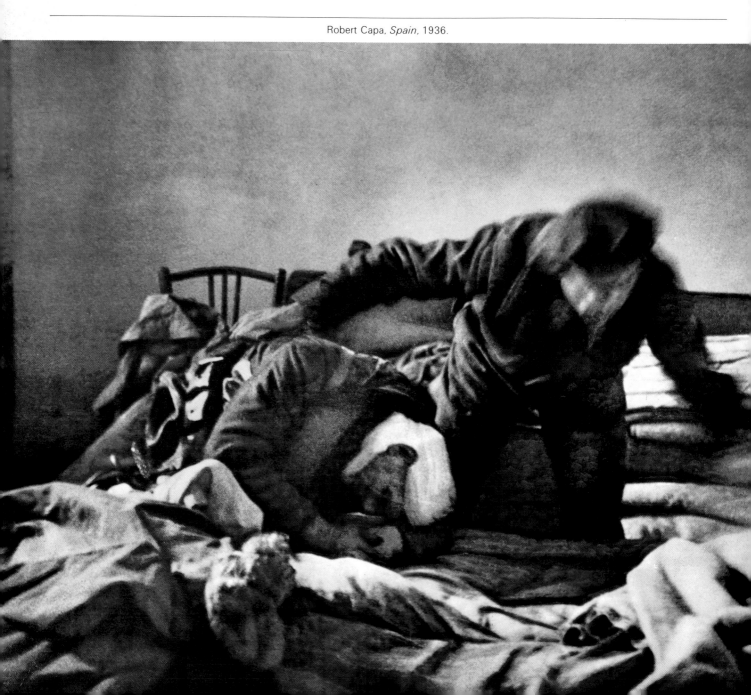

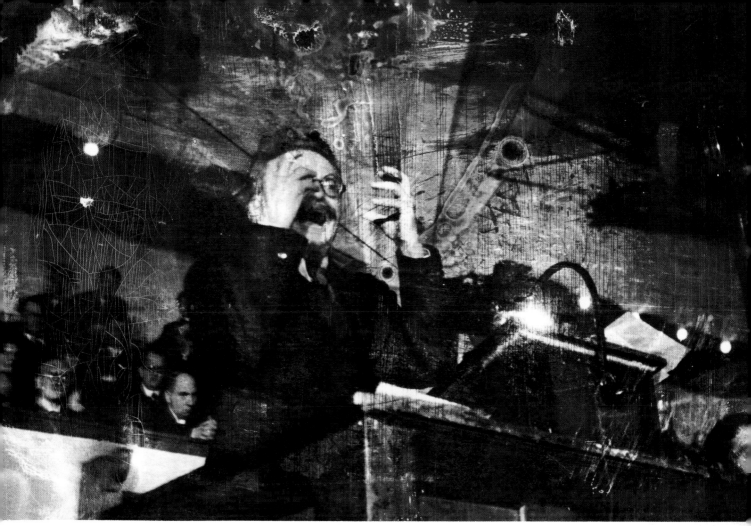

Robert Capa, *Leon Trotsky, Copenhagen, 1932*;
this is Capa's first published photograph.

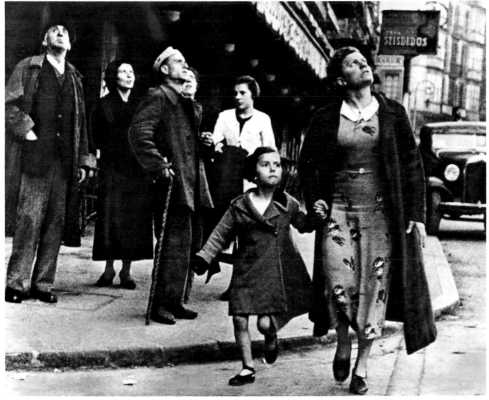

Robert Capa, *Spain*, 1936.

Aaron Siskind

b. 1903

Aaron Siskind, *Arizpe, Mexico,* 1966.

Born in New York City. Received degree from City College of New York, 1926. Taught English in New York public schools, 1926–49. Joined Film and Photo League, New York, 1930; worked in documentary style investigating social problems, 1932–41. Began working with flat plane with organic objects in strong patterns, 1943. Started teaching at Institute of Design in Chicago, 1951; appointed head of photography, 1959. Co-editor of *Choice,* magazine of poetry and photography, 1962. Work published in *Fortune, Graphis, US Camera Annual, Harper's Bazaar, Camera Time, Industrial Design.* Lecturer at Rhode Island School of Design, 1971; visiting lecturer at Harvard University. Camera: 4 × 5 inch Meridian with Dagor lens. Awards: Guggenheim fellowship, 1966. Exhibitions: 'Tabernacle City', Photo League, New York, 1941; Museum of Modern Art, New York, 1941, 1965, Egan Gallery, New York, 1947; Chicago Art Institute; Denver Art Museum; Santa Barbara Art Museum; International Museum of Photography, Rochester, New York, 1965. Collections: Museum of Modern Art; International Museum of Photography. Books: *Aaron Siskind: Photographs,* 1959; *Photographs by Professors* (catalogue, notes by Lew Parella), 1960; *Spring of a Thief,* 1963; *Aaron Siskind: Photographer,* 1965.

Siskind worked as a documentary photographer and became an exceptional photo-journalist interested in social problems of men. With a fine work on the Harlem slums to his credit, he had in the late 1940s a great change, a complete transformation, of personal vision.

Although his new work was appreciated by contemporary painters, most photographers, who in general are more short-sighted about trends in art, were baffled. Suddenly Siskind had said, 'For the first time in my life subject-matter as such has ceased to be of primary importance.' For his new style he confined himself to man-made structures and the designs within them, and his photographs of stones and strange menacing boulders in Rome were sometimes reminiscent of the work of the painter Rouault. But whereas Edward and Brett Weston, Ansel Adams and so many others had shown such subjects as details of nature, Siskind said, 'I'm not interested in nature, I'm interested in my own nature,' and he looked around and saw what no one else had seen as being strange and beautiful – part of a brick wall in Chicago, a plaster partition gashed by a workman to become a great abstract design, the erosion on the paint on a hoarding, the jagged pattern of broken glass in a window of an empty house, and – looking like a Matisse design of birds – oil stains on paper. Siskind has always had a super-positive sense of composition, and his original sharp, shiny images are technically unsurpassed in photography.

Before Siskind, students never thought of photographing the peeling plaster, the cracking cement, the scrawled designs and graffiti on walls. But his vision is so strongly individual that it has had an infectious effect on the young.

In *Spectrum* in 1956 he wrote, 'When I make a photograph I want it to be an altogether new object, complete and self-contained, whose basic condition is order (unlike the world of events and actions whose permanent condition is change and disorder). The business of making a photograph may be said in simple terms to consist of three elements: the objective world (whose permanent condition is change and disorder), the sheet of paper on which the picture will be realized, and the experience which brings them together.'

The work of certain American photographers today is very closely allied to that of contemporary painters. Aaron Siskind's extraordinarily beautiful abstract black-and-white prints have as much colour as many Mirós or Jackson Pollocks.

Cecil Beaton

1904–1980

Born in London. Educated at Harrow and Cambridge. Intermittently worked for Condé Nast publications, *Harper's Bazaar,* and produced several covers for *Life.* Official photographer to Ministry of Information during Second World War. Designer of scenery and costumes for ballets in London and New York including *Apparitions, Illuminations, Marguerite et Armand, Swan Lake, Picnic at Tintagel.* Designed the décor and costumes for theatrical productions in New York and London including *Lady Windermere's Fan, The Second Mrs Tanqueray, Quadrille, The Chalk Garden, My Fair Lady, Love's Labour's Lost;* for Metropolitan Opera Company's productions of *Vanessa, Turandot, La Traviata;* for Comédie Française's production of *The School for Scandal;* and for films *Gigi, The Doctor's Dilemma, My Fair Lady.* Cameras: folding Kodak No. 3A, 10 × 8 inch plate, Rolleiflex, Nikon, Pentax, Polaroid, Instamatic. Awards include: two Oscars for *My Fair Lady,* one for *Gigi;* knighthood, 1972. Exhibitions: Redfern Gallery, London (painting and stage designs), 1936; Sagittarius Gallery, New York (painting and stage designs), 1956; Redfern Gallery (scenery and costume design), 1958, 1965; Lefevre Gallery, London (painting), 1966; and those devoted to photography: Cooling Gallery, London, 1930; National Portrait Gallery, London, 1968; Sonnabend Gallery, New York, 1973; Kodak House, London, 1974. Books: *The Book of Beauty,* 1930; *Cecil Beaton's Scrapbook,* 1937; *Portrait of New York,* 1938; *My Royal Past,* 1939; *History under Fire* by John Pope-Hennessy, 1941; *The Glass of Fashion,* 1954; *It Gives Me Great Pleasure,* 1955; *The Face of the World,* 1957; *Japanese,* 1959; *Cecil Beaton's Diaries* (*The Wandering Years*), 1961; *Quail in Aspic,* 1962; *Images,* 1963; *Royal Portraits,* 1963; *Cecil Beaton's Diaries* (*The Years Between*), 1965; *The Best of Beaton,* 1968; *My Bolivian Aunt,* 1971; *Cecil Beaton's Diaries* (*The Happy Years*), 1972 and (*The Strenuous Years*), 1973. Play: *The Gainsborough Girls,* produced 1951.

Cecil Beaton, *Shell-Shattered Ceiling, Tobruk,* 1943

'It is not difficult to discern Beaton's influence in the work of others; a harder task is to identify those who have influenced him.' (Truman Capote in the Introduction to *The Best of Beaton,* 1968)

Brett Weston

b. 1911

Brett Weston, *Broken Window, San Francisco,* 1937.

Born in Los Angeles. The second son of Edward Weston, went to Mexico with father, 1925; started to photograph and exhibit his prints. Several times set up portrait studios with Edward, and when possible they went on photographic expeditions together. Worked for movie producers and aeroplane factories, 1941–3. During Second World War photographed in New York City. When Edward was stricken with Parkinson's disease in 1948, devoted several years to helping get out such projects as *50th-Anniversary Portfolio,* 1955, and *Archive* (eight prints off each of some 800 negatives), 1955–6. Photographs reproduced in *US Camera Annual, California Arts and Architectural, Fortune* and numerous international publications. Cameras: 10 × 8 inch and 11 × 14 inch view. Award: Guggenheim fellowship, 1946. Exhibitions include: Julien Levy Gallery, New York; M. H. de Young Memorial Museum, San Francisco; San Francisco Museum; Museum of Modern Art, New York. Collections include: Museum of Modern Art. Publications: 'Brett Weston, Photographer', *Camera Craft,* March 1940; *Brett Weston Photographs,* text by M. Armitage, 1956.

Brett Weston, son of Edward Weston, under his father's tutelage began photographing in Mexico at the age of twelve.

Although he considers Carmel in California as his home, he has spent much of his life travelling throughout the United States and to most countries of the world. His intention in photographing the landscape, man's structures and details of value is not only to make a record of exciting visual experiences, but to create a profound impression beyond verbal description.

For a long time he used a large-plate camera, but he found that a single-lens Rolleiflex gave him greater flexibility and depth. Like his father he chooses for his favourite subjects rock-forms, shapes and textures of sand, clouds and pine-trees. Like his father's they have a wonderful stillness. But Brett's prints – so crisp and clear – are stamped with a personal idiom that has been recognized internationally. He sells his prints individually and has produced seven portfolios of original photographs.

Yousuf Karsh

b. 1908

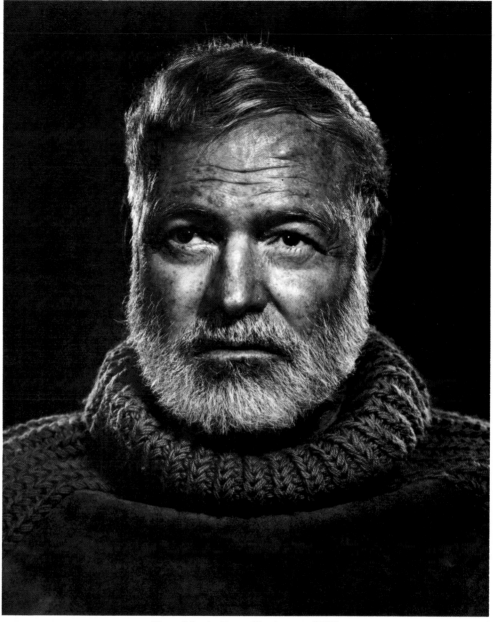

Yousuf Karsh, *Ernest Hemingway*, 1957.

Born Mardin, Armenia (Turkey); Canadian citizen. After arriving in Canada in 1924 studied photography for three years under John H. Garo, in Boston. Opened portrait studio in Ottawa, 1932. Became internationally prominent when his portrait of Winston Churchill appeared on cover of *Life*, December 1941. Cameras and films: 35 mm, $2\frac{1}{4} \times 2\frac{1}{4}$ inch Hasselblad, 4×5 inch and 8×10 inch view cameras; Tri-X and Kodachrome II for miniature work, Royal Pan and Ektachrome III for large cameras. Awards include: Medal of Service of the Order of Canada, 1968; Honorary Fellow of Royal Photographic Society, London, 1970; Major exhibitions: National Gallery of Canada, 1959; 'Men Who Make Our World', Expo '67, Canadian Pavilion and throughout the world. Major collections: National Gallery of Canada; Museum of Modern Art, New York; Metropolitan Museum of Art, New York; Art Institute of Chicago; St Louis Art Museum, Missouri; International Museum of Photography, Rochester, New York; Royal Photographic Society, London; Museum of Modern Art, Tokyo. Books include: *Faces of Destiny*, 1946; *Portraits of Greatness*, 1959; *This is the Mass*, 1958; *In Search of Greatness*, 1962; *Karsh Portfolio*, 1967.

Karsh has taken remarkable pictures of such photogenic marvels as Hemingway and Churchill. He apotheosizes the great, and gives his lordly ones the dignity that they feel they deserve.

Perhaps even more than in 'bringing out character', he is interested in the technical importance of lighting, posing and developing. The results are super-perfect. We can see every little pore on the cheek-bone, every sheen on the nose, we can, like a fly, crawl over the surface of the noble face, but even so Karsh's pictures remain static and wrought of wax. In spite of its technical perfection I feel much of it might well have been done half a century ago. Karsh is not a ladies' photographer. It is to his credit that even the man to whom photography means little, has heard the name of Karsh resounding from the top of the highest building.

Angus McBean

b. 1904

Born in Newbridge, South Wales. The son of a surveyor, spent early years as a bank clerk in Wales and for seven years as shop assistant at Liberty's in London. Spent a year at home making decorative masks and photographing; held small exhibition of his work, 1934. Worked in London studio of Hugh Cecil, 1934–5. Opened own studio in London in 1935. When first beginning, photographed theatre productions for nothing and sold pictures to *Sketch* and other periodicals. Photographed practically all the shows in London and took portraits of actors and actresses in his studio, 1931–71. Produced surrealist portraits for *Sketch* nearly every week for two and half years; often collaborated with artist Roy Hobdell who painted the backgrounds. Surrealist portraits published in *Lilliput* as eight-page supplement. Special subject: the theatre, portraiture. Camera: half-plate reflex fitted with $7\frac{1}{2}$ inch Tessar lens; Sinar 5 × 4 inch, Hasselblad. Award: Fellowship, Institute of British Photographers. Exhibitions: outside almost every theatre in England for thirty years; Kodak Gallery, London, 1964; 'Thirty Years of Opera', The Maltings, Snape, 1971; Benjamin Britten's 'Shrine of Music', Aldeburgh Festival. Collections: Harvard Theater Library; Royal Photographic Society, London.

Angus McBean must be stage-struck. He was to Shaftesbury Avenue what Florence Van Damm was to Broadway. For thirty years this tall, agile man with the dark red beard and bald head leapt backwards and forwards from the stage to the auditorium as he undertook every photo-call with his old-fashioned camera and heavy glass-slides.

Angus McBean, *Audrey Hepburn.*

Edouard Boubat

b. 1923

Edouard Boubat, *Lella*, 1959.

Born in Paris. Studied book-printing, design and typography at École Éstienne. Worked as a photogravure printer, making high-quality reproductions of paintings, 1942–5. Staff photographer *Réalités*, 1951–65; subsequently freelance specializing in reportage and portraits. Camera and film: Leica and Tri-X. Awards: Kodak prize at Bibliothèque Nationale exhibition in Paris, 1947. Exhibitions: La Hune Gallery, Paris, 1951; Museum of Modern Art, Stockholm, 1967; Bibliothèque Nationale, 1973. Collection: Bibliothèque Nationale. Books: *Ode maritime*, 1957; *Les Nouvelles messageries de la presse parisienne*, 1960; *Edouard Boubat*, 1966; *Woman*, 1972; *Miroirs*, 1973; *Edouard Boubat* edited by Daniel Mauprey, 1973. Films: *Chambre Noire* for French television, 1966; *Photo by Boubat* for Swedish television, 1967.

Howard Coster

1885–1959

Born at Ventnor, Isle of Wight. Apprenticed to his uncle, a photographer. In photographic section of RAF, 1918–19. Worked in South Africa as a professional photographer, 1904–26. Camera and film: Zeiss Super Ikontex and Rolleiflex; glass negatives to modern films. Collections: Central Office of Information, London; National Portrait Gallery, London; Royal Photographic Society, London.

Howard Coster's apprenticeship to photography began in his uncle's daylight studio in Ventnor, Isle of Wight. The young Coster prepared the wet plates and helped with the printing.

Howard Coster started his own professional career in South Africa in 1904. He took his camera around the Orange Free State to photograph the farmers, their assistants and their stock. Later, in Bloemfontein, he rose to become a photographer of children, weddings and funerals.

When he settled in London he became the self-styled 'Photographer of Men'. To his credit are some good portraits but his sunlit alfresco picture that has now become historic is of the legendary T. E. Lawrence.

Howard Coster, *Lawrence of Arabia*, 1935.

George Rodger

b. 1908

Born in Cheshire. Attended St Bees College, Cumberland. By the time he was eighteen had been round the world twice as a merchant seaman. Spent six years in the United States working for an up-state New York optical firm, canning company, fruit farm, etc.; started to photograph. Became a full-time professional in England by working for BBC, 1936–9. After freelancing for one year, *Life* gave him a roving commission on a retainer basis for seven years; photographs published in *Picture Post* and *Illustrated* as well as *Life*. Helped found Magnum Photos, 1947. Freelanced throughout the world, considerable time spent in Africa. Special subjects: reportage, documentary, feature articles. Camera and film: Leica, Pentax, Nikon; Ektachrome, Kodachrome II, Tri-X. Collections: Rijksmuseum, Amsterdam; Museum of Modern Art, New York; Bibliothèque Nationale, Paris. Books include: *Desert Journey*; *Red Moon Rising,* 1943.

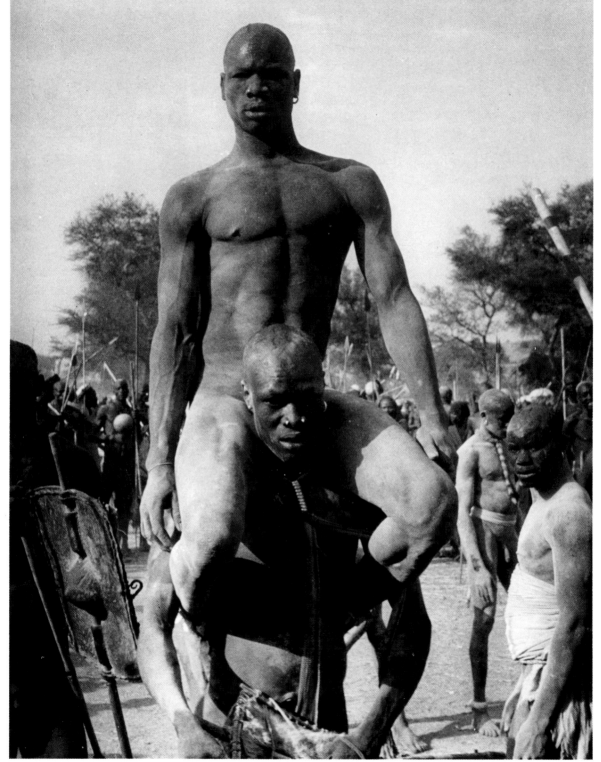

George Rodger, *A Korongo Nuba tribesman, victor of a wrestling contest.*

George Rodger is a born traveller. He joined the Merchant Navy at seventeen, and later gave up his import–export business in the United States in order to travel the world. His Leica was his *laissez-passer*. He became one of the first photo-reporters and made records of almost every country where stark drama is to be found.

During the war years he was in the Middle and Far East, in Italy, in France for the landings in Normandy, and in Germany at its time of defeat. So horrendous were some of the sights he photographed that he decided forthwith never to photograph another conflagration.

Instead he has concentrated on showing the vanishing life of the tribes and wildlife in Africa.

A friend of Robert Capa, David Seymour (Chim), and then Cartier-Bresson, Rodger formed the quartette that started the firm of Magnum. A warm-hearted man, he has the knack of making friends easily – an important attribute for the roving photographer. He does not pretend to be an artist and has said: 'I never attempt to interpret life – nothing as deep or abstract as that.' Although his work has given him renown, he remains the same unassuming man.

George Rodger wrote: '. . . I was interested in the minorities throughout the world, maybe downtrodden people, the people of Africa who didn't have a voice of their own. I liked to feel that by photographing and writing about the under-developed countries, I could put my photographs to some useful purpose. To me it was just wasting time to do some of the stories that I was supposed to do if I was on the staff of some magazine. I wanted to get on record what I call the Vanishing Africa – the wildlife that is fast disappearing as well as the last remaining primitive tribes. I think it could be said that, after seeing the awful havoc that war can create, I wished to spread understanding between one nation and another. I didn't develop to the extent of a crusade, but at the back of my mind, I think, that was my ideal.'

Wolfgang Weber

1902–1985

Born in Leipzig. Studied ethnography and music. Commissioned by the Phonetic Institute of the University of Berlin to research and record the music of the Vadjagga on Kilamanjaro. After doing some studio and advertising photography, became a picture-reporter under Simon Guttman and Felix Man. First photo-essays had strong cultural emphasis; later, more political. Early work published in *Berliner Illustrierte* and for Ullstein-Verlag. Chief reporter of 'Word and Picture', *Münchner Illustrierte Presse*, prior to Second World War. After war, chief reporter, *Neue Illustrierte*. From 1955 has photographed throughout the third world with Madeleine Beck; since 1964 worked for German television. Special subject: photo-journalism. Camera: Leica. Books: *Hotel Affenbrotbaum; Abenteuer einer Kamera; Barcelona-Weltstadt im Werden; Abenteuer meines Lebens; Auf Abwegen um die Welt.*

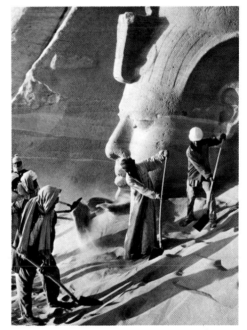

Wolfgang Weber, *Protecting the god's head with sand before lifting the Abu Simbel Temple, Southern Egypt.*

Herbert List

1903–1975

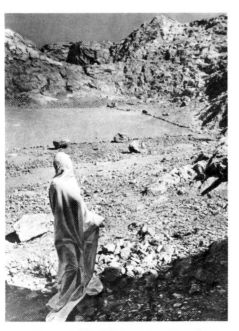

Herbert List, *View from Mount Lykabettos, Athens,* 1938.

Born in Hamburg. After leaving school entered family coffee business; travelled for the company through South and Central America, 1926–8. Left Germany without any money, 1936. An amateur photographer, started to work professionally from 1936. Photographs published in *Du, Harper's Bazaar, Life, Verve*, etc. until mid-1960s. Interested in Surrealism since the late 1920s, his book *Slow Motion Zero* never published. At present a collector of Italian manuscripts and drawings. Cameras: Rolleiflex, Leica. Books: *Licht über Hellas* (photographed 1937–8), 1950; *Roma*, 1956; *Caribia*, 1959; *Napoli* with text by Vittorio de Sica, 1962; *Nigerian Art* with Wragg, 1965.

Herbert List, a sad, distinguished, grey-haired man, made before the Second World War many photographs that were witty, strange, and 'before his time'. The youth of Germany was his special subject, but when he travelled abroad he found surrealistic subjects in unexpected places. The sculpture of ancient Greece took on new life in his lens. Later List made a reportage on the Caribbean Islands.

Margaret Bourke-White

1904–71

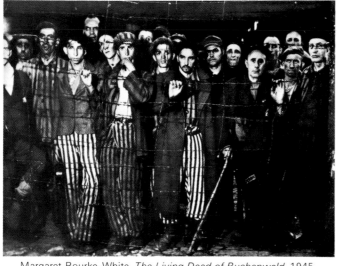

Margaret Bourke-White, *The Living Dead of Buchenwald*, 1945.

Born in New York City. Early interest in biology and technology. Took course at Clarence White School of Photography, Columbia University. Graduated from Cornell University, 1927. Became a professional photographer in Cleveland, Ohio, 1927. Associate editor *Fortune* magazine, 1929–33. With Alfred Eisenstaedt, Thomas D. McAvoy and Peter Stackpole formed original *Life* photographic staff, 1933. Official Air Force photographer during Second World War. UN war correspondent in Korea for *Life*, 1952. Collections: Library of Congress, Washington, DC; Brooklyn Museum, New York; Cleveland Museum of Art; Museum of Modern Art, New York; Royal Photographic Society, London. Books include: *Eyes on Russia*, 1931; *USSR Photographs*, 1934; *You Have Seen Their Faces* with Erskine Caldwell, 1937; *North of the Danube* with Erskine Caldwell, 1939; *Shooting the Russian War*, 1942; *Portrait of Myself*, 1963; *The Photographs of Margaret Bourke-White* edited by Sean Callahan, 1972.

Margaret Bourke-White may have taken more photographs than any other news photographer. She learnt that perhaps the least promising picture will turn out to be the big scoop, and with this knowledge she photographed tirelessly and fearlessly. It has been said that much of the credit of her fame should have gone to those who were steadfastly sifting and selecting the prints of her last excursion while she was already off on another. Certainly, among the hundreds and thousands they found treasure.

Margaret Bourke-White was perhaps less of an artist and more of an expert at objective recording of social conditions. Her book, *You Have Seen Their Faces*, showed the terrible conditions in the southern states of America of Negro chain-gangs and unimaginable poverty. In the war, she was torpedoed on her way to the east. During the hours that she was on a raft waiting to be rescued, she photographed with complete calm the harrowing scenes around her.

Among her best shots are the terrible vultures of Calcutta, and the half-crazed victims of Buchenwald, in their striped black-and-white grotesque prison pyjamas, with wild eyes and china-white faces, unbelieving as they peered through the wires in 1945.

Alfred Eisenstaedt

b. 1898

Born in Dirschau, West Prussia. Moved to Berlin, 1906; attended Hohenzollern Gymnasium and University of Berlin. Served in German army, 1916–18. Sold a photograph to a magazine and subsequently decided to make photography his profession, 1927. Employed by Pacific and Atlantic Picture Agency (soon absorbed by Associated Press), 1929–35; did many assignments for the *Berliner Illustrierte Zeitung*. Went to United States and worked for *Harper's Bazaar, Vogue, Town and Country*, etc., 1935. On staff of *Life*, from 1936. Books: *Witness to Our Time*, 1966; *The Eye of Eisenstaedt*, 1969; *Martha's Vineyard*, 1970; *People*, 1973.

Alfred Eisenstaedt was badly wounded in the legs by shrapnel in 1918, and when invalided out of the German army, to help his family ruined by inflation, he took a job selling buttons and belts. He had always been, in his own words ,'a fanatical camera-bug, working in a pictorial style, but with no idea that you could make a living from photography'. Eisenstaedt's employer called him to his office and warned, 'Mr Eisenstaedt, you have to make up your mind to be a salesman or be a photographer.' Eisenstaedt decided to make his hobby a profession.

He saved his money, never went to beer-halls, ate no lunch and spent whatever cash he had on photography. With Martin Munkacsi and Dr Erich Salomon, he became one of the first modern practitioners of photo-journalism, which started in Germany in the late 1920s.

During the 1930s in Berlin he was a much-sought-after freelance photographer; in 1935 he went to the United States and became a valued worker for *Life* magazine doing reportage jobs of every sort. His flexibility in style and his total dedication meant that he could always be relied upon to get the best out of every assignment.

Like Erich Salomon, Eisenstaedt would dress according to the occasion: for a formal *musicale* at an embassy he would wear white tie and tails, but the pockets were always reinforced to accommodate heavy metal plate-holders and other equipment.

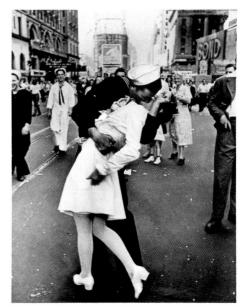

Alfred Eisenstaedt, *Sailor Kissing Girl.*

John Heartfield

1891–1968

Born in Berlin. The son of Franz Held, lived in Switzerland and Austria before apprenticed to bookseller in Wiesbaden, Germany, 1895–1906. Studied at School of Applied Arts, Munich, 1907–10. Commercial artist at paper-manufacturers, Mannheim, 1911–12. Attended Arts and Crafts School in Berlin, 1912–14. Military service; anglicized name from Helmut Herzfeld, 1914–16. Founded periodical *Neue Jugend* and publishing house Malik Verlag with his brother Wieland Herzfelde; directed scientific documentary films for UFA in Berlin, 1916–18. Joined Communist Party, 1918. Co-founder of Berlin Dada group, 1919. With Wieland Herzfelde and George Grosz edited satirical magazines *Jedermann sein eigener Fussball* and *Die Pleite*; with Grosz and Raoul Hausmann edited *Dada 3*, 1919–20. Scenic director of Max Reinhardt theatres in Berlin, 1921–3. Did photomontage book-covers for *Arbeiter Illustrierte Zeitung*, Malik Verlag and other publishers, 1929–33. Deprived of German nationality, 1934; left for London, 1938. Book-covers and illustrations for English publisher Lindsay Drummond and later for Penguin Books, 1938–50. Returned to Germany; settled in Leipzig and did scenery designs and posters for the Berliner Ensemble and Deutsches Theater, 1950. Professorship at Deutsche Akademie der Künste conferred, 1960. Special subject: political satire. Major exhibitions include: Moscow, 1930; Maison de la Culture, Paris, 1935; New York, 1938; Deutsche Akademie der Künste, 1957; Moscow, Peking, Shanghai and Tientsin, 1958; Pavillon der Kunst, Berlin, 1961; Warsaw, Prague, Budapest, Rome, 1964–5; West Berlin, Frankfurt am Main, Stockholm, 1966–7; Institute of Contemporary Arts, London, 1969. Collection: Deutsche Akademie der Künste. Books include: *John Heartfield* by Sergei Tretyakov, 1936; *John Heartfield, Photomontagen zur Zeitgeschichte* edited by Konrad Farner, 1945; *John Heartfield Leben und Werk* by Wieland Herzfelde, 1962; *John Heartfield Photomontages* (exhibition catalogue, London), 1969.

John Heartfield was an early master of photographic collage, and he exploited his original and extraordinary gift for political satire of the most devastating incisiveness.

Heartfield was born in 1891 and, because his father had been sentenced to a year's imprisonment for writing and publishing a revolutionary socialist poem, the family fled from Munich to the Alpine mountains of Austria. One night Heartfield's parents did not return to their cabin, and he and his brother and sister were left abandoned. As Heartfield grew up he, too, identified with radicals in art and philosophy. He anglicized his name as a protest against the anti-British campaign in Germany during the First World War.

Heartfield became an illustrator of books, made advertisements, and created décors for the stage productions of Bertolt Brecht. When with his friend, George Grosz, he first made collages, he realized his real bent.

Heartfield joined the Communist Party and his work is a pictorial expression of its policy. He believed in the class struggle and in action, and he considered it to be his task to 'make the invisible visible'. Heartfield's graphic creations – collages made up of photographs, advertisements and headlines cut up and pasted together at sharp angles – was the result of almost incredibly painstaking efforts, and his cartoons are of an extraordinary technical excellence. He used photography because of its reality, because he knew that by using this reality he could convince.

John Heartfield's brother said of him, 'He fought with scissors, paste and photos and often like his friend, Bertolt Brecht, with a peculiar gaiety.' Brecht said of him: 'Through this new form of art he exercises social criticism, steadfastly on the side of the working class, he unmasked the forces of the Weimar Republic driving towards war. Driven into exile he fought against Hitler; the works of this great satirist, which mainly appeared in the workers' press, are regarded as classics by many, including the author of these lines.'

Heartfield came to England as a refugee from Prague in 1938, and was interned, but soon released. His work appeared in *Lilliput*, by whom he was advertised as 'a master of political art'. While living in a colony of expatriates in Hampstead he worked for the Free German League's publication.

Heartfield, a great animal-lover, with piercing eyes and a remarkable, birdlike appearance, never tolerated injustice, indifference, falsehood or apathy. His cartoons full of skulls, swastikas, corpses and skeletons are essentially ugly; they are meant to be. One montage depicting a German family eating ironwork is headed 'Hurrah the butter is finished'. It is to illustrate Goering's belief, 'Iron always makes a country strong. Butter and lard only make people fat.' With supreme technique Heartfield gives a backside a pair of ears, converts Kaiser Wilhelm into Kaiser Adolf, and the memorial to Mussolini as a sphinx looks on to a pyramid of skulls. He shows us the dove of peace impaled on a German bayonet, and in a hundred devastating ways denigrated the age of Fascism and exposed Nazi tyrannies.

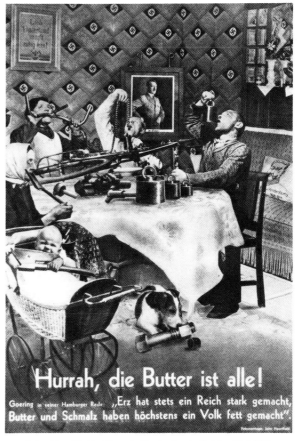

John Heartfield, *'Hurrah, the butter is finished!'*, 1935.

Felix H. Man

1893–1985

Born in Freiburg, Breisgau, Switzerland; British citizen, 1948. Studied art in Munich and Berlin, 1912–14; drafted into army, 1914. Attended art school and university, Munich, 1919–21. Contributor to *B-Z am Mittag, Ullstein Berlin* and *Tempo Berlin,* 1927–8. Production chief of 'Dephot' (Deutscher Photodienst), an association of journalists and photographers, end of 1928. Contributor to *Münchner Illustrierte Presse,* 1929–31; special assignments for *Berliner Illustrierte Zeitung,* 1929–34; came to England, 1934; with Stefan Lorant founded *Weekly Illustrated,* London, 1934. Worked under pen-name 'Lensman' for *Daily Mirror,* 1935–6; photographer on *Picture Post,* 1938–45; colour specialist for *Picture Post,* 1948–51; special assignments for Time-Life, 1951–2, *Sunday Times,* 1956–7. Cameras: Ermanox, Leica, Rolleiflex 35. Awards include: Deutschen Gesellschaft für Photographie Cultural Award, Cologne, 1965. Major exhibitions: Magdeburg, Germany, 1930; Cologne, 1965; Landesbildstelle, Hamburg, 1967; Landesbildstelle, Berlin, 1968; Stadtmuseum, Munich, 1971. Collections: Gernsheim Collection, University of Texas, Austin; International Museum of Photography, Rochester, New York; National Gallery, Canberra; National Portrait Gallery, London. Books: *Eight European Artists,* 1954; *150 Years of Lithographs,* 1953; *Lithography in England, 1801–10,* 1962; *Lithography in England, 1967; Artist's Lithographs,* 1970.

Felix Man can claim to be one of the pioneers of pictorial journalism, (telling a story by means of a sequence of photographs) which began in 1929 in Germany, sponsored by the Munich *Illustrierte Presse* and Dephot. Man had not been trained as a photographer, but knew just what pictures were needed for a 'story'. He was a journalist with the camera rather than with the pen. The most remarkable of Man's 'photo-interviews' was with Mussolini, in December 1930–January 1931. Il Duce imagined, quite erroneously, that he would be made to appear like a noble Roman head carved in marble. Felix Man knew well that such flattering pictures would be of no journalistic interest; nevertheless he took what was expected of him, but Mussolini did not notice that Felix Man was photographing him, between the posed shots, absorbed in his work, talking to underlings, telephoning, gesticulating angrily. When these pictures appeared they were not apotheoses of the 'great man', but were of such a refreshing novelty that they were published not only in Italian papers, but throughout the world. One of the most dramatic showed the whole length of the Audience Chamber in the Palazzo Venezia with Mussolini sitting at his desk at the far end.

Between 1929 and 1931 Felix Man produced over eighty 'photo-essays' for the *Müncher Illustrierte Presse* and over forty for *Berliner Illustrierte,* the best-paying and world's largest illustrated weekly. 'I tried to give the impression of movement which is so vital if the photograph is to make you believe that things are really moving.' Man took photographs for *Harper's Bazaar* in settings that were startlingly realistic; for sports clothes features he accompanied his models to a horse-sale or a smithy, or children to a science museum.

He has said, 'A good portrait has to convey the personality of the sitter, his soul and his spirit have to come to the surface. By modelling the moving masses of the face with the aid of natural light and shade this may be achieved by seldom-used artificial light.'

Man is gloomy about the present conditions of photography. According to him, film studios have ruined the taste of public and photographer alike and in spite of technical progress so-called 'studio-portraiture', with few exceptions, is worse than ever. Today Felix Man devotes himself to the study of art.

Felix H. Man, *Benito Mussolini in his study in the Palazzo Venezia,* Rome, 1931.

Eric Hosking

b. 1909

Born in London. Began career as a professional photographer, 1929; first serious field-work and nesting-season photography, 1930. Free-lance photographer; began lecturing, 1931. Pioneered use of high-speed photography in Britain and of photo-electric shutter release for photographing birds in flight. Director of photography on many expeditions around the world resulting in films for television and 'stills' for illustrating books and scientific papers. Photographic editor *New Naturalist, British Birds, The Birds of the World, World of Birds*. Special subjects: natural history, particularly birds. Equipment: 35 mm Contarex Electronic, 6×6 inch Hasselblad EL; Kodachrome, Agfa 50S Professional, Ektachrome X. Honorary Fellow, Royal Photographic Society, London, 1967. Major exhibitions: 'Looking at Birds', travelling exhibition, 1957; Royal Photographic Society, 1967; National Museum of Wales. Collections: Royal Photographic Society; National Collection of Nature Photographs at Nature Conservancy; National Museum of Wales; British Museum (Natural History); Hancock Museum, Newcastle-upon-Tyne. Books include: *The Art of Bird Photography*, 1944; *Birds in Action*, 1949; *Bird Photography as a Hobby*, 1961 (all these with Cyril Newberry); *Masterpieces of Bird Photography*, 1944; *Birds in Actionm* 1949; *Bird Photography as a Hobby*, 1955; *Nesting Birds, Eggs and Fledglings* with Winwood Reade, 1967; *An Eye for a Bird*, with Frank Lane, 1970

Eric Hosking,
*Barn owl
with vole.*

As a Cockney who left school at fifteen, Eric Hosking was always interested in photography and, at an early age, became fascinated by everything in nature. Soon this hobby centred on birds and led him into a unique career which made his work world-famous.

To obtain such results as his entails working long hours both day and night, often carrying heavy equipment across rough country, sometimes climbing to work at tree-top level or perched precariously on a cliff-face. Once in a hide Hosking has trained himself to freeze into immobility and remain motionless for hours while waiting for his quarry. If he clears foliage around a bird's nest in order to obtain an unobstructed view, he always replaces the foliage afterwards so that the young in the nest are properly hidden from their prey. Hosking's quest for bird photographs has taken him to many exciting places.

In collaboration with others, Hosking has written over a dozen books and illustrated another eight hundred. This has helped arouse in old and young alike an interest for both birds and photography, and the many letters his readers write to him come from all over the world.

For thirty-two years he travelled the British Isles, giving as many as eighty lectures in a winter. Occasionally in these audiences were schoolboys who today have made a name for themselves in the world of natural history.

James Abbé

1883–1973

Born in Alfred, Maine. As a boy photographed ships and sailors, and sold Kodak cameras. As a reporter for *Washington Post*, was the only newsman in the entire sixteen-ship fleet that President Theodore Roosevelt sent to Europe, 1910. Photographed Lillian Gish shooting *The White Sister* in Italy, *c.* 1912. Photographed a war in Mexico, 1928; covered crime in Chicago, 1929; took 'stills' during 'the birth of the talkies' in Hollywood, 1929. Photographed Hitler in his Munich Brown House two months before he became Chancellor, 1932; three months later did a photo-interview with Stalin in the Kremlin. Spent six months as a news photographer for the Russian government-controlled photo trust; departed from Russia 'by request' of the government. Covered the first eight months of the Nazi regime in Berlin; photographed Goering, Goebbels and top Nazi officials. Covered the Spanish Civil War for NANA, on Franco's side, 1936–7. Settled in Colorado as a rancher, 1937; became a radio commentator when Hitler invaded Russia, 1939. Wrote column on television for the *Oakland Tribune*. Books: *I Photograph Russia*, 1933; *Around the World in Eleven Years,* by Abbé's children, 1936.

Abbé's pictures of early film stars, taken on the Hollywood set, were valuable for they showed the well-known players in a manner that the retouched 'stills' and publicity department handouts would not have us see. Abbé's use of back-lighting – though not as fluorescent as de Meyer's – gave a note of backstage reality to behind-the-scenes shots of Pavlova, the Dolly Sisters, Follies Girls, Chaplin, Gish, Pickford and Valentino. Abbé can also be credited with having had two of the world's most loathsome monsters pose for him, for in 1931 he photographed Hitler, and in 1932 Stalin.

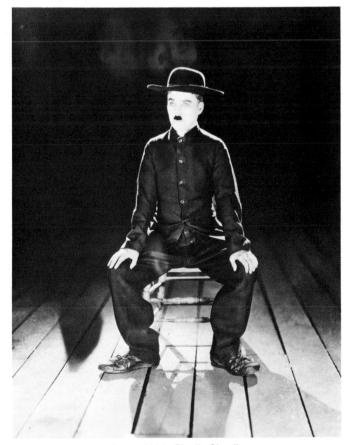

James Abbé, *Charlie Chaplin.*

Henri Cartier-Bresson

b. 1908

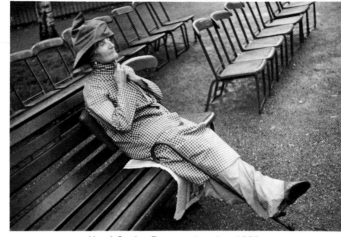

Henri Cartier-Bresson, *London*, 1938.

Born in Chanteloup, France. Studied painting with André Lhote, 1923; studied literature and painting at Cambridge, England, 1928. Began making fun holiday snapshots with Box Brownie, then became excited by the cinema and photographs of Man Ray and Atget. Began to photograph seriously, 1930; six years spent travelling. Returned to France and worked on Jean Renoir's film *Partie de Campagne,* 1936. Made *Return to Life,* documentary film about medical aid during Spanish Civil War. Drafted into army; corporal in film and photographic unit. Captured by Germans, 1940; thirty-six months in prisoner-of-war camps; escaped on third attempt, 1943, and worked for Paris underground. Made film for US Office of War Information, *Le Retour,* showing return of prisoners-of-war to France, 1945. With Robert Capa, David Seymour and William Vandivert founded Magnum Photos, 1947. Assignments all over the world; contributor to hundreds of magazines. Camera: Leica. Major exhibitions: Madrid, 1934; Mexico City, 1935; Julien Levy Gallery, New York, 1935; Museum of Modern Art, New York, 1946 and 1968; Pavillon de Marsan, at the Louvre, Paris, 1957. Collections include: Bibliothèque Nationale, Paris; Museum of Modern Art. Books include: *Photographs of China,* 1948–9, 1954; *Images à la sauvette,* 1952; *The People of Moscow,* 1955; *The World of Henri Cartier-Bresson,* 1968; Holmes H. Welch. *The Buddhist Revival in China,* 1968; *The Face of Asia,* 1972.

During the last forty years Cartier-Bresson has taken nearly a dozen photographs that are greater than any others that have been made in this century. These, quite rightly, are invariably included in exhibitions and publications showing the best since the invention of photography. To have created these masterpieces is a supreme achievement, and it must give Bresson lasting satisfaction. But Cartier-Bresson does not think of himself as a photographer *per se.* He has always been a painter and a draughtsman who still carries a notebook around with him to make sketches of the impromptu. But he confesses he cannot do 'immediate drawings' and thus the camera often deputizes for him. He was extremely pleased when, recently, the publisher Teriade said he should work less at photography and more as a draughtsman.

Henri Cartier-Bresson believes that any plastic medium has rules that correlate all the arts: that for him photography is a way of drawing. In his case his intent, with both the pencil and the camera, is to 'guess' at what the next moment will bring. He trains himself to guess when the 'useful' will happen. He

must learn to guess or, as André Breton said, to be the 'observer of chance'.

Henri believes that in the best of his pictures he is working entirely by intuition, and that the picture takes him and not he the picture. It is a question of 'guessing' in space and time.

Cartier-Bresson is one of the most intelligent of all photographers. His brain is dagger-sharp but profound. He sees through the immediate into wider horizons and comes back with some perverse and witty epigram. He retains his passionate interest in photography, feels inspired by the rugged strength of Joseph Koudelka's work but blanches at the mere cruelty of others. He is appalled at man's cruelty to his own kind, sees only a blacker future and would like to confine himself exclusively to living with his wife and newly adopted child.

Although he is continuously on the 'guess' hunt with his ultra-sharp eyes for 'the moment of realism', he is too disciplined to approve of taking thousands of random pictures in the hope that one may turn out to be decisive. With the practice of years he knows; his instinct guides him to the picture that he is looking for. In this quest he is armed with a great pictorial sense, an inborn talent for composition, and an eye that seems to be as quick as an insect's with which he detects the sad, the comic, the grotesque and the lyrical. His feeling of responsibility also brings him whenever possible to make a social comment. He is never cruel. Unlike many of his followers, he has compassion. In fact he is disgusted and embarrassed by the utter desperation of the American photographer who takes repulsive nudes of his mother, and the others who consider they are making a sociological survey of a 'sick' world.

Bresson is attuned to what is particularly typical of each country, and can show us the poignant beauty of its landscape. With his gradations from black to white he can convey everything about the hopelessness of ruins, the cold of winter and the thawing to springtime. Cartier-Bresson is best as a black-and-white photographer. He concedes that his use of colour eliminates his essential sting.

His shots of the aged Matisse with his doves in Vence; of Giacometti with his hunched shoulders and coat-collar up

186

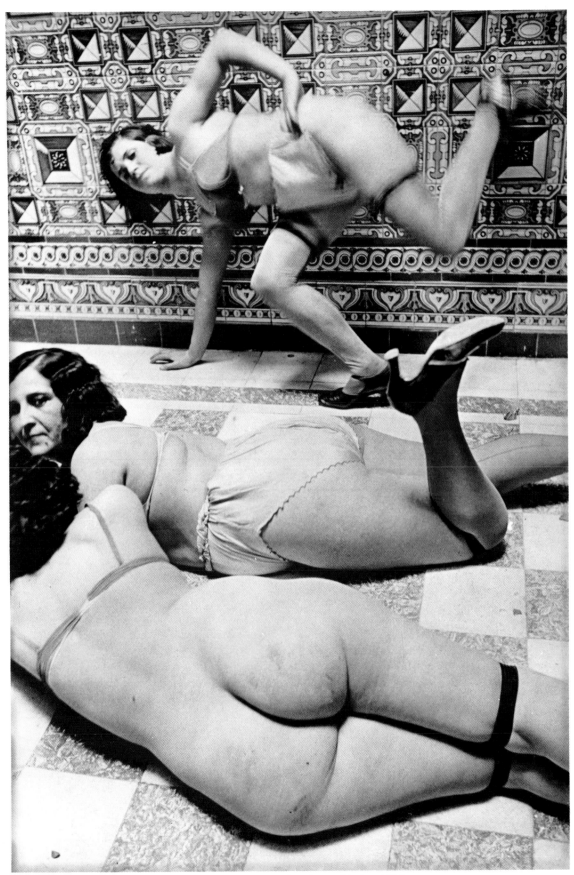

Henri Cartier-Bresson, *Prostitutes, Mexico,* 1934.

Henri Cartier-Bresson

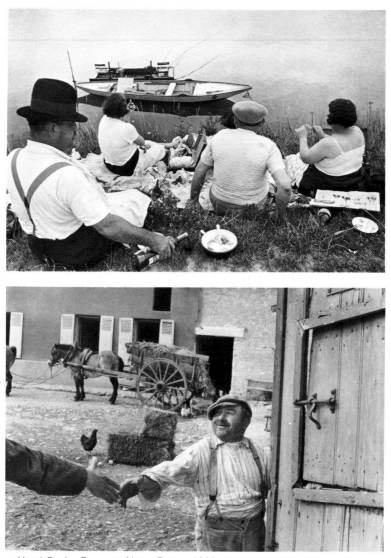

Henri Cartier-Bresson, *Above France*, 1960. *Top Banks of the Marne*, 1938.

hurrying across a street in a Paris rainstorm; and of William Faulkner with a dog stretching his hind legs in Mississippi, are outstanding among an olympian range. But perhaps the true essence of Cartier-Bresson is in his photographs of a picnic on the banks of the Marne; an old man with his dog watching a victory parade; the 'venerable figures' displaying ridiculous dignity; a rustic Buddha at his garden gate ruminating through wistaria and creeping vine while his cat sits uninterested under his master's chair. His finest evocations – of Mussulman women praying in the mountains of Kashmir, cripples and children at play in the mysterious, crumbling streets of Valencia, the dirty, moustachioed French *voyeur*, the Mexican tarts, and the groups of people oblivious of their strange backgrounds – perhaps of giant-size posters curving on metro walls – are all superb.

Henri Cartier-Bresson has glass-blue eyes, a rose-pink complexion of superlative healthiness, and sleek strands of mousy hair that have now become white. He is extremely energetic and strong. Due to his great wish to be as incon-

spicuous as possible while snapping among his fellow human beings, he dresses without individuality. The metal part on his Leica camera is covered with black tape so that its shine does not catch the eye. He seldom permits his likeness to be published: he is, therefore, unrecognized by strangers. But he told me how once, when photographing in the crowd in some Midwestern town in the United States, he was surprised when a smart-aleck student came up and grunted: 'Huh! The poor man's Cartier-Bresson, I suppose.'

Because Cartier-Bresson's work has had such influence, and his imitators are legion, it is hard for us to realize what impact his earlier work had. But this remarkably intelligent man – unlike many photographers who are intellectually incapable of knowing what they are doing – is quite certain of his aim and eventual goal. Untouched by the foibles of fashion, he continues happily in his search. 'Photography is for me the development of a plastic medium, based on the pleasure of observing and the ability to capture a decisive moment in a constant struggle with time.'

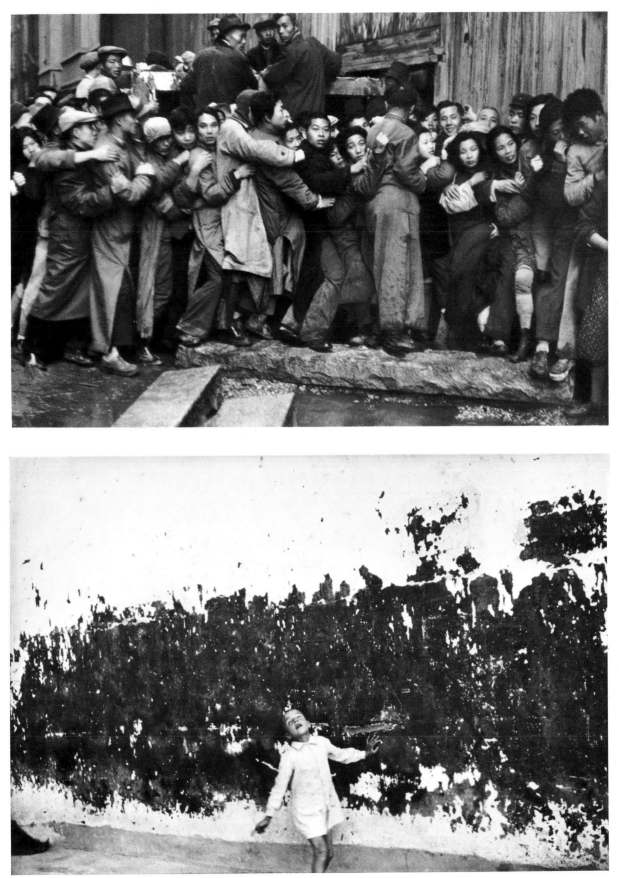

Henri Cartier-Bresson, *Above Valencia*, 1933. *Top Shanghai*, 1949.

Horst P. Horst

b. 1906

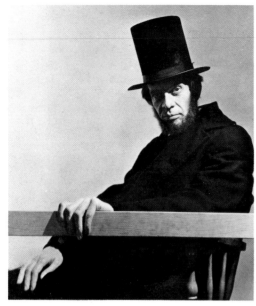

Horst P. Horst, *Raymond Massey as Abraham Lincoln.*

Born in Germany; US citizen. Studied architecture first in Hamburg and later in Paris under Le Corbusier. Began work for *Vogue*, 1932. Special subjects: fashion, portraits, travel, houses and gardens. Cameras: 8 × 10 inch studio, later Rolleiflex. Books: *Photographs of a Decade*, 1944; *Patterns from Nature*, 1946; *Vogue's Book of Houses, Gardens, People*, 1968; *Salute to the Thirties*, 1971.

Horst P. Horst, who was born in Germany, studied art and intended to be an architect until he posed in Hellenic attitudes for Hoyningen-Huene in pictures of skiers and athletes. He then became Huene's pupil. At first he was influenced by his master. When he was given his first assignment as photographer for the Paris collections for *Vogue,* he attempted to go even further than Huene in elaboration of settings. He filled the studio with blown-up backgrounds of romantic forests, trellis-work, gazebos, statues, gravel paths, potted plants and flowers by the bushel. He liked to pile Pelion on Ossa.

It was only slowly that Horst developed his own individual style. He has always shown a preference for a richly packed studio, and his continued use of props gives a personal touch to his fashion pictures.

Horst's lighting effects have always been extremely electric and complicated. By playing with harsh spotlights, he often achieves a strange *boîte-de-nuit* drama, but it is when he comes out into the open air that his work is at its most direct. When the inspiring Mrs Diana Vreeland became editor of American *Vogue,* she commissioned Horst to do a reportage on the Edwardian Consuelo Vanderbilt Marlborough Balsan and her collection of French works of art. Thereby she set Horst off on a new career. He is now second to none in his manner of creating pictures that show well-heeled people in the atmosphere of their taste in gardens, patios and living rooms.

Among Horst's best portraits are a surprisingly jolly Gertrude Stein, a raw-edged Raymond Massey as Abe Lincoln, the wicked-tongued Princess Jane San Faustino looking as if only spiritual thoughts possessed her, and the Mexican painter, David Alfaro Sigueros.

190

Toni Frissell

1907–1976

Born in New York City. Influenced to start photography by watching Horst, Beaton, Steichen and others. Special subjects: children, candid pictures of ways of life, war. Camera and film: Leica, Nikon, Rolleiflex, Hasselblad; Kodachrome, Ektachrome, Tri-X. Major exhibitions: IBM, New York and travelled; 'Hallmark', Philadelphia Museum, Pennsylvania; 'Man in Sport', Baltimore Museum, Maryland and travelled. Collections: Toni Frissell Collection, Bureau of Prints and Photography, Library of Congress, Washington, DC; Metropolitan Museum of Art, New York.

Toni Frissell's photographs have all the charm and freshness of the amateur. Her work is never sedentary; she is off at a leap into the cornfields, over the moors, into the sea, and she is always in the sun. Her healthy sweetness, her strength and out-of-door muscular vitality shine through her prints. But if she retains the spontaneity of the non-professional, she has learnt salient mastery of her technique. Her poetical side shows itself in her pictures of children, and none has done better than she with the best American families, such as the vast concourse of Cushings at Newport; her portrait of Churchill at No. 10 Downing Street at the time of the coronation is masterly.

Toni Frissell has never been accorded her public due, but that does not worry her. She is a dedicated, energetic photographer with no pretension, or hurt feelings if others are given excessive praise. She will muck in with two hundred other press photographers good-humouredly, knowing that perhaps the chances are against her making any sort of special catch. She is a daisy-like woman who knows what she is about – and what she is about is charming.

Toni Frissell, *Two generations – Mrs Bacon and her Granddaughter.*

Paul Strand

1890–1976

Born in New York City. Graduated from Ethical Culture High School where he had been a student of Lewis Hine, 1909. Set up as commercial photographer; experimented with soft-focus lenses, gum prints, enlarged negatives, 1912. In Army Medical Corps, received special X-ray training at Mayo Clinic, 1918–19. Appointed chief of photography and cinematography, Department of Fine Arts, Secretariat of Education of Mexico, 1932–4. President of Frontier Films, a non-profit educational motion-picture production group, 1937–42. Camera work on films for government agencies; actively supported F. D. Roosevelt through photography, 1943. Returned to still photography, 1944 to present. Special subjects: portraits, close-ups of nature, landscapes. Camera: large-plate. Major exhibitions: '291', New York, 1916; 'Seven Americans', Anderson Gallery, New York, 1925; Intimate Gallery, New York, 1929; An American Place, Museum of Modern Art, New York, 1945 and 1956; Kreis Museum, Feital, Germany (GDR), 1969; travelling exhibition organized for Administration Culturelles Françaises of Belgium, 1969–70; Stockholm, 1970; Philadelphia Museum of Art, 1971–2; major museums throughout United States, 1972–3. Collections include: Museum of Modern Art; International Museum of Photography, Rochester, New York; Bibliothèque Nationale, Paris; Philadelphia Museum of Art; St Petersburg Art Museum, Florida; Fogg Museum of Art, Cambridge, Massachusetts; Boston Museum of Art; Metropolitan Museum of Art, New York; Pasadena Art Museum, California; Musée Réattu, Arles, France. Books: *Mexican Portfolio*, 1940 (2nd edn 1967); *Time in New England*, text edited by Nancy Newhall, 1950; *La France de Profil*, text by Claude Roy, 1952; *Un Paese*, text by Cesare Zavattini, 1954; *Tir-A'Mhurain, Outer Hebrides*, text by Basil Davidson, 1962; *Living Egypt*, text by James Aldridge, 1966; *Paul Strand, A Retrospective Monograph*, 2 vols., 1971; *An African Portrait*, text by Basil Davidson, in preparation.

An ardent visitor to the exhibitions at the '291' gallery, Paul Strand was yet another aspiring youngster who brought his prints for criticism to Stieglitz. The great master was so impressed with Strand's abstract patterns in nature, of New York traffic seen from above, the 'hurt eroded people' in the streets, commonplace objects such as bowls and fences seen as forms and rhythms, his glimpses of movement, and his general approach to the medium, that he gave Strand a one-man show. This was praised as being 'brutally direct … an expression of today'. Others have said that no good photography had been seen in America for many years until Paul Strand came along.

In comparison to the shock effects aimed at by young contemporaries the first impact of Strand's work is not sensational. But the reaction to it does not have to be immediate. It is easy in the hurry of today to miss the significance of Strand's contribution. His work needs attention. In fact, it takes close scrutiny to realize its inner truths. By degrees one appreciates the strength and individuality of the statement he makes merely by photographing simple things.

Strand has expressed himself thus: 'It is one thing to photograph people: it is another thing to make others care about them by revealing the core of their humanness.' Strand's work, like peasant art, goes right into basic needs. He is an extraordinarily precise, sharp and accurate recorder. Among the most haunting of his close-ups are a young man with pale but wild glassy eyes, the raw-boned Georgia O'Keeffe and, most famous of all, the blind woman with her begging-cup.

Strand, always an intellectual photographer, expressed his fundamental views when he wrote,
'Photography is the first and only important contribution

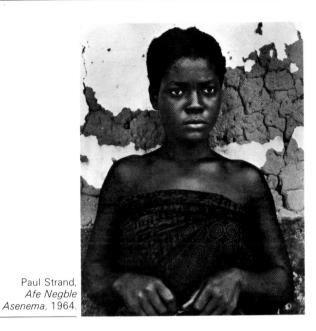

Paul Strand,
*Afe Negble
Asenema*, 1964.

this far of science to the arts; it finds its *raison d'être* like all media in a complete uniqueness of means. This is an absolute, unqualified objectivity. Unlike the other arts, which are really anti-photographic, this objectivity is of the very essence of photography, its contribution but at the same time its limitation. The full potential power of every medium is dependent upon the purity of its use, and all attempts at mixture end in such dead things as the colour etching, the photographic painting and, in photography, the gum print, oil print, etc., in which the introduction of handwork and manipulation is merely the expression of an impotent desire to paint. The photographer's problem, therefore, is to see clearly the limitations and at the same time the potential qualities of his medium, for it is precisely here that honesty no less than intensity of vision is the prerequisite of a living expression.'

After the First World War, in which Strand made medical films, he collaborated on the semi-abstract film *Manahatta*. In 1922 he became a freelance motion-picture cameraman in Hollywood, where he saved enough to enable him to do still work in Colorado or wherever he 'could find natural forms and forces – rocks, driftwood, cobwebs, mushrooms, waves, clouds'.

In the early 1930s in New Mexico, Strand, according to the magazine *Aperture,* found 'Deeper realization of the earth and sky rhythm and of architecture as human expression'. He supervised a documentary film about fishermen called *The Wave*, and later in the United States *The Plow that Broke the Plains*. In Vermont in the early 1940s he returned to 'still' work, and in 1948 went to France where he astonished photographers by his stately large-camera equipment, unhurried approach and magnificent prints.

Eliot Porter

b. 1901

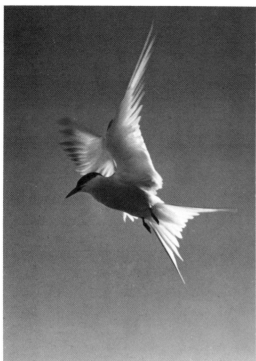

Eliot Porter,
Arctic Tern.

Born in Winnetka, Illinois. BSc, Harvard Engineering School, 1924, MD, Harvard Medical School, 1929. Instructor and researcher in bacteriology and biological chemistry, 1929–38. Early work largely in landscape, began photographing birds in 1937 and in 1940 started working in colour, making own separation negatives and dye transfer prints. Special subjects: wild life, the natural scene, birds. Cameras: Graphic View, 4 × 5 inch Linhof, Hasselblad, Nikon. Guggenheim fellowship, 1941 and 1946. Selected exhibitions: An American Place, 1939; New York Zoological Society, 1942; Museum of Modern Art, New York, 1943; Art Institute, Chicago, 1953; International Museum of Photography, Rochester, New York, 1960. Collections: Museum of Modern Art, Metropolitan Museum of Art, New York; University Art Museum, Albuquerque, New Mexico; International Museum of Photography; Santa Fe Art Museum. Books include: *In Wildness is the Preservation of the World*, 1962; *The Place No One Knew, Glen Canyon on the Colorado*, 1963; *Galapagos Islands, The Flow of Wildness*, 1968; *Down the Colorado*, 1969; *Appalachian Wilderness*, 1970.

Eliot Porter is one more of the long line of photographers who owe their career to the influence of Stieglitz. At an early age, he was also impressed by the sharp-focus work of Ansel Adams, and he began applying his own severe standards to his lifelong interest in birds. A clarity of print is characteristic of all his bird portraits. By using flash he could 'stop' the motion of small swift birds and still maintain a minute definition of their surroundings.

Porter, who is both scientist and artist, has made a remark-able series of colour pictures of birds taken with long-distance lenses. Somehow he seems able to catch the movement and activities around their nests far better than any other nature photographer. Porter has developed many ingenious methods for overcoming the physical and technical difficulties involved in photographing such difficult subjects as cormorants, meadow-larks and road-runners. His black-and-white prints have a rich velvety quality that tells the story in quiet tonality, but he knows when to use colour in order to show a bird that would otherwise be lost among grasses or in the shadows.

Gjon Mili

1904–1984

Born in southern Albania. Went to United States, 1923. Graduated from Massachusetts Institute of Technology with degree in electrical engineering, 1927. Worked as a lighting research engineer for West-inghouse Electric Co. Work has been published extensively in Condé Nast publications and in *Life*. Special subject: highspeed photography. Cameras include a specially built 4 × 5 inch view camera. Exhibitions include 'Dancers in Movement', Museum of Modern Art, New York, 1942; Paris Galerie, 1948; Arles, 1970; Louvre, Paris, 1971.

Mili's preoccupation was the capturing of movement. His first success was achieved by using a number of highly powered bulbs flashing simultaneously from many directions. In this manner he was able to photograph dancers, or black religious sects leaping in the air in a frenzied rhythm. These pictures, at the time, were perhaps too perfect in precision – too metallic to allow for atmosphere. Far more effective were his experiments in which exposures were made in quick succession of fast-moving subjects seen as if in a series of jerks from a faulty moving-picture projector. His most famous are the pictures of Picasso drawing with an electric lamp.

Mili developed the biplane filament light – the brightest incandescent tungsten light-source available. He has also done sterling work in interpreting photometric concepts by means of photographs that beam patterns, filament images and lighted glassware. He contributed numerous technical papers on his researches into light projection, optics and photography.

In collaboration with the great expert, Professor H.E. Edgerton, Mili has done much pioneer work in the field of high-speed photography.

Emmanuel Sougez

1889–1972

Born in Bordeaux, France. Entered Bordeaux School of Fine Arts at age of fifteen to study painting; began photographing. Photographed throughout Europe until the beginning of First World War. Founded in 1926 photographic section of *L'Illustration* and headed it until the magazine was dissolved. Photographs used to illustrate art and archae-ology books and in specialized magazines. Contributed annually to supplement 'Photographie' in magazine *Arts et Métiers graphiques*, and to yearbooks in France and abroad. A writer on photography, collaborated with R. Lecuyer in *Histoire de la photographie*, 1945; contributed articles to many magazines, especially *Camera* in the 1950s. Special subjects: still lifes, nudes, sculpture, archaeology, landscapes, nature, portraits. Cameras: large formats, up to 30 × 4 cm for professional work; Rolleiflex for 'pleasure' pictures. Exhibi-tions: 'Le Chasseur d'images, Paris, 1937; between the two world wars participated in photographic salons in France and abroad and exhibitions of French Photographic Society, Salon des Artistes Décorateurs, 'Le Rectangle' and 'Les xv'. Collections: Bibliothèque Nationale, Paris; Musée Français de la Photographie. Books include: *Regarde!*, 1931; *La Sculpture au Musée du Louvre*, (1936–58); *Arts de l'Afrique noire*, 1947; *Arts de l'Océanie*, 1948; *Art de l'Amérique*, 1948; *La Sculpture contemporaine française et étrangère*, 1961.

Kurt Hutton

1893–1960

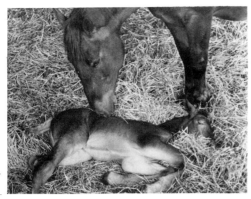

Kurt Hutton,
*New Born Suffolk
Punch.* 1950s.

Born Kurt Hubschmann in Strasbourg, Alsace (then Germany). Studied law at Oxford University, *c.* 1911–13. Self-taught in photography. Became a German Cavalry Officer during World War I. Met wife Gretl while convalescing in Switzerland; she later became his darkroom assistant, helped him develop ideas for picture stories and also worked in the *Picture Post* darkroom. Set up small commercial studio in Berlin, 1923. Invited to join Dephot, a new picture agency selling work to German illustrated weeklies, 1930. Later worked for agency Weltrundschau. To escape the Nazis, came to England 1934. Began contributing picture stories to the new English magazine *Weekly Illustrated* founded by Stefan Lorant, 1934. Worked for *Picture Post*, 1938–1957. Interned as enemy alien, Isle of Man, 1940–1. Changed name officially to Hutten in 1947, but since World War II had used name Hutton for his pictures. Special subject: human interest stories. Cameras: Leica, Contax. Book: *Masters of Modern Photography: Speaking Likeness, Photographs by Kurt Hutton*, edited by Andor Kraszna-Krausz, 1947.

Kurt Hutton, whose personal style and compassion helped create the legendary British weekly *Picture Post*, was the only staff photographer at both its inception and finale. His dictum: 'A photograph should suggest that behind the face – whatever sort of face it may be: young or old, pretty, plain or ugly, lively or quiet – there is a thinking and feeling human being' helped define the magazine with which his name is so closely associated. GB

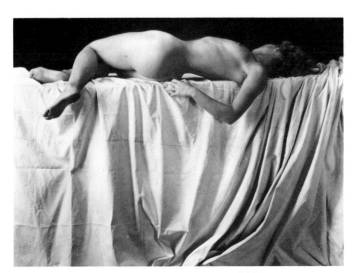

Emmanuel Sougez, *Rest, c.* 1938.

Harold E. Edgerton

b. 1903

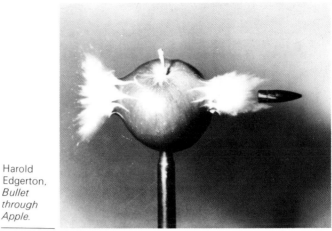

Harold
Edgerton,
*Bullet
through
Apple.*

Born in Fremont, Nebraska. Graduated from University of Nebraska with BSc degree in electrical engineering, 1925; M Sc degree, 1927, and PhD, 1931, both from Massachusetts Institute of Technology. Spent many years as Professor of Electrical Engineering and is now Institute Professor Emeritus, Massachusetts Institute of Technology. A founder partner of Edgerton, Germeshausen & Grier (now EG & G, Inc.) of which he is honorary chairman of the board. Adapted (with associates) the stroboscope for use in night aerial reconnaissance, 1939; went to Italy and England to direct the use of his equipment by Allied military forces during Second World War. Directed the use of his strobe cameras the night before D-Day when aerial photographs were taken of Normandy by piercing the clouds and the darkness with flashes of intense light. Took up underwater research, 1953; designed an electronic flashlamp and underwater camera capable of operating in the deepest parts of the ocean where the pressure is eight and a half tons per square inch. Books: *Flash, Seeing the Unseen* with James R. Killian, Jr., 1939; *Electronic Flash, Strobe*, 1970.

Dr Harold E. Edgerton, a scientist at the Massachusetts Institute of Technology, has long experimented with a high-speed camera. Dr Edgerton is responsible for the development of the stroboscope and the related electronic flash equipment, now used in engineering and science to gather information concerning objects moving too quickly for the human eye. 'Stroboscope' means literally 'whirling viewer'. His early pictures show us a pack of playing-cards being shuffled and falling in the air. He then took pictures with a hundred flashes per second of an ancient pistol being fired, of finches, and of a water-wheel. Later, with supersonic flash he took extraordinarily surprising pictures of water dripping, acrobats in mid-air, divers, ballet-dancers in motion. Edgerton's pioneer work has been adopted widely in the sphere of engineering and science.

Dr Edgerton, with his almost incredibly brilliant and rapid flash repeated intermittently by electrical discharges from condensers, has been able to take startling photographs of a bullet in flight piercing a lemon or an apple, the motion of a hummingbird's wings, the explosion of a dynamite cap, the impact of a ball on a bat. By photographing a drop of milk falling on to a plate that was covered with a thin layer of milk Dr Edgerton produced a coronet decorated with pearls raised above the rim – an object of beauty. He specialized in photographing what the scientists call 'surface tension'; the delicate shapes are none the less beautiful because they are too ephemeral for any eye other than that of a high-speed camera.

Bill Brandt

1904–1983

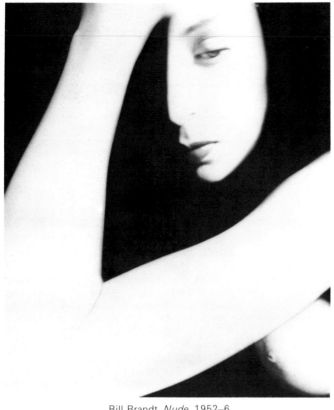

Bill Brandt, *Nude*, 1952–6

Born in London. Parents British but spent much of his early life and schooldays in Germany. After recovering from ill-health in Switzerland, left for Paris, 1929. Studied with Man Ray; learned about experimentation, portraiture and Surrealism. Returned to England, 1931; concentrated on documentary photography, especially depicting social contrasts of the time, until outbreak of Second World War. Photographs published in *Picture Post, Harper's Bazaar, Lilliput, News Chronicle, Minotaure* and *Verve*. During the war worked much of the time for *Lilliput*; commissioned by them to take night pictures of London during the black-out, 'Young Poets' series, etc. For Home Office made a photographic survey of underground shelters, and for National Buildings Record photographed buildings of special interest. Following the war concentrated his photography on portraiture, landscapes and nudes. Cameras: Kodak 8 × 6 inch mahogany stand camera without shutter and with extremely wide-angle lens with pinhole aperture for his nude studies; Hasselblad; Rolleiflex. Films: Trix-X, roll film Ektachrome. Major exhibitions: Arts et Métiers Graphiques, Paris, 1938; Museum of Modern Art, New York, 1969; Hayward Gallery, London, 1970. Collections include: Museum of Modern Art; Victoria and Albert Museum, London; International Museum of Photography, Rochester, New York; Bibliothèque Nationale, Paris. Books: *The English at Home*, 1936; *A Night in London*, 1938; *Camera in London*, 1948; *Literary Britain*, 1951; *Perspective of Nudes*, 1961; *Shadow of Light* 1966.

Bill Brandt is the Samuel Beckett of photographers. Gaunt, direct, stark, his work is always one step ahead. A pupil of Man Ray, Brandt has been first in many things. It is sometimes difficult to realize this, since imitators catch up on him so rapidly. No other photographer in England has gained such respect for the purity and intensity of his work.

Bill Brandt made early documentaries of middle-class life

which he collected in a remarkable book, *The English at Home*. He showed the stiff-upper-lipped parlour-maids, with their starched caps and aprons, standing by the laden dining-table, running the hot bath, or pulling down the blinds on to this ugly, cosy, virginia-creepered world. In the 1930s Brandt concentrated on showing the black depression of England in her economic crisis. He was subsequently influenced by the Surrealists; his Surrealism is perhaps nearest to Chirico and Magritte.

Sometimes Brandt's pictures are so gentle that the mood is almost evanescent: only by degrees does it assert itself. Brandt talks about the 'atmosphere' in his pictures: 'I found atmosphere the spell that charged the commonplace with beauty and I am still not sure what atmosphere is. I only know that it is a combination of elements … which reveals the subject as familiar, yet strange.' Perhaps his stone figures in a crepuscular garden, or covered with hoar-frost at early morning, or the stray stork, illustrate best this intention. The odd juxtaposition of statues in museums, or junk in backyards, is also strangely atmospheric.

In order to give new meaning to the nude female body Brandt showed it in extraordinary distortion and often in incongruous surroundings. He has given us Brancusi-like shapes seen in a traumatic mirror-reflection of the cliffs by the sea which typifies his enjoyment of a strange combination of nature and artifice. He photographed perspectives of portions of anatomy in an eerie nightmarish empty room, or a close-up of an ear against a landscape of Friar's Bay. His portraits of Edith Sitwell on a gloomy Sunday, Harold Pinter against coal-black bricks, and Francis Bacon out on the heath at dusk lead the way to Diane Arbus and her coterie. These followers have also done most of their work as the day is fading, but they have thought it necessary to compensate the lack of actinic strength with a flash, thus completely marring the magical atmosphere. Brandt alone seems to acknowledge the fact that at twilight details are minimized and perhaps only enough of the figure, apparently hewn out of stone, is visible to create a masterpiece.

In 1948 Brandt said: 'The photographer must have and keep in him something of the perceptiveness of the child who looks at the world for the first time. We are most of us too busy, too worried, too intent on proving ourselves right, too obsessed with ideas to stand and stare. We look at a thing and think we have seen it, and yet what we see is only after what our prejudices tell us should be seen, or what our desires want to see. Very rarely are we able to free our minds of thought and emotions and just see for the simple pleasure of seeing, and so long as we fail to do this, so long will the essence of things be hidden from us.'

Brandt never repeats himself. He quietly continues his experiments.

Bill Brandt is surprisingly different from the preconception one has formed through seeing his photographs. To see him in his room with its dark-green walls, his books, solid furniture, the glass-polished ancient mahogany camera which he still uses, the Victorian knick-knacks, early family photographs, coloured prints and surrealistic collages, one would not

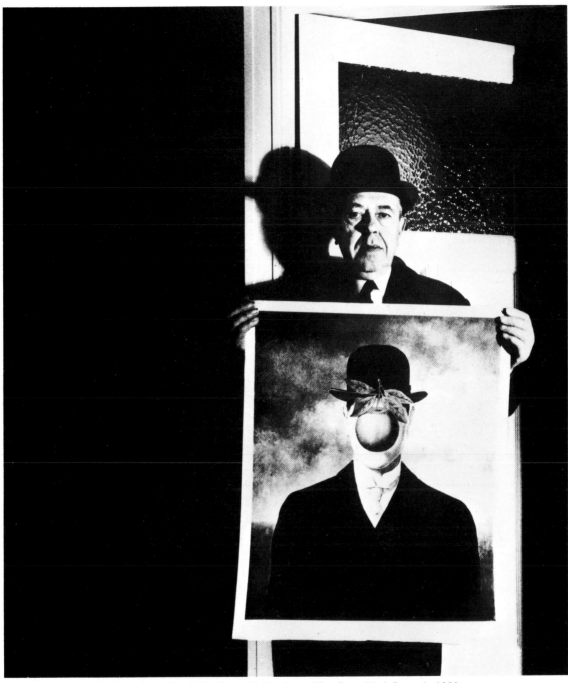

Bill Brandt, *René Magritte with his picture 'The Great War', Brussels,* 1966.

imagine him being able to foray into the noisy, rugged purlieus of East End pubs, miners' towns or railway cuttings.

Bill Brandt speaks in a voice that is little more than a whisper. His accent seems as velvety as that of the Viennese or the Scots. He reminds one of Delius – his bony features jutting from the taut skin, with aristocratic aquiline nose, deeply set eyes of a wonderful sky-blue and disarming sympathetic smile. In his long-limbed way he is the acme of elegance, and his tapering hands are indicative of his distinguished mind.

Brandt is seemingly disinterested as he shows his photographs. He hardly glances at them. He knows them well, and the order in which they appear in his many books. Of late he has become so busy carrying out the orders for his original prints that come from America, indeed from all over the world, that he has little time for new ventures.

From the pictures published in coveted, often unobtainable volumes, one can tell more about Bill Brandt than he allows us to see of himself as he sits staring out of his large windows at the tall trees. From these books one senses Brandt's love of the weather in its less halcyon phases; the threatening skies at dawn and twilight; of frost on lawns and statues, of early mists and late shadows underneath the inspissated arches.

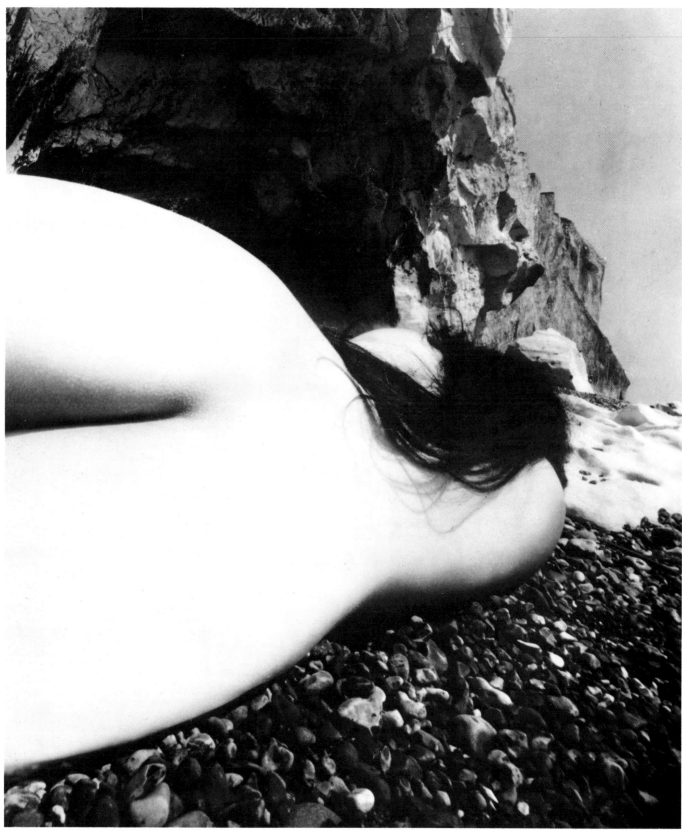

Bill Brandt, *Nude*, 1952–6.

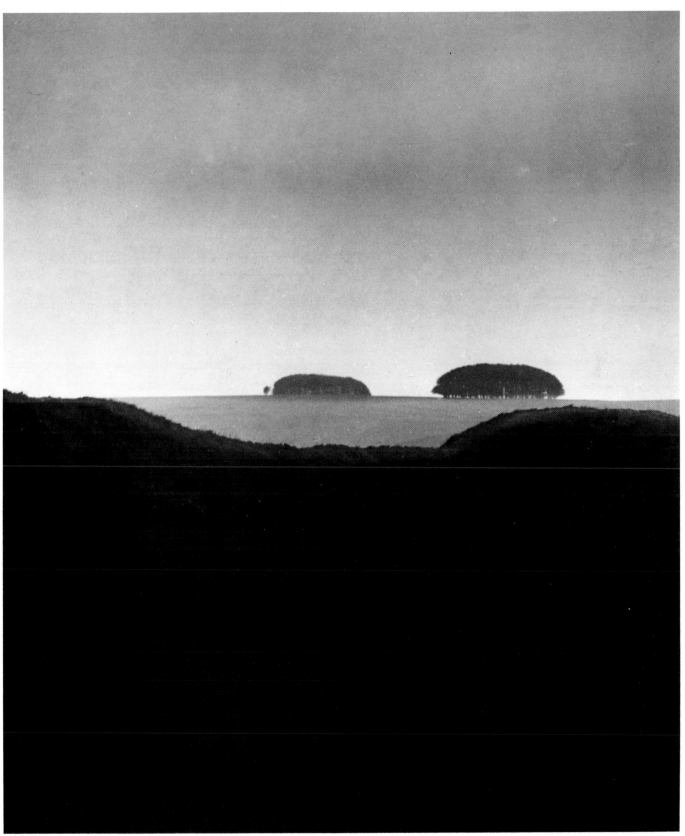

Bill Brandt, *Barbary Castle, Marlborough Downs, Wiltshire,* 1948.

Ansel Adams

1902–1984

Born in San Francisco. Trained as a concert pianist. Took first photograph in Yosemite Valley in 1916 but did not become a full-time photographer until 1930. Founder member of Group f/64, 1932. Started Ansel Adams Gallery, San Francisco, devoted to photography and other arts, 1933. Board of Directors of Sierra Club, San Francisco, 1934–71. Helped Beaumont Newhall and David McAlpin found first department of photography as a fine art at Museum of Modern Art, New York, 1940. Appointed photomuralist to Department of Interior, Washington, DC, 1941; developed Zone System of exposure. Worked with Dorothea Lange for Office of War Information, 1942. Founded first department of photography at California School of Fine Arts, San Francisco, 1946. A founder member and first president of Friends of Photography, 1967. Lecturer and teacher in creative photography from 1933; from 1955 conducted workshops in Yosemite. Cameras: 4 × 5 inch, 5 × 7 inch, and 8 × 10 inch view and Hasselblad. Awards include: Guggenheim fellowship, 1946, 1948, 1958; Conservation Award from Steward Udall, Secretary of Interior, 1968; progress medal, Photographic Society of America, 1969. Selected exhibitions: Smithsonian Institution, Washington, DC, 1931; M. H. de Young Memorial Museum, San Francisco, 1932 and 1963; An American Place, New York, 1936; San Francisco Museum of Art, 1939, 1965, 1972–3; Museum of Modern Art, New York, 1944; Art Institute of Chicago, 1951; International Museum of Photography, Rochester, New York, 1952; Philadelphia Print Club, Stanford University Museum of Art, California, 1972. Collections: most major museums in the United States; Bibliothèque Nationale, Paris; Royal Photographic Society, London; etc. Books include: *Taos Pueblo*, text by Mary Austin, 1930; *Sierra Nevada: The John Muir Trail*, 1938; Basic Photo Books (series) *Camera and Lens*, 1948, *The Negative*, 1948, *The Print*, 1950, *Natural-light Photography*, 1952, *Artificial-light Photography*, 1956; *My Camera in Yosemite Valley*, 1949; *Death Valley*, text by Nancy Newhall, 1963; *Fiat Lux: The University of California*, text by Nancy Newhall, 1967; *The Tetons and the Yellowstone*, text by Nancy Newhall, 1970; *Ansel Adams*, 1972.

Adams perfected new ways of exposing and developing and felt he had produced the supreme negative. This technical mastery has been the foundation upon which he has built a great business, selling his pristine, impeccable prints throughout America, where they can be seen on the walls of motels or in popular galleries.

A beaky raven of a man, Ansel Adams was said to be 'sensitive to a remarkable degree to all aspects of daylight'. He was struck also by the effects of moonrise. A prime nature-lover, he is master at photographing trees, the roots of trees, leaves and driftwood: his landscapes are on the grandest scale. He was in his element photographing the sharp, clear rocky desert of the West Coast, or the Yosemite National Park with its huge boulders leading up to mist-draped mountains. He has been able to create his own world by photographing in 'close-up' a pinecone or a seashell. He can create beauty out of a sand fence near Keelah, California, and can make an old shack come to life with his dramatically sharp light and shadows.

Although thousands of students have attempted to follow in his path they have never achieved the intensity that made his early prints such a new experience. Adams has created cathedrals out of a formation of rocks, and made crags into vast stalactites, and a small church at the summit of a long gritty hill into a child's toy.

An essentially outdoor type, with an atmosphere of spume and sea-spray about him, he is never involved in magic. He is the direct honest-to-God photographer whose influence in the States, both as a teacher and as a conservationist, cannot be exaggerated.

Albert Renger-Patzsch

1897–1966

Born in Würzburg, Germany. The son of an enthusiastic amateur photographer, began photographing before he was fifteen. Youth spent in Essen and Thüringen; studied at humanistic college in Sondershausen and Kreuzschule in Dresden. Military service, 1916–18. Studied chemistry at Technical College, Dresden. Director of photographic department of Folkwang Publishing House, Hagen. Settled in Bad Harzburg as an independent photographer after various jobs as bookkeeper, salesman and accountant in a pharmacy in Romania, 1925. Not having sufficient work as a photographer, organized craft exhibitions, typed theses, etc. Appointed director of department of pictorial photography at Folkwang College; stayed on two terms, 1933. War correspondent and produced documentary illustrations during Second World War. His studio in Folkwang Museum and 18,000 negatives destroyed by bombs, 1944. Moved to Wamel, near Soest in Westphalia, in 1944 and lived there until the end of his life. Cameras: Linhof 9 × 12 cm, mirror reflex, and Felding camera. Collections: Bibliothèque Nationale, Paris; International Museum of Photography, Rochester, New York; Deutsche Staatliche Landesbildstelle; Royal Photographic Society, London. Books include: *Das Gesicht einer Landschaft*, 1926; *Die Welt ist schön*, 1928; *Lübeck*, 1928; *Norddeutsche Backsteindome*, 1930; *Das Muster in Essen*, 1930; *Eisen und Stahl*, 1930; *Land am Oberrhein*, 1944; *Beständige Welt*, 1947; *Im Wald*, 1965.

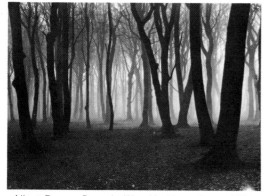

Albert Renger-Patzsch, *Wood in November,* c. 1934.

'Many of Renger-Patzsch's photographs are possessed of such a convincing simplicity that they seem to have no special excellence other than that of fulfilling their purpose to perfection,' wrote Professor Karl Georg Heise in the introduction to *Die Welt ist schön* (*The World is Beautiful*) in 1924. How aptly this summarizes one's immediate reaction upon seeing the work of Renger-Patzsch. His contribution to photography was best stated by his fellow countrymen when the Gesellschaft Deutsche Lichtbildner awarded him the David Octavius Hill medal: 'On his 60th birthday, we honour the pioneer of modern German photography, which owes to him its maturity and honesty. At the same time, we recognize a life's work of exemplary unity, rigid discipline and uncompromising conviction.' GB

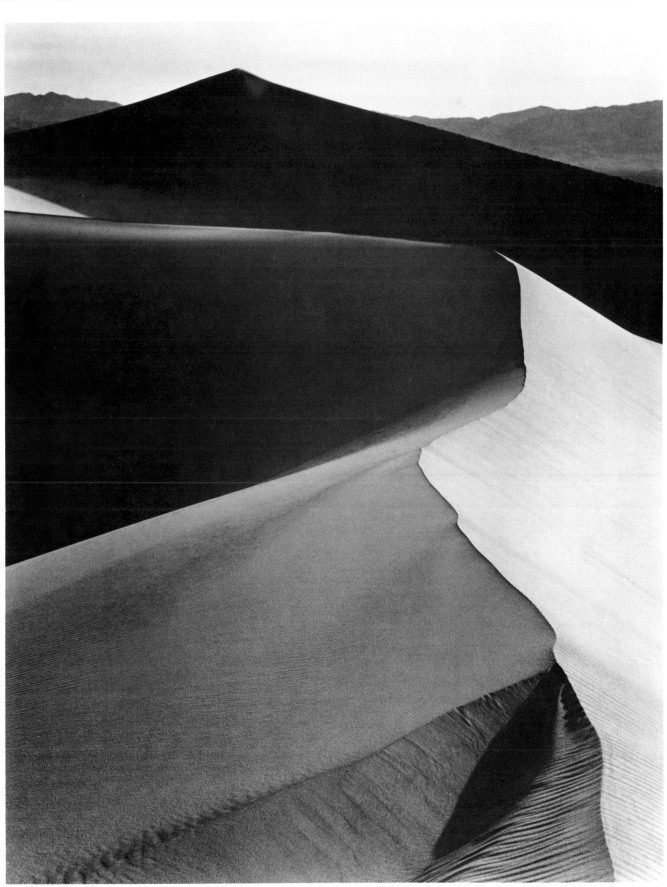

Ansel Adams, *Sunrise, Dunes, Death Valley National Monument*, 1948.

Josef Sudek

1896–1976

Born in Kolin nad Labem, Czechoslovakia. Trained as a bookbinder at State Graphical College, Prague, 1922; started photography as an amateur in 1913. Severely wounded while fighting on the front during First World War. In 1922 attended State School of Graphic Art in Prague. During 1930s took photographs for publishers Druzstevni Práce. Special subjects: landscapes, still lifes, panoramas. Cameras: 13 × 18 cm or 30 × 40 cm format camera or Kodak Panorma made in 1894 with negatives of 10 × 30 cm. Major exhibitions: International Exhibition of Photography at Museum Mánes in Prague, 1936; New York, 1972, etc. Major collections: Museum of Decorative Art, Prague; Moravská galerie, Brno, Czechoslovakia. Books include: *The Hradcany Castle, Prague,* 1947; *Our Castle,* 1948; *Josef Sudek* with Jan Rezáč, 1961; *The Charles Bridge*, 1961; *Josef Sudek,* 1962.

Sudek, born on the River Elbe in Bohemia, is Czechoslovakia's greatest living photographer. He lives in isolation and poverty.

Sudek lost an arm during the First World War and while spending three years in a military hospital, he occupied himself by photographing his fellow patients. After his release he came under the long-distance influence of Clarence White and the purist trend in American photography. He realized photography must be his career, and in spite of his amputation carried his big plate camera under the remaining arm to photograph for calendars, picture-postcards and advertisements.

Sudek still has a passion for old cameras; he finds the antiquated instruments extremely sensitive. In 1958, using a camera made in 1894, he made a fantastic set of panoramas of Prague showing a unique use of light and shadow – in fact, he presents Prague as a city of dreams and poetry.

Sudek, a lover and connoisseur of music, seems to imbue his landscapes with a rhythmic sensuality: he chooses trees to photograph as he would men, giving them their strength and weakness, qualities analogous to life. He has the ability to humanize the inanimate object. The titles of his pictures do not give sufficient indication of the rarity of his point of view. They read, *Forest path leading to holes of foxes, Summer calm, My garden in summer.*

Rezáč says in the introduction to Sudek's book on photography, 'His photographs reflecting the dreams of one who is pure in heart are offered to us as the rarest of rare potions.'

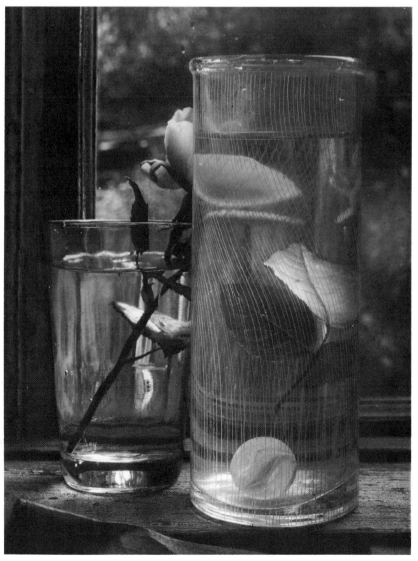

Josef Sudek, Untitled photograph.

Clarence John Laughlin

1905–1985

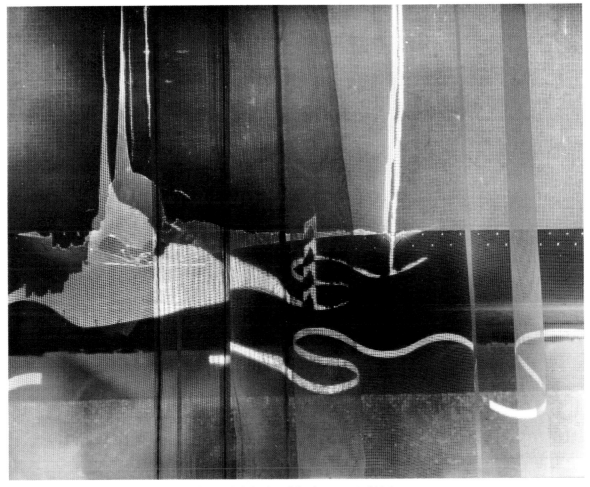

Clarence John Laughlin, *Language of Light.*

Born in Lake Charles, Louisiana. Lived on a plantation before moving to New Orleans, 1910. Education stopped after first year of high school; started writing prose poems and macabre fiction after discovering French Symbolists, c. 1925. Began photography, 1935. Fashion photography, *Vogue*, 1940–1; photography department of National Archives, 1941–2. Lectured on aesthetics of photography and American Victorian architecture, from 1948. Photographs have appeared in *The Saturday Book,* London; *Harper's Bazaar*; *Architectural Review*; *Life*; *Du*; *Aperture*. Camera and film: 4 × 5 inch view camera, sheet film. Major exhibitions: Delgado Museum of Art, New Orleans, 1936; Julien Levy Gallery, New York, 1940; 'The Camera as a Third Eye', Philadelphia Museum of Art, 1946; 'Ghosts Along the Mississippi', Phillips Gallery, Washington, DC, 1949; 'Old Milwaukee Re-discovered', Milwaukee Public Museum, 1965; Philadelphia Museum of Art, 1973. Collections: Metropolitan Museum of Art, New York; Fogg Museum, Cambridge, Massachusetts; Museum of Modern Art, New York; Phillips Gallery, Washington, DC; Smithsonian Institution, Washington, DC; Art Institute of Chicago; Bibliothèque Nationale, Paris; Philadelphia Museum of Art. Books include: *New Orleans and Its Living Past*, 1941; *Ghosts Along the Mississippi,* 1948 (reprinted 1962); *Aperture* monograph with text by Jonathan Williams, 1973.

Laughlin, known as one of the chief white luminaries of New Orleans, is a photographer whose prints are not so much pictures of places and things as symbols of his own thoughts. Dr Fritz Gruber has said that Laughlin's pictures are always in the domain of the psychic interior and that he tries to see beneath the surface. Indeed, there is always a romantic-mystical quality about Laughlin's work, and through the introduction of his spiritual images he has created a new kind of documentary photography. Nothing could be more successful, yet so simple, as his picture of the light-patterns seen through a curtain blowing in the wind. One can read so much into this remarkable shot – which is Laughlin's intention, for he is concerned with hidden suggestions. He explains his photograph *The Language of Light* as follows:

'What we see in this photograph is sunlight, falling through a torn, and carefully adjusted, window shade and curtain, onto the old wire screen. But space multiplies, and the light-forms begin to exist as though *independently* of the objects which helped create them. This is not only an example of how space can be expanded by the camera, but also, of the translation of the concrete into the abstract, and finally, of the pure magic of light itself.'

Laughlin enjoys superimpositions – a face seen in a stone, a form that becomes a spider. He works in Louisiana, high up in an impersonal apartment-block, with a large library and a collection of fourteen thousand of his negatives. The titles of some of his prints are significant: *Passage to Never-Never Land, The House of the Past, Three-Dimensional Poem in Two-Dimensional Space*. His collected pictures create tremendous atmosphere.

Dmitri Kessel

b. 1902

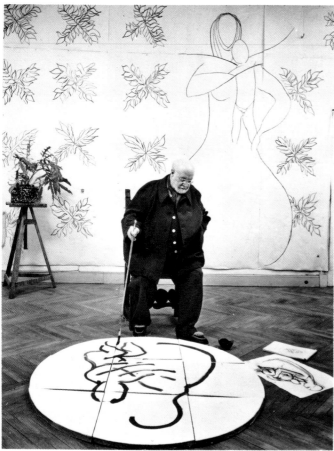

Dmitri Kessel, *Matisse*, 1950.

over, Kessel took photographs of the carnage but a Ukrainian leader seized his camera and broke it over Kessel's head.

In 1921 Kessel went to a technical school in Moscow where he studied industrial chemistry and leather tanning. In the following year, on seeing his family off to Russia, he was arrested by Polish guards, escaped, went to Rumania, where he was again arrested, released and arrived in the United States.

Kessel took a course in photography with the renowned Rabinovitch, though he said the most important thing he learned was self-criticism. He walked the impersonal street, took trips on buses and overhead railways and photographed unfamiliar people. By degrees he began to specialize in industrial photography. At last he was taking well-paid pictures for factory-owners, then naturally he migrated to the magazine *Fortune*.

Kessel is perhaps best known as a news cameraman. His outstanding pictures have been of violence – in the Congo – in the Greek Civil War, and he showed terrifying pictures of the chaos left in their wake – the cruelty, plunder, starvation, murder and wreckage of the country – of the German retreat in 1945.

But Kessel also has an intense response to beauty. His series on the islands of Greece shows his enjoyment to visible nature at its best. When he returned to his native land for the first time in forty-three years he took marvellous photographs of the Hermitage.

Kessel's camera gives an extraordinary fidelity in his colour studies of works of art: technically he is beyond comparison in his recording of the pleasurable forms among the treasures of the Vatican, the Sistine Chapel, the mosaics of Ravenna, St Mark's in Venice, and the sculpture of Bernini and Michelangelo.

Nickolas Muray

1892–1965

Born in Szeged, Hungary; US citizen. Went to a graphic arts school in Budapest to learn photo-engraving, lithography and fundamentals of photography and application, c. 1904–8; became a journeyman engraver and received International Engraver's Certificate. Took a three-year advanced course in colour photo-engraving in a German state technical school; learned how to make colour filters (no ready-made ones were available in those days). Worked two years for Ullstein Verlag. Arrived in New York, 1913; first job was as a colour-printer in Brooklyn firm. By 1916 was doing colour-separation half-tone negatives for Condé Nast. Opened own studio and photographed artistic, literary, musical and theatrical world of 1920s for *Harper's Bazaar* and *Vanity Fair*. Changed from portraiture to advertising, fashion and commercial photography, c. 1928. A fencing champion, included in US Olympic team 1928, 1932 and 1936. Under contract to do colour fashions for *Ladies' Home Journal* from 1930; contract with *McCall's* from 1935. Took the photographs for an eight-month trip around the world for Wenner-Gren Foundation for Anthropological Research directed by Dr Paul Fejos. Exhibitions include: Royal Photographic Society, London; International Photography Fair, Coliseum, New York; Kodak Exhibit Center, Grand Central Terminal, New York; 'Twenties Revisited', Gallery of Modern Art, New York, 1964; Bishop Museum, Honolulu. Collections: International Museum of Photography, Rochester, New York; Museum of Modern Art; Royal Photographic Society. Book: *Pre-Columbian Art*, 1958.

Born in Kiev, Russia; US citizen. Attended a combination gymnasium and military academy in Nemirob, Russia. Served as professional soldier and cavalry officer in both Ukranian and Red armies in their campaign against Poles, 1919–21. Studied industrial chemistry and leather-tanning in Moscow, 1921–2. Arrived in United States via Rumania, 1923. Contributed to Russian newspapers and magazines; attended night classes at City College, and took courses at Rabinovitch School of Photography, New York, 1934. Concentrated on industrial photography; first photographic assignment from *Fortune*, 1935. Covered Second World War for *Life* beginning in 1939. *Life* staff photographer, 1944–72. Special subjects: photo-reporting, colour photography. Camera and film Linhoff (4 × 5-inch), Nikon; Kodachrome, Ektachrome. Exhibitions include a Time-Life travelling show of his colour pictures of Sistine Chapel. Collections: Metropolitan Museum of Art, New York. Book: *The Splendors of Christendom*.

Dmitri Kessel was born in the Podolia district of the Ukraine. At the age of ten he left his father's beet plantation and went to a school which was a combination of a European college and military academy, where students, upon graduation, were commissioned into the army. During the First World War Dmitri Kessel became embroiled in the Ukrainian National Movement. Kessel had always taken pictures since he was old enough to hold a box camera. He was still at school when some Ukranian peasants revolted against a Polish unit that had been pillaging their villages and killed the entire squadron of cavalry – about two hundred men. When the massacre was

Alexander Liberman

b. 1912

Alexander Liberman, *Van Dongen in his Paris studio,* 1959.

Born in Russia; US citizen. Baccalauréat at Sorbonne, Paris. Studied architecture with Auguste Perret, painting with André Lhote and graphics with Cassandre. Came to New York, 1941; joined staff of *Vogue*. Appointed Art Director, *Vogue*, 1943, later of all Condé Nast publications in United States and Europe. Camera and film: Leica; Kodachrome II and Tri-X. Photographic exhibitions: 'The Artist in His Studio', Museum of Modern Art, New York, 1959. Collections: Photography in the Fine Arts – II, III, IV Collections, New York; Museum of Modern Art. Books: *The Artist in His Studio*, 1960; *Greece, Gods, and Art*, 1968.

Alexander Liberman, a Russian refugee living in Manhattan, is a sculptor and painter and also chief art director on the Condé Nast magazines. But in addition to his work choosing and editing other people's photographs, he is expert with a camera.

Liberman has been lavish with his spare-time energy, and by conscientiously visiting every notable studio has made an interesting in-depth visual reportage of each of these men who, with the passing of a few years, have now gone into history.

Liberman's book on ancient Greece is the result of many years spent visiting the same sites in order to find the most suitable conditions for pinpointing his subject.

Nickolas Muray published an impressive album of his *Portraits of the Twenties*, but today many of the chosen pictures appear surprisingly archaic: the women's hands are extremely affected, Ravel is seen in a laboriously monumental pose, Scott Fitzgerald is frozen with selfconsciousness. Moreover, Muray was handicapped by the fashion for 'flattery by retouching'. Had he been born ten years later he would have realized that his sort of embellishment was unnecessary and would have given his negatives their true values. His bare-shouldered Garbo pictures, virtually unpublished, are, with the exception of those made by Genthe and Steichen, the least artificial of all the thousands taken during her years in Hollywood. Muray photographed Ted Shawn and other dancers in the nude, using what became a cliché in the 1930s – the application of oil to the body to give a metallic sheen. He carried this habit over into advertising, and his nude for a firm of towel-makers was the first naturalistic colour nude in American magazine advertising.

Perhaps Muray's best work was done outside his studio. Certainly his picture of Monet in a setting of all that he loved – under a rose-covered archway with his beloved water-lilies close at his feet – shows us far more than any of the better-known photographs of the old man in his last years.

Nickolas Muray, *Claude Monet in his garden.*

W. Eugene Smith

1918–1978

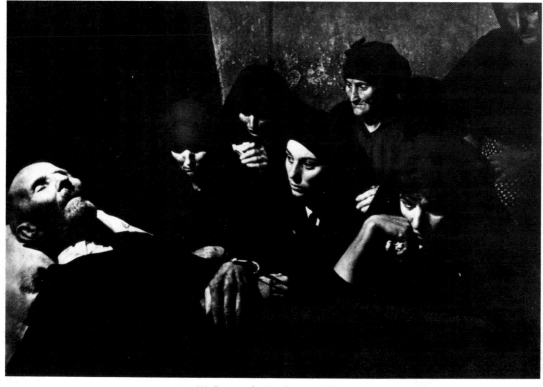

W. Eugene Smith, *Spain*, 1951.

W. Eugene Smith, *Tomoko in Her Bath*, Minamata, Japan, 1972.

Born in Wichita, Kansas. News photographer at fifteen; photographic scholarship to Notre Dame University, 1936; left early in 1937. Photographer for *Newsweek*, 1937–8. Joined Black Star Agency; stories for *American Magazine, Collier's, Harper's Bazaar* and *Life*. Retainer contract with *Life*, 1939–41. War correspondent for *Popular Photography* and their Ziff-Davis publications, 1942–4; for *Life*, 1944–5. Covered thirteen invasions, made twenty-three combat air missions, was seriously wounded at Okinawa, 1945. Returned to photojournalism and *Life*, 1947. Resigned from *Life* and joined Magnum Photos, 1955. Began photo-essay 'Pittsburgh'. Commissioned by American Institute of Architects to photograph in colour contemporary American architecture, 1956. Resigned from Magnum, 1959. Commissioned by Japanese industrial firm, Hitachi Ltd, to photograph its operations, 1961. Special Editor, *Visual Medicine* magazine, 1966–9. Associated with faculty, School of Visual Arts, New York. Cameras: miniatures. Guggenheim fellowships, 1956, 1957, 1968. Exhibitions: University of Oregon; Rochester Institute of Technology, New York University; Museum of Modern Art, New York; International Museum of Photography, Rochester, New York, etc. Collections: International Museum of Photography, Museum of Modern Art; Art Institute of Chicago. Books: *A Chapter of Image,* 1963; *Hospital for Special Surgery* with Carole Thomas, 1966; *W. Eugene Smith; Photographer,* with an afterword by Lincoln Kirstein, 1969.

A man of high ideals, he was always being hurt. He felt it was the fact that he had no university degree which made his life particularly difficult; he was prone to persecution. In the Second World War he became a correspondent-photographer and was badly wounded. After two years of recuperation, his first picture was of two children walking hand-in-hand towards the light; this was used for the theme of the great exhibition 'The Family of Man'.

Eugene Smith became enormously respected as one of *Life* magazine's best staff photographers. From his window in New York he captured the life going on in the windows opposite; looking down on to the street, he saw a woman crossing a white traffic line and created a mysterious and beautiful effect as of a trapeze artist on the high wire. The most successful of his photo-reportage was of a country doctor with film-starry dark lashes around his pale sad eyes, called out late at night to perform an emergency operation on a small child's head; these haunting pictures were filled with true drama. Memorable too was his picture-story of that admirable black nurse, Maude

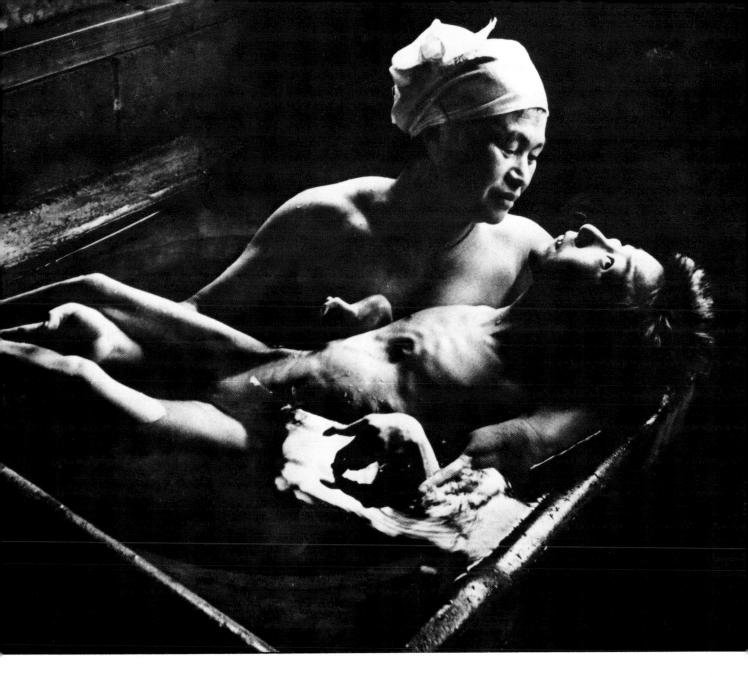

Callen, helping in the delivery of a baby. Smith told us that literally thousands of people depended upon Miss Callen who was full of compassion, truth and real pride.

Smith often took exception to the manner in which his photographs were laid out by *Life* editors: he considered they were cut, or placed in a way that was not synonymous with what he had tried to illustrate. At last, disgusted with their treatment of his Albert Schweitzer story, he quit.

Smith photographed for two years in Pittsburgh. He photographed in Wales, he photographed in Africa. Working on a feature he tried not only to portray the true essence of his characters, but also to convey what they did during that day, what and how they felt, as well as his own feelings – perhaps of anguish or admiration – towards them.

It was a private revenge on those most despicable of all-white trash that Smith, who despised bigotry, should contrive to photograph the members of the Ku-Klux-Klan to appear black-skinned against the white of their gowns.

Smith took a grotesque shot of a bomb explosion – a minia-

ture version of that most terrible of all bombs – with its black-and-white smoke, and in the foreground a shrubbery blasted and burnt, while, sheltered by rocks, a group of soldiers appear as unconcerned as if playing bridge on a picnic. Smith suffered during many of his experiences and wrote: 'Sticks and stones, bits of human bones, a lashing out on Iwojima.' He felt that his war pictures were not successful and that soon he would be forgotten. In this instance he was mistaken.

His most memorable war photographs include a naval burial at sea, about which he wrote: 'His one life has been used up by his country, and he is shunted into the sea. A few brief words, a loud splash, and war goes on.'

Not only for his eye for composition and the clarity of definition is Smith's work appreciated, but for the purity of his intent. When he depicted a Spanish village in 1950, in its entirety, he lived for over a year among its inhabitants in order to become a friend and not an interloper, and thus was able to show every aspect of this poor community. His group with a dead octogenarian surrounded by his grieving family is an epic.

Edwin Smith

1912–71

Edwin Smith, *Royal Palace, Caserta,* 1963.

Born in London. Trained as architect, painter by inclination. Concerned with every form of visual experience, started to photograph just prior to First World War. Regular contributor to *The Saturday Book*. Special subjects: architecture and landscape. Camera and films: Ruby (early 1900s, mahogany and brass) and two old-fashioned hand-bellow type; pancromatic and ordinary plates. Exhibition: Aldeburgh Festival, 1973. Books illustrated by Smith include: *English Parish Churches,* 1952; *English Cottages and Farmhouses,* 1954; *The British Museum,* 1957; *Venice,* 1962; *Athens,* 1964; *Hatfield House,* 1973; *English Parish Churches,* 1974. Books written and illustrated by Smith: *All the Photo Tricks,* new edition 1973; *The Graphic Reproduction and Photography of Works of Art,* 1969.

Of recent years the photography of great architecture has floundered between the Scylla of the super-technological and the Charybdis of the amateur snapshotter. With ever more highly sensitized film, and a greater accuracy of colour emulsion, particularly in France, Germany and the United States, architectural photographs have become so precise that one can discern with equal clarity, and with very little difference of emphasis, the urn of carved fruit in the foreground and the brick on the farthest rooftop. The antiseptic quality of the results is apt to rob the subject of its innate mood, particularly when flash, strobe and other artificial means of lighting are used to obliterate shadows and add perfection of detail.

In contrast the work produced by hand-held cameras has introduced us to other distortions – that of a Samsonesque effect with columns falling inwards and perspectives intentionally false. By placing the camera close to an egg-cup or a silver candlestick the foreground is given more importance than the distant triumphal arch. These effects may have added an 'atmospheric' excitement and 'contemporary' feel, especially when the result is printed with excessive contrast, but this is not the definitive rendering of the scene.

Perhaps in any case the evocation of so essentially static a subject as architecture is the least suitable to be essayed by the candid camera (which is presumably aimed at catching the bird or butterfly on the wing). But bringing the greatness of good architecture to a print takes experience, not only in the sense of knowing how to compose, light and expose a picture, but also in the later stages of the technical processes of printing and developing when all the values of texture and tone can be brought out.

Edwin Smith's photographs are a happy mean between the two schools of architectural photography. When photographing inside buildings where tripods were not permitted he used a small camera. One of his peculiarities was that his hands were so steady that he could make quite long exposures without moving the lens. But with his large plates he too gives the shock-value of the 'significant detail' in the foreground, and the range of shadows on sculptural ornaments, or of sunlight filtering through the clouds onto a curving colonnade. But although Smith was adept at catching a dramatic effect there are no clumsy misuses of horizontals, no accidentally falling columns or tottering towers. Only in his colour plates does he exaggerate the perspectives on the gilded ceiling at Vaux-le-Vicomte in order to emphasize the flying quality of the figures with their fluttering drapery. Even in black-and-white he was able to suggest the richness of the dark Christmas-pudding panelling below the brandy-butter stucco ceilings of English country houses, the delicate spirals of the wood-carving at Chatsworth, Belton or Petworth.

Editors who were foolish enough to try to dictate to Edwin Smith were ignored. He was completely independent. He knew his job. Travelling without an assistant or even a light-metre, he merely brought to each expedition his understanding of architecture, his enthusiasm and his artistry. He enjoyed the 'gorgeous' risk of returning from a long and strenuous voyage abroad with all his undeveloped film in one basket. Often he was delighted to discover that by screening the lens from light, final prints revealed details that had eluded him, thus proving that the camera can pick out things that we cannot see for ourselves.

Douglas Glass, *The Slade School.*

Anthony Ayscough

1910–39

Born in Edinburgh. Attended Corpus Christi College, Cambridge, and Westminster School of Art, 1935–6. Special subjects: Baroque statuary and plaster-work buildings. Camera: Rolleiflex. Books: *German Baroque Sculpture*, 1938; *Country House Baroque*, 1940.

Anthony Ayscough, a tall, willowy young man with fakir-thin limbs (his great-grandmother was Burmese) was becoming a spectacular figure in London in the late 1930s. His manner of dressing showed his aesthetic tastes, his hair turned light gold in the sun, and his eyes slanted behind huge spectacles. He was a promising painter and his use of colour showed an Indian influence. In addition, the extremely original photographs which he took were being sought after for books on architecture. Suddenly and tragically he was killed by a lorry while learning to ride a bicycle.

It was because Anthony Ayscough ('To' to his devoted friends) was dissatisfied with the guide-book and picture-postcard photographs he bought as souvenirs of places he visited, that a friend gave him a Rolleiflex and suggested that he take his own pictures.

Astonishingly quickly 'To' created his own technique; he was able to go into any richly ornamented room and immediately pick out among the plaster-work the most interesting and important detail. He always managed to find the area of essential beauty in a ceiling, the best garlands of the frieze, and the prettiest traceries of patisseried flowers high on a wall or in the shadows above an altar. He sought the particular grace that could be discovered in a swooning saint in nun's habit, or the one angel that gesticulated with longer fingers and more floating wings than any of the others. His eye was unique. For his collaboration with Sacheverell Sitwell on *German Baroque Sculpture* his lenses lit upon stucco figures from the altar of the Benedictine church at Zwiefalten near Ulm, the painted *Endymion* in the palace at Bruchsaal, and on many features in the unforgettable library at Wiblingen.

Anthony Ayscough,
Architectural detail.

If Ayscough's technical knowledge of photography was small, it was enough – for his determination to express his enthusiasm overcame all difficulties. By sheer will-power he forced the camera to do his bidding, and he achieved some astonishing results. Ayscough showed us the delicate nuances of variety and freedom in the embellishment of the more elaborately decorated houses of England and Ireland, and his ceiling of the drawing-room at Easton Neston made a superb cover for his book on country-house baroque.

Ayscough's influence has been far-flung. Today's architectural photographers attempt less to photograph a vast panorama than to concentrate upon illustrating the beauty of a single cartouche. They have learnt that sometimes the individual order is more eloquent than the structure as a whole. This is only part of Anthony Ayscough's influence. His prints have a silvery quality, and a unique spirit which shines through to record for us his own individual feeling for beauty.

Douglas Glass

1901–1978

It seems that the habit of running a series of photographs in magazines or newspapers is in eclipse. This is a pity. It was always rewarding to turn to the *Sunday Times* 'Portrait of the Week' when Douglas Glass gave us a regular treat. Glass was specifically a portrait photographer, yet there was nothing banal or expected about the way in which he saw even the least inspiring of his sitters. Somehow a dreary bore, full of pomposity, could become a curiously interesting-looking individual when seen by Glass's bright twinkling eyes.

As he is a lively and readily amused human being, Glass could come to terms with the most unlikely of subjects and make something of them that was rewarding to all. He was never in awe of even his most illustrious sitters.

By doing just the 'wrong' thing with his lighting – a blob of highlight on the tip of the nose, or a shadow where it should not be, he made his dullest sitters come alive. Even if they may not have been at ease, he managed to make them appear relaxed, for instance by showing the way they interlocked their fingers.

Jean-Pierre Sudre

b. 1921

Jean-Pierre Sudre, *Above, left Lilies,* 1955. *Right Dish with Strawberries.*

Born in Paris. Attended École Nationale de Cinématographie de Paris, 1941–3; Institut des Hautes Études Cinématographiques, 1943–5. A lecturer and member of Jury of École Nationale d'Architecture et des Arts Visuels, Brussels, from 1965. Founded photographic departments of Galerie La Demeure, Paris and of École Supérieure d'Art Graphique, 1968. Head of Stage Experimental Photographique at Lacoste, France (a research centre of creative photography), 1974. A member of board of directors of Société Française de Photographie, from 1968. Special subject: creative photography. Camera: 5 × 7 inch plate. Major exhibitions: Galerie La Demeure, Paris, 1952; First Venice Biennale, 1957; Palais des Beaux-Arts, Brussels, 1962; Retrospective, Cologne, Essen, Berlin and other German cities, 1965; Museum of Modern Art, New York, 1967; Les Contards, Lacoste (with D. Brihat), 1968; 'Exposition 2: Jean-Pierre Sudre and Hill and Adamson', La Demeure, Paris, 1969; National Museum, Moscow, 1972; Bibliothèque Nationale, Paris, 1973. Collections: Museum of Modern Art; Bibliothèque Nationale; Musée Réattu, Arles, France; Palais des Beaux-Arts, Brussels. Publications: *Bruges,* by F. Cali, 1963; *Diamantine,* preface by Sudre (limited edition of original photographs), 1964; *Parlinne,* 1967 and *Argentine,* 1968 (original photographs in limited editions).

'Sudre prefers large-format pictures, and he does his own laboratory work with great care and enthusiasm. While it is true that this has been the case for twenty years, it must be said that an impressive aesthetic development has taken place over this period which is without doubt due to his constant experimentation. A first "objective" period in which his choice of subjects was restricted almost entirely to motives from the plant world and still lifes was followed by an "abstract" period in which the artist disovered a new reality: the invisible aspects of matter.

'For above all, Sudre is a devotee of the single picture, the original. He is convinced that there is a public which appreciates a photograph all the more because there is only one of it in existence, and that the uniqueness of a picture makes it particularly desirable. The fact that his work has been sold in art galleries and that he is a regular exhibitor in the Galerie Veranneman in Brussels would certainly appear to lend weight to his theory.' (Romeo E. Martinez in *Camera,* November 1966)

Lilo Raymond

b. 1922

Born in Frankfurt, Germany; United States citizen. Started photographing when in her late thirties. Studied with David Vestal, 1961–3. Photographs all subjects. Camera and film: Nikon F; Tri-X. Exhibitions include: New York Public Library, 1964, 1966; 'Festival of Women', University of Toronto, 1971; Midtown Gallery, New York, 1973. Publications include: US Camera Annual, 1964, 1967, 1970, 1971; *Popular Photography Annual,* 1964; 1967, 1968, 1971; *Time-Life Library of Photography Series – The Art of Photography, Photographing Children, Special Problems.* Collections: Women Artists Archive at California Institute of the Arts; Bibliothèque Nationale, Paris.

In her enormous quiet loft on New York's famous Fourteenth Street, works as a photographer a beautiful German woman of middle age with kind dark eyes. Her occupation was previously that of a professional tennis champion. Her neighbourhood is among the most squalid in the world. Puerto Ricans screech at one another over the din of heavy traffic. On her block are hot-dog stands, Spanish movies, sleazy shops, and there, bums with snot and scab-covered faces urinate into the subway exits. It is in these neighbourhoods that certain artists in New York must seek rooms in abandoned industrial buildings in order to

have enough space for free creativity in the cramped city. And it is here that an artist such as Lilo Raymond must practise extreme concentration in order to obtain the serenity she achieves in her photographs. Her talent can isolate ordinary, even plain objects, and infuse into them great beauty and meaning. Objects seem to her to have a spiritual dignity far beyond their everyday usage. Or perhaps it is their usefulness that elevates them to symbolic importance. Previously, this was the job of painters alone, but Lilo Raymond, a highly cultured woman evokes in her photographs not only art but art history. Her straw basket with eggs brings to mind Oudry, her wooden bowl with pears conjures up Chardin and often her still lifes seem about to slide off the bottom corner of the table top as do the fruit compositions of Cézanne. The illustrated avalanche of freshly-opened oysters are reminiscent of Braque.

Art history may be part of her approach to her photography but at the same time it is undeniably contemporary in spirit. In her isolation Lilo Raymond produces prints that inspire discussions about the fundamental qualities and meanings of art.

Lilo Raymond, *Oyster Shells.*

Lennart Nilsson

b. 1922

Lennart Nilsson, *Sperm cells enlarged about 15,000 times in the scanning electron microscope.*

Born in Strängnäs, Sweden. First worked as an ordinary press photographer; in early 1950s began making close-ups of living organisms. A freelance photographer, began collaboration with *Life* magazine in the late 1950s. Author of many scientific publications illustrated with his own pictures; attached to the World Health Organization and a member of the Swedish Medical Association. Photographic investigations include the study of the human heart, brain, eye, ear. Special subjects: the behaviour and functions of the human body; science. Cameras: all types; specially designed very short focal length lenses (from 1–4 mm). Awards: Photographer of the Year, University of Missouri, 1965; Picture of the Year, National Press Photographers' Association, 1965; American Heart Association medal, 1968; Europhot, 1970; and many gold medals and plaques from Swedish and Norwegian organizations. Exhibitions: Museum of Modern Art, Stockholm, 1973. Books: *Ants,* 1959; *Life in the Sea,* 1960; *Salvation Army in Sweden,* 1963; *A Child is Born,* 1965; *Behold Man,* 1973; *The Human Body,* 1974.

Lennart Nilsson does not enjoy being classified a 'medical photographer', yet this remarkable Swede has taken such revelatory pictures of human processes that he has gained the highest honours in the world of photography and science.

Nilsson explains himself as a news photographer who gives people 'information about themselves in ways they can see and understand'. He is constantly experimenting and breaking new grounds and seldom repeats himself. 'I never work in one field only, because life is too short; when I go on to new things, I feel just like an amateur photographer,' Nilsson has said.

Nilsson was born in Strängnäs, a small town in a rural district near Stockholm, where his passionate interest in nature was cultivated. Already by the age of five he had made a collection of the local flora and fauna. When he was twelve, he was given his first camera, a box model camera costing two crowns ($·50) which his father, an amateur photographer, taught him to use. Later an uncle, who earned a living as a studio photographer, gave young Nilsson more professional advice.

Nilsson worked closely with one of Stockholm's major hospitals where he inserted specially designed lenses into the aortas of cadavers to record damage from arteriosclerotic lesions. His enthusiasm for showing the mysteries of life was shown in his colour photographs of 'Drama of Life before Birth', in which for the first time a live baby was seen inside the womb. Nilsson photographed the growth of the embryo from fertilization to a stage just before birth.

Recently Nilsson experimented with optical devices which were capable of magnifying images of minute objects up to 50,000 times larger than reality, and thus was able to show us sections of bone marrow, and how cells in the inner ear receive sound vibrations and translates them into electrical impulses which in turn are transmitted to the brain. He also showed the spinal cord, the small intestines, fallopian tubes, and white blood corpuscles and of how they ward off attacking staphylococcus clusters, and finally ingest the bacteria with its pseudopods.

Lennart Nilsson's pictures were taken in black and white, later laboriously tinted in three colours approximating the cells' actual appearance.

Ceaselessly searching for new methods, Nilsson hopes to produce lenses with focal lengths as small as 1/25th of an inch for 'taking pictures where no eyes have seen', and to make available photographs of human cellular processes seldom inspected outside laboratories.

Although his pictures have illustrated scholarly medical papers and his collaboration with important scientists has been of long standing Nilsson has never formally studied science.

When working as a freelance for *Life* his most popular essays were of a polar bear and her cub made in Spitsbergen, and on the African jungle. Another remarkable feature was on Ingmar Bergman, the Swedish movie director, for whom he has much sympathetic understanding, and with whom he has often worked in harmony in the difficult task of film making.

Werner Bischof

1916–54

Born in Zürich. Always interested in painting, entered the teachers' seminar at Schiers (Graubünden) but left it for the Zürich School of Arts and Crafts where he studied photography with Hans Finsler. From 1936 worked as a freelance photo-journalist for *Du, Picture Post, Epoca, Life, Paris-Match, Observer, Fortune.* Editorial staff of *Du,* 1942–4. Joined firm Magnum Photos, 1949. Major exhibitions: 'Japan', Chicago Art Institute, 1955; 'Ten Years of Photography', International Museum of Photography, Rochester, New York, 1959; Smithsonian Institution, Washington, DC, 1961 and 1969; 'The Concerned Photographer', New York, 1967; Tokyo and other principal cities of Japan, 1968–9. Collections: Art Institute of Chicago; Metropolitan Museum of Art, New York; Museum of Modern Art, New York; Riverside Museum, New York. Books: *Japan,* text by Robert Guillain, 1954; *The World of Werner Bischof,* text by Manuel Gasser, 1959; *Indiens Pas Mort,* text by Georges Arnaud with works contributed by others, 1959; *Werner Bischof,* a monograph edited by Anna Farova, 1968.

Bischof died at a very early age, leaving a remarkable reportage of the terrors of war in France, Holland, Korea and Germany. He also left memorable records of the famine in India. Bischof was deeply affected by the tragedies he witnessed, and it was a

Frederick Sommer

b. 1905

Frederick Sommer, *Coyotes,* 1941.

Born in Angri, Italy; US citizen. Father German, mother Swiss; from 1913 family lived in Rio de Janeiro. Master's Degree in Landscape Architecture, Cornell University, 1927. Practised landscape architecture and city-planning in Rio de Janeiro, 1927–30. In early 1930s worked primarily at drawing and painting; started to photograph after spending week with Alfred Stieglitz, 1935. Corresponded and exchanged work with Edward Weston from 1936. Taught photography at Institute of Design, Illinois Institute of Technology, 1957–8. Special subjects: Arizona landscape, reassembled 'found' objects, and more recently, smoke-on-glass, paint-on-cellophane and cut-paper images. Camera: 10 × 8 inch. Major exhibitions: 'Photographs', Santa Barbara Museum of Art, 1946; 'Photographs and Drawings', Egan Gallery, New York, 1949; 'Drawings, Paintings and Photographs', Institute of Design, Chicago, 1957; Light, New York, 1972; and Washington Gallery of Modern Art; the Pasadena Art Museum; Philadelphia College of Art. Collections: many major ones in US.

One day in Mexico, Sommer noticed a doctor walking along a street carrying a bag. He asked: 'What have you in there?' The doctor supplied the information: 'The amputated foot and leg of a tramp.' Sommer then insisted upon photographing it. This he did, in grotto-like darkness, with a background suggesting crustacean-covered underwater rocks. Sommer made of this curious object, with its congealed blood and livid deadness, a thing of horrific beauty – almost like a detail from a painting by Grünewald.

Sommer's photographs, of lids of paint-cans, dismembered dolls, broken slides, dry thistles, bits of dappled earth or cracking soil, have never been popular because of the unease that they create in the viewer. He de-guts, then photographs a raw bird: some dead and disintegrating coyotes are considered ideal *objets trouvés*. At first people seeing his pictures wanted to ignore them.

Sommer is a meticulous surrealist, or cautious *fantaisiste* who chooses the strange objects that he juxtaposes with a fervour that is almost religious. His aim is to create a new world out of the commonplace through the selective camera-eye together with the inner eye of the subconscious. Everything you see in his pictures is photographed directly on the negative.

Sommer, who suffered from tuberculosis, went to live in Arizona in 1935, where he spent much time reading philosophy. He is of all photographers perhaps the most articulate. He describes himself as 'walking about the world searching for something we carry within ourselves'. Some of the aphorisms from his *Aperture* monograph, 1962, are:

Reality is greater than our dreams,
Yet it is within ourselves that we find the clues to reality.
Clues are essences and keys and keys are stronger
Than the doors they open.
Life itself is not the reality.
We are the ones who put life into stones and pebbles.

welcome change for him to embark upon a book on Japan.

In the Japanese book his selection of detail is remarkable – ripples in raked sand, the texture of stones in winter, the iris-leaf like a samurai's blade signifying strength, and a lotus-leaf, the symbol of purity. His understanding of that country is of an uncommon quality. In the picture of Shinto priests crossing a courtyard of the Meiji temple in Kyoto, in the snow under the snow-covered pines and umbrellas of oil-paper, he gives us a view of Japan as it was a thousand years ago.

In his use of colour Bischof was a pioneer; he soon realized that because the camera is capable of recording most colours in the spectrum, they are truly effective when severely censored and controlled. This is seen to be the case in *The Bride*, a study in white with only a few touches of scarlet. His pictures of long lengths of cotton waving in the wind, as they dry after being dyed in the river, are among the best that have ever been taken of this incredibly photogenic sight. Every page of his book has its delight.

Werner Bischof, *Dhobis Flying in the Wind,* Japan.

Wynn Bullock

1902–1975

Born in Chicago. Attended Columbia and West Virginia Universities; studied photography at Los Angeles Art Center School with Edward Kaminski. Involved in commercial and creative photography, 1939–57; from 1957 to the present involved in purely creative photography. Camera and film: Ansco view camera and Isopan film, 1950–60; $2\frac{1}{4}$ inch Rolleiflex twin lens and SL 66, 35 mm Leica and Nikon cameras, 1960–70. Selected exhibitions: Los Angeles County Museum, 1941; University of California at Los Angeles, 1954; International Museum of Photography, Rochester, New York, 1957; Art Centre of Czechoslovakia, Prague, 1958; 'Subjective Fotographie 3', Saarbrücken, Germany, 1958; 'The Sense of Abstraction', Museum of Modern Art, New York, 1960; San Francisco Museum of Art, 1969–70; Institute of Design, Illinois, 1969; American Cultural Center, Paris, 1972. Collections: Smithsonian Institution, Washington, DC; Museum of Modern Art; Mills College, Oakland, California; Kalamazoo Institute of Art, Michigan National Gallery of Art, Washington, DC; Addison Gallery of Fine Arts, Andover, Massachusetts; Virginia Museum of Fine Arts; University of California at Los Angeles; University of California at Santa Cruz; Yale University; Museum of Photography, Paris. Books: *The Widening Stream,* 1965; *Photographers on Photography* edited by Nathan Lyons, 1966; *Wynn Bullock,* text by Barbara Bullock, 1971; *Wynn Bullock, Photography a Way of Life,* 1973.

Wynn Bullock made the famous picture of the naked child sprawling in the forest that was seen by nine million people in the exhibition, 'The Family of Man'. Bullock, who as a young man sang in the *Music Box Revue* and was trained as a tenor in Paris, London and Berlin, switched to creative photography after working on technical photography for manuals in the armed forces during the war. Influenced by Moholy-Nagy and the early work in the style of the Bauhaus, he became a master printer in solarization, reticulation, double exposure, reversed and multiple negative printing. He holds many patents for his scientific work of which he is a technical innovator.

Bullock sees nature as of feathery lightness and even rocks and forests as something ephemeral – almost moving through him. He loves to make super-sharp statements which represent these visions.

Bullock discovers visions in the details of his landscapes: a boulder has hidden facets, soil-erosion is seen as a procession of hooded monks, tree-barks have faces. Many of his pictures instinctively contrast the softness of a naked human body with its harsh and sometimes threatening environment. Bullock says: 'Through the camera I want to express man and nature as they are, and when I start on a photographic trip I want to marshal all my power of seeing.' He advocates the exploration of the negative image for its many potentials. His work shows that he has total control of his medium, and that this goal is to 'extend awareness, to generate growth'. His photographs often show his principle of opposites – solid rocks against the flow of water; a naked girl in a redwood forest.

His three principles are (so he tells us): 'space-time' – that in seeing objects in terms of their spatial and temporal qualities they soon cease to be 'objects' but rather become space-time events; that nothing is conceivable without an opposite; that nothing can define itself. 'Reality and existence – only those things that happen in one's mind can one really know. Reality created through personal experience.'

Wynn Bullock, *Sea Palms,* 1968.

Minor White

1908–1976

Born in Minneapolis, Minnesota. Studied botany and English at University of Minnesota, 1928–33. Worked as a houseboy, waiter, bartender while writing verse, 1933–7. Appointed 'creative photographer' for Works Progress Administration (WPA), 1938–9. Teacher of photography and director of La Grande Art Center, WPA centre in Oregon, 1940–41. Produced first sequence of photographs; drafted into army, 1942. Baptized into Catholic Church, c. 1943. Studied art history and aesthetics in Columbia University Extension Division; studied museum methods with Beaumont and Nancy Newhall at Museum of Modern Art, New York, 1945–6. Photography faculty, California School of Fine Arts (now San Francisco Art Institute), 1946–53. With Dorothea Lange, Nancy Newhall, Ansel Adams, Beaumont Newhall, Barbara Morgan, Ernest Louie, Melton Ferris, Dody Warren founded *Aperture*; editor from first issue in April 1952 to present. Assistant curator at International Museum of Photography, Rochester, New York, 1953–6; editor of *Image*, 1956–7. Joined faculty of Rochester Institute of Technology, 1955. Conducted workshops, 1956–present. Appointed visiting professor in Department of Architecture at Massachusetts Institute of Technology, 1965; professor of creative photography there until 1974 (end of full-time teaching). Personal photography: a 'statement of position'; emphasis on landscape. Cameras include: Sinar view for black-and-white; Leica for colour. Selected one-man exhibitions: 'Portland Iron Front Buildings' and 'Portland Waterfront', travelling WPA exhibition, 1939–41; *First Sequence*, YMCA, Portland, 1942; 'Song Without Words', San Francisco Museum of Art, 1948; 'Intimations of Disaster', Photo League, New York, 1950; 'Fifth Sequence', 'Sequence 6' and 'Intimations of Disaster', San Francisco Museum of Art, 1952; 'Sequence 7', International Museum of Photography, 1954; 'It's All in the Mind', Carl Siembab Gallery, 1967; 'Sequence 16/Sound of One Hand', Ringling Museum of Art, Sarasota, Florida, 1968. Collections: International Museum of Photography; Museum of Modern Art, New York, and many other museums and private collections. Books: *Mirrors, Messages, Manifestations*, 1969; *Visualization Manual*.

Minor White's appearance is not what one would expect of America's most intellectual photographer – for that is what he is. The impertinent upturned nose might have been made for comedy.

White's grandfather, whose hobby was photography, encouraged him, when very young, to follow his same interests. But Minor White switched his enthusiasm to botany until he felt that really he was an embryonic poet. While trying to evolve his own philosophy in life he hated having to earn his living as a houseboy. Suddenly he knew that, after all, it was photography that was to be his life work.

Minor White's photographs see nature in a sensuous manner. He looks at writhing rock-formations, swirling water and rugged landscapes, then gives them an extra charge of emotion. His pictures are small, sharp, impeccably printed, and reach a high perfection. He 'reads' photographs for hours at a time, and the power of his sensibility is reflected in his series of nature pictures. With his unique knowledge of what can be done in developing, Minor White can even provoke a tree to turn white; but, above all, it is the drama with which he infuses his images that gives them their final quality. His straightforward portraits of his friends – treated more as sculpture or natural objects – are the least successful aspect of his work.

Perhaps more than anyone today, Minor White has made a great contribution to photography for, with his many workshops of instruction and his theories of 'equivalents', he has had vast influence. His three canons are: be still with yourself until the object of your attention affirms your presence; let the subject generate its own composition; when the image mirrors the man and the man mirrors the subject, something might take over. Sometimes White would make his students spend half their time in meditation with him before a class, then, on an impulse of the moment, take them out to look at one particular fine tree. He has a deep love of self-analysis and study, and is ceaselessly searching the inner essence of the photographer. His primary spiritual sources are Gurdjieff, Zen, I Ching and *Gestalt* philosophies.

On his subject of 'equivalence' White says: 'Equivalence is explored and tested first with photographs to visually match the mood-feeling of specific pieces of music, or poems. From the objective exercise of equivalence we move to the subjective, and try to make photographs which are equivalent to personal feelings or personal feeling states.' One of his most often repeated quotes reads: 'To photograph some things for what they are, and others for what else they are. To pursue chance and change into their lairs of permanence.'

Minor White helped to found and edits the excellent magazine *Aperture*, and has written an enormous number of tracts and essays, including *Mirrors, Messages, Manifestations*.

Minor White, *Two Forms Moving Left and Right*, 1949.

213

William Klein

b. 1928

William Klein, *Railway station, Moscow,* 1960.

Born in New York. Received degree in social science from City College of New York; studied at Sorbonne, Paris. A self-taught photographer. Since 1948 has lived in Paris; worked with Fernand Léger. A painter, photographer and film director. Worked for *Vogue*, 1957–67. Directed the films *Zazie dans le Métro, Broadway by Light, How to Kill a Cadillac, The Big Store* and *Cassius the Great.* Wrote and directed *Qui êtes-vous, Polly Magoo?* Prepared the scenario for *Mister Freedom, Loin du Vietnam, Panafrican Festival of Culture* and *Eledridge Cleaver Black Panther.* Special subjects: reportage, abstract, fashon, portraits. Camera and film: Leica; Tri-X and Kodachrome II. Voted by an international jury at Photokina 1963 as one of the thirty most important photographers in the history of photography. Exhibitions include: Fuji Gallery, Tokyo, 1961; Stedelijk Museum, Amsterdam, 1967; Photokina, Cologne, 1963; Collections: Museum of Modern Art, New York, Stedelijk Museum, Amsterdam; Biliothèque Nationale, Paris; Metropolitan Museum of Art, New York; Museum of Modern Art, Tokyo; etc. Books *New York*, 1956; *Rome*, 1959; *Moscow; Tokyo*, 1964; *Mr Freedom.*

In 1956 a book of photographs of New York was published in France. It was unlike the many other photographs on this subject, and William Klein's work became famous overnight; it was so dynamic and penetrating.

A good-looking American who lives in Paris, he did not come to his own unconventional form of photography by chance. He started as a painter and did big typographical compositions of letters on canvas. He turned to the camera when the paintings lost their purpose and became abstract, but he wanted to tell about reality as he saw it; his *Rome*, published in 1959, confirms the assumption that it was photographed by a man with an eye unaffected by academic training. Federico Fellini said: 'This book could be a movie, and one day, so I hope, Klein will do it. Anyhow, this is the best Rome and Klein is the best existing photographer. He knows Rome like a book, and this is it.' Such superlatives can raise doubts in one's mind, but Klein took on further life with an aggressive verve. He went to Tokyo and Moscow: two similar books were produced.

Klein produced some irritating movies for television, one of which gave grotesque behind-the-scene glimpses of a big fashion show. Klein uses black-and-white, as well as colour, to dynamic excess, but all his pictures are somehow the exercises of an artist who wishes to pass the bounds of his previous experiments.

Arthur H. Fellig ('Weegee')

1899–1969

Born in Zloczew, Poland; US citizen. Father a rabbi, with family emigrated to United States, 1909. Left school at twelve years old. Started photographic career as a tintype street photographer with a pony called Hypo. Worked as a printer in news-picture agency darkroom for about twenty years. Did freelance news photography at night in New York City; lived in room across the street from Manhattan police headquarters. Hollywood bought his book of photos of New York, *The Naked City*, for the movie by the same name, *c.* 1945. Did advertising photography for *Vogue, Holiday, Life, Look* and *Fortune*. Had offices in Hollywood, New York and London, from 1955. Special subject: violence. Collection: Museum of Modern Art, New York. Books: *The Naked City*, 1945; *Naked Hollywood* with Mel Harris, 1953; *Weegee's Creative Camera* with Roy Ald, 1959; *Weegee by Weegee*, 1961; *Weegee's Creative Photography*, 1964.

Weegee was born in Poland, emigrated to the United States at the age of ten, and earned money by day so that he could photograph at night. On the back of his photographs he stamped: 'Credit Weegee the Famous'. He was a raucous, self-advertising, cigar-chewing character, living alone in a room piled high to the ceiling with his pictures of the alleyways and the dark side-streets of New York, the crime, robbery, murders, fires, and the drop-jawed crowds who came for excitement to see these lurid things.

To begin with Weegee's work was not accepted by the public. But his aim was not merely sensationalism: he said he wished to show that ten and a half million people lived together in a city in a state of total loneliness.

Helen Levitt

b. 1918

Born in New York City. Studied photography with Walker Evans, 1938–9; studied art at Art Students' League, 1956–7. Began photographing children chiefly in Harlem, New York, 1936; in Mexico, 1941. Photographs published in *Fortune, Harper's Bazaar, Time, New York Post, Cue, US Camera Annual, Formes et couleurs*, etc. Began to concentrate on film-making. Special subjects: people in streets. Camera: Leica. Guggenheim fellowship, 1959, 1960. Exhibitions: Museum of Modern Art, New York, 1943; Chicago Institute of Design, 1952; 'Three Photographers in Color'; Museum of Modern Art, 1963. Collections: New York Public Library; Museum of Modern Art; Metropolitan Museum of Art, New York. Book: *A Way of Seeing*, with essay by James Agee, 1965.

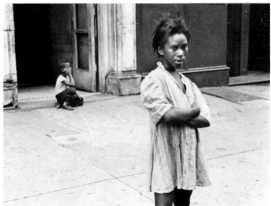

Helen Levitt, Untitled photograph.

He slept with his clothes on, his photo-gear at the ready, with a short-wave telephone by his bedside, so that if a major crime was committed he was up and there before the police. He had a sixth sense about where excitement would crop up. He was wherever trouble was to be found. All his pockets were zipped so that they could not be picked by thieves in the Bowery. It was said that fortune-tellers would ask Weejee to give them a helping hand with their predictions.

Sometimes Weejee used his flash-camera to produce grotesque pictures of terrible types juxtaposed so that each caricature appeared more fantastic. His pictures somehow avoid being cruel because they are funny, even if the joke may be on the borderline of sickness. Weejee photographed rich old ladies drunk at the opera, or tied up in their diamonds being gawked at by monsters in the crowd.

Weejee's *The Naked City* is a stark and extraordinary documentation showing the dirty floors of Manhattan bars, the cigarette-butts, and a picture of nine children all sleeping together in one bed. One of his prize shots was of a debauched baby-faced drunk in a bar, with dirty nails and wearing a smart tuxedo evening suit, tenderly stroking a young pig that belonged to the gauche young farmer sitting nearby. He also made a Greek tragedy photograph of an agonized mother and grandmother after a fire that had killed their offspring. He later made tasteless photo-caricatures or photo-distortions of little interest.

Robert Frank

b. 1924

Born in Zürich; US citizen. Began photographing seriously and became an apprentice to Hermann Eidenbenz, Basle, and Michael Wolgensinger, Zürich, 1942. Photographer at Gloria Films, Zürich, 1943–4. Photographed fashion for *Harper's Bazaar* in USA; received encouragement from Alexey Brodovitch, 1947. Freelance photographer, work published in *Fortune, Junior Bazaar, Life, Look, McCall's, New York Times*, 1948–55. Accompanied Edward Steichen to Europe to collect photographs for exhibition 'Post-War European Photographers', 1953. Became first European photographer to receive Guggenheim fellowship, 1955; travelled throughout the United States, 1955–6. Began film-making, 1958. Camera: 35 mm. Exhibitions: Museum of Modern Art, New York, 1948, 1949, 1952, 1954, 1955; Helmhaus, Zürich, 1955; Art Institute of Chicago; International Museum of Photography, Rochester, New York. Collections: Museum of Modern Art; New York, International Museum of Photography, Rochester. Books: *Les Americains*, text by Alain Bosquet, 1958; *The Americans*, text by Jack Kerouac, 1959; *Incas to Indians* (with additional photographs by Werner Bischof and Pierre Verger), 1956; *Pull My Daisy* with Jack Kerouac and Alfred Leslie, 1961; *Zero Mostel Reads a Book*, 1963; *The Lines of My Hand*, 1972. Films include: *Pull My Daisy*, 1959; *Me and My Brother*, c. 1965–8; *Kaddish*, c. 1965–6; *Conversations in Vermont*, c 1969; *About Me – A Musical*, 1971.

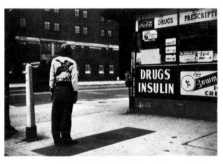

Robert Frank, *Chicago.*

Miss Helen Levitt, dark-haired and as beautiful as Shylock's Jessica with her large eyes, dresses in clothes that are nondescript. They are meant to be. For her passion is to roam the streets unnoticed in her search for unexpected glimpses of the deprived – for whom she feels love and sympathy.

Helen Levitt was inspired by Cartier-Bresson and trained by Walker Evans. She is opposed to documentary photographers with large view cameras for she wishes only to record the unforeseen, the fleeting, which are more likely to be captured by an unobtrusive and handy apparatus. A Leica equipped with a right-angle sight enabled her to avoid looking directly at her wayward subjects.

Her pictures taken in a suburb of Mexico City of children employed in their fantasies and games were exceptionally successful. She is remarkably clever at finding odd pieces of childish lore chalked upon walls – graffiti, messages and clues to magic delights. She discovered nimble urchins leaping over the obstacles of life. One waif was waiting outside an embossed church-door, wearing black and in her wiry hands holding a precious offering of a funeral lily enshrined in asparagus fern.

With James Agee she made movies of the strange and often poignant spontaneous occurrences that take place along New York's crowded streets, on the vacant lots, in empty houses, abandoned yards, or against the walls scribbled with messages: these she utilizes to create a mood of poignancy and mystery.

Frank is a Swiss-born immigrant who became part of the New York underground scene. Allen Ginsberg was a friend of his; so also was Jack Kerouac who wrote an introduction to Frank's book, *The Americans*, which shocked America when it first appeared. Robert Frank stood for the communist image. Patriotic Americans were incensed by the objectivity of the pictures; people seen in isolation, lonely in crowded cafés, in dingy cafeterias. A book, *The Lines of my Hand*, carries on his very special vision of his adopted country. Frank's work at first sight often creates a gut reaction. Such pictures by being so widely imitated have now lost their quality of outrage.

Frank photographed Paris in the 1940s for *Harper's Bazaar* and other magazines, but he did not consider himself to be a photo-journalist. He does not like to work under pressure; 'The 1950s, that was the time for me because there were no datelines.' He considers the photograph should stand on its own without benefit of text. Frank can create a traumatic picture of a dog jumping in a street, of ordinary people in odd groupings, faces of just anyone who may not be particularly interesting. He is 'at home' at a raucous movie première, in an empty bank, at a motorama, at a funeral spread with plastic flowers, in a men's room in a railway station in Tennessee. Two glimpses of note: a store window 'for formal wear' complete with dinner-jacket and a blow-up of Eisenhower, and the USA 285 road stretching straight towards a ceaseless horizon.

Larry Burrows

1926–71

Born in London. First job was as a messenger-boy in the photographic department of *Daily Express*. Joined Keystone Press Agency as a dark-room assistant. At sixteen exployed by *Life*, London, as a darkroom printer. First photographs for *Life* were of paintings and museums. Major assignments include Vietnam, Taj Mahal, Angkor, British East India Company, etc. Photographs reproduced in *Life*, *Time*, *Paris-Match*, *Stern*, *Quick*, *Daily Express*, etc. Based in Hong Kong as *Life* staff photographer, 1961–71. Cameras: Sinar, Leica, Nikon. Collections: Museum of Modern Art, New York; Royal Photographic Society, London. Major exhibitions: British Press Awards; University of Missouri; Royal Photographic Society, 1971; Photographers' Gallery, London; New York World Fair; Museum of Modern Art; Brooklyn Museum, New York; Rochester Institute of Technology; travelling exhibition, USA, 1972–7. Book: *Compassionate Photographer*, 1972.

compositions of Meissonier. They are *tableaux vivants,* packed with incident and details of extraordinary horror and beauty, showing us the wounded, those about to die, and those recently dead. They are the nearest we have to a demonstration that the camera could say everything that the grandoise historical paintbrush has ever attempted. Burrows's most famous news shots are of the wounded in an aeroplane and men jumping with parachutes.

Some of Burrows's most memorable pictures from Vietnam are in colour, and the colours he used were the dull, drab greys, sand and olive-greens that accentuate the horrors and squalor.

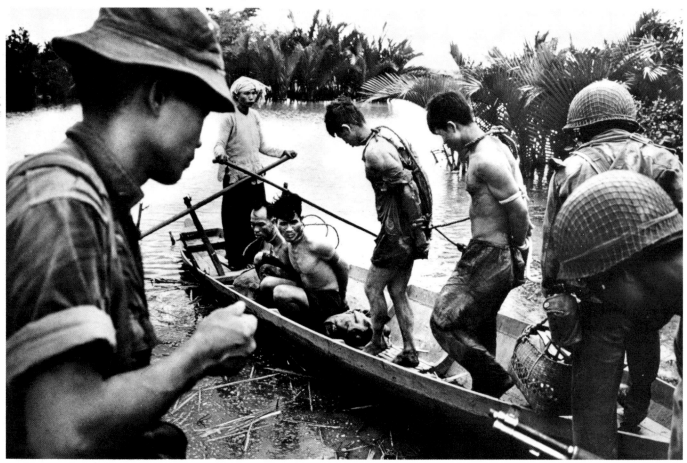

A tall, gaunt-boned Abraham Lincoln of a man with particularly long arms, wrists and fingers, Larry Burrows was cockney-born. After the war he was given an assignment to photograph for *Life* and this led to a connection with the Luce organization that lasted for nearly thirty years. He became a superb photo-journalist, bringing a fresh approach to even the most un-promising subject. (He made a remarkable job of C. P. Snow in a four-poster.) Not only did Burrows supply *Life* with some of its best picture-stories, but he wrote the text for them. He had a way with words that corresponded to the vivid poignancy of his film.

With the war in Vietnam, Burrows achieved his apogee. Some of his pictures are contemporary versions of the grand

It is difficult to single out the best from such an enormous output, but the unforgettable ones are of the woman in agony at the discovery of her husband's burnt remains in Hué, and the young communist prisoners about to be towed across a river with a turbaned woman watching with crossed oars: from the expression on her face we read a world of emotion. With typical lack of sensitivity *Life* magazine advertised his work on its cover: 'In Color: Ugly War in Vietnam.'

Somebody once said that Burrows was a fatalist about his own safety, and he himself remarked: 'I can't afford the luxury of thinking about what could happen to me.' His was a heroic life and his best pictures are on a heroic scale.

Above Larry Burrows, *Vietcong captives in the Mekong Delta,* 1963.

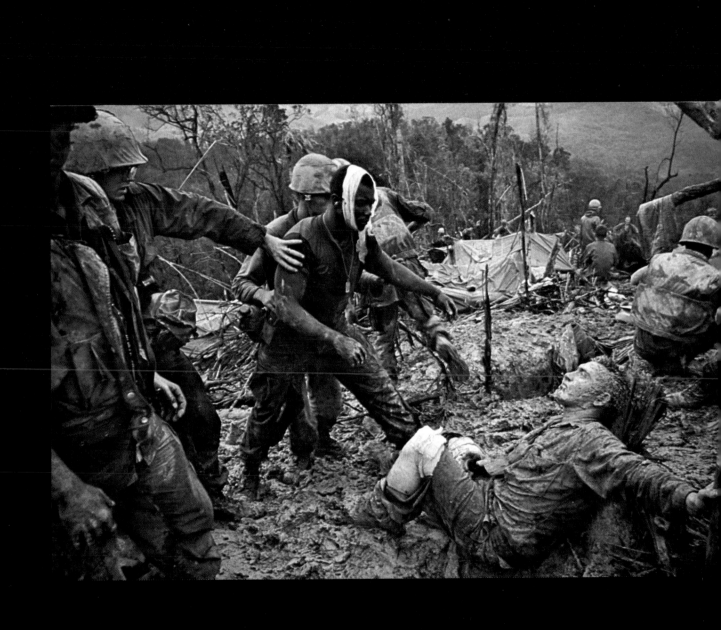

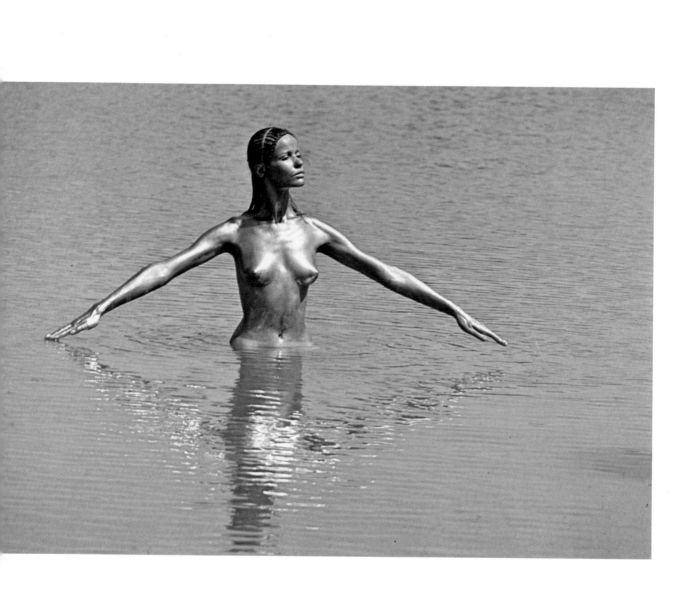

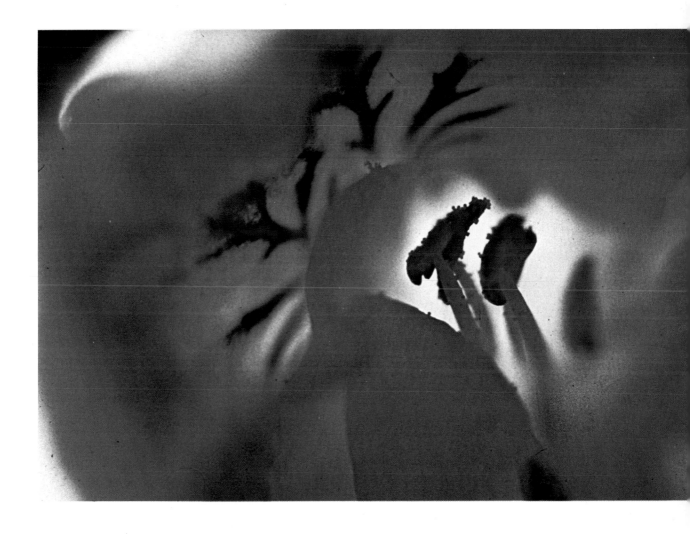

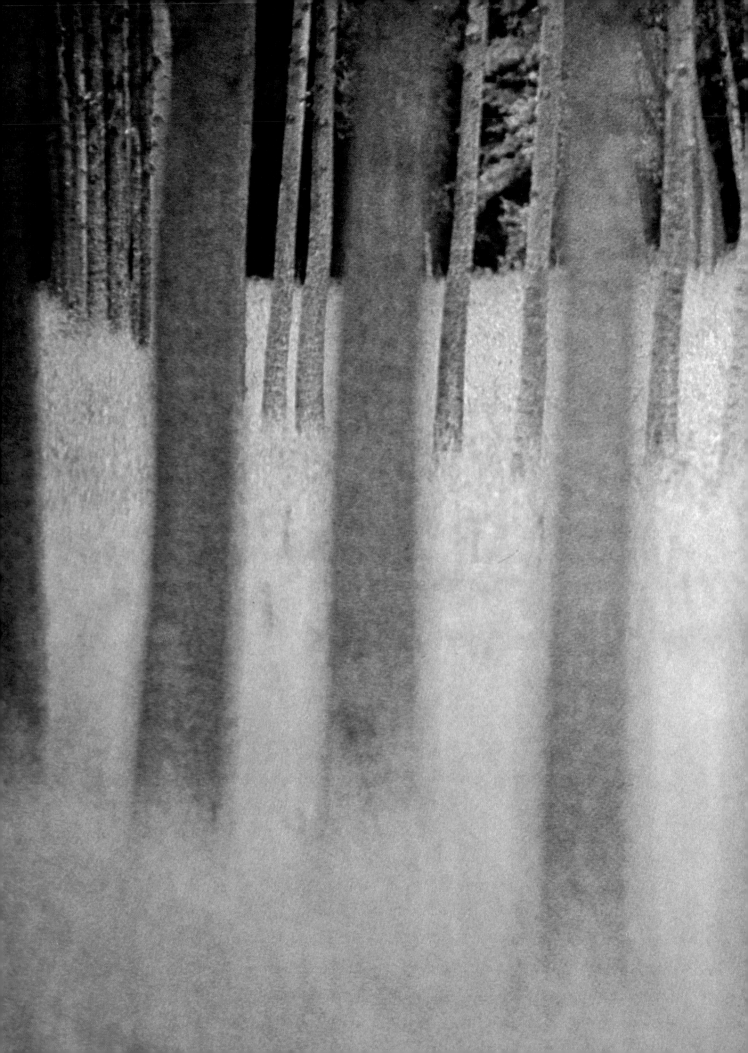

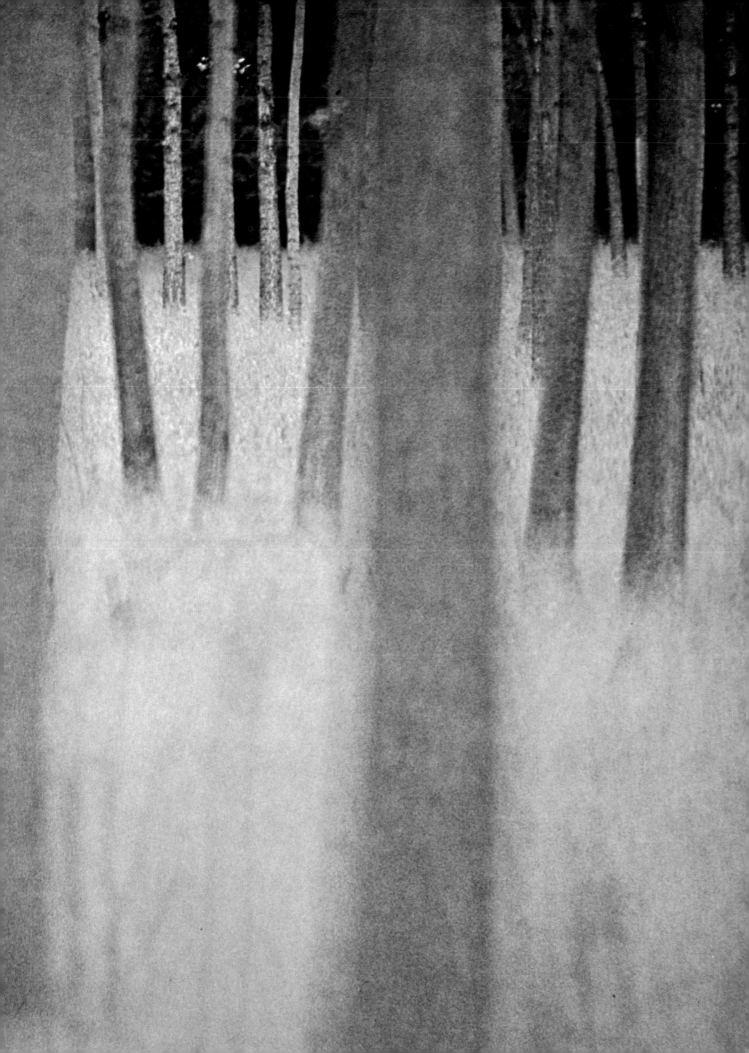

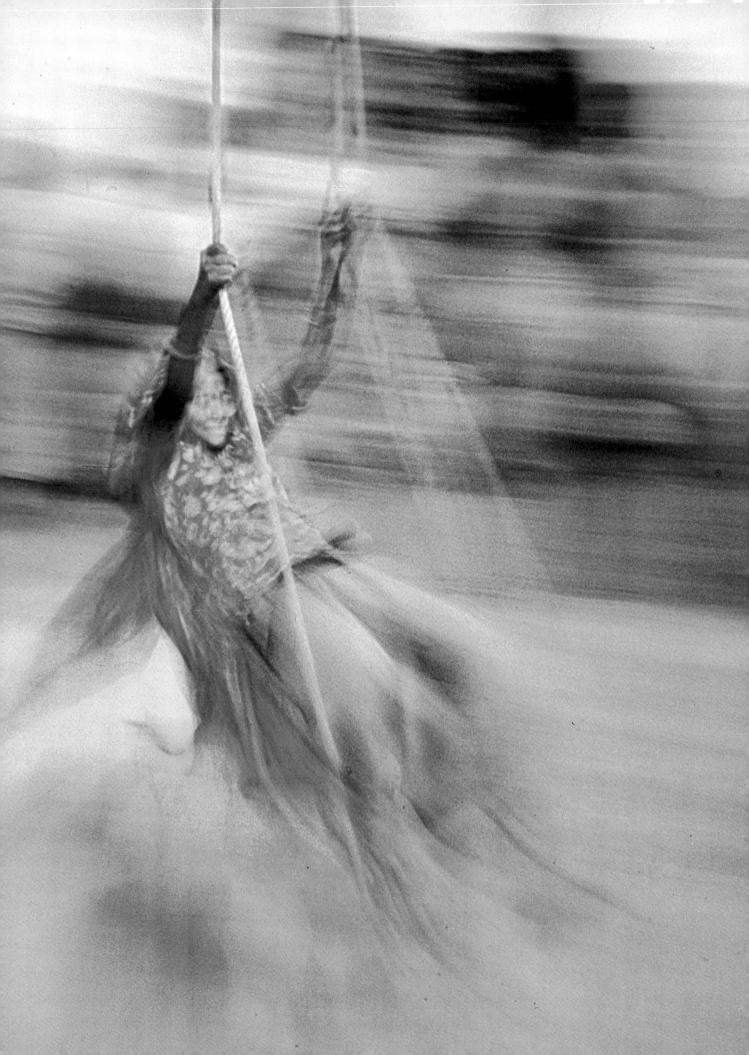

Georg Gerster

b. 1928

Born in Winterthur, Switzerland. Received Ph.D. in German literature and philology from the University of Zurich. Science editor, *Weltwoche*, Zürich, 1950–6. Freelance writer and photographer specializing in science reports since 1956. Travelled extensively in Europe, Africa, Near, Middle and Far East, North, Middle and South America, Antarctica. Regular contributor to *Neue Zuercher Zeitung*, Zürich. Photographs published in the *National Georgraphic Magazine*; *Time/Life* Books; *Sunday Times Magazine, Paris Match,* etc. Special subjects: aerial photography, archaeology. Camera and films: Nikon, Ekta- chrome, Kodachrome, FP-4. Exhibitions: 'Kirchen im Fels', travelling 1968–9; Swissair's Muba pavilions (Basle Trade Fair) on North America, 1965; Africa, 1966; South America, 1967; North America, 1968; Japan, 1969; Swissair Worldwide, 1970; USA, 1971. Books include: *Sahara-Reiche Fruchtbare Wueste,* 1959; *Augenschein in Alaska,* 1961; *Kirchen im Fels,* 1968; *Faras-Die Kathedrale aus dem Wuesten- sand,* 1966; *The World Saves Abu Simbel,* 1968; *Churches in Rock,* 1972; *Nubians in Egypt,* text by Robert A. Fernea, 1973.

Georg Gerster, *Contoured ploughed field in Georgia, U.S.A.*

Colour illustrations

Arnold Newman

b. 1918

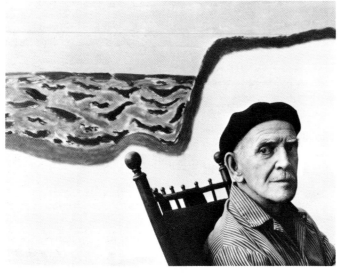

Arnold Newman, *Milton Avery*, 1960.

Born in New York. Raised and attended schools in Atlantic City, New Jersey and Miami Beach, Florida. Studied art at University of Miami, 1937–8. Began photography in a chain portrait studio in Philadelphia, 1939. Opened studio in New York City, 1946. Freelance photographer contributing to *Look, Holiday, Life, Time, Fortune, Harper's Bazaar, Esquire*, etc. Special subjects: portraits and still-life. Cameras: 8 × 10 inch, 4 × 5 inch, $2\frac{1}{4} \times 2\frac{1}{4}$ inch, 35 mm. Major exhibitions: 'Artists Look Like This', Philadelphia Museum of Art, 1945–6; Camera Club, New York, 1951; Chicago Art Institute, 1953; Portland Art Museum, Oregon, 1955; Santa Barbara Museum of Art, California, 1956; Contemporary Arts Center, Cincinnati, Ohio, 1958; Phoenix Art Museum, Arizona, 1961; Fourth Internazionale Biennale della Fotografia, Venice, Italy, 1963; International Museum of Photography, Rochester, New York, 1972; the Light Gallery, New York, 1972; the Berkeley Museum of Art, University of California, 1973. Collections: Museum of Modern Art, New York; Metropolitan Museum of Art, New York; Chicago Art Institute; Smithsonian Institution, Washington, DC; Philadelphia Museum; International Museum of Photography. Book: *Bravo Stravinsky*, 1967.

Newman is a master of lighting. His early work reflects his interest in abstract art and artists. The most professional of photographers, his particular interest is in the relationships between a man's personality and his life's work. In the 1940s he was particularly successful in photographing famous people. His sitters are seen in an atmosphere that is symptomatic of their work, or in a setting that contrives somehow to resemble it. Piet Mondrian holds his easel, which somehow appears as part of a Mondrian composition; Alfred Krupp is seen against a sinister background of factory trains; Willem de Kooning peers through a paint-splashed sheet, Aaron Copeland is vulture-profiled against a page of music, Martha Graham is at the practice bar, Max Ernst in a cloud of smoke. P. Jenkins is seen in a setting of the backs of his canvasses in rows turned to the wall; Shelagh Delaney is plaintive in a Midlands slum, Jean Dubuffet bald against a stain in the wall, Stravinsky a human chessman at a desk on a large chequerboard floor; Brooks Atkinson, the drama critic, sits in a field of empty theatre stalls, and the Emperor Haile Selassie in a fantasy throne-room.

Newman is extremely well informed about his sitters and their work. He studies them in advance and depicts them in a setting which he has devised for them after serious consideration; there is nothing of the haphazard in his choice. Newman's work has gained him a well-deserved position as one of the most reliable portraitists of today.

Bert Hardy

b. 1913

Albert Hardy was born in poverty, the eldest of seven children, the family living in two dingy rooms in the Elephant and Castle district of London. At the age of fourteen he left school; it was by chance and the fact that, as he says, 'I couldn't multiply 13 × 13,' that he got a job starting in a developing and printing works. Hardy spent nine years gaining experience and saving enough money to buy himself a Leica. He then became one of the first photographers in England to adopt a small camera for serious reportage.

Leicas were not considered seriously as cameras to be used for press purposes. But when Bert showed a photographic agency his 12 × 15 inch prints he was given an assignment, and his photo-stories were published in many magazines including *Picture Post*. As a staff member of that magazine he contributed many remarkable series, the best being 'Life in the Gorbals'. In 1942 Hardy joined an army photographic unit. Later he covered the Korean war. Altogether Hardy has photographed six major conflicts.

Few photographers know as much about lighting as Bert Hardy. When flash or strobe are necessary he knows exactly how to achieve the desired effect.

Hardy, a rugged pipe-smoking man with a disintegrating straw hat, knows what he is about, and he is able to explain his intentions. 'The photographer totally absorbed in his work may not think of that particular shot as being particularly significant at the time of taking it, but when a photographer is working at full stretch that occasional exceptional shot is bound to come. He is, all the time, composing from his surroundings and his feelings rather than his intelligence, and will react immediately to the combination of things that makes a great picture. Natural feeling, I think, makes the individual pictures, intelligence makes the story as a whole. The ideal picture tells something of the essence of life, it sums up emotion, it holds the feeling of movement thereby implying the continuity of life. It shows some aspect of humanity, the way that the person who looks at the picture will at once recognize as startlingly true. Without the help of the miniature camera these pictures would be even rarer than they are.'

Philippe Halsman

1906–1979

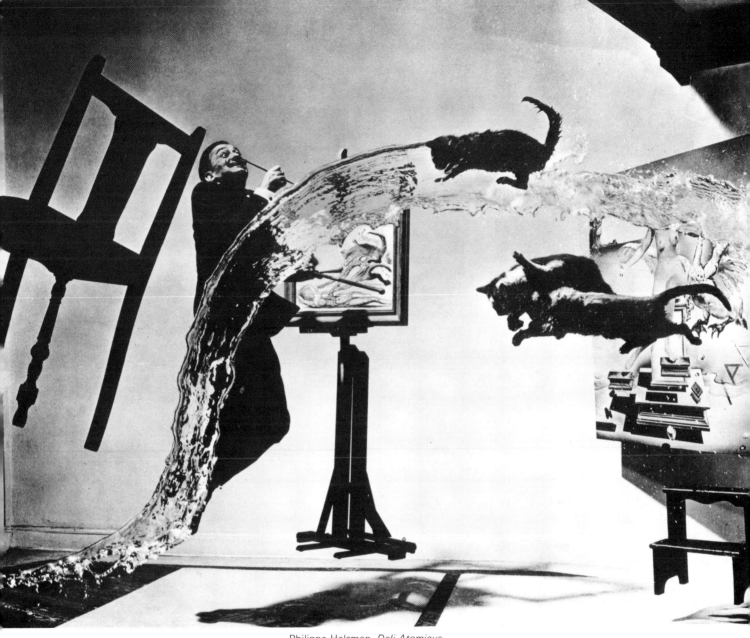

Philippe Halsman, *Dali Atomicus*.

Born in Riga, Latvia; US citizen. Studied electrical engineerng at Technical University, Dresden; courses at Sorbonne, Paris. Became a professional photographer in Paris, 1931. Arrived in New York (with the help of Albert Einstein, who arranged for an emergency visa), 1940. After difficult times, succeeded in freelance photography. In 1960 was given permission to photograph in Russia leading Soviet personalities; a journalistic *coup*. Assignments for *Life*, *Time*, etc. Work divided into three parts: magazine stories, advertising pictures, private portraits of men and children (not women). Has made 101 *Life* covers. Was first president of American Society of Magazine Photographers. Cameras: 4 × 5 inch Halsman-Fairchild twin reflex and Hasselblad. Exhibitions: Smithsonian Institution, Washington, DC. Collections: Metropolitan Museum of New York; Smithsonian Institution; Museum of Modern Art, New York; Congressional Library, Washington, DC; Royal Photographic Society, London. Books: *The Frenchman*, 1949; *Piccoli*, 1952; *Dali's Mustache* with Salvador Dali, 1953; *Philippe Halsman's Jumpbook*, 1959; *Halsman on the Creation of Photographic Ideas*, 1961; *Halsman: Sight and Insight*, 1972.

Philippe Halsman was the photographer of the greatest number of cover pictures for the now defunct *Life* magazine. Technically the pictures were impeccable. In some instances they proved that he had a manner of bringing out the human qualities of his renowned sitters. Sometimes he made even such over-exposed faces as that of Einstein appear as anonymous, gentle and real as any country neighbour. But perhaps Halsman's salient achievement was to persuade a number of distinguished people to make complete fools of themselves by taking off their shoes and jumping a few inches off the ground. A more undignified, ugly collection than his 'Jumpers' cannot be imagined.

Elliot Erwitt

b. 1928

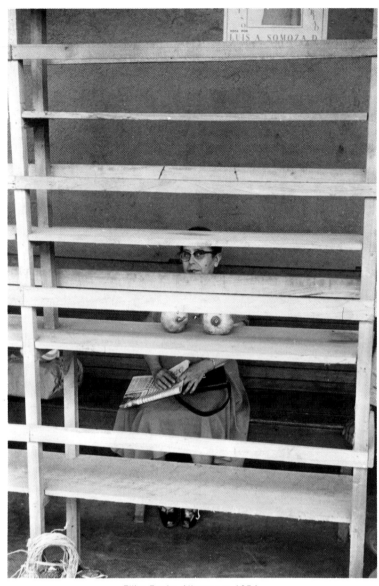

Elliot Erwitt, *Nicaragua*, 1954.

Born in Paris; US citizen. Became interested in photography while a student at Hollywood High School; worked as a darkroom printer in a Hollywood studio. After attending classes at Los Angeles City College, moved to New York, 1948. First job was to take portraits of eminent authors for book-jackets. Edward Steichen helped him find employment in a prominent commercial studio called Sarra. Took classes in film at New School for Social Research in exchange for taking photographs. Worked with Roy Stryker at Standard Oil, 1949–50; went with him to Pittsburgh to document the city for Mellon Foundation. Entered army, 1951; worked in an army darkroom and took personal photographs, mostly in France. Joined Magnum Photos, 1953; president for longer period than anyone previously. Work includes films, advertising, personal snaps, photo-journalism and architectural photography; photographs published in most magazines. Cameras: from underwater to 10 × 8 inch view, mostly Leicas. Major exhibitions: Smithsonian Institution, Washington, DC; Museum of Modern Art, New York; Metropolitan Museum of Art, New York; Photographers' Gallery, London. Collections: Museum of Modern Art; Bibliothèque Nationale, Paris; Smithsonian Institution. Books: *Eastern Europe; Photographs and Anti-Photographs*, 1972; *Observations on American Architecture*, text by Ivan Chermayeff, 1972.

Erwitt is one of those rare photographers who have a great sense of fun. His roving eye picks out the most unexpected and ridiculously amusing sight, and somehow, before it has disappeared, he has captured it on negative. One feels that luck must always be on his side. Why else did that woman not get up from her lair behind the shutters, but remained with two turnips on the ledge in front of her so that she appears as if they were her decorated breasts? Why else did the dove fly past as the Shinto priest sat in meditation?

Elliot Erwitt seems to have roamed the world, and everywhere animals, particularly dogs, have produced, especially for him, their strange effects – sometimes tragic. Some of the dogs are lonely, some blasé: some seem to be the only relic of a major disaster – the only living thing to remain on earth – but, just as often, they are part of a quite hilarious farce.

Erwitt earns his living making advertisement photographs, but it is the pictures that he takes for fun that are his genuine and valuable contribution.

Robert Doisneau

b. 1912

Robert Doisneau,
'Marseillaise' by
Rude on the Arc
de Triomphe, 1955.

Born in Gentilly, Seine, France. Studied lithography at École Éstienne, Paris, 1926. After Second World War started photographing for leading international magazines. Special subjects: Paris and French life. Camera: Nikon. Major exhibitions: Bilbiothèque Nationale, Paris; Museum of Modern Art, New York, 1951; Art Institute of Chicago, 1960. Books: *Les Parisiens tels qu'ils sont*; *Instantanés de Paris*; *La Banlieue de Paris*, 1950; *My Paris* by Maurice Chevalier; *Paris Parade*, 1956.

Robert Doisneau, engraver and painter, liked to make pictures of turreted castles, meadows dotted with sheep, shepherds and their dogs. They were excellent for the lids of chocolate boxes, but the young man soon realized their banality. When he took to photography and won a prize for his reportage on the Flea Market in Paris, he gave up his former profession.

When Doisneau discovered it was not easy to make a living as a roving photographer, he served as an assistant to the sculptor Vigneau. Then, for five years, he worked as an industrial photographer in the Renault car factory. When dismissed from there for too-frequent absences, he took up advertising and postcard photography. During the Resistance he rediscovered his skill as an engraver and began to make forged passports and identification papers. He took photographs of the Liberation and after the peace agreement returned to the kind of photography that he enjoys – full of humour and wit, charm and a certain poetry. Doisneau is now known as one of France's best reportage-photographers. He feels that in this role his function is to draw the public's attention to the little amusing things of daily life which usually go unobserved. He states: 'The photographer must not be content with easy and trite effects, such as exaggerated perspectives, back-lighting for the sake of overgrown shadows; he should rather attempt to render what he sees with his own eyes and not what looks pretty in the viewfinder of the camera.'

Robert Doisneau, a man of extreme modesty, has said: 'I only set up my camera and let it do the work.' He does not philosophize about his efforts, and considers photographers apt to talk too much about 'new aesthetics'.

On the prowl in Paris, Doisneau finds lovers embracing by a flower-stall, Steinberg, the cartoonist, in a china-shop, and – a shot for all time – *The Furtive Look*, a 'dirty Frenchman', accompanied by his bourgeoise wife, interested in a painting of a naked lady's bottom.

Norman Parkinson

b. 1913

Born in Roehampton, England. Educated at Westminster School. Apprenticed at Speight Ltd, photographers. Work published in *Life, Look,* and most especially, *Vogue*. Before Second World War became a weekend farmer in Gloucestershire; during the war combined farming with photography. Did series for Ministry of Information of soldiers, sailors and airmen. Exhibition: Jaeger, London, 1960.

Ronald William Parkinson Smith, known as Norman Parkinson or 'Parks', is the son of an Italian mother and an English brief-less barrister. He says his forbears were butter-and-egg merchants and that his real passion is for farming. Instead he has been, for over thirty years, one of the most reliable of photographers. This reliability is a quality that is rare today when so many people are erratic or elusive or eventually disappear through lack of staying power. The Queen is staunch, Queen Mary was staunch, 'Parks' is staunch. Staunch people never give an 'off' performance: they never disappoint.

Norman Parkinson has complete mastery of his craft: it changes according to the necessities of the day, and his variety is as fresh and unstereotyped as Cleopatra's. His enthusiasm gives him an interest in all the latest technical improvements and he utilizes them to great benefit. He once told Polly Devlin in an interview that he was the world's most famous unknown photographer. To a certain extent he has, until recently, been underrated, but the public were given the chance to see what wonders he can perform when he transformed Princess Anne into a romantic, yet sophisticated beauty.

But his anonymity is not entirely because, as he says, he has avoided the cult of personality. Norman Parkinson, sensationally tall and muscular, with flamboyant moustaches and eyebrows, and small, but incredibly brilliant eyes, is not self-conscious. He dresses conspicuously in hats and caps of the 1900s and gear of his own *avant-garde* style which few others could sport with such *panache*. He confesses that he sees himself as a retired army officer, uses military slang and deports himself with ramrod stiffness. But he is, in fact, not at all what he appears to be. He is a bit 'flash'; he is, as he says, on the knife-edge of bad taste, and can be acid as well as disarmingly unsure of himself. All this makes him into a near-eccentric – and men of that almost extinct breed seldom go by unnoticed.

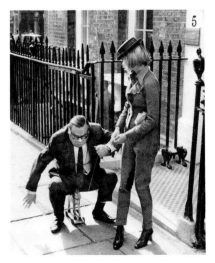

Norman Parkinson,
Untitled
photograph.

George Platt Lynes

1907–55

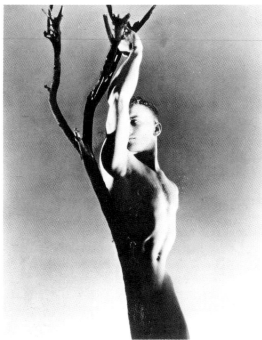

George Platt Lynes, Untitled photograph.

American. An entirely self-taught photographer, worked on *Town and Country* and *Harper's Bazaar,* and ran *Vogue* studios in Hollywood. Work appeared in several *Camera* magazines. Specialist subjects: nudes, celebrities, fashion, portraits of writers and artists. Cameras: 8 × 10 inch view camera in studio, Rolleiflex outside. Exhibitions: Julien Levy Galleries, New York; Chicago Arts Club; Chicago Art Institute, 1960; Pierre Mastisse Gallery; New York Cultural Center. Collections: Museum of Modern Art, New York; Metropolitan Museum of Art, New York; Library of Lincoln Center of Performing Arts, New York; Institute of Sex Research, Indiana; Monroe Wheeler and Glenway Wescott Colleges.

A true and serious practitioner of the 8 × 10 inch camera, Lynes was at his best when concentrating on the faces of the artists and writers he admired, and on ballet-dancers, and the nude bodies of muscular young men. Although Platt Lynes earned a living making fashionable pictures for *Harper's Bazaar,* he loathed photographing mannequins in the modish poses and surrealist guises of the 1930s. His work in this field now reveals his lack of interest and appears wooden, imitative and often ridiculous. In his best ballet photographs or neo-romantic compositions he was aided by the painter Tchelitchev, who would come to his studio and fashion odd backgrounds out of paper, fishing-nets or tinfoil and place the sitters in unexpected attitudes. Platt Lynes had an extraordinary talent for using his spotlights to bring out the incandescent quality of human skin. As a friend said, 'He painted with lights.'

Platt Lynes, a most lovable and loving youth, decided to leave New York and try his skill in California, where his friends Stravinsky and Aldous Huxley were living. He considered that most film stars had not been intelligently photographed by the studio 'stills' men, so he took some remarkable shots of Judy Garland and others, but he would not indulge in grotesque flattery or the fashionable retouching, so like many another talented photographer he was 'killed' by Hollywood.

Otto Steinert

1915–1978

Born in Saarbrücken, Germany. Studied medicine in surgical clinic of Charité, Berlin; received degree, 1939. Served as a health officer during war. While waiting for an appointment to a medical post in 1947, started to work as a portrait photographer to give himself temporary employment; soon his psychological and dramatically lit portraits were in great demand. Appointed to head a photographic department in newly founded State School for Arts and Crafts in Saarbrücken, 1948; became a director, 1952. Helped found a group of young photographers called 'fotoform' whose aim was to exhibit together outstanding photography, 1949. Group disbanded and came together in a larger international form representing 'subjective photography'. Director of German Photographic Society, 1954; president, 1964. Since 1959 teaching at Folkwang School, Essen. Organized exhibitions including one on Bayard and one on Hill and Adamson. Special subjects: personal photography – from abstract photograms to psychological and pictorial reportage. Award: DGPh (German Photographic Society) Cultural Award, 1962. Exhibitions include: French–German exhibition, Neustadt, 1949; Milan Winter Salon, 1949–50; Photokina, Cologne, 1950, 1951, 1952; 'Subjective Photography', German Society for Photography, Cologne and International Museum of Photography, Rochester, New York, 1952; 'Subjective Photography 2', State School for Arts and Crafts, Saarbrücken, 1954–5, and travelled to Paris, 1955, Japan, 1956–7; 'Subjective Photography 3', Photokina, Cologne, 1958. Books: *Subjective Photography* with Franz Roh, and J. A. Schmoll, 1952; *Subjective Photography 2* with J. A. Schmoll, 1955. *Otto Steinert und Schüler* (exhibition catalogue, Folkwang Museum) with essay by J. A. Schmoll gen. Eisenwerth, 1959.

David Seymour ('Chim')

1911–56

Born in Warsaw; US citizen. Studied to be a concert pianist but decided to go into father's publishing business. Went to Leipzig Academy for Graphic Arts to study printing, art and photography; went to Sorbonne, 1931. Became a photo-journalist, 1933. A story showing the anguish of the civilian population during Spanish Civil War published in *Life* won him an international reputation, 1938. Arrived in United States in 1939; served in American army doing photographic reconnaissance. Photographed children for UNICEF, Israel fighting and winning independence, etc. With Robert Capa, George Rodger, Henri Cartier-Bresson founded Magnum Photos, 1947; President Magnum Photos, 1954–6. Died by Egyptian machine-gun fire. Exhibitions include: 'Quelques Images de Hongrie', Paris 1949; 'Chim's Children', Art Institute of Chicago, 1957; Photokina, Cologne, 1958; 'Man's Inhumanity to Man', 1962; 'Chim's Times – A Retrospective Exhibit', Israel, Europe, United States, 1966; School of Visual Arts, New York, 1967; 'The Concerned Photographer', Riverside Museum, New York, 1967. Collections: Art Institute of Chicago; Boston Museum of Fine Arts; Houston Museum of Fine Arts, Texas; Metropolitan Museum of Art, New York; Museum of Modern Art, New York; National Gallery of Art, Washington, DC. Books: *Children of Europe,* 1949; *The Vatican* by Ann Carnahan, 1950; *Little Ones,* 1957; *David Seymour – 'Chim'* 1966; *The Concerned Photographer,* 1968.

David Seymour ('Chim') was born in Poland, the son of Benjamin Szymin (the name Chim came from the pronunciation of this surname), who was a renowned Hebrew and Yiddish publisher. He studied printing, art and photography in the Leipzig Academy. With the rise of Hitler and the depression of the thirties, Chim was no longer able to be supported by his family and decided on a career in journalism, being as he was, extremely involved in social and political ideals.

Chim became one of the pioneer photo-journalists and roamed throughout France, Europe and North Africa doing freelance work. He shared a darkroom with Robert Capa and

Robert d'Hooghe wrote in his review of Photokina 1950 (published in *Frankfurter Allgemeine Zeitung*) that the exhibition of the young group called 'fotoform' had the effect 'of an atom bomb in the compost-heap of German photography'. This bombshell was the brain-child of Professor Otto Steinert. Steinert has given the decisive impulse not only to 'fotoform' but also to many of the most progressive developments in contemporary German photography. Steinert as photographer, teacher and exhibition organizer is the dynamic force behind what is universally called 'subjective photography'. This movement, which emphasizes the creative impulse of the individual photographer and encourages experimentation in order to arrive at new visual experiences, embraces all areas of personal photography, from abstract photograms to psychological and pictorial reportage.

Steinert's photography covers a large range of techniques and subjects. In 1949 he was making photogram-montages distinctive in their geometric construction. He followed this with solarized landscapes of coal-fields on the Saar. Straight representation would not have given Steinert the harsh outlines and surrealist appearance he sought in his interpretation of industralization. He continued his solarizations and negative printing practices in to the field of portraiture. Many of his portraits, however, are straight, strong recordings of a face. 'Metropolitan man', fleeting, disappearing, always moving, is a distinctive Steinert theme and his photographs from this period are immediately recognizable. And finally, but certainly not of least importance, are the Professor's totally subjective, stark landscapes and still lifes that always surprise and stimulate and enhance one's way of seeing the world. GB

Otto Steinert, *Negative Nude*, 1958.

Henri Cartier-Bresson, and later they together founded Magnum Photos.

Passionately liberal and anti-fascist, Chim was glad to go to Spain during the Civil War, and although he did not operate in the front lines as Capa did, he concentrated on showing the everyday Spanish people under aerial bombardment. One of his most trenchant of essays was of the anguish of the civil population of Barcelona.

Chim was in Mexico covering a story about loyalist Spanish war refugees when the Second World War broke out. He crossed into Texas and although he could not speak a word of English, and knew few people in the United States, settled in New York where he spent many lonely years.

When America joined the fight against Hitler, Chim volunteered and worked in photo-reconnaisance. In the aftermath of war he made tragic and tender pictures of the children of Europe for UNICEF. On returning to Warsaw he learned that his parents had been killed in the ghetto of Otwocz. He was pleased to discover that his old home in the pine forests had been turned into an orphanage for little war victims.

Chim read a dozen newspapers a day, kept abreast of all intellectual writing and movements in many countries. When Capa was killed in Indo-China, Chim became head of Magnum.

He was present at the major events of the Vatican, and his picture – taken in the Borghese Galleries – of B. B. Berenson is perhaps the most conclusive of that most photogenic and too often photographed subject. Chim loved Italy and thought of himself as a Mediterranean.

Chim, a bachelor, an essentially lonely man without children, became the adopted uncle of children throughout the world: he photographed them going to school in the early morning sunlight of Calabria – and receiving their first pair of shoes; his most significant exhibition was entitled 'Chim's Children'.

Chim was a gentle and sensitive man, and abhorred violence, yet most of his life was spent amidst war and its aftermath. His best pictures are of tragic subjects, strikers, devastation after earthquakes, wounded and blind children, funerals, children leaving their mothers for school, a woman among the street of devastated Port Said carrying her remaining pieces of furniture on her head.

Chim died violently by Egyptian gunfire on 10 November 1956 when a truce was supposed to be in force.

David Seymour ('Chim'), *Blind, armless boy reading braille with his lips, in a home for crippled children, Rome.*

Jerry N. Uelsmann

b. 1934

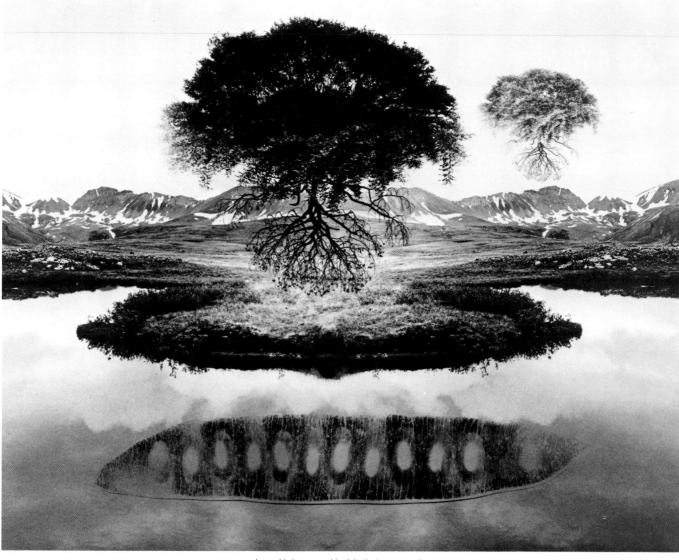

Jerry Uelsmann, Untitled photograph.

Born in Detroit, Michigan. Received Bachelor of Fine Arts degree, Rochester Institute of Technology, 1957; Master of Fine Arts degree, Indiana University, 1960. Began teaching photography, University of Florida, Gainesville, 1960; currently professor of art. Special subject: experimentation in multiple-print techniques. Guggenheim fellowship, 1967. Exhibitions include: San Francisco Museum of Art, 1968; Long Island University, Brooklyn, 1968; Creative Photography Gallery, Massachusetts Institute of Technology, 1968. Major collections: Addison Gallery of American Art, Andover, Massachusetts; International Museum of Photography, Rochester, New York; University of Nebraska; Museum of Modern Art, New York; Metropolitan Museum of Art, New York. Publications include: *US Camera Annual,* 1961; *Infinity,* May 1962 and February 1967; *Image,* vol. 11, no. 4, 1962; *Camera,* January 1967; *Persistence of Vision,* 1967; *The Photographic Journal,* April 1971; *Aperture,* 1967, 1968.

Jerry Uelsmann uses a great deal of photomontage and for many years has been considered an exciting young American photographer. His ironic motto is 'Robinson and Rejlander live' for he, like them, goes in for many negatives. Uelsmann's images are psychological, his prints made by exposing them sequentially to different negatives, or by exposing them through sandwiched negatives, or through other prints used as negatives. Sometimes he places a leaf or some other semi-transparent object as a negative. His photomontages are generally of nature, of landscapes, surprising double reflections and reflections that are quite different from what you expect. A woman sits under a tree hung with huge dolls, the seashore is lined with peculiar tropical fruit, a tree bursts out of a little island like the atomic bomb, an ornamental shrub has rocks instead of leaves for vegetation, and its root-like forms are seen in the water.

Hiroshi Hamaya

b. 1915

Born in Tokyo. Started to photograph in Tokyo city, 1935. Became a freelance photo-journalist, 1937; travelled to Manchuria, China, Europe, North America, Mexico, 1940–67. Became contributing photographer to Magnum Photos, 1960. Special subject: Japanese folklore; relationship of man and nature. Cameras: Leica, Hasselblad, Linhof super-technika, and many Japanese brands. Major exhibitions include: 'The Red China I Saw', 1957; 'Ook Dit is Japan', Netherlands, 1959; 'The Document of Grief and Anger', 1960; 'Twelve photographers: An International Exhibition of Contemporary Photography', Gallery of Modern Art, New York, 1965; 'Hamaya's Japan', Gallery of Asia House, New York, 1967; 'The Concerned Photographer 2', Israel Museum, Jerusalem, 1973. Major collections: Museum of Modern Art, New York; International Museum of Photography, Rochester, New York; Bibliothèque Nationale, Paris; Modern Art Museum of Japan, Tokyo. Books: *Show Land*, 1956; *Japan's Back Coast*, 1957; *The Red China I Saw*, 1958; *A Volume of Selected Works by Hiroshi Hamaya*, 1958; *Children in Japan*, 1959; *The Document of Grief and Anger*, 1960; *Landscapes of Japan*, 1960; *American America*, 1971; *Latent Image Afterimage: Hiroshi Hamaya's Memoirs*, 1971.

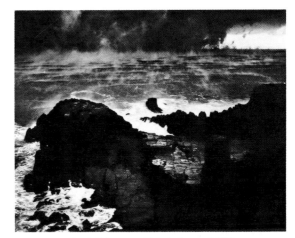

Hiroshi Hamaya, *Fukui, Japan*, 1960.

Hamaya took his earliest photographs in downtown Tokyo where in adolescence he lived in great poverty. Now fifty-nine years old, his wish is to convey the importance of environment in the lives of the denizens. Unlike the general idea of the lotus-flower or a goldfish, Hamaya's intention has always been to show people and their problems in relationship to their surroundings. Even when he photographs the snow country, or the harvesting of rice, the results are 'manscapes'.

Paul Caponigro

b. 1932

Born in Boston, Massachusetts. Entered College of Music, Boston University, for one year, 1950. Apprenticed in a commercial photographic concern, 1952. Studied with Benjamin Chin, Alfred W. Richter, Minor White, 1953–8. Assisted Minor White with summer photographic workshops, 1959. Instructor and lecturer in photography at colleges and other centres in the United States, from 1960. Helped found Association of Heliographers and their Gallery Archive in New York, 1963. Special subject: personal photographs of nature. Camera: 5 × 7 inch Deardorff with 4 × 5 inch back. Selected exhibitions: International Museum of Photography, Rochester, New York, 1958; Museum of Modern Art, New York (circulated), 1968; Friends of Photography, Carmel, California, 1969; Princeton University, 1970.

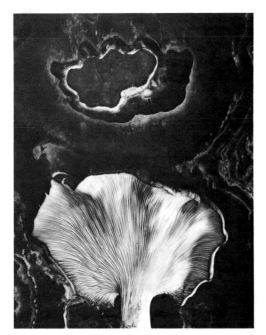

Paul Caponigro, Untitled photograph.

Paul Caponigro writes passionately about his work: 'Of all my photographs, the ones that have the most meaning for me are those I was moved to make from a certain vantage-point, at a certain moment and no other, and for which I did not draw on my abilities to fabricate a picture, composition-wise or otherwise. You might say that I was taken in. Who or what takes one to a vantage-point or moves one at a certain moment is a mystery to me. I have always felt after such experiences that there was more than myself involved. It is not chance. It happens often. In looking back at a particular picture and trying to recall the experience which led to it, that inexplicable element is still present. I have no other way to express what I mean than to say that more than myself is present. I cannot deny or put aside these subtle inner experiences. They are real. I feel and know them to be so. I cannot pass it off as wild imagination or hallucination. It is illusive, but the strength of it makes me yearn for it, as if trying to recall or remember an actual time, or place, or person, long past or forgotten. I hope, sometime in my life, to reach the source of it.'

(From *Paul Caponigro*, a monograph, 1971).

Marc Riboud

b. 1923

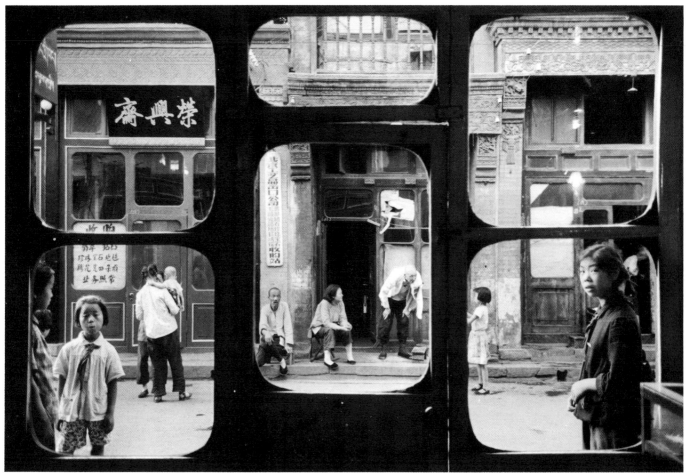

Marc Riboud, *Above Peking Shop,* 1965. *Below Pope Paul VI,* 1972.

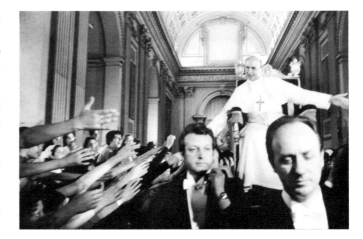

Born in Lyons, France. Fought with Resistance and French army during Second World War. Received a degree in engineering at Lyons, 1948. Was working as an industrial engineer when he started his photographic career, 1952. Joined Magnum Photos at the invitation of Robert Capa and Henri Cartier-Bresson, 1954. Worked on the film *Around the World in Eighty Days,* 1956. Photographed in China, 1957, 1965, 1971. Photo-correspondent, Soviet Russia, 1960. Photographed in the Congo, 1961; in North Vietnam, 1968. Covered Indian–Pakistani War, 1971. Work reproduced in leading picture magazines in Europe and United States. Special subject: photo-reportage. Camera: Leica. Major exhibitions: Chicago Art Institute, 1964; Asia House, New York, 1966; Institute of Contemporary Arts, London, 1967; 'Behind the Great Wall: 100 Years of China', Metropolitan Museum of Art, New York, 1972; 'The Concerned Photographer 2', Israel Museum, Jerusalem, 1973. Collections: Museum of Modern Art, New York; Metropolitan Museum of Art. Books: *The Three Banners of China,* 1966; *The Face of North Vietnam,* 1970; *Bangkok,* 1972.

Of Marc Riboud, Charles Reynolds wrote: 'Here is a man who is concerned with people, their unique portion of the earth, and their continually intense reaction upon each other.'

Riboud was in Lyons, France, when, as a young man, undertaking an industrial engineering course, he took a week off to make photographs. Thereafter he never returned to engineering.

Now working for Magnum and based in Paris, he travels widely, particularly to China which he has visited at least three times since 1957. His photographs are deeply philosophical, and although often starkly realistic they have a visual awareness that gives a moment of glory to some scenes of labour in its most squalid forms. His starving *Mother and Child in Bangladesh* is not only deeply upsetting but shows the quiet and dignified acceptance of misery of both these victims. It is a picture that will not only remain unfaded in memory, but is lyrically beautiful.

Bruce Davidson

b. 1933

Born in Oak Park, Illinois. Became actively interested in photography at age of ten. Studied photography at Rochester Institute of Technology, 1953–6; studied painting and philosophy at Yale University, 1957. After serving in US army, freelanced in Paris and New York. Joined Magnum Photos, 1959. Photo-essays appeared in *Réalités, Du, Esquire, Queen, Look, Life,* 1959–69. Taught photography, School of Visual Art, 1964; private workshops, 1965–6. Photographed extensively in Los Angeles, 1966; in East 100th Street, New York, 1968–70. Camera: 4 × 5 inch view. Exhibitions include: 'Photographs by Bruce Davidson', Art Institute of Chicago, 1965; New York, 1966; 'Bruce Davidson: Photographs', Museum of Modern Art, 1966; 'The Concerned Photographer 2', Israel Museum, Jerusalem, 1973. Collections: Museum of Modern Art; International Museum of Photography and other major ones in United States. Book: *East 100th Street,* 1970.

Bruce Davidson is a middle-aged man with wisps of long hair and a huge dome-like forehead; his eyes appear to be of unequal size. One eye seems wide with surprise or horror and the eyebrow shoots up at an unexpected tangent, while the other eye seems screwed up and intent – perhaps the better to select the significant detail in his reportage of the Civil Rights activities in the 1960s, the Welsh miners, or the Brooklyn teenage gang.

Bruce Davidson is one of the photographers working for Magnum, the agency that has many of the best talents under its wing. Unlike the others in the group, Davidson brings his tripod and lights to his work. He lived for a considerable time in Harlem, New York, and went around, not with an inconspicuous Leica, but with a big plate-camera and tripod, which he took into people's homes. He described his two-year sojourn in East 100th Street in Harlem: '"What you call a ghetto, I call my home." This was said to me when I first came to East Harlem, and during the two years that I photographed people of East 100th Street, it stayed with me. . . . I entered a life-style and, like the people who live on the block, I love and hate it and I keep going back.'

Davidson gave out some two thousand prints to people on the block in appreciation of their co-operation. Many of these pictures of poverty and poignance, often deeply stirring, now hang on the walls in apartments on East 100th Street. These straightforward records, often taken with but one strong flash, are without artistic intent, yet are more effective than the work of others who have brought a 'Porgy and Bess' picturesqueness to the very same stark subject.

Gordon Parks

b. 1912

Born in Fort Scott, Kansas. Moved to St Paul, Minnesota; worked as busboy, piano-player, lumberjack, dining-car waiter, professional basketball-player, 1928–37. Decided to become a photographer and bought first camera, 1937. Worked for Farm Security Administration in its last days, 1942. Joined Office of War Information as a correspondent, 1943. On staff of *Life,* 1949–70. Directed and wrote the films *Flavio,* 1962; *The Learning Tree,* 1968; *Shaft,* 1971; *Shaft's Big Score,* 1972. Exhibitions: Chicago Art Institute, 1953; Time-Life Gallery, New York, 1966; 'The Concerned Photographer 2', Israel Museum, Jerusalem, 1973. Books: *The Learning Tree,* 1963; *A Choice of Weapons,* 1966; *A Poet and His Camera,* 1969; *Whispers of Intimate Things,* 1971; *Born Black,* 1971; *In Love,* 1972.

Intent and deeply serious-looking, with long, bony face pierced with worried eyes, Gordon Parks is seemingly inexhaustible. As well as photographing almost ceaselessly, his creative activities include directing films, writing poetry, prose, and six musical compositions including a concerto for piano and orchestra. Paramount signed him to produce and direct a movie of his autobiography.

Born in Kansas, at sixteen he went to poverty-stricken St Paul, and then made a small living taking photographs for fashions in Chicago. Later he worked all over the United States making picture-reportages of the Depression. After the outbreak of the Second World War he transferred to the Office of War Information as a correspondent cameraman. Later he became one of a team who made documentaries for the Standard Oil Company in New Jersey. The photographing of oil installations took him from the Arctic to Saudi Arabia.

For *Life* magazine he made many stories: 'American Blacks', 'The Black Muslims', and a famous reportage on Brazil. He was favoured with interviews from Malcolm X.

Parks is the first black photographer to gain world-wide recognition. He has said that only a black man could understand and portray the poignancy of life in the poorest Negro quarters. He strongly criticized the New York Metropolitan Museum's exhibition, 'Harlem On My Mind', as superficial and prejudiced.

Parks has done some vivid mosaics of New York. His colour is apt to be gaudy – *The Girl in the Bistro,* with artificial flowers and glass decorations, is typical – his advertising of elegant fashions crude; but his sinister black-and-grey pictures are the most remarkable.

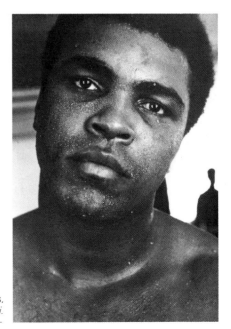

Gordon Parks,
Mohammed Ali.

Philip Jones Griffiths

b. 1936

Born in Rhuddlan, Wales. Studied and practised pharmacy; simultaneously worked for many publications, notably *Manchester Guardian*, and served as a cameraman with a Granada TV documentary programme. Became a full-time photographer, 1961; worked for *Observer* and *Town* magazine. Freelance photographer, from 1963; photographs published in *Queen, Look, Life, McCall's, Sunday Times Magazine, New York Times*, etc. Commission to photograph in Rhodesia, Zambia, Zanzibar and Mauritius from *Sunday Times Magazine,* 1965–6. Photographed in Vietnam July 1966–June 1968 and throughout 1970. Camera: 35 mm. Book: *Vietnam Inc.,* 1971.

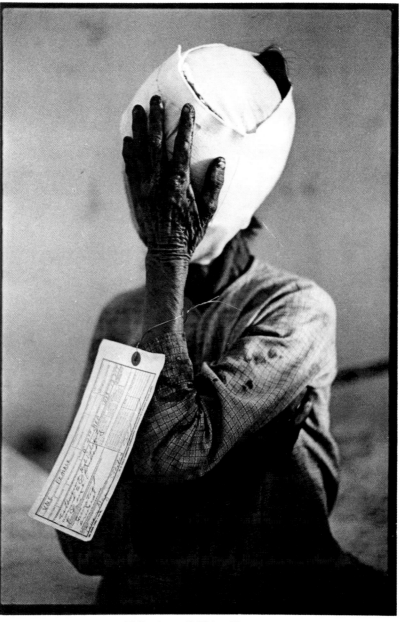

Philip Jones Griffiths, *Vietnam.*

Those with queasy stomachs are not likely to enjoy even a glance at Jones Griffiths's beautiful photographs. Yet nobody should be allowed to ignore his devastating book *Vietnam Inc.* It is the most horrendous indictment of war that has yet been seen: a triumph of what a photographer with an eye and an intellect can do when he also has the talent to show what he feels must be seen.

Jones Griffiths' pictures seem to stab the viewer, and yet they reveal tenderness; they convey most poignantly that it was the innocent peasants who bore the brunt of the worst suffering. He does not spare us pictures of the amputated babies, the napalm victims, the hag screaming with pain as her wounds are tended in hospital, and the wounded monk alive three days after he had put his own intestines in an enamel bowl and then strapped it to the yawning gap in his middle. His courage inspired human compassion in one GI who gave him clean water to drink. But not all the GIs appear to have retained their understanding of the dignity of the human race: Jones Griffiths shows how this incomprehensible war can make decent beings into monsters. 'Why the hurry?' asks a colonel, as a woman with a broken back is kept waiting for hospital treatment. 'If she recovers she'll only be raped and killed.'

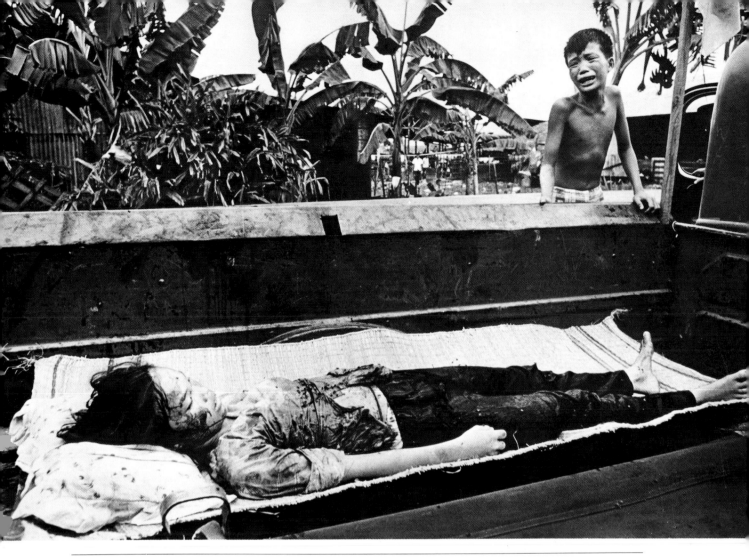

Above and below Philip Jones Griffiths, *Vietnam.*

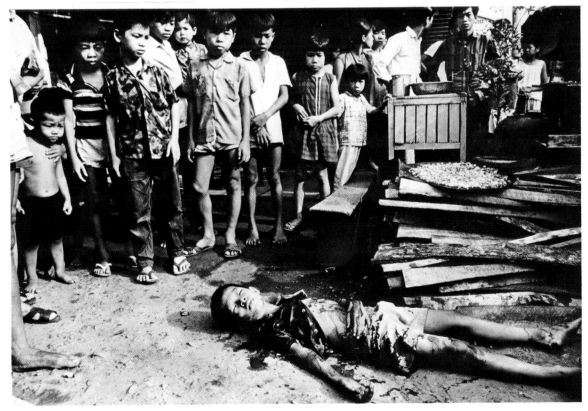

237

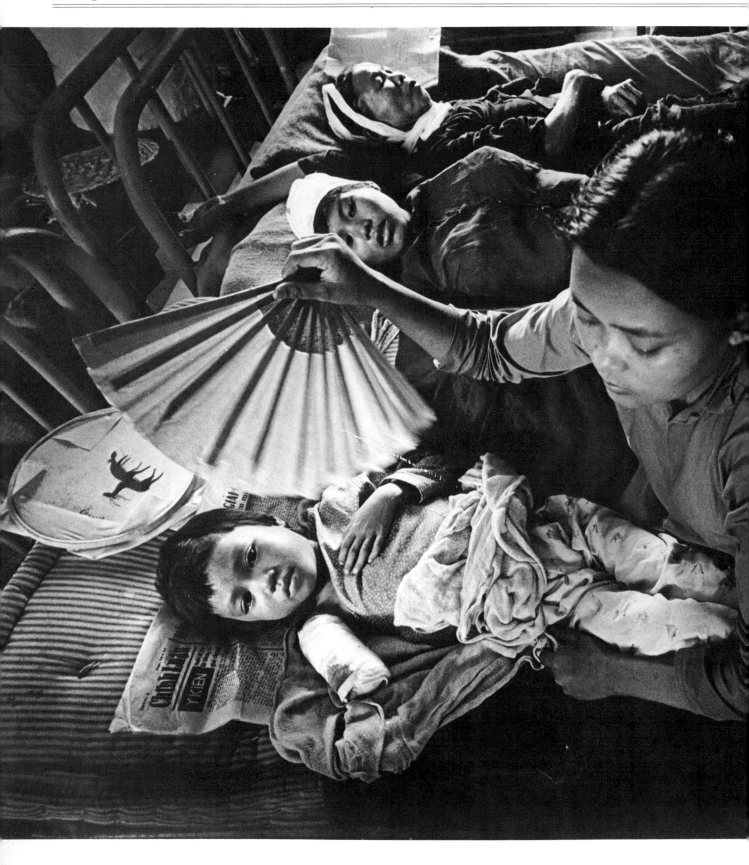

He shows us one GI, about to rape a girl, while his friend leans eagerly forward to watch with a bestial smile on his face.

But Jones Griffiths's *Vietnam Inc.* is not so much anti-American as anti-war. It asks why the homes of such defenceless people must be made into an Armageddon. And by whom? Who is really responsible? How can those who have perpetrated such needless cruelty and witnessed such scenes ever be the same again?

Jones Griffiths's pictures possess an extra value in that they show more than their surface interest: he imparts the terrible influences of an alien culture on a simple religious people – their disillusion and resentment. The Saigon waterfront has become one huge hoarding for advertisements: the beautiful little Vietnamese boy uses a Coca-Cola can as a flare. Jones Griffiths carries subconsciously within himself a sense of how a picture should be composed. Few of his photographs are meant to be picturesque, yet many of them – taken in a moment of frenzy or fury – contain the abiding laws of contrasting shapes and colour. His picture of the head of a GI – expressionless in death – is an extraordinary piece of geometric construction where the planks of scaffolding, a dropped revolver and the photographer's own shadow make a complete, strong and original composition. Ruthlessly descriptive captions heighten the pathos and increase the impact of these revelations.

Jones Griffiths has enormous heart and compassion and he makes one suffer along with him. He is a great photographer.

Jones Griffiths's intention has been to portray the needless, and all the more appalling, tragedy of a conflict where, for the most part, few people who are involved in the holocaust have any means of understanding its cause. Why, in order to ensure freedom for Vietnam, must the whole country be raped and reduced to complete degradation? Why must these exquisite, flower-like mothers with their children be made to suffer the most terrible deaths? The incongruousness of the torment is all the more haunting when one sees the beauty of the Vietnamese people together with the young, clean-cut American boys who should be home with momma eating her apple pie.

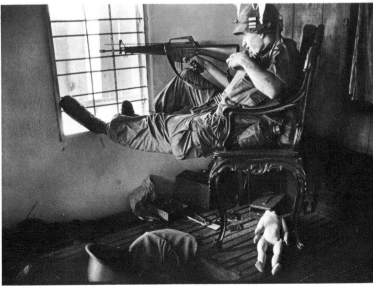

Philip Jones Griffiths, *Above and right Vietnam.*

239

Irving Penn

b. 1917

Born in Plainfield, New Jersey. Studied design under Alexey Brodo-vitch at Philadelphia Museum of Art. Spent year in Mexico painting. Returned to New York City and was offered a job in art department of *Vogue* by its art director Alexander Liberman, 1943. Originally employed to design front covers, soon photographed them himself. Joined American Field Service, 1944; served on ambulance duty with British army in Italy and India. Continued work for Condé Nast publications. Special subjects: portrait, fashion and advertising. Collections: Metropolitan Museum of Art and Museum of Modern Art, New York. Book: *Moments Preserved*, 1960.

Irving Penn, *Rudolf Nureyev's Legs*, 1961.

Irving Penn, *John Dewey*.

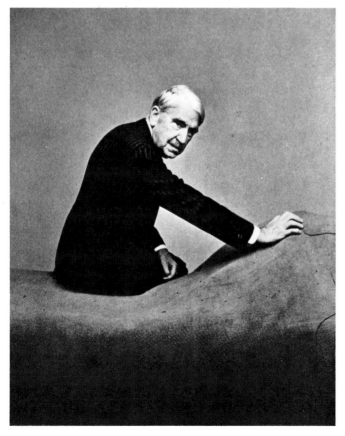

Sometimes one is startled by the first impact of certain remark-able portraits reproduced in albums, books or magazines. Yet on second study, the initial shock-value diminishes. The opposite is the case of Penn's work; with time it improves – like good wine – for it is, as the French say, *dans le vrai*. There is nothing trumpery or transient about it.

His excellence emanates from a character that is completely without pretensions or interest in the game of fashion – be it even the fashion of photography. Penn's approach to his work is a deadly earnest one: nothing is going to distract him. Perhaps Penn has little humour; he does not play jokes. He is at his best when in a serious vein he shows rugged character, and when focusing on artists of exceptional integrity and those who know nothing of pretence. In order to achieve this intensity of devotion and feeling, Penn makes everything extremely hard for himself. He employs no gadgets, no special props, nothing but the simplest lighting – probably a one-source light coming from the side of the sitter's head. But it is the burning intensity of his own being that puts the value into his pictures.

Penn can be relied upon always to produce an extraordinary likeness-in-depth, and this cannot be the result of any facile accomplishment. Penn has monumental photographic instinct plus experience: he knows how to create effects as well as any transient smart-aleck starlet-photographer, but it is the determination to show the very essence of the sitter that places him at the top in the hierarchy of contemporary camera

Penn has made many extraordinary productive journeys to photograph the life of far-distant countries. A trip to Morocco was particularly rewarding for instance, for a photograph of two running children in Rabat, and his documentation of African and Peruvian natures brought startling results. He has made impressionistic colour experiments – not always success-ful though often daring, and his bull's-eye portraits are so numerous that it is impossible to name them all. However, his *John Marin* is the most vigorous we have seen of this very photogenic subject, and his *Picasso* stands out from the many thousands of this probably over-photographed face. Penn had a period when he made still lifes that showed a cool and refreshing personal eye at work, but sometimes his touches of surrealism failed to include piquancy.

Penn's close-ups of dew-spangled flowers transcend the banality of this genre of photography, for they too have been removed from their natural habitat and are seen under Penn's very personal microscopic conditions. His tulips are writhing beautifully in death in a light they never knew in life.

For a quarter of a century Penn has successfully risen above the whims of the season, and his particular quality is timeless. When one looks back at his earlier work it is still as strong, brisk and direct as when one first saw it.

Penn is never in a hurry: his work has always been a reflection of his meditative and more profound attitudes. At a time of economic crisis in the fashion-magazine world it was typical of him to close his fashion-picture studio and turn his interests not to the making of movies or television pictures, but to the quiet and gentle 'still' which he knows is his most real means of expression.

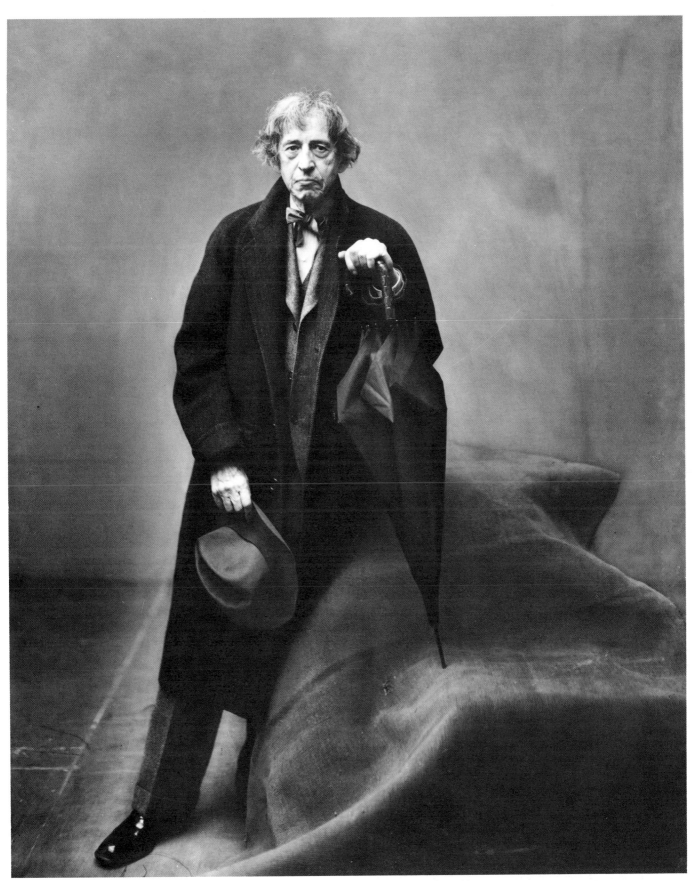

Irving Penn, *John Marin*, 1947.

Irving Penn

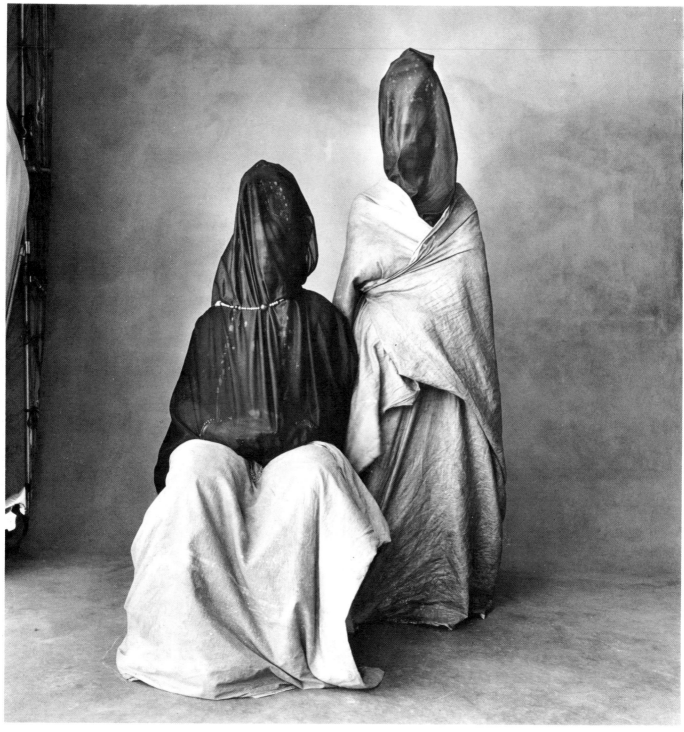

Irving Penn, *Two Guedras, Morocco*, 1971.

In the laboratory in his house in the country he is experimenting with platinum printing. Since platinum paper has long since ceased to be on the market, Penn himself enjoys the lengthy process of coating his own paper by hand. Thus he is making superb prints that are a complete defiance of the present-day trend towards doing nothing by hand that can be done more inefficiently with a machine, a tendency to ignore quality in the rush to create more and more quick-fire sensations.

Even if, at the present time of crisis, no publisher is able to gamble in producing a book of Penn's dew-splashed flowers, his prints will undoubtedly be collectors' items of the future. Penn's are the virtues that abide long after febrile electric shocks of sensation-seekers have long since been forgotten.

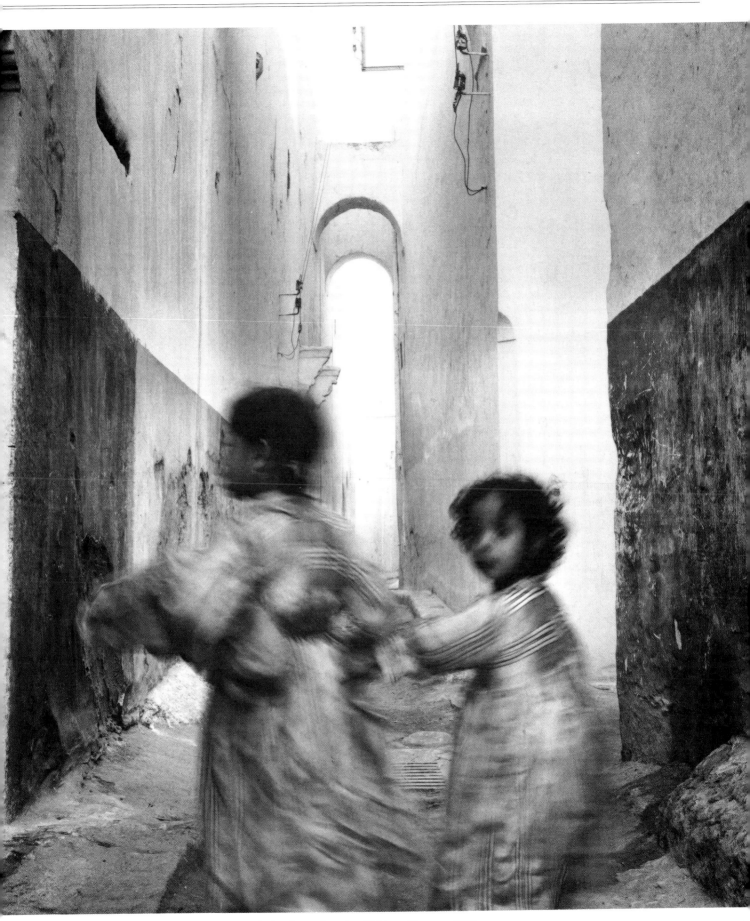

Irving Penn, *Running Children—Morocco,* 1951.

Ralph Eugene Meatyard

1925–72

Born in Normal, Illinois. Studied at Illinois Wesleyan University and Williams College. Optometrist. Studied photography with Van Deren Coke, Henry Holmes Smith, Minor White. Camera: $2\frac{1}{4}$ inch twin-lens reflex. Selected exhibitions: Tulane University, 1959; 'Sense of Abstraction', Museum of Modern Art, New York, 1959; Carl Siembab Gallery, Boston, 1962; University of Florida, 1962; University of New Mexico, 1967; Ohio University, 1970; Visual Studies Workshop, Rochester, New York, 1971; International Museum of Photography, New York, 1970; Witkin Gallery, New York, 1973. Collections: International Museum of Photography; Massachusetts Institute of Technology; Metropolitan Museum of Art, New York; Musuem of Modern Art, New York; Universities of Louisville, California at Los Angeles, Nebraska; Visual Studies Workshop. Books: *Ralph Eugene Meatyard*, 1970; *The Unforeseen Wilderness*, Wendell Berry, 1971; *The Family Album of Lucybelle Crater*, 1973; *Ralph Eugene Meatyard*, 1974.

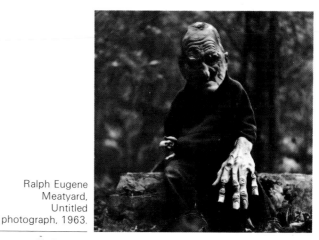

Ralph Eugene Meatyard, Untitled photograph, 1963.

Gene Meatyard goes in for the odd effects of blurred movement: one child stands still and remains sharply pinpointed while another falls from a loft and appears as an ectoplasmic blur. Parker Tyler's gaunt Indian features are seen as a smudge while his typewriter is in perfect focus. Sometimes Meatyard's children wear masks and are confused with dolls. He has a sense of the macabre and if he can find men with hooks for arms will immediately ask them to pose.

Meatyard's last major body of work was a complex, but poetical, visual statement called *The family Album of Lucybelle Crater*. The works of Gertrude Stein always fascinated him, and he translated that lady's curious word-images in the photographs that he took specially. By degrees he had all the illustrations he needed for Gertrude Stein's story of an imaginary Southern woman and her relations. In each picture his personages wear masks, usually of old men.

Diane Arbus

1923–71

Born in New York City. Attended Ethical Culture and Fieldston Schools. Studied photography with Lisette Model, 1959. Professional fashion photographer; photographs published in *Esquire, Show, Harper's Bazaar, Infinity,* etc. Taught at Parsons Schools of Design, 1965–6; Cooper Union, 1968–9. Committed suicide, 1971. Guggenheim fellowships, 1963 and 1966. Exhibitions: Museum of Modern Art, New York, 1965, 1967 and 1972; Fogg Museum, Cambridge, Massachusetts, 1967; Museum of Contemporary Art, Chicago; Baltimore Museum of Art; Walker Art Center, Minneapolis; National Gallery of Canada, Ottawa; Venice Biennale, 1972; Hayward Gallery, London, 1972–3. Collections: Museum of Modern Art; International Museum of Photography, Rochester, New York: Book: *Diane Arbus*, 1972.

When Diane Nemerov Arbus's stark photographs were shown at the Museum of Modern Art in New York the queue for admission was as if for a popular and pornographic new movie. Her straightforward, perhaps even somewhat merciless shots of waifs, transvestites and tough matrons were just what the younger generation found to their liking.

Yet no doubt few knew that these glimpses of so austere a life were taken by someone who was the daughter of a rich store-keeper, who lived in a charming house in Greenwich Village where there was a garden, objects in delightful taste, pretty baskets, shawls and delicious meals. Few would have guessed that she had been a fashion photographer, a pupil of Avedon, and that she worked with a great deal of facility. Diane Arbus was small, dark and goggle-eyed. Extremely emotional, she could readily be reduced to tears. Many of the sights that attracted her no doubt filled her with grief, but in spite of this an eye for the grotesque and a mischievous streak helped her to create some devastating pictures. For Diane Arbus took

her flash camera into places where other sensitive people would have been too timid to enter. She, too, was appalled at the task she set herself, yet she was impelled to burden herself with another of the many crosses she felt it was her lot to bear in life. Thus, once inside a home for the mentally unbalanced she could not resist aiming her lens at the most bizarre and often sickly comic aspects. After a visit to a nudist colony she remarked that one of the inhabitants wore nothing but a band-aid.

Diane Arbus's most often recurring subjects were elderly women frantically fighting the approach of old age, in their negligées, in fancy-dress head-dresses or impossible wigs. She seemed mesmerized by such subjects as identical twins, hermaphodites in undress, or ageing stripteasers.

Diane Arbus has written somewhat incoherently about her aims and intentions. She has admitted: 'I do feel I have some slight coma or something about the quality of things. I mean it's very subtle and a little embarrassing to me, but I really believe there are things which nobody would see unless I photographed them.' She wrote of her fascination with freaks: 'Most people go through life dreading they'll have a traumatic experience. Freaks were born with this trauma: they've already passed their test in life.' But when studying her prints, images mostly taken in a Bill Brandt twilight or in inspiccated blackness with a cruel flash, one looks for compassion: it is difficult to find it.

Lord Snowdon (Antony Armstrong-Jones)

b. 1930

English. Born Antony Armstrong-Jones. Educated at Eton and Cambridge. Began photographing while at school. At twenty years old served as an assistant to the photographer Baron. From 1959 photographs published in *Sketch, Tatler, Country Life, Picture Post, Vogue, Queen, Harper's Bazaar, Sunday Times,* etc. Joined staff of Council of Industrial Design, 1961, continuing on a consultative basis, 1962 and as editorial adviser of *Design* magazine. Artistic adviser to *Sunday Times* and *Sunday Times* Publications, from 1962. Married HRH Princess Margaret, 1960. Special subjects: photo-journalism, portraiture. Cameras: 35 mm, Hasselblad. Books: *Malta,* 1958; *London,* 1958; *Private View* with John Russell and Bryan Robertson, 1965; *Assignments,* 1972; *A View of Venice,* 1972.

Lord Snowdon is enthusiastic to undertake all sorts of assignments – sometimes extremely arduous, even hazardous – and is a most energetic professional photographer. In an introduction to a publication of his work it was said that 'the subjects could hardly be more varied, and there is no uniformity of style in their representation. This is intentional.' Lord Snowdon has admitted: 'I don't think my pictures are recognizable as being mine. I would like to think that one changes. In the very early days one did appallingly gimmicky pictures. The older one gets the simpler one has tried to become.'

Snowdon has been everywhere, and can always be relied upon to come back having given a good account of himself. He is particularly understanding of children. His reportage on Peru, and his yellow, misty, wintry views of Venice in the manner of the Visconti film are fine examples of his abilities. But he seems loath to proclaim his essence; even his most outstanding photographs – the white horses, the white whale, Miss Terese Lessore (lonely in her art gallery), John Betjeman among the puddles on Broad Street Station platform, Tolkien, and Stravinsky with the withered parchment skin on the back of his fingers – might have been taken by any six of the best photographers. Snowdon is nearest to himself when he displays a slightly impish humour. Probably his best are the nannies in Rotten Row, and the ladies in lesbian attire showing off their dogs at Crufts. Recently Snowdon has been making television films in which the photographic aspect is always of superior quality.

Lord Snowdon, *Terese Lessore.*

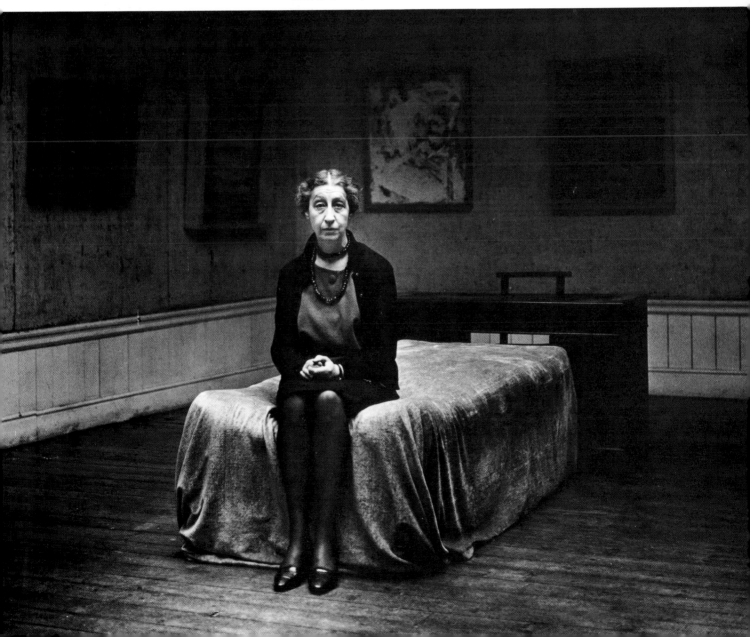

Danny Lyon

b. 1942

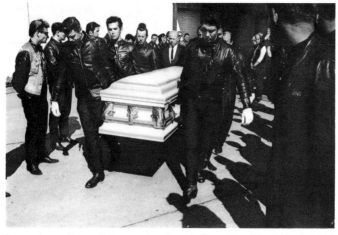

Danny Lyon, *Funeral, Renegades, Detroit* (from *The Bike Riders*), 1966.

Born in Brooklyn, New York. Educated University of Chicago, 1963. Became interested in photography while at university. Photographed civil rights movement in the South, 1962–4; staff photographer for Student Non-violent Coordinating Committee. Began series on motor-cyclists, 'The Bike Riders', 1963. Did study of white Southerners in Uptown Chicago, 1965; staff photographer Chicago Outlaws, 1965–6. Exhibitions include: 'The Photographers' Eye', Museum of Modern Art, New York, 1964; Art Institute of Chicago, 1966; 'Toward a Social Landscape', International Museum of Photography, Rochester, New York, 1966. Book: *The Movement*, 1964.

Danny Lyon is one of the generation that forces you to look at things that perhaps you do not wish to see. He knows it is a salutary exercise to show life as it is in some of its less pictur-esque aspects. For him no thatched cottage and hollyhocks, no fair-haired children in the sunshine by the river. He does not understand the wish to flatter. He feels impelled to look at the world in its hard and often sinister aspects. In a harsh clinical light, Danny Lyon depicts low-life up-town in Chicago, the inferno of the speedways, the male world of Hell's Angel motor-cyclists, tough 'Bikers' splashed with mud – or is it blood ? – the convicts and their 'bosses' in prison. Sometimes Lyon per-mits himself to make patterns in his pictures, but more often they are plain statements about things of which some of us would prefer to remain in ignorance. Danny Lyon's prime quality is his serious determination not to hide any aspect of reality, however brutal.

Hirsute, bearded, and 'butch', Danny Lyon has an obvious sympathy for those who have found themselves undergoing punishment for their crimes. His most thorough investigation is of the life inside half a dozen prisons in Texas. Few out-siders have been permitted such an unrestricted view of the inmates – some of whom have committed murders, some of whom are mental cases, as well as the most dangerous and un-manageable. Danny Lyon's trenchant documents somehow manage to convey the humanity and emotions that seep through the interminable corridors of these soul-destroying, anonymous metal enclosures.

Leonard Freed

b. 1929

Born in Brooklyn, New York. Originally wanted to be a painter; be-came interested in photography after studying with Alexey Brodo-vitch. Spent two years in Europe and North Africa photographing seriously, late 1950s. Produced film *Dansende Bromen* for Dutch tele-vision, about the Hassidic Jews of New York and Jerusalem, 1963. Travelled about the United States gathering material for a book on the plight of American blacks, 1964–5. Produced film for Dutch television about American blacks, 1966. Freelance photographer for *Sunday Times Magazine*, London, and numerous other magazines. Camera: 35 mm. Exhibitions: 'What is Man ?', London, 1967; 'The Concerned Photographer', Riverside Museum, New York, 1967; 'Spectre of Violence', Photographers' Gallery, London, 1973; 'Inside White-chapel', Whitechapel Art Gallery, London, 1973. Books: *Joden van Amsterdam*, 1959; *Deutsche Juden Heute*, 1965; *Black in White America*, 1968; *Leonard Freed's Germany*, 1971.

Leonard Freed began to be interested in photography while attending the marvellous Alexey Brodovitch's classes in New York. The involvement with photography developed during a two-year period hitch-hiking in Europe and North Africa. This experience led to his first published book *Joden van Amsterdam*, demonstrating a talent for photo-reportage. This was followed by *Deutsche Juden Heute* and *Leonard Freed's Germany*.

Freed, a short, black-haired man with glasses, is a solitary figure who seems to wish to rediscover his cultural heritage. This has lured him to Germany and to Israel, and his acute so-cial conscience takes him to photograph the unemployed in the north of England and to make a record of life of the blacks in the slum quarters of New York.

Whereas Cartier-Bresson shows a certain poetic attitude to-wards photographing the unexpected event, Leonard Freed's reportage is always objective and clinical. Little or none of the author is allowed to intrude into the terrible scene after an acci-dent – be it a head-on collision or the result of a heart-attack or a murder. Freed seems to be omnipresent where violence breaks out and with a high level of technical excellence his lens penetrates every aspect of a drama-crowded scene.

Leonard Freed, *Hassidic Wedding, New York City.* The men dance in one room, the women in the other.

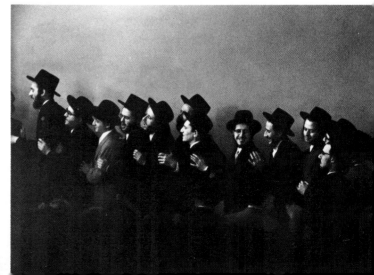

Many of us prefer to remain ignorant of what happens to a felon after he has been found guilty of some heinous crime. Danny Lyon follows the man handcuffed entering the prison, and shows every aspect of his existence in these new surroundings. He photographs the contents of the man's wallet – with snapshots of girl-friend, wife or children; he shows him in the showers, the open lavatories, queuing for the meal that is laid out on a knifeless and forkless metal tray, or locked behind the bars of his cell playing dominoes. We see him with the other inmates – cotton-picking or clearing the land, as part of a hoe-squad – where some hefty young men faint from heat exhaustion. Lyon shows us the 'muster', the 'shakedown', and the men taking the guard dogs for exercise.

These crew-cut men appear exceptionally fit, often of great muscular beauty and impeccable cleanliness. Some of them are perhaps employed in the physical labours that might be their chosen lot in ordinary civilian life, but we read into Lyon's pictures the over-hanging knowledge that from here, there is no escape.

Just as contemporary painters ignore the 'pretty' if it exists in modern civilization, so too the youngest photographers set out to illustrate urban life in some of its ugliest and bleakest aspects. Perhaps already we begin to feel we have seen too many albums of 'concerned' youngsters. That will pass, but this unflinching honesty has been a salutary influence and, among the masters of this school, Danny Lyon is undoubtedly the most exigent.

Ian Berry

b. 1934

Born in Preston, Lancs. Studied modern languages at school; wanted to be a journalist. Emigrated to South Africa and worked for a professional photographer. After working for a Johannesburg newspaper as photographer, opened own commercial studio. After a few years sold studio and travelled around Africa shooting reportage pictures. Moved to Paris; joined Magnum Photos. Works as photo-journalist based in London. Major exhibitions: Photographers' Gallery, London, 1972; Whitechapel Art Gallery, London, 1972; Arts Council of Great Britain Exhibition, 1973.

The Sharpeville massacre in South Africa in 1960 brought attention to Ian Berry, whose terrifying photographs appeared in the influential African magazine *Drum*.

Raymond Moore

b. 1920

Born in Wallasey, Cheshire. Studied painting at Wallasey College of Art, 1937–40; Royal College of Art, 1947–50. Started photographing seriously in 1956. Worked with Minor White at Massachusetts Institute of Technology, 1968. Teaches creative photography at Watford College of Art. Camera and film: 35 mm. single-lens reflex, Tri-X and FP4. Major exhibitions: University College, Aberystwyth, 1966; 'Modfot One', 1967; Welsh Arts Council travelling exhibition 'Photographs by Raymond Moore', 1968; International Museum of Photography, Rochester, New York, 1970; Photographers' Gallery, London, 1973.

'Human fragility and the practical demands of life seldom render us capable of reacting with sufficient awareness to record the image of a happening at maximum intensity. In fact we spend most of our lives in blinkers, insensitive to the import of what is around us. If we were only capable of transcending our space-time limits to some extent, we could witness happenings undreamt of.'
(Raymond Moore in *Creative Camera*, June 1973).

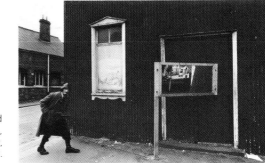

Raymond Moore, *Reading*, 1973.

Determined to become a journalist, but disillusioned with the jobs of reporting court cases or social functions, Berry had emigrated to South Africa where again he worked on local newspapers, but as a photographer. He started his own studio where he photographed machinery for industrial clients, but gradually he realized his bent was towards photo-journalism. Having given up his studio in order to travel around Africa, he worked on the Johannesburg *Daily Mail*, then on the permanent staff of the magazine *Drum,* which was edited by the brilliant Tom Hopkinson, the ex-editor of *Picture Post*.

After living for three years in Paris, Berry came to London.

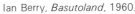

Ian Berry, *Basutoland*, 1960.

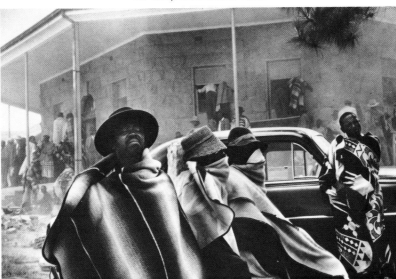

Mirella Ricciardi

b. 1933

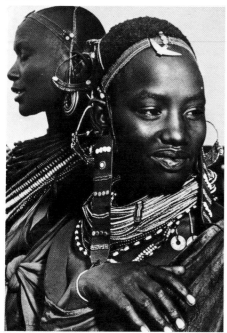

Mirella Ricciardi,
*Samburu women,
Northern Frontier
District, Kenya,*
1956.

Born in Kenya. Came to England at eighteen; left shortly after for Paris. Served as an assistant to Harry Meerson, photographer in Paris, 1953–5. Returned to Kenya; engaged in both commercial and personal photography. Spent two years in New York as freelance photographer. Special subject: people in their natural settings. Cameras: Nikon, Minolta. Exhibitions: *Time-Life* Building, London, 1971; Snack Gallery, Paris, 1972; Nikon Gallery, New York, 1972; Tryon Gallery, London, 1973. Book: *Vanishing Africa,* 1971.

This beautiful young woman, brought up during the last war in difficult circumstances in Africa, took many photographs in Kenya after being on a safari after elephant in the Belgian Congo.

When the war was over, Miss Ricciardi wanted to go on with photography and so took a job as an assistant to Meerson, the French photographer. She went to New York for two years, then returned to depict the fate of Africa. This she has done with dramatic effect in a book called *Vanishing Africa* (designed by the cool layout expert, Barney Wan). Here we see, caught in very striking compositions by her long-focus lens, the extraordinarily beautiful members of the Masai tribe, with the elongated figures, using their arms in surprising poses and standing on one long leg. Surely no better purpose has yet been made of this lens for creating ingenious and 'different' patterns. Many of Miss Ricciardi's designs of bodies could not have been created by any other means. We catch the somewhat usual glimpses of fishermen returning with their catch, and of native dancers wearing extraordinary clothes and extraordinary expressions on their extraordinary painted faces. But the manner in which these etiolated figures compose themselves in her telescopic lens, makes them quite new.

Some of Miss Ricciardi's colour transparencies justify themselves for they show the quality and exact tones of the red-painted bald heads and the ornamental 'abstract' make-ups, and her close-up lens catches the transient and elusive expressions on the faces of these fabulous-looking creatures.

Roloff Beny

1924–1984

Born in Medicine Hat, Alberta, Canada. Graduated from Trinity College, Toronto, and did postgraduate work at three universities in the United States in art history, archaeology and graphic arts. Also studied etching, engraving and lithography which helped link three main interests of painting, photography and book-design. Contributor to *Harper's Bazaar, Queen, Châtelaine, Maclean's, Sunday Times, Connaissance des Arts,* Horizon Books, Time-Life Book Division, etc. Cameras: Nikon and Hasselblad. Major exhibitions: Institute of Contemporary Arts, London; 'A Time of Gods' and 'Metaphysical Monuments', Rome and Toronto; 'Pleasure of Photography–The World of Roloff Beny'. Major collection: University of Calgary. Books include: *The Thrones of Earth and Heaven,* text by Freya Stark, Bernard Berenson, Jean Cocteau, Rose Macaulay, Stephen Spender, 1958; *A Time of Gods,* 1962; *Pleasure of Ruins,* text by Rose Macaulay, edited by Constance Babington-Smith, 1964; *To Everything There is a Season,* edited by Milton Wilson, 1967; *Japan in Colour,* text by Anthony Thwaite, 1967; *India,* text by Aubrey Menen, 1969; *Island: Ceylon,* edited by John Lindsay Opie, 1970; *The Proud and Angry Dust.*

The personal idiom of the Canadian, Roloff Beny, is difficult to analyse. It is evasive and subtle, and one would not necessarily recognize a photograph as being by him; yet, once knowing the authorship, we realize that of course it could only be the work of this most excellent photographer. Doubtless no one is more aware of that excellence than the photographer himself, who energetically continues to produce magnificent books of his dramatic, atmospheric views of well-known distant places interspersed with grandiose tributes from the most auspicious names: Freya Stark, Bernard Berenson, Jean Cocteau (for *The Thrones of Earth and Heaven*) and Rose Macaulay (for *The Pleasure of Ruins*). Aubrey Menen wrote the text for *India,* and Herbert Read the introduction for *Japan in Colour.* Roloff Beny's energy and vitality are untiring, his travels are unending: he has made photographic surveys of Nepal, Ethiopia, Burma, Cambodia, Iraq, Iran, Syria, Jordan, Egypt, Libya, Peru, Tunisia, Turkey, Greece, Yugoslavia and Ceylon. His books are published throughout the world, and he has collected more honours, medals and degrees than any other living photographer.

Beny is one of the few photographers who think in terms of illustrated books. It is true that some of his images are prematurely snatched by magazine editors, but Beny's ambition is to create more exquisitely reproduced, better-presented volumes on one particular subject than any other so-called 'coffee-table' book. To achieve this end he goes to great lengths. He will take five years on the illustrations for one book on some distant continent, and make many extra journeys there in order to fill in any gaps. In his capacity as his own book-designer he insists that he should approve the final look of his production. Since Beny started life as a painter it is easy for him to design the lettering of the title pages, to plan the startling layouts, and to put together the various contrasting coloured papers.

Beny's books do not make a comment. His subjects are romanticized – sometimes even sentimentalized. He does not concentrate upon the seedier aspects of the countries he depicts. He has an exceptional eye for idyllic beauty, and with an extraordinary technical ability he is able to record it.

Unlike most travel-photographers he keeps regular office

hours, and when he returns home, with unflagging energy he spends six days a week writing captions and articles and trying to sort out some of the mountains of pictures. A man of assurance and a dignity that has something tragic about it, he displays great courage in his far-from-easy life. In remote places he battles alone with bureaucracy in its most maddening forms. He seldom takes the smoothest path. Many of his difficulties are of his own making for he is a perfectionist who fights to the end for what he knows is best. Beny is willing to take infinite trouble for he does not feel that his books are for a season, but are destined for perpetuity.

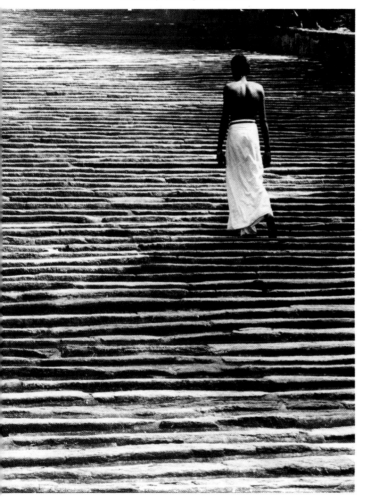

Roloff Beny, The sacred shrine of Mihintala, Ceylon, a stairway leading to heaven.

Ernst Haas

1921–1986

Born in Vienna. Attended medical school and studied photography at Graphischen Lehr- und Versuchsanstalt, Vienna; left both without completing courses. Began doing assignments for American-sponsored magazine *Heute*, 1946; 'Homecoming' published, 1947. Became member of Magnum Photos, 1949. Photo-essays for *Life, Paris-Match, Esquire, Holiday,* 1952–60. Photographed on movie sets of *The Bible, Little Big Man, The Misfits, Hello Dolly,* etc. Special subjects: colour; American Indians. Camera 35 mm. Major exhibitions: 'Homecoming of Austrian Prisoners-of-War', Vienna, 1947; 'Ernst Haas: Color Photography', Museum of Modern Art, New York, 1962; 'Poetry in Color', IBM Gallery, New York, 1964; 'Ankor and Bali: Two Worlds of Ernst Haas', Asia House, New York, 1968; 'The Creation', Rizzoli Gallery, New York, 1971 and Kodak Gallery, London, 1973. Book: *The Creation,* 1971.

Ernst Haas was a medical student in Vienna when war interrupted his studies. With the end of hostilities he made a great photographic reportage on prisoners returning to their homes. This led to his becoming one of the rare columnists with a camera.

Haas has earned sufficiently large sums documenting the execution of such flamboyant Hollywood films as *Hello Dolly* to enable him to take the pictures which he really likes; these are often close-ups of nature in its most unexpected forms: of foam, surprising in texture and design, of the abstract pattern made by the setting sun on an abalone shell, waves rippling on the water of a fjord, all unreal, yet straight, pure photography.

But Haas will be remembered for his signal contribution to the colour camera.

Garry Winogrand

1928–1984

Born in New York City. Began photographing while in Air Force during Second World War. Studied painting at City College of New York, 1947–8 and at Columbia University, 1948; photography with Alexey Brodovitch at New School for Social Research, 1951. Since 1952 a freelance photographer primarily in advertising; teaches and lectures. Special subject: photographs of American life. Guggenheim fellowships, 1964 and 1969. Exhibitions include: 'Five Unrelated Photographers', 1963; 'New Documents', 1965; 'The Animals', 1969; Museum of Modern Art, New York. Book: *The Animals,* 1969.

Garry Winogrand, born in 1928, is a real New Yorker. Apart from a year and a half in the army in the Second World War, and another teaching in Chicago and in Texas, he has remained on Manhattan all his life. He studied photography, after beginning as a painter, under Alexey Brodovitch at the New York School of Social Research.

Winogrand has a whimsical sense of humour which is rare in photographers, and this often helps to enhance his effectiveness. He has given us glimpses that are frightening and, at the same time, funny: a woman with flippers underneath the water being chased by a porpoise; a bagpiper, incomprehensibly, in a *pissoir*. He likes to feature dwarfs, oddities, and freaks in his pictures; but some shots of a scabrous variety, such as monkeys peeing into each other's mouths, are neither funny nor upsetting – merely an abortive attempt to create attention. Others are traumatic: a small child, like a little white celluloid doll, coming out of a soulless dwelling in a huge, sinister Arizona background, has a nightmarish mystery.

249

Jeanloup Sieff

b. 1933

Born in Paris. Studied philosophy at college; photography for six months at school in Vevey, Switzerland. Started as a freelance photographer, 1954. Reporter and fashion photographer, *Elle*, 1955–8. One year with Magnum Photos, 1959. Contributor to *Réalités, Jardin des Modes*. In New York worked principally for *Harper's Bazaar* and *Look, Esquire*, 1962–6. Opened studio in Paris, 1966, and contributed to *Vogue, Queen, Nova*, etc. Cameras: all types, mainly 35 mm. Exhibitions: Bibliothèque Nationale, Paris, 1967; Museum of Contemporary Arts, Belgium, 1971; Underground Gallery, New York, 1971; Fine Art Museum, Brussels, 1972; Moscow, 1972; Nikon Gallery, Paris, 1972; Tokyo, 1973. Collections: Bibliothèque Nationale; Museum of Contemporary Arts, Belgium; Het Sterckshof Museum, Deurne, Belgium.

Jeanloup Sieff has worked for *Nova* and *Queen* and turns in strong black-and-white prints, sometimes taken with red filters. His women, his landscapes, his objects are all sad. He contrives to make a row of bathing-huts full of poignance. He knows his limitations and his aim is to create a mood of unusual emotion: in this he is an artist.

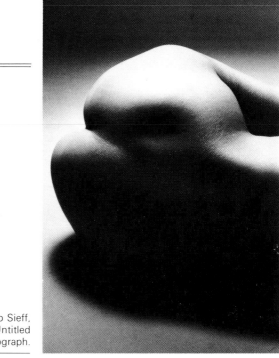

Jeanloup Sieff, Untitled photograph.

Gerry Cranham

b. 1929

Born in Farnborough, England. Had a parallel career as a middle-distance runner, was a torch-bearer at 1948 Olympics, won inter-services half-mile title. Became a part-time professional photographer covering weddings, dog-shows, etc., 1957. Photographs have appeared in numerous publications including *Athletics Weekly, Sports Illustrated, Sunday Times, The Observer*. Special subjects: sports and action subjects. Cameras: mostly Nikon, also 5 × 4 inch MPP. Major exhibitions: 'Man in Sport', Baltimore Museum of Art touring exhibition, 1969; Victoria and Albert Museum, London, 1971 and then touring; Kodak Ltd, London, 1962. Collections: Victoria and Albert Museum; Baltimore Museum of Art. Book: *The Professionals* with Geoffrey Nicholson.

'Because he [Gerry Cranham] had been a competitor himself, he left the finishing line to the others and went to the bend where the critical effort was made.

'Because he was an athlete, still training even though he didn't compete, he took photographs – especially at cross-country races, scrambles, point-to-points – from places on the course that a man with less stamina simply could not have reached in time. No one quite so literally *covered* an event.' (Geoffrey Nicholson, Catalogue of the Victoria and Albert Museum exhibition of Cranham photographs.)

Gerry Cranham, *Six-Day Event Cyclist*, 1969.

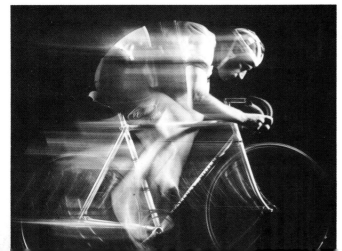

Lee Friedlander

b. 1934

Born in Aberdeen, Washington, USA. Began photographing in 1948. Photographs published in *Esquire, McCall's, Collier's, Seventeen, Sports Illustrated, Art in America*. Special subject: the city and its people. Camera: 35 mm; electronic flash. Guggenheim fellowship, 1960 and 1962. Exhibitions: Milan, 1960; International Museum of Photography, Rochester, New York, 1963. Books: *Self-Portrait; Work from the Same House* with Jim Dine, 1969; *E. J. Bellocq: Storyville Portraits*, 1970.

He has been claimed as the representative of a new generation of documentary photographers. With a 35 mm camera he uses a city and its people as the subjects for his continual investigation. He manoeuvres himself discreetly among the crowds until he finds the telling composition of types and appendages. Friedlander has a casual way of snapshotting, almost as if he does not take his work seriously, but his targets are carefully sifted: store windows, a church spire, telegraph wires, neon lighting, men in the ugliest possible twentieth-century environments, awful bedroom suites and television studios. To these Friedlander brings an element of the surrealist and the romantic with enigmatic overtones of 'porn'. He enjoys reflections: a dog in a show-case is like a Francis Bacon. Friedlander photographs the cigarette-smoke and noise of the city, the atmosphere that can be felt rather than seen.

A most articulate master of the tape recorder, his aims have been published, together with his photographs, in many remarkable books. Perhaps the most significant is his collection of 'Gatherings' – pictures taken at dozens of parties given by himself and others during the past years. They show people looking bored, even unhappy, and wishing themselves elsewhere. Friedlander takes un-pretty pictures.

A friend of Jim Dine, with whom he has had a close working relationship, Friedlander collaborated on *Work from the Same House* with Dine's etchings. He made a book, *Self-Portrait*, of his shadows in the street, in plate-glass and mirror reflections – intended as records of an artist rather than to be judged as creations of the artist.

Erwin Fieger

b. 1928

Erwin Fieger is a former graphics-designer turned photographer. A moustachioed, smiling man whose facial features and inexpressive arms and wrists give no indication of the fine artist that he is, he is interested in all cultural activities. He lives in Stuttgart whence – through no other reason than this genius for colour photography – his work goes out, to be widely appreciated, throughout Europe. Using only colour with a telephoto lens with its small depth of focus on his 35 mm camera, he is unquestionably the most imaginative colour photographer of his day. The originality of his vision, his unexpected sense of the dramatic and his physiological use of colour place him in a class quite by himself.

Fieger is unmindful of popular acclaim, and despises the unethical and crass attitudes of many editors of popular magazines. Much of his work is unseen until it is collected in grandiose albums of his design. Of these the most recent, *Thirteen Photo Essays*, is remarkable not only for the quality of his photography but also for the brilliance with which the engravers, printers, publisher and others have helped in producing this book. They have obviously been dedicated in their determination to achieve the almost impossible and to translate the translucent dyes of Fieger's colour transparencies on to the printed page.

This beautiful book – the result of five years' work – displays Fieger's intuitive gifts and depth of expression at his best; but his other books, *London, City of My Dreams*, 1962, *The Magic of Colour* and *The Sense of Movement* (a *grand prix*), also show that he is a contemporary master.

The thirteen essays present a fresh vision of the over-photographed New York, of Paris and the Champs-Elysées, seen as never before, like a display of *baguette* jewellery; accentuate the fine features and wide craniums of Africans; allow us to see Indians fighting for existence, starving in Calcutta or lying dead and about to be set alight on the burning-ghats; the Kabuki female-impersonators; the bull-fights and the jagged-toothed mother describing the death of her son, a toreador.

Throughout the series the imaginative use of colour intensifies the significance of the unusual interpretation. Often the colour is made unrealistic with filters, and especially striking is the use of scarlet and magenta in juxtaposition, and the emeralds and dark spinach-greens. Some of the silvery textures seen among coloured lights, and the effects of moving objects that shine, are nothing short of fantastic. No one else has used in colour large expanses of black to such effect. One aerial picture of a winding river is the photographic counterpart of the work of the painter Barnet Newman.

Helmut Gernsheim has said of Erwin Fieger that he has raised the power of photographic expression to hitherto unknown heights. Certainly some of his shots of swirling waters reflecting unexpected patches of coloured light, his *Mother Carrying a Child* (taken from a moving car), and his mountainscapes, are memorable. Some of his vast head-shots, with open pores covered with paint and sweat, are dramatic, but less personal than those in which, through a crowd or foliage, he catches a fine glimpse of a fragment of a face.

Lucas Samaras

b. 1936

Born in Macedonia, Greece, became US citizen, 1955. Attended Rutgers and Columbia Universities. Equipment: Polaroid. Major exhibitions: Documenta (Germany), 1972; Whitney Museum, New York, 1972. Book: *The Samaras Album*, 1971.

A thirty-seven-year-old Greek from Macedonia, now an American citizen, Samaras is in many ways a remarkable, baffling artist. He has recently made experiments with a Polaroid camera. The extraordinary results are published in *The Samaras Album*. In explanation he wrote, 'I have wanted to photographically explore my body for years and was going to have a professional photographer do it, but I have never been able to work well with others, and I was not going to a photography school to learn photography.' Polaroid came in handy. He has photographed himself exclusively. When the Polaroids have been over-exposed Samaras is pleased, for they have given him the opportunity to help, alter, revive or 'juice-up' the prints with ink dots and linear designs. With this use of pointillism he makes backgrounds eat into part of the naked body. The effect becomes quite gruesome and marvellous. Sometimes these dots and lines diminish the photographic perspective and bring the background space forward. Sometimes it is not clear whether these are photographs or paintings, or perhaps some kind of tattooing.

Samaras has made many Polaroids of a dazzling technical excellence. With this odd raw eye he has photographed himself in close-up, pulling every sort of face. Some of the experiments do not succeed, some are obscene. Some of the effects are horrendous – the double exposures grotesque – and it is unpleasant to see his penis being burned by a candle-flame, or see his face in agony in some other unnamed situation.

The Samaras Album is laid-out in a different manner. He has not chosen the definitive perfect shot; rather he shows us the variations on the theme, good and bad, and this creates an extra effect, gives extra stretch and flexibility. Some of the lighting is truly inspired and the depth of the detail is surprising. Samaras's failures are often the means of showing us what he wished to achieve and are therefore interesting. At his best Samaras is doing something that can never be successfully copied.

Lucas Samaras,
Untitled
photograph, 1971.

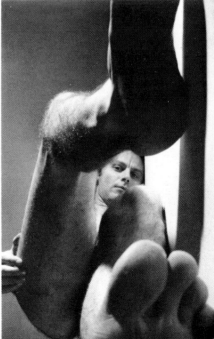

Richard Avedon

b. 1923

Born in New York City. Left school at seventeen. First job as an errand-boy at small photographic concern. Enlisted in Merchant Marine, 1942; father gave him a Rolleiflex. Spent two years in photography branch of Marines. Student of Alexey Brodovitch. Staff photographer *Harper's Bazaar*, 1945–65 and *Vogue* from 1965. Camera and film: Rolleiflex and Panatomic-X. Major exhibitions: Smithsonian Institution, Washington, DC, 1962; Minneapolis Institute of Arts, 1970. Collections: Haags Gemeentemuseum, The Hague, Netherlands; Metropolitan Museum of Art, New York; Minneapolis Institute of Arts; Musée Réattu, Arles, France; Museum of Modern Art, New York; Philadelphia Museum of Art; Rhodes National Gallery, Salisbury, Rhodesia; Smithsonian Instituion; Toledo Museum of Art, Ohio. Books: *Observations*, text by Truman Capote, 1959; *Nothing Personal*, text by James Baldwin, 1964; *Dairy of a Century*, photographs by Jacques-Henri Lartigue (editor), 1970; *Alice in Wonderland*, text by Doon Arbus, 1973.

Richard Avedon was born on Manhattan, a descendant of a family which had migrated from Russia two generations before. His father was co-owner of a women's-wear department store called Avedon's Fifth Avenue. Young Avedon had wishful dreams about becoming a poet, a writer or a dramatist. He was also interested in photography and when studying the fashion magazines discarded by his father was impressed by the work of Martin Munkacsi, whose snaps of models, leaping like gazelles, he pinned around his walls. When the war interrupted his daydreams the nineteen-year-old Avedon joined up and worked in the photographic department of the Marines. His job was to take photographs of servicemen for identification

By the time he was twenty-two Avedon had already achieved success working as a fashion photographer under the aegis of Alexey Brodovitch at *Harper's Bazaar*. His pictures showed young ladies enjoying life to the full as they preened and jumped with joy in their Paris confections. Avedon's photographs did not perhaps have technical perfection, and they were all the

Richard Avedon, *Below Nureyev. Right Twiggy,* Paris, 1968.

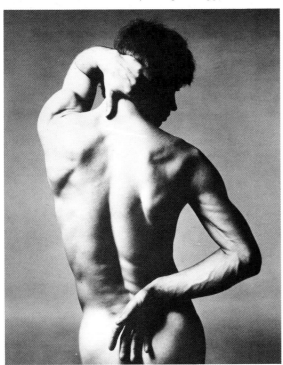

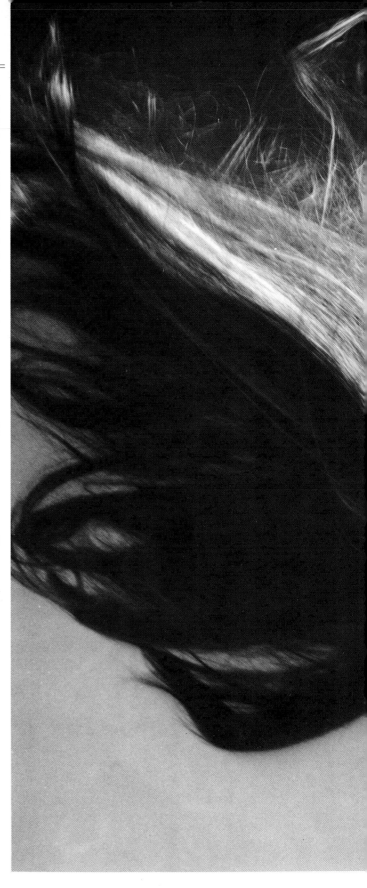

better for this, for they created the statement that he wished to make – of movement caught forever by his lens. His photographs could be relied upon to make an impression of enthusiasm and delight. Avedon showed little interest in the faces of his models for he saw them as butterflies in flight. His stage

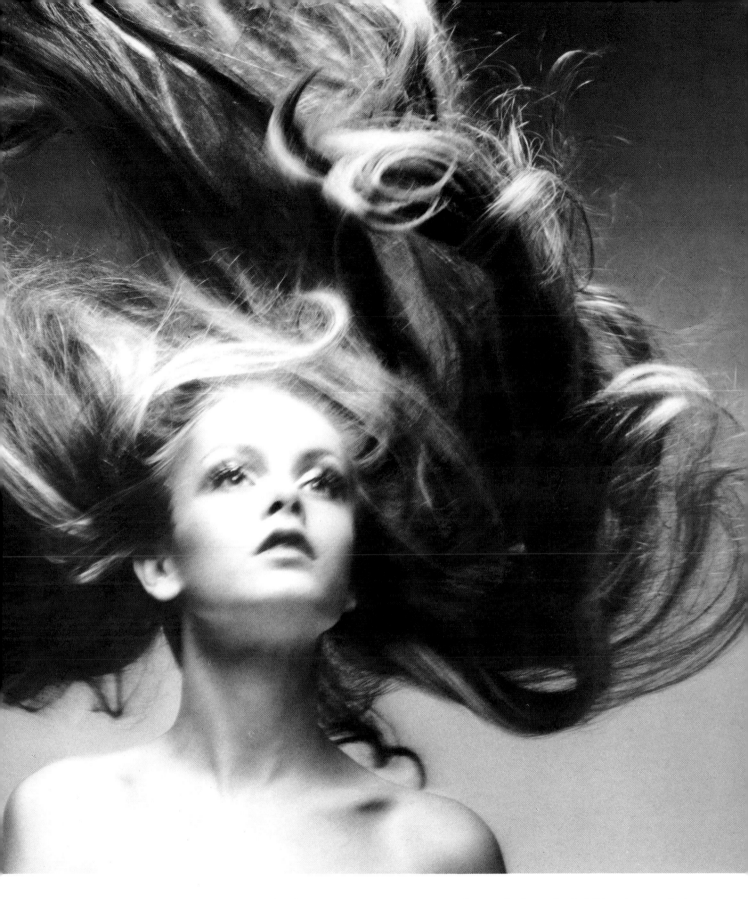

and ballet photographs were also invigorating after the static poses or monumental portraits of Steichen and others.

Avedon instigated many new fashion poses, one of which was the model seen in a wind-machine tornado with her legs wide apart. For a while he photographed his girls with hand-some young men, then made them wheel children in perambulators, or, roaring with laughter, clasp champion cyclists. Then, gradually, perhaps a little gravity – or could it be maturity ? – crept into some of Avedon's pictures : children looking forlorn and lost in some open space, faces of old age – sad and haunted.

Richard Avedon

Winthrop Sergeant, in a profile on Avedon in the *New Yorker,* wrote: 'His is a world of imagination, a composite of mists, glowing lights, the mood of nocturnal revellers, nostalgic memories of bars and gaming tables and theatres and such ephemeral minutiae as the feeling of enchantment at the sight of a taxi in the rain whose door is open to receive a suave and mysterious beauty. His pictures have an unrehearsed and improvised, almost accidental, air about them; his camera often invades a penumbral region in which the blur, for years regarded by professionals as the mark of the bungler, is a means of poetic evocation. ... The Avedon blur has, in fact, become a sort of colophon.'

Avedon explained: 'I began trying to create an out-of-focus world, a heightened reality – better than real – that suggests rather than tells you. Maybe the fact that I am myopic has something to do with it. When I take off my glasses, especially on rainy nights, I get a far more beautiful view of the world than 20/20 people get. I wanted to reproduce this more poetic image.'

Avedon described models in general as being a group of 'undeveloped, frightened, insecure women, most of whom had been thought ugly as children – too tall and too skinny. They are all subject to trauma where their looks are concerned: you have to make them feel beautiful.' Perhaps Avedon was the first fashion photographer who did not treat the models as attractive packages that arrived at a certain time and left after the sitting forever. He became on such close terms with his favourite models that he jokingly said that in order to work with them successfully he had to be a bit in love with them.

By degrees Avedon began to feel ill-at-ease working outside his studio. It is said he once started a reportage of New York for *Life* magazine, but felt incapable of carrying it through. He no longer enjoys location pictures. He writes, 'I always prefer to work in the studio. It isolates people from their environment. They become in a sense symbolic of themselves. I often feel that people come to me to be photographed as they would go to a doctor or a fortune-teller – to find out how they are. So they're dependent on me. I have to engage them. Otherwise there's nothing to photograph. The concentration has to come from me and involve them. Sometimes the force of it grows so strong that sounds in the studio go unheard. Time stops. We share a brief, intense intimacy. But it's unearned. It has no past, no future.'

Avedon has said that daylight is a very romantic light, that he loves it, but 'it's like loving something from long ago that I can't believe in any more. It would be a lie for me to photograph with daylight in a world of Hiltons, airports, supermarkets and television. Daylight is something I rarely see – something I must give up ... like childhood.'

Perhaps Avedon was right when he intimated that he only came of age when he discovered the strobe light. Certainly he is the greatest practitioner of this almost overwhelmingly popular means of getting light, shadow and detail in one extraordinary split second: we think we can see all the tobacco stains on Humphrey Bogart's upper lip, every vein in the eyes of Giacometti. With others the technical perfection of strobe is apt to become master of the performance. Not with Avedon. Somehow he creates a world of his own with the light that flashes from under the Victorian umbrella.

Avedon's use of distortion by means of the wide-angle lens combined with an exaggerated camera angle was a passing phase, but it prevented him from showing us the great beauty in the almost mummified skeleton of Baroness Blixen shortly before she became, in fact, a corpse. Somerset Maugham and Chanel, with their chins high and arrogant, would never have agreed to the drainpipes in their throats becoming their salient features. The strength of Avedon's present portraits is that they are unlikely likenesses of interesting people caught in an improbable light and mood.

Air-brush retouching sublimates the reality of a representation: a large *poitrine* is carved in half or a young girl is given a neck the length of a swan's. Avedon's pictures often pack a big punch, and on first sight one is apt to reel. Yet the effect is not a lasting one, and a retrospective collection of his photographs is less stimulating and dramatic than one would have expected. Certain tricks that have been effective in the 15 April issue of *Vogue* magazine have lost their surprise by Christmas time. Yet Avedon would be the last to worry. He made the effect that he wanted at that particular time. He always knows what he wants and he does nothing that he does not wish to do. His approach is intellectual.

Avedon is quiet, energetic, lithe, agile. He is a canny businessman and, although living luxuriously, does not wish to have a house in the country or an expensive car. He knows he belongs in New York and in the studio. He does not go out to meet people. He says, 'If a day goes by without my doing something related to photography, it's as though I've neglected something essential to my existence ... as though I'd forgotten to wake up. I know that the accident of my being a photographer has made my life ... possible.'

Avedon has turned out an extraordinary quality of work for much longer than most photographers could manage to endure, especially within confines where daylight is never seen and almost nothing from nature contrives to enter. Yet his own vision remains strong enough to maintain complete authority.

For the last four years he has been experimenting without showing any of the results. But these are likely to inspire the usual number of imitators when at last they are seen in the exhibitions and books he is now planning.

David Bailey

b. 1938

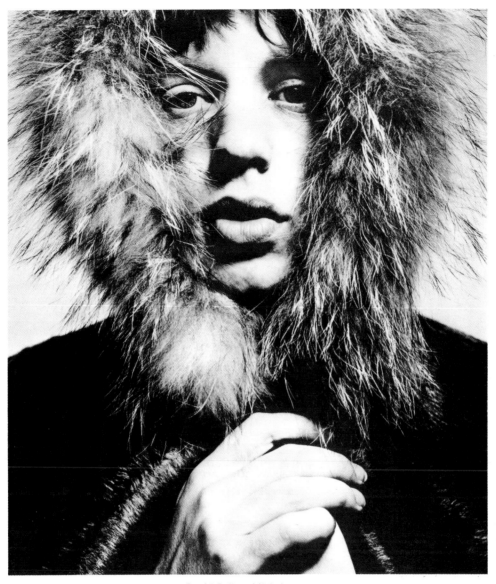

David Bailey, *Mick Jagger*.

Born in London. Left school at fourteen; various jobs in the East End and City. Conscripted into Air Force, 1957–8. Assistant to photographer John Franch for eleven months, 1959. Commissions from *Daily Express*, etc. led to features. Contract with *Vogue* since 1960. Photographs reproduced in *Sunday Times, Daily Telegraph, Elle, Glamour*, etc. Special subjects: fashion, portraiture, reportage. Cameras: Pentax, Nikon, Rolleiflex, Hasselblad, 4 × 5 inch plate, 10 × 8 inch plate. Exhibitions: 'Snap', National Portrait Gallery, London, 1971; Nikon Gallery, Paris, 1972; Photographers' Gallery, London, 1974. Books: *The Truth about Modelling* by Jean Shrimpton, 1963; *Box of Pin-ups*, 1965; *Goodbye Baby & Amen*, 1969; *Andy Warhol Transcripts and Photographs*, 1973; *Beady Minces*, 1973. Films: *Beaton by Bailey*, 1971; *Andy Warhol*, 1973.

Bailey, a dark, Raeburnesque boy, with lots of picturesque gear and an eye for beautiful young girls, at once showed vast assurance – even bravura. Also he had a talent for the 'way out' at a time when a change was needed. Bailey has always had a desire to shock.

But when the criticism has died down Bailey continues to work with relentless enthusiasm and energy. His preferred subjects have been Pop singers and controversial 'stars' who have long since become extinct. He was early to spot the *photogenique* qualities of Mick Jagger and he has put many new faces on the road to fortune if not fame.

The albums and catalogues he has published have not shown him at his best. The bubble shock of their first impact is likely to be pricked early on.

He has passed through many phases, and although perhaps one may consider that his latest style is not truly part of his idiom, he can play his new role as well as another. He has weathered many storms, but has stood the test of time.

For him, as for so many other young people, the cinema and television medium is a great lure. It would be sad if a craftsman as adept at one particular form of self-expression as Bailey were to branch out into too many distracting diversions.

George Silk

b. 1916

Born in New Zealand; US citizen. After leaving school worked as a 'cow puncher'. An amateur photographer, turned professional, 1939. Joined the Australian Army as a photographer; was a 'desert rat' recording the fighting against Rommel and covered the campaign in New Guinea, walking and photographing the 700 miles of the Kokoda Trail. *Life* photographer from about 1943–72. Special subjects: the outdoors; sport. Camera and film: Nikon; Kodachrome.

George Silk,
Slashing Dive.

David Douglas Duncan

b. 1916

Born in Kansas City, Missouri. Studied Marine zoology and deep-sea diving, at University of Miami. Since 1938 has travelled around the world as a photographer, foreign correspondent and art historian. Was official cameraman for the Michael Lerner Chile–Peru Expedition of American Museum of Natural History. Sent by Office of Inter-American Affairs to make photographs in the interest of hemisphere solidarity. Served as a combat photographer in the South Pacific during Second World War. After war became a *Life* photographer; worked in Palestine, Greece, Korea and Indo-China, 1946–56. Joined *Collier's* magazine to go to Russia with John Gunther, 1956, later sold parts of story to *Saturday Evening Post, Life* and *Look*. Under joint assignment from *Life* and ABC-TV covered the war in Vietnam. Special subjects: war photography, pictures of Picasso and his work. Cameras: Leicas and Nikon F. Books: *This is War!*, 1951; *The Private World of Pablo Picasso*, 1958; *The Kremlin*, 1960; *Picasso's Picassos*, 1961; *Yankee Nomad*, 1966; *I Protest*, 1968; *Self-Portrait: USA*, 1969; *War Without Heroes*, 1971; *Prismatics*, 1973.

David Douglas Duncan has had a life of great adventure. As a photographer in the Marine Corps, he made some extraordinary pictures from the air, from the sea, and of the army in agonizing conditions; but danger never prevented him from taking more war photographs: Korea, in 1950, provided him with the panorama which he used as only a master of reportage could.

In a totally different genre Duncan brought off another coup by photographing Picasso, day in, day out, in every mood, for months on end. Sometimes he photographed the maestro in playful vein, and some of the 'clowning' pictures, with blob on nose, added to the feeling among younger generations that the great man had become too much of a buffoon in his craving for publicity. But Duncan also photographed Picasso's own pictures and these are a valuable addition to the archives of art history.

Harry Callahan

b. 1912

Born in Detroit. Studied engineering, Michigan State University, 1936–8. Self-taught as a photographer, began photographing, 1938; worked as processor, photo laboratory, General Motors, 1944–5. Began teaching at the Institute of Design, Chicago, 1946; head of department, 1949–61. Associate professor and head of Department of Photography, Rhode Island School of Design, 1961; professor, 1964. Cameras: 8 × 10 inch Deardorff, 9 × 12 cm Linhof, Rolleiflex. Guggenheim Fellowship, 1971. Exhibitions: Kansas City Art Institute, 1956; International Museum of Photography, Rochester, New York, 1958; (with Robert Frank) Museum of Modern Art, New York, 1962; 'Ideas in Images', Worcester Art Museum, Massachusetts, 1962;

Born in Michigan in 1912, Callahan began taking photographs after having studied engineering for two years. He worked as a processor in the photographic laboratories of General Motors, where he was strongly impressed by lectures given by Minor White and by the life and influence of Stieglitz. When he met Moholy-Nagy in 1946 he realized photography was his real *forte*. He began teaching at the Institute of Design in Chicago where he became head of the photography department. In 1957 he was given a year's leave to photograph in France, and it was here that he made the impeccable close shots of grasses and wild flowers around Aix-en-Provence that look like details of wrought-ironwork. An exceptional elegance of line is seen in almost all his works.

Of his pictures, which divide themselves into two definite groups, the studies of nature, a mother and child, a tree seen like filigree blowing in the wind are in complete contrast to his abstractions and his montages. He makes curious double exposures of Chicago street scenes on a woman's naked back, or a field that shows also a woman's crotch. In 1940 he made a face appear across a landscape. Callahan enjoys multiple images, and in one collage went so far as to combine hundreds of fragments cut from photographs of the hands and limbs of fashion models. The net result was unfortunately ruined by the artificiality of the subjects. His most famous success is of a woman in silhouette made by Callahan into a cat-like Egyptian figure.

Harry Callahan, *Eleanor*, 1948.

Duane Michals

b. 1936

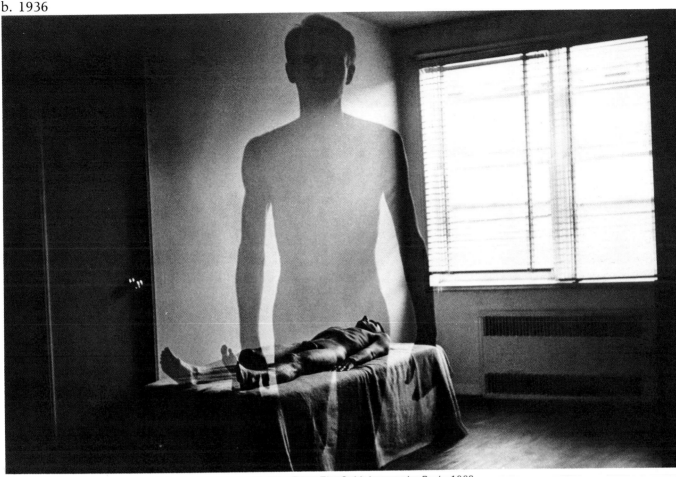

Duane Michals, From *The Spirit Leaves the Body*, 1969.

Born in McKeesport, Pennsylvania. Started photography on a tourist trip to Russia, 1958. Started doing sequences, 1969. A freelance photographer in New York; sells both commercial work and personal work to magazines. Special subjects: sequences and portraits. Camera and film: Nikon and Tri-X. Major exhibitions: Museum of Modern Art, New York, 1970; Chicago Art Institute, 1968; San Francisco Art Institute, 1972; Kunstverein, Cologne, 1973; Delpire, Paris, 1973. Collections: Museum of Modern Art; Bibliothèque Nationale, Paris; International Museum of Photography, Rochester, New York. Books: *Sequences*, 1971; *Journey of the Spirit After Death*, 1971.

Duane Michals is mainly influenced by the painters Magritte and Balthus, who provide him with his love of an interplay between the surrealistic and the ordinary. He enjoys taking photographs that make demands on the viewer. 'Nice photographs are not enough.' His images are based on very specific ideas and feelings: there are no accidents in his pictures. They are carefully thought out before the time of exposure. Sometimes they are based on memories and his own awarenesses. He calls them 'the drama of the interior world, which may ultimately be more real than the exterior world'. He has pronounced that he illustrates the mystery of himself and his life and the reality of his death and what he could do with the camera to salute it.

In 1969 Michals started making a series of photographs – each with only a slight variation – to explain an event more fully than one single image could. One of these 'sequences' he likens to 'a journey of the spirit after death'. He describes how he wishes to take pictures as if 'someone comes back and sees what is happening in the world and to his family and home. He sees himself looking at himself dead.' He contrives a fantasy against a simple, ordinary setting, and with a straightforward, unobtrusive technique. The sheer banality of the approach and portrayal makes the mystery a reality: the pseudo-events become fact because the photographs prove that the impossible has happened. The man and woman in a Douanier Rousseau interior of potted palms pose for the camera without moving: the man is seen in each shot to wear less and less clothing. Duane Michals would not allow the seated figure of Bill Brandt to move while he, firmly holding his clicking camera, moved round his sitter in a complete circle. That was a 'sequence'. One feels that movies would be an admirable medium for an extension of his ideas; but this does not appeal to him, and he makes enough money with commercial photography without having to teach.

Michals is always striving for something different. He considers that photographers' work should be ninety per cent thinking and ten per cent action. His intellect and an eerie sense of the absurd guide him.

257

Bernhard and Hilla Becher

b. 1931 and 1934

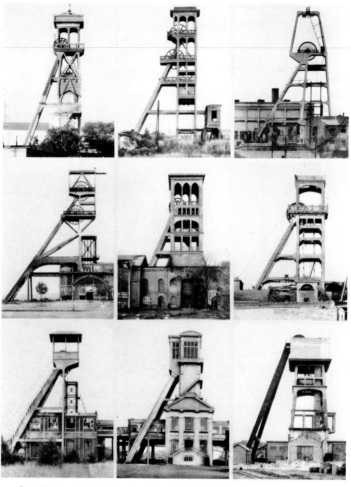

Bernhard and Hilda Becher, *Typologie, Winding Towers*, 1966–71.

Bernhard Becher was born in Westphalia, Germany. Studied at the Art Academies in Stuttgart and Düsseldorf; primary concerns, etching, lithography, oil painting. Began photographing, 1956; gave up painting and graphic art in favour of photography, 1957.

Hilla Wobeser was born in Potsdam, Germany. Trained as a photographer and worked in advertising. Continued photographic studies at Düsseldorf Art Academy. Began collaboration with Bernhard Becher, 1959; married him, 1961.

Special subjects: photographs of industrial constructions which have a clearly recognizable function, and residential buildings. Camera: Plaubel 13 × 18 cm. Major exhibitions: State Academy, Düsseldorf; City of Düsseldorf Art Galleries; City Museum, Ulm (all almost annually); Second Biennale, Nuremberg, 1971; Sonnabend Gallery, New York, 1972. Book: *Anonymous Sculpture*, 1973.

Bernhard and Hilla Becher have travelled under drab grey skies to the most unpromising industrial quarters of their native Germany. They have also visited England, Scotland, Wales, France, Belgium and Holland. Their quest has been for buildings and other structures which have been planned and erected with no respect for aesthetics, but exclusively according to mathematical calculations. These constructions are for the purpose of storage, transformation, processing or transporting of materials, liquids and gases – their prototype being the pot-oven, chimney, winch, pump or laboratory. They are thus completely different from domestic and factory buildings.

It is said that every mother sees her progeny as beautiful, and every farmer knows his sheep individually; no doubt the Bechers are in ecstasies over their subjects, but for the viewer it is difficult to tell one gas-holder, blast-furnace, cooling-, winding- or water-tower, lime kiln or silo from another. Neither do the Bechers allow us to see their gasometers in varying settings.

But there is no doubt that the Bechers have succeeded in showing us with fresh eyes that some of these turn-of-the-century utilitarian edifices are quite fantastic – as if built as a folly for some gala evening. Even those of the 1850s and 1860s have a certain Lewis Carroll or W. Heath Robinson charm, and by degrees we admire – as if looking at sculpture – the forms, silhouettes and textures. Some cooling-towers with their cross-work strapping might have been etched by Bernard Buffet – in a bad phase – while Fernard Léger could have been inspired by the iron ore, coke and chalk blast-furnaces for making crude iron. Some of the water-towers would not be out of place in the garden of George IV's pavilion at Brighton.

The ability of an artist to make one see afresh is a rare accomplishment, and between 1960 and 1970 Hilla and Bernhard have certainly made us see, understand and share their extremely esoteric passion; it has resulted in a remarkable collection of photographs, published under the title *Anonymous Sculpture*.

Tony Ray-Jones

1941–72

Born in Wells, Somerset. Studied graphic design, London College of Printing, 1957–61. Scholarship to Yale University for graduate work in design, 1961–2. Studied with Alexey Brodovitch and Richard Avedon, Design Laboratory, New York, 1962–3. Final year at Yale University, graduating with degree of Master of Fine Arts, 1963–4. Associate art director to Alexey Brodovitch on *Sky* magazine, 1964. Freelance photographer in United States, 1965–6. Worked on assignments for European and American magazines; portfolios in *Horizon* magazine, *Creative Camera, Album, Saturday Evening Post, Sunday Times Magazine,* etc. Travelled throughout England photographing festivals, old customs and seaside resorts, 1966–71. Appointed visiting lecturer to Department of Photography, San Francisco Art Institute, 1971. Died in London of a rare form of leukaemia, 13 March 1972. Camera: Leica M2 and M4. Exhibitions: 'Spectrum', Institute of Contemporary Arts, London, 1969; 'Vision and Expression', International Museum of Photography, Rochester, New York, 1970; 'The English', Gallerie Rencontre, Paris, 1970; San Francisco Art Museum, 1972; Photographic Workshop of Institute of Contemporary Arts, Royal Photographic Society, 1972; Pasadena Art Museum, California, 1972; Fotogalerie Wilde, Cologne, 1973; Arts Council of Great Britain, 1973. Collections: Bibliothèque Nationale, Paris; Museum of Modern Art, New York; International Museum of Photography; San Francisco Museum of Art; Royal Photographic Society; Arts Council of Great Britain. Book: *A Day Off: An English Journal,* 1973.

'Photography for me is an exciting and personal way of reacting to and commenting on one's environment and I feel that it is perhaps a great pity that more people don't consider it as a medium of self-expression instead of selling themselves to the commercial world of journalism and advertising.'

Tony Ray-Jones, who died tragically at the age of 31 in March 1972, wrote this statement to accompany a portfolio of his pictures published by *Creative Camera* in 1968. It is a succinct summary of his philosophy, for Tony despised what, privately, he would describe as the 'phoney-balony' in photography. Of all the photographers I have met there have been none who were so fiercely determined to maintain their personal integrity, even at the expense of passing up commercial assignments. This attitude, together with his incredible energy, led him to devote every possible minute to his personal projects, travelling up and down England in a minibus, shooting pictures that, somehow, managed to bring together a very subtle blend of innocent joy at the whimsies of human nature and a masterful understanding of the revelations possible in juxtaposition.
(Peter Turner, *Creative Camera*, London, 1973)

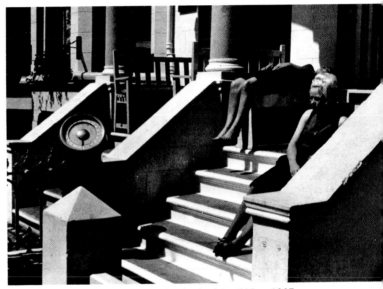

Tony Ray-Jones, *Sunbathing in the Isle of Man*, 1967.

Gianni Berengo Gardin

b. 1930

Born in Santa Margherita, Italy. Lived in Switzerland and in Rome until 1947; spent several years in Paris and Venice working in tourist industry. Became interested in photography, 1954; first professional work commissioned, 1964. Settled in Milan, 1964; work published in *Domus, Epoca, Il Mondo, L'Espresso, Time, Stern, Harper's Bazaar, Réalités, Vogue, Le Figaro,* etc. Special subject: pure reportage. Book: *L'occhio come mestiere.*

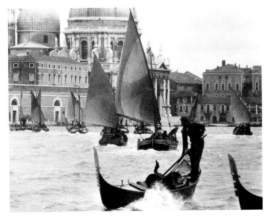

Gianni Berengo Gardin, *Venice.*

'Gianni Berengo Gardin is an Italian photo-journalist whose work is little-known outside his own country, in spite of the inclusion of his work in exhibitions at the Museum of Modern Art, George Eastman House [International Museum of Photography] and Photokina. But these are exceptions. Gianni Berengo Gardin has never courted popularity or attempted to "plug in" to the usual outlets for picture appreciation by fellow photographers. Most earnest photographers seem to focus the zeal of their efforts on being recognized and applauded by a small group of esoteric photo-critics; a few seem to turn their backs on their own kind, and project their pictures for the appreciation of their vast non-photographic audience. Gianni Berengo Gardin, along with Édouard Boubat and Elliott Erwitt, demand respect for their total involvement with their subjects, not with photography. Their spontaneous, if emotional, reaction to reality anchors photography to life and prevents its flight into the painters' realms of fantasy. It is in this attitude that the traditions of the best photography are rooted.' (Bill Jay, 'Gianni Berengo Gardin', *Album*, No. 12, 1970) GB

Donald McCullin

b. 1935

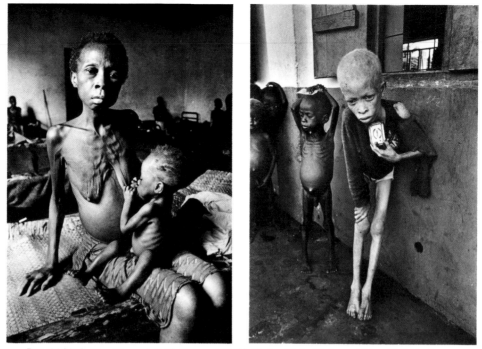

Donald McCullin, *Above, left Mother and Child, Biafra. Right Biafra – Albino Child in Camp.*

Born in London. Father a street trader who was mostly out of work, mother charred and did odd jobs; evacuated out of London during bombings, 1940. Attended Tollington Park Secondary Modern School; won a Trade Arts Scholarship to Hammersmith School of Arts and Crafts, 1948. Father died, relinquished scholarship, went to work, 1950. Called up to do National Service; joined RAF, photographic assistant working on aerial reconnaissance printing, 1953–5. Returned to former employer, Larkins, cartoon-makers, 1955–8. Photographed the building of Berlin Wall; pictures bought by *Observer*, London, 1961. Began career as a war photographer on assignment in Cyprus, 1964. Joined London *Sunday Times*, 1964. Covered Congo, 1967; Tet Offensive, South Vietnam, 1968; Cambodia, 1970; Civil War, Biafra, 1970–71; Indian–Pakistani war, 1971; Indo-China, 1972; famine, Sahara, 1973. Cameras: Nikons. Exhibitions: 'The Uncertain Day', Kodak House, London, 1970; 'Four Internationally Famous Magazine Photographers', Photokina, Cologne, 1972; 'The Concerned Photographer 2', Israel Museum, Jerusalem, 1973. Books: *The Destruction Business*, 1971; *Is Anyone Taking Any Notice?*, 1974.

Don McCullin was an East End boy. His tough beginnings have served him well throughout his brilliant career as a reporter in the midst of horror. With wiry, wavy hair, handsomely blunt features and the quick eye of a bird, he looks the part of the intrepid news photographer who never flinches. In fact Don seems to be infatuated with disaster and does not baulk at the sight of blood and butchery. But he is no blood-sucking ghoul; his forlorn face shows his personal suffering. His loathing of war and his reluctant wish for danger are symptomatic of a dual personality. He feels he must be in the thick of things where he knows the different sounds of bullet and shell; yet he is seen in a trance of misery carrying on his shoulder the dead body of a close friend. He has written: 'The photographer must be a humble and patient creature, ready to move forward or disappear into thin air. If I am alone and witness to happiness or shame, or even death, and no one is near, I may have had

choices, one to be the photographer, the other the man; but what I try to be is human.'

It must give him much satisfaction to know that he has helped in many a good cause. For who, having seen his poignant pictures of starving mothers and children, has not immediately made even some small effort to help? During the war in Vietnam he was always to be found in the most dangerous positions – perhaps even courting danger – but he managed to bring back some of the most telling pictures of the fighting. He is not an indiscriminate recorder with the lens, but is always able to convey the substance of a given situation.

One can read so much into his pictures: the *Girl in a Liverpool Alley* is a picture of poverty, under-care, of shame for lost innocence. His *Albino Child – Biafra*, the huge head like a melon and limbs like matchsticks, hits one in the stomach; so, too, does his shot of the terrified blind black soldiers. In Vietnam, the disfigured head of a corpse, long since lying in Pre-Raphaelite undergrowth, cigarette-stub in the blurred, contorted cheek, is something that, no doubt, Francis Bacon would find repugnant.

When floods or famine produce great misfortunes Don is there to record the terrible scenes. Who could easily forget the shock of his documentation of disease and starvation in India, in Africa? Near home he is at his finest when making pictures of the 'down-and-outs' in London's Skid Row. They may make the squeamish recoil, but here is the essence of truth in the terms of a contemporary Dostoevsky.

Don McCullin is articulate. He says: 'I use the camera like a toothbrush. It does the job. ... I want to blend in – I creep around delicately trying to shoot pictures. It is as if I'm in the middle of a circus, and I'm the tightropester and everybody is watching to see me make a mistake. I don't.'

260

Opposite Donald McCullin, *Down and Out – London, Aldgate.*

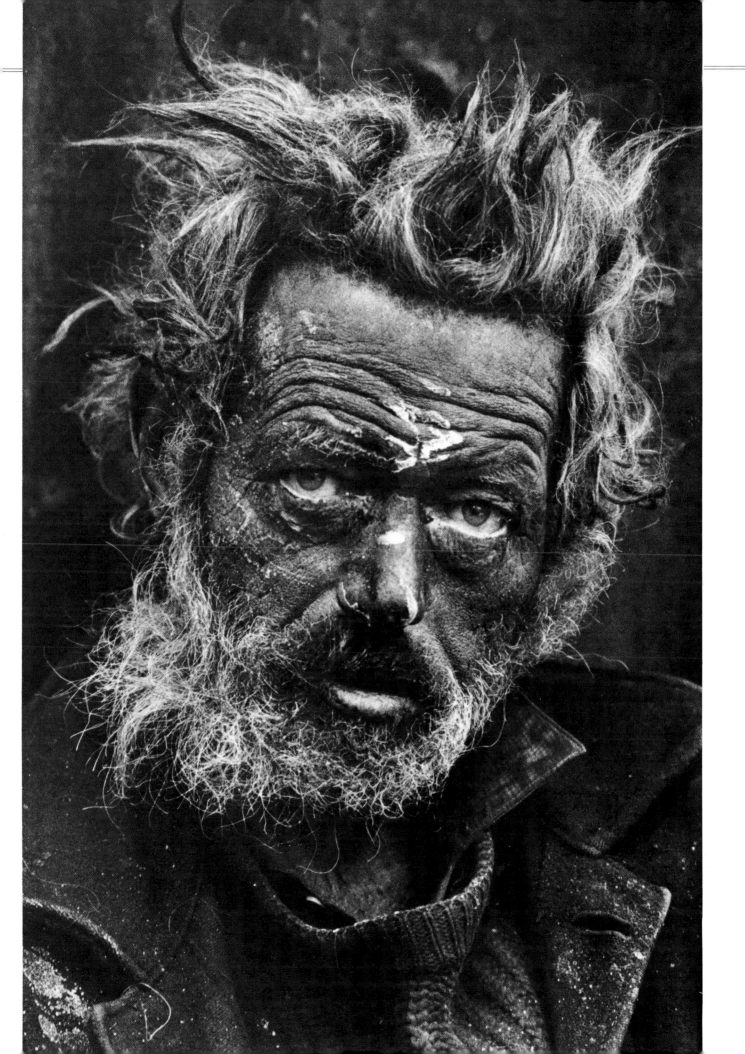

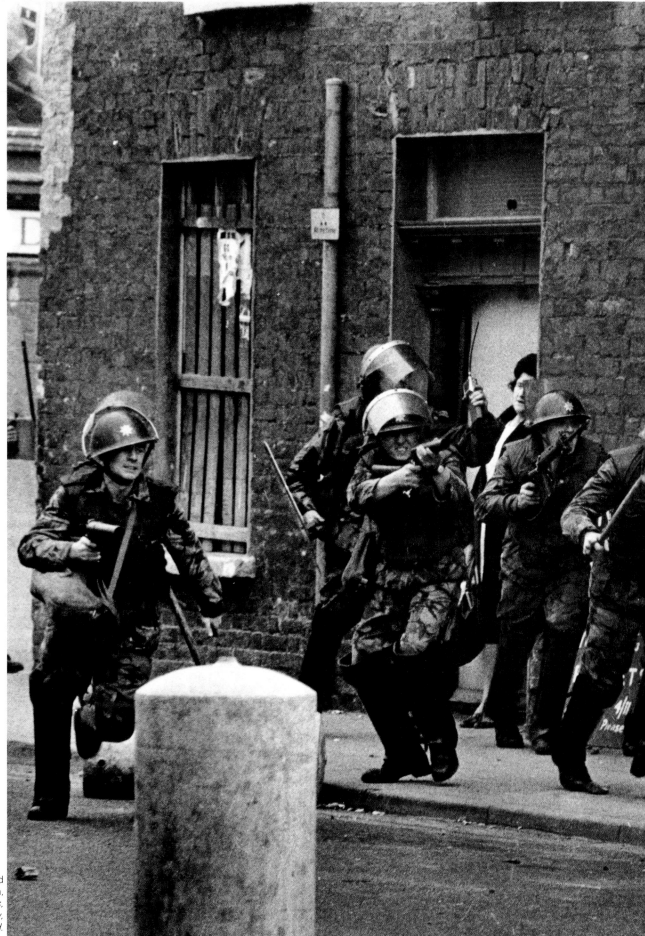

Donald
McCullin,
*British soldiers,
Londonderry,
Northern Ireland.*

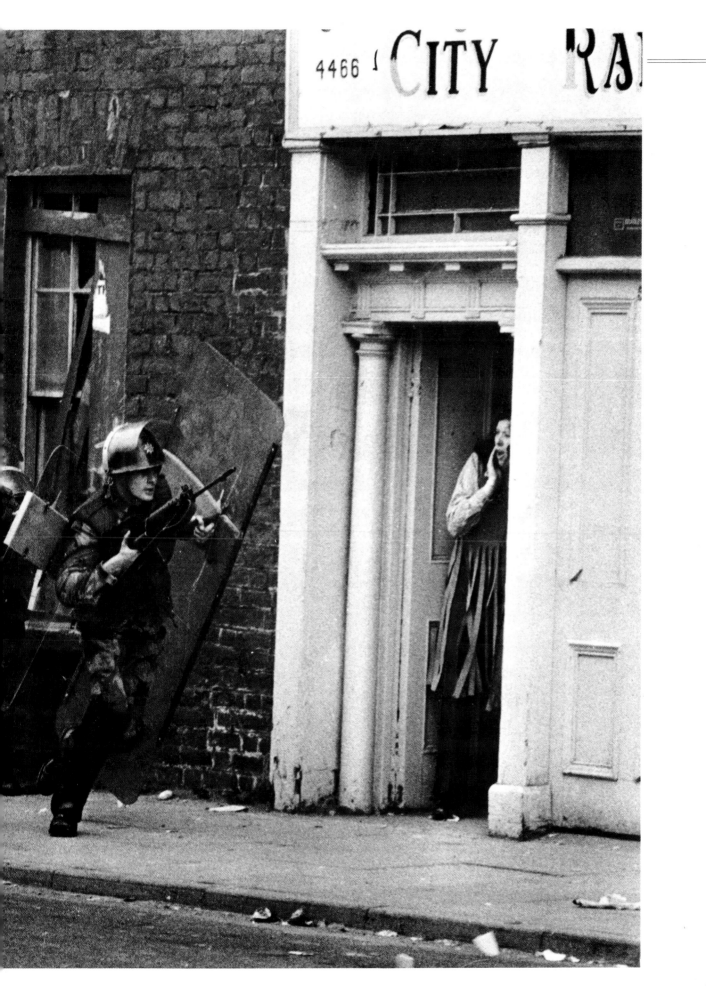

Mario Giacomelli

b. 1925

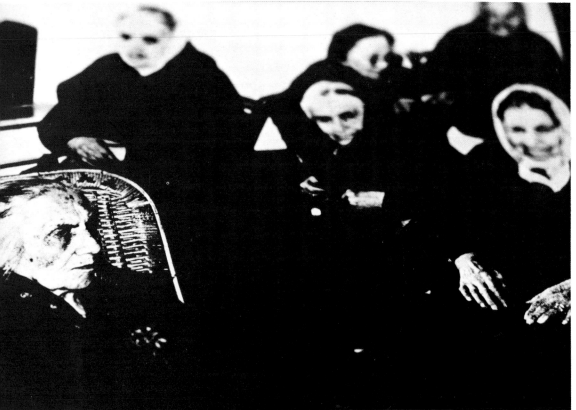

Mario Giacomelli, *Left
and opposite 'Verrà la
morte e avrà i tuoi
occhi.'* ('Death will come
and it will have your
eyes.')

Born in Senigallia, Italy. Learned typography as a child; operated shop in his native town. Poet and painter; since 1954 also self-taught photographer. Has contributed to many Italian and international magazines, and to the illustration of *New Skies and New Worlds* and *The Beach of Fermo*. Has illustrated for Italian television the Leopardi poem 'To Silvia', and prepared, with photographic illustration, 'Caroline Bronson' from *Spoon River Anthology* by Edgar Lee Masters. Major exhibitions: Museum of Modern Art, New York; International Museum of Photography, Rochester, New York. Publications include: *Camera* September 1958; *Progresso Fotografico,* December 1959; *Subjective Photography* 1963; *US Camera International Annual,* 1963; *US Camera Annual,* 1964; *Photography Annual,* 1965.

Ronald Traeger

1937–68

American. Studied two years at San Francisco Art Institute. Specialist subjects: reportage, portraits, fashion, mixed media. Camera and film: Nikon, Kodachrome.

Ron Traeger was an experimental, delicate, perceptive, versatile young artist. He was a painter and graphic designer, and he became a photographer. In order to afford time for thought about his intentions, and to delve into the caves of original photography, he accepted offers from advertisers and his technical ability stood him in good stead. But his heart was in his more experimental work. He made many interesting combinations using body-colour unrealistically on his prints as if on his paintings.

Traeger had so much imagination that he was able almost weekly to produce a bottomless cornucopia of new and strange effects: for a fashion sitting for *Queen* he turned his camera violently, in the manner of a sports photographer, on to a girl on a swing so that she remained in focus while the background became a beautiful blur suggesting great movement. He experimented with the 'wrong' exposures and produced the right result. He had an eye that was fresh so that he made an over-photographed face look like something quite raw. His felicities were endless.

Traeger died at a very early age – a tragic loss. His pictures, treasured by his adoring wife, are an impressive memorial to a young man who was well on the way to becoming one of the most brilliant photographers of today.

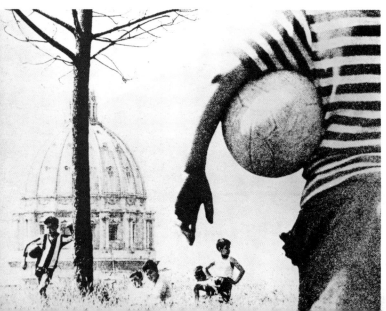

Ronald Traeger, *Rome, c.* 1965.

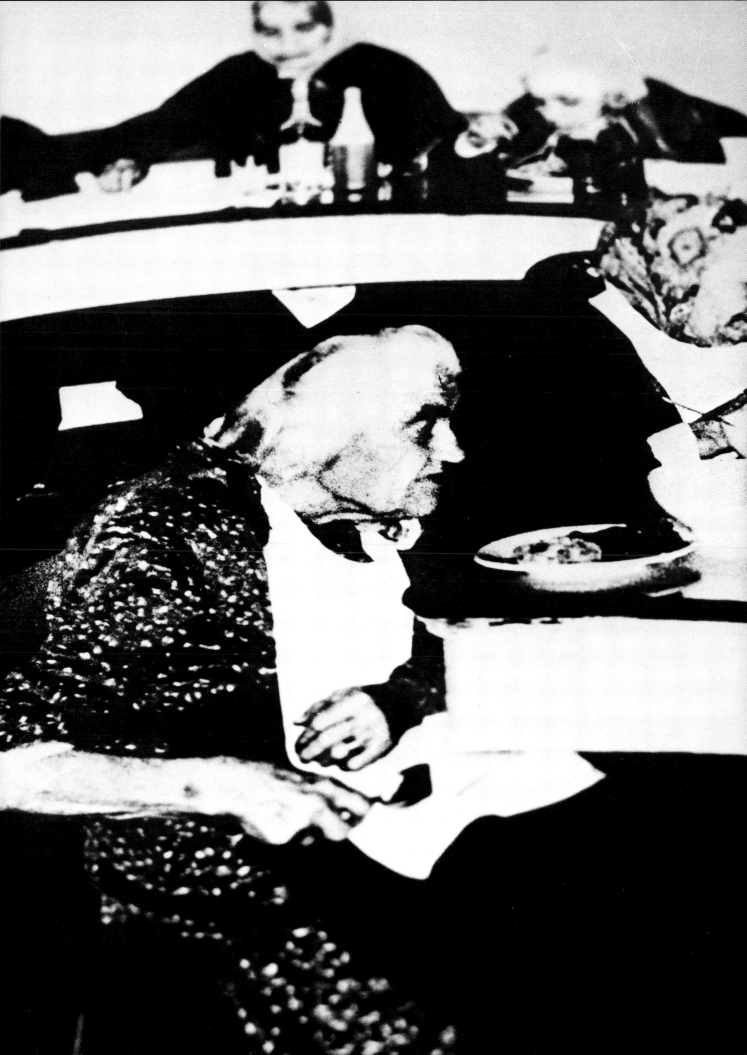

Josef Koudelka

b. 1938

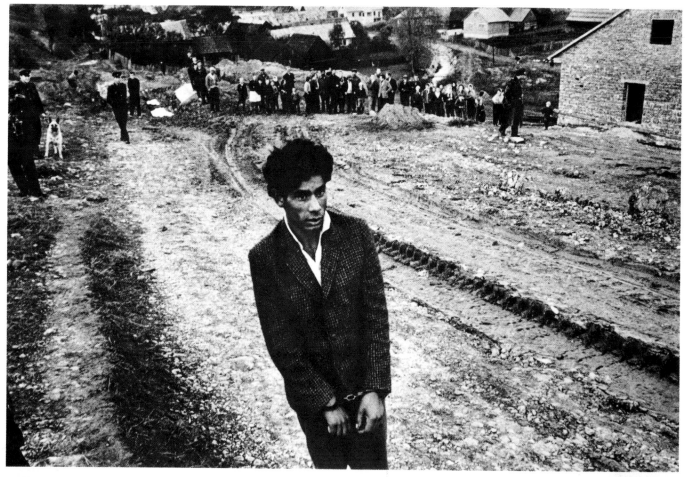

Born in Boskovice, Czechoslovakia. Studied aeronautical engineering; received degree from the Technical University, Prague, 1965. Had first exhibition in Prague, 1961; subsequently began photographing gipsies in Czechoslovakia and Rumania. Took theatre photographs for Divadlo Theatre, Prague, 1962–70. Joined Czechoslovakian Union of Artists, 1964. Work published in Czech theatre magazines, *Look*, *Sunday Times Magazine*, *Epoca*, *Camera*, etc. First trip to England, 1969; since 1970 British resident. Invited to join Magnum Photos, 1971. Special subject: gipsies of Eastern and Western Europe. Camera: 35 mm. Exhibitions: Semafor Theatre, Prague, 1961; Bratislave Theatre, Prague, 1962; Davaldo za branou, Prague, 1967 (gipsies' photographs, 1961–6) and 1970 (theatre photographs, 1965–70); Bergamo, Italy, 1970; 'Two Views', Arts Council of Great Britain travelling exhibition, 1973. Collections include: Museum of Modern Art, New York; Royal Photographic Society. Publications: *Camera*, Nov. 1967 and March 1970; books on Czechoslovakian gipsies and European gipsies in progress.

Josef Koudelka, Untitled photographs.

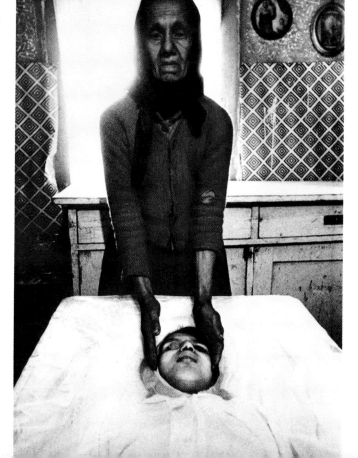

Koudelka's work would today be categorized as that of a photo-reporter; but so definite is his personal point of view, so strange the intensity of his eye, so acute his antennae for the macabre and the noble, that his images create a mysticism that perhaps no other photo-reporters have achieved. This once more bears witness to the fact that just when we may feel we have seen everything new, and that too many people are practising in the genre of 'candid camera', an extraordinary talent such as that of this Czechoslovakian proves that true photography is always advancing, and that fresh visions can still be conjured up out of the same mechanical equipment.

Koudelka was at first an engineer dealing in aeronautics, but through the influence of the photographer and critic, Jiri Janicek, became the photographer for theatre magazines and books in Prague. But it is the Czechoslovakian gipsies that make his most memorable pictures: those in which his metaphysical approach is uppermost. His mastery over black and white is unique, and without the usual variety of tones or definition he is able to suggest the essence of his subjects. Gail Buckland has said that she never wishes to know the colours in his pictures – they seem so remarkably complete as they are.

Koudelka has now left Czechoslovakia where, under the régime of today, he would be *persona non grata*. We, too, are fortunate that, after an interval of several years, his gipsy negatives have been brought back to us, for they are a valuable addition to the history of photography.

Koudelka exerts tremendous influence on such sophisticated people as his friend Henri Cartier-Bresson; in fact, Koudelka's genius is so strong that Cartier-Bresson is willing to be advised to a remarkable degree by the younger and comparatively unknown person.

Photography nurtures seeds of creativity – in odd places and in unpredictable circumstances – if only the artist can detect and nourish them. As in music, where some may feel every note combination must be exhausted, there is always another permutation; but someone like Koudelka is needed to be on hand to reveal these seemingly endless possibilities with the photograph.

Josef Koudelka, Untitled photograph.

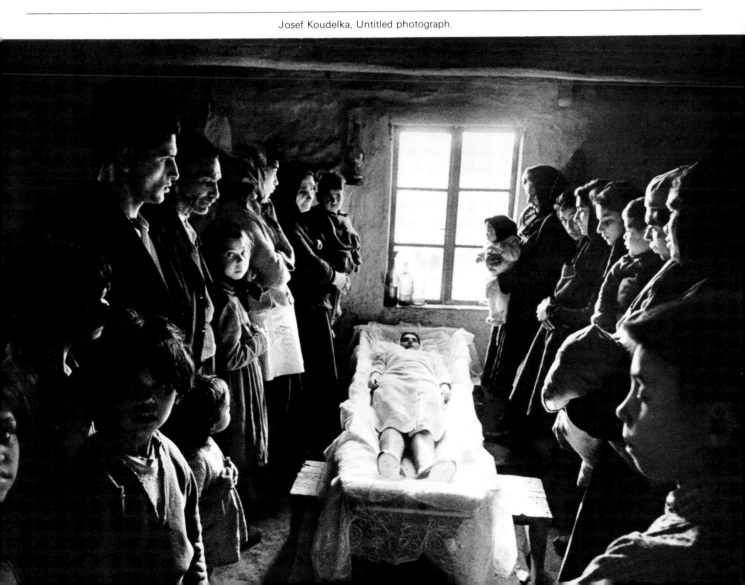

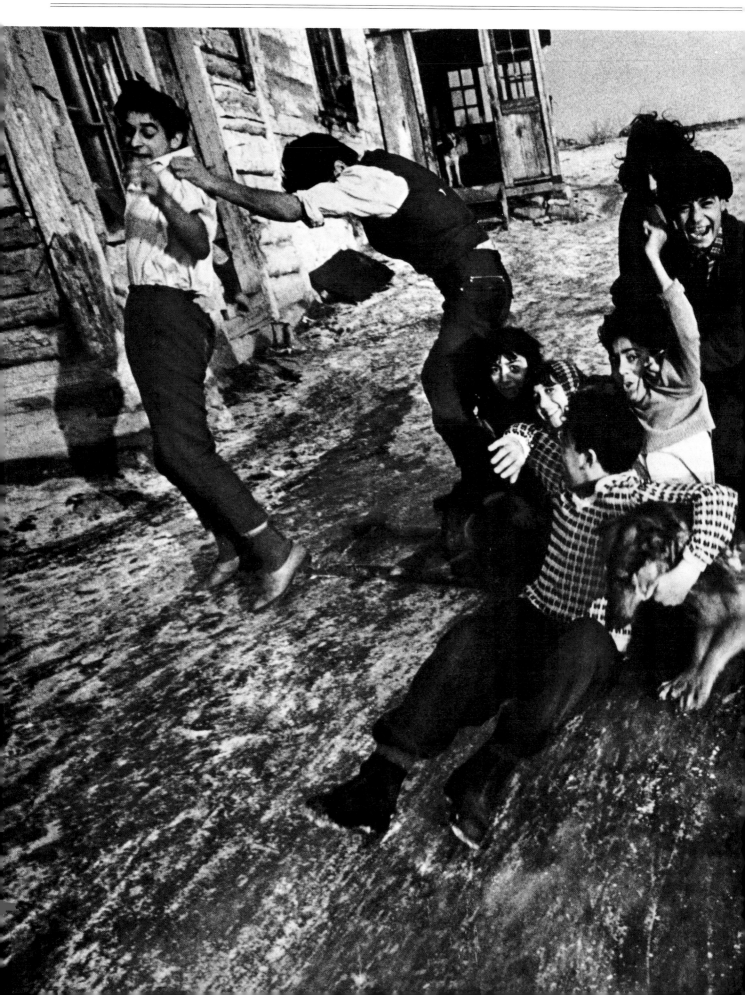

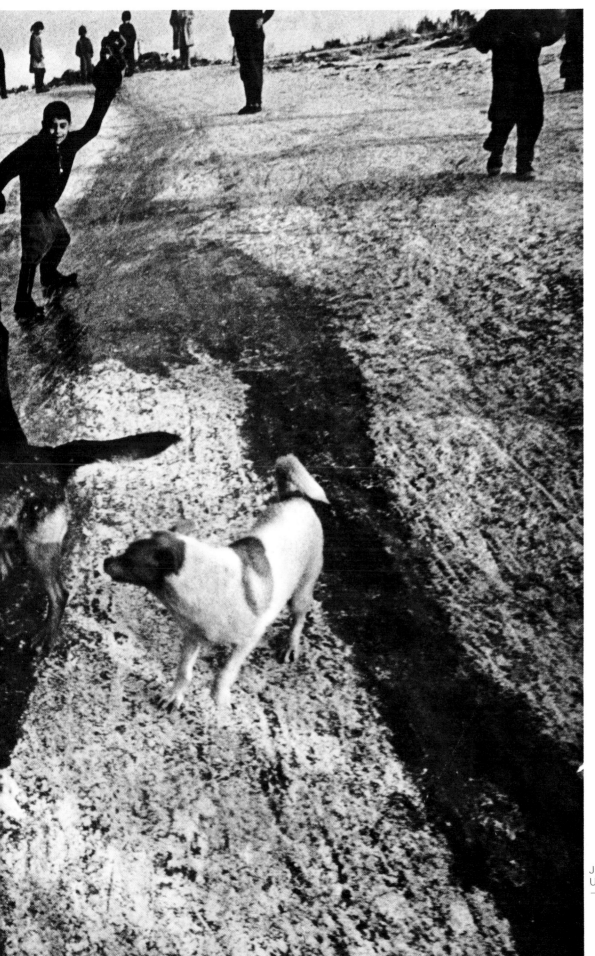

Josef Koudelka,
Untitled photograph.

APPENDICES

Commercial Photographers of the Victorian and Edwardian Eras

The *London Stereoscopic Company* started during the 1860s to photograph the celebrities of the day, and continued to do so until the 1900s. The firm was established in a large house at a corner of Regent Street; and passers-by flattened their noses against its glass windows, to behold the representation of the stars of the social and theatrical firmament depicted in a stereotyped posture, neck-rest and body-support inadequately disguised by a crudely draped curtain.

Window & Grove and *Elliott & Fry* thrived as straightforward unpretentious photographers; other firms, without any ambition to be considered artists but popular during the Victorian period, were *Southwell Bros., Samuel Walker* and *J. & C. Watkins*. *Fred Hollyer* aimed his lens a little higher. He made delightful conversation pieces of the Queen and her children, and Mendelssohn, in the 1880s, produced portraits dark in tone, strongly influenced by the paintings of Watts. He was adept at draping dark velvets over his sitters' chairs or shoulders. Miss Ellen Terry, in an aureole of light, and the professional beauty, the Duchess of Leinster, helped him to achieve his finest portraits.

The impersonal firm of *Messrs W. & D. Downey* compiled an enormous collection of documentary photographs of royalty and biscuit-box beauties. Queen Alexandra, with her egg-shaped head, flower-stack neck and large, luminous and slightly bovine eyes, was the firm's loveliest sitter.

Throughout her reign, each year Queen Alexandra visited Messrs Downey for a sitting in her court robes. On each occasion she would ask the photographer: 'Do you think I am putting on a little weight?', and the photographs prove that the reassuring denial was, in fact, not far from the truth.

In America the firm of *Byron* made an astonishing record of the changes in the faces of all the leading cities, the historical and the unimportant events, and the celebrities of the epoch. Other photographers specialized in the portrayal of the houses of the rich, both exterior and interior, and by so doing have earned their niche in social history. By the excellence of their technique, lighting and composition, and in the emphasis of details, they have supplied a source of valuable research material.

Such firms as *Coe & Sons* of Broadway and *Messrs Sidman* gave valuable advice. They photographed Mrs Baylies's Italianate residence – a jungle of dark carving, gilt bosses, knick-knacks, Raphael reproductions, and brass beds. Almost as strange are the interiors of the Stanford White house in Gramercy Park in New York, furnished and decorated with Renaissance ceilings, French pilasters; Elizabethan portraits, antlers and *prie-dieux* brought by the liner-load from Europe. In the Music Room we can count nine harps and every conceivable musical instrument hanging upon the brocaded walls. It is surmised that it was Frances Benjamin Johnston who photographed every gorgeous aspect of the P. A. B. Widener house in Philadelphia. As a result of such detailed documentation one can venture through the gilded wrought-iron gates of Lynwood Hall, along the immaculately raked avenue, past the balustrated terraces and parterres, to be faced by a giant imitation of the 'French Style' palace. It is dazzling white. It is vastly imposing with its balustrated roof, awnings at every window and rows of potted hydrangea. Quite unexpectedly we spy a young child of the house in starched white frills who, out of curiosity, is peeping through the front door. She flees at our approach – and soon, we pass through the deserted hall of marble, white bear-skins on floors, gold and silver embroidered velvet banners hanging from the minstrels' gallery. We mount the luxuriously curving staircase to see the ballroom, all in a 'French' style that would give le Roi Soleil pause to wonder. The chief bedrooms and guest rooms – room after room – are resplendent in their luxury. We marvel at the full ball-like roses on the dressing-tables, with their long stems – roses then fashionable but which, unhappily, we never see today. A forgotten world thus is brought back to us, a world that flourished at the same time as that which existed when Jacob A. Riis and Jessie Tarbot Beales felt it their duty to reveal to the world their photographs of the destitution and the tragic conditions in which the poor existed rather than lived only a short distance away.

In London, *Alice Hughes*, a successor to the *cartes-de-visite* photographer, *Silvy*, was a highly successful Edwardian photographer with a woodland setting, complete with heather and fallen tree-trunk, in her Bond Street studio. Here she posed, in sentimental attitudes, the grand ladies who came to visit her in their lacy tea-gowns, fondling their pomeranians or their young and semi-nude offspring or – if not fecund – they posed admiring a bunch of Madonna lilies. The metallic sharpness of Alice Hughes's lens was at variance with the lyrical mood she wished to convey, and although apt to be stilted and sometimes absurdly artificial, these photographs, for a long while treated as a high status symbol, have a certain period charm.

If Miss Hughes had not existed, the sisters, the late Edwardian portrait photographers, *Lallie Charles* and *Rita Martin*, would not have flourished as they did. Each of them also showed their sitters in sentimental attitudes, admiring flowers, or draped upon a chaise-longue. But these talented sisters simplified their studies – they dispensed with painted backgrounds, and showed only a world of pearly whiteness. Their negatives were then printed upon a paper that was as if an opal surface were stained with carrot-juice: very flattering. Rita Martin and Lallie Charles worked in their separate studios, like large conservatories, with the daylight controlled with white blinds that could be pulled backwards or forwards according to the effect needed.

Lallie Charles was the most temperamental of the two sisters; they eventually became rivals and enemies. Miss Charles allowed her sitters, many of whom were the most fashionable

personages of London and New York society, to realize that they were about to have a great honour bestowed on them when this red-haired 'artist', with long ropes of pearls and flowing black dress, deigned to press the rubber valve at them. Sometimes Miss Charles placed her aristocratic subjects against a rented lattice-window, or she sat them upon a tall Cromwellian chair. Often they were made to arrange a vase of irises on a tall empire *guéridon*. But before these ladies appeared in her studio, they were forced into special corsets which moulded their figures in the desired shape.

Rita Martin was the theatrical photographer of the family, and all the musical-comedy stars, and less promising subjects, became beautiful when seen through her lens.

Both sisters transcended the stereotyped. They showed a tyranny over their subjects, who were willing to do their bidding, for they knew that they were being beautified.

Lady Diana Manners recalled how she and her sisters would visit Lallie Charles to be made to look lovely, just as today women go to the beauty parlour. Photographic portrait flattery became big business: women were delighted to see themselves with hair fairer than they ever imagined it to be, and eyes much bigger, lips rosier. Men, too were pleased, and would submit to putting themselves completely into the photographer's hands in the knowledge that no after-six shadow would show.

For fifty or even sixty years *Miss Compton Collier*, based at West End Lane, Hampstead, has toured the English countryside. With her haversack of heavy photographic equipment, wooden camera and tripod she has stalked the great English families in their lairs. Her alfresco conversation pieces were often marred by formal artificiality (a prying eye could spot the small cushion, or car rug, placed under her Ladyship's backside as she sat on the flagged steps with crossed feet, fondling the retriever). But at her best Miss Compton Collier was delightful. She created a silvery world of her own. She made even the great yews and lawns of England and Scotland yield to her will. Everywhere the gardens provided the backgrounds that she liked – and she was scornful of anything but the best in taste. She used to full advantage stone urns, sundials, rose-covered archways and white-painted love-seats.

Miss Compton Collier is a formidable spinster, who still continues to air her opinions in no uncertain terms. But for a weak heart as a child she would have become a painter. She shows an undoubted flair for a 'picture' and her love of the countryside shows itself in her photographs in the details of lichen on branches, weathering on old stone, wild daisies, London Pride, and the variegated herbs which sprout from the flagged paths of even the best-tended garden.

Above, left Queen Alexandra, by Walery. *Right* Elinor Glyn, 1904.

Centre Mr and Mrs Henry Labouchere, by a Brussels photographer.

Above Queen Alexandra and King Edward VII.

The 1920s were an exciting time for photographers and all who were interested in the latest manifestations of the arts. In Paris they were inspired by Corbusier's buildings which gave a new look to architecture, Art Deco provided a fillip to interiors, the Barcelona chair was an innovation. Lalique glass was moulded into odd shapes, and the effect of Marie Laurençin's almond-eyed, noseless girls could be seen in the preponderance of pink

Right Cléo de Mérode.

Below, left Lady Astor, by Alice Hughes.
Right Lily Elsie by Rita Martin.

Left Justine Johnstone, by Hugh Cecil, *c.* 1928.

Right Lady Pamela Smith, by Marcus Adams.

and grey décors in Poulenc's ballet *Les Biches*. In London Aldous Huxley's *Brave New World* appeared. On Sundays enthusiasts went to see the boldly photographed German films, Zasu Pitts in *Greed*, Conrad Veidt in *Dr Caligari*, and the young Garbo in *Joyless Street*. The American, Hoytie Wiborg, gave supper-parties for Artur Rubinstein and her *tutti fiori* guests at Boulestin's with its Dufy-patterned curtains and crackled-shiny-yellow walls, and Curtis Moffat photographed the pick of the bunch.

Curtis Moffat, born in Brooklyn, a gentle man interested in goodness and quality, was versatile in the arts. An abstract painter, he successfully 'painted with light' by placing pipes, corkscrews and reels of cotton on to sensitized paper on to which he flashed his 'enlarger' lamp. He made 'rayograms' with Man Ray in Paris. When, in a magnificent Bloomsbury mansion, he joined forces with *Olivia Wyndham* to make portraits of their friends, his influence was immediate. Even the most stereotyped of Bond Street photographers attempted to emulate his enormous heads thrust from naked shoulders. Curtis Moffat's negatives were printed on soft-grade paper of vast size, then were mounted on layers of different coloured papers. Often he made the well-known actresses, painters, writers and beauties appear as fragments of heroic sculpture: Augustus John might have been carved in wood during the thirteenth century; Mrs Patrick Campbell assumed the grandeur of a Bernini bronze. Obviously the products of an artist's sensibility, the mammoth prints might have been passport-photographs of the gods.

Olivia Wyndham was never mistress of her camera, a huge

concertina affair. Although she produced some beautiful 'Mrs Camerons', the technical aspects were always a bafflement to her: mechanism had a sure way of defying her. Olivia was connected by marriage to the Queen of Spain who, on arrival at the Fitzroy Square studio wearing twenty rows of pearls the size of gulls' eggs, would say: 'I have left my personality behind.' This meant that she allowed herself to be treated as an ordinary human being. It is said that, half way through Olivia's session with the Queen, the concertina-camera with all the plates was dropped and the sitting became a non-event.

Barbara Kerr Seymour started as an assistant to Olivia Wyndham, then blossomed on her own to photograph the decorative young intellectuals, particularly the boys who adopted sailor fancy dress. Occasionally, in an effort to achieve 'realism', some tattoo designs were painted and a modicum of artificial sweat applied to their torsos, and always a vaselined highlight gave emphasis to the cheekbones. Her *Sandy Baird* and *Brian Howard* are true 1930s period-pieces.

Hal Linden was Harry Lindsay, a painter who took to photography in the 1920s. A younger brother of the artistic and 'soulful' Violet, Duchess of Rutland, and a man of charm, he had no difficulty in luring the notoriously beautiful young ladies to his Wimpole Street studio. Here he stripped them of their finery, draped their naked shoulders in black crêpe or silver lace and proceeded to use his lights as if he had no idea what he was about. Being of a lecherous nature he preferred taking nudes. If there are such things as rules in lighting, Hal Linden certainly broke them, but his results were often

extremely successful, odd and strange: Phyllis Boyd, an exotic, embryonic Cleopatra, held two bunches of Madonna lilies bought straight from a street barrow; although her large glass-green eyes showed surprise, she admitted that here was the only successful photograph of that most elusive and *avant-garde* beauty of her epoch.

The early 1930s were the heyday of the commercial camera-artist and the portrait photographers. The 'studies' were placed on an elaborate folder, having been mounted perhaps on thick crinkly cream paper and rice-paper, with the photographer's signature scrawled below in a corner. Just as the label inside a Paris dress was part of the glamour, so signatures were important. Dorothy Wilding's signature was typically theatrical and full of flourish, while Bertram Park's autograph was particularly recognizable and felicitous in a more distinguished, slanting, flowing calligraphy, and even more coveted than the label, 'A Van Dyke Portrait'.

Certain photographers sent out letters to almost anyone whose name appeared in the newspapers, suggesting that they should accept a complimentary sitting, since the press were so interested. To the more gullible recipients these invitations seemed extremely flattering, but often the press was not in the least interested – unless felicitous disaster might occur, or wedding-bells were in the air. In fact the sitters might find themselves landed with a large bill and possibly a batch of unwanted pictures although it was then easier to distribute photographs to friends than it is now. It was the fashion to give huge, spectacular 'likenesses' for birthday presents, at Christmas-time, to be framed and put on the piano. Royalty and important personages went into silver frames.

The display of their wares outside photographers' premises was one of the shoppers' delights. A walk down Bond Street was almost an endless exhibition of Swaine, Harlip, Dorothy Wilding, Foulsham and Banfield and many others. Nowhere was the vast ground-floor window photograph exhibition more impressive than at Elliott & Fry's in Baker Street with the King and the Queen in the centre of the galaxy, the Prime Minister, the Archbishop of Canterbury and lesser personalities ranging towards the flanks.

Working together in the same building in Dover Street, and closely affiliated in the presentation of their work (both used a soft-focus lens in the enlargement from a sharp negative), were *Marcus Adams* and *Bertram Park*. Marcus Adams's forte was portraiture of children. By simple means he made romantic Raeburnesque portraits of little girls on a heather moor with storm-cloud backgrounds. Though his royal family groups were his most widely appreciated, his best was of Lady Pamela Smith looking like a robin in a taffeta pannier dress.

Bertram Park's overwhelming success necessitated his taking on at least five sittings a day. Sitters arrived from America and Italy, and certain royal families came to England to pay him a yearly visit. Occasionally Park's wife, Yvonne Gregory, who had been a miniature-painter, would photograph some of the theatrical ladies for him. She had a light, grey and more feminine touch.

Perhaps Bertram Park did not realize how much he was influenced by the Baron de Meyer. Nonetheless his electric-storm flashes and back-lighting were certainly derived from the 'master of silver's' pictures, although Park used the soft-focus effects more in portraying burnished gold.

Bertram Park found that although he enjoyed the honour of photographing the English royal family, the hard-and-fast rules set down by the Palace were extremely outdated and irksome.

Although no other photographer was able to find an identical star-flashing soft-focus lens to that of de Meyer, his imitators did their best to copy his aureoles of light. *Hugh Cecil,* who until the last war carried on a prestigious business in an opulent studio in Grafton Street, knew exactly how earnestly he was following in the steps of the master.

Hugh Cecil lacked taste and he made de Meyer's use of tissues and lamés look like an outdated haberdashery counter, but he obviously enjoyed his gold and silver waltz-time. Hugh Cecil's pictures of Gertrude Lawrence as a Parisian pierrot conjure up exactly the spirit of the 1920s. He was an irascible man and a door-slammer, who was easily bored and in an indefensibly rude manner was apt to show his lack of interest in his more ordinary sitters. Sometimes he gave the responsibility of impersonating himself to a terrified young student, *Paul Tanqueray.* Tanqueray, a far too self-effacing but a delightful man, set up his own studio, became an accomplished portraitist of too-heavily made-up stage beauties and early English film stars of whom the youth of the present day have unaccountably made such a cult.

Lenare might be said to have won and sustained fame through non-representation. It is as if he had said to his subjects: 'If you have defects – warts, moles, lines, sagging jowls or any features of which you are not proud – tell me and I will not show them.' Somehow with the minimum of retouching, but with a pea-soup density of fog, Lenare has continued to show only what his specialized sitter wishes.

Dorothy Wilding, a podgy, delightfully gay little woman unsullied by business, enjoyed her success for a considerable time, and laid on the flattery with even greater authority. She succeeded in giving Tallulah Bankhead, Ivor Novello and the Queen the same horizontally flared eyelashes, the same rosebud

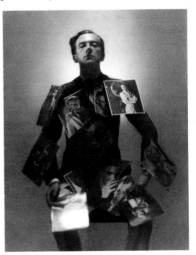

Cecil Beaton, by
Paul Tanqueray.

273

mouths and the same expression. *Mme Yevonde* had a definite attitude of mind – very feminine – so that her pictures, always too flattering, could easily be recognized.

Some photographers were, of course, too grand and popular and successful to give complimentary sittings, but *Pearl Freeman* and *Janet Jevons* and *Claude Harris* were extremely generous in their invitations and they all had their particular way of seeing their sitters in a flattering guise. This might be the result of a lengthy ritual: 'Would you turn the head to the left – a little more, a little bit more – now lower the right ear.' Perhaps the sitter's head would be deftly moved by the photographer's firm fingers. The hands also were placed rigidly as dictated by fashion with wrists arched and the first finger placed on top of the second to make the hand appear more slender. No matter how uncomfortable it was to keep the pose while the photographer made adjustments to the camera, the photographer cooed from under the black cloth: 'I promise you it will be beautiful.' And it was.

In the 1920s *Sasha* wrote his signature with a dashing red crayon at the right-hand corner of thousands of pictures of theatrical and society celebrities. However, when he procured the rights to a new invention, a bulb filled with tinfoil which let off a flash and made easy snapshotting at night-clubs and at parties, the 'Sasha Light' was born. Sasha soon retired, we hope having made his fortune, before the Sasha Light gave way to less bulky ways of creating light-flashes.

Schwaebe was also a haunter of night-clubs and parties, and his son has now succeeded in the father's industrious career.

Perhaps it was in the late 1920s that commercial photographers perfected the art of flattery to such an extent that it sometimes became embarrassing to compare the sitter with the 'presentation copy'. Inevitably a reaction set in. In Middle Europe and subsequently in America realism took over: 'candid' pictures had arrived; for a few the shock was violent. But the influence was a healthy one, and many stuffy studio windows were opened to invigorating breezes.

Architectural Photographers

Of recent years the photography of great architecture has floundered between the Scylla of the super-technological and the Charybdis of the amateur snapshotter. With ever more highly sensitized film, and a greater accuracy of colour emulsion, particularly in France, Germany and the United States, architectural photographs have become so precise that one can discern with equal clarity, and with very little difference of emphasis, the urn of carved fruit in the foreground and the brick on the farthest rooftop. The antiseptic quality of the results is apt to rob the subject of its innate mood, particularly when flash, and strobe, and other artificial means of lighting are used to obliterate shadows and add perfection of detail.

In contrast the work produced by hand-held cameras has introduced us to other distortions – that of a Samsonesque effect with columns falling inwards and perspectives intentionally false. By placing the camera close to an egg-cup or a silver candlestick the foreground is given more importance than the distant triumphal arch. These effects may have added an 'atmospheric' excitement and 'contemporary' feel, especially when the result is printed with excessive contrast, but this is not a true rendering of the scene.

Perhaps in any case the evocation of so essentially static a subject as architecture is the least suitable to be essayed by the candid camera (which is presumably aimed at catching the bird or butterfly on the wing). But bringing the greatness of good architecture to a print takes experience, not only in the sense of knowing how to compose, light and expose a picture, but also in the later stages of the technical processes of printing and developing when all the values of texture and tone can be brought out.

Brian Batsford wrote recently that most of the photographers whose work his firm of publishers used over the last forty years went around the country in tweed breeches photographing ancient buildings only whenever the sun came out. Of these the best were *Dixon Scott, Will F. Taylor* and *Brian C. Clayton*. Probably the most colourful, eccentric character was *Herbert Felton* who was a superb architectural photographer though he seldom produced work unless bullied into doing so. On the wall of his office he had framed a letter from one of his clients which read simply: 'Dear Mr Felton, How are things in Australia, and when are you likely to return?'

Brian Clayton used to go about with knee-breeches and an old Marlboroughian tie photographing the churches and the best houses of the west country. He is long dead and lived in Ross-on-Wye.

There were also such men as *F. H. Crossley* whose photographs adorned the early Batsford books and were sharp in detail and ideal for half-tone reproduction. In fact, the firm of Messrs Batsford were responsible for encouraging the best architectural photography.

The *Architectural Review* had under contract many excellent photographers, such as *Judges, Gibson & Sons* of Penzance, who produced postcards on a large scale and toured around even photographing views of the Scilly Isles.

The firms *F. Frith & Company* of Reigate, *Judges* of Hastings, and *Valentines* of Dundee between them provided virtually the whole stock of postcards on British architectural subjects for over half a century. The Gordon Fraser cards are their present day equivalents.

Above, left Cléo de Mérode, by Reutlinger, *c.* 1895.
Right Redfern *tailleur,* by Reutlinger, 1904.

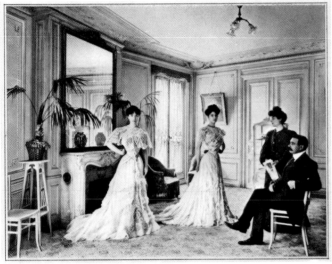

Above Robes du soir. *Below* Garden Party by Boyer.

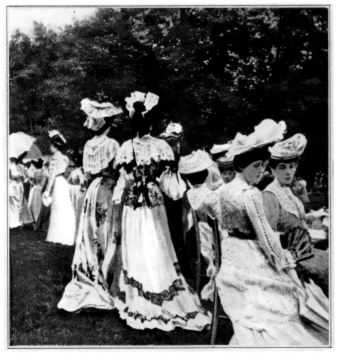

The first time fashion illustration was made by the camera rather than the draughtsman and engraver was in Paris, at the beginning of this century. The first big commercial success came to *Mlle Reutlinger,* a sister of the actress Cécile Sorel, who had a large and gracious studio that looked like a Visconti film-set with tapestries, grand furniture, balustrades, palms and lots of shallow steps and stairways, the better to show the flowing trains on the ladies' gowns. These ladies were sometimes borrowed from the Comédie Française or Opéra Bouffe, or they were well-paid cocottes, and they were delighted to pose in flattering, but formal positions – as traditional as in classical ballet. But delightful, quaint and interesting as some of these oddities may seem today, the photographs could never have laid claim to be anything but straightforward renderings of the current foibles.

The first artist in fashion photography was de Meyer. For a time he was a member of the Stieglitz coterie and photographed ladies darkly in Edwardian hourglass fashions and big hats. But he came into his own when he discovered a starry lens which he used for high-key effects. He created a silver world of grace and poetry that had not before been encountered in the somewhat stereotyped approach to fashion photography. Using a preponderance of lilies, apple-blossom, cobweb filigree and all manner of shiny surfaces his powers of invention never flagged. From the turn of the century he worked ceaselessly, until the Second World War sent this great star into eclipse. De Meyer has been ridiculed and considered too theatrical – in some of his commercial work his idiom is admittedly somewhat exaggerated. Perhaps in this respect his most famous photograph was that used as trademark by a well-known firm of beauty specialists: a lady with lilies and bandaged head looking like a 'Folies-Bergère' nun. In fact, de Meyer had played a hoax on the lady who owned the beauty firm, and the 'nun's' head was that of a male wax dummy.

After the war de Meyer wished to continue working for fashion magazines, but he was out of sympathy with the new styles and faded into oblivion in the Californian sun. Recently de Meyer's work has begun to be appreciated again, for it has a quality that cannot be ignored and a poetical sense that transcends fashion.

Steichen, Condé Nast's other star, was at the opposite end of the fashion pole from de Meyer. Edward Steichen had been one of the Secessionist group dominated by Stieglitz, and earliest photographs showed his models against a rough canvas screen on which an etching was artfully placed. Perhaps a green glazed pot with reeds or a thistle might creep into a corner of the composition. His first fashion photographs of women wearing dresses by the great Paul Poiret are today remarkable for their validity and honesty. These women seem to be of normal – even squat – proportions with lots of sinew and muscle. Slightly out of focus, but without retouching, they are grouped on an oak staircase, and they have the domestic quality of a Vermeer. The *Sketch* in London showed them as 'Examples of the New Art of Photography'.

After a while working for *Vogue* Steichen's models inevitably

in private life the wife of E. E. Cummings, the poet, was far removed in spirit or sympathy from the world of fashion. But once her hair was sleeked down like a satin cap and she was arrayed in the imported confections from Callot, Louise Boulanger and Chanel, she gave her own built-in distinction to every pose. Most of their work was done in Condé Nast's rich Park Avenue apartment. Marian Moorehouse managed, with her enigmatic smile, to hint that she was not impressed by her surroundings, Elsie de Wolfe's lacquer screens, rock crystal chandeliers, hand-painted Chinese wallpapers and mirrored walls. It was when Steichen photographed her in riding clothes in stable yards that a breath of true air invaded his fashion photography.

Steichen often showed himself lacking in the quality of taste, and this was particularly apparent when he made the composition *White,* which consisted of three mannequins posturing meaninglessly in day and evening clothes in what must be a white-tiled public lavatory, into which a white circus horse had been interpolated. It is fortunate that he seldom used more than a plain background – sometimes half black, half white, against which to play his electric lightspots.

Steichen nonetheless had great influence and many were his brilliant disciples. Chief among them in Paris was *George Hoyningen-Huene.* He used to his own ends the master's barrage of spots to create dramatic shadows and highlights but his prints had a more metallic sheen. Born a Baltic baron,

Above Baroness de Meyer, by de Meyer, *c.* 1904.
Right and opposite Poiret dresses. Photographs by Steichen in *The Sketch,* 2 August 1907.

became less stocky, their hair glossy, and their feet placed stylishly in the manner of the time. Imperfections and excess of cartilage went under the retoucher's knife. In comparison to the early Poiret ladies, Steichen's Manhattan models were like mere clothes-pegs. However in the etiolated, humorously thinking Marion Moorehouse he was given the first great fashion model. This ravishing giraffe-like creature,

Huene, a refugee living in France, operated among the intelligentsia of Paris in the 1930s and 1940s; but perhaps his greatest gift was in showing the dresses of Grès (Alix, as she was called at that time), Schiaparelli and Vionnet.

He made many innovations: he shot at his models from above as they lay in a Greek frieze with their draperies pinned in stylized folds. He used over-life-size flowers and sculptures as blow-up backgrounds. He became greatly influenced by all things Hellenic and imported into the studio plaster casts of horses' heads, granite hands and Grecian urns (which para-doxically he filled with pampas grass). He bought a house in Tunisia, so brought back to Paris Moorish designs and little slave-boys. He went to Spain, so everything in the Avenue Friedland had to be Spanish. He went to Hollywood. This was a tragic mistake – because he was so impressed that he ended his days there. Like de Meyer and Platt Lynes – another excellent photographer, though interested in fashion only through economic necessity – Huene's real worth was unappreciated and his talent evaporated in the harsh Los Angeles sun.

H.P.Horst, Huene's pupil and successor, developed his own personality, though he has always been influenced by Huene's theatrical lighting and telling use of props.

Henry Clarke, a quiet American living in Paris, has turned out an astonishing amount of work during the last twenty-five years. His soft tonality is his trump card and no one is more expert at producing the half tones and subtleties of twilight, or the slightly misty effect in smoky restaurants on a dull day.

André Durst, another disciple in Paris, had but a brief spell of success. The importation of a field of corn to the studio was his swan-song and Durst became dust.

Man Ray did some memorable experiments with elongation lenses and solarization, but fashion photography was not his forte.

In London in the 1930s, *Peter Rose Pulham* was in advance of his time. He took beautiful poisoned pot-shots at Victor Stiebel's and Charlie James's dresses. His prints were stained dirty, his fantasies seem full of *pourriture,* but he could make a romance out of cheesecloth, tarlatan, and torn paper. He took few photographs that were ordinary and commonplace enough to earn him a living. Stiebel, the enlightened dressmaker, and an editor of *Harper's Bazaar* was exceptional in that he saw Rose Pulham's possibilities as a man of extreme originality. His ectoplasmic pictures of Tilly Losch dancing to a harp were haunting. Some of his concoctions with backgrounds painted by himself were near to the Surrealism of Chirico, but the neo-romanticism of Tchelitchev and Bérard had a more lasting influence. When disappointed that London, during the late 1930s, paid scant attention to his work, he went to Paris; he took pictures of the inevitable celebrities of the day. But Peter Rose Pulham's photographs were anything but inevitable. They would seem outrageous, inelegant – worse – unflattering. But they lead the way to Guy Bourdin and so many followers today.

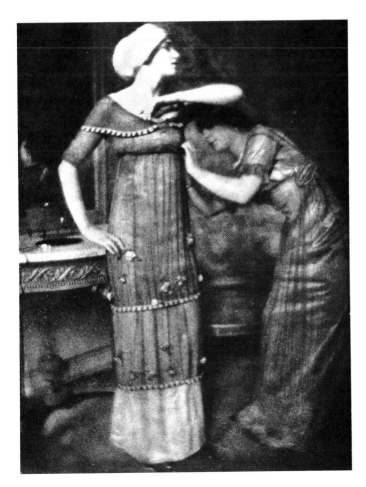

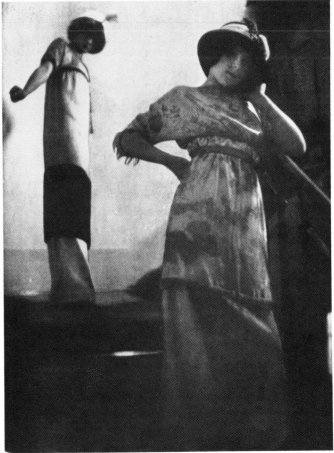

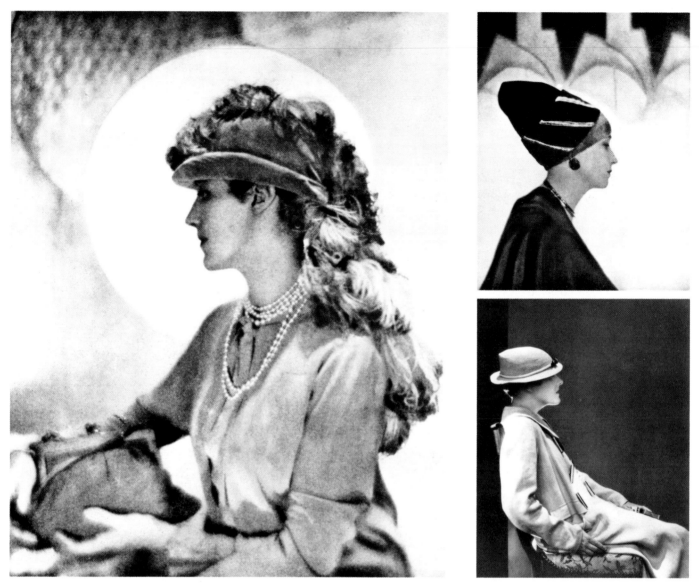

Daisy Fellowes by de Meyer. *Above, left* Gloria Swanson by de Meyer. *Top* Agnes hat by de Meyer.

Rose Pulham reversed the process of painter into photographer and became a Surrealist painter in the Chirico vein. An unusually articulate and intellectual man, he died young. This was a tragedy, for one senses that he could have been acknowledged as a most interesting and individual camera artist.

For Harper's Bazaar, *Louise Dahl Wolfe* brought a new feminine perhaps almost Mary Cassatt quality to her fashion prints. A sensitive and understanding portraitist and photographer of nudes, her fashion pictures seemed as if they were taken in the nursery – so refreshing was her appreciation for muslin, spotted cotton, broderie anglaise, lace curtains and linen. Although she says she was always concerned with form – one shape against another – and to this end she used a battery of spotlights – it was her clean colour transparencies that gave the effect of lightness. In fact colour has, since she was a child, been her chief passion. Louise Dahl Wolfe's were the most controlled and exact of the early colour plates.

Shaw Wildman's name was everywhere in England in the

1930s and 1940s. He made clear and startlingly sharp images which were excellent for advertising purposes, and he was much sought-after by such firms as Fortnum & Mason. For his fashion pictures he was an out-of-door enthusiast and he would take his models to airports or to the racetrack at night. His girl in a white dress on Chesil Beach was a hallmark.

The most important breakthrough in the pages of fashions was then made by the Hungarian *Martin Munkacsi* who took his small camera outdoors and caught his models leaping over puddles, playing golf, jumping off boats – always, I fear, in rather poor weather conditions. The swing and flair of his tweedy clothes-horses was the thing that interested him. He, perhaps more than anyone else, is responsible for the way much of fashion is shown today.

It was Munkacsi's gazelles that first inspired *Richard Avedon*. To catch the butterfly on the wing has always been his aim, and his method of taking hundreds of shots of his subject with a Rolleiflex is in the direct tradition of the Victorian,

Muybridge. In more recent years Avedon has taken few pictures outside his studio. In fact, he has said that he never sees the light of day – living as he does in subways, offices or cinemas – and that the strobe flash in his studio approximates most to the world that he sees. Nonetheless, he always manages, in a remarkably fresh way, to say something new in the very restricted confines he sets himself, with an anachronistic parasol poised above a lighting-flash on to an 'oblivion' background (in fact, the inevitable no-seam paper).

Avedon succeeds brilliantly, but how many young photographers have been struck by strobe – and died! Some have even said that strobe killed photography. Nonetheless, it must be admitted that this bolt from heaven (for the art department!) gives a fantastic degree of definition to silk or sow's ear. And many of today's fashion photographers rely on its obvious merits: Bert Stern, Duffy, Bailey, Lichfield, Clive Arrowsmith, Barry Lategan – all avail themselves of its advantages.

Bert Stern is a high-powered operator with an enormous studio and enormous overhead expenses; it has been said that such is his hurry that a special elevator has been built to take him from one floor to the other with the greatest speed, in order that he can work almost simultaneously in more than one studio. Among his best, taken in New York or Los Angeles – and his average is astoundingly good – are his razzle-dazzling Marilyn Monroes.

The first Polaroid photographs of *Marie Cosindas* had a unique range of muted colour, and her sitters seemed to come from an old-fashioned world. They had a sweet poignance that could not fail in its appeal. When this most original artist agreed to take a series of photographs for a commercial product, it soon became obvious that the influences of the advertising world were suffocating her, and although the pictures showed their subjects in the best of health and spirits, wearing pristine evening-dresses of great expense, the Polaroids seem to have lost their former pathos.

Of the photographers who have succeeded over the last thirty years, *Norman Parkinson* is one of the youngest and most inspired and is still turning out work that places him in the vanguard of fashion photographers. When working he is highly keyed, nervous, electric, always on the lookout for the unexpected – the fluke that makes a success. Unlike so many young 'shutter-bugs', who in no way are more contemporary in spirit, 'Parks' does not click the lens in a senseless series of duplication or meaningless variations on the same theme. He never takes one picture more than is necessary.

Another photographer who has taken fashion photographs without damage to his integrity is the magnificent *Irving Penn*. Penn does not know the meaning of the word 'facility'. Everything is felt to the marrow – in his tissues and veins. He takes on each sitting – with its self-imposed restrictions of one-source lighting and nebulous background – with such dedication and devotion to his art that the result has that 'unique' quality. Other photographers may – and do – use exactly the same arrangements; lighting, pose and exposure, and even the same model. But they never attain that nobility that is very near that of fine sculpture.

But where is the embryonic Penn of today? Too many young photographers are too impatient to get on to the next sitting to bother even about looking at their contact prints. 'That's of now,' they say, as they run to the nearest betting-booth or fly off to Afghanistan or Mexico. You may be sure those proofs, though publishable, contain nothing memorable. Again they will say they are not working for posterity.

Cartier-Bresson and *Bill Brandt* could never become fashion photographers because their very essential spirit resides in the honesty and directness of their approach. Whether we like to admit it or not, fashion photography entails a certain degree of legerdemain. This may not amount to actual cheating, yet even by choosing an over-six-foot-tall model, and then probably

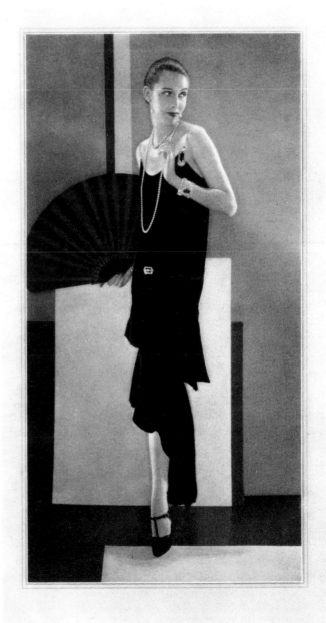

Marian Moorehouse wearing a Chanel gown, photographed by Steichen for American *Vogue*, 1920.

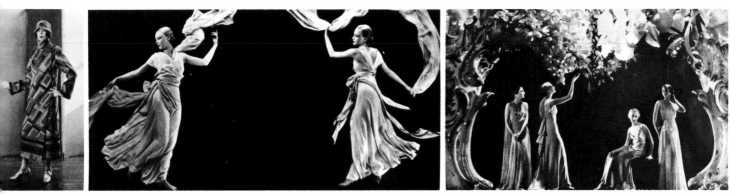

Above, left Nancy Cunard, by Curtis Moffat. *Centre, right and below* Photographs by George Hoyningen-Huene for *Vogue*.

asking her to stand on a couple of hidden telephone books, we are making the clothes look better than they would on any ordinary human being.

Fashion photography is an insidious profession. In art, it is what sex-appeal is to love. Artifice can be a dangerous thing; when misapplied, the results are vulgar and tawdry. Its correct use depends on instinct. It is up to the fashion photographer to create an illusion. In doing so, he is not behaving with dishonesty, but when properly invoked, the result is not merely an illusion; rather, it makes the observer see what he *should* see.

Fashion photography is a profession in which it is extremely difficult to remain uncontaminated: the sex-appeal has to become more and more brash, and love has long escaped.

Yet nature too can be capricious. To the untutored eye, one daisy may look like another; but when we examine a daisy with a botanist's lens, we find a great inequality in petals and stamens. It is thus not only with all things in the mineral, vegetable or animal world, but the complexion, features, height, hips and breasts of women vary according to the laws of an unpredictable universe. If nature loves the unique, why should *we* not allow these variations latitude? One trick is to give the unique a universal appeal – which paradoxically enough is to stress its very difference.

Paris may have produced only a handful of serious photographers in the last twenty-five years, but in the field of fashion photography today the young generation have successfully overthrown the tried-out tenets of what was once considered 'elegant': the Egyptian or Greek-frieze posturings are completely discarded, for the limbs of the models are now mostly seen in Mantegna-like perspectives, probably with feet greatly enlarged in the foreground. Ladies sit like basketball-players or footballers with their legs wide apart, and the expressions on their faces should never be those of boredom, haughtiness, complacency, affectation or self-satisfaction, but of horrified surprise, distaste, surliness and anger.

Guy Bourdin was a sculptor-painter, and still paints cats and does strange pen-and-ink drawings. His mind is interestingly twisted. His photographs, the most intellectual in contemporary France, are mostly horizontal in direction and contain a unique sense of movement. In Guy Bourdin's photographs you know something is happening: you are not sure what it is, but you are intrigued. There is something weird,

even kinky, about his happenings. His work would not seem to be commercially interesting, but for twenty years it has give the pages of fashion magazines that extra little shock that is rare. But his work is not just an attempt to shock – although the first time one saw ladies displaying flowery hats underneath a row of pigs' heads hanging in a butcher's shop, the impact was terrific. But Bourdin succeeds for he creates beauty out of a strangeness and, as Francis Bacon inferred, that is a necessity. Bourdin is always looking for something different, and his experiments have become more and more wild. Some editors

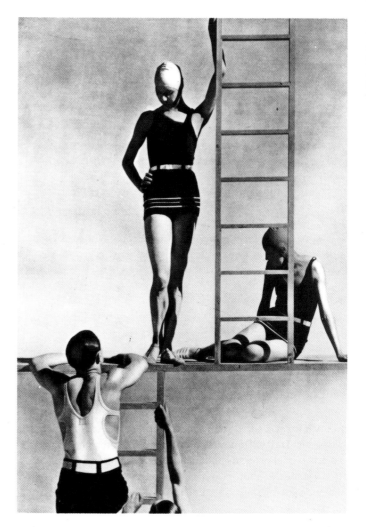

consider his latest work 'beyond the pale', while others snatch greedily for the discarded ideas. Bourdin has that precious seed that germinates rich new growth.

Guy Bourdin, who has recently used the strobe less, seems now to enjoy a return to spotlights. In the cast shadows behind them, he shows us nasty sneering girls, and his male models are the antithesis of the handsome type that was once thought a prerequisite. Bourdin prefers that they are ugly little men, with drooping moustaches and a hirsute wiriness seen at neck and wrist. Bourdin has altered the tenet that a fashion model must create an apotheosis. He despises the tall, elegant woman of graceful mien, conscious of her superiority. He insists on showing his grotesque little *gamines* doing ugly

Duffy was one of the three cockney boys who emerged from John French's darkroom to make such a stir in the 1960s. His photographs show a lack of kindliness, a quality which was beneficial at a time when flattery and romanticism in photography was over-done – especially in fashion. A dose of cathartic was necessary and Duffy, together with Donovan and Bailey, administered it. He photographed details with a rare precision – hair skeins and fibres.

Every photographer is likely to be influenced by another. Perhaps Duffy was influenced by the Arab, Fuelli, who, in turn, was influenced by Louis Faurer who, in turn, was influenced – though much more freely – by Coffin, whose work could be traced back to von Sternberg films. A great

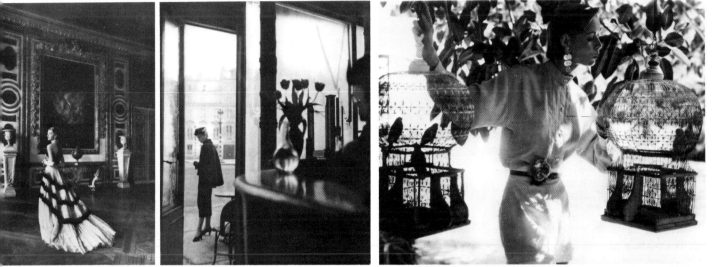

Above, left Photograph taken at Versailles by Georges Saad for *L'Art et la Mode*, 1952–3. *Centre* Schiaparelli *ensemble* photographed by Coffin for *Vogue*, April 1948. *Right* Photograph by Norman Parkinson for *Vogue*.

things in the rain, putting out their tongues, or making faces. He has lowered the social strata. The models are no longer 'ladies', but 'birds', and they do not drink champagne but prefer something like Coke; they are seen outside métros, bistros and zoos and in inelegant parts of Paris. Sometimes among them a person wears the mask of a monkey.

Bourdin, a shy, difficult man of over forty who looks half his age, works in terms of painting, and his more elaborate compositions are the nearest photo-thing we have to painting. He is apt to compose in horizontals, and often thinks in terms of the double-page spread, now despised; but this form of presentation gives him great scope when he finds interest in some particularly unprepossessing environment. To create a strange world he may apply Fellini-like wigs and make-ups to his models, whom he contrives to assume gymnastic poses although encumbered with dreadful shoes. The result seldom fails in its interest, and Bourdin is unquestionably the most interesting fashion photographer in Paris today.

John French, the fashion photographer, had as darkroom assistants Duffy, Donovan and Bailey. All had come from cockney backgrounds and all succeeded in a remarkable way to conquer the photographic world of London in the 1960s. They broke down many barriers and became known as 'The Terrible Three'.

theorist and talker, Duffy has a certain viciousness in his mentality that gives force to his work. His cockfight pictures, taken long ago, are among his best.

Terence Donovan is the son of a lorry-driver and accompanied his father all over the country instead of going to school. A self-styled 'freak for knowledge', Donovan is largely self-taught. He spends time endlessly and eagerly reading books and encyclopedias. He has accumulated quantities of information on the subjects that interest him – from Buddhism to film theory. He likes 'getting the opportunity to work on new ideas'. He is good at 'springing surprises' and looks at things differently. He photographs beer, and his fashion pictures are strong, stark and remind one of *L'année dernière à Marienbad*. As early as 1962 he was taking the sort of crepuscular pictures made today by Sarah Moon. But Donovan's young girls had no innocence and he somehow contrived to make them look as if they were wearing soiled underwear. Donovan's early interest in still-photography was followed by his making nine hundred television commercials in six years. Now feature films are his chief interest. He is still bitten with a driving ambition that never allows him to rest. 'There is too much lethargy around,' he says.

His early work was done for *Nova, Queen, Daily Express* and *About Town*. He says: 'New people have to come up with

Photograph by
Guy Bourdin
for *Vogue*.

something fresh.' His feature movie, *Yellow Dog*, on the
Japanese police, is a milestone in his interesting career. His
latest enthusiasm is Japan. 'In a 'still' you're isolating time: in a
[moving] film you're trying to re-create it.'

Often there is a danger that young photographers who
meet with wide popular success quite suddenly are pushed
further than they can naturally go. They rise too high on the
ladder too quickly. They are offered great sums for advertising.
They then are apt to become too commercial and their work
deteriorates. However, often these young stars move into other
orbits, some launching into television, advertising-film work,
and even going into theatrical or film-production.

David Bailey, the most highly publicised of the 'Terrible
Three', has had a remarkable success as a fashion photographer
in spite of a feeling that he is not deeply interested in the
ephemeral world of dressmaking. Yet Bailey has often given
enormous *éclat* to designers whose work is hard to illustrate.
He has done much to make the talented young English
couturiers hold a high place in the Sixties.

Bailey will take a whole collection of fashions and be on
another job before the negatives of the first one have been
processed. He will fly to most distant places for a couple of
sittings. It is impressive that Bailey should have photographed
fifteen dresses a day for over fourteen years, and turned out an
extraordinarily high average of published pictures. The rebel
has proved himself to be extremely reliable. He is full of
curiosity, diversity, and tricks.

Helmut Newton is often like a mischievous boy. He plays
tricks on his audience, and is always bringing out a new
surprise. Suddenly he will make his girls have eyes that shine
pink in the dark like cats' eyes. He is sometimes sadistic with
his models, but he achieves a 'sexy' look that few other
fashion photographers can manage without going over the
borderline to vulgarity. He takes odd happenings around a
swimming pool at night.

Barry Lategan, in the studio, builds up his picture step by
step, Polaroid test after Polaroid test, until he has achieved,
maybe after several hours, the exact lighting he desires and
the look of boredom on the model's face that he admires. A
master of soft-focus technique, he is at his best in close-ups,
and his alfresco shots are full of sunlight and happiness.

Sarah Moon, practising in Paris, shows us an Alice-in-
Wonderland world of fashion. Her models are young adoles-
cents who are only on the threshold of sophistication and who
cling to a poetic fantasy. She rummages among Victorian junk
for her reflections and double images. She has a very pure-in-
heart attitude to her world which she ignores as having dealings
in dross and usury. She is as wide-eyed in her approach to her
work as her young girls seen with cobweb silken hair and the
unselfconscious grace of animals out of captivity.

Jonvelle is the complete contrast. A young man working
in Provence, he seems to be aiming at producing a special

reality out of rustic idylls where young folk are all individual
and somehow transcend the fact that they are advertising
merchandise. By finding girls and shabby, loony-looking
boys in steel spectacles, and then taking away any inhibitions
they may have about the camera, he produces strange pictures
that have quite an affinity to poetry, yet are definitely down
to an earthy reality.

William Klein is an excellent photographer of many facets.
As a fashion photographer he always finds the most strangely
suitable settings for the clothes he must show. With a model
wearing a coat with a zig-zag pattern in it, he motors around
Paris and the suburbs until his quick eye spots the jagged
design of a Gothic church roof. He borrows a bicycle from a
passing boy, photographs the model on it and again achieves a
remarkable result. 'How far can you go?' he seems to ask. Even
when working in a studio he seems never to be stating a theme,
but is still lashing out in all directions for the unexpected
which, though harder to find in these confines, he manages to
do. He is now interested in movies since he broke through into
this world with an extraordinarily photographed *Polly Magoo.*

Peter Knapp trained in graphics, is excellent when composing
in terms of layouts in *Elle* and other magazines, taking fashion
pictures that are subordinate to the general design. But even
as fashion photographers go his shots possess little depth of
feeling.

Patrick Lichfield, good-looking, with long, curly hair, lithe

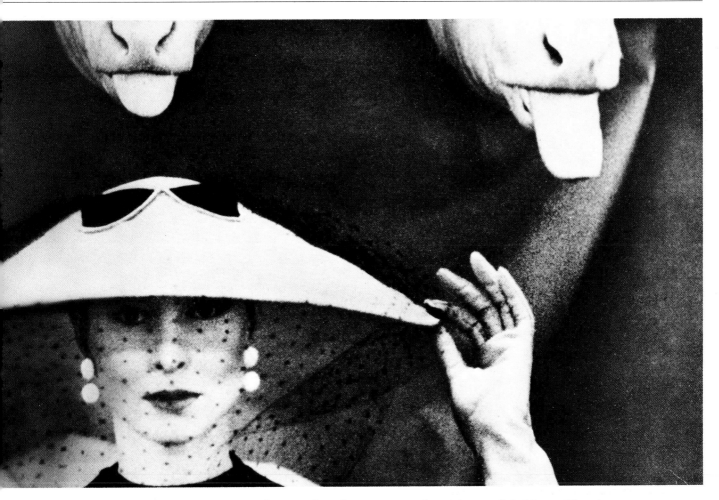

and energetic, has had a meteoric career as a photographer of many different genres. Starting as portraitist of high-class young girls, he went on to fashion and advertisements, including a lengthy series of himself wearing a number of different suitings against backgrounds of family mansions, ancestral portraits, cigar-boxes and dogs. He produced quite a remarkable group photograph of the royal Family to celebrate the twenty-fifth wedding anniversary of the Queen.

Dominique Ruat takes fashion pictures of baby-faced middle-class girls wheeling modern plastic baby-carriages in the rain. The clothes are wild, the weather poor, the scene anything but glamorous, but that is part of the intention.

Uli Rose uses a Nikon and a Polaroid and takes a child wearing a tiger's head among a lot of Japanese – again they are peering in horror or making ugly faces in the bathroom mirror with, on a shelf, the toothbrushes and ordinary appurtenances of everyday life. When the word goes round that he is fashion's most promising young photographer, he disappears and who knows when he will reappear?

Of the many photographers who snap the girls in squalid settings and rich clothes, the Milanese *Oliviero Toscani* seems to catch the fleeting with a delightful appreciation of the youthful but not entirely guileless innocents. *Ken Griffiths* and *Keith Collie* are others invigorating the pages of British *Vogue*.

David Hamilton is a poet when he shows, in a soft opal light, innocent young girls with pale silken hair, nude, or possibly wearing the minimum of clothing or Victorian transparent nightdresses. He chooses as his props baskets, simple house-hold utensils and coarse willow-pattern cups and saucers. His colour is delicious – alabaster – his texture delicately spider-skeined. Hamilton said in an interview in the *Image*: 'There are no ideas in my photographs My search is for beauty which I find in the innocence and shyness of a young girl.'

Hamilton spends his Julys and Augusts in Sweden looking for the young girls who will come to Provence and live with him and his wife (Hamilton married one of his older models) for a long holiday. Hamilton says: 'It's a very relaxed atmosphere. They go swimming, play around on the beach. We only take photographs for probably an hour, two hours, a day, so they don't get the feeling of work.' He chooses Scandinavians for he says: 'They're just more natural in everything they do. They have less complexes about their bodies and are often brought up in families where nudity is totally accepted.'

But his true idiom is best seen when, in the warm sunlight of late afternoon, he induces virginal young creatures to posturize in his St Tropez bedroom. His nudes and semi-nudes of young girls kissing one another, sprawling on brass beds absorbed in a novel, are oddly romantic. The apricot sun suffuses the room, and for greater comfort and coolness the muslin shift is rucked up and shows just a little of the pudenda. For fashion pictures he sometimes takes his young girls out into the woods and photographs them with white doves.

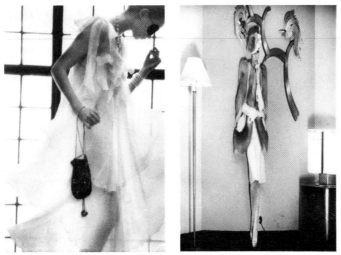

Photographs by Sarah Moon (*above, left*)
and David Bailey (*right*) for *Vogue.*

The life span of Hamilton's models is but two years: the natural qualities of youth fade fast. Hamilton says: 'Adolescence is the shortest time in a young girl's life, and I've watched it go in two summers.'

David Hamilton can utilize candlewick bedspreads, bed-linen, muslin window-curtains, and even ordinary head-scarves to lyrical purposes. He can make scanty shifts, tights, stockings, even brassières, into things that, seen so softly, become as delicately pretty as anything worn in the pastels of Fragonard or Boucher.

David Hamilton's work is certainly erotic, but never porno-graphic – for he is an artist of taste. His two books on ballet dancers are delightful.

The Japanese photographers have become more remarkable at inventing tricky techniques both in colour and in black-and-white. Avedon's pupil, *Hiro*, spends nights and days in the darkroom experimenting and probably knows more about photography than any other practitioner today. His fashion pictures show his own concept of design, with groups in wonderful and unusual attitudes that make one feel that this is something different and part of the taste of tomorrow. *James Moore*, another Japanese pupil of Avedon, has also achieved success with compelling and often weird effects.

Below Photograph by Helmut Newton for *Vogue.*

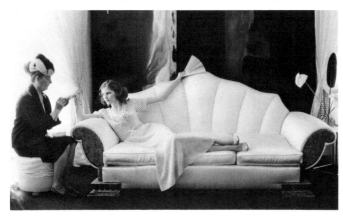

The Algerian, *Jérôme Ducrot,* makes reflections in mica in mirror. High backlighting is strong. He is interested in pigmentation in freckles, wet skin, naked bodies under strange conditions. He likes to photograph mothers and new-born babies, babies squatting on lights or a lighted surface. He makes the skin, enlarged, look like a polyps or an undersea plant.

Nowadays it is not just a question of 'taking a sitting' for an hour or so after lunch with some girls sent round by the model agency. The photographer must go out into the world to find who he considers the ideal model. In the case of Avedon's most productive trip to Ireland, he arranged for the boy and the girl he chose to pose to get to know one another well in advance, then it became obvious they liked one another, were happy in each other's company; thus a delightful intimacy came through in these extraordinarily atmospheric pictures. They had a reality that is seldom seen in fashion photography, for it is difficult to combine fashion and truth.

Since fashion-photography expeditions can be tough it is only wise that editors are apt to give the assignment to the photographer who is reliable and can put up good-humouredly with the hazards, even dangers, involved. Sometimes, after many days of flying, the group will arrive at some given place to find that there is nothing for them to use as a background except a row of palm trees. Geniality is called for when, at each dawn, the sitting starts before the heat of the day, or disease strikes, or the photographer himself falls backward over a parapet.

Types in fashion photographers change surprisingly. It was always thought that homosexual men were the most under-standing of fashion and the way girls look, but in recent years it has been considered that men who care for girls are apt to bring out the best in the models. Some models com-plain that it would be difficult for them to work with female photographers; they would feel embarrassed to do certain charades, or perhaps exert physical attraction in front of somebody of their own sex.

It is paradoxical that in America where photography has always played an important role, and never more so than today, it is, due to economic setbacks, in an extremely pre-carious situation at the present time. With magazines unable to pay the rising costs of printing and general expenses, editors consider they are able to dispense with the services of highly paid photographers and turn to the *paparazzi* 'flashlighter'. Twenty years ago in Italy the *paparazzi*, by some fantastic law of averages, were occasionally able to take a remarkable fluke picture of some celebrity off-guard. But the day of the news-shock-picture is over, and it certainly does not work for fashion photography, as no doubt the computer will discover. It is said that magazine proprietors now have their pages researched to find out which is successful; a further extension of the computer. Small wonder that these magazines today hold comparatively little individuality or personal interest.

Opposite Photograph by Hiro

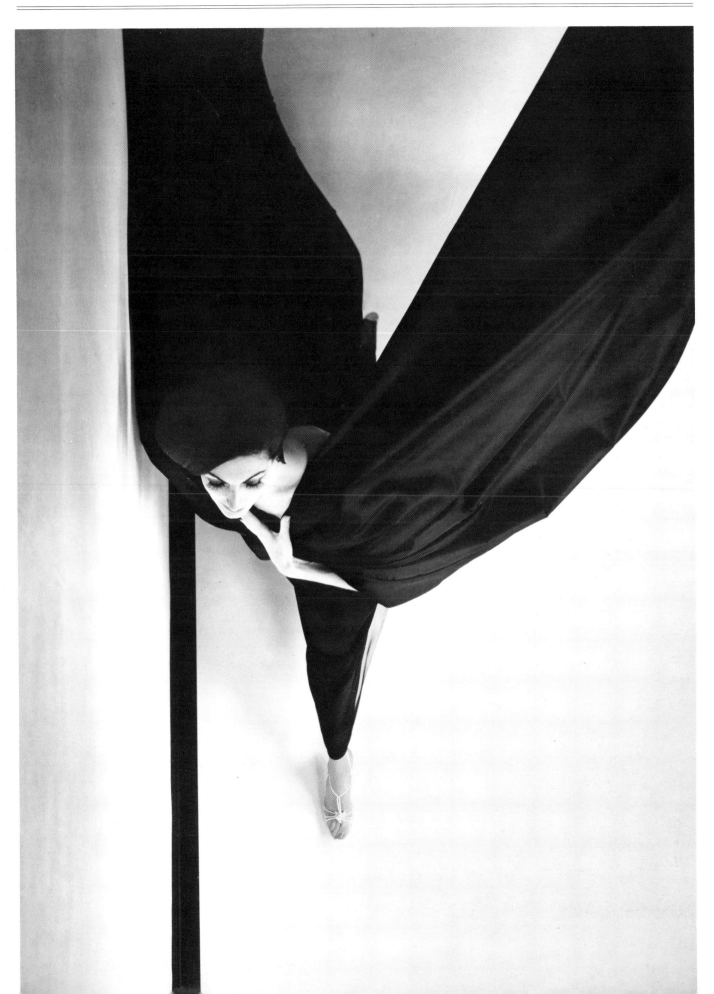

The public is too apt to take for granted the excellence of the photographs seen every day in the newspapers. It does not realize the expertise needed to capture the publishable picture: it does not realize that most probably it was taken under conditions of extreme difficulty, possibly even danger. It is a good sign that annual prizes are awarded for the best Press pictures of the year, and when the results are published, it is often a revelation to see that it is Stanley Devon, or Victor Blackman who has succeeded in such a widely stretching spectrum. Although Press photographers are apt to remain anonymous, the works of Arthur Fellig, Pat Candido, Walter Kelleher are among the best known.

In the last World War, Army photographers made fine pictures of the desert warfare that have lasting value with their own high aesthetic interest. Many of the Army radio flashes were dramatic and vivid with the transmission dots and dashes adding to their powerful effect.

Sports pictures are often not only remarkable documents of a particular event but are a triumph of stop-watch-motion and physical energy caught with startlingly beautiful results. Perhaps one might say that there are certain aspects of contemporary life that can only be conveyed by the camera.

Above, left Sarah Bernhardt with Houdini. *Above, right* King Edward arriving at the Ritz Hotel in Paris. *Far left* Suffragette demonstration. *Left* Queen Alexandra-Rose Day.

Above The last evening court held at Buckingham Palace, photographed by Bertram Park.

Above, left The wedding of Princess Elizabeth, 20 November 1947. *Centre* Funeral of King George VI, February 1952. *Right* Queen Mary.

Left Official British war photographs of the Allied offensive in North Africa. *Below* The aftermath of Hiroshima. (*Time/Life*)

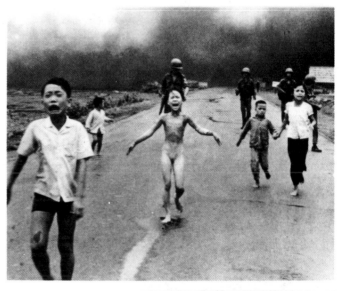

Above, top left Victim hanging head first down elevator shaft.
Photograph by Bob Costello (New York *Daily News*).
Top right Flood waters near Los Angeles (*Associated Press*).
Above, left Badminton (*Sport and General Press Agency*).
Above, right Relief during the Ethiopian famine (*Paris-Match*).

The standard of photography as seen in *Paris Match* and the English weekly supplements has given an enormous incentive: Churchill's funeral, State visits and Royal Weddings, the Queen at the Aberfan disaster, droughts and famine in India and Ethiopia, heads of State meeting violent deaths.

Present day crime has given Press photographers an enormous opportunity for showing us sights of excruciating horror – perhaps unparalleled since medieval days. The Museum of Modern Art in New York showed Press pictures of great variety and such vividness that one felt one was present at the very instant the boy discovered his dead dog, or Max Oboler hung upside down in the elevator shaft, his ankles jammed between the fifth floor elevator doors. The reality was appalling as the terrified man tried to shut his drawing room door against a tidal wave, or the motor-car came through the roof of a sitting room. One was aghast at the sight of the gangster slumped in the pool of his blood and the black lying dead in the well of a derelict staircase. With vivid precision one was shown the brutality of the wrestling or boxing ring, the Ku Klux Klan, the Presidential absurdities, the flaming Graf Zeppelin Hindenburg crashing to the ground, and the grotesque contestants in the 'Miss World' competition. A dazzling display by photographers who are virtually unknown.

Above, top Weegee, *The Critic.*
Centre South Vietnamese children fleeing from Napalm. Photograph by Nick Ut (*Associated Press*).
Right Streaker (*Paris-Match*).

289

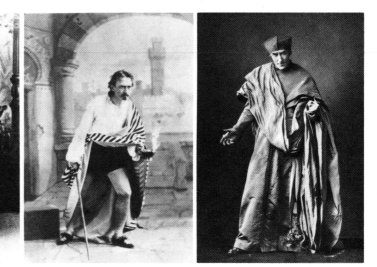

Above, left to right Charles Keen as Lear, 1858, by Laroche. Durward Lely in *Patience*, 1881. Edwin Booth as Iago in *Othello*, 1881. Henry Irving as Wolsey, 1892. *Opposite, left* Mary Anderson as Galatea, 1883. *Centre* Gaby Deslys by Talbot, *c.* 1912.

Below Sarah Bernhardt by Tourtin.

The earliest photographs of stage personalities were daguerrotypes and *cartes-de-visite*. In nearly all cases the Victorian performers were badly presented by the photographers. Charles Kean in 1842, impersonating Hamlet, resembles more a portly landlady in a bad wig, while the large-nosed Mrs Kean is likewise ludicrous as Portia. Yet these pictures were taken by the most esteemed of early theatrical photographers – *Messrs Southwell* of Cavendish Square and *Window & Grove* of Baker Street. Against their crudely painted backgrounds Marie Tempest, William Jervis and other matinée idols posed for their public and for posterity. *Walker Herbert*, in 1858, made stereoscopic studies, and *Adolf Bow* in the 1860s took theatre pictures, as did *King* of Bath, who had started life as a composer of music, but took to photography; he achieved one beautiful picture of Ellen Terry looking into a mirror. *Payne* of Islington and *Phelps Company* in England were as famous as *Napoleon Sarony* or *Falk* of Broadway in America. All used sepia cabinet-size pictures mounted on stiff cardboard and took the leading ladies of the 1870s and 1880s. *Ellis & Wallery* often used highly unsuitable backgrounds against which the most famous stage-players re-enacted scenes from plays. Not until the 1890s were there pictures showing the interiors of theatres. *Watkins Herbert* made his name for taking the first photograph on stage of the Charles Kean productions of *Richard III* and *The Winter's Tale*.

After the turn of the century, in the West End of London the theatrical productions and their leading players were, for many years, photographed by *Messrs Foulsham & Banfield*. These two gentlemen (I believe they are still alive and living in retirement in Leeds) were also gainfully employed in producing the glossy picture-postcards of the matinée idols. If their studio work was wooden and stiff, their full-set stage pictures, which as they proudly advertised were taken with a 'new magnesium process', were rather remarkable. One has only to compare them with their equivalents across the Atlantic to judge their technical achievement.

Although the portraits of *Napoleon Sarony* in New York reached a high standard in the likenesses of the boyish Maud Adams, the violently corseted Lilian Russell, and Oscar Wilde in knee-breeches, he could not lay claim to 'artistic achieve-

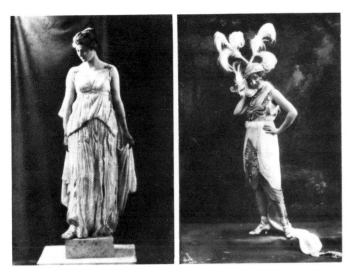

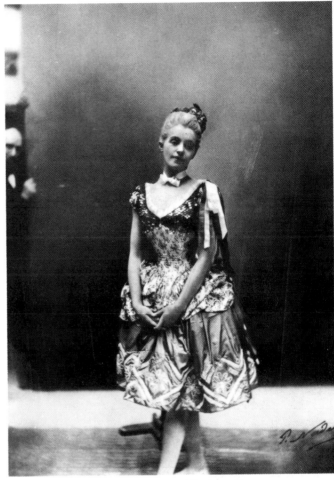

Réjane by Paul Nadar.

ment; and *White's Studio*, the New York equivalent to Foulsham & Banfield, recorded a long period of theatrical activity without giving a semblance of the glamour of what must have been a magnificent period in Broadway history. However, the mountainous bulk of work provides valuable research material – documenting all aspects of nearly half a century of theatrical productions.

For a number of years following the success of White's Studio, the ubiquitous *Florence Van Damm* hovered around actors in every part of the scene, in painted doorway and flowered arbour, on uncomfortable sofa, and on fake Louis-style *fauteuil*. Miss Van Damm's lights were unyielding and sharp – no doubt this was an asset when the glossy prints were reproduced in daily papers – but even the young actors were in need of much retouching and in this respect Miss Van Damm obliged to a point of gross flattery. Miss Van Damm became an almost essential asset to theatreland and its inhabitants. She hoed a very long row in the documentation of Broadway entertainment.

Alfred Valente made sporadic efforts to elevate the average of theatrical photography, but his efforts amount to little today.

Hoffner made one outstanding portrait of Ethel Barrymore, a profile like that on a Greek coin.

A few photographers such as *Charlotte Fairchild* purveyed to a responsive public the stage beauties or show girls in fashionable taffeta panniers and shepherdess hats. Some achieved almost as much notoriety as the water-colourist, Harrison Fisher, whose paintings adorned the covers of magazines.

Alfred Cheney Johnston showed, in soft focus, the Ziegfeld Follies girls in a studio north light against a background of stretched linen. Although these ladies posed with arched wrists cupping the Spanish shawl that scarcely concealed their breasts, and wore their hair in waves expertly set by the coiffeur in corrugated ruts, the aim of the photographer was to elevate the subjects from the vulgar to the artistic. In his day Mr Johnston achieved a great renown. 'We proudly present Mr Alfred Cheney Johnston's Portfolio of Beauty!'

Ellen Terry by James Craig Annan.

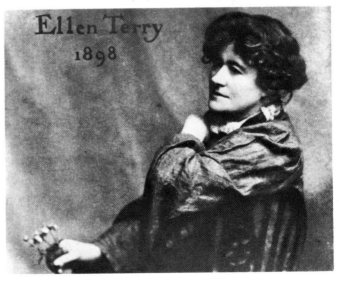

291

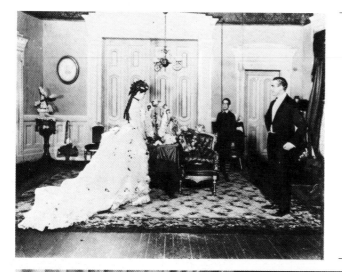

Left Ethel Barrymore in *Captain Jinks of the Horse Marines,* photographed by Byron, 1901. *Below* Robert Michaelis and Lily Elsie ending *The Dollar Princess*. Photograph by Foulsham and Danfield. *Bottom, left* Sarah Bernhardt, sculptress. *Centre* Gladys Cooper in The Betrothal. Photograph by Bertram Park. *Right* Iris Tree in *The Miracle*. Photograph by Curtis Moffat.

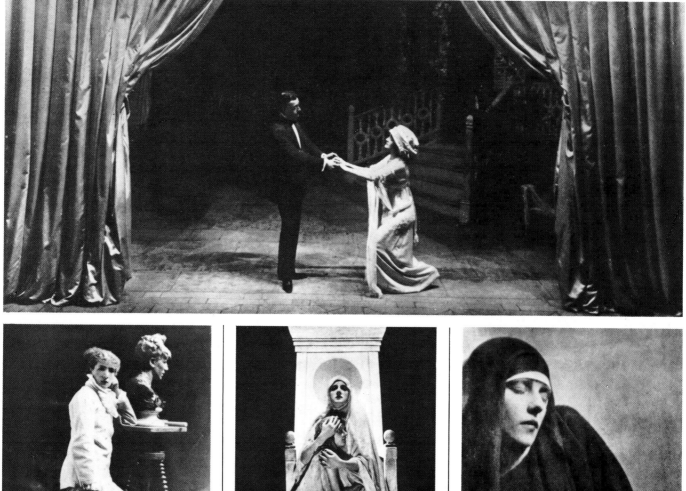

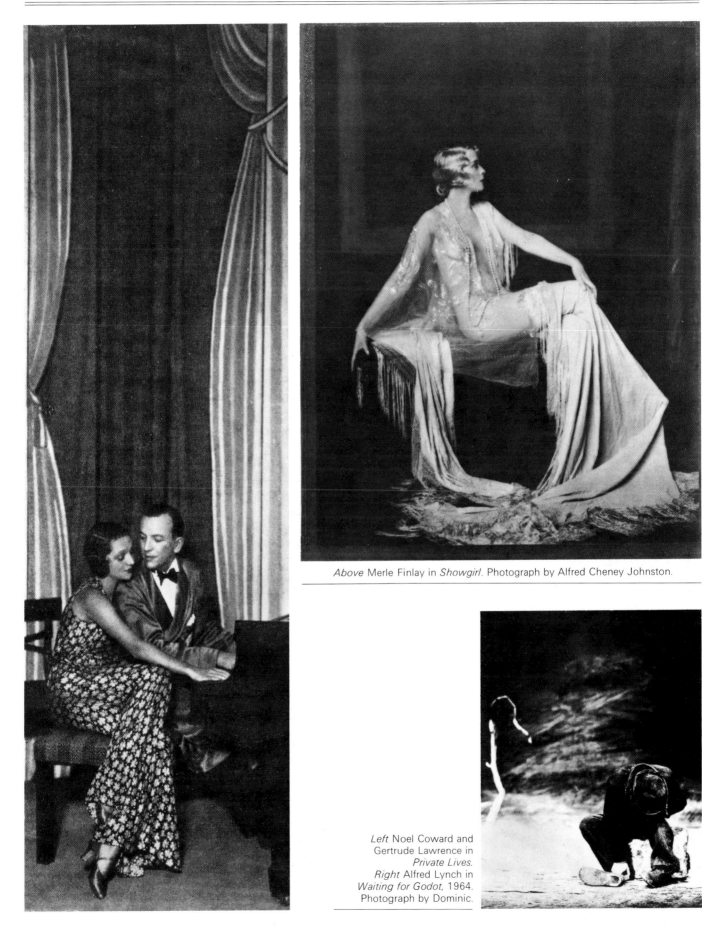

Above Merle Finlay in *Showgirl*. Photograph by Alfred Cheney Johnston.

Left Noel Coward and Gertrude Lawrence in *Private Lives*. *Right* Alfred Lynch in *Waiting for Godot*, 1964. Photograph by Dominic.

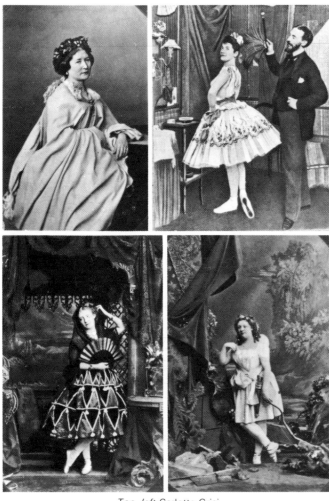

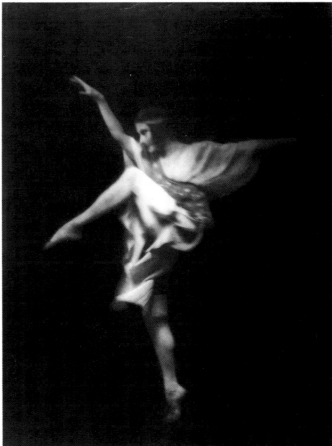

The genre of ballet photography has always been an extremely difficult one; few photographers have succeeded in creating the illusion that we enjoy when we watch the dancers from 'front of house'. The first photograph of the Diaghilev ballet that gave an impression of atmospheric lighting was of *The Good-Humoured Ladies* taken by *Maria Pearson,* and was obviously taken during a performance. It succeeded in conveying the romantic, mysterious effect created on the eye by moonlight on Bakst's Venetian décor (one of the most romantic and haunting milestones in the history of theatre design). This picture – together with Miss Pearson's vision of Tchernecheva in *Children's Tales* – was a breakthrough. At that time, no camera or film could register moving objects under ordinary theatre-lighting conditions. It was therefore customary for publicity purposes to send the dancers off to daylight studios where they must try to hold a difficult pose for many seconds. often their costumes and make-up appeared extremely coarse under such unaccustomed and close scrutiny. Seeing these unflattering documents it was hard to imagine that Lopokova and Karsavina could create such magic on the stage.

Pavlova, however, managed more successfully with her favourite, *Mishkin,* who was wont to hang around the Metropolitan Opera House in New York and preferred to photograph the overweight opera stars rather than the scrawny ballerina. *Arnold Genthe* brought off what he considered 'a miracle' when he captured Pavlova, though somewhat hazily, in motion against dark curtains. Pavlova herself

Top, left Carlotta Grisi.
Top, right Dressing-room study.
Above, left Lydia Thomson, by Southwell Brothers.
Right Clara St Casse as Cupid.
Bottom Pavlova.
Right Pavlova in *Réveil de Flore*. Photograph by Arnold Genthe.
Opposite and overleaf Vaslav Nijinsky in *Le Pavillon d'Armide*.
Photograph by de Meyer.

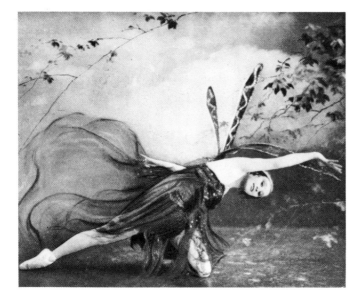

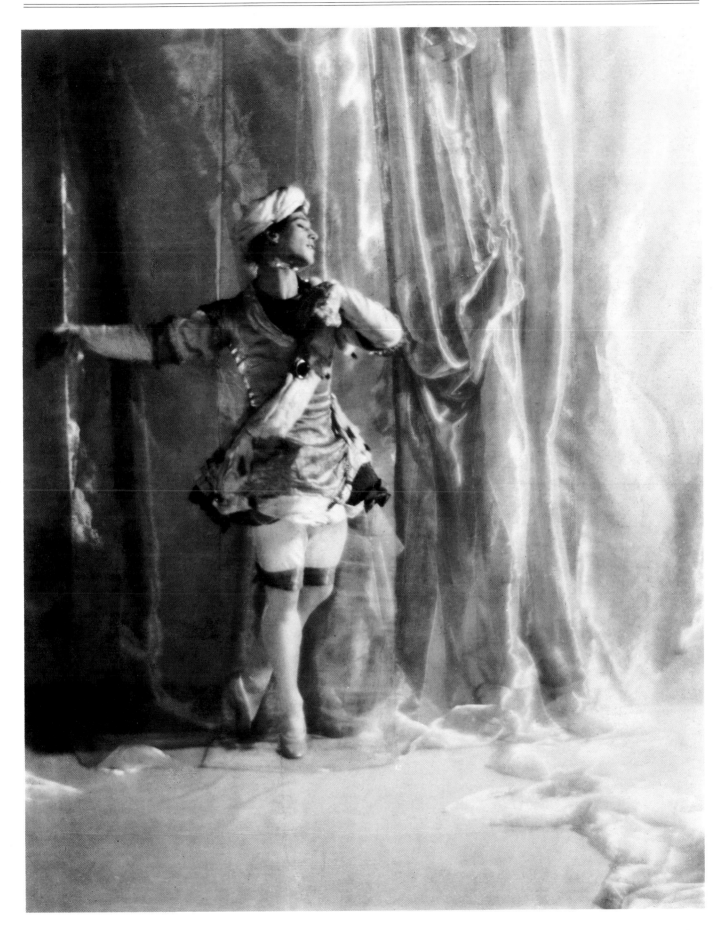

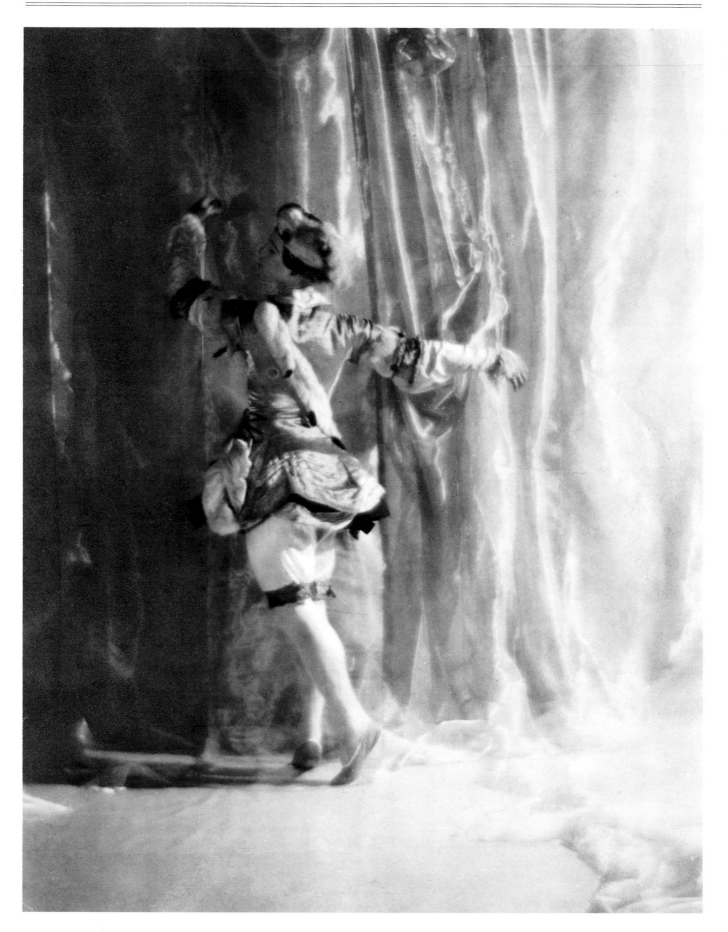

possessed an artist's eye, was a sculptress and made small figures in china which had a true understanding of movement, so she considered that whenever she 'sat' for a photograph she felt impelled to participate in the process. Not only did she insist that she should be given the negatives, and if they displeased her they were destroyed, but she was responsible for much retouching, and on the glass plates herself etched out the nobbles on her feet so that she appeared to be *en pointes* that were like tiny darts.

When the Diaghilev ballet first came to Paris, *Bert* used an easily recognizable leafy *L'Après-midi* background. A count named *Jean de Strelechi* also showed himself an enthusiast of the latest developments of the dance and photography. *De Rosen,* perhaps not so talented, was resourceful, enthusiastic and energetic, and *Balough* took some strange and interestingly ugly close-ups of Nijinsky in *Le Spectre de la Rose. De Meyer* must have spent several days making his fine collection of this greatest male dancer in all his principal roles. De Meyer gave grace and fluidity to these studio poses – taken mostly in a silver world that somehow conveys the magic of the early *Le Pavillon d'Armide* and other ballets. *Lipnitski*, who also attempted to photograph the leading dancers in Les Ballets Russes, signed his name at the bottom of his prints with a

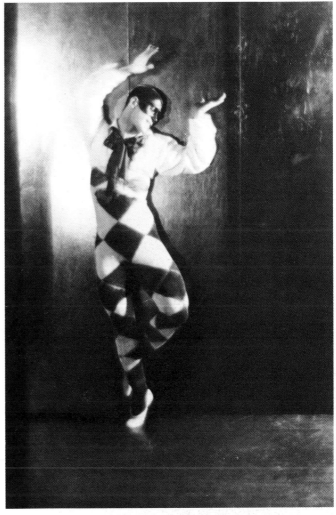

Above Nijinsky in *Carnaval.* Photograph by de Meyer.

Below Maria Pearson in *The Good-Humoured Ladies.*

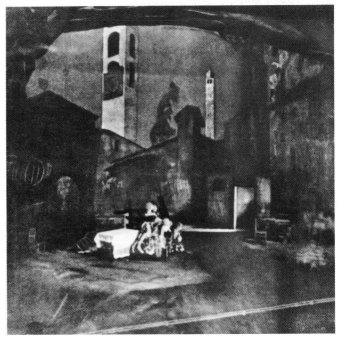

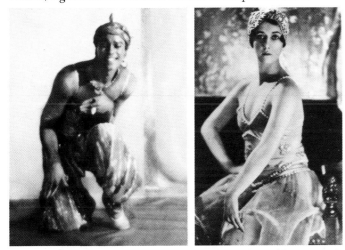

Above, left Nijinsky in *Schéhérazade. Right* Karsavina, by Bertram Park.

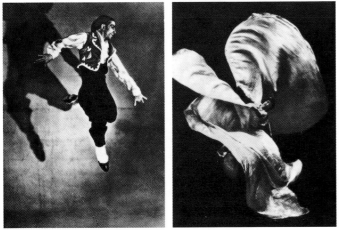

Above, left Leonide Massine in *Le Tricorne.* Photograph by Gordon Anthony. *Right* Loïe Fuller.

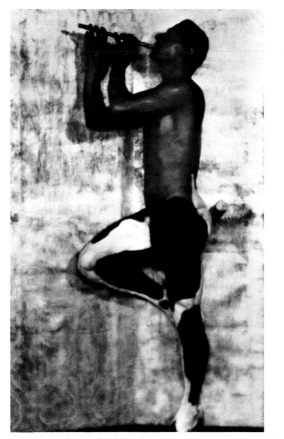

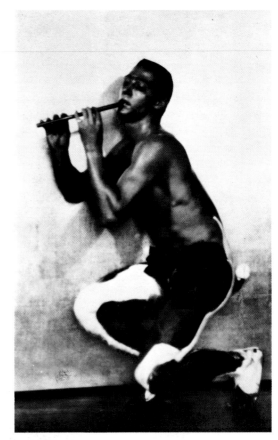

This page and opposite Rudolph Valentino as the Faun in *L'Après-midi d'un faune*. Photographs by Maurice Beck and Helen MacGregor.

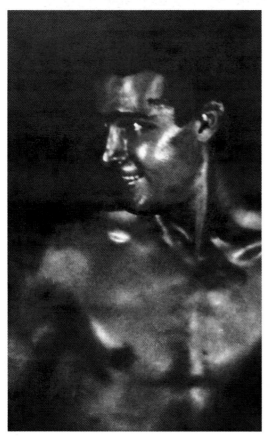

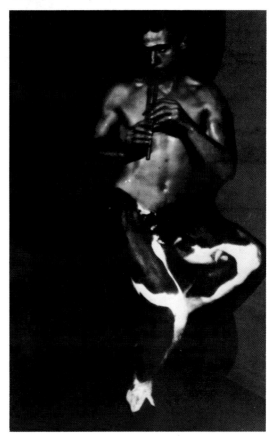

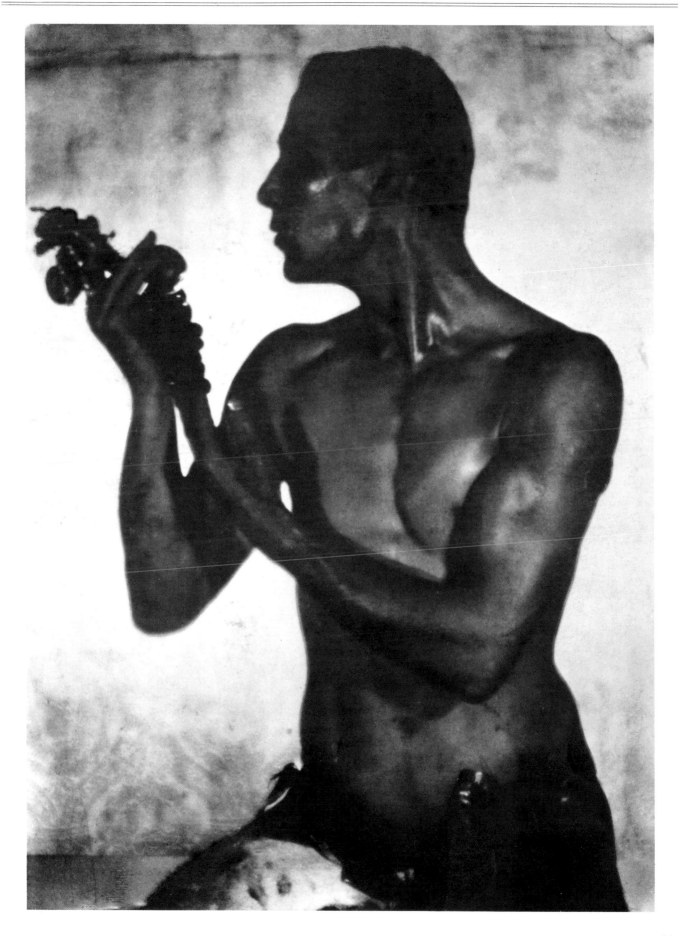

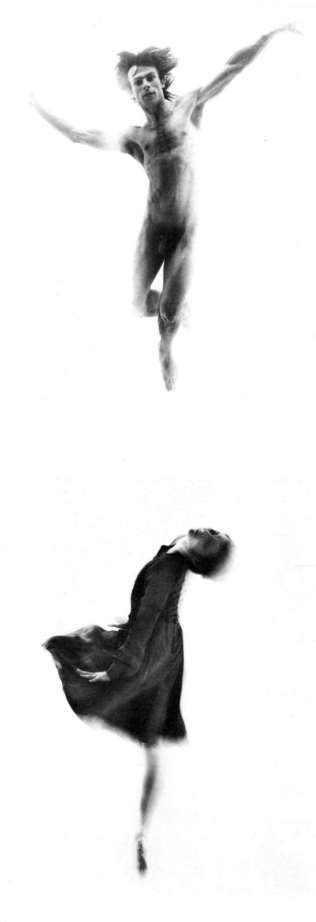

great flourish in black ink, while *Maurice Seymour* in Chicago signed his shiny ballet prints with horrible white ink. *Druet* came nearest to success with studies of Ida Rubinstein and Nijinsky in *Schéhérazade* taken in Jacques-Emile Blanche's studio with its coramandel screens.

E. O. Hoppé photographed many members of the Diaghilev ballet in his studio. His interpretations of Karsavina in *Carnival* and *Papillons* are in a Whistlerian twilit mood.

In the United States *Barbara Morgan* set herself the aim of being the best interpreter of the dance in the world. Martha Graham, with whom she spent five years, was her super-star, but she has also concentrated upon Mary Wigman and, most recently, Merce Cunningham and other dancers on the advanced American scene. *George Platt Lynes* also became immersed in making a collection of all the dancers of New York City Center. His 'eight-by-tens' of Tchelitchev's ballets were haunting and strange in the neo-romantic manner of that inspired stage-designer.

Of the beginnings of English ballet *Gordon Anthony* was the first and almost official photographer; his pictures were

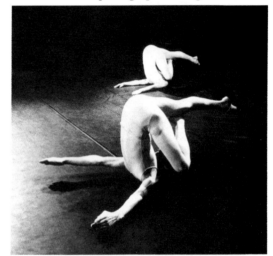

Above Dancers in *Common Ground.* Photograph by Helen Leoussi.
Left, top Micha Bergese, by Anthony Crickmay.
Bottom Lynn Seymour, by Anthony Crickmay.

taken with spotlights in a studio with shadowy and transparency effects in his backgrounds. *Peter Rose Pulham's* delightsome interpretations were full of eerie atmosphere, particularly when the young Frederick Ashton brought his *Valentine's Eve* to the old Mercury Theatre. *Baron* made a speciality of this difficult form of photography.

Roger Wood was an expert on action pictures and would make as many as a thousand exposures in an attempt to achieve one that was highly pleasing. Many of the salient successes appeared in Richard Buckle's noted magazine *Ballet.* (Roger Wood now concentrates more on creating superlative books on ancient monuments in Jerusalem or Athens.)

Anthony Crickmay, a faithful devotee of the dance, has developed a beautiful technique, cloudy and misty, inviting his favourites to his studio where in a romantic mist he creates vaguely Turneresque effects. *Zoë Dominic* is another ardent

balletomane and her pictures are always among the best of the photo-call where dozens of photographers are given little opportunity and have to take 'pot-shots' at the fleeting figures during a rehearsal. Then when the prints are made nothing of the scenery is registered.

Penn interested himself for a while in reverting to paper negatives to photograph Markova as a 'Sylphide', and in another vein he enjoyed, in the same exposure, contrasting still figures with those seen only in hazy motion. Penn brought off a *coup* with a close-up of the legs of a boyish Nureyev that showed not only the muscles in the dancer's thighs, but the veins and sinews: an evocative and disturbing revelation of the work that goes to make such apparently easy grace.

Avedon's strobe-shots of Rudolf Nureyev in mid-air, and his close-ups of the well-known Michelangeloesque torso, have brought elements of his fashion photography to this – and less remarkable ballet subjects – with refreshing success.

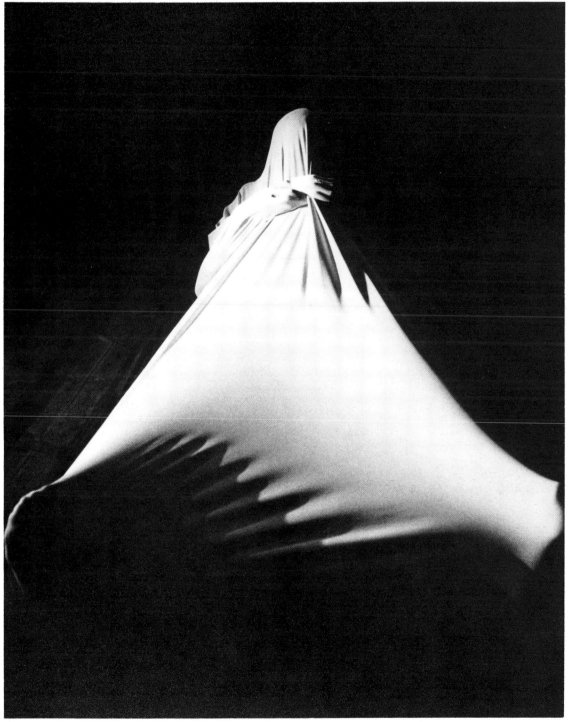

Stage II, Experimental Theatre Group. Photograph by Dominic.

GLOSSARY

Air Brush A mechanical sprayer working by means of compressed air and used for finishing and working up both prints and negatives; invented by Charles L. Burdick of Chicago in 1892. A portable air brush, similar in form to a pencil, is known as the *aerograph*.

Albumen paper Introduced by Blanquart-Evrard in 1850; paper coated with eggwhite before being sensitized with silver salts. The albumen coating gave a smoother surface and finer detail than the calotype and salted papers previously used. The most popular printing paper until the 1890s.

Ambrotype The American name for glass collodion positives.

Autochrome process A process of screen-plate colour photography invented by Auguste and Louis Lumière in 1903, based on the use of equal amounts of microscopic starch grains dyed red, green and blue violet, mixed and sifted on to glass coated with a tacky surface. The screen-plate was then coated with a pan-chromatic emulsion and was exposed in the camera with the mosaic towards the lens and then reversed through processing. Patented in England, 1904; marketed on glass plates, 1907; on sheet film, 1933.

Bromoil process A bromide print is treated with a solution which both leaches the silver image and bichromates the gelatin. After this treatment the print is washed until the yellow stain of the bichromate is removed and it is then fixed with hypo. The print is now pigmented with greasy inks supplied for the purpose. The greasy inks are absorbed by the gelatin in proportion to the amount of silver in the original bromide print. Introduced by C. W. Piper and E. J. Wall in 1907.

Bromoil transfer The inked image of the bromoil print is transferred by pressure to another base. To increase the tone range or to adjust tone values, several bromoil images can be transferred in register, thus affording the increased control of tone rendering.

Calotype (or Talbotype) process In September 1840 William Henry Fox Talbot discovered that by briefly exposing photogenic drawing paper to light he produced a latent image which could be developed with gallic acid. Positives were made from the negatives by contact printing in daylight (about 30 to 90 minutes) without development. Virtually the only negative/positive process in use before 1851.

Camera lucida An instrument used for delineating views from nature and copying drawings. Introduced by W. H. Wollaston in 1806. It consisted of a small prism supported over drawing paper. Described by W. H. F. Talbot in *Pencil of Nature*.

Camera obscura Literally 'dark chamber'; an optical instrument invented by Battista Porta in 1569, although there is evidence of earlier knowledge of its principle and properties. Depended on the fact that if a tiny hole is made in a room from which light is otherwise excluded, a small reversed image of the view outside will, under favourable circumstances, be thrown on the opposite wall. Later, portable devices were used in the form of a box with a lens, mirror and ground glass screen from which an image could be traced or copied.

Carbon process Invented in 1864 by Sir Joseph Wilson Swan. Carbon tissue, consisting of paper carrying a layer of gelatin containing a coloured pigment, is sensitized, dried, and exposed under a negative. Where light strikes the paper the gelatin is hardened and rendered insoluble in water. The exposed surface of the tissue is attached to transfer paper and soaked in tepid water. As the water dissolves the unhardened gelatin, the picture is revealed on the transfer paper. The final image is a permanent photograph, often reversed. The Autotype company acquired Swan's patent in 1868 and at one time sold as many as 50 or 60 different colours of tissue.

Carte-de-visite A popular size of professional studio portrait. The size of the mount measured 4 by 2½ inches. Extremely commonplace in the 1860s.

Collodion A solution of cellulose nitrate (gun cotton, pyroxylin) in equal parts of alcohol and ether. Used as an early binder for silver halides in the wet-collodion process.

Collotype Ground glass is coated with bichromated gelatin, the surface of which is reticulated by hot air drying. Exposure under a continuous tone negative causes selective tanning of the gelatin. After washing and treating with glycerin the surface becomes selectively hygroscopic and greasy ink adheres most readily to the areas containing least water. The resulting continuous tone image is then printed on paper. Often used in book illustration: e.g. John Thomson's *Illustrations of China and Its People*, 1873.

Combination printing The technique of making a print by the use of two or more negatives. The simplest form was the printing of a cloud into a landscape. Popular in the 1850s and 1860s; most famous practitioners were H. P. Robinson and O. G. Rejlander.

Daguerreotype The name given to the process introduced in 1839 by L. J. M. Daguerre by which an image was formed upon the silvered surface of a copper plate after sensitizing with iodine vapour. The image was developed with mercury vapour. The process comprised five operations: cleaning and polishing the silvered plate, sensitizing, exposing in the camera, developing, fixing and finishing. Went out of general use after the mid 1850s.

Detective camera Name given to early hand-held cameras, frequently disguised as parcels, books, etc., or concealed under clothing. Popular betweeen 1885 and 1900.

Diorama Theatrical entertainment invented by Daguerre and popular during the first part of the nineteenth century. Huge translucent paintings were given animation and drama by changing lighting, movement, etc.

Dry plates Sheets of glass of given sizes coated with gelatin emulsions. The term arose in the early days of photography to differentiate them from wet collodion plates.

Du Hauron colour process In 1869 Louis Ducos du Hauron published a detailed account of his accomplishments in colour photography in a pamphlet titled *Les Couleurs en Photographie, Solution du Problème*. The most important method he evolved combined dye images. It required three black-and-white negatives representing the red, green and blue in the subject. Each positive image is transformed by a complex series of steps into an image made of a dye, and the dye images are super-imposed to provide a single picture with the colour already in it.

Ferrotypes Positives produced by the wet collodion process, a black or brown enamelled iron plate used as a support instead of glass. Also known as *tintypes*.

Glass collodion positive Name given to a wet collodion negative which when set against a dark background appears positive. Popular for portraiture in the 1850s and 1860s. They were cheap imitations of daguerreotypes and like them, came in standard sizes to fit into decorative cases

Gum bichromate process A process by which a coating of bichromated gelatin containing a pigment was exposed to light under a negative and then developed with water. The areas of the gelatin rendered insoluble by the action of the light remain to give a positive picture.

Heliography A process discovered in 1826 by Joseph Nicéphore de Niepce in which a copper plate coated with silver and covered with a film of bitumen was exposed to light in the camera for several hours. Pictures, as well as engravings from the etched plates, were called *heliographs*.

'Instantaneous' photography In the early days of photography, the term was loosely used to refer to exposures of less than one second.

Linked Ring In May 1892 Alfred Maskell and fourteen other photographers founded the Linked Ring Brotherhood. Initially opposed to the uncreativeness of the entries in the annual exhibition of the Photographic Society of Great Britain. A printed statement declared that 'The Linked Ring has been constituted as a means of bringing together those who are interested in the development of the highest form of Art of which Photography is capable. …' Was a cross between a secret society, an exhibition selection committee, and a dining club. The first roll of the Linked Ring on 16 July 1892 included many well known names: B. Alfieri, Lyonel Clark, G. Davison, H. Hay Cameron, J. Gale, A. H. Hinton, F. Hollyer, H. P. Robinson and his son Ralph, L. Sawyer, F. Sutcliffe. By 1907 a total of one hundred and one Links had been elected and the roll now included the names of: F. Evans, J. C. Annan, A. L. Coburn, G. Käsebier, A. Stieglitz, E. Steichen, C. H. White, R. Demachy, H. Henneberg, H. Kühn, W. Bennington, W. Cadby, R. Craigie, F. H. Day, F. Eugene, C. Job, A. Keighley, J.Keiley, B. de Meyer, Puyo, J. B. B. Wellington.

Magnum Founded in May, 1947 by Henri Cartier-Bresson, Robert Capa, George Rodger and David Seymour ('Chim'). The name they chose meant to them 'to live in the pursuit of great pictures'. A co-operative movement owned by its members, Magnum was organized to give its members the opportunity to arrange their own photographic life in accordance with their own particular desires. It was meant to provide a joint solution of the business and operational problems confronting the individual. It was also partly derived from a need for close contact and friendly exchange of ideas between photojournalists.

Panoramic cameras Cameras which allow photographs to be taken with an abnormally wide field of view.

Photo-Club of Paris Group of photographers whose view of photography as an art was in sympathy with other secessionist movements around the world. Their first Salon was held in January 1894 and the rules of entry emphasized that 'only work, which, beyond excellent technique, presents real artistic character … will be accepted.' Leading members were Bucquet, Le Bègue, Demachy, Lacroix and Puyo.

Photogenic drawing The name given by W. H. F. Talbot to his early experiments dating from 1834. It was the first process to give fixed negatives. Were made either by placing an object on the sensitized writing paper or in the *camera obscura*. Sometime between 1835–9 Talbot began to make positives by placing the negative in contact with a second sensitized piece of paper and exposing it to light. May be lilac, pink or yellow depending on the fixative used.

Photogram Patterns and silhouettes made by placing flat or three-dimensional opaque or translucent objects directly on photographic material and illuminating from above.

Photogravure A photo-engraving intaglio process for reproducing continuous tone illustrations and text. Basically the process required a photographically engraved copper plate, made through a carbon resist, which is inked and the excessive ink wiped off by hand. A moist paper is brought into contact with the plate which is then passed through the copper plate printing press.

Platinotype A printing-out process using light-sensitive iron salts; the final image is, however, formed by precipitated platinum. As the platinum process uses no colloid layer, the image is directly embedded in the paper fibre. The prints yield very rich black tones, an accurate tone scale and very permanent images. When platinum became too costly at the time of the First World War, palladium replaced it for a time.

P.O.P Printing-out paper. Generally understood to mean gelatino-chloride paper used for all types of work. Initials first used by the Ilford Company in 1891.

Salted paper The earliest form of silver halide contact printing paper. Prepared by coating paper with a solution of common salt, drying and then floating face downwards on silver nitrate solution and drying in the dark. Later, gelatin was added to the salt pre-bath and the final image was gold or platinum toned before being fixed in hypo and washed.

Stereoscope Viewer in which a stereoscopic pair of pictures can be seen as a single image in three dimensional relief. They were a familiar feature in Victorian drawing rooms after the Great Exhibition of 1851.

Stereoscopic photography The production of pairs of photographs which give a visual impression of depth. The photographs are made from two viewpoints whose distance apart is normally the same as that of a pair of human eyes.

Stipple In retouching, working-up enlargements, etc. The covering of surfaces or filling-in of spots and imperfections with small points or dots is known as *stippling*.

Stroboscopic flash Electronic flash unit which can be fired repeatedly at intervals ranging from hundreds to thousands per second to produce multiple flash exposed photographs recording progressive stages of a movement on one film. Often abbreviated as *strobe light*.

Stump work (*stumping*) The application of powdered colour to a photographic print by means of a paper or leather stump, or with a finger-tip, the print being first prepared by rubbing with very fine pumice powder.

Tintype see Ferrotypes

Toning The process by which the tone or colour of the photographic image is changed by chemical treatment. Many toning processes also make the image more permanent.

Vienna Camera Club A group of photographers who in the late 1880s were seriously discussing the question of photography as an art form. In 1891 the Club held an exhibition devoted exclusively to photographs judged as works of art. The Club's most prominent members were Heinrich Kühn, Dr Hugo Henneberg, Professor Hans Watzek, Dr F. Sptizer.

View Camera Large-format camera originally intended for landscape photography but used today for general commercial and technical work as well. Also referred to as a *field camera* or *stand camera*.

Vignetting Technique used while making prints in which the image is faded away gradually towards the edges of the picture. Used extensively in portraiture in the nineteenth century.

Waxed paper process A modification of the calotype process introduced by Gustave Le Gray in 1850. The paper was treated with wax before sensitizing, making the paper more transparent and improving its keeping qualities.

Wet collodion process Collodion containing potassium and other iodides was coated on glass and immersed in silver nitrate. The glass plate was exposed while wet and then immediately developed in acidified ferrous sulphate and fixed in sodium or potassium cyanide solution. Published by F. Scott Archer in 1851; also referred to as the *wet plate process*.

Wet plates Early type of photographic plate used in the wet collodion process.

Woodburytypes Reproductions having a full range of delicate half-tones made by the process invented by Walter Bentley Woodbury in 1865. Produced by a continuous tone intaglio process, they can be any single colour and do not have any grain. Almost indistinguishable from carbon prints.

Index

The figures in **bold** indicate the main catalogue entry on each photographer; the figures in *italics* indicate illustrations.